The Tradition of Constructivism

The Tradition of Constructivism

Edited and with an Introduction by Stephen Bann

A DA CAPO PAPERBACK

Library of Congress Cataloging in Publication Data

The Tradition of constructivism / edited and with an introduction by
 Stephen Bann.
 p. cm. — (A Da Capo paperback)
 Reprint. Originally published: New York: Viking Press, 1974. (The
Documents of 20th-century art)
 Includes bibliographical references.
 ISBN 0-306-80396-8
 1. Constructivism (Art) 2. Art, Modern — 20th century. I. Bann,
Stephen. II. Series: Documents of 20th-century art.
N6494.C64T7 1990 89-25823
709'.04'057 — dc20 CIP

This Da Capo Press paperback edition of *The Tradition of Constructivism* is an unabridged republication of the edition published in New York in 1974. It is reprinted by arrangement with Viking Penguin, a division of Penguin Books USA Inc.

Published by Da Capo Press, Inc.
A Subsidiary of Plenum Publishing Corporation
233 Spring Street, New York, New York 10013

Acknowledgments

I would like to record my indebtedness to Philip Steadman and Michael Weaver, fellow editors of *Form;* also to Joost Baljeu, Anthony Hill, and Peter Wollen, who have given me much useful advice; and in particular to John Bowlt, whose expert knowledge of the Russian texts has been invaluable. Of the various libraries that I have been able to consult, the library of the Stedelijk Museum in Amsterdam stands well to the fore, both in the unequaled richness of its holdings and in the courtesy and efficiency of its personnel.

The names of those who have contributed translations to this collection are mentioned elsewhere. It may, however, be necessary to mention that those texts in a foreign language that already existed in English versions have, for the most part, been reproduced without substantial change. In some cases, the version itself has the status of a historical document as a result of the time and circumstances of its publication. In other cases, slight emendations have been made to secure greater fidelity to the original.

It is perhaps important to emphasize that the primary aim of these translations has been to remain faithful to the distinctive phraseology of the original texts, and that some of the more opaque passages are therefore condemned to remain opaque. The constructivists worked on language and through language; their writings formed an integral feature of their program. But clarity and elegance of expression neither were nor could have been their ultimate aim in all circumstances.

<div align="right">Stephen Bann</div>

Canterbury, November 1971

<div align="right">vii</div>

Contents

II. Toward International Constructivism: 1921–22

III. Constructivism and the Little Magazines: 1923–24

IV. Extension of Constructivist Principles: 1923–28

V. Retrospect, Theory, and Prognosis: 1928–32

From *The Construction of Architectural and Mechanical Forms* by Jakob Chernikov (1931) 148

VI. The Constructive Idea in Europe: 1930–42

From *Circle—International Survey of Constructive Art* (1937) 202

VII. The Constructive Idea in the Postwar World: 1948—65

List of Illustrations

xiii

Brief Chronology

1915 Gabo makes his first constructions.
 Tatlin exhibits his "counterreliefs" in St. Petersburg.
1917 Founding of De Stijl movement in Leiden by Mondrian and Van Doesburg.
1919 Tatlin is appointed instructor at the Free Studios in St. Petersburg and begins to plan the Monument to the Third International.
 Gropius founds the Bauhaus at Weimar.
1920 Gabo and Pevsner write "The Realistic Manifesto" on the occasion of their open-air exhibition in Moscow.
 Tatlin re-erects the model for the Monument to the Third International in Moscow on the occasion of the Eighth Soviet Congress.
1921 Varvara Stepanova speaks "On Constructivism" at the Moscow Inkhuk (Institute of Artistic Culture).
1922 Gabo, Lissitzky leave Russia for Berlin.
 International Congress of Progressive Artists in Düsseldorf: Lissitzky, Van Doesburg, and Hans Richter form the International Faction of Constructivists.
 Exhibition of Russian Art at the Van Diemen Gallery, Berlin.

1923 Moholy-Nagy joins the Bauhaus.

Van Doesburg and Van Eesteren exhibit architectural models in Paris.

Project for Palace of Labor by Vesnin brothers.

1924 *Gosplan for Literature* is published by the Literary Center of Constructivists.

1925 Soviet Pavilion for the Paris International Exposition of Modern Decorative and Industrial Arts by Melnikov.

Lissitzky returns to Russia.

1926–28 Van Doesburg collaborates with Arp and Sophie Taeuber-Arp in designing the interior of the Aubette Restaurant, Strasbourg.

1927 Esther Shub's film *The Great Road* appears on the tenth anniversary of the October Revolution.

1928 Gropius and Moholy-Nagy leave the Bauhaus. Hannes Meyer takes over control.

1930 Seuphor and Torres-García found the Cercle et Carré group in Paris.

Van Doesburg publishes *Art Concret*.

1931 Schemes by Gabo and by Le Corbusier rejected in competition for the design of a Palace of the Soviets.

1932 Abstraction-Création group founded in Paris.

Individual artistic groups in the Soviet Union dissolved by party decree.

Tatlin exhibits his Letatlin flying machine in Moscow.

1933 Bauhaus closed by Hitler.

Tatlin and other modern Russian artists subjected to merciless criticism in the official party organs for their artistic tendencies.

1937 Gabo edits the *Circle* anthology in London, with Ben Nicholson and J. L. Martin.

1946 Salon des Réalités Nouvelles founded in Paris.

1948 Biederman publishes *Art as the Evolution of Visual Knowledge*.

1951 Victor Pasmore and Mary Martin make their first reliefs.

1955 Vasarely produces his "Yellow Manifesto" on the occasion of the "Movement" exhibition at the Denise René Gallery, Paris.

1957 Gabo's *Bijenkorf Construction* completed in Rotterdam.

1958 Joost Baljeu founds *Structure* magazine with Eli Bornstein.

1961 Schöffer's luminodynamic tower erected in Liège.

1962 "Experiment in Constructie" exhibition at the Stedelijk Museum, Amsterdam; the first corporate expression of the group that had arisen around Joost Baljeu's magazine *Structure,* including work by Baljeu, Biederman, Gorin, Hill, and Mary Martin.

1969 First Nuremberg Biennale, on the theme "Constructive Art: Elements and Principles."

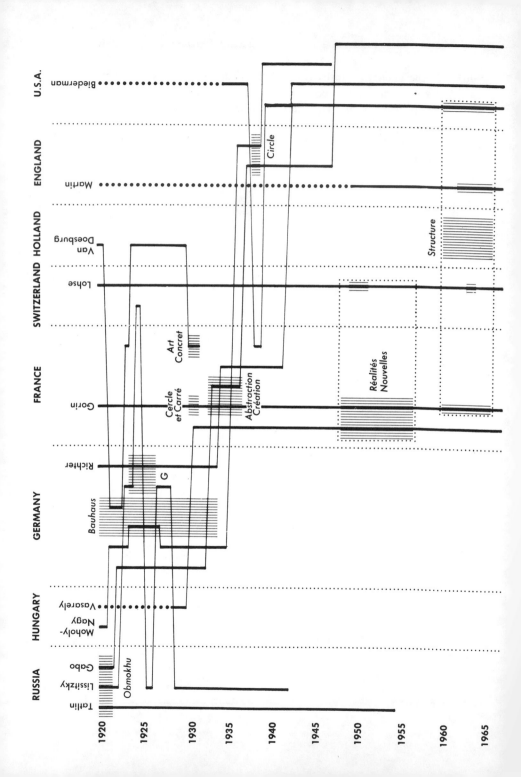

Preface

Constructivism and the New Man

It is a frequent complaint addressed to abstract, geometric art that it has failed to maintain contact with humanity, that man cannot identify his most profound emotions and his most soaring ambitions with a type of artistic expression that restricts itself to the purity and impersonality of geometrical form. This is a view of man's relationship to art, and to his environment, that seems to presuppose a lingering adherence to the "pathetic fallacy" of the romantics; to the view that external phenomena exist to provide a kind of sympathetic sounding board to human feeling, and that the artist should try to re-create this resonance in his work. What can be stated quite categorically about constructivism is that it rejects the comfortable assumption of a "given" harmony between human feeling and the outside world. In contrast, it implies that man himself is the creator of order in a world that is neither sympathetic nor hostile, and that the artist must play a central role in determining the type of order that is imposed.

Constructivism takes its stand, therefore, upon the obligations and the aspirations of the New Man. In the dark days of the First World War, the poet Isaac Rosenberg could dedicate his art to the "Soldier: Twentieth Century":

> I love you, great new Titan!
> Am I not you?
> Napoleon and Caesar
> Out of you grew.

But if Rosenberg's Titan recalls the aspirations of English vorticists and Italian futurists, the constructivist model was to be the Russian revolutionary, who, issuing from the Great War, confronted the gigantic task of building a new society. In *Doctor Zhivago* Boris Pasternak has memorably outlined his character in the *persona* of Strelnikov:

> He absorbed an immense amount of information and after taking his degree in the humanities trained himself later in science and mathematics.
> Exempted from the army, he enlisted voluntarily, was commissioned, sent to the front, and captured, and on hearing of the revolution in Russia he escaped in 1917 and came home. He had two characteristic features, two passions: an unusual power of clear and logical reasoning, and a great moral purity and sense of justice; he was ardent and honorable. . . .
> Filled with the loftiest aspirations from his childhood he had looked upon the world as a vast arena where everyone competed for perfection. . . .

We can recognize Strelnikov in Lissitzky's portrayal of the *New Man* in his Kestner Portfolio of 1923: in this striding, purposeful figure who has a black and a red star for eyes, while Lissitzky's *Old Man* is characterized by a head drooping "two paces behind." We can perhaps recognize him later in Michel Seuphor's evocation of "Man the constructor," with its explicit reference to the opening of the "Futurist Manifesto": "There are some who are announcing the new day, who can see the dawn rise before the others. Have they not, these people, been awake the whole night questioning the stars?"

And yet the identification of constructivism with the New Man poses as many questions as it resolves. Pasternak himself was swift to diagnose the limitations of Strelnikov from the creative point of view:

> But he would not have made a scientist of the sort who break new ground. His intelligence lacked the capacity for bold leaps into the unknown, the sudden flashes of insight that transcend barren, logical deductions.

And if he were really to do good, he would have needed, in addition to his principles, a heart capable of violating them—a heart which knows only of particular, not of general, cases, and which achieves greatness in little actions.

Constructivism, like the Bolshevik Revolution, may have been centrally concerned with clear and logical reasoning, with the perfection of human institutions, and with the establishment of general laws based on scientific fact. Yet the foremost constructivist artists were those who

El Lissitzky: *The New Man*, 1923.

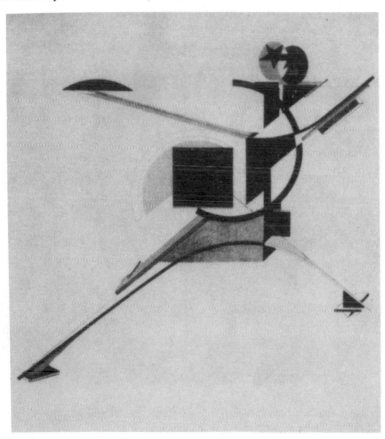

saw the world through the "prism" of their own technique. Lissitzky himself emphasizes the point in his judgment on Tatlin, who "assumed that intuitive artistic mastery of the material led to discoveries on the basis of which objects could be constructed irrespective of the rational, scientific methods of technology" and "proved the justice of his conception" by completing the model for the Monument to the Third International "without any special technoconstructive knowledge." And when Lissitzky composed his own self-portrait, *The Constructor,* in 1924, it was to emphasize—through an exquisite photomontage— the superimposition of the artist's hand and the artist's head; the compass that traces a flawless circle on graph paper is controlled by this union of manual and intellectual skill.

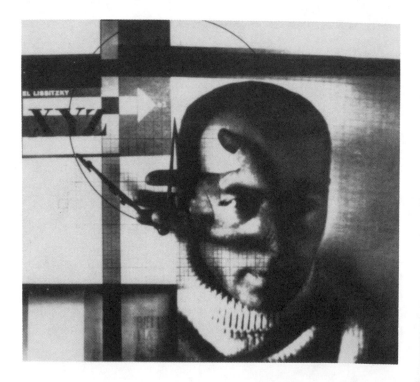

El Lissitzky: *The Constructor,* 1924. This "photogram" involves the superimposition of Lissitzky's head and hand.

Much of the fascination of constructivism lies in these tensions provoked by the image of the New Man. Theo van Doesburg's friend Peter Röhl portrayed the dilemma in a charming satire when he caricatured the meeting of "natural and mechanical man" at the Bauhaus in 1922. On a less caricatural level was the conflict that impelled Gabo to leave Russia in the same year, since he saw the liberty of the individual artist threatened by the utilitarian demands of "production art" and the intellectual straitjacket of Marxist doctrine.

The notion of constructivism as the art devised for, and in some respects by, the masses had its notable successes—in the "actorless" documentary films of Esther Shub and in the amazing development of architecture and planning in the Russia of the 1920s. But ultimately, in the absence of conclusive support from the state, responsibility for the future of constructivism was bound to revert to the individual artist, who had to reconcile within himself not only the claims of the New Man and the Old, reason and intuition, but also the paradox of creating models for a society that clearly did not exist. "We regarded our art as an art both of the present and the future," writes Gabo. "But such an art needs a new society."

Thus the constructive ideal leads us, by way of historical documentation, to the problems of the present day and the prospects for the future. The present collection sufficiently attests the vigor of the constructive tradition, which has now endured effectively for half a century. Are we nearer to the birth of the New Man? Or must the constructive artist continue to provide new models for a society that simply requires confirmation of its ancestral patterns of thought? The question is perhaps unanswerable. Yet Arthur Koestler suggested long ago in his essay *The Yogi and the Commissar* that there may be a "pendular rhythm" between "rationalistic" and "romantic" periods; between the quietism and irrationality of the Yogi and "unneurotic repression" of the Commissar, who is in a sense the official embodiment of our constructive "New Man." No one could deny the predominant prestige of the Yogi in recent years. Yet maybe the pendulum has already started to swing.

Introduction

Constructivism and Constructive Art in the Twentieth
Century

From the early 1920s, there has been both an inclusive and an ex-
clusive definition of constructivism. For an example of the latter, we
may refer to El Lissitzky and Hans (Jean) Arp's *Die Kunstismen* of
1925, where the short paragraph on constructivism is supplemented by
illustrations of work by Tatlin and Gabo, an architectural project from
the studio of Ladovsky, and a general view of the Obmokhu (Society
of Young Artists) group exhibition in Moscow in 1921. Apart from
Lissitzky himself, who adheres to his own "proun" movement, such
artists as Rodchenko, Nathan Altman, and Moholy-Nagy are placed
in the rather dubious separate category of "abstractivism." [1] * By con-
trast, the report in *De Stijl* of the Congress of International Progressive
Artists (Düsseldorf, May 1922) anticipates a far more general usage of
the term. In a note explaining the significance of the International Fac-
tion of Constructivists (I.F.d.K.), whose interventions at the Congress
were led by Theo van Doesburg, Lissitzky, and Hans Richter, Van
Doesburg himself underlines that the term is being used in direct con-
trast to "impulsivist." [2] In other words, "constructivism" is being used
to consolidate a common front against "the tyranny of the individual"
in art.

This confusion of terms has certainly not disappeared with the pas-

* Superscript numbers refer to notes to be found beginning on p. 297.

sage of time. In fact it has intensified. In 1967, George Rickey published a study entitled *Constructivism: Origins and Evolution,* in which he argued that "the pioneer work of the early Constructivists established a base from which many of the diverse and inventive non-objective tendencies of the decade 1957–67 have sprung." [3] A number of reviewers questioned whether this wide application of the term did not reduce the notion of constructivism to a lowest common denominator that distorted its historical significance and rendered it almost valueless. Yet Rickey's position was very closely reflected in the organization of the Nuremberg Biennale of 1969, devoted to Constructive Art, where works by such artists as Lissitzky, Van Doesburg, and Kassák were juxtaposed with extremely diverse examples of contemporary geometric work. [4]

The differences in attitude revealed here testify not so much to a disagreement over factual matters as to a conflict of purposes. An operative definition of constructivism, which reflects not only how the term arose but how it was extended and perhaps distorted, is bound to be unsatisfactory to those who require a purely historical or genetic definition in terms of the original movement. Yet the broader lines of historical development within the arts of this century will never be understood if the divisions between identifiable movements are made to seem absolute. The historian who wishes to confine the term constructivism to its initial flowering in Russia evades the question of why, and under what terms, artists of the thirties, forties, fifties, and sixties have continued to regard their work as "constructive."

These considerations are particularly applicable to the present collection of documents. While the historian of a movement can justifiably argue that too inclusive a definition renders any attempt at historical precision more or less fruitless, the collator of documents is bound to take a more catholic view. Clearly he cannot regard every text from a defined period that employs the word "constructivist" or "constructive" as of equal importance. At the same time he cannot afford to have rigid preconceptions about the direction or extent of the "movement" to which his documentary evidence testifies.

As a corollary to this nominalist approach, the present collection embodies no precise view of the origin of constructivism. While the historian of the movement would be obliged to weigh in the balance, for example, Gabo's view of the essential unity of Russian artistic

development,[5] and Malevich's statement that Tatlin introduced "spatial Cubist painting" [6] from France, the collection of documents must reflect, simply, the stage at which the term began to communicate a recognized meaning. The fact that Gabo, for example, was using the term "construction" for his work before 1920 [7] does not alter the claim made by Alexei Gan in 1922: "Constructivism is a phenomenon of our age. It arose in 1920 amid the 'mass action' leftist painters and ideologists." [8]

Naturally there is a great deal more to say about this process; it may be emphasized immediately that the "mass action" constructivists differed considerably in attitude from such artists as Gabo and Pevsner. All the same, from 1920 on, this dialectic within Russian art took place with reference to the developing ideology of constructivism. In Gabo's phrase, the "oral period" [9] was over.

Just as in Russian art the word "constructive" antedates the rise of constructivism, so the more diffuse phenomenon of international constructivism is itself anticipated by significant uses of the term in the art, literature, and critical theory of the years before 1920. The critic Irving Sandler has referred in a recent article on contemporary American sculpture to "the Constructivist aesthetic, most fruitful in twentieth-century sculpture." [10] Yet the consistency and fruitfulness of an aesthetic cannot be explained wholly in terms of the fortune of constructivism as a movement. It depends upon the fact that constructivism, unlike any other child of the modern movement, with the possible exception of surrealism, was able to appropriate an overall aesthetic position that had already been sketched out and developed in other terms for the needs of other generations. A short account of the way in which this position gradually became identified with "constructive" ideas is a necessary prelude to the materials included in this collection.

First of all, it is important to recognize the unique position of the concept of "construction" as a description of the creative process and a metaphorical representation of the order of the work of art. Roland Barthes has suggested in his article on Michel Butor's novel *Mobile* that criticism of the novel has traditionally depended on the acceptance of certain "sympathetic metaphors"; [11] Butor, who explicitly devised *Mobile* as a "constructed" work, runs the risk of violating the reader's sensibility since he neglects the precept that a novel must "flow," thus perpetuating in the narrative "the myth of life itself."

Several points might be made in connection with this judgment, among them the point that it was precisely the Russian formalist critics of the 1920s, friends and collaborators of the constructivists, who, in raising such issues as "the notion of construction" [12] with regard to literature, anticipated Barthes's own structuralist approach. But the main principle that Barthes contributes to my argument is that there do exist such "sympathetic metaphors," which are particularly appropriate to specific branches of art and literature, but at the same time reflect so basic a truth that they can be applied to the whole range of creative activity. There is no essential reason why a novel should not be created or analyzed in terms of construction, just as there is no reason why an architect such as Gaudí should not conceive of a building "representing waves on a stormy day."

If we recognize, in the broadest terms, that the romantic movement involved an acceptance of spontaneity, "flow," and "the myth of life" to the exclusion of intellectualism and the axiom of conscious control, then the development and extension of constructive ideas can be seen as a delayed reaction to romanticism. And while constructivism in the 1920s offers the best evidence for the breadth of this reaction, the increasing attachment of nineteenth-century architects to their "sympathetic metaphor" of construction can be seen as an early indication of the same process. Nikolaus Pevsner traces this theme through such architects as the Englishman Pugin, the American Russell Sturgis, and the Belgian Van de Velde in his *Pioneers of Modern Design,* and he notes that by the end of the century a painter such as Cézanne was abandoning "sensuous appeal" in favor of "an abstract scheme of construction." [13]

This parallel between constructive values in architecture and in painting was not restricted to the creative artist. It is surely no accident that the end of the nineteenth century saw the beginning of the rise to popularity of Piero della Francesca, later termed by André Lhote the "first cubist," whom Longhi was discussing in 1913 in terms of his "perspectival construction" and "central construction." [14] The effort to establish constructive principles common to both architecture and the plastic arts had to wait until the early 1920s, but on the threshold of the decade Mondrian was still expressing the painter's admiration for the "beauty of the construction" of the Paris subways, and still envying the position of the engineer, who "devotes his life ex-

clusively to construction, and . . . creates pure relations by sheer necessity." [15]

While it is easy to understand that the cubists and their followers valued the image of construction, it is perhaps more surprising that artistic tendencies of an apparently contrasting character should have produced similar equations. Theo van Doesburg suggested in 1916 that it was Kandinsky who occupied the crucial place in the transition between "abstract-romantic" and "constructed" [16] styles. But of the expressionist generation, Franz Marc had already written of the need for an "inner mystical construction" [17] to set the world to rights. The dadaist Jean Arp also made significant use of the term "construction," [18] just as Raoul Hausmann was to write, of Berlin dada, that he and his fellow dadaists regarded themselves as "engineers" and their work as "construction." [19] There is surely much truth in Hans Richter's observation that far from being antithetical to constructivism, "the law of chance which Dada had discovered" was the "counterpart" to the "tendencies for an order, a structure" that characterized the later movement.[20]

Of course these varied reactions to the notion of constructed form did not take place in an aesthetic vacuum. The need not simply for "construction," but for "reconstruction," was emphasized by Mondrian as a necessary sequel to the "destruction" of naturalistic painting.[21] But Balla and Depero's manifesto for the "Futurist Reconstruction of the Universe," [22] dated March 11, 1915, was clearly intended to embody prescriptions for the reintegration of society and art in the havoc after the First World War. This motif of "reconstruction" was later to be stressed by El Lissitzky when he looked back at the achievement of Soviet architecture in the decade that followed the Revolution of 1917.[23]

His reference to the distinctive situation of Russia in the years that followed the First World War leads me to stress the fact that these generalized tendencies toward constructive art and constructive attitudes would, in all probability, have given rise to no coherent movement if the Soviet example had not acted as a galvanizing force. Russia became the source and catalyst of constructivism because conditions for a few years after the Revolution permitted a conjunction of practical and creative aims that was unprecedented. As Tatlin and his fellow artists emphasized on the last day of 1920, the Revolution of

1917 had been anticipated by a revolution in pictorial methods that could be dated as early as 1914. Yet this pictorial revolution alone would not have impelled them to envisage the "work of creating a new world."

It is in this context that Tatlin makes reference to the need for a "modern classicism." And it is this equation of constructive with classicist principles that allows us to glimpse the ultimate consequences of using the metaphor of construction as an antidote to romantic vitalism. In relation to the nineteenth-century tradition, and indeed to the earlier phase of the modern movement, constructivism signified a revival of the belief in a fixed, classical vocabulary. As Lissitzky and Ehrenburg wrote in 1922, quoting from Mayakovsky's notorious manifesto "A Slap to the Public's Taste," published in December 1912: "It is as laughable as it is naïve to talk nowadays about wanting 'to throw Pushkin . . . overboard.' In the flux of forms binding laws do exist, and the classical models need cause no alarm to the artists of the New Age." [24]

The Russian constructivists were by no means the first artists to proclaim a revival of the principles of classicism. Maurice Denis, in particular, had devoted his considerable critical talent to the evocation of a "new classical order," [25] based essentially upon the work of Gauguin and Cézanne. Yet Denis's call for a return to the French classical tradition was hardly valid beyond his own country, or outside the confines of traditional art. When Gide was asked, in 1921, to provide a definition of classicism, he concluded that the "sole legitimate" form was that in which "all of the elements in ferment in the modern world, after having found free expansion, will organize themselves according to their true reciprocal relationships." [26] It was in revolutionary Russia, initially, that this "free expansion" took place. Artists were able to aspire once again to what Gide called "an integration within themselves of the totality of the ethical, intellectual, and emotional preoccupations of their times." [27]

The texts assembled here can be divided, for the sake of convenience, into three groups, which coincide with the 1920s, the 1930s, and the postwar period. Each of these divisions reflects a crucial transformation in the development of constructivism and constructive art in general. At the same time, it is necessary to take account, from the very start, of the broad division between Russian and international constructivism that has already been mentioned.

It hardly requires stating that the course of Russian constructivism was almost completely autonomous. Gan's remark, which situates its origin in 1920, has already been quoted. But it would be oversimplifying the issue to introduce the three Russian texts that date from that year as constructivist manifestoes without any reservations. Camilla Gray has suggested that by December 1921, when Varvara Stepanova spoke "On Constructivism" at the Moscow Inkhuk (Institute of Artistic Culture), the term had been accepted by artists as a legitimate description of their ideas.[28] And, clearly, this particular month, when Tatlin spoke at Inkhuk also and was authorized to extend its activities to Petrograd, did represent a crucial stage in the dissemination of constructivist ideology. But if the stimulus of a group exhibition may be regarded as significant in diffusing a common attitude, then the Obmochu exhibition, which took place earlier in 1921 and was illustrated in *Die Kunstismen,* must be taken into account.

None of these factors prevents us from viewing the three manifestoes that open this collection as invaluable evidence of the way in which ideas had begun to crystallize at the outset of the new decade. "The Realistic Manifesto" of Gabo and Pevsner, which stands first not only in date but in reputation, has a Januslike status that makes it particularly valuable at this point. As Gabo has emphasized, it embodies a searching glance at the course of modernism in Russian art up to that date, "in the spirit of a résumé more than a program." Yet its many partial and complete reprintings—in the first number of *G* (July 1923), in the first number of *Abstraction-Création* (1932), in English, German, French, and Spanish translations—testify, like the career of Gabo himself, to the continuing vigor of the constructive idea.

"The Realistic Manifesto" was printed and posted all over Moscow to coincide with an open-air exhibition of work on the Tverskoy Boulevard. By contrast, Tatlin's short statement "The Work Ahead of Us" was intended to serve as an explanatory note to a single work— the model for a Monument to the Third International, which was erected in Moscow in December 1920, at the time of the Eighth Soviet Congress. Tatlin had traveled from Petrograd for the occasion, and his fellow signatories were young artists who had assisted him in the construction.[29]

As Lissitzky suggested in his study of Russian architecture since the Revolution, Tatlin's ideal was "intuitive" rather than "rational." Nonetheless his craftsmanlike dedication to materials and his "call [to]

. . . producers to exercise control over the forms encountered in our new everyday life" could easily be extended to embody a thorough-going rejection of all but utilitarian purposes by the artist. It was this tendency that Gabo later stigmatized as a "kind of Nihilism" and that he attacked by implication in "The Realistic Manifesto" when he vindicated the independent social role of art. In the "Program of the Productivist Group," which appeared "several months after" the Gabo-Pevsner manifesto, the ideology of "scientific communism" and "historical materialism" was invoked to provide ammunition against the point of view that Gabo represented.[30] The authors were Rodchenko and Varvara Stepanova, who published their statement in the catalogue of an exhibition they had organized.

In the manifestoes of both Gabo and Tatlin, the concepts of "constructive technique" and "construction" occupy vital stages in the respective programs. In the productivist program, the words "construction," "constructive," and "constructivist" are stressed to the point of becoming clamorous. What is more significant, the terms "constructivist" and "productivist" are used as synonyms. In a collection of articles entitled *Iskusstvo v proizvodstve* (Art in Production), which appeared in 1921, this identity becomes the subject of a more coherent and more prolonged discussion. A. Filippov begins his article on "Production Art" with a distinction between two different types of artistic imagination, "the reproductive and the constructive," and two different kinds of art, the "imitative" and the "productional, productive." The constructive imagination is essential to the realization of productional art, of which such "completely new forms" as "obelisks and vases, carpets and porticoes, furniture and temples" are typical examples. Both Filippov's piece and a companion article by A. Toporkov, which celebrates the beauty of the motorcar, reflect the doctrines of Russian futurism in their ideal of transforming life through art. However, they anticipate the junction of futurism and productivism/constructivism in 1923, in Mayakovsky's *Lef* (Journal of the Left Front of the Arts).[31]

What I have called international constructivism dates essentially from 1922, though such a document as the "Call for Elementarist Art," composed in Berlin in October 1921 and published in *De Stijl,* provides a foretaste of the movement. In 1920, Konstantin Umanskij had pub-

lished in German a book on revolutionary art in Russia, in which he mentioned Tatlin's "machine art." The same year Tatlin was commemorated by a special poster in the Berlin exhibition of the dadaists, while Raoul Hausmann composed a collage showing *Tatlin at Home* among mechanical and biomorphic forms. Besides Hausmann and his fellow dadaist Hans Arp, the other two signatories to the "Call" are of particular interest. László Moholy-Nagy had just moved to Berlin from Budapest, where the adherents of expressionism had sneered at the "emotional barrenness" of the postsuprematist work in which he was engaged. The Russian Ivan Puni, who had been an early adherent of suprematism, and a contributor to Osip Brik's journal *Iskusstvo kommuny* (Art of the Commune) in 1918–19, was to take up his position alongside the constructivists at the Congress of International Progressive Artists in Düsseldorf (May 1922).

It was this congress—following upon the renewed contact between Russia and the West symbolized by the founding by Lissitzky and Ehrenburg of the magazine *Veshch/Gegenstand/Objet* in March 1922 —that established the vital axis of avant-garde artists necessary to the propagation of constructivism on a European scale. Faced by the attempt of a heterogeneous majority of groups and individual artists to steamroll decisions of policy through the congress, the trio of Lissitzky, Theo van Doesburg, and Hans Richter joined forces and constituted themselves the International Faction of Constructivists. Each signed a separate statement on behalf of his particular group, but all combined in a communal statement condemning the "tyranny of the individual," which was impeding "the systematization of the means of expression to produce results that are universally comprehensible."

The great exhibition of modern Russian art that took place at the Van Diemen Gallery, Berlin, toward the end of 1922, was a powerful reminder of what the Russian constructivists had achieved. But it can hardly be said to have affected the course of the new international constructivism, which developed apace from the information and theory disseminated by Lissitzky, Van Doesburg, and Richter. In 1923, after *Veshch* had ceased to appear, Lissitzky joined Richter in founding *G—Zeitschrift für elementare Gestaltung,* which was advertised in Van Doesburg's *De Stijl* as "the organ of the constructivists in Europe." Van Doesburg himself, having published in *De Stijl* the various state-

ments made at the Düsseldorf congress, returned later in the year to a further "Manifesto of International Constructivism." This was signed in Weimar in September 1922 by Karel Maes of Belgium and Max Burchartz of Germany, in addition to the three original members of the I.F.d.K.[32]

As a direct result of all this activity, other groups of artists began to define their own positions in relation to the new ideology. In Vienna, in July 1922, a group of Hungarian artists including Kassák and Moholy-Nagy signed a statement giving their support to the I.F.d.K., which was duly published in *De Stijl*. Their magazine, *Ma*, had in fact already produced a Van Doesburg number. When the Czech artist Karel Teige published the first number of *Disk* in Prague in May 1923, his highly individual editorial defined the picture as a "constructive poem of the beauties of the world." In the following year, the editors of the Warsaw magazine *Blok* gave a detailed account of "What Constructivism Is." They had been in touch with Lissitzky and quoted liberally in this editorial from the architectural writings of Van Doesburg.

The editorial from *Blok* enables us to take account of the development of international constructivist ideas between 1922 and 1924. Particularly significant is the way in which it points to the influence of Van Doesburg's theory of "elemental formation," which had been published in the first number of *G* (July 1923). The previous year, in the Düsseldorf statement of the I.F.d.K., Van Doesburg and his colleagues were calling for the "systematization of the means of expression." In *G*, he attempted to solve the problem of a "systematic making of rules" by presenting in schematic form the "ground bases" of painting, sculpture, and architecture. His architectural schema is directly echoed in the first number of *Blok,* in a design by Mieczyslaw Szczuka, while his concept of problematic construction can be detected in the advocacy of "the problem of CONSTRUCTION and *not* the problem of *form*" in *Blok,* no. 6–7. Above all, the editors of *Blok* testify to the adoption of a common attitude to technology and the industrially produced object. Van Doesburg had suggested in *G,* no. 1, that the "precision, the explicitness" that he desired in the work of art had "the same roots as the . . . technological perfection" of everyday, functional objects. The editors of *Blok* stated succinctly: "Constructivism does not imitate the machine but finds its parallel in the simplicity and logic of the machine."

At this point it seems possible to establish a comparison between Russian and international constructivism, as they had developed by 1924. The main contrast between the two doctrines, as exemplified on the one hand by Mayakovsky's magazine *Lef* and on the other by such kindred productions as *G, De Stijl,* and *Blok,* can be seen to derive from the Russian commitment to materialism. Alexei Gan had written in 1922: "Without art, by means of intellectual-material production, the constructivist joins the proletarian order for the struggle with the past, for the conquest of the future."

This commitment on the part of the artist led almost inevitably to the position that Arvatov defined in 1923 in his work on *Art and Class,* where he declared that "the creative processing of practical materials" was "the basic, even the sole, aim of art." In practical terms, the artist's role became that postulated by Osip Brik in his article for *Lef* on Rodchenko. Rather than relying on "immutable laws of construction," Rodchenko was bound to start "from the conditions set by the individual case." His superiority to the applied artist depended not on the fact that he was concerned with a different type of object, or a wider range of objects, but simply on his correct understanding of "the material that underlies the design." Brik went on: "The applied artist has nothing to do if he can't embellish an object; for Rodchenko a complete lack of embellishment is a necessary condition for the proper construction of the object."

By contrast, the concern with "binding laws" and "systematic making of rules" that characterizes Lissitzky and Van Doesburg presupposes quite a different scale of values. With them the analogy between artistic formation and mechanistic production is always made on the level of the respective *processes,* and the artist is never expected to take the place of the industrial designer, as in Brik's scheme. In part, this difference can be seen as an inevitable result of the differing social climates in which the two groups of constructivists were working. Whereas the Russian artist could identify himself with the struggle of the proletariat through "intellectual-material production," the European (and in this case Lissitzky must be counted among the Europeans) was forced to concentrate his attention upon the sheer problem of communication, across existing barriers of nationality and profession. To Hans Richter, who was exploring through *G* "the possibility of a culture in the unholy chaos of our age," the only solution lay in an appeal to the specialist to look beyond the immediate confines of

his subject. *G* was to encourage him by laying out "general, not merely specialized" guidelines.

In addition to this area of difference, we must take into account the related fact that if Russian constructivism was obeying a political and social imperative, international constructivism was obeying an aesthetic imperative. Richter's suggestion that constructivism was the "counterpart" to "the law of chance which Dada had discovered" [33] helps to explain the fruitful, though curious, juxtaposition of the two strains in the period under review. It helps to explain, for example, the fact that the dadaist Kurt Schwitters collaborated with Van Doesburg in 1922, when several public performances were arranged in Holland "in Konstruktixistik manner," [34] and in 1924 joined with Lissitzky to edit the issue of *Merz* entitled "Nasci," which was concerned with "constructive" analogies between natural and man-made forms.

This suggestion that dadaism was the unspoken, or normally unspoken, premise of constructivism makes it easier to understand the complex role of Van Doesburg himself, who in 1922 used the pseudonym I. K. Bonset in founding the dadaist periodical *Mécano.* The manifesto "Toward a Constructive Poetry," which he contributed to the last number of *Mécano,* in 1923, points clearly to the connection between "destruction of syntax" and the "reconstruction" of the new poetry, and fully acknowledges the preliminary work of such poets as Albert-Birot, Arp, and Schwitters in this direction. Van Doesburg's insistence that "when reconstructing art, it does not matter whether the result is useful or not" could hardly be further removed from the official policy of the Russian Literary Center of Constructivists, which proclaimed in 1924 "a system of maximum exploitation of subject" and stated that "constructivism is a motivated art."

However, this sharp difference of emphasis should be seen less in terms of the antithesis between Russian and international constructivism than as a stage in the polemic between Van Doesburg and the tendencies that he associated with the Bauhaus. It was largely in order to counteract these tendencies, which he had observed at the Bauhaus in 1921, that Van Doesburg founded *Mécano* and adopted the satirical stance of the dadaists. Since it has become customary to regard the Bauhaus as perhaps the central institution of constructivism outside Russia, the logic of Van Doesburg's position must be explained a little more fully.

In 1925, the typographer Jan Tschichold, friend and disciple of El Lissitzky, summarized the history of the various modern artistic movements, from impressionism to constructivism, and concluded that the founding of the Bauhaus by Walter Gropius in 1919 constituted a movement "parallel" to Russian constructivism if entirely separate from it.[35] But while it is possible to accept in general terms Gabo's point that the Bauhaus adopted and extended the principles of art education pioneered in the Russian Vkhutemas (Higher Technical Artistic Studios),[36] it would be wrong to see the history of the Bauhaus in any terms other than those of deep internal ideological conflict. And the respective parties in the conflict could not all be classified as constructivists by any means. Johannes Itten, who set up the all-important preliminary course, was taken to roaming the corridors in his "black monk's outfit," while supervising "the students' pre-class breathing exercises." [37] Between 1921 and 1923, Van Doesburg frequently visited the Bauhaus to combat this "romantic phase" with his "new theory of Stijl-Constructivism," and in the latter year, when Van Doesburg himself came near in his own estimation to "overturning the directory" and "was forced to leave," Gropius dispensed with Itten's services.

"Bauhaus however has gone constructivist," [38] wrote Van Doesburg, reviewing these events in 1927. Presumably the most important aspect of this change was the appointment of Moholy-Nagy to take over the preliminary course from Itten. And those of the staff who were "devoted to the extremes of German expressionism" undoubtedly saw this appointment as a move to subvert the old order with the aid of a "Russian trend" based on "exact, simulatively technical forms." [39] However Moholy-Nagy had a persistent distrust of the "catchwords" [40] used to classify artistic styles, and saw "constructivism" as no exception to the rule.[41] Though it is certainly justifiable to regard the course that he directed between 1923 and 1928 as a practical demonstration of constructivist principles, it is important to recognize the deeply humanistic tendency of his teaching. As he explained in his letter of January 17, 1928, which gave his reasons for leaving the Bauhaus: "The spirit of construction for which I and others gave all we had—and gave it gladly—has been replaced by a tendency toward application. My realm was the construction of school and man." [42]

For the two years after Moholy-Nagy's departure, the Bauhaus moved toward "a program of increased technology" under the direc-

tion of Hannes Meyer. The distinction between constructivism and pure functionalism, whose combination had been the decisive reason for the achievement of the Bauhaus in the mid-1920s, was accentuated by the constricting attitude of Meyer, who inclined toward the belief that "there was no aesthetic factor involved in design" and that "form was a product of arithmetic." Only with the replacement of Meyer by Mies van der Rohe in 1930 did the Bauhaus recover its balance. Mies was ready to concede that architecture had "its roots completely in the functional" but maintained that it reached "above and beyond" into the "sphere of pure art." [43]

This bitter struggle between the constructivists and the functionalists, which in some ways recalls Gabo's original campaign against "production art," was in no sense confined to the Bauhaus. Hannes Meyer, an orthodox Marxist, was introducing a polemic that was also running its course in Russia during the late 1920s and early 1930s. In 1926, El Lissitzky had undertaken the design of *Asnova,* the bulletin of the Moscow Association of New Architects, whose activities were occupying a large part of his time.[44] Three years later, however, *Asnova* had become the organ of the functionalists and was leading the attack on the constructivist architecture championed by A. A. Vesnin, co-editor of the rival magazine *SA* (Contemporary Architecture).[45] The reverberations of this conflict were by no means confined to Russia. In 1929 Le Corbusier, who had just completed the Centrosoyuz Building in Moscow, wrote an article for *Stavba* of Prague in which he defended "Alexander Vesnin, founder of constructivism" against the functionalist views of Karel Teige, erstwhile editor of *Disk.*[46]

In contrast to the exuberance and optimism of the early 1920s, the last years of the decade seem to suffer from a slowing down of pace that issues such as this did little to counteract. A sure indication of this tendency was the growing desire to see the first years of constructivism in a historical perspective. In one of his articles on "New Art," published in 1929, Malevich proclaimed:

> An attempt was made to throw aside the new type of "pure art," but it was a spectacular failure, and once again "pure art" occupies its own place and applied art—its own. . . .
>
> We would make a great mistake if we were to throw aside new art; we would be left only with the forms of utilitarian functionalism, or the art of the engineer, arising not from aesthetic but from purely utilitarian aims.[47]

Despite Malevich's conviction, it is hard to concede that "the new type of 'pure art' " occupied any kind of place in the Soviet society of 1929, and if it had indeed been finally disentangled from utilitarian functionalism by this stage, the effect was only to allow functionalism a more dominant position. On this point, the fascinating account of the development of modern architecture in Russia that El Lissitzky completed in 1929 is as significant for its omissions as for its general conclusions. After several sections dealing with the origins of constructivist architecture, and the work of such pioneers as Alexander Vesnin, Lissitzky concludes with a dialectical schema of the path of architectural development.

(a) Repudiation of art as a mere emotional, individual, romantically-isolated matter.

(b) "Material" creation, in the silent hope that later the resulting product will eventually be regarded as a work of art after all.

(c) Conscious fixity of purpose in creating an architecture based on previously worked-out, objective scientific principles, which presents a coherent artistic impression.[48]

Lissitzky's schema is an apt representation of the development of constructivism from the early 1920s. But on the practical level it must be pointed out that by 1929 there were no longer any opportunities to reap the harvest of this intensive preparation. Le Corbusier's Centrosoyuz building can be said to have remained "the most modern and self-assured building in Moscow more than twenty-five years after its completion." In 1931 his project for a Palace of the Soviets was rejected and a "neo-classical wedding cake of fantastic proportions" erected in its place.[49] As S. O. Khan-Mahomedov has written in his article on Russian architecture "Creative Trends, 1917–1932," the successive stages of the competition for the Palace of the Soviets clearly demonstrated the unrest in architectural circles at the time. This was epitomized by the founding in 1929 of the All-Russia Union of Proletarian Architects (Vopra), which took a polemical position against the constructivist and modernist groups but offered little of its own in return.[50]

Although Le Corbusier cannot be seen as any more than a sympathizer of the constructivists, his failure in Moscow in 1931, together with his lack of success in the competition for the League of Nations Palace in Geneva, four years earlier, marks in ironic terms the setback

to modernist architecture which was also defeating constructivist aspirations. It would have been impossible to imagine a more appropriate conclusion to this classical phase of Russian and international constructivism than the construction of these two symbols of national and international cooperation according to their own principles. The fact that both were entrusted to indifferent traditional architects demonstrates how very far from official acceptance the constructivists were by this stage.

Beside these opportunities denied them, two minor but significant achievements—one practical and one theoretical—may be placed. At least from 1923, when he signed the manifesto "Toward a Collective Construction" with Van Eesteren, Van Doesburg had been directing his ultimate aims toward an architectural resolution. By 1928, when he published a historical survey of "Elementarism and Its Origin" in *De Stijl*, he was able to point to the "plastic expression" of elementarism in his completed scheme for the interior of the Aubette restaurant, Strasbourg.[51] While this perfected example of elementarism can hardly be regarded as the direct descendant of international constructivism, the theoretical work of Jakob Chernikov carries out in the most comprehensive fashion Lissitzky's prognostic of "an architecture based on previously worked-out, objective scientific principles." His book *The Construction of Architectural and Mechanical Forms*, published in Leningrad in 1931 and hailed by Gollerbakh in its introduction as the first investigation "devoted specifically to the questions of constructivism," traces a gradual development from purely formal exercises, through the design of industrial components and theater sets, to the finished architectural work of his contemporaries. Thus he cites Leonidov's final project at the Vkhutemas, a project for a Lenin Institute in Moscow (1927), as a demonstration of "spherical edifices on firm solid constructions," by means of which "spatiality is clearly expressed."

Chernikov's work, with all its rigor and synthetic power, can serve only as a kind of valediction to Russian constructivism, which is echoed by Tatlin's unreserved commitment to technology in the following year. Yet at the same time international constructivism was undergoing a substantial mutation that would secure its persistence throughout the new decade. The loose grouping of the I.F.d.K. and

the closer association of its various component groups had long ceased to be operative by 1930, and Van Doesburg underlined the point in autumn of that year when he branded Moholy-Nagy, Lissitzky, Eggeling, and Rodchenko as "experimentalists" who had not understood the difference between "new painting and old illusionism." [52] Van Doesburg himself had reaffirmed, in April of the same year, his own doctrine of "concrete art," but because this statement was itself produced in direct response to another artistic statement, the latter must have priority.

Michel Seuphor's magazine *Cercle et Carré,* which appeared for the first time on March 15, 1930, claimed to embrace the whole range of international artists working in the constructive field. The note it struck is aptly conveyed by Jan Brzekowski's statement:

> After twenty years of research to establish the new art, we find ourselves in a period of stabilization and standardization in line with the true artistic values. The only way of achieving and preserving this stabilization is by sustaining the order and discipline imposed by the rules of artistic construction. [53]

In accordance with this desire for "stabilization," Michel Seuphor's initial editorial took no polemical stance vis-à-vis the hostile groups of the 1920s. His general theory of the destiny of nonfigurative art owes more to Mondrian's neoplasticism than to any other source, and is concerned with the spiritual and philosophical aspects of the artist's "architecture," rather than with his role in society.

It is significant that the appearance of the magazine was quickly followed by a large international exhibition, sponsored by the group, that took place at Paris in spring 1930. The traditional capital of international modernism, which had played a relatively small part in the dissemination of constructivism throughout the 1920s, was to be the center of the constructive tendency in the early 1930s. Van Doesburg, whose short and precise manifesto of "Concrete Art" forms a striking contrast to Seuphor's editorial, was undoubtedly offended by the fact that Seuphor had persuaded his former associates, such as Mondrian, Vantongerloo, Vordemberge-Gildewart, and Schwitters, to exhibit under the aegis of *Cercle et Carré*. But it is surely probable that, beyond his personal feelings, he saw in the new grouping the type of loose organization that he had condemned at the Düsseldorf congress: one that existed not as an instrument for transforming the artist's role, but

as a convenient central body to hold exhibitions and foster communication within the traditional framework. No one could possibly claim that the Cercle et Carré group embodied a strongly positive commitment to a particular type of art in the same sense as, for example, the Stijl group had done. Indeed the general administrator of *Cercle et Carré,* the Uruguayan Joaquín Torres-García, was consciously elaborating a southern, as opposed to a "northern," constructivism, which would draw on the world of real forms.[54]

The role of *Cercle et Carré,* both as a magazine and as a group, was taken over in 1932 by *Abstraction-Création,* under the direction first of Herbin and later of Vantongerloo, Gorin, Gleizes, and others. Attempts were made in the first number to establish lines of descent from the tradition of the previous decade, with Gabo providing an explanation of the significance of the term constructivist.[55] But the stated program of the group was appropriately defined more in negative than in positive terms: "Cultivation of pure plastic art, to the exclusion of all explanatory, anecdotal, literary, and naturalistic elements." [56] As the decade advanced, it became clear that the many-sided activity of the 1920s had resolved itself into a relatively simple antithesis between figurative and nonfigurative, the former trend being sustained almost exclusively by the surrealists and the latter by a combination of "abstract," "concrete," and "constructivist" tendencies that had become hopelessly confused. Sufficient evidence of this fact is provided by the composition of three important exhibitions that took place in 1936–37: "Cubism and Abstract Art" at the Museum of Modern Art, New York (1936); "Abstract and Concrete" at the Lefèvre Gallery, London (1936); and "Constructivism" at the Kunsthalle, Basel (1937). Works by Calder, Domela, Gabo, Hélion, Kandinsky, Moholy-Nagy, and Mondrian were included in all three, while the Basel exhibition even displayed work by Picasso.[57]

This blurring of distinctions that had been so sedulously preserved in the 1920s was in part a result of the worsening of the political climate in Europe, and particularly in Germany, where the Bauhaus was closed in 1933. T. S. Eliot has written of the "gradual closing of the mental frontiers of Europe" [58] in the 1930s, which affected his position as editor of *The Criterion.* An exactly parallel process took place among artists, and as early as 1932, Moholy-Nagy wrote from the Château de La Sarraz, near Lausanne: "We are all so busy find-

ing a new orientation in the political decisions of Europe that the easy group-spirit is gone." [59] Joaquín Torres-García, writing from Madrid in 1933 to proclaim the existence of a new "constructivist group," was bound to concede that the present phase of artistic development was still "barbaric," and that the "superclassicism" would arrive only in a "far-off time." By 1936, when Jean Gorin was writing in *Abstraction-Création* on "The Aim of Constructive Plastic Art," it was necessary to supplement the customary mention of the "new age" with a reference to "the tragic phase of the evolution that we are now experiencing." In these circumstances, Gorin insisted, the most that the artist could do was to develop the new plastic art in the traditional genres of "objects, pictures, or sculptures," and wait for the "social conditions that will enable it to be fully developed in the context of everyday life."

The sense that art, like society, could be utterly transformed in the here and now had possessed not only the Russian constructivists but also their West European colleagues in the early 1920s. By the late 1930s this sense of vocation had yielded to the pressure of events, and even the conviction that the separate branches of the arts formed an essential unity, which was the common faith of all constructivists, had virtually disappeared. Yet in 1937 *Circle,* an "international survey of constructive art," appeared in London to stress the "one common idea and one common spirit" of the works within the "constructive trend." Its aim was "to gather here those forces which seem to us to be working in the same direction and for the same ideas, but which are, at the moment scattered, many of the individuals working on their own account and lacking any medium for the interchange of ideas."

The editors of *Circle* were Gabo, J. L. (later Sir Leslie) Martin, and Ben Nicholson, and it was undoubtedly Gabo's decision to make his home in London from around 1936 that lay behind the book's appearance at this time. Among the contributors were pioneers of the modern movement such as Mondrian, Le Corbusier, Gropius, and Moholy-Nagy. They were joined by a number of younger English artists—Winifred Dacre, Ben Nicholson, Barbara Hepworth, and Henry Moore. Gabo himself provided two lengthy articles on "The Constructive Idea in Art" and "Sculpture—Carving and Construction in Space."

To a great extent, the *Circle* collection attests the vitality of the constructive idea, even in the Europe of 1937. Of particular interest

is the section on architecture, where such British architects as Martin and Maxwell Fry were juxtaposed with Marcel Breuer, late of the Bauhaus, and S. Giedion, writing on "Construction and Aesthetics." In the final section, on "Art and Life," contributors ranged from Gropius on art education to Massine on choreography and Tschichold on typography. Yet despite this wide range of personalities and subjects, it could hardly be claimed that the "one common idea" exerted as strong a force at it had done in the previous decade. In particular the position of the English contributors, who had little experience of the constructivism of the 1920s, was still far from that of a coherent group or movement. Anthony Hill has rightly cast doubt on the usefulness of regarding any English artist of that generation as a constructivist.[60]

This distinction between early constructivism and the international constructive movement—for it was the latter that the English artists recognized and responded to—was by no means overlooked at the time. Myfanwy Evans, writing as editor of the magazine *Axis* in 1936, stressed that while Ben Nicholson and Barbara Hepworth concerned themselves exclusively with painting and sculpture, an artist such as Moholy-Nagy aimed at a more ambitious and visionary goal: "to build with space and to create a new art out of the finds of industry: an art which will express public needs by some other means than the bronze statue." [61] The evidence for Moholy-Nagy's program lay to hand in the survey of his work undertaken in 1936 by the magazine *Telehor,* published in Brno. Yet even he had, by this year, turned away from grandiose projects and addressed himself to the specifically pictorial investigation of three-dimensionality that was to occupy him for the rest of his life.[62]

For a few years Britain had been within the orbit of the constructive movement. Communication had been fostered among the international fraternity of artists who had been deprived of their roots in the societies that earlier they had sought to transform. With the onset of the Second World War, even this limited area of interchange was denied to them. Gabo, questioned by Herbert Read in the middle of the war about his art, wrote: "I try to guard in my work the image of the morrow we left behind us in our memories and foregone aspirations and to remind us that the image of the world can be different." Thirteen years later, when his *Bijenkorf Construction* had risen

over the new Rotterdam, he could have looked back triumphantly to this period when it seemed almost fruitless to imagine his sculpture in such a context—"where the masses come and go and live and work." [63]

The "constructive trend" of the 1930s had at least been continuous with the constructivism of the 1920s, even if it reflected a gradual narrowing of horizons in response to the worsening of communications and the deterioration of political conditions. Postwar constructive art, however, had to come to terms with a tradition that had been abruptly curtailed. Not even the loose affiliation of Cercle et Carré or Abstraction-Création could be resurrected on a truly international scale. At the same time, the various small movements and artistic figures that did emerge could in almost all cases be related to specific strains within the overall tradition of international constructivism.

Gabo and his brother Antoine Pevsner remained unique, as they had been in the 1930s, for their links with Russian constructivism. Gabo himself stressed the unity of his artistic thought and practice over the years and regarded his eloquent lecture on "Constructive Realism," delivered at Yale in 1948, as "a larger and more comprehensive clarification" [64] of the principles inherent in "The Realistic Manifesto" of 1920. Pevsner, who had lived in Paris since 1927, identified himself with the founding of the Salon des Réalités Nouvelles in 1947, and so helped to propagate the new, Paris-centered movement that was the successor to the international groupings of the 1930s.

The prime movers of the Salon des Réalités Nouvelles were actually those who had been prominent in Abstraction-Création: in particular, Herbin, who became vice-president of the Salon, and Gleizes, Gorin, and Pevsner himself. To these artists must be added the name of the secretary-general of the Salon, Del Marle, who was working in the tradition of neoplasticism. The intention of this group to define their relationship to the past was apparent from the very first number of the catalogue and yearbook *Réalités Nouvelles*, which was published to accompany their exhibitions. Pride of place was reserved to masters such as Delaunay, Van Doesburg, Malevich, Eggeling, Lissitzky, Kandinsky, and Mondrian, who were lauded for having "opened the way" and provided a "source of inspiration and instruction for the young." [65] But as this list demonstrates, the tradition invoked was

less constructivist than broadly nonfigurative. This was emphasized by the chart published in 1948 to show the ancestry of the Salon, in which lines were traced back through the modern movement as far as impressionism, and the specifically constructivist contribution was simply one among many.[66]

Although the Salon des Réalités Nouvelles was intended to revive the internationalism of the 1930s, it suffered from the fact that Paris was no longer the capital of modernist art—for the English-speaking nations in particular. The fall of Paris had been noted before the outbreak of the Second World War, both by the American critic Harold Rosenberg and by the American artist Charles Biederman. In the course of a visit to Paris in 1936, Biederman became acquainted with the theories of De Stijl and constructivism to a limited extent. But of far greater importance was his dissatisfaction with the traditional media that European constructive artists had continued to employ. His distinctive contribution to the development of constructive ideas was to be the revaluation of the relief, not as one medium among many, but as a new medium appropriate to the needs of a new art.

This factor helps to explain the considerable influence of Biederman's monumental work, *Art as the Evolution of Visual Knowledge,* written in the years 1938 to 1946 and published in 1948. As a historical record of the development of constructivism, this work was necessarily incomplete. Biederman was obliged to rely, during the war years, on readily accessible publications such as the *Circle* anthology, and did not become aware of such an artist as Jean Gorin, who shared his interest in the relief, until 1947. Nevertheless Biederman's analysis offered a complete reassessment of the tradition of modern art. As with *Réalités Nouvelles,* the account opened at impressionism. But where the French laid emphasis on the most general lines of development, and saw as their terminal point the rather less than exciting genre of "nonfigurative art," Biederman insisted on a genuine "evolution of vision" in the modern period, which led inexorably from Monet and Cézanne to the constructed relief.

It was above all the force and logic of Biederman's position, rather than his works themselves—which have only recently been seen in Europe in any quantity—that accounted for his catalytic influence on the European constructive tradition. On the most general level, as Victor Pasmore has stated, Biederman was concerned with a reorienta-

tion of the "cubist constructive outlook." [67] In a period dominated in America by the first manifestations of the action painters, and in England by neoromanticism and the "geometry of fear," this was no idle purpose. On a more precise level, Biederman was concerned with an artistic synthesis, deriving from the twin currents of constructivism and De Stijl, which was to center around the notion of the relief as the medium of a "new nature vision."

Biederman's doctrine of "constructionism," known as "structurism" from 1952 on, could therefore be assimilated on a number of different levels. And among European artists at any rate, reactions were far from uniform. If it is a question of the reanimation of the constructive outlook, then Pasmore can be seen as being in Biederman's debt. If it is a question of predominant cultivation of the relief, then Pasmore must be ruled out, and the case of Anthony Hill becomes more relevant. If it is a matter of using the relief to establish a "new nature vision," then Anthony Hill's intentions do not correspond with Biederman's. Indeed the Dutch artist Joost Baljeu, who is concerned with both the relief and the new vision of nature, must at the same time be differentiated from Biederman as far as the character of this new vision is concerned.

It will be evident that the fine distinctions being made at this point imply a view of the constructive tradition far less generalized than that of the Réalités Nouvelles group. Biederman probably deserves the credit for reintroducing this vital and contentious element, but there would have been little chance for European artists to define and defend their own positions if it had not been for Joost Baljeu's magazine, *Structure,* which first appeared in 1958 and ceased publication in 1964. It would clearly be inaccurate to describe *Structure* as narrowly or even predominantly constructivist in its approach, since Baljeu himself wrote in the first issue that the "New Art" was an "outgrowth" of several past movements: "the great movements of Impressionism and Post-Impressionism . . . Cubism, Suprematism and Neo-plasticism (De Stijl), as well as Constructivism." All the same, it must be emphasized that Baljeu's successive issues on "Art and Nature," "Art and Motion," "Art and Mathematics," "Art and Architecture," and so on revived discussion on a level comparable to that of the pioneers of international constructivism among a group of artists working within the constructive trend.

A majority of the contributors to Structure came from within the English-speaking world, and the magazine itself was published in English. The Continental artists who provided articles were chiefly those who had retained strong links with the prewar movements, such as the French neoplasticist Gorin and the Swiss Richard Lohse, who, together with Max Bill, had adopted and extended Van Doesburg's doctrine of concrete art. *Structure* had no direct connection with the rise of new movements that drew to some extent on the constructive tradition, such as kinetic art—though Kenneth Martin was able to show that the laws of constructions were not at variance with the laws of chance and change. Above all, *Structure* challenged the aesthetic of the Nouvelle Tendance (New Tendency) movement, which had by the early 1960s established itself almost as an orthodoxy among younger constructive-oriented artists. Baljeu's open letter to the Groupe de Recherche d'Art Visuel, which appeared in *Structure* in 1962, challenged the materialist assumptions of this group, and the whole New Tendency, claiming "that it is not by changing the functioning of the eye (eye-sight) that art changes, but by the artist's visual understanding changing in accordance with the changes in life." [68]

It has been widely held, and emphasized in exhibitions such as the 1969 Nuremberg Biennale, that the artists and groups associated with the New Tendency are the true heirs to the constructive tradition. But it is surely more consistent to regard their development as "a reasonable aesthetic alternative . . . to . . . Constructivism," in Jack Burnham's terms.[69] This is partly because of their predominantly experimental approach, their complete rejection of what Max Bill has referred to as "non-changeable, elementary truth." [70] Yet this would clearly not debar their alliance with the Russian tradition, if they showed any inclination to extend their notions of design from the art work to an architectural scale. In effect, their commitment to an aesthetic of "instability"—to quote the Groupe de Recherche d'Art Visuel—lends itself much more readily to the modification and distortion of existing spaces than to the construction of new ones. Though this may have fascinating and even profound results, it ultimately tends toward the kind of nihilism that Baljeu has correctly discerned in the German Zero group, "which holds that in the end any activity or project of man leads to nothingness." [71] This is of course the exact contrary of the constructive stance.

It would, however, be a gross distortion to suggest that those artists belonging to the European kinetic movement, which draws its ancestry at least in part from such pioneers as Gabo and Moholy-Nagy, should be regarded as altogether outside the constructive tradition. Two artists in particular, both based in Paris but Hungarian by birth, maintain a close link with the prewar constructive movement while elaborating visions of the future that depend radically upon a kinetic approach. For Vasarely, who studied under Alexander Bortnyik at the Mühely (the Hungarian counterpart of the Bauhaus) before taking up residence in Paris, the concern with instability and permutation coincides with a desire to organize the basic "cells" of our environment into a "unity of construction" that is also an "aesthetic unity." For Schöffer, who has lived in Paris since 1936, time itself becomes a "new raw material to be molded": "Temporal architecture, or rather, the intemporalization of time, constitutes the great problem in which space, movement and light will be integrated as constructive elements."

A final question arises, though it is a question that by its very nature can receive no definitive answer. To what extent have the artists within the constructive tendency succeeded in establishing the "new classical order" anticipated before the modern movement had run its course? Compared to the new generation of American minimal artists, they do indeed appear classicist in their adherence to absolute formal values, based on mathematical constants.[72] Yet it would be a mistake to identify the constructive tradition with an overriding dedication to the formal and the static. As Van Doesburg anticipated in his treatise *Classique—Baroque—Moderne,* and as the approach of such modern artists as Vasarely and Schöffer amply confirms, the dialectical conflict between order and chaos, between the static and the dynamic, is by no means confined to the Russian pioneers of constructivism. It is because of this perpetual and fruitful conflict that one is led to concur with Joost Baljeu's conclusion: that "the constructive approach, the oldest in modern plastic expression, is still the youngest today."

I.
Constructivism in Russia:
1920-23

NAUM GABO and ANTOINE PEVSNER: The Realistic Manifesto (1920)

While it would be impossible to explain, in simple terms, the astonish-
ing development of Russian art in the early twentieth century, it is
clear at the same time that any discussion of the subject tends to con-
verge upon one basic problem: To what extent should the Russian
contribution to the modern movement be viewed as the outcome of a
native tradition and to what extent as a graft from an alien culture?
In the case of the Italian futurists, the issue is perhaps more clear.
The reaction against the arrested development of Italian art and
voracious ingestion of the French avant-garde tradition could go hand
in hand in a culture where so much was held in common with its
neighbors. Russian modernism was perhaps only superficially touched
by the Italian flurry. The decade of the 1910s may have begun with
manifestoes of a futurist stamp, but by its close the work of a painter
such as Malevich and a poet such as Khlebnikov testified to a profound
cleavage between Russia and the West.

The rise of constructivism in Russia represents at the same time
the full recognition of this cleavage and a hint that it was to become
less absolute. "The Realistic Manifesto" of Gabo and Pevsner is in
a sense retrospective, pointing out with unerring accuracy the limita-
tions of cubism and futurism. But it also signifies that the roles of
teacher and pupil are about to be reversed. The Russian artist no longer
simply has nothing to learn from the West; he now has something
to give.

Implicit in this new attitude is the situation created by the Revolu-

First published on August 5, 1920, by the Second State Printing House,
Moscow. This translation by Naum Gabo was first published in *Gabo: Con-
structions, Sculpture, Paintings, Drawings, Engravings* (London: Lund Hum-
phries; Cambridge, Mass.: Harvard University Press, 1957). Copyright ©
1957 by Lund Humphries, Ltd., reprinted by permission of Harvard Uni-
versity Press and Lund Humphries, Ltd.

tion of 1917. Gabo refers to "us who have already accomplished the Revolution or who are already constructing and building up anew." The ambiguity between social and political revolution is probably intentional. And the parallel is brought out even more clearly in Tatlin's short statement on "The Work Ahead of Us," which confirms that the conjunction of revolution in art and in the state allows the Russian artist to envisage the task of "creating a new world."

For Gabo and Tatlin, the change in the artist's role is initially seen in quantitative terms. Instead of continuing to work in conventional media and on modest proportions, he is able to confront the heady prospect of creating symbolic embodiments of the new society on a monumental scale. But in the period covered by the passages that follow, the artist's role was also to be transformed qualitatively. Rejecting Gabo's view of the independent social function of art, artists and theorists drew the implications of Tatlin's concern with "the forms encountered in our new everyday life." When the term "constructivism" first came into common use at the end of 1921, it could hardly be said to denote the work of a number of artists bound together by common stylistic properties. It embodied the determination of the artist and the theorist to pursue the implications of a marriage between art and social revolution, even if this investigation meant a revision, or indeed a reversal, of existing conceptions.

Naum Gabo was born in Briansk, Russia, in 1890. He made his first constructions in Norway in 1915. He worked in Russia from 1917 to 1922, when he left Moscow for Berlin. From around 1936 to 1946 he lived in England, moving finally to the United States, where he still lives. His older brother, Antoine Pevsner, was born in Orel, Russia, in 1886; he worked with Gabo in Norway from 1916, and returned to Moscow with him, but established himself in Paris from 1923 on.

A third brother, Alexei Pevsner, has described the genesis of this manifesto, which was written solely by Gabo, although Antoine appended his signature. The occasion of publication was an open-air exhibition on the Tverskoy Boulevard in Moscow at which both brothers were represented in addition to several young artists from the Vkhutemas (Higher Technical Artistic Studios).

Gabo has amusingly recalled that the commissar of the state printing and publication department, who was Trotsky's sister, gave permission for the official publication of the manifesto without reading

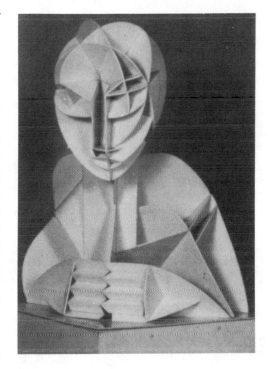

Naum Gabo: *Constructed Head*, 1916. (Louise and Walter Arensberg Collection, The Philadelphia Museum of Art) Gabo recently reconstructed this work in architectural steel and would like to execute it on a 10-foot scale. Although there are superficial analogies with cubism in this piece and in its companions from the same period, Gabo's central aim was to create a naturalistic image through the use of the stereometric system and to combine monumentality with economy in the use of materials. (*Photo Dr. Fred Block*)

it. *She was under the impression that it favored "realism" in the traditional sense and therefore welcomed an aesthetic position to which, on closer acquaintance, she found herself to be totally opposed.*

Above the tempests of our weekdays,

Across the ashes and cindered homes of the past,

Before the gates of the vacant future,

We proclaim today to you artists, painters, sculptors, musicians, actors, poets . . . to you people to whom Art is no mere ground for conversation but the source of real exaltation, our word and deed.

The impasse into which Art has come to in the last twenty years must be broken.

The growth of human knowledge with its powerful penetration into the mysterious laws of the world which started at the dawn of this century.

Naum Gabo and Antoine Pevsner: "The Realistic Manifesto," 1920.
This manifesto was written to accompany an open-air show on the
Tverskoy Boulevard, Moscow, at which both brothers were exhibiting.
Five thousand copies were issued and posted throughout the city.

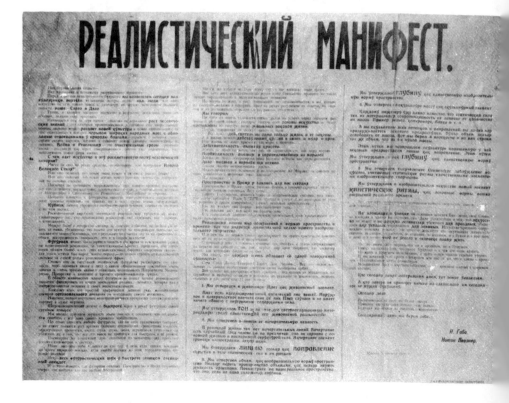

The blossoming of a new culture and a new civilization with their unprecedented-in-history surge of the masses towards the possession of the riches of Nature, a surge which binds the people into one union, and last, not least, the war and the revolution (those purifying torrents of the coming epoch), have made us face the fact of new forms of life, already born and active.

What does Art carry into this unfolding epoch of human history?

Does it possess the means necessary for the construction of the new Great Style?

Or does it suppose that the new epoch may not have a new style?

Or does it suppose that the new life can accept a new creation which is constructed on the foundations of the old?

In spite of the demand of the renascent spirit of our time, Art is still nourished by impression, external appearance, and wanders helplessly back and forth from Naturalism to Symbolism, from Romanticism to Mysticism.

The attempts of the Cubists and the Futurists to lift the visual arts from the bogs of the past have led only to new delusions.

Cubism, having started with simplification of the representative technique, ended with its analysis and stuck there.

The distracted world of the Cubists, broken in shreds by their logical anarchy, cannot satisfy us who have already accomplished the Revolution or who are already constructing and building up anew.

One could heed with interest the experiments of the Cubists, but one cannot follow them, being convinced that their experiments are being made on the surface of Art and do not touch on the bases of it, seeing plainly that the end result amounts to the same old graphic, to the same old volume, and to the same decorative surface as of old.

One could have hailed Futurism in its time for the refreshing sweep of its announced Revolution in Art, for its devastating criticism of the past, as in no other way could one have assailed those artistic barricades of "good taste" . . . powder was needed for that and a lot of it . . . but one cannot construct a system of art on one revolutionary phrase alone.

One had to examine Futurism beneath its appearance to realize that one faced a very ordinary chatterer, a very agile and prevaricating guy, clad in the tatters of worn-out words like "patriotism," "militarism," "contempt for the female," and all the rest of such provincial tags.

In the domain of purely pictorial problems, Futurism has not gone further than the renovated effort to fix on the canvas a purely optical reflex which has already shown its bankruptcy with the Impressionists. It is obvious now to every one of us that by the simple graphic registration of a row of momentarily arrested movements, one cannot re-create movement itself. It makes one think of the pulse of a dead body.

The pompous slogan of "Speed" was played from the hands of the Futurists as a great trump. We concede the sonority of that slogan and we quite see how it can sweep the strongest of the provincials off their feet. But ask any Futurist how does he imagine "speed" and there will emerge a whole arsenal of frenzied automobiles, rattling railway depots, snarled wires, the clank and the noise and the clang of carouselling streets . . . does one really need to convince them that all that is not necessary for speed and for its rhythms?

Look at a ray of sun . . . the stillest of the still forces, it speeds more than 300 kilometres in a second . . . behold our starry firmament . . . who hears it . . . and yet what are our depots to those depots of the Universe? What are our earthly trains to those hurrying trains of the galaxies?

Indeed, the whole Futurist noise about speed is too obvious an anecdote, and from the moment that Futurism proclaimed that "Space and Time are yesterday's dead," it sunk into the obscurity of abstractions.

Neither Futurism nor Cubism has brought us what our time has expected of them.

Besides those two artistic schools our recent past has had nothing of importance or deserving attention.

But Life does not wait and the growth of generations does not stop and we who go to relieve those who have passed into history, having in our hands the results of their experiments, with their mistakes and their achievements, after years of experience equal to centuries . . . we say . . .

No new artistic system will withstand the pressure of a growing new culture until the very foundation of Art will be erected on the real laws of Life.

Until all artists will say with us . . .

All is a fiction . . . only life and its laws are authentic and in life only the active is beautiful and wise and strong and right, for life

does not know beauty as an aesthetic measure . . . efficacious existence is the highest beauty.

Life knows neither good nor bad nor justice as a measure of morals . . . need is the highest and most just of all morals.

Life does not know rationally abstracted truths as a measure of cognizance, deed is the highest and surest of truths.

Those are the laws of life. Can art withstand these laws if it is built on abstraction, on mirage, and fiction?

We say . . .

Space and time are re-born to us today.

Space and time are the only forms on which life is built and hence art must be constructed.

States, political and economic systems perish, ideas crumble, under the strain of ages . . . but life is strong and grows and time goes on in its real continuity.

Who will show us forms more efficacious than this . . . who is the great one who will give us foundations stronger than this?

Who is the genius who will tell us a legend more ravishing than this prosaic tale which is called life?

The realization of our perceptions of the world in the forms of space and time is the only aim of our pictorial and plastic art.

In them we do not measure our works with the yardstick of beauty, we do not weigh them with pounds of tenderness and sentiments.

The plumb-line in our hand, eyes as precise as a ruler, in a spirit as taut as a compass . . . we construct our work as the universe constructs its own, as the engineer constructs his bridges, as the mathematician his formula of the orbits.

We know that everything has its own essential image; chair, table, lamp, telephone, book, house, man . . . they are all entire worlds with their own rhythms, their own orbits.

That is why we in creating things take away from them the labels of their owners . . . all accidental and local, leaving only the reality of the constant rhythm of the forces in them.

1. *Thence in painting we renounce colour as a pictorial element, colour is the idealized optical surface of objects; an exterior and superficial impression of them; colour is accidental and it has nothing in common with the innermost essence of a thing.*

We affirm *that the tone of a substance,* i.e. *its light-absorbing material body is its only pictorial reality.*

2. We renounce *in a line, its descriptive value; in real life there are no descriptive lines, description is an accidental trace of a man on things, it is not bound up with the essential life and constant structure of the body. Descriptiveness is an element of graphic illustration and decoration.*

We affirm *the line only as a direction of the static forces and their rhythm in objects.*

3. We renounce *volume as a pictorial and plastic form of space; one cannot measure space in volumes as one cannot measure liquid in yards: look at our space . . . what is it if not one continuous depth?*

We affirm *depth as the only pictorial and plastic form of space.*

4. We renounce *in sculpture, the mass as a sculptural element.*

It is known to every engineer that the static forces of a solid body and its material strength do not depend on the quantity of the mass . . . example a rail, a T-beam, etc.

But you sculptors of all shades and directions, you still adhere to the age-old prejudice that you cannot free the volume of mass. Here (in this exhibition) we take four planes and we construct with them the same volume as of four tons of mass.

Thus we bring back to sculpture the line as a direction and in it we affirm depth as the one form of space.

5. We renounce *the thousand-year-old delusion in art that held the static rhythms as the only elements of the plastic and pictorial arts.*

We affirm *in these arts a new element the kinetic rhythms as the basic forms of our perception of real time.*

These are the five fundamental principles of our work and our constructive technique.

Today we proclaim our words to you people. In the squares and on the streets we are placing our work convinced that art must not remain a sanctuary for the idle, a consolation for the weary, and a justification for the lazy. Art should attend us everywhere that life flows and acts . . . at the bench, at the table, at work, at rest, at play; on working days and holidays . . . at home and on the road . . . in order that the flame to live should not extinguish in mankind.

We do not look for justification, neither in the past nor in the future.

Nobody can tell us what the future is and what utensils does one eat it with.

Not to lie about the future is impossible and one can lie about it at will.

We assert that the shouts about the future are for us the same as the tears about the past: a renovated day-dream of the romantics.

A monkish delirium of the heavenly kingdom of the old attired in contemporary clothes.

He who is busy today with the morrow is busy doing nothing.

And he who tomorow will bring us nothing of what he has done today is of no use for the future.

Today is the deed.

We will account for it tomorrow.

The past we are leaving behind as carrion.

The future we leave to the fortune-tellers.

We take the present day.

VLADIMIR TATLIN, T. SHAPIRO, I. MEYERZON, *and*
PAVEL VINOGRADOV:
The Work Ahead of Us (1920)

Vladimir Evgrafovich Tatlin was born in 1885, either in Kharkov or in Moscow. He exhibited paintings with a number of Russian artistic groups in the years 1911–13 and was closely associated with the painter Mikhail Larionov. But his attitudes were transformed in the course of a visit to Paris in 1913, when he was able to see the cubist reliefs

Dated Moscow, December 31, 1920. This translation by Troels Andersen *et al.* was first published in *Vladimir Tatlin* (exhibition catalogue, Stockholm: Moderna Museet, July–September 1968) and is reprinted here with permission.

of Picasso. On his return he began to work on the series of "counter-reliefs" that were the foundation of his constructivist style.

With the Revolution Tatlin's leading position among progressive artists was soon recognized. In 1918 he became head of the Visual Arts Department of Narkompros (Commissariat for People's Enlightenment) and in the following year instructor at the Free Studios in Petrograd. In December 1920, in connection with the meeting of the Eighth Soviet Congress, he went to Moscow to reconstruct his model for a Monument to the Third International, first exhibited in Petrograd on November 8 for the anniversary of the Revolution. It was in Moscow that he produced this short manifesto, which was also signed by two students from the Free Studios who were assisting him—I. Meyerzon and T. Shapiro—and by Pavel Vinogradov, who likewise took part in the re-erection. The title commemorates the founding of the Third (Communist) International, or Comintern, in 1919.

After 1920, Tatlin himself turned increasingly to the task of achieving "control over the forms encountered in our new everyday life," as anticipated in this document. His last major project was the Letatlin flying machine described in "Art Out into Technology" (see p. 170). He died in Moscow in 1953.

The foundation on which our work in plastic art—our craft—rested was not homogeneous, and every connection between painting, sculpture and architecture had been lost: the result was individualism, i.e. the expression of purely personal habits and tastes; while the artists, in their approach to the material, degraded it to a sort of distortion in relation to one or another field of plastic art. In the best event, artists thus decorated the walls of private houses (individual nests) and left behind a succession of "Yaroslav Railway Stations" and a variety of now ridiculous forms.

What happened from the social aspect in 1917 was realized in our work as pictorial artists in 1914, when "materials, volume and construction" were accepted as our foundation.

We declare our distrust of the eye, and place our sensual impressions under control.

In 1915 an exhibition of material models on the laboratory scale was held in Moscow (an exhibition of reliefs and contre-reliefs). An exhibition held in 1917 presented a number of examples of material

Vladimir Tatlin: *Corner Relief, Suspended Type,* 1914–15. Tatlin visited Picasso in Paris in 1913 and saw his cubist reliefs incorporating actual objects. His own counterreliefs and corner reliefs were developed over the next two years and exhibited at the "Tram V" show in Petrograd in 1915, where they created a great scandal.

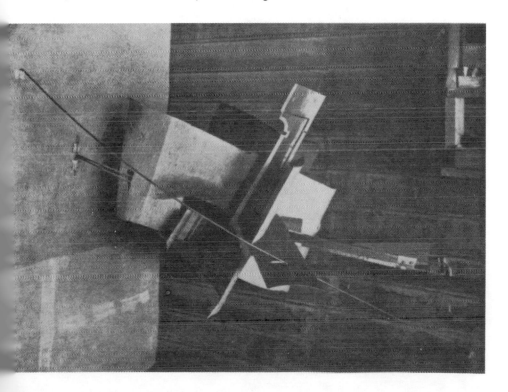

combinations, which were the results of more complicated investigations into the use of material in itself, and what this leads to: movement, tension, and a mutual relationship between [them].

This investigation of material, volume and construction made it possible for us in 1918, in an artistic form, to begin to combine materials like iron and glass, the materials of modern Classicism, comparable in their severity with the marble of antiquity.

In this way an opportunity emerges of uniting purely artistic forms with utilitarian intentions. An example is the project for a monument to the Third International (exhibited at the Eighth Congress).

The results of this are models which stimulate us to inventions in our work of creating a new world, and which call upon the producers to exercise control over the forms encountered in our new everyday life.

NIKOLAI PUNIN: Tatlin's Tower (1920)

Nikolai Punin was one of the first critics to champion the "organized" methods of constructivism as opposed to the "bomb-throwing" of the early futurists. In the Petrograd journal Iskusstvo kommuny (Art of the Commune), January 1919, he was already championing the notion that the principle of utility and the principle of construction were not in conflict, and that modern beauty was entirely dependent upon their reconciliation. In the last number of the magazine (April 1919),

From *Veshch/Gegenstand/Objet* (Berlin), no. 1–2, March–April 1922; the text dates from 1920. This translation and all other translations by John Bowlt were made especially for this volume.

*however, he prophesied the end of art as a separate discipline, which
would inevitably follow such developments in the theory of aesthetics.*

*Punin was aware of the development of Tatlin's model for the
Monument to the Third International from its early stages. It was in-
deed only in the planning stage when he wrote his first article on it
in* Iskusstvo kommuny, *March 9, 1919. Punin claimed that the project
showed "in what direction the artist is to work, when he has grown
tired of heroes and busts." In his view, Tatlin was "the most forceful
and clear-sighted master of our age" (translation by Andersen,* Tatlin
[exhibition catalogue], pp. 56–57).

*The passage reprinted here first appeared in a pamphlet on the
monument published in 1920. Lissitzky was no doubt eager to feature
this symbol of the new Soviet art in the first issue of* Veshch/Gegen-
stand/Objet, *which appeared in Berlin in March–April 1922.*

In 1919 the Visual Arts Department of the Commissariat for People's
Enlightenment commissioned the artist V. E. Tatlin to work out a
project for a Monument to the Third International. The artist, Tatlin,
immediately set to work and made a model.

The basic idea of the monument took shape on the basis of an or-
ganic synthesis of architectural, sculptural, and painterly principles
and was to have afforded a new type of monumental construction unit-
ing creative and utilitarian forms. In accordance with this idea, the
model of the monument is composed of three large glass spaces ele-
vated by a complex system of vertical pivots and spirals. These spaces
are located one above the other and are enclosed in different, har-
monically linked forms. Utilizing mechanisms of a special type, they
can move at different speeds. The lower space, which has the form of
a cube, moves on its axis at a speed of one revolution per year and
is intended for official purposes. Here conferences of the International
and sessions of international congresses and of other large official as-
semblies can take place. The next space, in the form of a pyramid,
revolves on its axis at a speed of one revolution per month and is in-
tended for executive purposes (the executive commissariat of the Inter-
national, the secretariat, and other administrative/executive organs).
Finally, the upper cylinder, revolving at a speed of one revolution per
day, is intended for centers of an informational type: an information
bureau, a newspaper, offices for public proclamations, pamphlets, and

manifestoes—in short, all the various mass media for the international proletariat, in particular telegraph, projectors for a big screen located on the axes of a spherical section, and radio transmitters, whose masts rise above the monument. One must point out that according to Tatlin's plan, the glass spaces are dependent on double partitions containing a vacuum (thermos), which will make it easy to maintain the temperature within the spaces. Separate parts of the monument, like all the spaces, will be connected to the ground and to each other solely by electric elevators of complex construction; they will be adapted to the various rotary speeds of the spaces. These are the technical bases of the project.

Vladimir Tatlin: Model for the Monument to the Third International, 1920. Tatlin constructed this 15½-foot model in what had been the mosaic workshop of the Academy of Arts in Petrograd. In this photograph, taken in Petrograd, Tatlin is the figure facing front.

Louis Lozowick: Woodcut of Tatlin's Monument to the Third International, 1920. The schematic buildings in the background emphasize the fact that Tatlin's project was designed to be higher than the Eiffel Tower.

Program of the Productivist Group (1920)

There is some uncertainty over the precise origin of the following manifesto, which has sometimes been associated directly with the name of Tatlin. Gabo has underlined that the constructivist/productivist group, which arose around 1920, was "led by Tatlin." But this program from an exhibition catalogue published "several months after the Realistic Manifesto" and "as a reply to it" carried only the signatures of Alexei Rodchenko and his wife, Varvara Stepanova, who had organized the exhibition. Troels Andersen has informed me that Tatlin's name is specifically omitted from a list of the main supporters of the program given by Jacques Tugenkhol'd in the annual Pechat' i revolutsya *(The Press and Revolution), vol. VII, 1927.*

Rodchenko, who was born in St. Petersburg in 1891, was one of the Russian artists most ready and able to embrace the new task of design for production. Though he was undoubtedly influenced by Tatlin, his search for a synthesis of architecture, sculpture, and painting began as early as 1917, and in 1919 he made a design for a telephone kiosk. From 1920 on he was to take part in a multitude of different projects, designing covers for Mayakovsky's magazine Lef, *posters for the new Soviet cinema, and planning numerous architectural interiors, such as that of the Soviet Pavilion at the Paris International Exposition of 1925. Varvara Stepanova was also closely concerned with the theory and practice of production art (see p. xxxii).*

The task of the Constructivist group is the communistic expression of materialistic constructive work.

Originally published in 1920. This translation was first published in *Egyseg* (Vienna), 1922, and was reprinted in *Gabo: Constructions, Sculpture, Paintings, Drawings, and Engravings* (London: Lund Humphries; Cambridge, Mass.: Harvard University Press, 1957). Copyright © 1957 by Lund Humphries, Ltd., reprinted by permission of Harvard University Press and Lund Humphries, Ltd.

It tackles the solution of this problem on the basis of scientific hypotheses. It emphasizes the necessity of synthetizing the ideological and formal part so as to direct the laboratory work on to the tracks of practical activity.

When the group was first started the ideological part of its programme was as follows:

1. The sole premise is scientific communism, based on the theory of historical materialism.
2. The cognition of the experimental trials of the Soviets has led the group to transplant experimental activities from the abstract (transcendental) to the real.
3. The specific elements of the group's work, namely "tektonika," construction, and "faktura," ideologically, theoretically, and by experience justify the changing of the material elements of industrial-culture into volume, plain [sic], colour, space, and light.

These constitute the foundations of the communistic expression of materialistic construction.

These three points form an organic link between the ideological and formal parts.

"Tektonika" is derived from the structure of communism and the effective exploitation of industrial matter.

Construction is organization. It accepts the contents of the matter itself, already formulated. Construction is formulating activity taken to the extreme, allowing, however, for further "tektonical" work.

The matter deliberately chosen and effectively used, without however hindering the progress of construction or limiting the "tektonika," is called "faktura" by the group.

Among material elements are:

1. Matter in general. Recognition of its origin, its industrial and productional changes. Its nature and its meaning.
2. Intellectual materials: light, plane, space, colour, volume.
 The Constructivists treat intellectual and solid materials in the same way.

The future tasks of the group are as follows:

1. Ideologically:
 (a) Proving by word and deed the incompatibility of artistic activity and intellectual production.

 (b) The real participation of intellectual production as an equivalent element, in building up communist culture.

2. In practice:

 (a) Agitation in the press.

 (b) Conception of plans.

 (c) Organization of exhibitions.

 (d) Making contact with all the productive centres and main bodies of unified Soviet mechanism, which realize the communistic forms of life in practice.

3. In the field of agitation:

 (a) The group stands for ruthless war against art in general.

 (b) The group proves that evolutionary transition of the past's art-culture into the communistic forms of constructive building is impossible.

The Slogans of the Constructivists

1. Down with art.
 Long live technic.
2. Religion is a lie.
 Art is a lie.
3. Kill human thinking's last remains tying it to art.
4. Down with guarding the traditions of art.
 Long live the Constructivist technician.
5. Down with art, which only camouflages humanity's impotence.
6. The collective art of the present is constructive life.

From *Art in Production* (1921)

The notion of productivism, or "art in production," which is equated with constructivism in the preceding manifesto, can be traced convincingly before 1920 to the Russian futurist movement of the previous decade. The idea that the artist should control the forms of everyday life was, after all, a logical derivative of the futurist concern with removing the barriers between life and art. As early as December 1918, the literary critic Osip Brik had written in the futurist magazine Iskusstvo kommuny, of which he was editor: "Go to the factories, this is the only task for artists."

The two articles that follow reflect the convergence between futurist theory and the new constructivist ideology, later to be reaffirmed by the founding of Mayakovsky's magazine Lef. Both were included in a small collection entitled Iskusstvo v proizvodstve (*Art in Production*), which was published by the Art-Productional Council of the Visual Arts Department of Narkompros in 1921. There is a dearth of biographical information on the two authors. But it is known that the first article was the work of the artist and critic Alexei Vasilevich Filippov (1882–1956). The author of the second article, A. Toporkov, reappears subsequently as a contributor to SA (Sovremennaya Arkhitektura [Contemporary Architecture]) in 1928.

A. FILIPPOV: Production Art

The psychology of art establishes two kinds of artistic imagination—the *reproductive* and the *constructive*. The first of these proceeds from ready-made forms already existing in nature and life reflects them in the representational or distorting mirror of visual art. The second, audaciously and actively, contrasts Man's creation with Nature's creation by expressing the instinct of life, its beauty and its energy and, instead of imitating and reflecting its ready-made forms, creates completely new forms as signs and symbols of Man, the conqueror of Nature. Over the millennia of Man's existence the cultural layer of the earth's crust has been rich in the creations of Man's constructive imagination; obelisks and vases, carpets and porticoes, furniture and temples, dress and symbols of religion and state—are, in the prototypes of their artistic forms, typical representatives of this art. The first kind of art we generally call imitative, the second kind we call *productional, productive* art. Artists with a reproductive imagination are irrelevant to active, productional art—in this they are merely "appliers," sticking their sweet, imitative pictures onto the ready-made forms of life.

After the so-called epoch of the Renaissance and, more precisely, with the transition of art into the authority and patronage of academies, art became more and more passive and imitatively figurative. The constructive imagination weakened and dried up through lack of continuous practice. From a creative point of view the forms of life and reality degenerated. Only amid the masses glimmered here and there the sparks of active art engendered by the constructive imagination and the joyous need to decorate life. In cities and amid the cultural

From *Iskusstvo v proizvodstve* [Art in Production] (Moscow: Art-Productional Council of the Visual Arts Department of Narkompros, 1921). Translated by John Bowlt.

elite new phenomena of productive art became rare. Only individual artists in the cities attempted to replace the production of duplicates of Nature by a productional art of objects nonexistent in Nature.

With the founding of academies, the convention of taste and of aesthetic worship took as its objective the art of easel painting, reflective and abstracted from life, in which everything is enclosed within the confines of chance and personal caprice—art which has no contact with life since its incorporeal, reflected beauty is detached from the essential. Creative products of the constructive imagination suffered the fate of being virtually ignored by society. Soothing theories were created about architecture being the art of millennia, which misshaped and crystallized its forms in imitation of antiquity. Theories subservient to established tastes also subdivided art into "pure" and "applied." And the "artists" who sank into the sphere of this "applied art" stuck their figurative, reproductive imitations onto old ready-made constructive (more often not constructive) forms.

But in accordance with the notion of rationality existing in the world, ideas and individual attempts to conceive art and its embodiment in a different way have long been present. The task of our time is, possibly, to formulate this conception and to realize it in practical life.

The aspirations of the new productional art can be formulated by applying to artists K. Marx's idea about scientists: artists in varying ways have merely depicted the world but their task is to change it.

These ideas, once introduced into life, will inevitably collide with the backward tastes of the intellectual masses and the many still existing orthodox professional painters of the old order. The obstinate vulgarity and stagnation of these tastes sprang from the badly digested scholastic literary ideology of the 1840s: even after Belinsky and probably . . . Stasov, it found no new, firm support for its judgments on art and for its apprehension of art and was nurtured only by the topical observations of newspaper critics.

One of the most dangerous of these intellectual judgments, killing art by its generality, is the idea of "high" and "pure" art—with its weak, pansy inspirers, craftsmen, and performers. Even the obvious imitators—the artisans passively continuing to produce pictures with a succession of dead, uncreative forms—speak with such aplomb and arrogance about everything that is irrelevant to "the sweet little heads

of girls from Brittany" that they produce. Here is a conversation that took place eighteen years ago between the "artist" K. E. Makovsky and a St. Petersburg newspaperman—is it really so old-fashioned and atypical even nowadays?

"I hear," observed K. M. not without venom, "that some decadent artists have undertaken to open a furniture shop or something like that in Petersburg. . . . I must confess that this doesn't surprise me in the slightest. When artists can't paint pictures, then there's nothing left for them to do except apply themselves to sofas."

"But in your opinion, couldn't furniture be a branch of art?"

"Of course it can, but in that case one can say boots are a branch of art. . . . No, if you're an artist, first and foremost *paint pictures,* and if you don't want to paint, then you're not an artist."

With the standard of this home-baked conception of art, even of its representatives, the impoverishment of productive art seems even more natural: the railroad station and the theater at present do not have their own forms, but the forms of contemporary life, such as the automobile and the sewing machine, have completely done without the touch of the artist's hand.

It should be said that our ideas preclude the propagation of any dogma concerned with a hierarchy of arts, and abstract easel art as creative search and design we accept as positive artistic achievement. But today, as young artists become more and more aware of the necessity to materialize easel art, as they give greater and keener attention to surface and texture in painting (elements always present in products of productional-industrial art), this new easel art becomes especially close to productional art. And often the fine and easily eradicated dividing line between abstract and productional art can present us with a new synthesis and new, joyful, artistic attainments.

In our age of a scientific, materialistic world view when religions no longer guide the life of the people and are unable to direct it, the only highroad of great art is productional and productive art; and, of course, it holds within its new, inexhaustible potentialities of form and its immense variety of materials not a decline in standard but an artistic upsurge and intensification.

The art of constructive imagination could be especially close to Russia.

Russia's creative diapason in the art of paint, line, and form has

already been sufficiently defined over the course of its history: from the beginning of its existence as a state Russia has boasted among its highest achievements the creation of construction and decoration, fabulously beautiful monuments of architecture, utensils and costumes of the north, monumental frescoes and icons as part of the church's pictorial finery.

The artificial, unhealthy historical progress of Russia's normal decorative-constructive development toward reproductive art was dictated by the academies; it did not give us equivalent monuments of easel art and only stressed how destructive and alien this path was, its products hitherto being merely second-rate, provincial, crude lessons from the West. And only the new development of Russian art toward constructive-creative works that are transforming the very face of our life can once more present the world with great Russian art. The very disintegration of Russian reality caused by the unprecedented social revolution only helps artists in their search for new forms for a new way of life.

Productional art must create and provide a foundation for its own creative methods and must break both with intellectual easel art and with applied art, which adapt the ready-made forms of the reproductive, so-called imitative arts to objects of everyday use.

Productional art is understood, grounded, and introduced into life (1) as a higher aspect of the artist's creative effort to organize in new forms the outer appearance of life and the complex of objects surrounding us, (2) as something created by the essential, vital demands of life and by the constructive imagination of the artist-creator, and (3) as the comprehension, mastery, and transformation of material.

Productional art is a whole world view and has hardly been touched on in these cursory lines. The accurate and lucid formalization of its individual features and points is a task of the immediate future.

A. TOPORKOV: Technological and Artistic Form

I.

By exerting the nerves and muscles of visual proof, I shall surely be enabled to speak without lyricism and rhetoric, which are always false.

First of all, a lucid account must be given of the essence of technological form, which provides the key to the understanding of artistic form.

Technological form is dictated by expediency alone; for example, a machine must carry out definite work as economically as possible and with the least expenditure of material, energy, and time. Such is its task. This is conditioned, first, by the level of knowledge, second, by the qualities of the material, and third, by the state of technology.

It is easy to show that these three conditions mutually and in turn condition each other. One could say that science, which furnishes the principles for designing machines, is itself created by machines; indeed, scientific apparatus promotes discoveries that could never have been made without it. Similarly, the material essential for the construction of machines is in turn manufactured by machines. All these points are strictly coordinate with each other.

In its concrete implementation, technological form is conditioned by them. A definite task is given; it has to be accomplished. A technical designer is assigned simply by his aims, his knowledge, and his potential to apply them. Technological form comprises nothing more. It would seem that aesthetics could have no place within the sphere of pure calculation and utility. It is essential to demonstrate clearly why such a conclusion is false.

First of all, one should bear in mind that despite the advance of

From *Iskusstvo v proizvodstve* [Art in Production] (Moscow: Art-Productional Council of the Visual Arts Department of Narkompros, 1921). Translated by John Bowlt.

technology, despite its ever-growing progress, it has by no means coped with its problems up to now; by no means have all the forces of Nature been tamed and subordinated to the conscious and systematic will of Man. We are only on the threshold of this development, and before us there is a great deal still to be accomplished on this path. The elements are still at liberty, matter is still unconquered. The victory over Nature is the task of the future, of tomorrow, but not of today.

Technological form does not wholly and completely shape an object; much remains in it that is unshaped, elemental, and unchanged. It is not difficult to show that Nature will never be completely conquered by Man's technological creation; in fact, modern technology is based on science; even though science penetrates Nature's secrets and establishes new laws and relations between phenomena, the very progress of knowledge merely opens up the depths of that which is still unidentified; every resolution of a cognitive problem leads us merely to the discovery of new problems. The horizon widens as the sun rises. The path of knowledge leads into eternity; nowhere is a final point given, a limit beyond which it is impossible to go. Technology, based on science, is exactly the same and will never be in a position to provide definitive formulas for the mastery of matter, which under its influence will forever reveal its still unknown and unapprehended qualities. Technological design leads into eternity as does scientific knowledge.

The impossibility of giving shape to matter gives full scope to a new design for it, which is not a technological one. Every machine apart from those that are designed technologically, is of necessity designed in a different way; its appearance, its components, and its construction are not wholly and completely determined by scientific formulas and strict calculations.

A machine can be a work of art when technological form is inadequate and requires a supplement. In this way many machines manifest great beauty: the possibility of such beauty lies in an inadequate technological design; art here, as indeed everywhere, is the leader. Calculation is possible only on the grounds of wide-awake intuition, and one can construct only when one possesses great creative imagination. The machine, it must be confessed, is not only clever, but also fantastic.

It is essential to dwell on this point. As I have said, technological form does not wholly and completely determine an object. Of course,

technology has a brilliant history. Its achievements and attainments are striking. Before our eyes the centuries-old dreams of mankind are being realized in a new way. Aeronautics is perhaps the most significant example of this. Undoubtedly this is the case, and yet one can say that modern technology astounds the layman more than it does the specialist, who is seeking, wanting, and aspiring toward greater things.

We have only to glance at any volume on the history of mechanical engineering to convince ourselves how imperfect were the machines that, when they first appeared, seemed to be a kind of supernatural miracle to their contemporaries. The modern miracles of technology seem miraculous only to us; in fact, they are timid and naïve attempts to approach a problem directly and simply. Using the language of aesthetic criticism, we would say that technological form leaves many gaps. Moreover, technological form is very timid. Usually a machine is constructed according to a definite calculation based on scientific formulas and data on the resistance of materials, but this calculation is never followed wholly; the designer always ensures himself and doubles, trebles, the strength of the construction—although it would be strong enough without all that. All kinds of things might happen. Who will guarantee, for example, that the metal contains no cavities when it is cast? A flywheel, quite correctly calculated, may nevertheless turn out to be unsuitable for its work; hence it is better to reassure oneself by making it twice as strong.

II.

It is not so easy for a person outside technology and industrial life to perceive the potential aesthetic design of technically designed objects.

We are hypnotized too much by the particulars of our predominantly intellectual culture. Our ideals and values are to a great extent inherited by us from the remote past; our souls remain medieval. For most people technology is an indifferent extrinsic instrument.

The futurists coined an undeniably successful word in labeling these tendencies of contemporary society "passéisme."

People today are essentially "last year's people." Contemporary culture is divided, an enemy unto itself, and this is noticeable in its elu-

sive details. The Philistine above all values his little house, his little bookstand, his little sofa, and his little vase. He spends his day on "business"—at a factory, at a plant, in a bank, in private or public work. This activity goes on within particular conditions. Here at work it seems that all objects, all the furnishings, are adapted to business but not to the man; they are indifferent to him. For example, so-called American furniture—those various cupboards, revolving shelves, desks, registers—are indispensable in work that entails the compiling of complicated accounts, estimates, and business correspondence. But, of course, he usually wants to furnish his private study in quite a different way. Here are the required armchairs upholstered in leather with heraldic insignia, and a sofa as deep as a grave, and some kind of bust (sly or pensive depending on taste); here something intimate, something affectionate is required.

Such are the usual tastes. They were created once upon a time. In any case, they are now outdated; they are relevant to the past, they are an inheritance that hangs over us like fate and prevents us from living our contemporary, new life. Let us dismiss them, forget them, let us glance afresh at the new aesthetic object, the machine, with the eye of the technician, the professional, the designer. Let us attempt to define aesthetic form in connection with technological form.

It is easy to show that what previously appeared to us to be something extrinsic, blind, and soulless will appear to us revitalized, full of creation, inner energy, and meaning, almost animated.

In fact, in the eyes of a person alien to technology, the machine is first and foremost a mechanism whose whole is conditioned by its parts. It is possible to take a clockwork to pieces leaving nothing, absolutely nothing behind apart from the wheels, screws, levers, springs, etc. From these parts a skillful clockmaker can put the clock together again. Similarly, a steam turbine ordered from America comes to us dismantled; the steam fitter sets it up, joins together the bits one by one—and the turbine is ready. We see the machine as a form of mechanical, extrinsic, blind necessity; in this it is in opposition to man who works, produces, and creates guided by an intrinsic sense; it is in opposition to an organism whose parts are conditioned by the whole; it is in opposition to life itself. We cannot live with the machine, we cannot grow fond of it; it is in opposition to our freedom and creativity.

Although these words sound convincing, they are essentially false. One who speaks like this not only does not understand what a machine is, but, one might say, has not even seen it. . . .

The machine is much more like an animate organism than is generally thought. Its parts have no existence prior to the whole; on the contrary, they are, of course, conditioned and created by the whole. This whole is the creative motive that lies at the basis of construction. The machine is the word that has become flesh.

At the basis of the machine lies the creative motive, the living idea that cannot be completely analyzed. Neither a plan nor a construction can express ultimately the "idea" of a given machine; all its parts—the wheels, levers, belts, frames—are merely manifestations of this idea; the general motive exists prior to the parts, and they are all conditioned by it.

Therefore, we must learn to regard the machine not as something dead, something mechanical, but as something animated, organic, alive. Moreover, the machines of the present time are alive to a much greater extent than the people who build them. The principle of infinity is realized in machines; the principle that creates them is integral and differential calculation, i.e., the calculation of infinitely large and infinitely small quantities. While modern man, if taken individually, actually emerges as an extremely limited being, the machine appears as a power far more impressive, absolute, and purposeful.

Such a thesis becomes even more obvious to us if we examine the machine from another point of view, i.e., from the point of view of the idea of development. In actual fact, any concrete machine is merely a single point, inseparable from that which precedes it and that which follows it. Every machine has its prototype; it is the improvement or modification of a previously existing machine. Each engineer contributes very little. For example, the modern form of the bicycle did not appear at once; it developed very slowly and consistently from its primitive forms. Similarly the modern battleship can be traced back in its forms to the primitive canoe, the hollowed-out piece of oak.

We must learn to regard the machine not statically, but dynamically. Only to the eye of the uninitiated does it repose, lie locked up in its motionless form. In fact, this form is in constant movement and flux;

this form is alive, and the life of this form animates the machine's dead material.

It is, therefore, neither false nor fortuitous that people working with machines have personalized parts of them. The engine driver, fond of his steam engine, calls it "Mashka"; to him it is a live being with whom he shares his joys and sorrows. This personification is the residue of primitive animism and answers an entirely legitimate need. In working with a machine, a man merges with it in a general rhythm with his breath, his heartbeat, and his blood; only in this way does his work reach maximum production, and only through this can he come to love his work.

Here, in these feelings, this love, this psychological mood of technicians and professionals lies the key to the understanding of the machine as an artistic product. Here emerges a new beauty. Here is born a new aesthetic form.

Art by its very essence has nothing to do with estimates of utilitarian effect, with the laws of Nature, or with mathematical formulas. It is the expression of life, a token of love, the spontaneous comprehension of an object, intuition. Art has its source in life, it is its continuation and its flowering into beauty. The man who does not understand the machine's ultimate purpose with his inner being, for whom the machine is merely a dead thing, will never grow to love it, will never give it artistic shape.

There are undoubtedly many vulgar, ugly machines adapted simply to fulfilling a specific not very pleasant task, there are many machines that remain on the wrong side of aestheticism, as if their creators had lost their aesthetic-creative ability and their machines had been wholly determined by their reason, by need and use. They lived by something different, their vital interests were directed elsewhere, bitter fate and insolvency forced them to turn to the machine and technology.

But understandably, it is not these people who are able to create a new life, but those who in some way or other have come to love the path they have chosen and, in following it, live fully—not only by their reason but also by their feelings and by their will; who, by their own creativity, participate in the development of our general creativity.

Inventions great and small are not possible without enthusiasm, pas-

sion, fanaticism, and freedom. For the real creators of our techno-
logical culture, the material things of this culture are not only objects
of utility, but also immediate experiences, events in their spiritual life.
Such an attitude toward the machine leads to its aestheticization: there
are not only expedient machines, but also beautiful machines. At many
exhibitions prizes are awarded for beautiful motorcars, and anyone
who likes cars is well aware that a car really can be beautiful.

Of course, nowadays there are already many machines aesthetically
designed and beautiful in the full sense of the word. This nonhuman
beauty, this new form, is curious, differing as it does profoundly and
essentially from the forms established in contemporary art.

It is interesting to note who first implemented these forms. Not being
artists by profession, they prejudiced acceptance of these forms through
their own influence; but it was these people—engineers, designers, pro-
fessional workers—who were the first, perhaps unconsciously, to divine
a new beauty, a new life, where they had previously been inclined to
see only the art of necessity, utility, and constraint. Love of the ma-
chine gave birth to the machine's beauty; without this love its finish,
its color, its polish, and even its form would have remained a void
aesthetically. The artistic implementation of its motive is manifest in
the inexorable details. This has been an unconscious impulse, the ger-
mination of a new life on the ruins of the old.

By now, it seems to me, the new creative will has sufficiently defined
itself, but consciousness of it and understanding of it have still not
been clarified by any means. It is essential to work along these lines.
The word of liberation must be pronounced.

ALEXEI GAN: From *Constructivism* (1922)

Alexei Gan's Konstruktivizm *(Constructivism) was published in the
small town of Tver in 1922, though two of its short statements bear*

These excerpts from *Konstruktivizm* [Constructivism] (Tver, 1922) have
been translated by John Bowlt.

the dates 1920 and 1921. Arising from the foregoing program of the Productivist Group, it is the first attempt to present constructivism as a novel and coherent artistic ideology. And it is worth emphasizing that the typographical design is integral to this aim. Lissitzky was later to single out Gan in this connection, as a producer of books who worked "in the printing-works itself, along with the compositor and the machine." Obviously this close relationship between the typographer and the worker on the shop floor directly exemplified Gan's view of constructivism.

In addition to his graphic and typographic work, Gan was to be associated with the OSA, or Union of Contemporary Architects, founded by M. Ginsburg and the Vesnin brothers in 1925. He designed the title page of their magazine, SA (standing for Sovremennaya Arkhitektura [Contemporary Architecture]), which began publication in 1926, and contributed critical articles on such topics as "Constructivism in the Cinema" (see p. 127).

CONSTRUCTIVISM IS A PHENOMENON OF OUR AGE. IT AROSE IN 1920 AMID THE "MASS ACTION" LEFTIST PAINTERS AND IDEOLOGISTS.

THE PRESENT PUBLICATION IS AN AGITATIONAL BOOK WITH WHICH THE CONSTRUCTIVISTS BEGIN THE STRUGGLE WITH THE SUPPORTERS OF TRADITIONAL ART.

Moscow, 1922

WE DECLARE UNCOMPROMISING

WAR ON ART!

The 1st Working Group of Constructivists
1920,
Moscow

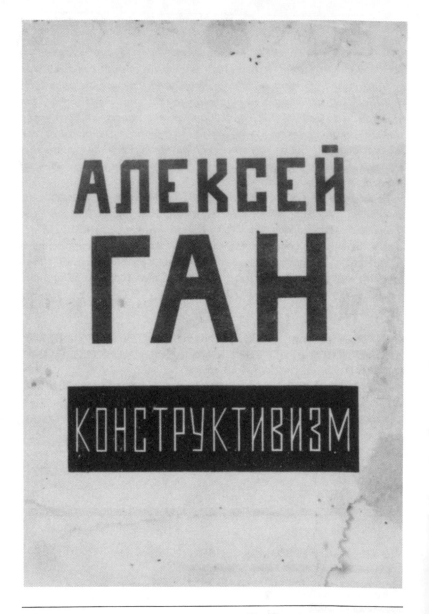

Cover of Alexei Gan's *Constructivism*, 1922. The ground is white, with Gan's name in red and the word "Constructivism" in white on a black block.

LONG LIVE

■■■■■■■■■■

THE COMMUNIST EXPRESSION

■■■■■■■■■■■■■■■

OF MATERIAL

■■■■■■■■■■

CONSTRUCTIONS!

■■■■■■■

> The 1st Working Group of Constructivists
> 1921,
> Moscow

From: Revolutionary-Marxist Thought in Words and Podagrism in Practice

. . . But the victory of materialism in the field of artistic labor is also on the eve of its triumph.

The proletarian revolution is not a word of flagellation but a real whip, which expels parasitism from man's practical reality in whatever guise it hides its repulsive being.

The present moment within the framework of objective conditions obliges us to declare that the current position of social development is advancing with the omen that artistic culture of the past is unacceptable.

The fact that all so-called art is permeated with the most reactionary idealism is the product of extreme individualism; this individualism shoves it in the direction of new, unnecessary amusements with experiments in refining subjective beauty.

ART
—

IS INDISSOLUBLY LINKED:
————————————————

WITH THEOLOGY,
————————————

METAPHYSICS,
——————————

AND MYSTICISM.
——————————

It emerged during the epoch of primeval cultures, when technique existed in "the embryonic state of tools" and forms of economy floundered in utter primitiveness.

It passed through the forge of the guild craftsmen of the Middle Ages.

It was artificially reheated by the hypocrisy of bourgeois culture and, finally, crashed against the mechanical world of our age.

DEATH TO ART!

IT AROSE NATURALLY

DEVELOPED NATURALLY

AND DISAPPEARED NATURALLY.

MARXISTS MUST WORK IN ORDER TO ELUCIDATE ITS DEATH SCIENTIFICALLY AND TO FORMULATE NEW PHENOMENA OF ARTISTIC LABOR WITHIN THE NEW HISTORIC ENVIRONMENT OF OUR TIME.

In the specific situation of our day, a gravitation toward the technical acme and social interpretation can be observed in the work of the masters of revolutionary art.

CONSTRUCTIVISM IS ADVANCING—THE SLENDER CHILD OF AN INDUSTRIAL CULTURE.

FOR A LONG TIME CAPITALISM HAS LET IT ROT UNDERGROUND.

IT HAS BEEN LIBERATED BY—THE PROLETARIAN REVOLUTION.

A NEW CHRONOLOGY BEGINS

WITH OCTOBER 25, 1917.

ON THE OTHER SIDE OF OCTOBER ARE

> THE EPOCHS OF PRIMEVAL
>
> AUTHORITARIAN AND
>
> INDIVIDUALISTIC
>
> CULTURES—
>
> OF POWER AND SPIRIT

ON OUR SIDE IS
THE FIRST CULTURE
OF ORGANIZED LABOR AND INTELLECT!

Past cultures, i.e., cultures of power and spirit, depicted art. "Beautiful" and "imperishable," it served by its visual means religion, philosophy, and all the so-called spiritual culture of the past.

Art speculatively materialized "spirituality" by illustrating sacred history, divine secrets, universal enigmas, abstract joys and sorrows, speculative truths of philosophy, and other childish games of adults whose norms of behavior were determined by the economic conditions of society in this or that historical reality.

THE SOCIOPOLITICAL SYSTEM CONDITIONED BY THE NEW ECONOMIC

STRUCTURE GIVES RISE TO NEW FORMS AND MEANS OF EXPRESSION.

THE EMERGENT CULTURE ▬▬▬▬▬▬▬ OF LABOR AND INTELLECT

WILL BE EXPRESSED BY ▬▬▬▬▬▬▬

INTELLECTUAL-MATERIAL PRODUCTION.

THE FIRST SLOGAN OF CONSTRUCTIVISM IS DOWN WITH SPECULATIVE

ACTIVITY IN ARTISTIC LABOR!

WE—PROCLAIMED THE CONSTRUCTIVISTS IN THEIR PROGRAM—

DECLARE UNCOMPROMISING WAR ON ART.

OUR AGE IS THE AGE OF INDUSTRY.
AND SCULPTURE MUST GIVE WAY TO
A SPATIAL SOLUTION OF THE OBJECT.
PAINTING CANNOT COMPETE WITH PHOTOGRAPHY.
THE THEATER BECOMES LUDICROUS WHEN
THE OUTBURSTS OF ''MASS ACTION'' ARE
PRESENTED AS THE PRODUCT OF OUR TIMES.
ARCHITECTURE IS POWERLESS TO HALT
THE DEVELOPMENT OF CONSTRUCTIVISM.
CONSTRUCTIVISM AND MASS ACTION ARE
INDISSOLUBLY LINKED TO THE LABOR SYSTEM
OF OUR REVOLUTIONARY WAY OF LIFE.

TECTONICS
TEXTURE
CONSTRUCTION

Having preserved the firm material and formal bases of art—i.e., color, line, plane, volume, and action—artistic work, materialistically intelligible, will rise to the conditions of purposeful activity, and intellectual-material production will open up new means of artistic **expression.**

We should not reflect, depict, and interpret reality but should build practically and express the planned objectives of the new actively working class, the proletariat, which "is building the foundation of future society and is building it in the capacity of a class subject, an organized force having a plan and the supreme will power to carry out this plan despite all obstacles"!

And it is now, when the proletarian revolution has conquered, and its destructive-creative course is blazing further and further the iron paths to a culture organized on the great plan of social production, that the master of color and line, the combiner of spatiovolumetrical solids, and the organizer of mass action—all must become construc-

tivists in the general business of construction and movement of the human millions.

In order to approach this new work, which has never been met with in the whole of human history, it is necessary first of all to embark on fresh paths of practical searches.

To find the Communist expression of material constructions, i.e., to establish a scientific base for the approach to constructing buildings and services that would fulfill the demands of Communist culture in its transient state, in its fluidity, in a word, in all the formations of its historical movement beginning with the period of destruction— this is the primary objective of intellectual-material production in the field of building, i.e., constructivism.

Its second objective consists in establishing scientific bases for approaches to the organization and consolidation of mass labor processes, mass movements in all of society's production, i.e., to inaugurate the first planned scheme of living human "mass action."

These are the basic and primary objectives of intellectual-material production in the field of artistic labor.

If we study the disturbed concrete reality in which we have been living since the first hour of the days of October 1917, if we analyze step by step the stages of these revolutionary transformations, and if we learn the complicated maneuvers of proletarian strategy, we will be convinced that we have endured and are enduring so many calamities simply because not everywhere and not always have there been and are there any comrades prepared and able consciously to master the functions arising spontaneously during revolutionary development.

This phenomenon affected all fronts of the Revolution.

We do not mean this or that profession, this or that trade. That's not the point.

Revolution is the highest form of social transformation, it requires specific *knowledge* and *initiative* that only it possesses.

It was possible to comprehend this practical truth fully in the Revolution itself after the many victories and intense efforts to consolidate its achievements.

Similarly, in art profound and significant changes occurred.

Proletarian October gave black earth to the seeds of leftist art. Its best and most talented creators came to power. For four years groups of specialists small in quantity but important in quality supervised art

throughout the country, rebuilding schools and mobilizing forces. But even this fortunate atmosphere did not succeed in firmly establishing new forms of artistic expression since the leftist groups did not find in their midst socially conscious revolutionaries. They placed individual and professional achievements in their craft above the tasks of the proletarian revolution. This was the main reason for their downfall.

But the Revolution develops and intensifies, and along with it the innovators of leftist art develop and grow intellectually.

Intellectual-material production is confronted with this problem: by what means, *how* to create and educate a group of workers in the sphere of artistic labor in order really to cope with and come to grips with the everyday problems that rise before us as if out of the ground at every turning in the race of evolution.

From a formal point of view some of the masters of leftist art possess exceptional gifts and sufficient wherewithal to set to work. They lack the principle of organization.

Constructivism is attempting to formulate this.

It indissolubly unites the ideological with the formal.

The masters of intellectual-material production in the field of artistic labor are collectively embarking on the road of Communist enlightenment.

Scientific Communism is the main subject of their studies.

The Soviet system and its practice is the only school of constructivism.

The theory of historical materialism through which the constructivists are assimilating history as a whole and the basic laws and course of the development of capitalist society serve them equally as a method of studying the history of art. The latter, like all social phenomena, is for the constructivists the product of human activity conditioned by the technological and economic conditions in which it arose and developed. While not having an immediate and direct relation to it, they, as production workers, are creating in the process of their general study a science of the history of its formal development.

We must bear in mind that our present society is one of transition from capitalism to Communism and that constructivism cannot divorce itself from the basis, i.e., the economic life, of our present society; the constructivists consider the practical reality of the Soviet system their only school, in which they carry out endless experiments tirelessly and unflinchingly.

Dialectical materialism is for constructivism a compass that indicates the paths and distant objectives of the future. The method of dialectical materialism opens up an unexplored field in the planning and discovery of new forms of material constructions. This abstraction does not divorce it from empirical activity. Constructivism strides confidently over the earth while all its essential ideas are to be found in Communism.

In order to single out qualified (in a Marxist sense) practitioners and theoreticians of constructivism, it is essential to channel work into a definite system, to create disciplines through which all the experimental labor processes of the constructivists would be directed.

Behind the leftist artists lies a productive path of successful and unsuccessful experiments, discoveries, and defeats. By the second decade of the twentieth century their innovative efforts were already known. Among these precise analysis can establish vague but nevertheless persistent tendencies toward the principles of industrial production: texture as a form of supply, as a form of pictorial display for visual perception and the search for constructional laws as a form of surface resolution. Leftist painting revolved around these two principles of industrial production persistently repulsing the old traditions of art. The suprematists, abstractionists, and "nonideaists" came nearer and nearer to the pure mastery of the artistic labor of intellectual-material production, but they did not manage to sever the umbilical cord that still held and joined them to the traditional art of the Old Believers.

Constructivism has played the role of midwife.

Apart from the material-formal principles of industrial production, i.e., of texture and of constructional laws, constructivism has given us a third principle and the first discipline, namely, tectonics.

We have already mentioned that the leftist artists, developing within the conditions of bourgeois culture, refused to serve the tastes and needs of the bourgeoisie. In this respect they were the first revolutionary nucleus in the sphere of cultural establishments and canons and violated its sluggish well-being. Even then they had begun to approach the problems of production in the field of artistic labor. But those new social conditions had not yet arisen within which they would have been able to interpret socially and to express themselves thematically in the products of their craft.

The proletarian revolution did this.

Over the four years of its triumphant advance the ideological and

intellectual representatives of leftist art have been assimilating the ideology of the revolutionary proletariat. Their formal achievements have been joined by a new ally—the materialism of the working class. Laboratory work on texture and constructions within the narrow framework of painting, sculpture, and senseless architecture unconnected with the reconstruction of the whole of the social organism has, for them, the true specialists in artistic production, become insignificant and absurd.

AND WHILE THE PHILISTINES AND AESTHETES TOGETHER WITH A CHOIR OF LIKE-MINDED INTELLECTUALS DREAMED THAT THEY WOULD "HARMONICALLY DEAFEN" THE WHOLE WORLD WITH THEIR MUSICAL ART AND TUNE ITS MERCANTILE SOUL TO THE SOVIET PITCH;

WOULD REVEAL WITH THEIR SYMBOLIC-REALISTIC PICTURES OF ILLITERATE AND IGNORANT RUSSIA THE SIGNIFICANCE OF SOCIAL REVOLUTION, AND WOULD IMMEDIATELY DRAMATIZE COMMUNISM IN THEIR PROFESSIONAL THEATERS THROUGHOUT THE LAND—

The positive nucleus of the bearers of leftist art began to line up along the front of the revolution itself.

From laboratory work the constructivists have passed to practical activity.

TECTONICS ▆▆▆▆▆▆▆▆▆▆

TEXTURE ▆▆▆▆▆▆▆▆▆

AND CONSTRUCTION ▆▆▆▆▆▆▆▆▆

—these are the disciplines through whose help we can emerge from the dead end of traditional art's aestheticizing professionalism onto the path of purposeful realization of the new tasks of artistic activity in the field of the emergent Communist culture.

WITHOUT ART, BY MEANS OF INTELLECTUAL-MATERIAL PRODUCTION, THE CONSTRUCTIVIST JOINS THE PROLETARIAN ORDER FOR THE STRUGGLE WITH THE PAST, FOR THE CONQUEST OF THE FUTURE.

BORIS ARVATOV: From *Art and Class* (1923)

Boris Arvatov was born in Kiev in 1896 and died in 1940. During the 1920s, he became a member of the Russian Academy of Sciences (Artistic Department). He also worked at Inkhuk (Institute of Artistic Culture) both in Moscow and Petrograd. In 1923, the year Iskusstvo i klassy *(Art and Class) was published, he took part in founding* Lef *and was a cosignatory of the first editorial: "Whom Is Lef Alerting?" His theoretical work represents one of the most rigorous attempts to place art upon a firm and practical basis in the new revolutionary society.*

From Easel Art

. . . modern painting has passed from the imitative to the abstract picture. This process advanced in two directions. The first of them— expressionism— . . . was the path on which forms were treated emotionally, the path of extreme idealistic individualism.

The second direction among the so-called abstract painters is quite contrary to the first. It is constructivism (Cézanne—Picasso—Tatlin).

The radical leading faction of our modern intelligentsia, i.e., the so-called technological intelligentsia, has been brought up in the industrial centers of our contemporary reality, has been permeated with the positivism of the natural sciences—has been "Americanized." The spirit of action, work, invention, and technological achievement has become its own spirit. Whereas the former intelligentsia soared in the cloudy heights of "pure" ideology, the new, "urbanized" intelligentsia has made the world of objects, material reality, the center of its attention. These people wanted first and foremost to build and construct.

These excerpts from *Iskusstvo i klassy* [Art and Class] (Moscow/Petrograd, 1923), have been translated by John Bowlt.

Their representatives are (for the most part unwittingly) the constructivists.

The constructivists have declared that the creative processing of practical materials is the basic, even the sole, aim of art. They have widened the applicability of artistic craftsmanship by introducing into easel compositions many other materials (apart from paint) that hitherto have been considered "unaesthetic"; stone, tin, glass, wood, wire, etc., have begun to be used by artists—to the complete bewilderment of a society unable to comprehend the aim and meaning of such work.

However, painters once and for all have discarded the illusion of perspective because it does not correspond to the actual qualities of material, and have switched from the two-dimensional picture to the practical three-dimensional construction (Tatlin's counterreliefs).

It should be noted that easel painting always had material-technological significance. All paints, except for the recently invented aniline paint, were originally invented by artists and only subsequently came to be used in everyday existence, in industry and private life. Easel painting was, therefore, an unconscious laboratory of dyestuffs. And the momentous significance of constructivism lies in the fact that it was the first to tackle this aspect consciously. No less significant is the fact that just at the time when our powerful chemical industry has undertaken to perfect paints, artists have simultaneously turned to the color and form of other materials that have been completely neglected—not colorific, but constructional, materials.

A single but decisive step now remains to be taken.

Indeed.

The whole difference between the constructivist and the real organizer of objects, the engineer or worker, lay in the fact that the constructivists had been building nonutilitarian forms—all possible combinations of paper, fabric, glass, etc. Brought up in the traditions of easel painting, the new artist sincerely thought that such creative work, of direct use to nobody, had its own, self-sufficient meaning; the new artist spoke of the revolution of consciousness, the revolution of taste, etc., imagined that he was creating independent worlds of forms, and, consequently, wallowed in the mire of art for art's sake, remaining firmly bound to the old easel.

The October proletarian revolution was necessary; the slogan

"Everything for Practical Life," bandied about by the working class, was necessary for the constructivists to see the light.

They realized:

(1) that the practical, creative processing of materials would indeed become a great organizing force when it was directed toward the creation of necessary, utilitarian forms, i.e., objects;

(2) that collectivism required the replacement of individual forms of production (the lathe) by mass mechanized production;

(3) that the handicraftsman-cum-constructivist would have to become an engineer-cum-constructor.

In 1921—and it is worth noting this year in the history of world art—at the conference of the Institute of Artistic Culture in Moscow more than twenty of Russia's greatest masters unanimously resolved to discard the self-sufficient forms of easel art and to take measures for artists immediately to enter industrial production.

Easel art died with the society that begot it.

From The Proletariat and Contemporary Trends in Art

In *painting* the new movement began when artists, while still not discarding representation, began to try to present in their pictures not the external appearance of the world, but the constructive forms that lie at the basis of visual reality (Cézanne considered the cylinder, the sphere, and the cone to be such forms); thanks to this, painting adopted its own kind of architectural constructions with the aid of paint. This process, of course, had to develop from representation, but now the latter has become the occasion for constructive compositions. Artists gradually adopted abstract painting, withdrawing into the study and construction of painterly materials. With the division of labor some came to study the problems of volume; others, those of color; yet others, those of dynamics. The most important thing about this is that the artist began to regard the picture not as a space for the illusional transmission of objects, but as a practical object. He began to process the picture just as a joiner processes a piece of wood. In other words, the artist became the organizer of elemental activity, of matter, and attempted to construct out of it this or that form independent of the objective that he set himself. The artist began to show interest in the surface of the picture, its materials (canvas, colors, its

properties, etc.), he became, in his own way, a technician, a production worker, and the only thing that revealed the individualist in him was the fact that the construction was for him an end in itself. Of course, this subjective attitude does not destroy the great objective historical significance of the new art that I include under the term constructivism.

Another side to the question lies in the fact that after shattering the canonized stereotypes of forms idolized like fetishes, artists managed to pass on to the practical, laboratory analysis of the materials from which every form is constructed. For the first time artistic creation was presented with the possibility of independent construction based only on scientific knowledge, technical skill, and the organizational objective that artistic creation wished to set itself. The philistine point of view that sees in abstract art the worship of sensual form is based on a very gross error. On the contrary, abstract art renounces the fetishism of form, replacing it by constructions from the materials of whatever has to be constructed at a given moment—whether it is the introduction of art into machine production, work on propaganda posters, or finally, fresco painting. The important thing here is that, for the first time, thanks to the abstract school, which teaches the mastery of materials in their pure form, the artist can create a form for a given objective or content not from a stereotype and not photographically, but by proceeding from a given concrete case and from experimental, laboratory practice. This affords the possibility of artistic creation, in essence, contemporary, socially, technologically, and ideologically useful, profoundly vital and evolutionary. . . .

In the sphere of *architecture* the new art has come to renounce aesthetic stylization in imitation of past ages and to utilize the contemporary mechanized technology of reinforced concrete, steel, and glass. The new artists wanted to march in step with contemporary technology by transforming its achievements into purposeful simplicity and intensive expressiveness.

In the *theater* constructivism took as the basis of work movement and action, action being manifested in this movement. The theater established as its objective not the imitation of everyday life but the construction of new forms. One of its inevitable offshoots will be abstract theatrical art, thanks to which the theater will be presented with the opportunity of experimenting with the material elements of its

profession (the dynamics, in general, of light, color, line, volume, and, in particular, of the human body). And this will permit results obtained in the stage laboratory to be transmitted into life, thereby reshaping our social, practical existence. The theater will turn into an agitator of the new life, into a school, into a tribune for creative forms.

In this way, inasmuch as constructivism is not form but method, inasmuch as this method is dependent on collectivization, inasmuch as it assumes as a basis the principle of social and technological utilization of materials, and finally, inasmuch as it sets as its direct objective the organization not only of ideas and people but also of objects, so constructivism emerges as a historical movement passing from art alien to the life of the workers, from benumbed forms, to socially vital and evolutionally dynamic art, i.e., to art of the proletariat. Apart from that, it should be noted that constructivism, in bringing the artist and engineer closer, is one of the most characteristic manifestations of the historical process that is making the intelligentsia the direct leader of society, and, in particular, is changing it on a mass scale into a technological intelligentsia.

Not in vain are abstract artists now going beyond the confines of painting and beginning to work on practical materials (stone, wood, iron, glass) and their combinations (counterreliefs, for example), which is a simple step toward the artist's participation in industrial production: here, being not merely a performer but a constructor-inventor, he can give engineering a higher creative form. And, in fact, many constructors (e.g., Tatlin) are already striving toward a polytechnic education with the aim of synthesizing the objectives of the engineer and the artist. This alone makes constructivism an art transitory with regard to proletarian art—which is summoned to expose and overcome the basic defects of constructivism: (1) home-made individualism of forms, (2) specialization, (3) subjectivity and unorganized arbitrariness of artists' objectives.

Hence, constructively significant work on materials must become the starting point of proletarian art. This work is not an end in itself, as it is for bourgeois artists, but a laboratory making the artist the master of his trade. Only in this way is it possible to create works of art that are uncanonized and independently creative. Only by these

means is it possible for art to penetrate industry not under the guise of "mechanical applied art" but as an organic fusion of the labor process and the artistic process of design. Moreover, if, for example, a proletarian painter has to paint a revolutionary poster, he will be able to create a form appropriate to the given task or objective of the given poster (the place where it will be put, the time and milieu in which it will be seen, the public to whom it will be shown, the ideological point that is to be stressed in it, the character of the phenomena depicted on it) only when he is capable of using in any way the constructive qualities of pure color, line, and other materials.

Similarly, the musical roar of our time will allow the proletarian artist to work on the design of factory products and, in the theater, on the correspondence of this music to the action being presented on stage; he will be able to turn the theater into an active instrument for re-creating reality and Man; he will be able to make poetry independent of the conservatism of skeletal forms and to create works of art in which form will follow naturally from the planned objective and will not be artificially presented as form premeditated and independent of objective. In other words, proletarian art will become independent of class only when it discards all stereotyped models, when it comprehends art as an active instrument of social construction, and when it proceeds not from form, but from the factors that go to make a given form. These factors are: (1) material, (2) process of production, (3) organizational objective, (4) conditions of perception. Hence, the so-called problem of form and content is dismissed as nonexistent and as falsely presented. If by content one understands subject matter, then for the artist this is the same material as everything else; if by content one understands the ideological aspect of a work of art, then it will either be included in the organizational purpose, as one of its elements, or, if fulfilling the role of the organizational purpose in one part, it will become in the other, just like the subject matter, material for design. Art is nothing but a higher type of any creation, a type of creation harmonious, free, consciously and deliberately integral, immediately realizable and immediately apprehensible; its sociobiological meaning is expressed in the fact that only art provides the possibility of the complete and synthetic display of all the activities of the creative individual or the creative collective.

II.
Toward International Constructivism:
1921-22

Raoul Hausmann, Hans Arp, Ivan Puni, *and* László Moholy-Nagy: A Call for Elementarist Art (1921)

What is here termed "international constructivism" derives from two distinct points of origin: from the immediate effect of Russian constructivism on the rest of Europe, and from the operation of more long-term causes that predisposed European artists to the Russian model. During the First World War the dadaists had initiated an international movement that subverted the traditional categories and supposed "laws" of art. With the conclusion of the war, it seemed imperative to many artists that the dadaist critique be accepted and the laws of art reformulated from firm and objective bases. Most characteristic of this trend of thought were the writings of the Dutchman Theo van Doesburg, who founded the magazine De Stijl together with Mondrian in 1917 and made propaganda trips throughout Italy, Belgium, and Germany in the next few years. Another symptom of this tendency was the founding of the Bauhaus by Walter Gropius in 1919, with a program paralleling that of the Russian Vkhutemas in offering an artistic education based on the fundamental analysis of form.

Despite the efforts of Van Doesburg, it was at first difficult to maintain the international emphasis of the new art. For example, Van Doesburg's attempt to attract the English vorticist painter David Bomberg into the Stijl movement met with no success. And yet the universally accessible art based on the clarity of geometrical form that Van Doesburg was advocating demanded to be seen in a wider context than that of the individual nation or linguistic group. For this reason,

From *De Stijl* (Amsterdam), vol. IV, no. 10, 1922; the text is dated Berlin, October 1921. This translation was made by Nicholas Bullock especially for this volume. Used by permission of Raoul Hausmann.

it is not surprising that the document that follows was published prominently in De Stijl. *Van Doesburg is not a signatory, but the reference to the need "to reach the STYLE" obviously echoes the program of his group and his magazine, just as the "Call for Elementarist Art" anticipates the development in his own position two years later* (see p. 91).

It is worthwhile noting the very diverse origins of the four artists who signed this document. Both Raoul Hausmann and Hans Arp had been closely associated with the dada movement, in Berlin and Zurich respectively. Ivan Puni was a Russian artist who had been associated with the futurist and suprematist movements before he left Russia for the West around 1920. László Moholy-Nagy had also been strongly influenced by suprematism in his native Hungary. He was to remain in Berlin until 1923, when he became a master at the Bauhaus.

We love the brave discovery, the regeneration of art. Art that is the expression of the forces of an epoch. We therefore demand the expression of our own time, by an art that can be only of our making, that did not exist before us and cannot continue after us—not a passing fashion, but an art based on the understanding that art is always born anew and does not remain content with the expression of the past. We pledge ourselves to elementarist art. It is elemental because it does not philosophize, because it is built up of its own elements alone. To yield to the elements of form is to be an artist. The elements of art can be discovered only by an artist. But they are not to be found by his individual whim; the individual does not exist in isolation, and the artist uses only those forces that give artistic form to the elements of our world. Artists, declare yourselves for art! Reject the styles. We demand freedom from the styles to reach the STYLE. Style is never plagiarism.

This is our manifesto: seized by the dynamism of our time, we proclaim the revision in our outlook brought about by the tireless interplay of the sources of power that mold the spirit and the form of an epoch and that allow art to grow as something pure, liberated from usefulness and beauty, as something elemental in everybody.

We proclaim elemental art! Down with the reactionary in art!

EL LISSITZKY *and* ILYA EHRENBURG:
The Blockade of Russia Is Coming to an End (1922)

*As the previous document suggests, Berlin was in 1921 the meeting
point of artists from East and West. Until 1923, when it yielded pre-
eminence to Paris, the German capital harbored a particularly large
number of Russian writers and artists, among them, Gabo, Pevsner,
Archipenko, Mayakovsky, Pasternak, and Skhlovsky. At this stage,
there was official encouragement from the Soviet government to pub-
licize the recent artistic developments in Russia. With this end in view,
El Lissitzky joined the writer Ilya Ehrenburg in founding the maga-
zine* Veshch/Gegenstand/Objet, *which offered parallel texts in Rus-
sian, German, and French. The message that the "blockade" of Russia
was nearly over, which is the subject of this initial editorial, implied
that the fruits of revolutionary experience in the arts could now be
transmitted to the rest of Europe.*

*El (Lazar Markovich) Lissitzky was born in Polshinok, in the
Smolensk province of Russia, in 1890, and died in 1941. He was
trained first as an engineer and later as an architect; his distinctive
work as an artist dates from 1919, when he became a colleague of
Malevich at the art school in Vitebsk. It was at this time that he de-
vised the notion of "proun"—"the interchange station between paint-
ing and architecture." During the 1920s he developed this notion in
a number of fields, including graphics, theater design, and architecture.
Since Lissitzky rejected both Gabo's view of the independent social
role of art and the extreme position of Rodchenko and the produc-*

An editorial in *Veshch/Gegenstand/Objet* (Berlin), no. 1–2, March–April
1922. This translation was made by Stephen Bann especially for this
volume.

tivists, he was well suited to be the bridge between Russia and the West at this crucial point.

The appearance of *Objet* is another sign that the exchange of practical knowledge, realizations, and "objects" between young Russian and

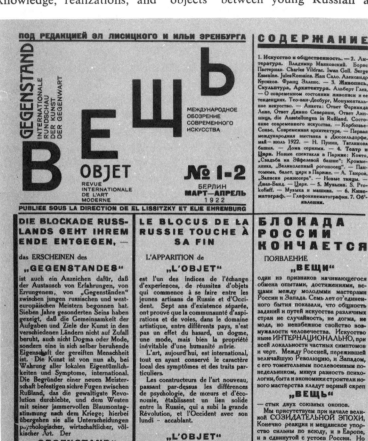

Title page of the first number of *Veshch/Gegenstand/Objet*, March–April 1922.

West European artists has begun. Seven years of separate existence have shown that the common ground of artistic aims and undertakings that exists in various countries is not simply an effect of chance, a dogma, or a passing fashion, but an inevitable accompaniment of the maturing of humanity. Art is today international, though retaining all its local symptoms and particularities. The founders of the new artistic community are strengthening ties between Russia, in the aftermath of the mighty Revolution, and the West, in its wretched postwar Black Monday frame of mind; in so doing they are bypassing all artistic distinctions whether psychological, economic, or racial. *Objet* is the meeting point of two adjacent lines of communication.

We stand at the outset of a great creative period. Obviously reaction and bourgeois obstinacy remain strong enough on all sides in Europe as well as in disoriented Russia. But all the energy of those who cling to the past can only, at the very most, delay the process of constructing new forms of existence and communal work. The days of destroying, laying siege, and undermining lie behind us. That is why *Objet* will devote the least possible amount of space to combating the epigones of the academy. The negative tactics of the "dadaists," who are as like the first futurists of the prewar period as two peas in a pod, appear anachronistic to us. Now is the time to build on ground that has been cleared. What is dead will pass away without our help; land that is lying fallow does not require a program or a school, it needs work. It is as laughable as it is naïve to talk nowadays about "wanting to throw Pushkin overboard." In the flux of forms binding laws do exist, and the classical models need cause no alarm to the artists of the New Age. What we can learn from Pushkin and from Poussin is not how to animate forms that are ossified but the eternal laws of clarity, economy, and proportion. *Objet* does not condemn the past in the past. It appeals for the making of the present in the present. That is why the immediate vestiges of yesterday's transitional phases are inimical to us—symbolism, impressionism, and the rest.

We hold that the fundamental feature of the present age is the triumph of the constructive method. We find it just as much in the new economics and the development of industry as in the psychology of our contemporaries in the world of art. *Objet* will take the part of constructive art, whose task is not to adorn life but to organize it.

We have called our review *Objet* because for us art means the crea-

tion of new "objects." That explains the attraction that realism, weightiness, volume, and the earth itself hold for us. But no one should imagine in consequence that by objects we mean expressly functional objects. Obviously we consider that functional objects turned out in factories—airplanes and motorcars—are also the product of genuine art. Yet we have no wish to confine artistic creation to these functional objects. Every organized work—whether it be a house, a poem, or a picture—is an "object" directed toward a particular end, which is calculated not to turn people away from life, but to summon them to make their contribution toward life's organization. So we have nothing in common with those poets who propose in verse that verse should no longer be written, or with those painters who use painting as a means of propaganda for the abandonment of painting. Primitive utilitarianism is far from being our doctrine. *Objet* considers poetry, plastic form, theater, as "objects" that cannot be dispensed with.

It is with the closest attention that *Objet* will follow the reciprocal relations between the new art and the present age in all its varied manifestations (science, politics, technology, customs, etc.). We observe that the development of communal activity in the course of recent years has been influenced by various phenomena that lie outside the so-called pure arts. *Objet* will, however, investigate examples of industrial products, new inventions, the language of everyday speech and the language of newspapers, the gestures of sport, etc.—in short, everything that is suitable as material for the conscious creative artist of our times. *Objet* stands apart from all political parties, since it is concerned with problems of art and not of politics. But that does not mean that we are in favor of an art that keeps on the outside of life and is basically apolitical. Quite the opposite, *we are unable to imagine any creation of new forms in art that is not linked to the transformation of social forms,* and understandably, all *Objet*'s sympathy goes to the *young creative forces in Europe and Russia that are constructing the new objects.*

The new collective, international style is a product of work undertaken in common. All those who play a part in its development are the friends and comrades-in-arms of *Objet*.

The fever of construction, as we are experiencing it nowadays, is on such a general scale that work can be found for all. We are not founding any sects, we are not contenting ourselves with surrogates

for the collective in the form of different trends and schools. We aim to coordinate the work of all those who are really anxious to work and do not wish to live merely on the investments of previous generations.

Whoever is accustomed not to work but to passive enjoyment, who wishes only to consume and not to create, will find *Objet* paltry and insipid.

There will be no philosophical orientation in *Objet*, or any elegant frivolities. *Objet* is a matter-of-fact organ, a herald of technique, a price list for new "objects" and a sketch for objects that have not yet been made.

From the sultry gloom of a Russia that has been bled white and from a Europe grown fat and drowsy the battle cry rings out:

An end to all declarations and counterdeclarations! Make *"Objects."*

Congress of International Progressive Artists (1922)

The Congress of International Progressive Artists, held in Düsseldorf May 29–31, 1922, was a clear sign of the widespread desire among artists to frame a common policy that would disregard national affiliations. Yet the following passages, which were published in De Stijl *after the congress, suggest that what the organization proposed on that occasion amounted to little more than an association for mutual convenience—a "financial [rather than] an artists' international." Among the most prominent of the artists who objected to the proposed arrangements were Theo van Doesburg, El Lissitzky, and Hans Richter. Claiming that they were in a minority in wishing to put artistic considerations first and foremost, they produced individual statements of protest on behalf of their respective groups and magazines, and combined to make a positive declaration of principle under the grouping of the International Faction of Constructivists (I.F.d.K.).*

A Short Review of the Proceedings

The Young Rhineland group, along with a number of other German groups—the November Group (Berlin), Darmstadt Secession, Dresden Secession, among others—took the initiative in forming a kind of union with the backing of a majority of medium-sized groups in order to set up an International of Progressive Artists. But in this, as in everything, there is agreement in theory but not in practice. With their

From *De Stijl* (Amsterdam), vol. V, no. 4, 1922. The translation is by Nicholas Bullock.

fine-sounding manifestoes the leaders of the French and German groups drummed out the following proclamation:

"FOUNDING PROCLAMATION OF THE UNION OF PROGRESSIVE
INTERNATIONAL ARTISTS"

"From all over the world come voices calling for a union of progressive artists. A lively exchange of ideas between artists of different countries has now become necessary. The lines of communication that were torn up by political events are finally reopened. We want universal and international interest in art. We want a universal international periodical. We want a permanent, universal, international exhibition of art everywhere in the world. We want a universal, international music festival that will unite mankind at least once a year with a language that can be understood by all.

"The long dreary spiritual isolation must now end. Art needs the unification of those who create. Forgetting questions of nationality, without political bias or self-seeking intention, our slogan must now be: 'Artists of all nationalities unite.' Art must become international or it will perish.

"[Signed:] The Young Rhineland, Düsseldorf; Dresden Secession; November Group, Berlin; Darmstadt Secession; Creative Group, Dresden; Theodor Däubler, Else Lasker-Schüler, Herbert Eulenberg, Oskar Kokoschka, Christian Rohlfs, Romain Rolland, Wassily Kandinsky, Han Ryner, Edouard Dujardin, Marcel Millet, Tristan Remy, Marek Schwarz, Marcel Sauvage (Groupe l'Albatros), Paul Jamatty, Prampolini, Pierre Creixamt, Henri Poulaille, Maurice Wullens, Pierre Larivière (Guilde des Artisans de l'Avenir), Josef Quessnel, Germain Delafons (Les Compagnons), Stanislaw Kubicki, A. Feder, Jankel Adler, Arthur Fischer."

Being in the majority, the Unionists thought themselves strong enough to win over the minority of really progressive artists to their side and to force them to sign the Union proclamation unconditionally. In true Prussian tradition everybody who did not obey was to be thrown out. This provoked a violent reaction from the progressive minority. At this point active intervention by the International Faction of Constructivists (Van Doesburg, Lissitzky, Richter) resolved the conflict, and the enforced signing of the manifesto was changed to simply recording on a list the signatures of those present.

Group photograph taken at the Congress of International Progressive Artists, in Düsseldorf, May 1922. From left to right: Werner Graeff, Raoul Hausmann, Theo van Doesburg, Cornelis van Eesteren, Hans Richter, Nelly van Doesburg, unidentified figure, El Lissitzky, Ruggero Vasari, Otto Freundlich, Hannah Höch, Kurt Seifert, Stanislaw Kubicki.

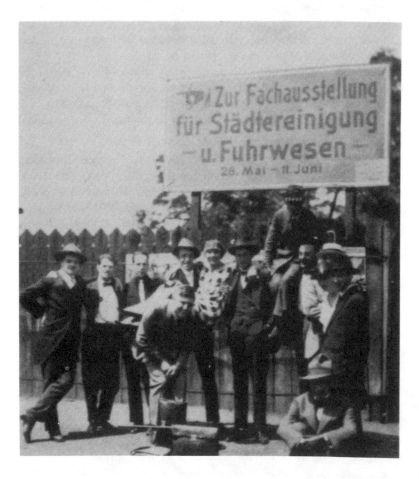

The next thing the Unionists did was to read aloud and applaud the program of the Young Rhineland group. Their program . . . consisted of no less than 149 paragraphs, devoted almost exclusively to the problems of finance and exhibitions and to starting an annual music festival and setting up an international periodical (whose appearance was announced in the catalogue of the international exhibition at Düsseldorf). Next those who had come with the intention of forming an organization of creative forces, and who put artistic considerations before everything else, turned against the program. From this it was apparent that the whole International was already prepared, behind the backs of those present (except, of course, the Young Rhineland), for the real issue at stake in deciding the aims of the congress: to form a group of progressive artists from those present, who collectively, rather than as individuals, would destroy anything that might stand in the way of the development of the creative arts. The I.F.d.K. (Van Doesburg, Lissitzky, Richter) wanted to know first of all what kind of International this would be: was it to be a financial or an artists' International?

In addition they demanded that a committee should be elected from everybody present (not just from the Young Rhineland). Everybody should then submit his ideas on the way in which the International should work to the committee through the secretariat and these would then be openly discussed. But again all questions about the character of the International were only answered evasively. Even the formation of a definite committee was shiftily dealt with. At the twentieth point in the 149-paragraph program the speaker (Mr. Wollheim) was interrupted by loud protests. Several suggestions were made at this point, among them, that a committee should be nominated which should then select the program of the Union. At the request of the I.F.d.K. a copy of the proceedings was circulated to all present.

After that the sitting was adjourned and the participants joined for a boat trip.

Second day (May 30)

After a speech by a member of the Young Rhineland group and the reading of some telegrams, the floor was thrown open to all members of the congress. In this way it was hoped to take account of the

demands and suggestions of those present. The dadaists, who had been protesting continuously from the beginning, declared themselves opposed to the whole character and setup of the congress. Mr. Henryk Berlewi (Poland) asked for a clear definition of the term "progressive artist."

One of the French representatives declared France ready to hold exhibitions of German art provided that the Union would make reasonable suggestions. Another French representative pointed out the necessity for a new romantic movement (protests from the progressive artists). Mr. Kubicki called attention to the need for a truly friendly and brotherly way of working together (applause). By this time the congress had lost all sense of leadership and there was continual shouting going on. The last speakers were Lissitzky, Richter, and Van Doesburg. They explained their reasons for attending the conference in a statement that was interrupted partly by applause, partly by protest. This impartial statement of the position of the different factions, with its accompanying declaration, printed here in full, was given to the Unionists, the French, and the Italian representatives at the end of the congress. After that Mr. Raoul Hausmann (dadaist) read a protest in both French and German declaring that he was neither for the progressives nor for the artists, and that he was no more international than he was a cannibal. He then left the room.

Mr. Werner Graeff concluded the reply to Van Doesburg with the following words: "I am nearly the youngest of all of you and I have reached the conclusion that you are neither international, nor progressive, nor artists. There is therefore nothing more for me to do here."

This was greeted with loud applause by the I.F.d.K. group. Then with intense applause on the one side, and with the boos and cheers of the other side, the I.F.d.K. group, the futurists, the dadaists, and the majority of others walked out of the Düsseldorf congress buildings.

Statement by the Editors of *Veshch/Gegenstand/Objet*

1 I come here as representative of the magazine *Veshch/Gegenstand/ Objet*, which stands for a new way of thinking and unites the leaders of the new art in nearly all countries.

2 Our thinking is characterized by the attempt to turn away from the old subjective, mystical conception of the world and to create an attitude of universality—clarity—reality.

3 That this way of thinking is truly international may be seen from the fact that during a seven-year-period of complete isolation from the outside world, we were attacking the same problems in Russia as our friends here in the West, but without any knowledge of the others. In Russia we have fought a hard but fruitful struggle to realize the new art on a broad social and political front.

4 In doing so we have learned that progress in art is possible only in a society that has already completely changed its social structure.

5 By progress we mean here the freeing of art from its role as ornament and decoration, from the need to satisfy the emotions of the few. Progress means proving and explaining that everybody has the right to create. We have nothing to do with those who minister to art like priests in a cloister.

6 The new art is founded not on a subjective, but on an objective basis. This, like science, can be described with precision and is by nature constructive. It unites not only pure art, but all those who stand at the frontier of the new culture. The artist is companion to the scholar, the engineer, and the worker.

7 As yet the new art is not always understood; it is not only society that misunderstands it, but more dangerously, it is misunderstood by those who call themselves progressive artists.

This statement, delivered by Lissitzky on behalf of Ehrenburg and himself, is from *De Stijl* (Amsterdam), vol. V, no. 4, 1922. The translation is by Nicholas Bullock.

8 To combat this situation we must join ranks so that we really can fight back. It is essentially this fight that unites us. If our aim were only to defend the material interests of a group of people called artists, we would not need another union, because there are already international unions for painters, decorators, and varnishers, and professionally we belong to these.

9 WE REGARD THE FOUNDING OF AN INTERNATIONAL OF PROGRESSIVE ARTISTS AS THE BANDING TOGETHER OF FIGHTERS FOR THE NEW CULTURE. Once again art will return to its former role. Once again we shall find a collective way of relating the work of the artist to the universal.

Statement by the Stijl Group

I I speak here on behalf of the Stijl group of Holland, which has been set up because of the need to release the potential of modern art, that is, to solve universal problems in practice.

II For us the most important thing is to give form, to organize the means into a unity.

III This unity can be achieved only by suppressing subjective arbitrariness in the means of expression.

IV We renounce the subjective choice of forms, we are working toward the use of a universal and objective medium of design.

V "Progressive artists" are those who fearlessly accept the consequences of this new aesthetic theory.

VI Long ago, as early as the war, the progressive artists of Holland adopted a theoretical position that was internationally recognized (cf. the introduction to *De Stijl*, vol. I, 1917).

VII This international exhibition was made possible only by the development of our work. It arose from our experience of working. The same needs arose also from the developments of advanced artists in other countries.

From *De Stijl* (Amsterdam), vol. V, no. 4, 1922. The translation is by Nicholas Bullock.

VIII In the certainty that the same problems were being taken up in every country (and in the fields of science, technology, architecture, sculpture, painting, music, etc.), we published our first manifesto as early as 1918.

IX The manifesto proclaimed the following points:

MANIFESTO 1 OF DE STIJL, 1918

1 There is an old and a new consciousness of time.
The old is connected with the individual.
The new is connected with the universal.
The struggle of the individual against the universal is revealing itself in the world war as well as in the art of the present day.
2 The war is destroying the old world and its contents: individual domination in every state.
3 The new art has brought forward what the new consciousness of time contains: a balance between the universal and the individual.
4 The new consciousness is prepared to realize the internal life as well as the external life.
5 Traditions, dogmas, and the domination of the individual are opposed to this realization.
6 The founders of the new plastic art, therefore, call upon all who believe in the reformation of art and culture to eradicate these obstacles to development, as in the new plastic art (by excluding natural form) they have eradicated that which blocks pure artistic expression, the ultimate consequence of all concepts of art.
7 The artists of today have been driven the whole world over by the same consciousness, and therefore have taken part from an intellectual point of view in this war against the domination of individual despotism. They therefore sympathize with all who work to establish international unity in life, art, culture, either intellectually or materially.
8 The monthly editions of *De Stijl*, founded for that purpose, try to set forth the new comprehension of life in a clear manner. Cooperation is possible by:
9 i. Sending, as an indication of approval, name, address, and profession to the editor of *De Stijl*.
ii. Sending critical, philosophical, architectural, scientific, literary, musical articles or reproductions.
iii. Translating articles in different languages or disseminating ideas published in *De Stijl*.

Signatures of the collaborators:

Theo van Doesburg, Painter Antony Kok, Poet
Robt. van 't Hoff, Architect Piet Mondriaan, Painter
Vilmos Huszár, Painter G. Vantongerloo, Sculptor
 Jan Wils, Architect

X This manifesto grew out of the common endeavor of painters, designers, architects, sculptors, and poets and was enthusiastically received by the progressive artists of every country. This demonstrated that an international organization was feasible and indeed necessary.

Statement by the Constructivist Groups of Rumania, Switzerland, Scandinavia, and Germany

I speak here as the representative of the groups of constructivist artists from Switzerland, Scandinavia, Rumania, and Germany. I agree in general with the views of El Lissitzky. The work we wish to produce as an international poses the same kind of problems that we have been trying to solve as individual artists—indeed we have gone beyond our own individual problems to the point where we can pose an objective problem. This unites us in a common task. This task leads (beyond the scientific methods of investigating the elements of art) to the desire for more than just the creation of a better painting or a better piece of sculpture: to reality itself.

Just as the feeling for life prevented us from painting like the impressionists, prevented us from accepting the old, it now makes us wish to paint, to build, to create the new reality.

We had hoped to find this spirit in the International. This spirit should generate the strength and the initiative necessary to identify and solve the problems of society in their entirety.

From *De Stijl* (Amsterdam), vol. V, no. 4, 1922. The translation is by Nicholas Bullock. Used with the permission of Hans Richter.

But to build an International around economics is to misunderstand the need for an International. The International must not only support its members, but also create and document a new attitude. To show that it is possible to achieve such a new position in a comradely collective way, using all our strength to create the new way of life we so badly need, that is indeed a worthy task!

But this cannot be achieved if everybody thinks that it is enough simply to fulfill his personal ambition in society. We must first understand that this can be created only by a society that renounces the perpetuation of the private experiences of the soul.

Neither in open discussion, nor, above all, in what it expects from the International, does this congress give any assurance that this point of view is shared by the majority.

If we assumed for a moment that we were agreed in principle, what would we do? How could we successfully achieve the intentions of the International?

As a working community!

We will set ourselves the problems: space, the house, surfaces, color, and so on. Because our aim is to make use of each other's work and because our work will be criticized only by others who are themselves familiar with the same problems, we will be able to defend only that part of our work which is objective, which solves problems; this will give everybody a personal interest in the work. If I want to build, I need elements that I know to be reliable. There can be no excuse for anything that does not clarify the intention behind a piece of work; people must not just sympathize, they must understand the work.

You believe that we should choose exhibitions, magazines, and congresses as a means of reorganizing society. But if we are so far advanced that we can work and make progress collectively, let us no longer tack between a society that does not need us and a society that does not yet exist, let us rather *change the world of today*. In the sureness of our mission we represent a real force that has yet to be felt.

On behalf of the constructivist groups of
Rumania, Switzerland, Scandinavia, and Germany
Signed: Hans Richter
For Baumann, Viking Eggeling, Janco

Statement by the International Faction of Constructivists

We came to Düsseldorf with the firm intention of creating an International. Yet the following has proved to be the case:

Unionists	*We*
I As a basis for organizing the International, the Unionists propose the "lively exchange of ideas between artists of different countries."	I Good will is not a program and cannot therefore be used as the basis for the organization of the International. Good will disappears just at the moment it should be shown toward the opposition in the congress.
II There is complete confusion over the purpose of the Union: should it be a guild to represent the interest of the artists, or should it provide the economic basis for carrying out certain cultural intentions?	II To us it is clear that, first of all, our position vis-à-vis the arts must be defined and only on this basis can economic questions be considered.
III There is no definition of the term "progressive artist." Questions of this kind were *refused* consideration on the agenda on the grounds that the way people tackle the problems of art is an entirely personal matter.	III We define the progressive artist as one who fights and rejects the tyranny of the subjective in art, as one whose work is not based on lyrical arbitrariness, as one who accepts the new principles of artistic creation— the systemization of the means of expression to produce results that are universally comprehensible.

From *De Stijl* (Amsterdam), vol. V, no. 4, 1922. The translation is by Nicholas Bullock. Used with the permission of Hans Richter.

IV As is evident from the founding proclamation, the Unionists have envisaged a series of undertakings that aim essentially at creating an international trade for the exhibition of painting. The Union must therefore be planning to start a bourgeois colonial policy.

IV We reject the present conception of an exhibition: a warehouse stuffed with unrelated objects, all for sale. Today we stand between a society that does not need us and one that does not yet exist; the only purpose of exhibitions is to demonstrate what we wish to achieve (illustrated with plans, sketches, and models) or what we have already achieved.

From the foregoing it is obvious that an International of progressive artists can be founded only on the following basis:

a) Art is, in just the same way as science and technology, a method of organization which applies to the whole of life.

b) We insist that today art is no longer a dream set apart and in contrast to the realities of the world. Art must stop being just a way of dreaming cosmic secrets. Art is a universal and real expression of creative energy, which can be used to organize the progress of mankind; it is the tool of universal progress.

c) To achieve this reality we must fight, and to fight we must be organized. Only by doing so can the creative energy of mankind be liberated. In this way we can bridge the gap between the most grandiose theories and day-to-day survival.

THE ARTISTS OF THE CONGRESS HAVE PROVED THAT IT IS THE TYRANNY OF THE INDIVIDUAL THAT MAKES THE CREATION OF A PROGRESSIVE AND UNIFIED INTERNATIONAL IMPOSSIBLE WITH THE ELEMENTS OF THIS CONGRESS.

From the Catalogue of the *First Exhibition of Russian Art, Van Diemen Gallery, Berlin (1922)*

The great exhibition of Russian art that took place in Berlin in the autumn of 1922 marked the apogee of artistic interchange between Russia and the West. The works exhibited—posters, architectural designs, and pottery as well as paintings and constructions—were by no means confined to the most recent developments. But there were sufficient works by artists such as Gabo, Tatlin, Rodchenko, and Lissitzky to give an idea of the early development of constructivism.

The commissar in charge of the exhibition was David Shterenberg, who provided a Foreword to the catalogue as well as contributing as an artist. A left-wing journalist, Arthur Holitscher—who a year earlier had published a book entitled Drei Monate in Sovjet-Russland *(Three Months in Soviet Russia)—provided an analysis of this new art for his fellow Germans. The proceeds were officially allocated to "those who are starving in Russia."*

At the end of the Berlin showing, the exhibition moved to Amsterdam. Lissitzky accompanied it there and renewed contact with Van Doesburg and other members of the Stijl group.

DAVID SHTERENBERG: Foreword

During the blockade Russian artists tried to keep in touch with their Western counterparts by issuing proclamations and manifestoes. But it is only with the present exhibition that the first real step has been

From *Erste russische Kunstausstellung* [First Exhibition of Russian Art] (exhibition catalogue, Berlin: Van Diemen Gallery, 1922). The translation was made by Nicholas Bullock especially for this volume.

taken to bring the two groups together. In this exhibition our aim has been to show Western Europe everything that depicts the story of Russian art during the Revolution and the war years. Russian art is still young. The great majority of our people first came into contact with it after the October Revolution and only then were they able to infuse new life into the dead, official art that in Russia, as everywhere else, was regarded as "high art." At the same time the Revolution threw open new avenues for Russia's creative forces. It gave the artist the opportunity to carry his ideas into the streets and the squares of the towns and thus to enrich his vision with new ideas. The decoration of towns, so changed by the Revolution, and the demands of the new architecture naturally called into existence new forms of creation and construction. The most important of these changes was that each artist no longer worked for himself alone, stuck away in a corner, but sought the closest contact with the people. They eagerly accepted what they were offered, greeting it sometimes with enthusiasm, sometimes with sharp criticism. This was the testing ground of Russian art. Many artists did not survive the test and were immediately forgotten. Others, however, emerged tempered and strengthened from the ordeal. They were no longer content with canvas, they rejected the stone coffins that passed for houses, and they fought to reshape the environment for the new society. They would undoubtedly have succeeded had the blockade and the war not made their goals unattainable.

The greater part of artistic activity in the first years of the Revolution was concerned with the decoration of public spaces. It would of course be nonsensical to include this kind of work in an exhibition. The only works exhibited are those by the different movements that have been active in Russia over the last few years. The works of the leftist groups illustrate every type of experimental development that has led to the revolution in art. At the same time groups that are concerned mainly with the achievement of certain optical effects are also included. Artists of the following Russian groups are represented: the Union of Russian Artists (this includes the artists of the older schools), the World of Art (Mir Iskusstva), the Jack of Diamonds group (Bubnovy Valet), the impressionists, and finally the leftist groups (cubists, suprematists, and constructivists). In addition, certain artists are included whose work does not fit the confines of any particular school

but is nevertheless of the greatest importance for the development of Russian art. Finally, there are posters from the civil war and works from the state porcelain factory, as well as work of students at the art schools, where the majority of students are either workers or peasants. We hope that this first visit will not be the last and that our Western comrades, whom we would like to see in Moscow and Petrograd, will not be long in coming.

ARTHUR HOLITSCHER: Statement

The dissolution of one epoch, the emergence and beginning of a new one, are felt and communicated more readily by the sensitive nerves of artists than by the "real" power of the politicians, the leaders and reformers of our economy. (This does not apply to the great leaders, the theoretical apostles of revolution; they are true prophets, seers gifted with prophetic ability to foresee the future, like artists with their control over the elements of space.)

If one examines the development of art in the last fifty years, one cannot but be surprised by the profusion and quick succession of different movements, of different schools, stormy petrels of the Revolution, premonitions of the great upheaval that has shaken the world.

It would be perverse to dismiss the struggles of these different movements and schools with slighting irony simply as "studio revolutions," precisely because it was in "studio revolutions" that the real initiators of the new developments in art, the leaders driven by their own vision, won over their followers.

In the new order of art, what really is new and affirms the coming of the spiritual revolution is sensed first of all, apart from the great leaders of art, by a small group of artistically precocious and recherché enthusiast-critics or poet-critics. Their discovery is shared with a circle of connoisseurs, collectors and dealers, museum directors avidly

From *Erste russische Kunstausstellung* [First Exhibition of Russian Art] (exhibition catalogue, Berlin: Van Diemen Gallery, 1922). This translation was made by Nicholas Bullock especially for this volume.

in search of innovation, and with the great, insensate crowd of snobs. Revolutionary art is thus sucked down into bourgeois society. It immediately becomes the object of the wiles of the commercial world, of the search for something new, of social ambition; only in the rarest cases does it become the object of the pleasure and satisfaction of inner understanding. It is, after all, only the masses who, by imitating and speculating without judgment, set the seal of success on the new in art. It is also this element of success, of the crowd's dull speculation, which fully or half-consciously spurs on the unsought following of every great revolutionary artist to new achievements—which, perhaps with subconscious understanding, with the knowledge of theory alone, with the fatefulness of the moment, swings the mood of the masses, once slow, now capricious.

Thus it is really revolution, both its good and bad side, that emerges from the artist's studio, even if it does not affect the life of the masses in any way, even if it does not influence them from afar. In general people listen more attentively to those who guide their political and economic interests than to those who realize their transcendental urges and needs. In a few glorious and isolated periods of art, in antiquity, in the Middle Ages, socially periods of enslavement for the masses, the community played a larger part in the creative works of a few illustrious contemporaries; today we no longer understand the way in which a Praxiteles, the cathedral builders, a Michelangelo or a Dürer worked. In those distant times the great artist still had the power to change and to cast the times in the image of his own vision, of his own convictions. Art possessed the strength to shape the political and economic aspirations of a people.

We used to believe that if once the foundations of society were shaken—that if the most far-reaching upheaval of our times came to pass—that the revolutionary artists would be the first to declare themselves with passionate enthusiasm for the new, for the untried. They would spring to its defense and give eye, heart, or hand, give their last drop of blood to preserve it. Yet this is only partly true. By and large the revolutionary artist is no less shaken than the rest of the indifferent majority by the incisive effect of the Revolution on the private life of individuals in society; he is more than shaken. Only a few, isolated people realize that the recent Revolution is at once the explanation, cause, and aim of their involvement, the enthusiasm to which their

life has unconsciously been attuned for so long. These few, the select, singled out both as human beings and as artists, enter active politics and serve the destiny of the people from their inner conviction. They forget their own individuality, which is of course only a result of the tyrannical isolation in which bourgeois society suspends its court jesters. They attempt to link up with the masses, whom they have listened to for so long in their need and in their enthusiasm. The "studio revolutionaries" stand on the sidelines—they pretend to join in—they sabotage. Now that the greatness of the new vision has been brought out into the open air of the streets, the squares, the bridges, and the barricades, into the vigorous atmosphere of the life of the people, they (the studio revolutionaries) crawl away frightened to death into the haze of the oil paint of their studios. It is no longer the prophetic vision of a single man that carries art forward; now it is the gigantic choir of the people's triumphant spirit, the natural urge of the spirit to rise upward from the primeval depths toward the light of delivered humanity. Theory, born and fostered in the studio, the theory of schools of art, theory that the passage of time has disclosed to be unclear and barely decipherable, is now banished from the purified atmosphere of the victorious Revolution.

Art conceived at such a time is worthy of consideration and study. Its aesthetic, the analysis of its essence, does not take as its starting point the criticism of works from revolutionary epochs of artistic activity. To criticize works of art from the time of the political upheaval, to criticize works that are truly born of the revolution, is to be like the historian who must seek to understand the time from political and economic sources. Only those who themselves carry the fire of the Revolution should dare to approach the problems of the art of the Revolution. The works they must consider are not to be measured by the same scale as that used for the art of protest, for the art of regeneration set up in opposition to the old-fashioned. The art of the Revolution is revolution. It carries forward the seed of great and total revolution. It will create new laws for evaluation. Pouring forth from pure springs, it will teach a new aesthetic: to subject oneself to the eternal will of world change, whose visible manifestation is social revolution. The aesthetic of the art of the Revolution will itself mean revolution, and not a mere segment of the Revolution. It will mean the totality of the creative forces of an epoch—not an isolated aspect of its many possible manifestations.

From Introduction

We now turn to nonobjective painting: first, suprematism. This is represented best in the paintings of Malevich, who both in his work and in his ideological propaganda is among the most important suprematists and appears to act as their leader. To this group also belong Kliun, Rosanova, Popova, Exter, Lissitzky, Drevin, Mansurov, and a few of Rodchenko's works. Their paintings are based on rhythms of abstract planes that, according to suprematist theory, have their own precise laws; it is from these that the great nonobjective movement in art has developed. Our suprematists exhibit a whole range of simple forms: circles, squares, and the rhythmic play of these elements on the canvas. Kandinsky has also adopted the same position although he has chosen a different branch of nonobjective art. Both his writings and his views on art are already known in Germany. At this point we should also mention Tatlin, who was the first in Russia to exhibit counterreliefs, where real materials extend in space from the surface. In the exhibition, Tatlin is represented by nonobjective works that constitute a stage in the transition to productivist art. His Monument to the Third International in Moscow may be regarded as a first step in this direction.

The artistic movements of the left branch out even further: the representatives of one group, completely renouncing the use of canvas, are moving toward *productivist* art and are producing a whole range of nonobjective constructional forms that display no utilitarian characteristics. Rodchenko belongs to this group, and he is represented by his strong suprematist and constructivist works. He is now moving toward a kind of architectonic utilitarian construction. Working in the same vein, but nevertheless clearly distinct, are Stenberg, Meduniezky, Miturich, Klutsis, Yoganson, Stregeminsky, and others. Rather apart is Nathan Altman. With him starts yet another branch of nonfigurative art. In the visible composition of the painting he approximates the actual construction of the object and thus endows it, in his case, with

From *Erste russische Kunstausstellung* [First Exhibition of Russian Art] (exhibition catalogue, Berlin: Van Diemen Gallery, 1922). This translation was made by Nicholas Bullock especially for this volume.

a certain social content. His works attempt to influence not only the eye but the consciousness of the beholder. The starting point of his works is the particular material that he is considering, which he then attempts to enrich.

As against the suprematists, the painter Shterenberg demonstrates in his works that a painting can be organized in a purely painterly manner without, however, becoming nonobjective. He is the first to build up the painting in contrasting strokes, depicting the basic form of an object in such a way that it suggests reality, and in doing so he displays the concentrated pictorial content of this object.

Parallel to the constructivists is the sculptor Gabo, whose works have revolutionized sculpture, for they are no longer "sculptures of mass" but constructions in space. The system behind Gabo's sculpture is based on the diagonal intersections of the planes of a basic form creating a construction in space. In this way space acquires depth. It is interesting to note that Gabo's constructions are not just static, but dynamic. In them time too becomes a new element of art.

There are also a number of works by students at the art schools. These are interesting primarily because they show the results of new methods of teaching and the use in the schools of new materials derived from peasant and industrial spheres. The works of the state porcelain and engraving factories are of great interest as experiments with a mass-produced object closely connected with art. The section on the theater illustrates the works of a number of painters, for example, Yakulov's sketches for *Brambilla* by Hoffmann, which was produced by the Moscow Kamerny Theater. Yakulov was the first, with Tatlin, to design stage sets in a constructive way. N. Altman's work on *Uriel Akosta* for the Jewish Theater in Moscow is a new constructive solution to the handling of volumes in space. Exter with her designs for *Romeo and Juliet* (at the Moscow Kamerny Theater) has developed a sculptural arrangement of theater sets using very intense colors. Boguslavskaya is represented here in the exhibition by her mannequins for the theater.

In the exhibition there are also a few posters, which in small measure illustrate the approach of the Russian painters to posters for the Revolution.

Naturally these artists are only loosely affiliated with the movements mentioned. That they have formed closer groups within these may be seen from the works exhibited.

III.
Constructivism and the Little Magazines: 1923-24

From *Lef* (1923)

Reference has already been made to Lissitzky's founding (with Ehren-burg) of the magazine Veshch/Gegenstand/Objet *in 1922. As his widow has remarked: "Periodicals sprouted like mushrooms in those days, and like mushrooms they often had only a short existence." However, it should not be assumed that, because these publications were often ephemeral, they must be regarded as the mere offscourings of contemporary activity in the arts. On the contrary, they were the means of bringing the work of different types of artists into relation, and so defining a common position, at a stage when the most inde-pendent and adventurous practitioners felt it necessary to acquire this common foundation of principle. By 1923, both in Russia and in the rest of Europe, the central ideas of constructivism were no longer a novelty. But the task of bringing these ideas into relation both to the practice of the individual artist and to the needs of society was by no means complete.*

The two magazines that most effectively illustrate this crucial phase, in Russia and in Europe respectively, are Lef *and* G. Lef *(Journal of the Left Front of the Arts) was first published in 1923, with a print order of 5,000 copies. Mayakovsky later wrote in his autobiography,* I Myself:

> 1923. We organise *Lef*. *Lef* is the envelopment of a great social theme by all the weapons of Futurism. This definition does not ex-haust the matter of course—I refer those interested to *Lef* itself. Those who united closely together: Brik, Aseev, Kushner, Arvatov, Tret'yakov, Rodchenko, Lavinsky. . . . One of the slogans, one of the great achievements of *Lef*—the de-aesthetisation of the pro-ductional arts, constructivism.

Richard Sherwood, from whose excellent introduction to Lef *in* Form *no. 10, the previous passage is quoted, goes on to point out that the editoral office of* Lef *was the second-floor Moscow flat of Osip and Lily Brik, "to which people were constantly coming and going, and where lengthy discussions were frequently conducted." Osip Maksimovich Brik, who was born in 1888 and died in 1945, ranks with Arvatov, Gan, and Taraboukin as one of the foremost theorists*

of Russian constructivism. From December 1918 to April 1919 he had edited Iskusstvo kommuny, *where the junction between futurism and production art was effectively carried through. He later worked as a film writer, notably for Pudovkin's* Storm over Asia. *But as early as 1916 he was writing and editing articles on the theory of poetical language, thus anticipating his contribution in the next decade to the school of literary critics now known as the Russian formalists.*

Brik made a spirited defense of the formalists, and stressed their relevance to Marxism, in an article for Lef *on "The So-Called Formal Method." But the article included here has more direct bearing on the development of constructivism since, in Rodchenko, Brik isolates the model features of the constructivist artist and, in particular, underlines his essential points of difference from the mere applied artist. In the third extract from* Lef, *Arvatov embodies another definition of the constructivist artist in action. Anton Lavinsky is portrayed as the successor to the utopian tradition of Thomas More, Fourier, and William Morris, and so to a heritage of social planning integrally linked with that of Marx.*

It is worth bearing in mind that Lavinsky was making "suggestions" to the engineer and architect, rather than presenting concrete schemes. Around 1923 there was close contact between the Lef group and a group of architects that had formed around A. A. Vesnin, a prominent lecturer at the Vkhutemas in Moscow. Architectural constructivism was to gain considerable momentum of its own with the founding of the magazine SA *by the Union of Contemporary Architects in 1926.*

Whom Is *Lef* Alerting?

This is addressed to us. *Comrades* in *Lef!*

We know that we, the "left" master craftsmen, are the best workers

Editorial from *Lef* (Moscow), no. 1, March 1923. The translation is by Richard Sherwood.

in today's art. Up to the Revolution we piled up highly correct draft plans, clever theorems, and cunning formulas for the forms of the new art.

One thing is clear: the slippery, globular belly of the bourgeoisie was a bad site for building.

During the Revolution we amassed a great many truths, we studied life, we received the task of building a very real structure for the centuries ahead. A world shaken by the booming of war and revolution is difficult soil for grandiose constructions.

We temporarily filed away our formulas, while helping to consolidate the days of revolution.

Now the globe of the bourgeois paunch exists no longer. Sweeping away the old with the Revolution, we cleared the field for the new structures of art at the same time. The earthquake is over. Cemented by spilt blood, the U.S.S.R. stands firmly. It is time to start *big things. The seriousness of our attitude to ourselves is the one solid foundation for our work.*

Futurists!

Your services to art are great, but don't dream of living on the dividends of yesterday's revolutionary spirit. Show by your work today that your outburst is not the desperate wailing of the wounded intelligentsia, but a struggle, laboring shoulder to shoulder with all those who are straining toward the victory of the commune.

Constructivists!

Be on your guard against becoming just another aesthetic school.

Constructivism in art alone is nothing. It is a question of the very existence of art. Constructivism must become the supreme formal engineering of the whole of life. Constructivism in a performance of shepherd's pastorals is nonsense. Our ideas must be developed on the basis of present-day things.

Production artists!

Be on your guard against becoming applied-art handicraftsmen.

In teaching the workers learn from the worker. In dictating aesthetic orders to the factory from your studios you become simply customers. Your school is the factory floor.

Formalists!

The formal method is the key to the study of art. Every flea of a rhyme must be accounted for. But avoid catching fleas in a vacuum.

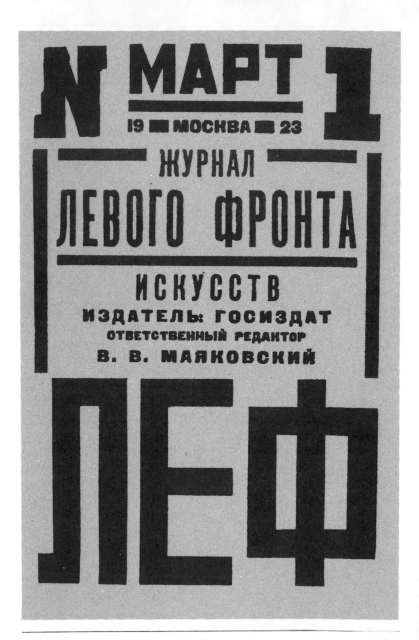

Title page of *Lef* (Journal of the Left Front of the Arts), no. 1, 1923, designed by Rodchenko.

Only together with the sociological study of art will your work become not only interesting, but necessary.

Students!

Avoid giving out the chance distortions of the dilettante striving for innovation, for the "dernier cri" of art. The innovation of the dilettante is a steamship on the legs of a chicken.

Only in craftsmanship have you the right to throw out the old.

Everyone together!

As you go from theory to practice, remember your craftsmanship, your technical skill.

Hack work on the part of the young, who have the strength for colossal things, is even more repulsive than the hack work of the flabby little academics.

Masters and students of *Lef!*

The question of our very existence is being decided. The very greatest idea will perish if we do not mold it skillfully.

The most skillful forms will remain black threads in blackest night, will evoke merely the annoyance and irritation of those who stumble over them if we do not apply them to the shaping of the present day, the day of revolution.

Lef is on guard.

Lef *is the defender for all inventors.*

Lef is on guard.

Lef *will throw off all the old fuddy-duddies, all the ultra aesthetes, all the copiers.*

OSIP BRIK: Into Production!

Rodchenko was an abstract artist. He has become a constructivist and production artist. Not just in name, but in practice.

From *Lef* (Moscow), no. 1, March 1923. The translation is by Richard Sherwood.

There are artists who have rapidly adopted the fashionable jargon of constructivism. Instead of "composition" they say "construction"; instead of "to write" they say "to shape"; instead of "to create"— "to construct." But they are all doing the same old thing: little pictures, landscapes, portraits. There are others who do not paint pictures but work in production, who also talk about material, texture, construction, but once again out come the very same age-old ornamental and applied types of art—little cockerels and flowers or circles and dashes. And there are still others who do not paint pictures and do not work in production—they "creatively apprehend" the "eternal laws" of color and form. For them the real world of things does not exist; they wash their hands of it. From the heights of their mystical insights they contemptuously gaze upon anyone who profanes the "holy dogmas" of art through work in production, or any other sphere of material culture.

Rodchenko is no such artist. Rodchenko sees that the problem of the artist is not the abstract apprehension of color and form, but the practical ability to resolve any task of shaping a concrete object. Rodchenko knows that there aren't immutable laws of construction, but that every new task must be resolved afresh, starting from the conditions set by the individual case.

Rodchenko knows that you won't do anything by sitting in your own studio, that you must go into real work, carry your own organizing talent where it is needed—into production. Many who have glanced at Rodchenko's work will say: "Where's the constructivism in this? Where's he any different from applied art?" To them I say: The applied artist embellishes the object; Rodchenko shapes it. The applied artist looks at the object as a place for applying his own ornamental composition, while Rodchenko sees in the object the material that underlies the design. The applied artist has nothing to do if he can't embellish an object; for Rodchenko a complete lack of embellishment is a necessary condition for the proper construction of the object.

It is not aesthetic considerations but the purpose of the object that defines the organization of its color and form.

At the moment things are hard for the constructivist production artist. Artists turn their backs on him. Industrialists wave him away in annoyance. The man in the street goggles and, frightened, whispers: "Futurist!" It needs tenacity and will power not to lapse into the peace-

ful bosom of canonized art, to avoid starting to "create" like the "fair copy" artists, or to concoct ornaments for cups and handkerchiefs, or daub pictures for cozy dining rooms and bedrooms.

Rodchenko will not go astray. He can spit on the artists and philistines, and as for the industrialists, he will break through and prove to them that only the productional-constructive approach to the object gives the highest proficiency to production. Of course, this will not happen quickly. It will come when the question of "quality" moves to the forefront; but now, when everything is concentrated on "quantity," what talk can there be of proficiency!

Rodchenko is patient. He will wait; meanwhile he is doing what he can—he is revolutionizing taste, clearing the ground for the future nonaesthetic, but useful, material culture.

Rodchenko is right. It is evident to anyone with his eyes open that there is no other road for art than into production.

Let the company of "fair copyists" laugh as they foist their daubings onto the philistine aesthetes.

Let the "applied artists" delight in dumping their "stylish ornaments" on the factories and workshops.

Let the man in the street spit with disgust at the iron constructive power of Rodchenko's construction. There is a consumer who does not need pictures and ornaments, and who is not afraid of iron and steel. This consumer is the proletariat. With the victory of the proletariat will come the victory of constructivism.

Boris Arvatov: Materialized Utopia

Towns of the future have existed in the past too: More, Fourier, Morris, etc. Yet Lavinsky's project has a quite special new significance. Lavinsky has also created a town of the future. Naturally this

From *Lef* (Moscow), no. 1, March 1923. The translation is by Richard Sherwood.

was only to be expected. Not from Lavinsky. From today's revolution-
ary artists in general. For Lavinsky, of course, is only one particular
case.

The romance of the commune, and not the idyll of the cottage. That
is the first thing. Second, previously it was only discussed (by Wells
and others), but Lavinsky has sketched it out plainly. He has drawn
it in his own style, unusually representational—but what of it?! There
was just one purpose: to demonstrate, and not to discuss, and the
purpose has been achieved. Third, and most important: *the artist
wanted to construct.*

One could name hundreds of professors, academics, and so on who
did not even "want." Yet architecture turned into form, ornamenta-
tion, the aesthetic cult of beauty. But what of the engineers? Of course
they have been building, and still are. They build straightforwardly, in
modern fashion, on the basis of the latest industrial techniques. But
there's one odd thing: as long as they occupy themselves with specific
structures (bridges, cranes, platforms), all goes well; but as soon as
they take on a larger-scale construction, it's enough to make the old
familiar face of the aesthete peer out from beneath the mask of the
engineer. Brought up according to the canons of bourgeois art, the
engineer is almost always just as much of a fetishist as his blood brother
the architect. So engineering falls into the sweet embrace of aestheti-
cism and thereby voluntarily condemns itself either to a narrowing
of the problems, or to social conservatism.

With all these facts in mind, I maintain that Lavinsky's project,
using engineering in its future dynamics, engineering as a universal
method, engineering released from beneath the molds of art and subor-
dinated only to the law of sociotechnical expediency, this project
strikes at both the artist and the engineer. To the former it says plainly:
Hands off the business of life, you who have remained on Parnassus.
The latter it summons to revolutionary boldness and to a break with
traditional aesthetizing, toward the organization of life in all its exten-
siveness.

This docs not exhaust the significance of Lavinsky's experiment,
however. Lavinsky is a constructivist. What is constructivism?

In the past when the artist set about using his material (paint, etc.),

he regarded it only as a means of creating an impression. Such an impression was attained in the various forms of representation. The artist "reflected" the world, as people like to say. The furious growth of individualism broke up representational art. Abstract art appeared. And at one and the same time, while some (the expressionists, for example) were highly delighted with such a novelty and, even though they did not crawl from the swamp of impressionistic creation, tailored it in the style of metaphysics, others saw in the abstract form a new, unprecedented possibility. Not the creation of forms of the supremely "aesthetic," but the efficient construction of materials.

Not the "end in itself," but "value of content."

Replace the word "content" by the word "purpose," and you will understand what it's all about. But how can one speak of a "purpose" in an abstract construction? Between the construction and the object there is a gulf—the same sort as between art and production. But the constructivists are still artists. The last of the Mohicans of a form of creation divorced from life represent themselves as the finish of the end-in-itself nonsense, which eventually revolted against itself. Herein lies their great historical significance—and also the tragedy of their situation. The crusaders of aestheticism are condemned to aestheticism until a bridge toward production can be found. But how can this bridge be built in a country where production itself is scarcely alive? Who will turn to the artist, who will permit himself the luxury of a gigantic, unprecedented experiment where it is necessary at present simply to hold out? And the proffered hand of the constructivist will stay hanging in mid-air. That is why I do not smile when I look at Lavinsky's sketches. Pioneers always hold in their hands just a banner, and often a torn one at that. Surely they do not cease to be pioneers for that?

Manilov busied himself with utopias in his spare time: a little bridge, and on the bridge, etc. etc. His utopias were born passively. The economist Sismondi created utopias of another sort; it was the past that fascinated him. Fourier was also a utopian; his utopia was a revolutionary one. Taking root in the bosom of the historical process, such a utopia becomes a material force that organizes mankind. And that is when we can say with a capital letter: Utopia. For who does not know that without Fourier and others there would have been no

Marx? It is to this particular category of utopias that Lavinsky's project belongs. If a "materialized" utopia is at present only alliteratively similar to a "realized" utopia, then one conclusion must follow: *Help to realize the path indicated.* Or finally: Develop, continue further, reform, but do not turn aside. May this individual attempt, this romantic leap across the abyss, turn into a collective, deliberate collaboration organized on laboratory lines. Abroad (e.g., in Germany) we are already aware of a series of experiments and projects for a future city. These efforts are considerably nearer to present-day Western resources than is Lavinsky's project to Russian resources. They are "simpler," more realizable, more productionlike. But they have a bad heredity; with an old architect for a father, and an expressionist painting for a mother, you won't get far beyond aestheticism!

A city in the air. A city of glass and asbestos. A city on springs. What is this—an eccentricity, a modish novelty, a trick? No—*simply maximum efficiency.*

In the air—to release the earth. Made of glass—to fill it with light.

Asbestos—to lighten the structure.

On springs—to create equilibrium.

All right, but as to the circular plan, surely it's that cursed old symmetry again? Yes, but not as form; instead, as an economic principle.

It's marvelous, but what purpose is there in these strange houses rotating? Who will dare say that this is not futurism, the futuristic aesthetization of life? In other words, surely this is that same old aestheticism but in a new guise? Such an objection may apply not only to the houses; it bears down even more heavily on the unusual appearance of the springs and the radio station. This is surely futurism, dynamics, a fracture, a confusion of planes and lines, antiquated displacements, all that old assortment of Italian futurist pictorial rubbish.

Not at all! Because:

1. The rotation of the buildings pursues the very same everyday object as do Japanese houses made of paper. The difference is in the technique.

2. The springs and the radio are built as they are, and not otherwise, in the name of freedom and economy of space.

There is still one question, this time the last: Are such systems

technically possible? How will theoretical mechanics react to them? I do not know. I am ready to assume the worst—that a literal realization of the plan in all its details is unthinkable either with today's or with any other level of technique. "My business is to make suggestions," as Mayakovsky declared to the angels. Lavinsky declares the very same thing to the engineers, since what has chiefly concerned Lavinsky is the social side of the matter—*the form of the new life.* Let the engineers now say (they are not angels, fortunately) what is possible and what is not possible, how they can amend, and where they can amplify. That would not be useless work.

From G (1923-24)

Although Theo van Doesburg's magazine De Stijl *provided an invaluable forum for international constructivism from 1922 on, it was not completely identified with the new movement. It remained essentially the organ of the Stijl group. On the other hand, Hans Richter's magazine,* G, *which began publication in July 1923, was explicitly intended to be "the organ of the constructivists in Europe." The original idea for the magazine had come as early as 1920, when Hans Richter invited Theo van Doesburg to his parents' home in Klein-Kölzig. Richter and Viking Eggeling were at this time looking for ways of raising money to produce their abstract films, and Van Doesburg suggested that they should set up a magazine to publicize their ideas. However, the form* G *eventually took was clearly influenced by the common stand of Richter, Van Doesburg, and Lissitzky at the Düsseldorf congress of 1922. The title itself, standing for* Gestaltung *(Formation), was suggested by Lissitzky. And in Richter's words, the "shape of a square behind this title honored Doesburg."*

It was therefore entirely appropriate that the first number of G *should include Van Doesburg's manifesto on "Elemental Formation." This simple yet compelling statement served as a reply to the I.F.d.K. call for "the systemization of the means of expression" in the previous year. It laid down a system of "ground bases," or elemental forms, which were to differentiate firmly among painting, sculpture, and architecture. Since this system was rooted in geometrical constants, it would transcend national frontiers and establish a genuinely international constructive method.*

Hans Richter's editorial from the third number of G *has a rather different emphasis. But it bears directly, from another point of view, on the central problem of international constructivism: that of establishing and maintaining a unity of purpose and practice among European artists at a time when postwar conditions and the deterioration of the economic situation made the artist's role a peculiarly difficult one. Richter recently referred to this editorial from* G *as "the credo of the magazine."*

THEO VAN DOESBURG: Elemental Formation

I.

Two opposing modes of expression must be sharply distinguished: the **decorative** (which adorns) and the **monumental** (or formative). These two modes of expression define two completely diverse conceptions of art: that of the **past** and that of the **present.** The decorative principle aims at **centralization; decentralization** characterizes the principle of the monumental. Hitherto the evolution of art has run through all the stages from individualism to the most extreme generalization.

Individualism	Generalization
Decoration	The Monumental
Past	Present
Centralization	Decentralization

Within this tension lies the problem of the new style, of shaping the new art.

According to the decorative conception, creative activity was dependent on personal taste, discretion, or intuitive assessment of the elements of the work of art. This capricious practice, however, was not adequate to the requisite of our time:

PRECISION.

Those who have understood this demand intellectually, for example, believe they overcome the contradiction by labeling both fanciful and speculative procedure a "problem." They maintain that plastic art must be a question not of "artistic composition" but rather of "problematic construction." I assume that the difference between **composition** (assembling) and **construction** (synopsis, concentration) is an aspect of our time that cannot be underestimated. Yet neither can lead to a fruitful monumental art production *if we do not agree to the elemental means of forming it.*

From *G* (Berlin), no. 1, July 1923. The translation is by Richard Taylor.

Page from the first number of *G*, July 1923, showing part of Van Doesburg's manifesto "Elemental Formation."

What we demand of art is EXPLICITNESS, and this demand can never be fulfilled if artists make use of individualized means. **Explicitness can result only from discipline of means, and this discipline leads to the generalization of means.** Generalization of means leads to elemental, monumental formation.

It would be absurd to assume that all this does not belong to the sphere of creative activity. Art is subject to no logical discipline. It grows rather out of spontaneous, impulsive precedents within the individual. The precision, the explicitness, that we require of a work of art has the same roots as the scientific or technological perfection apparent in the nonartistic practical objects around us. In these objects, which derive from the needs of daily life, the contemporary artist sees that an end has come to impulsive and speculative procedures. **The age of decorative taste is past, the contemporary artist has entirely closed out the past.** Scientific and technological consistency force him to draw conclusions for his own domain. Creative consistency forces him into a *revision of his means, into a systematic making of rules,* that is, to *conscious* control of his elemental means of expression.

Secondary (auxiliary) means ———— **Primary (elemental) means**

Painting: illusion of form (object) anecdote, etc. ————	Painting: form-time-color
Sculpture: illusion of form anecdote, etc. ————	Sculpture: space-time-line, surface, volume
Architecture: closed-form type, decoration, symbol, etc. ————	Architecture: space-time-line, surface

II.

As early as 1916 we set the first and most important requisite: **separation of the different realms of formation.** In contrast to a still-rampant baroque (even in modern art), we have held that the formative arts must be separated from each other. Without this sharp division (sculpture from painting; painting from architecture, etc.) it is impossible to create order out of the chaos or to become acquainted with the elemental means of formation. Until now the means of formation have been so intermixed that people finally believed they were indivisible. This indefiniteness of means is a *remnant of the baroque,* in which the various arts destroy each other (by spreading over and *against each other*), instead of *strengthening* themselves through a clear relationship to each other.

Out of the elemental means grows the new formation. In it the various arts will relate to each other in such a way as to be able to develop a maximum of (elemental) expressive force.

HANS RICHTER: *G*

G, the "periodical for elemental formation," owes its existence to an overall optimism about the means and possibilities of our time. This

From *G* (Berlin), no. 3, June 1924. The translation is by Stephen Bann. Used with the permission of Hans Richter.

optimism consists before all else in the following: in still having the wish to diagnose the possibility of a culture in the unholy chaos of our age, in the fundamental disintegration in which we find ourselves, with both excess and deficiency of civilization.

We take our stand less on whatever brilliant individual achievements there may be than on the established fact that such achievements came about as evidence of a unitary vital instinct.

It is no accident
That questions like the industrialization of production, the normalization of the production process, the standardization of production problems, and hence generalization to the point of general validity, are dominant in every sector of life.

It is no accident
That exact scientific methods exist for all sectors of life.

The more consistently a sector develops today, the clearer this tendency becomes, the clearer the coherence of the vital process. Even a superficial comparison with the last generation's understanding and methods of life shows how fundamental is the difference between the one world and the other, as regards the direction of the development that this one has entered upon and the other pursued previously. (Whether this direction will be pursued, and a culture genuinely will arise in which all human energies take a place proportionate to their functions, we can only answer in the affirmative if we are optimists. For the spirit of the Middle Ages, the urge toward self-destruction, indolence, obscurantism, and all the organic peculiarities of the human-animal nature are fighting for it to remain as it was "in the olden days.")

But indubitably it appears to us that a society that is not striving toward attaining a culture, that is, a balance of its energies, must perish through an undirected and immoderate growth of these energies, and through this alone. But there is no point in trying to solve the problem in terms of any allegedly decisive single area; in today's terms, within the province of politics and economics. Admittedly these are important. But if people are not clear from the very beginning, that man—as an indivisible unity of qualities—only bestirs

himself if this unity bestirs itself, that is, all the qualities, and moreover in their organic totality, that all areas can only be fruitful TOGETHER and never separately, or at the expense of the others—if that is not already a vital constituent of our consciousness, we will always be forced to take our stand upon the Middle Ages, on dogma. A CULTURE is not a special province of science or art or any other area, and it is not the province of philanthropists or altruists either, but

THE WHOLE PROBLEM OF EXISTENCE

(if this allusion is still considered to be in any way necessary after 1914).

These speculations are addressed to a specific type of human being who still exists today, one who is not interested in prejudice, sentimental limitation, and a medieval sense of life, one who is not under the impression that by the dilettantism of compromise it is possible to solve the ever more redoubtable problems of the age, which have become the inseparable accompaniment of elementarist thought and practice, one who does not accept the chaos' in contemporary economics, politics, science, art, and so on, the chaos of, in themselves, highly developed forces, the chaos in a merely civilized way of life, and one for whom these questions are not merely a matter of abstract definition but of genuine practical significance.

In this sense, *G* is a specialized organ, but one that gathers material that is indeed not specialized but universal for requirements which are both of the time and outside it. How great this need is depends on the extent to which it already appears necessary in all fields, to set out general not merely specialized guidelines. The fact that such men, such interests, and such standards exist will justify the existence of the magazine.

Whom does *G* interest?
1. The reader who is interested in the free play of vital energies both in relation to a totality and as a phenomenon in itself.
2. The scholar, physicist, or engineer who does not confine himself to a schema or dogma appropriate to his calling and would like to examine just as much the questions posed by his specialization, such as: the effect that his activity might have outside its particular subject.

3. The artist who seeks above and beyond his individual problem what is valid on a general level, what is universal: the lever he can apply to individual sensibility—in order to endow this source of richness and his own activity with meaning.

4. The economist, merchant, organizer, or politician who expects it to be useful to him to know "in what direction things are moving" or himself to "be moving," who thinks that he can decipher these vital forces from a composite view of the whole situation. Who sees in "quality production" the ultimately decisive factor.

5. The manufacturing groups who wish to judge more precisely which products among a thousand, equally assertive ones should attract their attention—and for what reasons.

6. The contemporary who gets interest and pleasure from the development of the great body (humanity) to which he belongs, who does not suffer from inhibitions where life is concerned, and who is already equipped with all the modern instinctual apparatus for receiving and transmitting that secures his close contact with life.

<p style="text-align:center">Who is collaborating on G?</p>

All for whom these are matters of necessity, who find utility and pleasure in having something to express in a definite way, are unequivocally able to think in elementarist terms and . . . to create form.

From *Disk* (1923)

In addition to magazines such as Lef *and* G, *which represent the two central streams of constructivism, there are a number of magazines dating from this period that reflect the influence of Russia and Germany more or less indirectly. Among the most interesting of these are* Disk *and* Blok, *which were produced, respectively, in Prague and Warsaw and which both carried the writings of an active local artistic group.*

The editors of Disk *were Karel Teige, Kurt Seifert, and Krejcar. Teige, whose voice intervenes in the middle of this manifesto, was later to become involved in the bitter dispute between the Russian architects Vesnin and Ladovsky, and in the 1930s became known as a Communist who strongly opposed the Stalinist trials. But the evidence from the first number of* Disk *suggests that in 1923 the Czech avant-garde was still turning toward the West, and in particular to Paris. The French poet Pierre Albert-Birot was a contributor, and Ivan Goll (France) and the futurist Enrico Prampolini (Italy) were corresponding editors. In addition, there are illustrations of architectural work by Walter Gropius and passages quoted from Mies van der Rohe in the same issue. Yet as a counterpoise to this emphasis on the West, the language in certain parts of the manifesto suggests acquaintance with Russian constructivist doctrine.*

PICTURE

ŠTYRSKÝ*

PICTURE = living advertisement and project of a new world
 " = product of life EVERYTHING ELSE = TRASH!

* This is the adjectival form of Štyrsko, a region in North Bohemia under the Austro-Hungarian empire [TRANS.].

Editorial from *Disk* (Prague), no. 1, May 1923. The translation is by Mary E. Humphries.

obraz

Štyrský

OBRAZ živou reklamou a projektem nového světa a života
• produkt života VŠE OSTATNÍ KÝČ!

Funkce obrazu { praktické, účelné, srozumitelné
 propagační
 organisující a komponující

OBRAZ { energii
 kritikou } ŽIVOTA
 hybnou silou

Požadavek: obraz musí být aktivní
 musí něco dělat ve světě, v životě. Aby vykonal úlohu, uloženou v jeho ploše, nutno
 ho strojově rozšířiti 1.000, 10.000, 100.000 exemplářů. Reprodukce. Grafika letákem.

Nenávidím obrazy jako snoby, jež je kupují z touhy po jedinečnosti, aby mezi 4 stěnami estétského příbytku
originál — unikát *vzdychali před nimi v lenoškách (à la Matisse!). Obraz visící na stěně*
obraz není jen obrazem!! *v uzavřeném prostoru, jalová dekorace, pro nic a za nic, nic nedělá, nic*
 nechce, nic neříká, nežije.

Teige: BUĎ PLAKÁTEM!
reklamou a projektem nového světa

Návrh, projekt nového světa — vynalézáním nových, krásnějších, užitečnějších forem a hodnot
 života
 — tvořením nových, krásnějších, užitečnějších forem a hodnot
 života
Reklama a propagace nových, krásnějších, užitečnějších forem a hodnot života.
 Nový svět neleží ve hvězdách, v oblacích, ale na zemi. Mnohé z nového světa už známe, máme a žijeme

PROPAGACE
nové krásy, zdraví, rozumu, svobody, řádu, radosti, veselí života.

 Goll: Chapliniada (kino). — Černík: Radosti elektrického století. — Nezval: Rozumnost bezhlavé veselosti.
— Krejcar: Amerikanismus. — Birot: Poesie pleneru. — Teige: Paříž. — Seifert: Paříž. — Picasso-Seurat: Cirkus.
III. Internacionála. — Film (Variété, Cirkus)
Reklama: idejí
 knih
 revoluce
 akcí a atrakcí
 Rozhodně **o** propagace: „Mánesa", Ibsena, Stinnesa, Poincare, buržousie, sociálpatriotů, akademii, salonů,
KU-KLUX-CLAN
 OBRAZ
 stavět bourat
 kladná činnost záporná činnost
 objektivní osobní
ŽURNALISTICKÁ KARIKATURA REVOLUČNÍ ničí, bičuje, nenávidí.

First page of the *Disk* manifesto, May 1923. (Photo courtesy Stedelijk Museum, Amsterdam)

Functions of a picture ⎡practical, appropriate, intelligible
advertising
organizing and composing⎦

PICTURE ⎡energy
criticism
motive power⎦ **OF LIFE**

Requirement: a picture must be active
it must do something in the world. In order to accomplish the task allotted within its sphere, it is necessary to multiply it by printing press. 1,000, 10,000, 100,000 copies. Reproduction. Graphic art by pamphlet.

I hate pictures as much as I hate snobs who buy them out of the desire to be individual so that they can sigh in front of them in their easy chairs between the four walls of their aesthetic furniture (à la Matisse!). The picture hangs on the wall in a closed area, a barren decoration, for nothing, it does nothing, it wants nothing, it does not live.

original—unique
a picture is not only a picture!!

Teige: **BE A POSTER!**
advertise and project a new world

A plan, project of a new world—by exploring new, more beautiful,
more useful forms and values of
life

—by creating new, more beautiful,
more useful forms and values of
life

Advertisement and propagation of new, more beautiful, more useful forms and values of life.

The new world lives neither in the stars nor in the clouds, but on earth. Much of the new world we already know, have, and live.

PROPAGATION
of new beauty, health, wisdom, freedom, order, joy of life.

Goll: Chaplincade (cinema).—Černik: The joys of the electrical century.—Nezval: Wisdom of foolhardy merriment.—Krejcar: Americanism.—Birot: Poetry for everybody.—Teige: Paris.—Seifert: Paris.—Picasso-Seurat: Circus. Third International.—Film (variety, circus).

Publicity: of ideas
of books
of revolution
of actions and attractions

Definitely *not* propagation of: "Mánes," Ibsen, Stinnes, Poincaré, bourgeoisie, patriots of socialism, academies, salons, KU KLUX KLAN.

PICTURE

to build	to demolish
positive action	negative action
objective	subjective

JOURNALISTIC REVOLUTIONARY CARICATURE destroys, whips, hates.

FORM: Dictated by a purpose, brief, exact, intelligible, entertaining, lucid, constructive, simple; no decoration, ornament, pettiness, literature, psychology, mysticism.

BEAUTY WITHOUT SOUL
THE DESIGN OF A NEW GLOBE

PICTURE = constructive poem of the beauties of the world
NOT: reproduction, patching, imitation, restoration, idealization, sentimentalization. The writing in a picture has its practical sense. (Poster!) It speaks. What other sense has writing anyway? With cubists, books only decorated the area with their modern expressiveness.

THE PLAN OF A NEW WORLD CAN BE WORKED OUT ONLY
BY A NEW MAN
who has his work programed, is absolutely objective so that he must combat even good subconscious work as unreliable.

WORK—IS PROGRAM

A picture performs its function in life like any other product of human work.

Picture—a product of life for the consumer who is called the market.

A picture—will no longer multiply poverty, misery, despair, will not portray oppressive shortages of the present time, social injustices, capitalists' bellies, suburban atmosphere.

A picture—of social poverty will not help anybody, it is produced from the inability to create energetic revolution, new rules, a new world.

A picture is a product of the time. A picture is not a reproduction of time. A photograph, a film, a picture magazine, etc., will represent time.

PHOTOGRAPH: Objective truth and documentary clarity above all doubts. Trash killed the photograph (thank goodness!) but it did not kill the picture! It hastened the evolutionary lucidity of creation.

Photograph: document of time and of beauties of this world.

Picture: project and creation of new beauties, new values, a hand-drawn portrait cannot compete with it not even "for individual conception + soul of an artist" (qualities of people who create trash, empty phrases). A photograph is capable of enormous technical development (dimensions, color, clarity, speed). A colored Gauguin = 0 against the perfect colored photograph from the tropics.

Photography realized the dreams of old masters from time immemorial—why do fools still admire them today?—because their ideal of a painter was nothing but an imitator of reproductions. Illusionism.

NEW FORMS OF ART TODAY AND ARISING EVERY DAY
the most beautiful poem: telegram and a photograph—economy, truth, brevity.

In a film you saw Mary Pickford, standing at the sea, she was slowly turning her head and gazed at length and languidly with her clear eyes at us—that is, at several hundred, several thousand people. MONA LISA—you cannot compete!

Naturally, painters à la Nejedly and Beneš and whole lines of others fight against the modernness that is overwhelming them like an avalanche; in vain, they do not have enough strength to find a solid and suitable place for themselves and their work in the present time —they are quite useless parasites. A photo is a more perfect narrator than they are.

The art of the past	The art of the present	
Reproduction of the world and life	a) A Photo Reproduction of the world and life. More complete, more instructive.	b) Graphic Art and Poetry project of a new life, new beauty, new value.

We hate galleries, where for centuries pictures have been getting musty (eternal memory). The health of the world and its youth depends on the fact that everything is being used up and replaced by new things. Therefore, the world does not grow old, with every hour it gets younger and more beautiful. If there were no history, the world would be younger by several centuries.

TRADITION: Old masters studied historical masterpieces to see how they should not paint. The modern painter does it even better; he does not take any notice of them at all.

DO NOT PRESERVE THE DEAD! GET RID OF THE CORPSES BECAUSE THEY STINK!

Progress and development: nothing will be impossible, we will achieve all real projects, distance = relative. For sad lovers we will cultivate black roses. Our projects will not be feverish dreams, utopias, but they will be objectively poetic.

BEWARE:

The necessity to distinguish—the basis of a new world from today's world. A picture is born from thinking, construing, and combining objective elements and thoughts and will not become a superficial and enthusiastic view. Epigones multiplied and badly produced. The machine is taking their place—mechanical reproduction. There will be fewer pictures and more mechanical reproductions.

LOVE NEW PICTURES

From *Blok* (1924)

The editorial from Blok, *which dates from 1924, is much more centrally concerned than is the* Disk *statement with constructivism, for which it attempts to furnish a definition. The Blok group had been founded at Lodz, Poland, in 1922 by Wladislaw Strzeminski, who had worked with Malevich during the First World War and was subsequently to form his own movement—"unism." However, the magazine* Blok *was edited in Warsaw by a group of "cubist, suprematist, and constructivist" artists, in which Henryk Stazewski, Teresa Zarnowerowna, and Mieczyslaw Szczuka took a prominent part. Its first number, which appeared on March 8, 1924, showed an acquaintance with both Russian and international constructivism that was to be confirmed in subsequent issues.*

What Constructivism Is

Constructivism does not aspire toward the creation of style as an immutable stereotype relying on previously invented and established forms; but it accepts the problems of CONSTRUCTION—which can and must give way to continual changes and improvements under the impact of those newer and even more complex demands that the general development of life presents us with.

It is NOT a separate branch of art (e.g., a picture or a line of verse), but art as a **whole.** ■ 1
It is NOT an expression of its own particular experiences and moods, but a search for the PRACTICAL application of creative impulse. ■ 2

Editorial from *Blok* (Warsaw), no. 6–7, 1924. The translation is by John Bowlt.

It proceeds from the primordial instinct of art that is manifested in every product of man's labor.

The CONSTRUCTION of a thing with the aid of all available means should set as its aim **first and foremost** the **practical** efficacy of the thing. ■ 3

It does not mean that the program of constructivism would eliminate disinterested creative activity from art.

It is a SYSTEM of **methodological collective** work regulated by a conscious will; its aim is **inventiveness** and the **perfection** of the results of collective achievements in work. ■ 4

The MECHANIZATION of the means of labor. ■ 5

Forms made by hand present graphological deviations characteristic of individual artists—form is given absolute objectivism when made by machine (**Blok,** no. 1).

The ECONOMIC use of material. ■ 6

Only as much material as is essentially needed.

DEPENDENCE of the character of the created object on the material used. ■ 7

Constructive values of material—character of the appearance of the material's surface—color of material—differences in features of the material's surface depending on the processing—peculiarities of the reaction of material to light.

In its application to construction **T. v. Doesburg** says the following on color as a property of material:

"The new architecture makes use of color (and not painting), illuminates it, displays in it changes of form and space. Without color we would not be able to obtain the interplay of forms.

"In the new architectonic style accurate optical balance and the equivalent integration of individual parts can be attained only with the help of color. The artist's task is to coordinate color and wholeness (in the sense of space and time, not of two dimensions).

"At a later stage of development color can be replaced by reprocessed material (the task of chemistry).

"Color (and may architects, the enemies of color, understand this) is not decoration or applied art—it is an element similar to glass and iron, an organic growth from architecture."

("The Renewal of Architecture," **Blok,** no. 5)

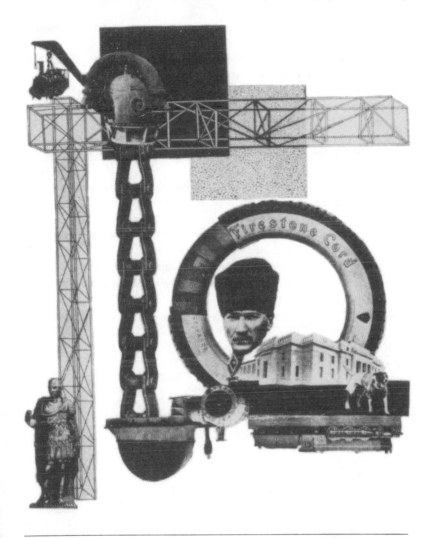

"Kemal's Constructive Program," from *Blok,* no. 5, 1924. Kemal Ataturk had recently consolidated his hold on Turkey and by 1924 had begun the intensive process of social and industrial reform that was to transform the country into a modern nation. This montage by Mieczyslaw Szczuka is particularly interesting for its juxtaposition of the vestiges of the classical past and the symbols of modernization.

The CONSTRUCTION of an object according to **its own principles.**

■ 8

Constructivism does not imitate the machine but finds its parallel in the simplicity and logic of the machine.

The DISCIPLINE of harmony and order. ■ 9

The problem of CONSTRUCTION and **not** the problem of **form.** ■ 10

Construction stipulates form.

Form proceeds from construction.

The **use** of **technological** achievements for expanding the area of potentiality. ■ 11

The direction of creative effort is primarily toward **building—the cinema—printing, etc., the world of fashion.** ■ 12

Out of aesthetic considerations architects have very often ignored the problems of hygiene and comfort—the builders of constructivism accept them as problems of the first rank.

The **introduction** of art into life on the principles of **participation** in general development and **dependence** on the changes arising in other branches of human creation.

First and foremost in technology. ■ 13

The INSEPARABILITY OF THE PROBLEMS OF ART AND THE PROBLEMS OF SOCIETY. ■ 14

IV.
Extension of Constructivist Principles: 1923-28

I. K. Bonset: Toward a Constructive Poetry (1923)

Both in Russia and in Western Europe the suggestion that construc-
tivism was an aesthetic of universal application left the way open for
an extension of constructive principles into the entire range of artistic
and literary activities. Poetry, theater, architecture, literature, and the
cinema were brought into the context of discussion, with varying de-
grees of success. As might have been expected, these applications
were strongly affected by the initial differences between Russian con-
structivism and its European counterpart.

Theo van Doesburg's speculations on "constructive poetry" below
illustrate the half-serious, half-satirical quality of Mécano, *the maga-*
zine he founded under the pseudonym I. K. Bonset in order to be able
to poke fun at the solemnities of the Bauhaus. Dadaists such as Arp,
Hausmann, Picabia, Schwitters, and Tzara were among the contributors
to Mécano. *And Van Doesburg is clearly building upon the sound*
poetry of the dadaists when he reviews the possibility of a new con-
structive poetry. The essential point is that the preceding poets whom
he mentions have all been concerned with "destruction," whether of
usage, psychological habit, or typography. Van Doesburg sees the
constructivist poet proceeding to reconstruction, and hence to another
step in the creation of the New Man. Presumably his own poems,
published under the same pseudonym in De Stijl, *give some idea of*
the model he had in mind.

The reconstruction of poetry is impossible without destruction. De-
struction of syntax is the first, indispensable, preliminary task of the
new poetry. The destruction has expressed itself as follows:

1. in usage (its meaning)
2. in the monstrous (psychic disturbance)

From *Mécano* (Leiden), no. 4–5: white, 1923. The text is dated Vienna,
1923. The translation is by Ita and Otto Van Os.

3. in typography (*la poésie synoptique*)
For 1. were important: Mallarmé, Rimbaud, Ghil, Gorter, Apollinaire, Birot, Arp, Schwitters, etc.
For 2: de Sade, de Lautréamont, Masoch, Péladan, *all* religious writings, Schwitters, etc.
For 3: Apollinaire, Birot, Marinetti, Beauduin, Salvat Papaseït, Kurt Schwitters, etc.

POETRY WITHOUT AN AESTHETIC BASIS IS UNTHINKABLE.

To accept the purely utilitarian as the whole foundation for a new art form = madness.

$$
\left.\begin{array}{l}
\text{utilitarian poetry} \\
\text{utilitarian music} \\
\text{utilitarian painting} \\
\text{utilitarian sculpture}
\end{array}\right\} = \text{madness}
$$

madness — madness — madness

We are living in an age of the provisional. We assume: that there is no distinction between webbing and backbone, between coitus and art.

BUT in art you do not use soap (except painters who need a good scrubbing), and you cannot go to heaven on top of a tomato. You cannot brush your teeth with art. Each thing implies its own usefulness.

SYPHILIS is not the aim of copulation

But: the blue jackets* of the new constructivist art claim:

EITHER	OR
a piece of iron nailed to wood;	a house without a ground plan;
a chair without a back;	a sword without a blade;
a car that won't run;	a (red) poem without contents—
a record player without sound;	all this is utilitarian art.

I.E., art that is rooted in real life!

No, all this is after all only syphilis in art.

* The term "blue jacket" (cf. German *blaujacke*) is slang for "sailor." Since the passage is generally directed at Russian constructivism, the reference is presumably to the Russian sailor as the symbol of the revolution [ED.].

Is there a type of poetry that you can sit on, like a chair? Or that you can drive, like a car? No. Perhaps there is only poetry you can spit on: utilitarian, revolutionary poetry. (I beg the gentlemen once more to pull the pigs' bladders over their heads and to stick the tubes up their noses.)

So: when reconstructing art, it does not matter whether the result is useful or not. As far as a piece of sculpture or a painting is useful—e.g., to sit on—it is neither sculpture nor painting, but "chair." And: efficiency by no means limits itself to the senses. If this were so, what we mean by spirit would also be a part of our bodies.

Let us try, for once, to make a poem with our feet that is just as good as a shoe. Do you know, gentlemen, what a city is like? A city is a horizontal tension and a vertical tension. Nothing else. Its image is two straight wires connected with each other. Each individual tries

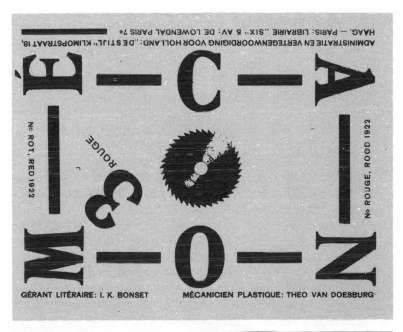

Title page of *Mécano*, no. 3: red, 1922. Theo van Doesburg (under the pseudonym I. K. Bonset) edited the four numbers of *Mécano*, which are identified by colors as well as numbers.

by means of: legs, train, tram, or explosions (the mode of transport of the future) to find the common center of these two tensions.

As is the city, so is the poem. Everyone tries, as immediately as possible, to picture the square root of the two (extreme) tensions. *Immediately,* i.e.,

The constructivist poet creates a new language for himself out of the alphabet: the speech of long distances, of *depth* and *height,* and by means of this creative language he conquers *space-time-motion.*

The new poet renders only by victory, by dissolution, by destruction (like our politicians), by ahumanist abstraction. In the new poetry there is construction, reduction.

Summary: the new poet constructs his language out of the ruins of the past, and since everything derives from language, he creates with it, in spite of the "abstraction désintéressée," a world and a new man.

THAT IS HIS EFFICIENCY

VLADIMIR TATLIN: On *Zangezi* (1923)

One field of artistic activity that the Russian constructivists entered with enthusiasm from the very first was that of the theater. In a lecture on the "New Russian Art" delivered in 1922, Lissitzky suggested that stage design had fulfilled the instinct for architectural expression in the few years when it was impossible to carry out any genuine building projects. He noted that Alexander Vesnin had adapted "the principles of the Tatlin tower" to the theater in his stage set for Chesterton's The Man Who Was Thursday. *But theater design was no mere stopgap for the constructivist artist. Vsevolod Meyerhold, who was the director of the Chesterton play, published shortly afterward his Bio-*

First published in *Zhizn' iskusstva* [Life of Art] (Petrograd), no. 18, May 1923. This translation by Troels Andersen *et al.* was published in *Vladimir Tatlin* (exhibition catalogue, Stockholm: Moderna Museet, July–September 1968) and is reprinted here with permission.

mechanics, *which embodied an entirely new theory of drama. The new Meyerhold theater became one of the most advanced in Europe, and some of its greatest triumphs were productions of work by the Lef group, such as Sergei Tretyakov's* Roar, China *and Mayakovsky's* The Bug.

Tatlin was one of the constructivist artists whose association with the theater continued for the longest period. Indeed after he had been discredited as an artist in 1933, he began to work almost exclusively for the theater. His first important achievement in this area was the design and production of Khlebnikov's poem Zangezi, *which was performed in Petrograd in May 1923. Velimir Khlebnikov, who was born in 1885 and died in 1922, had been no less prominent than Mayakovsky among the Russian futurists and contributed enormously to the work of the formalists in the mid-1920s. Tatlin's production, which made use of large numbers of students as well as the voice of the phonetician Lev Yakubinsky, was an attempt to create a unity out of two very different "materials": his own genuinely material "constructions," and the "word constructions" of his friend.*

On May 9 this year, in the Museum of Painterly Culture (Isakievskaya Square No. 9), are being arranged one theatrical production + one lecture + one exhibition of material constructions.

As a theme I have chosen Khlebnikov's last work to be published before his death, *Zangezi*. This piece constitutes the peak of Khlebnikov's production. In it, his work with the language and with the study of the laws of time have fused together in super-new form.

N. Punin will be giving a lecture on Khlebnikov's laws of time. The phonetician Yakubinsky will be speaking of Khlebnikov's word creations.

The *Zangezi* production is to be realized on the principle that "the word is a building unit, material a unit of organized space." Khlebnikov himself characterized this super-narration as an architectural work built of narrations, and each narration as an architectural work built of words. He regards the word as plastic material. The properties of this material make it possible to operate with it to build up "the linguistic state."

This attitude on the part of Khlebnikov gave me an opportunity to do my work in staging it. Parallel with his word constructions, I decided to make a material construction. This method makes it possible

to fuse the work of two people into a unity, in spite of their having different specialities, and to make Khlebnikov's work comprehensible to the masses.

Khlebnikov took sounds as elements. They contain the impulse to the birth of the word. The hard C sound, for instance, gives birth to cup, cranium, container. All these words have to do with the concept of a sheath. One body enclosed in another. The sound P has to do with a diminishment of energy which stands in relationship to the area in which it is used: as in paddle, position, palm, porringer.

In one of the "planks of the plan," the "planks" of which *Zangezi* is built up, we find a succession of "thing-like sounds," as in the "Song of the Astral Language":

There a swarm of two green KHA

and EL of clothing in flight

GO of skies over the games of men

VE of groups round an invisible fire,

the LA of labour and the PE of games and song . . .

To emphasize the nature of these sounds I use surfaces of different materials, treated in different ways.

"The Song of the Astral Language," and everything that Zangezi is saying, is like a ray moving slowly downwards from the thinker to the uncomprehending crowd.

This contact is established by means of an especially designed apparatus. Parts of *Zangezi* represent an ultimate tension and energy in verbal creation.

I have had to introduce machinery which by its movement forms a parallel to the action and fuses into it.

Zangezi is in its structure so many-faceted and difficult to produce that the stage, if it is spatially enclosed, will be unable to contain its action. To guide the attention of the spectator, the eye of the projector leaps from one place to another, creating order and consistency. The projector is also necessary to emphasize the properties of the material.

The actors are young people: artists, students from the Academy of Art, from the Institute of Mining, and from the University. This is intentional; actors are brought up in the traditions of the theatre, ancient or modern. *Zangezi* is too new to be subordinated to any existing tradition whatsoever. It is therefore best, if one is concerned

to realize Khlebnikov's work as a revolutionary event, to mobilize young people who have had nothing to do with the theatre.

Theo van Doesburg *and* Cornelis van Eesteren: Toward a Collective Construction (1923)

It has been emphasized in Joost Baljeu's most useful essay on "The Fourth Dimension in Neoplasticism" that Van Doesburg was preoccupied, as early as 1917, with the problem of the fourth dimension. His colleague in the Stijl group Mondrian shared this interest for a time, proclaiming around 1920 that "the idea of the fourth dimension manifests itself in the new art, through the total or partial destruction of the three-dimensional or natural order, and through the construction of a new plasticism with a less limited view." However, both Mondrian and Van Doesburg were soon to realize that this "new plasticism" could be achieved only in an architectural form. Mondrian preferred to remain within the limits set by the two dimensions of the pictorial surface, while Van Doesburg drew closer to the architects within De Stijl, who could help to fulfill the logic of his position.

Van Doesburg's first important contact with architecture, which showed him the new range of "plastic" possibilities, came in 1917 when he met the architect Robert van 't Hoff. Van 't Hoff had returned from America with material on Frank Lloyd Wright, whose notions of the interpenetration of volumes corresponded to Van Doesburg's own vision of a four-dimensional spatial projection. But Van Doesburg was initially unable to secure collaboration from De Stijl architects such as Van 't Hoff and Oud. His work in this direction was confined to models, made chiefly at Weimar in the early part of 1922 by his students, who were drawn from the Bauhaus.

From *De Stijl* (Amsterdam), vol. VI, no. 6–7, 1924. The text is dated Paris, 1923. The translation is by Stephen Bann. Used with the permission of Hans Richter.

It was after his meeting with Cornelis van Eesteren in spring 1922 that Van Doesburg's architectural research took on a more practical complexion. Van Eesteren was a young architect, born in 1897, who had just won a Prix de Rome for one of his designs. He first met Van Doesburg at Weimar, but it was after the latter had settled in Paris in the following year that their collaboration began in earnest. Their first communal project was a private house and the second the so-called studio house. Models such as these, which would admittedly have been impossible to build with contemporary construction techniques, created a scandal when exhibited in Léonce Rosenberg's Galerie de l'Effort Moderne, Paris. Van Doesburg's explanation of his aims in the passage that follows was succeeded by several further articles on the subject in De Stijl and other magazines. In practical terms, his architectural studies led him to two projects that were completed by the end of the 1920s: his scheme for the interior of the Aubette Restaurant, in Strasbourg, undertaken with Hans Arp and Sophie Taeuber-Arp in 1926–28, and his own house at Meudon, near Paris.

We must understand that art and life are no longer separate domains. That is why the "idea" of "art" as an illusion separate from real life must disappear. The word "art" no longer has anything to say to us. In place of that, we insist upon the construction of our surroundings according to creative laws deriving from a fixed principle. These binding laws, which are those of mathematical, technical, hygienic, and other forms of economy, have led to a new plastic unity. To define the relationships of these reciprocal laws, it is necessary to understand and to objectify them. Up to now the domain of human creation and its constructive laws have never been examined scientifically.

We do not imagine these laws. They exist. Only through working collectively and through experiment have we come to this conclusion.

The basis of these experiments rests upon simple knowledge of the primary and universal elements of expression, directed toward achieving a method of organizing them into a new harmony. The basis of this harmony is the knowledge of contrast, of the complex of contrasts, dissonance, etc., etc., which enables all that surrounds us to take on visible form. The multiplicity of contrasts engenders contrasts on a huge scale, which create, by mutual suppression, equilibrium and repose.

Theo van Doesburg (right) and Cornelis van Eesteren in their Paris studio, 1923. The architectural models they constructed together were exhibited at Léonce Rosenberg's Galerie de l'Effort Moderne, Paris, in that year.

This equilibrium of tensions forms the quintessence of the new constructive unity. And so we insist upon the application or genuine demonstration of this constructive unity in practice.

Our age is inimical to every subjective speculation in art, science, technology, etc. The new spirit that is already governing almost the whole of modern life is contrary to animal spontaneity (lyricism), contrary to the dominance of nature, contrary to artificial and involved methods in art.

To construct a new thing, we need a method, that is, an objective system. If we discover the same qualities in different things, we have found an objective scale. One of the fundamental fixed laws, for example, is that the modern constructor renders visible (by the method of his own branch) the relationship of the qualities of things and not the relationship of things in themselves.

The speculative method, a childish disease, has arrested the healthy development of construction according to universal and objective laws. Personal taste, including admiration for the machine (machinism in art), has no importance for the attainment of this unity of art and life. Machinism in art is an illusion like the others (naturalism, futurism, cubism, purism, etc.) and an even more dangerous illusion than any metaphysical speculation.

Development from this point depends upon control of the use of the elementary means of construction, with the exclusion of all metaphysical illusions. The future will see us finally reaching the expression of a new dimension in the reality of three dimensions.

Not in dynamism, or in statics, or in utilitarianism, or in art, or in composition, or in construction, but in the penetration of all the elements of a new creation of reality on a general basis. Since the formation of the Stijl movement in Holland (1916), painters, architects, sculptors, etc., have arrived, in the course of practical work, at the definition and application of laws that will lead to a new unity of life.

It is through the new conception born of reciprocal collaboration that these ways of categorizing work have begun to fall off one by one.

Today we can speak only of the constructors of the new life.

The exhibition of the Stijl group in the galleries of the L'Effort Moderne (Léonce Rosenberg) at Paris had as its objective to demonstrate the possibility of creating collectively on these general bases.

LUDWIG HILBERSEIMER: Construction and Form (1924)

While Van Doesburg's manifesto illustrates the approach of the plastic artist who has ventured into architectural construction, this article

From *G* (Berlin), no. 3, June 1924. The translation is by Stephen Bann. Used with the permission of Hans Richter.

by Ludwig Hilberseimer is written from the point of view of the professional architect who seeks to relate his practice to aesthetic constants. Hilberseimer, who was born in Karlsruhe in 1885 and died in Chicago in 1967, worked as a free-lance architect for a few years after 1910 and in 1919 turned to town planning and building projects in Berlin. From 1928 to 1932 he taught at the Bauhaus, first as director of architectural studies and construction design and then as director of the seminar on housing and town planning.

Hilberseimer's article in G is entirely consonant with the program that Hans Richter set out for the magazine in the same number: that of allowing the specialist to set out general "guidelines" that will make his own highly technical work accessible to the public (see p. 93). Hilberseimer's article is illustrated with photographs of a building by Peter Behrens and of the "Zollinger system" of construction in laminated wood. This system—based on the regular structural ordering of individually insignificant components—reflects the general tenor of Hilberseimer's article, with its call for a more rigorous, classical conception of architecture. Also in this issue there is an article by Mies van der Rohe on "Industrialized Building."

Identity of construction and form is the indispensable prerequisite of all architecture. At first sight, both appear to be opposites. But it is precisely in their close conjunction, in their unity, that architecture consists. Construction and form are the material prerequisites of architectonic formation. They are in continual interplay. So Greek architecture consists of the alternation of horizontals and verticals that is necessitated by construction in stone. It makes perfect use, in maintaining the unity of the material, of the possibilities of freestone. A Greek temple is a perfect piece of engineering in stone. Through the construction of the arch and the vault, the Romans substantially enriched the simple alternation of horizontals and verticals; however, they abandoned unity of material. As a measure of the separation into structural parts, filling-in work and façadism have created the method of architectural composition that has remained characteristic right up to our times, implying especially the framing of openings and the marking of divisions between stories with freestone. Through the vertical accumulation of several stories, articulated in terms of orders of columns, there emerged the conventional horizontal-articulation of

Hall construction in laminated wood according to the "Zollinger system." This appeared in *G* as an illustration to Hilberseimer's "Construction and Form." (Photo courtesy Stedelijk Museum, Amsterdam)

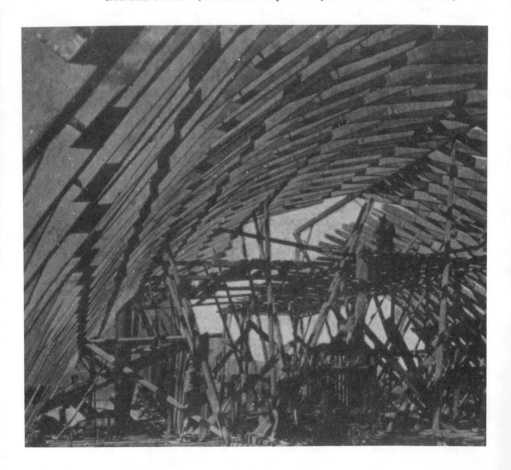

multistoried buildings. A principle that Michelangelo was the first to break with. He for the first time included several stories together within one order. Thus begins the totally decorative use of building forms derived from the ancient world. Increasingly they lost their significance in constructive articulation. They became mere appendages: nineteenth-century architecture!

Because of its new types of building requirement, city architecture was the first to create the need for new forms of construction and materials as an inevitable requirement. City architecture can use as building materials only those that facilitate the greatest utilization of space and combine the most intensive resistance to wear and tear and the effects of weather with the greatest stability. Iron, concrete, and reinforced concrete are the building materials that make possible the new forms of construction necessary for the requirements of cities: forms of construction for covering wide-reaching spaces, for the largest possible number of stories stacked one on top of another, and for cantilevering.

Concrete and ferroconcrete are building materials that set virtually no limits to the architect's fantasy. By this we do not imply their plasticity, the possibility of surmounting all material limitations through casting; on the contrary, we are referring to their constructive consequences, the possibiliy of producing a completely homogeneous piece of architecture, a combination of carrying and supported parts, a development that allows a pure system of proportional limitations, dispensing with all articulation through frames and claddings.

Through the constructive possibilities of concrete and ferroconcrete building, the old system of support and loads, which permitted building only from below to above and from the front backward, has been superseded.

Both permit building toward the front as well. Cantilevering out over the supports. They permit a complete separation into carrying and supported parts. A resolution of the architectural work into a carrying skeleton and noncarrying—just enclosing and dividing—walls. Thus there arise not merely new problems of technique and materials, but also above all a new architectonic problem. A total transformation of the seemingly so firmly founded static form of appearance of the architectural work.

These new forms of construction permit the logical elaboration of the office building from the basis of its requirements and preconditions. The meaning and form of this type of building is determined by the fact that the ground plan can be easily surveyed and changed and by the fact that maximum entry of light is obtained. While the Berlin office buildings of Alfred Messel revert in their essential traits, both of ground plan and structure, to the Renaissance palace, Hans Poelzig seeks to make use in a Breslau office building of the possibilities of the new type of construction. So he has vertically staggered the single stories in a way reminiscent of the wooden structure of the Middle Ages and achieved an essential structural transformation of the building.

Erich Mendelsohn has concerned himself with the same problem in his extension to the Mosse Building in Berlin. But in an indirect, rather than a direct way. Paraphrasing it symbolically, to a certain extent. By means of a lateral, slanting staggering of single stories, he aims at giving expression to his emancipation from plunging verticals.

Mies van der Rohe was the first to recognize the new possibilities of formation latent in the new notions of construction and to find an architectonic solution to them in his project for an office building. His form of construction is based on a two-handled system of frames with rows of projections on both sides. At the end of the cantilevers the cover plate is vertically applied at an angle onto the outer skin, which serves at the same time as a back wall for the stacks transferred from the internal space to the outer walls in accordance with functional considerations. Above these stacks lies an unbroken continuous horizontal band of windows extending almost up to the ceiling with no walls and supports appearing on the front. Thus the horizontal stratification of the tiered building is accented in a most energetic way. Through the dominant horizontal in combination with the lack of supports on the facade, the structural character of the building is totally transformed, so that an architecture of suspension and lightness arises from the lack of supports.

The ground plan and elevation of this office building are of rare clarity. It amounts to a complete fulfillment of purpose. It has been developed from the essence of the task with the methods of our time. The constructive function is synonymous with architecture. From the

constructive principles the formal elevation is developed. Construction and form have become one—clear, logical, simple, unequivocal, strictly regular.

Literary Center of Constructivists: The Basic Tenets of Constructivism (1924)

Tzvetan Todorov has provided an invaluable introduction to the texts of the so-called Russian formalists of 1915–30 in his collection Théorie de la littérature. *As he explains, these pioneers of structural linguistics were closely associated from the start with futurist poets such as Khlebnikov and Mayakovsky. The principal link lay in Mayakovsky's great friend Osip Brik, who was a founding member of the Opoyaz (Society for the Study of Poetic Language) in 1916. And when Mayakovsky and Brik collaborated in founding* Lef *in 1923, the vindication of the "formal method" naturally became one of the concerns of the magazine.*

However the very term "formalism" was applied to Brik and his colleagues in a pejorative sense. Brik was forced to recognize that his study of "the laws of poetic production" could easily incur the reproach of being divorced from human—and political—values. His reply to these "moth-eaten" Marxists was to reaffirm the utility of "exact technical meanings of the devices of contemporary poetic creation," as opposed to the futility of "hazy little chats about the 'proletarian spirit' and 'Communist consciousness.' "

From *Gosplan literatury* [Gosplan for Literature], a collection of articles from the Literary Center of Constructivists, edited by Kornely Zelinsky and Ilya Selvinsky, Moscow-Leningrad, 1924. This translation is by John Bowlt.

The manifesto of the Literary Center of Constructivists is particularly interesting in this context. Published in Moscow in 1924, it *seems to reflect not so much a dedication to the scientific study of literature as a commitment to further the Communist cause through "maximum exploitation of subject."* Though several of the critical *articles in* Gosplan literature *(Gosplan for Literature) do in fact make use of analytic techniques comparable to those of the Opoyaz group, it would appear from this statement that the Literary Center of Constructivists was adopting a position explicitly opposed to Brik and his colleagues. Perhaps this is reflected in the fact that their work is totally ignored in B. M. Eikhenbaum's "Teoriya formalnogo metoda' ("Theory of the Formal Method"), an extensive survey of contemporary research in this direction written in 1925 and published in 1927 in* Literatura, teoriya, kritika, polemika *(Literature, Theory, Criticism, Polemics) (Leningrad).*

1. The character of our contemporary industrial technology—a technology of high speed, economics, and expansion—also exerts an influence on our means of ideological presentation and subordinates all cultural processes to these intrinsic formal and organizational demands.

The expression of this heightened attention to technological and organizational problems is **constructivism.**

2. In the U.S.S.R. constructivism is acquiring a broad sociocultural meaning as a result of the necessity to cover, within a comparatively short time, the space that separates the proletariat, as a culturally backward class, from contemporary technological achievements and the whole developed system of cultural superstructures—superstructures that, in the conditions of the universally intensifying class struggle, are also being employed by the bourgeoisie as technical instruments of war.

3. Constructivism is the organizational formalization of this objective.

This caricature by Boris Efimov of the members of the Literary Center of Constructivists was published in their bulletin for August 1925. The members are (left to right): Ilya Selvinsky, Kornely Zelinsky, Boris Agapov, D. Tumanny, I. A. Aksyonov, and Vera Inber.

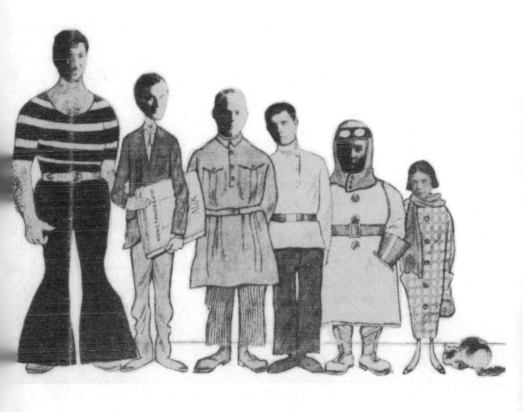

4. In this way constructivism appears as a systemization of ideas and social moods that forcefully reflect the organizational impact of the working class, a class compelled, in a land of peasants, after its attainment of power, to build the economy and to lay the foundation of the new socialist culture.

5. In the cultural field this impact is being directed primarily toward the technology of culture in all branches of skill and learning, beginning with the simple mastery of reading and writing.

6. The spearhead of the constructivist (i.e., organizational and energizing) and the sociocultural movement must be first and foremost the proletariat and, subsequently, intermediate social groups acting under the political influence of the proletariat.

7. Constructivism, transferred into the field of art, changes on a formal level into a *system of maximum exploitation of subject* or into a system whereby all composite artistic elements are mutually and functionally justified; i.e., viewed as a whole, *constructivism is a motivated art.*

8. As regards form, this requirement hinges on the so-called principle of loading, i.e., the increased load of demand per unit of material.

9. Reactionary social strata, intellectual and petty bourgeois groups are using the formal demands of constructivism as an aesthetic entrenchment for sitting out the onslaught of revolutionary contemporaneity seeking reinforcements in the subjects of art; in this case constructivism turns into a particular genre of easel art, i.e., an unmotivated display of device. This is equally true for both painting and poetry.

For the leftist social strata this demand for maximum exploitation is naturally linked to the search for a great epic theme and a compact form for it—which, thanks to the logic of its subject matter, introduces the techniques of prose into the sphere of poetry.

10. The principle of loading, when applied to poetry, comes to mean the demand for the construction of verse in the sphere of local semantics, i.e., the evolution of the whole fabric of verse from the basic semantic content of the theme.

11. The Literary Center of Constructivists (LCC) has taken as its banner the above-mentioned tenets; it is an organized society of people united by the common aims of Communist construction. It has set as its aim—by means of the combined, practical study of the

formal, technical, and theoretical aspects of constructivism—to give literature, in particular poetry, an active meaning within the conditions of contemporary culture.

The constructivists consider it essential in their literary work to manifest their revolutionary contemporaneity actively both thematically and in its technological demands.

ALEXEI GAN: Constructivism in the Cinema (1928)

In an article on "Theater, Cinema, Futurism" published in Kine-Journal *July 27, 1913, Mayakovsky posed the momentous question "Can the modern theater endure the competition of the cinema?" His answer, as can be imagined, was that theater was bound eventually to "hand over its heritage" to the cinema. The theater, with its "dead background," had to yield to the cinema, "which is firmly attached to the action of actuality." Encouraged by his own prediction, Mayakovsky himself wrote a film scenario in the same year. But he met with little consideration from the company to which he submitted it and was so discouraged that he abandoned the prospect of working in the cinema until after the Revolution of 1917.*

In 1918 Mayakovsky turned once again to the cinema and completed Shackled by Film *with the director Nikandr Turkin. But the disruption of the immediate postrevolutionary years prevented any significant advance in cinema technique, and it was only with the favorable conditions of Lenin's New Economic Policy, launched in 1921, that Russian cinema began to come into its own. In August 1922 a loosely based group of "film constructivists" published the first number of the magazine* Kino-Phot. *In their October issue Mayakovsky returned to the charge with an article on "Kino and Kino," which put forward the cinema as "almost a way to understand the world" rather than simply "something to look at."*

From *SA* [Contemporary Architecture] (Moscow), 1928, no. 3 (March). The translation is by John Bowlt.

The constructivist Alexei Gan was one of the most prominent par-ticipants in the publication of Kino-Phot, *and he gave his enthusiastic support to the film-maker Dziga Vertov, who had produced the first of his celebrated* Kino-Pravda *series in May 1922. Vertov's manifesto of the same year, printed in* Kino-Phot, *no. 1, recalls in many respects the tradition of the Italian and Russian futurists in its attitude to Man and the Machine. He speaks of "the poetry of the machine" and progress toward the ideal of the "perfect electrical man." Yet the pro-claimed concern for "the worker at his bench," "the farmer on his tractor," and "the engineer on his locomotive" acquires a new force in the light of Vertov's original documentary method: roving corre-spondents were employed to cover the country and shoot the greater part of the footage, which Vertov then edited in collaboration with his assistant, Elizaveta Svilova. Perhaps the climax of Vertov's work in the early revolutionary period is* A Sixth of the World *(1926), which uses this method of documentation to encompass and celebrate the vast extent and diversity of the Union of Soviet Socialist Republics.*

Constructivist influence on Vertov is apparent not only in his con-ception of the social obligations of the revolutionary artist, but also in his descriptions of cinematic technique. He writes in the Kino-Phot *manifesto: "What we demand of the editing: to discover the geometri-cal extract of each shot. . . . A work is constructed out of phrases, as a phrase is built up out of the intervals of a movement."*

Vertov, therefore, represents the desire to carry the principles of constructivism into all levels of cinematic expression, from the formal and technical to the social and ideological. Other contemporary Rus-sian film-makers made use of less radical importations, often taking the theater as their intermediate source. Lev Kuleshov, the first sig-nificant theorist of the Russian cinema, reflects Meyerhold's Bio-mechanics *in devising a form of physical expression proper to the cinema actor, as can be seen in such a film as* Mr. West in the Land of the Bolsheviks *(1924). In Jakov Protazanov's* Aelita *(1924), the imagined scenes on the planet Mars are greatly enlivened by the use of a gigantic stage set and costumes designed by Alexandra Exter and Isaac Rabinovich, which are directly related to A. A. Vesnin's con-structivist projects for the theater.*

The contradiction between Vertov's radical view of the cinema and that of Kuleshov, which admitted the value of the documentary but

still left great scope for the virtuosity of the actor, is reflected in the following article by Alexei Gan, which dates from 1927. Gan urges that the film should realize its distinctive potentiality by emancipating itself from "the idealistic concoctions of the theatrical cinema art." He cites three films made to celebrate the tenth anniversary of the Revolution: Vsevolod Pudovkin's* End of St. Petersburg, *Boris Barnet's* Moscow in October *(with designs by Rodchenko), and* October *by Eisenstein and Grigori Alexandrov. All these are judged inferior to Esther Shub's* The Great Road, *a sequel to her* Fall of the Romanov Dynasty *and composed in the same way—exclusively from existing sources of documentary film.*

It is not difficult to see how the "actorless" cinema of Esther Shub, which displayed in the most literal sense "the active struggle and construction of the evolving proletarian class," harmonized with the objectives proclaimed by Gan in 1922. To an even greater extent than Vertov, Esther Shub was concerned to respect the intrinsic reality of documentary material; much of the film that she incorporated into her work was salvaged from cellars and other improvised storehouses, and her own contribution was an unobtrusive, though masterly, use of montage. Yet Gan's absolute distinction between Esther Shub and the other three film-makers is perhaps artificial. Certainly Eisenstein did not regard himself as totally opposed to the documentary method in intention. He made use of Esther Shub's findings in the preparation of October, *and received valuable advice from her in filming* The General Line *(1929). In a discussion that took place in October 1927, Mayakovsky spoke of Eisenstein and Esther Shub together as "our cinematic pride."*

The constructivists have also entered the cinema with their materialistic program. The cinema is the aggregate of an optical and mechanical apparatus. The cinema *shows* on the screen a sequence of photographic stills, i.e., movement. This provides us with the opportunity to capture immediately and dynamically the processes of all kinds of work and activity of society.

The cinema must become a cultural and active weapon of society. It is essential to master the scientific and technical methods of cinema in order to learn how to display reality as it really is, and not as the philistine imagines it. It is essential to find the right devices and to

develop a working method of demonstration. This is not a dry logic of objects, it is not a formal definition. This is the class content of the new cinema industry in a country with a dictatorship of labor and socialist construction.

How does the Soviet state differ from other forms of social order?

First and foremost, it *actively*, by its own conduct, fights the old world. All class forces participate in this fight. The economic system, industrial relations, and the trifles of everyday life are being revolutionized, reorganized, and shifted from the positions they have occupied so long. Everyday reality is passing into a state of restive fermentation. The countless millions are encountering the unexpected and the unfamiliar. It is up to the avant-garde of our society to breach the strong walls of prejudice and superstition. And this is put into practice not through long roads of systematic education; it is fostered within the conditions of everyday reality, by the vital acts of revolutonary actuality. A mass method of education is impelled to search for faster, more mobile, and truer means of information and communication.

The printed word, the telegraph, the telephone, even radio broadcasts narrating events cannot replace the real demonstration and illustration of events. Only cinema, wrested from the tenacious paws of businessmen and art makers, is able to fulfill this national and international service. Only the cinema can, by visual apprehension, join society together and show the active struggle and construction of the evolving proletarian class.

Film that demonstrates real life documentarily, and not a theatrical film show playing at life—that's what our ciné production should become. It is essential to find a new ciné film. It is not enough to link, by means of montage, individual moments of episodic phenomena of life, united under a more or less successful title. The most unexpected accidents, occurrences, and events are always linked organically with the fundamental root of social reality. While apprehending them within the shell of their outer manifestation, one should be able to expose their inner essence by a series of other scenes. Only on such a basis can one build a vivid film of concrete, active reality—gradually departing from the newsreel, from whose material this new ciné form is developing.

This platform was promoted as a school at a time (1922) when the

From a subscription note for *SA,* no. 4, 1928. This forthright organ of architectural constructivism was edited in Moscow by the brothers A. A. and V. A. Vesnin and Alexei Gan, among others. The presence of distinguished foreign architects such as Oud, Mies van der Rohe, and Gropius on its list of corresponding editors testifies to the comparatively free situation this particular direction of constructivist activity enjoyed in Russia even at this date. (*Photo courtesy Gemuntemusea, Amsterdam*)

Soviet ciné industry was just emerging and when the restoration of the old, prerevolutionary cinema was proceeding more energetically.

At first the school's platform was ridiculed and our pamphlet, *Long Live the Demonstration of Life,* was characterized by the ciné press as "the demonstration of stupidity." Following this, the Agitation and Propaganda Department of the Party Central Committee declared at one of its conferences (1925) that "carefully selected films, both Soviet and foreign, can serve as agitational material on questions of politics and construction."

> The newsreel and the film magazine [its resolution says] should be considered as particularly useful films. The production of films of this type should be put on the right lines, and in essential cases a purposeful character should be imparted to separate strips.
>
> Films of this type should be acknowledged as more useful material for the needs of agitation and propaganda than the so-called topical films on everyday questions.

This resolution underlines the vitality of the ciné platform of constructivism. The actorless cinema is becoming a "legitimate phenomenon" in the Soviet cinema industry and a serious rival to the idealistic concoctions of the theatrical cinema art. This was particularly clear during the tenth October anniversary. At this time several jubilee films were shown: on the one hand, Esther Shub's *The Great Road,* on the other, Pudovkin's *End of St. Petersburg,* Barnet's *Moscow in October,* and the Alexandrov-Eisenstein *October.* In the first, the historical truth of the Revolution was demonstrated, its victory and construction, as genuine ciné documents. In the others, art makers attempted by various ways and means to re-create historical events by mobilizing all the magic forces of idealistic art. And despite the unequal conditions in production and the disparity in material resources, *The Great Road* proved to be the victor in this unfair competition.

Constructivism in architecture has been quite fully expressed in the magazine *SA.* Our opponents openly confess that it is precisely in this field that our school has achieved its firm and stable position, and they remark somewhat despondently that "for the time being architectural thought cannot counter constructivism with anything and thereby evidently recognizes its ideological superiority." *

* The article breaks off abruptly at this point with the indication that it is "to be concluded" in the next number of *SA.* However, it is not to be found there [ED.].

V.
Retrospect, Theory, and Prognosis: 1928-32

LÁSZLÓ MOHOLY-NAGY: Letter of Resignation from the Bauhaus (1928)

In the years between 1920 and 1928 the constructivist creed had been disseminated throughout Russia and the rest of Europe. Hardly any department of artistic activity had been left unaffected by it. Yet its true strength lay not simply in this geographical and generic extension but also in the fact that the principles of constructivism were enshrined in the teaching programs of such institutions as the Vkhutemas and the Bauhaus. It was through the conversion of such principles into pedagogic exercises that the constructivist artist could hope to transform the attitudes of the rising generation of student artists, architects, and designers.

But if these institutions represented a real strength, they were also extremely vulnerable to dissident pressures from within and to official pressures from outside. It has already been emphasized that the Bauhaus did not immediately adopt a program of instruction congenial to the views of the constructivists. The departure of Johannes Itten in March 1923, and the appointment of László Moholy-Nagy in his place, signified a reorientation of aims and ideals. In the same way, the resignation of Moholy-Nagy and the appointment of Hannes Meyer as director five years later signified yet another change in direction. Moholy-Nagy's letter of resignation, which follows here, is an eloquent defense of the "equilibrium" between vocational training and a more elevated educational ideal, which he considered to have been achieved at the Bauhaus. Almost a decade later, in 1937, he was to attempt to restore this balance through the founding of a New Bauhaus (subsequently the Institute of Design) in Chicago.

From Sibyl Moholy-Nagy, *Moholy-Nagy: Experiment in Totality* (New York: Harper, 1950). Reprinted by permission of M.I.T. Press.

For the Bauhaus begins now a time of stabilization conditioned by the length of its existence. As a consequence of the growing scarcity of money, it is demanded that it be productive, efficient—today more than ever.

Even though human and pedagogical considerations are not eliminated intentionally, they suffer because of this stabilization. Among the students, this reorientation is noticeable in their increased demand for technical skill and practical training above anything else.

Basically one can't object if human power wants to measure itself on the object, the trade. This belongs essentially to the Bauhaus program. But one must see the danger of losing equilibrium, and meet it. As soon as creating an object becomes a specialty, and work becomes trade, the process of education loses all vitality. There must be room for teaching the basic ideas which keep human content alert and vital. For this we fought and for this we exhausted ourselves. I can no longer keep up with the stronger and stronger tendency toward trade specialization in the workshops.

We are now in danger of becoming what we as revolutionaries opposed: a vocational training school which evaluates only the final achievement and overlooks the development of the whole man. For him there remains no time, no money, no space, no concession.

I can't afford a continuation on this specialized, purely objective and efficient basis—either productively or humanly. I trained myself in five years for a specialty, the Metal Workshop, but I could do this only by also giving all my human reserves. I shall have to resign if this demand for specialization becomes more intense. The spirit of construction for which I and others gave all we had—and gave it gladly—has been replaced by a tendency toward application. My realm was the construction of school and man. Under a program of increased technology I can continue only if I have a technical expert as my aide. For economic reasons this will never be possible. There is always money for only one of the two. I exerted great effort over these years to make the expert unnecessary. I can't give more than I gave so far; therefore I have to relinquish my place to him. I am infinitely sad about this. It is a turn toward the negative—away from the original, the consciously willed, character of the Bauhaus.

The school today swims no longer against the current. It tries to fall in line. This is what weakens the power of the unit. Community

spirit is replaced by individual competition, and the question arises whether the existence of a creative group is only possible on the basis of opposition to the *status quo*. It remains to be seen how efficient will be the decision to work only for efficient results. Perhaps there will be a new fruitful period. Perhaps it is the beginning of the end.

EL LISSITZKY: From *Russia: The Reconstruction of Architecture in the Soviet Union* (1930)

If the tone of Moholy-Nagy's letter is one of renunciation and regret, the mood of Russian constructivism in the last years of the decade was a far less simple one. Retrospect—the attempt to sum up what had been achieved to date—was supplemented by theory—the attempt to give more rigorous codification to the principles of constructivism. The determination of the constructivist artist to develop the revolutionary implications of these principles was at the same time increasingly frustrated by the growing hostility within official circles.

In the article that concludes the previous section, Alexei Gan helps to establish a context for the many-sided activity of these years. He concludes his remarks on constructivism in the cinema with a reference to architecture, where the constructivist school can be held to have achieved a "firm and stable position," with the effect that even its opponents recognize its "ideological superiority." This judgment by a pioneer theorist of constructivism points to at least two of the main features of the situation. In the first place, by 1928 constructivist concern with the traditional forms of art was very much a thing of the past in Russia. Gan singles out architecture and the cinema as the privileged directions of constructivist activity. In the second place, Gan refers to the achievement of the constructivist architects as tak-

From *Russland: Die Rekonstruktion der Architektur in der Sowjetunion* (Vienna: Schroll, 1930). The text is dated 1929. The translation is by Stephen Bann.

ing place in spite of opposition. This polemical background, which is also very much emphasized in his account of the cinema, cannot be ignored in any account of the development of Russian constructivism toward the end of the decade.

It is not possible here to try to sketch in any detailed terms the historical background to Gan's remarks. It might also be superfluous, since the history of Russian architecture in the 1920s has received considerable attention in the West during the past few years. But there remains a necessity to identify at least the bare bones of the situation. And this is particularly so because there seems to be widespread disagreement about where the lines are to be drawn—and indeed which lines are to be used.

In brief, there is a strong tendency, encouraged by Russian architectural historians, to treat the entire range of Russian modernist architecture in the 1920s under the general heading of constructivism. By contrast, there is also a tendency, well represented by Anatole Kopp, that lays stress upon the bitter polemic between two schools— ASNOVA and OSA. Under this interpretation, the OSA (Association of Contemporary Architects) would have a prior claim on the title of constructivist, while the ASNOVA (Association of New Architects) would be classed as rationalist or, in Lissitzky's terminology, "formalist." The ground of difference might be illustrated by the contrasting approaches of Moisey Ginsburg, a vice-president of OSA, and Nikolai Ladovsky, a leading member of ASNOVA. While Ginsburg's work up to about 1925 was primarily concerned with the aesthetic of construction and therefore with the wider artistic context that linked architecture to the other branches of constructivist activity, Ladovsky was confronting at the same time the more practical problem of testing man's visual orientation in space, through the use of models and devices that were built and tested in his laboratory at Vkhutemas. If we extend the comparison to the second half of the decade, Ginsburg has moved from the stylistic and aesthetic problems of construction to a more practical emphasis on architectural design. But projects such as his highly successful apartments on the Novinsky Boulevard, Moscow (1928–29), still show a fastidious concern with overall form and detail. By this stage, Ladovsky had left ASNOVA to found ARU (Association of Urban Architects) and was concerned not so much with individual buildings as with the planning of industrial towns and large

G. Barkhin: Izvestia Building, Moscow, 1927, from *SA*, no. 4. This photograph gives a clear view of the "capricious balconies" that, in the view of an anonymous commentator in *SA*, helped to brand Barkhin's building as merely in the "constructive style" rather than truly constructivist.

*housing complexes. Despite his brilliant theoretical work, he left very
few completed buildings. He came in second to another member of
ASNOVA, Konstantin Melnikov, in the competition for the Soviet
Pavilion at the Paris exhibition of 1925.*

*El Lissitzky's short account of the development of Russian architec-
ture up to the mid-1920s, which stresses the importance of Melnikov's
pavilion, does not undertake to analyze in great detail these shifting po-
sitions. At the same time, it serves the invaluable purpose of placing
architecture in the general context of artistic development. Lissitzky
casts a retrospective glance over the development of constructivism
in Russia and establishes its links with previous trends, while main-
taining that to the young constructivist architect even such projects
as Tatlin's Monument have come to seem formalistic or "symbolic."
It may be emphasized that Lissitzky himself was editor, with Ladov-
sky, of the first and only* Asnova News *(1926). But he also knew and
collaborated with Ginsburg and designed a one-room apartment for
him around 1934.*

The Substructure. The birth of the machine is the starting point of the
technical revolution that is annihilating handicrafts and becoming of
decisive importance for modern large-scale industry. In the course
of a century, the entire pattern of life has been transformed by the
new technical systems of production. Technology has today revolu-
tionized development not only in the social and economic fields but
also in the aesthetic. It is this revolution that has determined the basic
elements of the new way of building in Western Europe and America.

October 1917 was the beginning of our Revolution and thus of a
new page in the history of human society. The basic elements of our
architecture relate to this social revolution and not to the technologi-
cal one.

Today the place of the single, private employer has been taken
over by the "commission of society," as we call it. The point of em-
phasis has shifted from the intimate and the individual to the com-
munal and the multiple. Today there is another standard in force for
architecture. All the established guidelines that previously stood so con-
veniently at our disposal have suddenly lost their validity. The entire
sphere of architecture has become a problematic one. This problem
presented itself to a country that, exhausted by war and famine, was

hermetically sealed off from the entire outside world. To solve these new architectural problems, it was necessary first of all for the economy to be brought into order as a substructure. In productivity the prewar level was rapidly and successfully reached. But for our needs of today this level and this rate are too low. In order genuinely to fulfill our task in the world, we must strive to accelerate the rate of growth and force it ahead. This is possible only if we not merely further improve and develop what has been handed down to us, but also make a completely new start. Not only construct but reconstruct. We are reconstructing industry, we are reconstructing agriculture. This reconstruction of production establishes a new understanding of life. It is the fertile soil of culture—that is, of architecture also. The new architecture does not develop to a further stage a tradition that has been interrupted; rather it stands at a beginning and no longer must merely construct. Its task is to comprehend the new structures of life, in order to participate actively through corresponding forms of construction in the wholesale coming into being of the new world. Soviet architecture has taken reconstruction in hand.

Reciprocal Influences Among the Arts. In our country too, under West European influence, architecture several centuries ago was completely under the dominance of the court and committed to the supervision of the academy. In the shadow of the other arts, it carried on its somnolent and completely uncreative semblance of existence. Only those with state diplomas were allowed to put up buildings in Russia —but painting or writing poetry were open to everyone. So it was proficiency that came to be cultivated in architecture, but in painting, talent.

The new artistic endeavors found fertile soil initially in the bourgeois Moscow of the great merchants as opposed to the aristocratic and bureaucratic St. Petersburg. Here development took on an ever-quickening pace. People promoted painting in so fundamental and radical a way that they came down to the basic elements. Art became more and more isolated. Finally it was about to collape and degenerate into art for art's sake and drawing-room topics, as is today the case in the West. The Revolution achieved the redirection of this stream of energy. The Revolution immediately gave the radical artists such enormous scope that the work of several generations will be necessary to exhaust it. This is where the cultural work of the artist

begins—work that is of decisive moment in the reconstruction of our architecture.

Reciprocal influences between the newly evolving arts are an important factor in connection with the basic elements of modern building. The influences upon architecture have entailed many dangers in addition to their valuable and peculiar effects. Our art belongs to an age of exact sciences. We are putting to use the methods of this age; we are making analyses. As far as painting is concerned, experimentation in terms of the material has been least inhibited. Thus the new creative forces have, with the help of analysis, laid bare the elements of plastic formation. In the course of this work, two clear and definite conceptions of a clearly distinct nature have been crystallized.

"The world is given to us through sight, through color" was the first conception. "The world is given to us through touch, through materials" was the second. In both cases the world was a geometrical order. The first conception demands no more than pure spectral color confined in abstract form within the rational ordering of geometrical elements—a plane geometry of color. A world of crystalline organicism. This world emerges within an endless visual space. Its further consequences were the wholesale renunciation of the colors of the spectrum and the renunciation of the planimetric figure that finally remained (black and white). Painting was thus superseded and gave way to pure volume formation. The architectonic character of this stereometric formation was immediately understood. Thus painting became a transfer point for architecture. A new asymmetric equilibrium of volumes was set up, the tensions of bodies were expressed in a new dynamic way, and a new rhythm was established. Since the leader of the way of looking at the world through color was a painter (Malevich), he was incapable of recognizing the actuality of the world; he had always viewed it solely through his eyes and remained caught in the nonobjective. As architects, we had to draw the further consequences.

The second way of looking at the world, in terms of material, required not merely observation but also the tactile apprehension of things. The specific qualities of the respective materials served as a starting point for the development of the form. The leader of this movement (Tatlin) assumed that intuitive artistic mastery of the material led to discoveries on the basis of which objects could be con-

structed irrespective of the rational, scientific methods of technology. He thought that he was demonstrating this in his model for the Monument to the Third International (1920). He completed this work without any special technoconstructive knowledge or knowledge of statics, and thus proved the justice of his conception. This is one of the first attempts to create a synthesis between the "technological" and "artistic" domains. The attempt to create a completely new architecture to break up volume and establish spatial penetration externally and internally already finds expression here. Here we have genuinely created anew, in a new material and for a new content, an age-old construction of form, as for example was already evinced in the Pyramid of Sargon at Khorsabad.

This work, and a sequence of further experiments in material and design, are giving the watchword "constructivism" currency in the world. The present "constructivist" generation of professional architects today regards these works as formalistic or even "symbolic." We will return again to this dialectic of development. At this point it must be stated that these achievements in the neighboring arts have made a significant contribution to the reconstruction of our architecture.

However, the first pioneers did not reach the point of building. The war had interrupted the whole practice of building. In the first years of the Revolution all that people did was to carry off old materials as fuel for heating; as a result, room was created for building. The new building talent had to be brought to a state of readiness. School was still the place where the rising generation of architects received their training. In school new methods had to be created. Parallel to the previously mentioned process in painting, there had developed a movement of synthesis led by the architects (architecture + painting + the other plastic arts). These young architects who had themselves received their training in the classical school first had to slough off their own skins. Their first step had to be destructive, explosive. There was a struggle for expression.

The task was clear: it was a matter of bringing architecture in its artistic and practical value to a degree of importance corresponding to the age. Through this watchword the triumph of youth in the architectural schools was assured. The whole trend of life itself was on their side, and the old academics could offer in opposition only borrowed, alien, and exhausted verities.

The young had set themselves the objective of achieving a unity between the utilitarian function and the architectonic notion of space. There were no opportunities for practical work at the outset of this development, and so realities had to be discovered and thought out. (For example, the restaurant and landing stage at the foot of a cliff.)

Whereas in other circumstances the natural operation of selection is what brings an organic achievement to its full flowering, in this case the decisive factor lay in the planning project. Therein lay the danger of putting too much emphasis on sheer quantity of ideas.

Of decisive importance for the character of the new school was the work on the development of new methods for the scientific and objective clarification of the elements of architectonic formation, such

Sketch of architectural project for restaurant and landing stage from El Lissitzky's *Russia: The Reconstruction of Architecture in the Soviet Union*, 1930. (*Photo courtesy Stedelijk Museum, Amsterdam*)

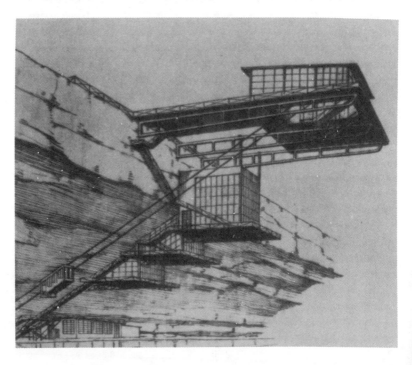

as mass, surface, space, proportion, rhythm, and so on. A new teaching method had to be found. This work, which was begun by the first pioneers such as Ladovsky, Dokuchaev, Krinsky, is today being taken further by the succeeding, younger generation of Balikhin, Korschev, Lamzov, and the rest. In the school of today the task is not only that of training surveyors or architectural draftsmen, but also of educating architects who will handle their own province scientifically.

This serious work on the basic elements of architecture has brought all forms of vital energy into play. A group has grown up that places the main accent upon building and demands the direct application of the methods of engineering and construction in architecture. The form is to arise spontaneously from the construction. This tendency is well known to us from the entire field of international architecture—but when it is applied to our situation, a fundamental point of difference must be established. In all countries, with the exception of Russia, people have to reckon with technical achievements as the realities of modern life. In America the architect comes into direct and reciprocal relation with this technology. Perhaps on precisely this account he can demand no more from it than it is able to give him. With us there are as yet no towns with the same urban character as that of Paris, Chicago, or Berlin. In technology we can establish contact with the latest achievement, whatever it may be, so it was possible for us to move directly from the hoe to the tractor, without retracing the usual path of historical development. For that reason we want to introduce the most modern methods of building and construction into our country—and for the same reason we see in the works and projects of the "formalists" and "constructivists" the most radical manipulation of constructions.

First tasks. Soviet architecture received its first new task in 1923. It was planned to erect in the center of Moscow, for the benefit of the new collective sovereign—the working population—a colossal building complex to serve as a Palace of Labor. It was to cater to large congresses, mass meetings, theatrical performances, and so on. The task was as colossal as the age itself. But the age had not yet crystallized out any kind of firm concepts of building. So the projects submitted were amorphous conglomerates of fragments from the past and from the present machine age, based much more on literary than on architectonic ideas. The project of the three Vesnin brothers is the

first step from destruction to the new craft of building. On a closed ground plan a clear stereometric volume is erected with the aid of an exposed reinforced concrete frame. The whole is still isolated, simply a single corpus, decidedly not thought out in terms of town planning. The power of the classical orders is still to be felt throughout, the whole project is crowned by romantic evocations of the radio, and the large space holding eight thousand people is still completely conventional. But nonetheless it is our first attempt at creating a new form for a social task that in itself was still unclarified.

The succeeding period offered ever more concrete tasks, with their purpose becoming clearer and their standard of achievement growing more considerable.

In 1924 came the project of the brothers A. A. and V. A. Vesnin for an office building for the newspaper Leningrad *Pravda*. The surface area of the building covered only 19⅔ x 19⅔ feet. The building is, for its time, which yearned after glass, iron, and ferroconcrete, a characteristic piece of work. All the accessories that the city street sticks onto the building—such as signboards, advertisements, clocks, loudspeakers—even the elevators on the inside, are included as parts of equal value in the overall design and given unity. This is the aesthetic of constructivism.

The first small building in which the reconstruction of our architecture can be genuinely documented is the Soviet Pavilion for the 1925 Paris International Exposition, by Melnikov. The fact that the pavilion stands close by the creations of international architecture demonstrated in the most glaring way the fundamentally different attitude and conception of Soviet architecture. This work belongs to the "formalist" wing of the radical front of our architects, to the section that first strove to create an architectonic idea for utilitarian tasks.

In this case the idea was to aim at breaking up volume by exposing the staircase. In the ground plan, symmetry is established on a diagonal basis and rotated 180 degrees. Thus the entire building is thrust out of its conventionally symmetrical state of equilibrium into movement. The tower is transformed into an open\system of masts. The building is constructed in honest wood, and displays not the national style of building with blocks, but modern techniques of wood construction. It is transparent. Unbroken colors. Hence no false monumentality. A new way of thinking.

Grundriß

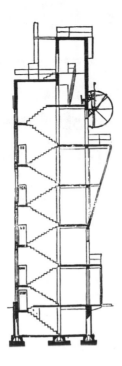

A. A. and V. A. Vesnin: Design for the Leningrad Pravda Building, 1924.

Melnikov: Designs for the Soviet ~ilion, Paris International Exposi~, 1925.

From *The Construction of Architectural and Mechanical Forms* by Jakob Chernikov (1931)

Jakob Georgiyevich Chernikov was born in Pavlograd in 1889 and died in Moscow in 1951. In 1914 he entered the Academy of Arts in Petrograd to study painting and architecture, but his studies were interrupted by a long period of military service and he did not qualify as an architect-artist until 1925. For the next ten years he taught in various Leningrad institutes and designed a large number of build-ings—in particular, industrial complexes—for Leningrad, Kiev, Yaro-slavl, Stalingrad, and other cities. About fifty of his projects were built. In 1932 he was appointed professor at the Leningrad Institute of Railway Transport Engineers and Academy of Transport. His last appointment, in 1945, was as head of the Department of Architecture at the Mussovet Building Institute.

Chernikov's remarkable work on Konstruktsiya arkhitekturnykh i mashinnykh form *(The Construction of Architectural and Mechanical Forms) was published in Leningrad in 1931. In the introduction Erik Fedorovich Gollerbakh, an author and critic who wrote widely on aspects of Russian culture—including a study of the state por-celain works (1922) and a life of Pushkin in pictures (1937)—de-scribes the book as the first comprehensive statement of constructivism. In view of the numerous theoretical statements that have already been quoted, the claim seems unjustifiable. But Chernikov must at least be credited with having traced, with unprecedented thoroughness, the development of forms from the purely abstract and geometrical to their embodiment in such complex ensembles as a theatrical stage set, an industrial plant, and a town plan. His aim was to provide not simply a grammar of constructivism but a set of examples illustrating the full development of that grammar.*

It should be emphasized that Chernikov's work owed a great deal to the programs of basic design and specialized architectural training

that had been developed at the Vkhutemas in the previous decade. His most elaborate examples are in fact based on celebrated architectural projects of the postrevolutionary period, such as the Vesnin brothers' Moscow Palace of Labor (1923) and I. Leonidov's Lenin Institute (1927). The fact that these projects are not attributed to their original designers reinforces Chernikov's exemplary and didactic purpose.

ERIK FEDOROVICH GOLLERBAKH: *From* The Problems of Constructivism in Their Relation to Art

In this epoch of the triumphant development of mechanical engineering and the ceaseless growth of industrialization, a new conception of artistic creation is being born; new demands are being made on visual art; old, decrepit forms are being discarded. Contemporaneity demands that visual art should directly serve the vital needs of our time.

Attentive to the demands of civilization, artists are attempting to find formative principles of their projects that will correspond to the industrial and technological character of contemporary civilization. These attempts are rarely successful if they come *from without* and are reduced to the "adaptation" of old forms to new content. Only the creation of new forms, which can satisfy the forms of life itself and meet its concrete demands, can lead art on to the right path. Instead of all kinds of adaptations *from without,* it is possible and indispensable to discover new values *from within,* i.e., in the sphere of the phenomena characteristic of the contemporary tenor of life and of the contemporary state of technology. Art can to a certain extent become engineering. From its former aimless decorativeness, from its aestheticism devoid of principle and divorced from life, it must

Introduction to Jakob Chernikov, *Konstruktsiya arkhitekturnykhi i mashinnykh form* [The Construction of Architectural and Mechanical Forms] (Leningrad, 1931). The translation is by John Bowlt.

pass to a practical and useful existence. In this respect the question of the re-creation of artistic forms must by no means remain wholly independent of ideological content, but must be resolved on the basis of a fundamental revision of the *means of expression.* Industrial and technological *"reality"* cannot but influence the artist's creative *"consciousness."* Of course, various other factors can also influence his consciousness—for example, in the modern art of Western Europe and on the left front of visual art in the U.S.S.R., one can perceive the influence of prehistoric, primitive art, of ancient archaic cultures, of the art of the savage, of children's art, of folk art, etc., but when we are told that artists in assimilating these influences "set up new traditions," "achieve one of the greatest revolutions ever known in the history of art," we are right to doubt the revolutionary character of these "new" traditions. Should we not rather consider them as imitation *sui generis,* as a conscious return to those forms—albeit great, but already realized and to a great extent extinct—that in countless numbers fill the age-old history of art, sometimes outgrowing their prototypes (created at the dawn of mankind), sometimes yielding to them forever? Is it necessary to search for the models of artistic creation in the cemeteries of art, in remote ages, or in the socially backward strata of contemporary humanity, when the progress of contemporary life is ceaselessly producing new forms, conquering the inertia of the elements, and clothing them in the steel chains of technology? Instead of *imitating* congealed and dead forms—even if they are beautiful—is it not better to look for the bases of new art in the essential congruence inherent in the organic and spatial structure of the phenomena of the outer world?

Investigation of this congruence leads to the identification of the geometric fundamental principles to be found in the most heterogeneous phenomena of the outer world. And it is precisely *investigation,* adducing the principle of the scientific basis of art, that makes possible the search for a synthesis of technology and all kinds of visual art in the single form of constructivist art.

●

Hitherto there has not been a single investigation devoted specifically to the questions of constructivism. Moreover, there has not been even an essay elucidating the very concept of constructivism and outlining the course of its development. People usually speak very superficially

and unconvincingly of constructivism: they indicate that constructivism is based on the principles of the mechanical and geometrical interrelations of materials and their forms; they mention that constructivism aspires to create practical, useful, and outwardly beautiful things (primarily, their design); finally, they underline the direct link of constructivism with the mechanization of life, with the intensive development of industrial production, etc. All these diffuse and hazy definitions do not provide a precise and true conception of constructivism. Indeed, it is difficult to give a definition of something that has not yet entirely defined itself; it is impossible to make an investigation of a subject whose very nature has not yet been completely ascertained. That is why at present constructivism should be written about not by art historians and art critics, but by art theorists, or, even better, by practical workers, i.e., the artists (or engineers) themselves—the constructivists.

●

The development of ferroconcrete technology, the titanic growth of metallurgy, the intensive progress of mechanical engineering have so far not exerted the radical influence on art that they could have if artists had grasped their significance in all its profoundly reformative sense. Such a demonstration of capitalist Europe's technological power as, for example, the Eiffel Tower appears today an empty and unnecessary enterprise; its restaurants, its advertisement for Citroën cars, and even its wireless station constitute a too insignificant "appendage" to this grandiose but absurd erection and, of course, in no way "justify" it. In this case technology did not want to be art, and art did not come to the aid of technology. The building art of Western Europe continues to waver among tasteless stylization, bourgeois decadence, modernist innovations, and barracklike standardization—standardization that encloses urban life in stone boxes divided up by monotonous corridors and creates equally depressing skyscrapers and uniform suburban houses. And only occasionally are buildings created that in some degree express the essence of our epoch and create a new style. A new architecture is being born whose beauty lies in its functionalism, its better utilization of material, and its rational constructiveness. A wide road must be opened up for this architecture in the Land of the Soviets—the land where socialist culture is being built, where mighty plants and factories, grandiose power stations, giant state

Theatrical set from Chernikov's *Construction of Architectural and Mechanical Forms,* 1931. The words incorporated into the design spell out "Music for the Masses." It embodies the following constructive principles: "unified dynamic composition of bent cylindrical solids, surfaces, raised letters, and signs." Chernikov prescribes "bright cold green and white with orange dashes" as the coloring for the set.

farms, the citadels of agricultural industry, are being created, where the whole of economic life is being reconstructed on socialist principles, where the conditions of social life are being remade, and where the cultural needs of the masses are continually increasing.

In this respect the works of leading architects take on particular significance. These architects are attempting to substantiate the forms of new building, to find the natural lines of development in the building art, and to place it on the firm rails of scientific investigation and artistic and technical experiment. . . .

JAKOB CHERNIKOV: The Constitution, Study, and Formation of Constructivism

The Constitution of Constructivism

The Need for Constructive Creation. The manifestation of constructive needs is by no means peculiar to every human being. It has been established that a great number of people lack not only these needs but also even the feeling for constructive principles. For many reasons it is extraordinarily difficult to develop this feeling.

●

One should acknowledge as the *first reason* the fact that very few people are interested in constructivism, and therefore, the number of people who wish to study and know constructive principles is extremely limited. Consequently, the foundations of constructivism have hitherto been insufficiently elucidated. Those who nevertheless have an inclination toward the study and understanding of constructions are so few that they are scarcely able to constitute a body of researchers in constructive principles.

From Jakob Chernikov, *Konstruktsiya arkhitekturnykh i mashinnykh form* [The Construction of Architectural and Mechanical Forms] (Leningrad, 1931). The translation is by John Bowlt.

●

One should consider as the *second reason* the fact that constructivism is a new creative inception: new insofar as particular attention has never previously been paid to this question. In many instances from the history of the ancients and the Middle Ages, it would be possible to show the presence of constructive qualities in the fields of both building and technology. One must not deny the fact that constructive principles have existed at all times since that would mean denying the gradual process of development in building and technology. However weakly developed the elements of constructivism were in ancient times, they nevertheless existed even then. Constructivism, like everything else, was at that time in an extremely embryonic state, but it existed. Nowadays construction as such is attracting our attention and engaging our intellect to a much greater extent than in previous ages. We are paying particular attention to the questions of constructivism and are trying to give a clear and precise basis to the concepts of constructive principles, laws, rules, their essence, etc. We are bound to come to the conclusion that "the age of active constructivism" has dawned.

●

One should count as the *third reason* the general indifference toward the question of construction. Even those who ought to pay particular attention to this question often either display a complete nonchalance or are unaware of the full value of this phenomenon. Because of the complexity involved in understanding and elucidating constructive principles in an intelligible form, many people attempt to resolve the problems of constructivism by intuition or experience. . . .

●

Despite the above reasons, which impede the fulfillment of the need for constructive creation, this need is constantly making itself felt. The search for constructive principles is essentially inherent in every living creature and, in particular, finds marked expression in man's activities. In all spheres of life man is by nature a builder, and this is evident from the very first moments of his existence. Without receiving any indications from without, a child often himself decides fairly complicated questions of constructivism during his games and pursuits. For example, it must be acknowledged that every knot (of thread, string, etc.) and every fastening together (of sticks, chips of wood, etc.) is essentially a construction; consequently, one can dis-

cover construction in the most primitive of children's pastimes, for example, when with the help of sticks a child quite rationally resolves the question of supports in fixing one piece to another, or when he is engaged in sewing dresses for dolls, etc. Man cannot help building and creating—hence emerges the necessity of dealing with an object's construction. This occurs involuntarily, spontaneously. The fact that in the first stage of his development a child loves to destroy should be recognized also as a characteristic phenomenon since almost every creative process is usually preceded by destruction. Everyone who discovers something new destroys something that had been elaborated and established earlier on, but in doing this he is by no means being absolutely destructive by nature. Evidently man's nature is so organized that after destruction he proceeds to creation. The instinctive need for constructivism, even though it may be unsystematic, is peculiar to every human being and ultimately must in the future be given a basis. This basis must be formulated in an intelligible and lucid shape and must comprehend the whole complex system of constructivism.

●

One must underline certain peculiarities that accompany the search for constructive principles in individuals who are inclined to embark on it. This need is quite sharply expressed in many works of an experimental type that bear the character of invention. Nobody would deny that every technical inventor has the natural gift of disposition toward constructive principles. . . . Man's need to construct the objects that surround his life imperiously dictates his quest for a rational and sound escape from a vague and indefinite situation. Both the mighty construction and grandiose technology of our time are advancing at such a rapid pace that man, surrounded by them, must grasp, understand, and study all the stages, laws, and qualities of constructivism. We not only *want* to know the bases of constructivism, we *must* know them. In other words, the need to know the principles of constructivism has become the need of our time.

The Meaning of Constructivism. The meaning of constructivism is concealed in the essence of all the concrete principles that it serves. A construction can exist in its own right without necessarily being justified by application, but in that case its value decreases. . . .

We observe a completely different picture when we see not only a compact amalgamation of volume and construction but also a rational meaning in this unification. . . . In all cases of building construction one can see a definite meaning in the unification of one body with another. It is possible to suggest many different solutions for any one part of a building . . . but in all cases we will suggest a "constructive" solution. This means that in creating a building we will resolve it constructively.

●

A machine, whenever exposed, speaks for itself. A machine cannot but be constructive because it embodies all the aspects and principles of constructivism. We can observe the best examples of constructive principles and bases in a machine and its parts. But in addition to the construction of heavy, solid objects, there is a second type of construction—of soft bodies and surfaces. The meaning of such construction is inherent in the very structure of clothing and the need for clothing. If at present man's clothing has not reached perfection, this should be explained by the imperfection of people's lives and by the many economic and domestic shortages. In the future man will surround himself by such finished articles of domestic and everyday use that he will automatically focus his attention on a form of clothing that would be entirely suitable for the most varied duties. Gradually progress is already being made in this direction, if only in questions of physical culture.

●

In all cases the very meaning of constructivism is contained in the fact that it creates the impression of an indispensable coordination of one element with another. By observing the functional dependence of a series of objects on each other and by justifying this dependence, we thereby affirm the constructive rationalism that we are seeking.

The meaning of constructivism lies also in the fact that it convinces us of the aspiration that certain objects have to encompass. Inherent in the prehensile articulation and unification of separate elements is the legitimation of the principle of cohesion. When one body is implanted in another—thereby engendering the dependence of one part on the other—a finished article is created from the aggregate of their interaction. In this we find a meaning: the collective unifications in a series of elements form a single definite whole. While

a separate element emerges as devoid of individuality in a general mass, a *group* of constructively unified elements emerges as a formalized unit, i.e., a definite, integrated unity.

●

We become even more convinced of the meaning of constructivism when we come up against questions of a practical nature in which this or that problem can be solved only by constructive means. In the constructions of such moving machines as the steam engine, the airplane, the motorcar, the steamship, etc., the meaning of all the constructively amalgamated parts testifies to a special, strictly calculated combination of all the elements. And insofar as everything is meaningful in these machines, they are logical.

The most interesting feature of constructivism is its rationality. Without this quality constructivism is inconceivable. The combination of such momentous and important principles as constructivism and rationality betokens the significance of the question under examination.

Finally, from a simple observation of constructive objects and buildings it becomes clear that constructivism is an indispensable need and a constant appendage of our tenor of life; without constructive principles it is impossible to decide most questions of technology and art. . . .

The Melody of Constructivism. The consonance of forms engenders "melody" in their harmonic combination. A construction, in its amalgamation of separate bodies, creates its own particular form and affects us not only by its visible mass but also by those correlations of interconnected bodies that our eye perceives. The feeling we experience when we see successfully resolved constructions equals in strength and value the feeling that arises from the contemplation of artistic objects of high quality. We are made aware of the beauty concealed in perfect constructions through the direct effect of objects created by the hand of man. This applies equally to both buildings and machines. We are affected by the whole aggregate of elements combined together in a definite scale. The feeling of pleasure we experience on contemplating a constructive creation, i.e., the impression we receive, depends on the specific features that this or that object possesses. Certain inner qualities introduce this distinction. It is extremely difficult

to establish the limits and boundaries of certain points at which constructive forms affect us. Nevertheless, it is possible to distinguish the following subdivisions of constructive melodies:

 (a) passive, confident articulations of solids,
 (b) grand aspirations in articulations of solids,
 (c) heavy, oppressive combinations of solids,
 (d) light, dynamic combinations of solids,
 (e) self-contained, assertive articulations of solids.

●

(a) The melody of passive, confident constructive articulations of solids usually occurs when we are confronted with the masses of a horizontal combination. The action of such forms on our psyche is based on the very character of the building or machine that our eye perceives. In general, it has been noticed that if an object is resting on a horizontal plane and is therefore in a horizontal position, it always has an effect on our eye and psychological state as a solid mass in a *passive* state. One should not, of course, infer from this that other forms in a different position cannot communicate a feeling of passivity.

●

(b) The melody of grand (aspiring) constructive articulation of solids in most cases affects us by the fact that the general mass of grouped elements is interconnected by a mutual, compact constructive combination. This was observed much earlier in Gothic buildings, which possess a refined and elaborate construction. Every flying apparatus possesses the same melody of aspiration. This aspiration can be felt in the whole aspect of an airplane. Certain engines and mechanical installations strike us by the power of their aspiration; this impression is conditioned by our confidence in the rationality of their constructive articulation. It is not without significance that many people hear in the din of machines, in their reciprocal combination and working, the special "music of our time." The reciprocal combination of constructive principles and movement in the machine itself creates a powerful sensation that grips us irresistibly; we are conquered by this "mechanical animation" and involuntarily glorify it. When authentic grandeur and aspiration are combined in any creative work of man, and when functional movements are present in it, we obtain a definite "melody," distinguishable from other constructive melodies.

●

(c) The melody of heavy (oppressive) constructive combinations "sounds" different because of its distinguishing features and qualities. Many monolithic buildings of religious culture with their particular constructive combinations of masses made an appropriate impression on those who used them. By certain appropriate combinations of volume we can arrive at the point where we obtain a volumetrical image that gives us a corresponding impression of heaviness. Many of us are familiar with a melody of somber parts oppressive in their heaviness. We are often deeply impressed by objects when we encounter them. Nevertheless, one must make the reservation that no mean role is played in this by paint (color) and illumination (light). In the aggregate of all these factors we obtain the complete melody of heavy, constructive combinations of masses.

●

(d) The melody of light, dynamic constructive combinations bears this title because constructive dynamics in most cases give the impression of lightness to those monoliths, buildings, and machines that possess these combinations. This lightness is acquired entirely by means of dynamics. It is essential to establish the fact that a construction of solids, volumes, etc., creates an impression of weight and heaviness in the elements that participate in its creation. We see and realize that a construction with a dynamic tendency creates an obvious impression of lightness. The melody evoked by such objects of a constructive type depends on the presence of dynamics in them. The psychological effect produced by buildings of this kind is different from that produced by the constructions described in the preceding paragraph. We feel at ease, we feel pleasure, invigorating impulses occur—as a result of our experience of the melodies that light, dynamic constructions evoke in us.

●

(e) The melody of self-contained, assertive constructive articulations is encountered quite often in buildings and machines. A peculiarity of successfully resolved self-contained constructions is the fact that from the first moment of perception such objects make an impression of wholeness on us. This wholeness is fixed in our consciousness as a definite solid mass, whose specific functions are un-

known to us. In other words, we are aware of some kind of work and objective of the constructive self-contained product. There arises in us, distinct from our will and inclinations, a feeling of confidence in the object we are examining and studying. While experiencing the general harmony of constructive self-contained elements, we perceive simultaneously a feeling of assertion communicated to us by these very constructions. In every constructive articulation of this kind, un-

Architectural project, also from Chernikov's long theoretical work, for the Lenin Scientific Research Institute of Social Sciences. It exemplifies the "constructive combination of cylindrical buildings with linear edifices."

doubtedly the latent symptoms of a legitimate rationality are present. This is available to us independent of its analytical foundation, and we can perceive it initially by intuition. That is why it is possible to define all the subtleties of our perception of self-contained constructions by the term "assertion." The melody of assertion is sanctioned by our consciousness that the articulation of the solids is correct.

Apart from the above facts that validate certain symptoms of this assertion, one should also determine others that establish the assertion of self-contained constructive forms. This is possible because in most cases the objects under consideration possess static principles. One can draw the firm conclusion that a statically arranged work, with its corresponding symptoms of a complete composition of solids, undoubtedly creates a harmony of assertion. Monuments, monolithic mechanical installations, etc., can serve as characteristic examples.

In generalizing the question of constructivist melody we must recognize as a peculiarity of constructive compositions the continuous presence of factors creating this melody. Under the influence of the images of a constructive type that we perceive, this or that mood is produced in us. In experiencing these moods immediately on or after contemplating objects of constructivism, we yield to them and find ourselves fascinated (influenced) by them. Because of the fact that constructive principles are gradually penetrating our life and are beginning to occupy an appropriate position, the harmony of constructive forms is more and more attracting our attention, mood, and experience. An urgent need for constructive designs is arising.

And hence, of course, there naturally appear those constructivist melodies that complete the complicated and interesting problem of construction.

The Laws of Construction. Hitherto all those who have been interested in the problems of constructivism have encountered many unresolved problems concerning which rules, norms, and laws exist or should exist for the interconstruction of solids. Despite the absence of these rules and laws one can see that at all times people have constructed and continue to construct. There is no doubt that laws of construction do exist and will be deciphered just as music has been deciphered in all its forms. The force of a blow, the force of a sound, the most subtle changes of musical vibrations have today

been given an explanation. Throughout the ages man has accumulated methods and knowledge in order to construct the most complicated buildings and machines, both in their graphic solution and in their natural visual images. To execute a construction we have at our disposal either very simple objects such as line (graphic or material), plane (graphic or material), surface (graphic or material), volume— or more complex objects that can be utilized for the aims of construction. But in order to reduce the indicated elements to a state of constructive interconnection, certain motives are required. At this juncture it stands to reason that in the first place we should advance the basic laws of construction as such.

●

First law: Everything that can be unified on the principles of constructivism can be material and nonmaterial, but it is always subject to the recording action of our brain by means of sight, hearing, and touch.

●

Second law: Every construction is a construction only when the unification of its elements can be rationally justified.

●

Third law: When elements are grouped together on a basis of harmonic correlation with each other, a complete constructive combination is obtained.

●

Fourth law: Elements unified in a new whole form a construction when they penetrate each other, clasp, are coupled, press against each other, i.e., display an active part in the movement of the unification.

●

Fifth law: Every constructive unification is the aggregate of those percussive moments that in varying degree contribute toward the wholeness of the impression.

●

Sixth law: Every new construction is the result of man's investigations and of his inventive and creative needs.

●

Seventh law: Everything that is really constructive is beautiful. Everything that is beautiful is complete. Everything that is complete is a contribution to the culture of the future.

●

Eighth law: Inherent in every constructive unification is the idea of the collectivism of mankind. In the close cohesion of the elements is reflected the concord of all man's best aspirations.

●

Ninth law: Every constructive resolution must have a motive on the basis of which the construction is made.

●

Tenth law: In order to create a constructive image absolute knowledge is essential, not only of the bases of constructivism, but also of the bases of economic reproduction.

●

Eleventh law: Before assuming its definitive form a constructive representation must pass through all the necessary and possible stages of its development and construction.

Observance of laws in all constructive buildings is further based on the fact that we can simultaneously prove the truth and correctness of the chosen solution by analytical means. The justifiability of the approach serves as a criterion for the legalization of the elaborated form.

In all cases of construction we face the necessity of giving foundation to and, thereby, as it were, of legalizing the construction that we have accepted. We must prove that the construction that we are proposing is correct and corresponds to the given case.

The Study of Constructivism

The Concept of Constructivism. The concept of constructivism can be defined as any compact combination and articulation of differing objects that can be united in a whole. Apart from that, a construction represents a concept that acquaints us in practical, visual, tangible,

and experimental forms with the different principles of unification. When certain solids in conjunction with others form something whole and harmonious, and this whole presents a definite coherent composition, the problem of constructivism is resolved. The totality of all the participating elements indicates that the combination of all the elements creates a phenomenon that we call a construction.

The Birth of Constructive Principles. The birth of constructive principles occurs when there is a real necessity and demand for it. But this birth is possible only when certain preparations and knowledge precede it. It is difficult to imagine the signs of birth of constructive principles in any subject without the appropriate preparation. Consequently, we face the necessity for education in constructivism. The more developed our practice in constructive buildings, the greater the wealth possessed by our imagination and the more frequent and easy our creation of constructive representations. It is essential only to create conditions that would offer the possibility of converting any constructive creation into corresponding forms. . . .

The Rules and Norms of Constructivism. The rules and norms of constructivism are in an embryonic state and hitherto have not been completely revealed. Nevertheless, it is essential to dwell on a few of these rules and norms in order to avoid as far as possible disparities and discrepancies in our constructive compositions. Thus, for example, it is essential to consider the following rules as indispensable:

(a) Wire constructions must never be combined with monolithic bodies.

(b) Volume must not be combined with a great quantity of planes and surfaces.

(c') When one solid surrounds another, the correlation should be such that the mass of one solid would not destroy the construction itself.

(c") When small volumes emphasize the features of a constructive composition, their relative size vis-à-vis the basic masses may be markedly small.

(d) The basic mass should not be so great that it makes another mass—of small volume and constructively linked to it—inconspicuous.

(e) In a graphic design it is essential to show a construction in such a way that it can be felt in its utmost harmony.

(f) Volumes are best united with each other either in the one general direction of their movement or perpendicularly.

(g) The best combinations of elements are those that contain neither reiterated forms nor reiterated dimensions.

(h) If an arranged static group has too weak a support, the value of the construction becomes insignificant.

(i) An unstable inclined construction may emerge as not constructive, if the laws of equilibrium are not observed in it.

(k) A construction incompetently executed (graphically or volumetrically) is the greatest evil in the study of constructive bases.

(l) To obtain the best effect in a constructive work it is desirable to make use of all means; i.e., the following must be taken into account: color, texture, lighting, material, visual angle.

(m) Every constructive composition must fulfill its ideology and reflect its complete idea.

(n) An ideal, successful constructive solution should be considered as one in which the parts are not felt to be bound together.

(o) If it is essential to reveal the elements that make up a construction, this must be done in such a way that the participating visible elements intensify the impression made by the construction.

(p) In compositions it is essential to aim at the manifestation of a constructive order of dynamic principles.

(q) In any construction its stable strength and cohesion should always be felt.

(r) No constructive work should ever be created in which heaviness and artificiality can be felt in its articulated parts.

(s) Any constructive work must reflect merely by its appearance the correctness of the chosen construction.

(t) The greater the simplicity and lucidity in a construction, the more valuable it is and the greater its specific gravity.

(u) To understand a construction is to know it; if we know a construction it is easier for us to present it in its visible aspects.

(v) The greater the rationality in a construction, the more valuable it is; in other words, the sense of constructivism lies in its rationality.

(w) A construction must by its appearance reflect its functional affiliation.

(x) It is necessary to present any planned construction in all its aspects, which illustrate the essence of the given constructive solution.

(y) The more deeply and carefully constructive principles are studied, the better the solution obtained in the definitive design.

(z) The highest form of construction is a rationally and functionally constructed solution. . . .

The Formation of Construction

. . . *The Bases of Constructivism.* As has been stated earlier, the construction as such has always, at all times, been an inseparable part of those works of man that demanded the principle of unification of parts. However embryonic man's first achievements in industry were, they nevertheless required a constructive unification of their parts. Aspects of constructive solutions were being advanced, developed, and perfected throughout the natural development of all technology. We should therefore acknowledge industrial technology and the gradual perfecting of each construction resolved by man as one of the fundamentals of constructivism. The trend of subsequent achievements in each of the above fields has not changed the foundations of constructivism. Hitherto the basis of constructive forms has remained immutable, but the path of evolution has provided many various solutions of the same problems. In each individual case in all our many and varied buildings, we are presented with interesting and original decisions. We can establish the irrefutable fact, observed when we study the problems of constructive research, that the most complex constructions are present above all in the machine. The machine imperiously demands that an exclusive concentration of constructive principles be applied to it. Most aspects of construction are to be found in machines and in their parts. Our age, the age of the machine's domination, undoubtedly influences the general tenor of our life. We therefore find the presence of constructivism throughout our whole environment. A supply of constructive principles comes in a ceaseless flow and envelops everything that is open to such a solution. That is why we cannot stand aloof from constructive designs, from constructive solu-

tions, and from the study of this question in general. The time has come to devote the most serious attention to the problem of constructivism and to investigate its basis from all possible aspects; these are the paths of the subsequent evolution and perfection of forms.

Conclusion and Inferences. We have examined all possible kinds of constructional formation. The fundamentals of constructivism outlined above make it possible for us to give the general characteristics of constructivism as a creative world view. The abundance, variety, and many-sidedness of the phenomena of constructivism prove that it is not some kind of abstract method having limited applicability. On the contrary, we are convinced that constructivism encompasses, and penetrates into, an extremely wide area of man's creative work. Consequently, it is possible to speak of constructivism as a world view.

What are the basic characteristics of this world view? The mechanization of movement and building in life peculiar to our time, the intense development of industrial production and of technology in general have radically changed our way of life and generated new needs, new habits, and new tastes. One of the most urgent needs of our time is the rational organization of objects, their functional justification. And this is the rejection of everything that is superfluous, everything that does not bear on the aim and purpose of the object. In this sense one can say that despite the extreme complexity of our life, despite the diversity of its structure, it is in certain respects being simplified through the perfection of technological achievement. In other words, many processes that previously were complicated and slow are now being simplified and speeded up. Hence the principles of simplification, acceleration, and purposefulness emerge as the constant attributes of a constructivist world view.

It is characteristic of constructivism that it forms a new understanding of the object and a new approach to the creative process; namely, without denying the value of such forces as inspiration, intuition, fantasy, etc., it places the materialistic point of view in the foreground. This point of view unites phenomena that were previously considered quite separate and disparate: the phenomena of engineering and technology and the phenomena of artistic creation. It is true, we know, that in former times these phenomena sometimes came into

contact with each other and appeared together in a harmonic synthesis, as, for example, in the best works of architecture, which satisfy both constructive requirements and the demands of good taste, our aesthetic sense. However, the durable, firm, and logical link between these phenomena envisaged by constructivism was lacking. Only by the absence of this link can we explain the widespread development of decorative motifs devoid of any functonal justification (especially in baroque and *art nouveau* architecture).

In former times machinery was considered something profoundly inartistic, and mechanical forms were excluded from the province of beauty as such; people did not talk about them as forms of artistic creation. But now we know and see, thanks to the development of the constructivist world outlook, that machinery not only lies within the confines of artistic conception but also has its own indubitable and convincing aesthetic norms and canons. These norms and canons are to be found in the fundamentals of constructivism, which—for the first time in the history of man—has been able to unite the principles of mechanical production and the stimuli of artistic creation. One must not consider constructivism something absolutely new, unprecedented, and unheard of. It could be said that in its elementary principles constructivism is as ancient as the building art, as man's creative abilities. Primordial man, in building his dolmens, triliths, crypts, and other edifices was unconsciously a constructivist. These initially primitive trends of constructivism gradually became complex and crystallized in the course of man's centuries-long cultural development. The forms of constructivism differentiated in proportion to the differentiation of culture.

The disunity of artistic and technological forms of which we spoke earlier is gradually taking the shape of a common, integral aspiration toward rational construction, or one could say that we are gradually uniting artistic construction and machine construction; the boundary dividing them is being smoothed out. A new conception of the beautiful, a new beauty, is being born—the aesthetics of industrial constructivism. If in its general, primary fundamentals its origin is very ancient, it is indebted for the concrete definition of its principles mainly to the artistic and technological research of the last decades in almost all the cultured countries of the world.

It must be recognized that the achievements of the so-called leftist

artists, the revolutionaries of art who are often repudiated and ridiculed, have by no means been their last. Undoubtedly constructivism has to a certain extent employed the formal and methodological results of modern trends. These directions have contributed a great deal to the understanding of modern architecture and mechanical forms. They have indicated the usefulness of laboratory research and the value of the study and analysis of form connected with contemporary, industrial technology. It is thought that constructivism has significance only as a means of overcoming eclecticism and technological conservatism. In fact, its role is much wider; it is not only destructive in relation to the old, but it is also creative in relation to the new. Furthermore, constructivism by no means denies art or supplants it by technology and engineering, nor does it ignore artistic content and the means of artistic effect, as is maintained by certain art historians of our time. Formal and technological functionalism, as a method of architectural work and analysis, does not exclude the possibility of a harmonic interrelation of the principles of form and content, nor does it exclude the possibility of the coordination of practical, utilitarian tasks and aesthetic attractiveness. Constructivism does not renounce critical utilization of experiment; it does not seek an isolated solution of the particular aspects of this or that task but aims at the best utilization of all possibilities, both formal-compositional and technological-constructional, by linking them together in a creative, synthesizing process.

We are convinced that the correct solution of the problems of constructive forms is equally important for all branches of man's creation—for architecture, mechanical engineering, applied art, the printing industry, etc. Constructivism can, and must, take into consideration all the concrete needs of contemporary life and must answer in full the needs of the mass consumer, the collective "customer" —the people.

VLADIMIR TATLIN: Art Out into Technology (1932)

In 1929 prominent constructivist architects had joined with film directors in founding a group known by the significant name October (The All-State Workers' Association in the New Fields of Fine Arts). The Vesnin brothers, Ginsburg, and Gan were members, as were Esther Shub and Eisenstein. But although Soviet cinema was to continue its triumphal progress, architecture was to meet with a considerable setback. While the Communist Party leaders were convinced of the utility of cinematic experiment, both as an aid to propaganda within the Soviet Union and as a means of securing the respect of the outside world, they were less well disposed to the modernist tradition in architecture. The competition for a design for the Palace of the Soviets, which attracted a fine project from Gabo as well as occupying the attention of the constructivist architects, was finally won in 1932 by the preposterous neoclassical wedding cake of architects Iofan, Gelfreich, and Roudnev.

With the beginning of the new decade, active official disapproval was not long in following the withdrawal of official patronage. In 1931 the October group issued a "Declaration for the Fight for Proletarian Positions in Art." The very next year all nongovernmental groups of artists were dissolved by official decree, and the proliferating associations of the previous decade were replaced by nonsectarian bodies such as the Union of the Architects of the U.S.S.R., founded May 18, 1932. Architects within this body did not completely abandon the modernist position, and in 1937 they welcomed Frank Lloyd Wright to their first congress. But after 1932 it became quite unrealistic to speak of a constructivist movement within the Soviet Union.

First published in the catalogue *Vystavka rabot zasluzhennogo deyatelya iskusstv. V. E. Tatlina* [Exhibition of Works of the Honored Art Worker. V. E. Tatlin] (Moscow-Leningrad, 1933); the text is dated 1932. The translation by Troels Andersen *et al.* was published in *Vladimir Tatlin* (exhibition catalogue, Stockholm, Moderna Museet, July–September 1968) and is reprinted here with permission.

Tatlin had taken very little part in the second wave of constructivist activity, which was symbolized by the founding of OSA and ASNOVA. By 1925, when a new version of the Monument to the Third International was exhibited at the Paris exposition, it was clear that there was no possible chance that the work would be constructed. Up to the end of the decade, Tatlin was chiefly occupied with various teaching jobs, in the Department of Theater and Cinema in Kiev and in the Vkhutein (Higher Artistic Technical Institutes) in Moscow. However in 1929 he began to work on a project for a kind of glider, and from 1930 to 1931 he was allowed to use the tower of the Novodevichy Monastery in Moscow to develop this project.

The text that follows was written in 1932 to explain and justify the new glider, or Letatlin (from the Russian letat: "to fly"), which was being exhibited in Moscow together with photographs of his other works. In order to put Tatlin's statement into a realistic context, it is useful to consider an article that appeared in Vechernaya Moskva *(Evening Moscow) in April 1932 (translation by Andersen,* Tatlin *[Exhibition catalogue], pp. 77–80). The author, Kornely Zelinsky, had been a founder of the Literary Center of Constructivists in 1924.*

Zelinsky looks back with remorseless clarity to the time when Tatlin's Monument was "circulating in the journals of Europe as a 'symbol' . . . of the artistic flowering of the Russian revolution." He demonstrates the connection between Russian and international constructivism, suggesting that Tatlin was looking for "the same universal geometrical premises, as the bourgeoisie had feverishly sought in crushed and trampled-over Europe." He notes that Tatlin, Rodchenko, and the other Russian artists were united, despite themselves, with such representatives of bourgeois capitalism as Le Corbusier and Van Doesburg. Finally he suggests that constructivism can now be regarded as a "purely bourgeois school," and that the artist must be prepared to see "work with spatial forms" no longer as mere "branching experimentation," but as a part of "Socialist world-revolutionary praxis."

As might be expected from the terms of this analysis, the Letatlin comes in for severe criticism from Zelinsky. "Can we really allow the performance of solo inventors to develop?" he asks. Tatlin's path from art to technology is seen as "alien, fatiguing and wrong." Zelinsky's analysis continues:

From the philosophical depths out of which "Letatlin" is to fly, heavy, reactionary prejudices have congealed into a porridge: nature worship, terror of the machine, the adaptation of technology to the feelings of the individual, a naive faith in the "wisdom" of organic forms, an escape from the industrial world. Geometrical Constructivism, which explored the clean lines, the texture, and the spatial forms, has unexpectedly been brought together with Tatlin's own technological Khlebnikovism. . . . This is a form of technology that is based on artistic "vision," intuition, and not on the scientific vision of mathematics and computation.

Though Zelinsky's article ends with the recommendation that Tatlin's work should be put to the test, the central message is clear. The art of Tatlin is seen as a compound of the intuitive vision that he shares with Khlebnikov the futurist, and the geometrical ordering that he holds in common with the bourgeois constructivists of the West. On both counts it is worthy of condemnation.

> During the epoch of reconstruction
> technology determines everything.
> —Stalin

The existing forms used in the art of building (architecture), in technology, and above all in aviation have assumed something of a locked and schematic character. There is normally a tension between simple rectilinear forms and forms determined by the simplest curves.

In architecture, the use of curves and forms, determined by complicated curvatures created by a complicated movement by a straight line or curve, is still of a fairly primitive character; the whole thing is limited to a common section of the simplest forms. This leads to monotony in the constructive and technical solution; it shuts in the artist, as it were, in a narrow circle of accepted building materials. This is clearly reflected in projects for world-wide competitions in modern architecture. In the case of the "small forms," a little group of formal results from the past—non-objective elements—have completely dominated artistic creation, even though they were the results of primitive forms of artistic thinking: they have not developed in any more complicated manner into synthetic, vital things.

A comment. The "Constructivists," in inverted commas, also operated with material, but secondarily, for the sake of their formal

tasks, in that they mechanically attached also technology to their art. "Constructivism," in inverted commas, did not reckon in its work with the organic connection between material and concentration. In reality, it is only as a result of these dynamic relationships that a form necessary to life emerges. It is not very remarkable that the "Constructivists," in inverted commas, threw themselves upon decoration and graphic art.

Work in the field of furniture and other articles of use is only just beginning: the emergence of new cultural institutions, vital in our daily lives, institutions in which the working masses are to live, think and develop their aptitudes, demands from the artist not only a feeling for the superficially decorative but above all for things which fit the new existence and its dialectic.

The conditions of aviation (the mobility of the machines and their relationships to their environment) create gradually a greater variation of forms and construction than static technology. All this excited my attention, and caused me to make the closer acquaintance of flight.

After studies, I drew the conclusion that in the qualitative sense there really exist certain other variations of curved forms and tension in the material in this field than there do in the forms of architecture.

I believe, however, that the use of curved surfaces, and experimental work on this, are also inadequately developed.

Therefore:

1. The lack of variation in the forms (which is not in reality necessitated by technical requirements) leads to a limitation in the use of materials, to a monotonous use of materials, and creates to some extent a ready-made attitude to the cultural and material shaping of objects; this in its turn leads to monotonous solutions to the constructive tasks set.

2. An artist with experience of a variety of different materials (who, without being an engineer, has investigated the question which interests him) will inevitably see it as his duty to solve the technical problem with the help of new relationships in the material, which can offer new opportunities of concentration; he will try to discover a new, complicated form, which in its further development will naturally have to be technically refined in more detail. The artist will in his

work, as a counterpart to technology, present a succession of new relationships between the forms of the material. A series of forms determined by complicated curvatures will demand other plastic, material and constructive relationships—the artist can and must master these elements, in that his creative method is qualitatively different from that of the engineer.

The further consequences are these:

1. I have selected the flying machine as an object for artistic composition, since it is the most complicated dynamic form that can become an everyday object for the Soviet masses, as an ordinary item of use.

2. I have proceeded from material constructions of simple forms to more complicated: clothes, articles of utility in the environment—as far as an architectural work to the honour of the Comintern. The flying machine is the most complicated form in my present phase of work. It corresponds to the need of the moment for human mastery of space.

3. As a consequence of this work, I have drawn the conclusion that the artist's approach to technology can and will lend new life to their stagnating methods, which are often in contradiction with the functions of the epoch of reconstruction.

4. My apparatus is built on the principle of utilizing living, organic forms. The observation of these forms led me to the conclusion that the most aesthetic forms are the most economic. Art is: work with the shaping of the material, in this respect.

5. Work has been completed in accordance with my project. I have consulated Comrades M. A. Geyntse, surgeon, and A. V. Lsev, pilot instructor.

The apparatus has been built in the experimental scientific laboratory for "the culture of material" with the assistance of A. S. Sotnikov and J. V. Pavilionov.

VI.
The Constructive Idea
in Europe:
1930-42

MICHEL SEUPHOR: In Defense of an Architecture (1930)

In Russia the development of constructivism led very swiftly beyond the traditional genres of the plastic arts into the wider fields of planning and design for a revolutionary society. When the constructivist approach to these problems was finally discredited, there was no possibility that it might be retained and developed on a more modest level in painting and sculpture. The West, on the other hand, did not have the same relentless drive toward more socially significant forms of activity. Van Doesburg worked hard to develop the constructivist attitude in a great number of fields, but he also continued to produce work in a traditional format. Mondrian had rejected Van Doesburg's view of four-dimensionality, with its architectural implications, by 1920, and the growing reputation he gained throughout the succeeding decade accrued to him as a painter first and foremost. Partly as a result of his presence, Paris was able to reassert its position as the focus of modernist art at a time when the Bauhaus was running into serious difficulty. But if Mondrian's austere and systematic work was, in the broad sense, "constructive," it was so individual in its manner, and so essentially painterly, that it belonged on the extreme margins of the constructivist movement.

The constructive art of the 1930s, which was to center initially upon Paris, and upon Mondrian in particular, stemmed therefore from little more than a union of like-minded artists in the cubist tradition, who had no desire to submit to common "elementarist" principles and were reconciled to the fact that they had to work on a modest scale. The group they formed, which bore the title Cercle et Carré [Circle and Square], justified its existence simply through a common exhibition and a common magazine (even though both were primarily concerned

From *Cercle et Carré* (Paris), no. 1, March 15, 1930. Reprinted with permission. The translation is by Stephen Bann. Used with the permission of Michel Seuphor.

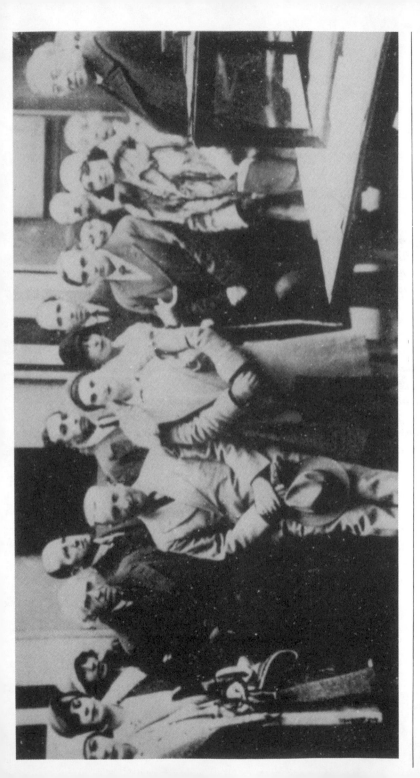

Group photograph taken at the Cercle et Carré exhibition, Paris, 1930. From left to right: Francisca Clausen, Florence Henry, Sra. Torres-García, Joaquín Torres-García, Piet Mondrian, Hans Arp, Pierra Daura, Marcelle Cahn, Sophie Taeuber-Arp, Michel Seuphor, Friedrich Vordemberge-Gildewart, Vera Idelson, Luigi Russolo, Mme. Kandinsky, Georges Vantongerloo, Wassily Kandinsky, Jean Gorin. This event was announced as the "first international exhibition of abstract art."

with allowing each individual member to express his point of view).
Although Mondrian was in a real sense the focus of the Cercle et
Carré group, he took little part in its organization. This was left prin-
cipally to the young Belgian artist Michel Seuphor (b. 1901), who was
a great admirer of Mondrian and subsequently wrote the first large
monograph on his work. Belgium had played a small but not insig-
nificant role in the development of constructivism in the 1920s, with
the architect Victor Bourgeois acting as a corresponding editor for
SA and Max Burchartz and Karel Maes joining Lissitzky, Van Does-
burg, and Richter in their "Manifesto of International Constructivism"
(1922). But Cercle et Carré was to encourage the dissolution of the
groupings of the previous decade. Paris had become the meeting point
between the predominantly northern movement of De Stijl and the
Bauhaus, and southern currents represented by the Uruguayan Torres-
García and the Italian futurist Russolo. The following piece, Seuphor's
editorial in the first issue of the magazine Cercle et Carré, *which clearly*
owes much to the theoretical writings of Mondrian, provides a suit-
ably metaphysical and nonsectarian statement of the constructive ideal,
which can have alienated none of the very disparate artists within the
group.
It is worth noting that Seuphor's concluding sentence—about being
"awake the whole night questioning the stars"—is a direct reference to
the opening of the first "Futurist Manifesto" (1909). Like Gabo and
Lissitzky, Seuphor defined his own position by contrast with that of
the futurists.

1. The different and comparative types of sensory experience form
within us, when transmitted to the brain, the inestimable certainty of
being alive. Of existing in time and space, moved by a dynamic force
that is nourished by the external world; of being a determinate wave

(Overleaf): Title page of *Cercle et Carré*, no. 1, March 15, 1930. The
first number of this magazine, under the editorship of Michel Seuphor,
appeared shortly before the exhibition held in Paris under its auspices.
With the Abstraction-Création movement, which grew out of it, Cercle
et Carré stands at the head of the development of constructive art in
the 1930s.

NUMERO 1 — 15 MARS 1930

PARAIT SIX FOIS L'AN

PRIX DE CE NUMERO : 3 FRS

ABONNEMENT :

FRANCE ET COL. : 20 FRS

ETRANGER : 30 FRANCS

RÉDACTION : M. SEUPHOR — 5 RUE KLÉBER — VANVES-SEINE (FRANCE)
ADMINISTRATION : J. TORRÉS-GARCIA — 3 RUE MARCEL SEMBAT — PARIS 18°

POUR LA DÉFENSE D'UNE ARCHITECTURE

1. Les expériences diverses et comparées de nos sens, transmises au cerveau, forment en nous l'inappréciable certitude de vivre. Exister dans l'espace et dans le temps, mû par une force dynamique intérieure qu'alimente le monde extérieur ; être une ondulation déterminée projetée sur l'écran de l'infini. A l'analyse : vague en perpétuelle transformation, répétition de continuité (fonction du branchage) ; sous un recul de synthèse : rythme simple en progression, croissance (fonction du tronc).

2. Nous sommes compris dans la nature, mais nous sommes aussi le sommet de la nature, la dernière conséquence de son évolution ; jusqu'à ce jour, et nous la résumions tout entière en nous. L'homme ne peut donc que s'appuyer à la nature et la première condition de son équilibre vital

jamais de nous, soyons heureux de cette clarté nouvelle, qui nous permet enfin de **mesurer le vrai** et d'établir les plans d'une humanité future, solidement construite avec le concours des Lois dans la volonté de l'ordre et de la paix. — Quel vide se fait tout à coup devant la misère de Dieu si évidente. Quelle tristesse. Mais c'est dans cette solitude que prend naissance la conscience de l'Etre. 8. Prenons la vie au sérieux. Non pas par un orgueil — très déplacé d'ailleurs — de vivre et de pouvoir penser, mais parce que nous pouvons concevoir la vie sur un plan plus large qui dépasse singulièrement celui de notre propre existence et de notre propre mort. S'il est certain que notre passé, même celui qui s'est à jamais effacé de notre mémoire, a fait de nous ce que nous sommes aujourd'hui et

chemin, l'homme, constructeur, s'arc-boute pour se défendre contre les rigueurs de sa sévère éducatrice. Souvent l'orgueil lui fera oublier sa descendance, mais fatalement il reviendra à celle dont il est issu, comme on reviant à une base solide, à l'unique réalité vérifiable, celle-la même où nous puisons les sources de notre grandeur. 4. Notre grandeur ? Elle n'est pas dans des gesticulations aux étoiles, ni dans l'intimité des d'eux Elle est dans la simple volonté de connaître clairement, dans la faculté de mesurer exactement les closes, de les comparer entre-elles méthodiquement et d'en tirer des conclusions types que l'esprit a la faculté de conserver sous forme d'abstractions afin de les reproduire à souhait et de les adapter utilement en toute circonstance. Notre grandeur : la conscience du travail précis de nos mains. Et cette conscience contient le secret de notre constante croissance, de notre devenir. Elle nous perm... C'approfondir en nous l'instinctif, l'intuitif, le pathétique, et d'asservir à l'esprit discipliné ces dons précieux de l'être, les canalisant vers un ordre supérieur, vers une conception constructive, supernaturelle, de la vie. 5. Un assez brusque développement de la mécanique et les grands progrès de la science tournèrent la tête à certains avant-gardistes du début de ce siècle. Aux dernières nouvelles ils décrétèrent que la machine serait mise au même rang que les divinités anciennes et ils annoncèrent que l'homme bientôt ne ferat qu'une bouchée de la nature. Quelle erreur d'enthousiasme! On a bien été forcé de se rendre compte une fois de plus que nous n'existons qu'en fonction de l'atmosphère qui nous entoure et que la nature est un cadenas sans paroles et parfois sympathique qui nous retient à la rotondité par simple compassion. Ses décisions premières restent et resteront irrévocables, quoi que l'on invente et que l'on inventera. 6. Dans un siècle prochain les conclusions ultimes ne seront pas plus heureuses qu'aujourd'hui et l'homme cherchera comme toujours un debout le mystique à l'envol de son esprit si facile à émouvoir. Mais une évolution progressive, qui nous guide malgré nous, nous aura rapproché de la compréhension de la nature dans son essence : la conscience de l'être, qui prend déjà racine en nous, remplacera par l'œuvre sainement tout aujourd'hui à elle par son expression) les « chocs d'idées » et les verbiages, qui nous sont aujourd'hui d'une si grande utilité de formation. 7. **Misère de Dieu.** Oui, il nous raconte une belle histoire, un beau mensonge (pieux) pour nous faire vivre de l'espoir de ses magnificences célestes. Mais nous ne pouvons plus être les dupes de ces belles légendes oiseuses; nous commençons lentement à ne plus être des enfants (gâtes ou non) Nous voyons clair, nous voulons maintenant avoir le courage de voir clair. Cette clarté nous apporte une déception immense, mais soyons heureux d'atteindre **la franchise**, sans laquelle **l'homme** ne naîtra

du passé, à faire l'humanité de demain et que notre œuvre, même quand son souvenir se perdra dans la nuit des temps, prendra part encore au développement spirituel de l'homme. 9. **Ce que j'entends par conscience de l'être.** C'est la lente et régulière approche de notre vrai intime fondamental, c'est la connaissance qui circonscrit le soi immuable, se resserre autour de lui pour le délimiter et pour définir minutieusement son essence. Le soi immuable (le vrai humain) est la substraction de notre via et le reflet direct du vrai universel, qui est la substraction de la nature. 10. Deux notions généralisées se partagent la nature tout entière : le beau et le vrai. Le beau, c'est la nature proprement dite telle qu'elle apparaît à nos sens ; le vrai, c'est la loi qui la régit, le principe. Il convient cependant d'ajouter que l'un peut être contenu dans l'autre, mais de façon assimilée, c'est-à-dire que le vrai contenu dans le beau devient une expression du beau et que le beau contenu dans le vrai devient une qualité du vrai. 11. Tout homme est pareillement attiré vers l'un et vers l'autre de ces deux notions du monde : d'un côté le principe, le volontaire, le vertical, de l'autre côté le naturel, le féminin, l'horizontal. Notre jugement est ainsi fait que ces deux pôles opposés l'impressionnent également. Le Beau naturel nous prend gentiment par la main et nous entraîne dans le sein de la matière, tandis que l'attirance du vrai nous incite à la pensée et nous élève à l'abstraction. Le chemin du beau est celui de l'expansion, du vivre physique : le chemin du vrai est celui de la structure et de l'évolution. 12. Vouloir réaliser directement le beau dans l'art ou dans la vie, apparaît donc comme indéfendable et d'ailleurs comme impossible. Le beau est vivant autour de nous et sur nous-mêmes, aimons-le, admirons-le, vivons avec lui en bonne entente. L'art est d'une autre évidence. Il ne peut sans s'avilir, et sans avilir le beau, établir une image de celui-ci. Il ne peut sans tricherie flagrante, c'est-à-dire sans condamner soi-même, représenter la vie, le mouvement, le naturel, le subconscient. L'art sera vrai ou il ne sera pas 13. **Parenthèse : comment nous arrivons à la connaissance du vrai.** Nous arrivons à la connaissance du vrai en observant la vie en nous et autour de nous dans ses aspects multiples. C'est en somme une reprise de l'expérience du réel, qui nous

formation projected upon the screen of the infinite. In analytic terms: a wave in perpetual transformation, a repetition of continuity (the branch function); synthetically, at one remove: simply rhythm in progression, growth (the trunk function). 2. We are a part of nature, but we are also the summit of nature, the ultimate consequence of its evolution up to this point, and we sum it up in its entirety within ourselves. Man can therefore do no other than rely on nature, and the prerequisite of his vital equilibrium is that there always should be constant harmony between the two of them. 3. Nature gives birth to man; and this man is a male, he will keep straight to his path. Man, the constructor, buttresses himself in order to ward off the rigors of his stern educator. Often his pride causes him to forget his origins, but inevitably he returns to the source from which he came, as one returns to a firm base, to the one and only verifiable reality, in which we find the springs of our greatness. 4. Our greatness? It does not consist in gesticulating at the stars, or in being close to the gods. It lies in the simple desire to have clear knowledge, in the ability to make exact measurements of things, to compare them methodically, and to draw from them general conclusions that the mind has the faculty of retaining in the form of abstractions, so that it may reproduce them at will and make good use of them in every circumstance. Our greatness: our awareness of the exact work of our hands. And this awareness holds within it the secret of our constant growth, our becoming. It enables us to intensify within ourselves the instinctive, the intuitive, the emotive, and the pathetic, and to subordinate these precious gifts of being to the trained mind, canalizing them into a superior order, into a constructive, supernatural conception of life. 5. A fairly swift development of mechanics, and great progress in the realm of science, turned the heads of some avant-garde figures of the beginning of the century. When last heard from, they decreed that the machine would occupy the same rank as the divinities of the past, and they announced that man would soon make short shrift of nature. A mistake due to excess of enthusiasm! We have certainly been forced to take account once again of the fact that we exist only in terms of the atmosphere that surrounds us, and that nature is a combination lock without a code, and of intermittent benevolence, which preserves us in a state of well-being through pure compassion. Its primal decisions remain and will continue to remain irrevocable, whatever man in-

vents or is destined to invent. 6. In future ages the ultimate conclusions will be no happier than they are today and man will continue to seek, as he has always done, a mystical release for his mind, which is so susceptible to emotion. But a progressive evolution, which guides us in spite of ourselves, will by that stage have brought us nearer to the understanding of nature in its essential aspects; the awareness of being, which is already taking root within us, will substitute the work of pure humanity (that is to say, a work that is united to nature in its principle while being opposed to nature in its expression) for those intellectual shock tactics and wordy declarations that today serve us so well in our development. 7. **God's Misery.** Yes, he tells us a fine tale, a beautiful (pious) lie, to make us live in the hope of his heavenly magnificence. But we can no longer be duped by these fine and pointless legends, we are slowly ceasing to be children (whether spoiled or not) any longer. We see clearly, we now wish to have the courage to see clearly. This clarity involves us in great disappointment, but we can rejoice in attaining that degree of **frankness,** without which **man** will never be born of us, we can be glad at this new clarity, which at last enables us to **measure the true** and to draw up plans for the future of a human race that is solidly constructed with the aid of Laws in accordance with a desire for peace and order. What a void opens up at once before God's misery in all its evidence. What a sadness. But it is in this solitude that His awareness of Being is born. 8. Let us take life seriously. Not through a pride—which is anyhow misplaced—in living and being capable of thought, but because we have the ability to conceive of life on a larger scale, going far beyond that of our own existence and our own death. If it is certain that our past, even the part that is forever wiped from our memory, has made of us what we are today and continues to have a hidden influence on all our actions—it is also certain that our efforts today contribute, together with all the activities of the past, to constituting the human race of tomorrow, and that our work, even though its memory may be lost in the mists of time, will nonetheless play its part in the spiritual development of man. 9. **What I mean by awareness of being.** It is the slow and regular movement toward our deep and innermost truth, it is the knowledge that circumscribes the immutable self, tightens around it to mark its limits and to define its essence most minutely. The immutable self (the human truth) is the

substructure of our lives and the direct reflection of the universal truth, which is the substructure of nature. 10. Two generalized notions cover between them the entire range of nature: the beautiful and the true. The beautiful is nature properly so-called, as it appears to our senses; the true is the law that regulates nature, its principle. However it should be added that the one may be contained within the other, by assimilation, with the result that the true contained within the beautiful becomes an expression of beauty and the beautiful contained within the true becomes a quality of truth. 11. Every man is equally attracted by each of these two notions of the world: on the one hand, principle, the strongly willed, the vertical; on the other the natural, the feminine, the horizontal. Our judgment is constituted in such a way that two opposite poles make an equal impression on it. Natural beauty takes us kindly by the hand and leads us into the bosom of matter, while the attraction of the true incites us to thought and elevates us to abstraction. The path of beauty is that of expansion, of life in its physical sense; the path of of truth is that of structure and evolution. 12. The desire to realize beauty directly in art or life would therefore appear to be indefensible and, moreover, impossible. Beauty is alive around us and upon us, let us love it, admire it, live on good terms with it. Art is another matter. It is incapable, without debasing itself and debasing beauty, of setting up an image of beauty. It is incapable, without flagrant cheating, that is to say, without condemning itself, of representing life, movement, the natural, and the subconscious. Art will either be true or it will not be art at all. 13. **In parentheses: how we arrive at knowledge of the true.** We arrive at knowledge of the true by observing the life within and around us in its multifarious aspects. This amounts to a restatement of the experience of reality that was brought upon us by our first certainty of being alive, but this time it is raised to a superior plane by our capacity to compare, measure, reason, and conclude. Let us therefore permit nature to work freely within us and around us, but let us keep watch on it and observe it ceaselessly so that we let slip no opportunity of catching it in the performance of its reflexes, of unexpectedly discovering the secret of its force. 14. **In defense of methodical objectivity.** The subjective present everywhere, but everywhere reduced to a minimum of authority. Never again will it have the largest say in art. The subjective reigns only in epochs of amorous

inaction, of incubation, childishness, and folly (revolution). 15. **One must belong to one's own epoch all along the line,** and of course life obliges us to do so. But it is always necessary to have the courage to carry to its final consequences at all times the immutable truth of which we have gained awareness. It is in this way that each new and specific manifestation of our age must undergo our rigorous inquiry, so that we may know what is developing within it and decide upon the attitude to take in the face of this manifestation, whether we are to place it upon the line of progress, or class it among the forces of reaction. So it is important, for example, for us to be sworn enemies of the "modernisms" of contemporary taste, which is very much the bad taste of any age, that is to say, the taste of this public which acquires more and more freedom but—through a lack of serious culture—does not know how to use this freedom, and so becomes increasingly snobbish, or is taken in by scribblers and money-makers, and becomes more and more enfeebled, in accordance with its cowardly and brutish reactions. There is in fact no possibility of seeing in this class a positive value that has the capacity to endow our age with its own distinctive mentality and the male confidence that should be thrusting it into the future. 16. In place of the romanticism of speed, which is already neutralized by habit and comfort, we put the slow pace of human awareness. In place of revolution, we put order and the will to perfection. 17. A sequel to 12. The secret harmony of nature, once it expresses itself, can result only in beauty. Given that the living beauty of nature exists only through the immutable truth of laws, and that the immutable truth exists only for the sake of the living beauty, it is impossible to attain the true by means of the beautiful that is its product, but it is inevitable that we attain the beautiful by the mere fact of expressing the true. And there is an unexpected conclusion. It is that beauty, which was not the desired goal and was indeed at first no more than an unexpected source of gratification, protects man's work and little by little becomes its principal substance. For, where knowledge and expression of the truth—I mean its vocabulary and its conventional techniques—change according to the new acquisitions of every age, surpassing and discrediting previous ones, beauty, the unwilled aesthetic of this truth, reveals itself in the work as a raw element that adapts itself to every circumstance, since it speaks directly to the senses. 18. But this last conclusion comes

about irrespective of our wishes. What is dependent on our wishes, on the other hand, is the first condition of every work: s t r u c t u r e . 19. To construct is to evaluate relationships, to calculate equivalences, to coordinate positive forces with neutralizing realities (for example, in music, sound and rhythm are positive forces; silence is the neutralizing reality), to organize all the data in such a way that unity, perfect stability is obtained. 20. It is, however, doubtful that people will ever make a work of art with figures alone. But this can indeed take place with a sensibility that is placed under the control of figures, a sensibility at once fine and robust, which our measuring capacity may canalize in its impulse toward precision in reaching an infinitesimal approximation to the indivisible unity. 21. Every work worthy of man must be verifiable, that is to say, it must carry within it its own clearly analyzable evidence. Henceforth a so-called work of art that displays only the more or less complex annotation of free sensibility or emotion (something that is particularly open to criticism and hard to regulate) will be considered as forming part of sexuality or of an infantile-pathological domain that it would be easy to set limits to. Sensual ardor, the rush of enthusiasm, the desire to shine, the blind onrush of mysticism are so many phenomena within us that form part of the animal-sexual domain. They are surface expansion, propagation, they are to be found in the basic plan (nature before man), upon which art (man), which is progression in **depth,** must establish its perpendicularity. 22. Well-governed sensibility, when it assumes an active part in us, becomes a form of right thinking or "pure reason," or again, if you wish, of our moral equilibrium. By uniting it in the work with its structural principle, we achieve what I shall call here an **architecture.** And there we have laid our finger on the entire role of the artist: 23. To establish upon the basis of a severe structure, simple and unadorned in all its parts, and according to a principle of close unity with this undisguised structure, an architecture that, by the technical and physical methods peculiar to the age, expresses in a clear language the immanent and immutable truth and reflects in its particular organization the magnificent order of the universe. 24. Music: architecture of sound, silence, time; poetry: architecture of vocable sounds, vocable rhythms with or without schematic signs of thought; sculpture and architecture properly speaking: three dimensions in space; painting: architecture of lines

and colors on a plane surface; dance: the cinematic art of geometrical movements of the human body or the manifestation of the body's stability by bringing its resilience into play. 25. We banish from us skepticism, melancholy, renunciation, and all that is associated with these impoverishing negations of the ideal. For though art is sullied by mercantile considerations, dragged in the mud by the momentary popularity, we have deep faith in its destiny. We believe that art is no longer merely baggage, but has become a part of ourselves—perhaps an encumbrance at times—with which we must reckon henceforth. And this is not a fact that needs to be studied within the realm of pathology, but one that should be inscribed among the positive acquirements that increase our intellectual capacity and enrich our activity. 26. All the same, for our cerebral hygiene and for the comfort of our moral faculties, let us reduce this element of art within us to its simplest expression, to a supple and transparent quintessence. 27. Before the Renaissance, man was an artist simply by coincidence, like a child. From the Renaissance on, awareness of art became implanted in man's brain. The role of the twentieth century will be to grasp hold of art in its clearest essence and to sweep away, without false modesty, the worn veils of mystery, which transformed it in the last century into a hallucinatory divinity of untruth and confusion. 28. Intuition may well be a very great thing in art and in life, but it is proper to allow that the exact sciences are also a very great thing: one only has to examine their credit balances. The errors committed in the name of mathematics are a result of our lack of cleverness and of genuine faults in application, while the errors committed every day in the name of intuition are entirely attributable to the latter, which has all freedom to take the wrong direction. I have no wish to sort out here the problem of whether our first source of knowledge is intuition or the direct experience of our senses. What is of primary importance for our purposes—as man exists only through and for his social milieu—is to arrive at the possibility of enunciating clearly the certainties to which man's thoughts are directed. And this task, whether it be in art, philosophy, pure mathematics, or literature, remains unalterably **a science.** A science that is not simply cold juxtaposition and classification, but also structure and copenetration of forces around the basic principle. 29. Emancipation of man through science. Emancipation of art through man. Art will no longer

be a product of the unconscious, an adventure—no matter how modern—of our animal reflexes with the support of our vices, our uncertain stance, our vain searchings, delicate expressions of so-called nuance and lyricism, of our unhealthy worries, our taste for declamation, licentious behavior, fantasies springing from haphazard invention, obscene sensuality, and spasms of delirium. Art will be subject to our desire for certitude and precision, to our strivings toward awareness of an order. Like everything that issues from our brain or from our hands, it will be examined, it will pass through an intensive control. The well-policed man will be able to dam up his low instincts, and thus make them obedient while at the same time nourishing them with a view to making wise use of their motor force. And the wild forces of primal nature within us will no longer submerge reason. Reason is in actuality the only one of our possessions not liable to depreciation, which may be fortified and safeguarded by a firm discipline. 30. **Relativities.** The time is no longer right for small gatherings of devotees and closed artistic groups. The age we are living through favors broad, productive (and generous) ideas; not stagnant ones, but ones that are capable of development and diversion into new areas. The age requires germinal ideas that carry within them the various aspects of a new, highly simplified (and at the same time very fully realized) conception of the world. That is, in daily life, just as in architecture properly so-called, we are proceeding toward a conception that is at once more supple and more solid. But the idea is within the realm of the spiritual, that is to say, of the absolute, while the realization of the idea belongs within the realm of matter, that is, the realm of accident. As a result, realization can come only more or less, or very relatively, close to the idea-thought. The tragedy of the idea is that it cannot exist without its intrinsic will toward realization. Just as the idea derives from the existence of the existing reality, and forms a spiritual quintessence of the real through the figures of thought, so every human realization exists in terms of the idea that has conceived it, but, in contradiction to the idea, it develops in a different milieu (the physical milieu) and is directed toward different ends. In such a way that when the idea and its realization come face to face (the latter in its most immediate or most perfect phase), one might conclude with the man in the street, that memorable poet, that the one gives only a very poor idea of the other. 31. We cannot de-

cipher the deep reasons in accordance with which an object is in certain respects different from another object. The physical existence of every object and of each of the parts of the object is determined by an unpredictable infinity of events, concurrent influences, monopolizing forces, and accidents. But while we cannot act efficaciously on what it is that separates things, we are at least able to determine, study, and subsequently make use of the forces of attraction that connect things among themselves, the primal truths that arrange them in order and unity within the same principle, the same law. By this path, we approach closer to the universal, the absolute. All forms of progress go under this sign. 32. The progress of humanity—there is the idea that preoccupies those of us who have enough breath and enough health to welcome an ideal whose breadth reduces to almost nothing the level of our individual existence, while at the same time offering a new and nobler significance to our humble everyday reality. For despite our vanity, our derisory egoism, and our pitiful hunger for glory, we do not live for ourselves. An object exists only **in relation** to another object, and man is conceivable only as a social being. 33. **Let me sum up.** Architecture = structure, solidity, precision, straight lines, clarity, discipline, repose, order, simplicity of elements, confidence in the real, actual knowledge of reality, awareness of human possibilities and limitations. Architecture = distrust of distortion, fanciful invention, the vague and the mysterious, for lousy execution, for systematic ugliness, for snobbish styles, for lack of consciousness and lack of control. Architecture is not limited to protest; it constructs with confidence, it establishes certainties. We are readopting this idea, which is not new, in a gesture of faith and with a view to contributing toward its crystallization in the world of today. 34. Either we are forced to conclude that for several years the straight line of evolution toward purity, wholesome strength, and simplification has been increasingly deserted in favor of a free-for-all and depravity of taste; that the public, having been led astray and remaining ignorant of the true subjects of today, of the positive essence of our age and its intrinsic value in relation to the dusty notions and so-called modern works that leave the hands of their "creators" in an already rotten condition, or the public is coming to the point of believing in the whole range of mere histrionics, demagogy, and political imposture and of condemning as childish, lamen-

table, decorative, insufficient, and out of date that which does in fact carry the imprint of an enlightened awareness, a work of integrity and a frank desire for good (by good I mean that which is open to the light and is found under the sign of peace) . . . a few of us have grouped ourselves around this basis, which remains unshakable, of **structure,** not to propagate this idea by revolutionary vociferation, but simply to study its principle, to consolidate it within us, to bring it to a fine point, and finally to display it in full view for the benefit of all. 35. **For** all that is rational. **Against** disorder of whatever kind, since disorder gives rise only to more disorder. (It is perfectly easy to imagine a revolution without romantic gesticulation, without recourse to brute force: a superior order methodically and irresistibly supplanting an inferior order: a revolution that is not social **war** but a phase in **the evolution** of the world.) 36. The safeguarding of peace through order is both a profession of faith and a final goal. Order and peace represent the heaven that we wish for and may realize over and beyond the nervous tension of our everyday life, our useless anxieties, our passions, our irrational enthusiasms, our narrow egoism; it is the horizontal line of the sea that is not disturbed, even in bad weather, by the detail of waves and spray; it is the fundamental principle and the deep schema (I might say, the soul) of the universe, when we try to envisage it beyond time and space; 37. and it is, with more immediate relevance to us, a will toward proportion, clarity, simplification, the abolition of the subject, the dismissal of the private and pretentious little idea in favor of a stability, a rhythm, a method, in a word, it is the attempt to achieve by awareness and reasoning—that is to say, in a scientifically verifiable manner—an infinitesimal approximation to the immanent and universal truth, quite independent of fortuitous circumstances and mere chance. 38. Structure is the innermost truth of all that exists. It has therefore always been indispensable in the work of art. Before the motor, the horse **symbolized** speed and strength. Order and rhythm are now no longer a substructure, no longer taken for granted: they have become the object itself, which realizes **in itself,** that is to say, synthetically, the speed and strength of the horse. What was a means becomes the object itself. What in other times was obscurely hidden beneath the graceful but mysterious forms of nature becomes for us a clear and everyday reality. What in other great periods of art was an almost

magical contribution, whose benefits could be seen in the work but could not be grasped in its own entity, can now be found ready to hand. We are becoming familiar with the true, we are penetrating it. Alchemy and obscure science gives way to open awareness. **Abstraction** of the real world, the world's mathematical and architectonic secret, becomes the **substantial** nourishment of our cerebral world. Yes indeed. The clear liquid no longer lies at the bottom of secret cellars: it shines in our glasses and beckons to us. 39. There are some who are announcing the new day, who can see the dawn rise before the others. Have they not, these people, been awake the whole night questioning the stars?

CARLSUND, VAN DOESBURG, HÉLION, TUTUNDJIAN, *and* WANTZ: The Basis of Concrete Painting (1930)

Theo van Doesburg, who by 1930 had taken up residence in Meudon, close to Paris, was bitterly opposed to the creation of the Cercle et Carré group, which had attracted his architectural collaborator Arp as well as previous contributors to De Stijl, such as Mondrian, Vantongerloo, and Vordemberge-Gildewart. In the month of the Cercle et Carré exhibition at Galerie 23, he published his own manifesto in collaboration with four other artists. The term "concrete" ("concret," "konkrete") had been used before in an artistic context by Max Burchartz, a cosignatory of the "Manifesto of International Constructivism" and contributor to De Stijl. But Van Doesburg may be said to have launched the term with this abrupt and incisive manifesto. By 1945 "concrete" had acquired general currency as a designation for nonfigurative art, as was established at an exhibition in the Galerie Drouin, Paris, which placed works by Arp, Kandinsky, Mondrian, Pevsner, Van Doesburg, and others under the heading "Art Concret."

From *Art Concret* (Paris), April 1930. The translation is by Stephen Bann.

ART CONCRET

GROUPE ET REVUE FONDÉS EN 1930 A PARIS

PREMIÈRE ANNÉE-NUMÉRO D'INTRODUCTION-AVRIL MIL NEUF CENT TRENTE

BASE DE LA PEINTURE CONCRÈTE

Nous disons :

1° L'art est universel.

2°. L'œuvre d'art doit être entièrement conçue et formée par l'esprit avant son exécution. Elle ne doit rien recevoir des données formelles de la nature, ni de la sensualité, ni de la sentimentalité.
Nous voulons exclure le lyrisme, le dramatisme, le symbolisme, etc.

3° Le tableau doit être entièrement construit avec des éléments purement plastiques, c'est-à-dire plans et couleurs. Un élément pictural n'a pas d'autre signification que «lui-même» en conséquence le tableau n'a pas d'autre signification que «lui-même».

4° La construction du tableau, aussi bien que ses éléments, doit être simple et contrôlable visuellement.

5° La technique doit être mécanique c'est-à-dire exacte, anti-impressionniste.

6° Effort pour la clarté absolue.

Carlsund, Doesbourg, Hélion, Tutundjian, Wantz.

1

Cover of *Art Concret*, April 1930.

EXISTE-T-IL UNE POESIE CONSTRUCTIVE?

From *Art Concret,* April 1930. Van Doesburg's open question ("Is there a constructive poetry?") provides a wry postscript to the manifesto of seven years earlier (p. 109).

Yet the success of the term "concrete," which appealed to many artists who refused to consider their work "abstract," was due only in part to Van Doesburg and the group he founded in 1930. Van Doesburg himself died in March 1931, while Tutundjian and Wantz soon gave up painting and disappeared from the artistic scene. Otto Gustav Carlsund also abandoned painting for many years; Jean Hélion (b. 1904) alone of the original group continued as an artist throughout the 1930s. It was the adoption of the term by Max Bill in 1936 and subsequently by Hans Arp that gave it continued viability throughout the later period.

The manifesto of 1930 is, in effect, as significant for what it excludes as for its contribution to the future. In contrast to his earlier statements, Van Doesburg directs attention exclusively toward the traditional genre of painting and so tacitly admits that the constructivist program is no longer applicable.

We declare:
1. Art is universal.
2. The work of art must be entirely conceived and formed by the mind before its execution. It must receive nothing from nature's given forms, or from sensuality, or from sentimentality.
 We wish to exclude lyricism, dramaticism, symbolism, etc.
3. The picture must be entirely constructed from purely plastic elements, that is, planes and colors. A pictorial element has no other meaning than "itself" and thus the picture has no other meaning than "itself."
4. The construction of the picture, as well as its elements, must be simple and visually controllable.
5. Technique must be mechanical, that is, exact, anti-impressionistic.
6. Effort for absolute clarity.

Joaquín Torres-García: The Constructive Art Group —Joint Collaborative Work (1933)

Joaquín Torres-García was born in Montevideo, Uruguay, in 1874, of a Catalan father and a Uruguayan mother. He had already made a reputation as an artist in Europe before the First World War, and in 1930 he undertook the general administration of the Cercle et Carré group and magazine with Seuphor. Later, as the following manifesto suggests, he was influential in carrying constructive art to Spain. And finally he returned to his native Uruguay, where he exhibited and published on a wide scale. In his manifesto "The Abstract Rule," dated February 5, 1946, he looked forward to the birth of "a virgin and powerful art" in the New World, away from the "Babel of Europe." The remarkable development of concrete and kinetic art in South America, which can be traced to such groups as Arturo, Arte Concreto, and Madí in postwar Argentina, owes a great deal to his example.

—With every contemporary work of art
—it is possible to say what is and what is not in harmony with the
moment of evolution.
—Bearing in mind that each period or full cycle
—passes, chronologically,
—through certain phases,
—it is possible to predict
—at any given moment
—the phase which must come next
—and therefore

From *Guiones* (Madrid), no. 3, July 30, 1933. Reprinted with the permission of Horatio Torres-García and Mrs. Manolita P. de Torres-García. All rights reserved. This new translation is by Ruth Brandon.

—to determine
—whether this or that work
—or movement
—is on the right lines or not.
—Not all peoples advance at the same pace
—and very different phases and cycles of civilization can exist at the
same moment
—therefore
—it will always be hard to decide
—truly
—which may be the particular one that marks the process of evo-
lution.
—Anyway,
—to generalize,
—we can now say this,
—historically speaking:
—we are now in the agony
—(agony because it hurts
—and because it marks the end of a great epoch)
—in which a romantic ideal of individualism is fading away
—(an individualism that has taken every shape imaginable)
—and
—we can now see
—(inside it)
—without much difficulty
—a nucleus or seed
—(which is already formed)
—of what the reaction will be
—(an opposite stand)
—and that
—despite all the efforts of those who would like to delay the fall of
this dying epoch
—it will grow and impose itself
—irreversibly:
—by the law of epochs.
—Without losing his personality
—(in the society of the future)
—the individual

—as individual
—as individual-center
—will count less
—or won't count at all;
—on the other hand
—he will count in the totality
—and
—as an indispensable element.
—That time is still far off
—since before then
—inescapably
—he must pass through a phase
—based on material things
—as is becoming increasingly apparent:
—the modern barbarism of the pseudo-civilized.
—Then let us go on
—though not immediately
—toward a constructive
—and superclassical epoch.
—Order
—moderation
—rule
—(very objective)
—will be
—in the future
—(and should be as of now)
—the course that Art sets for itself.
—To clarify even this
—let us try an exercise in the Pythagorean style:
—supposing everything observes a harmonic relation
—let us suppose
—as others have thought and said
—that
—between the life of man and the life of the world
—a relation exists
—so that
—each day of a man's life
—corresponds with a year in the life of our planet

—and each year
—to a century
—and so on always in the same proportion;
—let us suppose also
—that the phases through which a man's life passes
—are the same as those through which the Earth has already passed.
—From these calculations
—it would seem
—that our world is still very young
—no more,
—proportionately,
—than nineteen years old:
—that is to say
—the age that psychologists tell us is an age of reflection;
—the age when reason begins to dominate our instincts and fantasies;
—the beginning
—therefore
—(and only the beginning)
—of a constructive period
—which must come
—as has already been explained
—and as with earlier historical periods
—through various phases of development;
—barbaric to begin with
—(but always—now—within the constructive tendency)
—with an integral materialism;
—romantic next
—(but still with a constructive base—and so on another level of
 romanticism)
—so that
—still in a far-off time
—a superclassicism may arrive;
—the age of maturity of the world
—the era of plenty;
—the realization of that arcane idea of Man
—which must then become apparent
—with supreme clarity.
—It is, then,

—easy
—given these elements
—(more or less correct)
—to establish a criterion
—and to see
—which men
—and which works
—stand
—or do not stand
—in the rhythm fixed by time.
—The work of art that corresponds with our time
—will be
—by these calculations or guesses
—a *concrete realism* (figurative or otherwise)
—(that's to say
—not an imitative impressionism)
—and
—of course
—with *a constructive base.*
—The time that is coming
—rather than one of synthesis
—will be one of analysis
—(even though we are
—as we are
—in a spirit of synthesis—and cubism was an anticipation of that)
—a time of dissection
—of free will, of certainty, and of conscience
—(always through the spirit of synthesis).
—An age at the same time geometric
—(rabidly antinaturalist)
—in which the *concrete* will form the base of the plastic laws.
—This tendency will meet with great resistance;
—men don't like change
—and
—what is more
—the vested interests are against it;
—therefore
—the atmosphere will hardly be one in which to develop and prosper.

—Signs can be seen of all these things
—dotted about:
—incipient movements that lose their footing and disappear in con-
fusion . . .
—struggles
—reactions and counterreactions
—which reveal the profound crisis of this moment of transition.

JEAN GORIN: The Aim of Constructive Plastic Art (1936)

There were only three issues of the magazine Cercle et Carré, *though Torres-García produced a successor,* Círculo y Cuadrado, *in Montevideo from May 1936 to September 1938. In Paris, the deficiency was supplied by the founding of a longer-lived organ,* Abstraction-Création—Art Non-Figuratif, *which lasted from 1932 to 1936 and attracted many of the members of the previous grouping, with a total membership that approached four hundred. It appeared as a yearly almanac and sponsored frequent exhibitions. Although Auguste Herbin and Vantongerloo were the formal directors of* Abstraction-Création, *they did not lay down a prescriptive policy for the group or even employ the editorial voice. The organization flourished not because of vigorous direction, but because virtually every nonfigurative artist of note—Mondrian, Kandinsky, Gabo, and Arp included—either lived in Paris or looked toward Paris at this period. This was particularly so after the closing of the Bauhaus in 1933.*

Jean Gorin, who was born at Saint-Emilien-Blain, France, in 1899, was a prominent member of the group, and helped to edit the last

From *Abstraction-Création* (Paris), no. 5, 1936. The translation is by Stephen Bann. Used by permission of Jean Gorin.

number of the almanac in 1936. He had begun to work in the neo-plastic tradition in 1926 and was perhaps the first artist of this tendency to devote particular attention to relief constructions. After the Second World War, he participated in setting up the Salon des Réalités Nouvelles.

In the passage that follows, Gorin draws attention once again to the "fundamentally architectural" nature of constructive art, although he recognizes the futility of such a concern in the contemporary political situation.

The aim pursued by the new constructive plastic art is not an individualistic one. It is not an ivory-tower art, as people might be tempted to suppose at first glance. On the contrary, the bases of this new plastic art are deeply rooted in the new age through which we are living, an age of great economic and social upheaval, of the reign of science, collectivism, and universalism.

Art has evolved parallel to science, and today a purely constructive aesthetic has been created, one free from the figurative formalism of the past; an abstract plastic art, based on universal values, and on precise, mathematical laws.

This new aesthetic is capable in addition of giving complete expression to the equilibrium of body and mind and of universal and individual, to what is abstract and what is profoundly real, to the human quality that is sufficiently developed in every man.

Purely constructive plastic art is fundamentally architectural; it is the higher function of all genuine architecture. In and through architecture it attains its fullest expression, forming a *unity* with her. Thus an environment is created that is adapted to the development of collective life and favorable to the fullest flowering of the man of modern times. Throughout the tragic phase of the evolution that we are now experiencing, the new plastic art—still dominated by individualism and anarchy—is forced to manifest itself in the form of objects, pictures, or sculptures, while awaiting social conditions that will enable it to be fully developed in the context of everyday life. And so, in spite of everything, though it is kept within these limits, the new plastic art continues all the same to propagate the new beauty among mankind, and assists in man's liberation by revealing to him the *unity,* the *universality* that is within him.

Jean Gorin: *Relations of Volumes in Space,* 1930.

From *Circle—International Survey of Constructive Art* (1937)

The vorticist movement in Britain did not survive the First World War, and in the following decade British artists took no part whatsoever in the activity that centered upon Russian constructivism, De Stijl, and the Bauhaus. A partial exception might be made for architectural opinion, since Morton Shand did much to publicize the new developments in the Architectural Review *and* The Concrete Way.

After 1930, the situation changed rapidly. A convincing sign was the founding in 1933 of Unit 1, which included among its members Barbara Hepworth, Henry Moore, and Ben Nicholson, as well as a more romantic and surrealistic wing grouped around Paul Nash. Ben Nicholson, in particular, became interested in contemporary developments in France and joined the Abstraction-Création group. However, the real stimulus to constructive art in Britain came from the presence of Gabo, who participated in the "Abstract and Concrete" exhibition at the Lefèvre Gallery, London, in 1936 and shortly afterward took up residence in London. In 1937 Gabo collaborated with Ben Nicholson and the young architect J. L. Martin in editing Circle, *an "international survey of constructive art."*

The ethos of Circle *was entirely opposed to the materialism of Russian constructivism, and indeed to the elementarism of Van Doesburg. In his introductory article on "The Constructive Idea in Art," Gabo reaffirmed his faith in "the creative human genius" and suggested that the immediate task of the constructive artist was to influence the "state of mind" of society, as a result of which material transformations would follow as a matter of course. The anthology was equally balanced between sections on painting, on sculpture, and on architecture, and a final group of articles on the theme "Art and Life" that included Gropius on "Art Education," Massine on "Choreography," Moholy-Nagy on "Light Painting," and Tschichold on "The New Typography."*

202

Editorial

A new cultural unity is slowly emerging out of the fundamental changes which are taking place in our present-day civilization; but it is unfortunately true that each new evidence of creative activity arouses a special opposition, and this is particularly evident in the field of art. The inaccessibility of certain branches of science at least relieves the scientist from outside interference: the obvious utility of other advances gives the technician more or less freedom—it is not, of course, difficult to recall several far-reaching innovations which the public has shown itself willing to accept. But the creative work of the artist, for which it is difficult to claim any of the more practical virtues, is never free from interference in one form or another. Even a new development in architecture where it is certainly possible to show an advance in efficiency and economy of means, will not necessarily find itself applauded when it becomes clear that architecture, in changing its means, must also change its formal appearance.

It is indeed fair to say, that popular taste, caste prejudice, and the dependence upon private enterprise, completely handicap the development of new ideas in art. But, in spite of this, the ideas represented by the work in this book have grown spontaneously in most countries of the world. The fact that they have, in the course of the last twenty years, become more crystallized, precise, and more and more allied to the various domains of social life, indicates their organic growth in the mind of society and must prove that these creative activities cannot be considered as the temporary mood of an artistic sect, but are, on the contrary, an essential part of the cultural development of our time.

In starting this publication we have a dual purpose; firstly, to bring

From *Circle—International Survey of Constructive Art,* edited by J. L. Martin, Ben Nicholson, and N. Gabo (London: Faber and Faber, 1937). Reprinted by permission of Praeger Publishers, Inc., and Faber and Faber Ltd.

this work before the public, and secondly, to give to artists—painters, sculptors, architects and writers—the means of expressing their views and of maintaining contact with each other. Our aim is to gather here those forces which seem to us to be working in the same direction and for the same ideas, but which are, at the moment scattered, many of the individuals working on their own account and lacking any medium for the interchange of ideas.

Finally, this publication is not intended to be merely an impartial and disinterested survey of every kind of modern art. At the same time, we have no intention of creating a particular group circumscribed by the limitations of personal manifestos: the combined range of contributors represented here is a large one. We have, however, tried to give this publication a certain direction by emphasising, not so much the personalities of the artists as their work, and especially those works which appear to have one common idea and one common spirit: the constructive trend in the art of our day. By placing this work side by side we hope to make clear a common basis and to demonstrate, not only the relationship of one work to the other but of this form of art to the whole social order.

Naum Gabo: The Constructive Idea in Art

Our century appears in history under the sign of revolutions and disintegration. The revolutions have spared nothing in the edifice of culture which had been built up by the past ages. They had already begun at the end of the last century and proceeded in ours with unusual speed until there was no stable point left in either the material or the ideal structure of our life. The war was only a natural consequence of a disintegration which started long ago in the depths of the previous civilization. It is innocent to hope that this process of

From *Circle—International Survey of Constructive Art,* edited by J. L. Martin, Ben Nicholson, and N. Gabo (London: Faber and Faber, 1937). Reprinted by permission of Praeger Publishers, Inc., and Faber and Faber Ltd.

disintegration will stop at the time and in the place where we want it to. Historical processes of this kind generally go their own way. They are more like floods, which do not depend on the strokes of the oarsmen floating on the waters. But, however long and however deep this process may go in its material destruction, it cannot deprive us any more of our optimism about the final outcome, since we see that in the realm of ideas we are now entering on the period of reconstruction.

We can find efficient support for our optimism in those two domains of our culture where the revolution has been the most thorough, namely, in Science and in Art. The critical analysis in natural science with which the last century ended had gone so far that at times the scientists felt themselves to be in a state of suspension, having lost most of the fundamental bases on which they had depended for so many centuries. Scientific thought suddenly found itself confronted with conclusions which had before seemed impossible, in fact the word "impossibility" disappeared from the lexicon of scientific language. This brought the scientists of our century to the urgent task of filling up this emptiness. This task now occupies the main place in all contemporary scientific works. It consists in the construction of a new stable model for our apprehension of the universe.

However dangerous it may be to make far-reaching analogies between Art and Science, we nevertheless cannot close our eyes to the fact that at those moments in the history of culture when the creative human genius had to make a decision, the forms in which this genius manifested itself in Art and in Science were analogous. One is inclined to think that this manifestation in the history of Art lies on a lower level than it does in the history of Science, or at least on a level which is accessible to wider social control. The terminology of Science alone plunges a layman into a state of fear, humility and admiration. The inner world of Science is closed to an outsider by a curtain of enigmas. He has been educated to accept the holy mysticism of these enigmas since the beginning of culture. He does not even try to intrude in this world in order to know what happens there, being convinced that it must be something very important since he sees the results in obvious technical achievements. The average man knows, for instance, that there is electricity and that there is radio and he uses them every day. He knows the names of Marconi and Edison, but it is doubtful whether he has ever heard anything about the scien-

tific work of Hertz, and there is no doubt that he has never heard anything about the electro-magnetic waves theory of Maxwell or his mathematical formulae.

Not so is the attitude of the average man to Art. Access to the realm of Art is open to every man. He judges about Art with the unconstrained ease of an employer and owner. He does not meditate about those processes which brought the artist or the group of artists to make one special kind of Art and not another, or if occasionally he does he never relinquishes his right to judge and decide, to accept or reject; in a word, he takes up an attitude which he would never allow himself to take with Science. He is convinced that on his judgments depend the value and the existence of the work of art. He does not suspect that through the mere fact of its existence a work of art has already performed the function for which it has been made and has affected his concept of the world regardless of whether he wants it to or not. The creative processes in the domain of Art are as sovereign as the creative processes in Science. Even for many theorists of Art the fact remains unperceived that the same spiritual state propels artistic and scientific activity at the same time and in the same direction.

At first sight it seems unlikely that an analogy can be drawn between a scientific work of, say, Copernicus and a picture by Raphael, and yet it is not difficult to discover the tie between them. In fact Copernicus' scientific theory of the world is coincident with Raphael's concept in Art. Raphael would never have dared to take the naturalistic image of his famous Florentine pastry-cook as a model for the "Holy Marie" if he had not belonged to the generation which was already prepared to abandon the geocentrical theory of the universe. In the artistic concept of Raphael there is no longer any trace of the mythological religious mysticism of the previous century as there is no longer any trace of this mysticism in Copernicus' book, *The Revolution of the Celestial Orbits*. In the work of both, the earth is no longer the cosmic centre and man is no longer the crown of creation and the only hero of the cosmic drama; both are parts of a larger universe and their existence does not any more appear as the mystical and dematerialized phenomenon of the mediaeval age. At that time one and the same spirit governed the artistic studios of Florence and held sway under the arches of the Neapolitan Academy for the Empirical Study

of Nature led by Telesio. This tie between Science and Art has never ceased to exist throughout the history of human culture, and we can discern it in whatever section of history we look. This fact explains many phenomena in the spiritual processes of our own century which brought our own generation to the Constructive idea in Art.

The immediate source from which the Constructive idea derives is Cubism, although it had almost the character of a repulsion rather than an attraction. The Cubistic school was the summit of a revolutionary process in Art which was already started by the Impressionists at the end of the last century. One may estimate the value of particular Cubistic works as one likes, but it is incontestable that the influence of the Cubistic ideology on the spirits of the artists at the beginning of this century has no parallel in the history of Art for violence and intrepidity. The revolution which this school produced in the minds of artists is only comparable to that which happened at approximately the same time in the world of physics. Many falsely assume that the birth of Cubistic ideology was caused by the fashion for negro art which was prevalent at that time; but in reality Cubism was a purely European phenomenon and its substance has nothing in common with the demonism of primitive tribes. The Cubistic ideology has a highly differentiated character and its manifestation could only be possible in the atmosphere of a refined culture. In fact it wants an especially sharpened and cultivated capacity for analytic thought to undertake the task of revaluation of old values in Art and to perform it with violence as the Cubistic school did. All previous schools in Art have been in comparison merely reformers, Cubism was a revolution. It was directed against the fundamental basis of Art. All that was before holy and intangible for an artistic mind, namely, the formal unity of the external world, was suddenly laid down on their canvases, torn in pieces and dissected as if it were a mere anatomical specimen. The borderline which separated the external world from the artist and distinguished it in forms of objects disappeared; the objects themselves disintegrated into their component parts and a picture ceased to be an image of the visible forms of an object as a unit, a world in itself, but appeared as a mere pictural analysis of the inner mechanism of its cells. The medium between the inner world of the artist and the external world has lost its extension, and between the inner world of the perceptions of the artist and the outer world of

existing things there was no longer any substantial medium left which could be measured either by distance or by mind. The contours of the external world which served before as the only guides to an orientation in it were erased; even the necessity for orientation lost its importance and was replaced by other problems, those of exploration and analysis. The creative act of the Cubists was entirely at variance with any which we have observed before. Instead of taking the object as a separate world and passing it through his perceptions producing a third object, namely the picture, which is the product of the first two, the Cubist transfers the entire inner world of his perceptions with all its component parts (logic, emotion and will) into the interior of the object penetrating through its whole structure, stretching its substance to such an extent that the outside integument explodes and the object itself appears destroyed and unrecognizable. That is why a Cubistic painting seems like a heap of shards from a vessel exploded from within. The Cubist has no special interest in those forms which differentiate one object from another.

Although the Cubists still regarded the external world as the point of departure for their Art they did not see and did not want to see any difference between, say, a violin, a tree, a human body, etc. All those objects were for them only one extended matter with a unique structure and only this structure was of importance for their analytic task. It is understandable that in such an artistic concept of the world the details must possess unexpected dimensions and the parts acquire the value of entities, and in the inner relations between them the disproportion grows to such an extent that all inherited ideas about harmony are destroyed. When we look through a Cubistic painting to its concept of the world the same thing happens to us as when we enter the interior of a building which we know only from a distance—it is surprising, unrecognizable and strange. The same thing happens which occurred in the world of physics when the new Relativity Theory destroyed the borderlines between Matter and Energy, between Space and Time, between the mystery of the world in the atom and the consistent miracle of our galaxy.

I do not mean to say by this that these scientific theories have affected the ideology of the Cubists, one must rather presume that none of those artists had so much as heard of or studied those theories. It is much more probable that they would not have apprehended them

even if they had heard about them, and in the end it is entirely super-
fluous. The state of ideas in this time has brought both creative dis-
ciplines to adequate results, each in its own field, so that the edifice of
Art as well as the edifice of Science was undermined and corroded by
a spirit of fearless analysis which ended in a revolutionary explosion.
Yet the destruction produced in the world of Art was more violent
and more thorough.

Our own generation found in the world of Art after the work of
the Cubists only a conglomeration of ruins. The Cubistic analysis had
left for us nothing of the old traditions on which we could base even
the flimsiest foundation. We have been compelled to start from the
beginning. We had a dilemma to resolve, whether to go further on
the way of destruction or to search for new bases for the foundation
of a new Art. Our choice was not so difficult to make. The logic of
life and the natural artistic instinct prompted us with its solution.

The logic of life does not tolerate permanent revolutions. They are
possible on paper but in real life a revolution is only a means, a tool
but never an aim. It allows the destruction of obstacles which hinder
a new construction, but destruction for destruction's sake is contrary
to life. Every analysis is useful and even necessary, but when this
analysis does not care about the results, when it excludes the task of
finding a synthesis, it turns to its opposite, and instead of clarifying
a problem it only renders it more obscure. Life permits to our desire
for knowledge and exploration the most daring and courageous ex-
cursions, but only to the explorers who, enticed far away into un-
known territories, have not forgotten to notice the way by which they
came and the aim for which they started. In Art more than anywhere
else in the creative discipline, daring expeditions are allowed. The
most dizzying experiments are permissible, but even in Art the logic
of life arrests the experiments as soon as they have reached the point
when the death of the experimental objects becomes imminent. There
were moments in the history of Cubism when the artists were pushed
to these bursting points; sufficient to recall the sermons of Picabia,
1914–16, predicting the wreck of Art, and the manifestos of the
Dadaists who already celebrated the funeral of Art with chorus and
demonstrations. Realizing how near to complete annihilation the
Cubist experiments had brought Art, many Cubists themselves have
tried to find a way out, but the lack of consequence has merely made

them afraid and has driven them back to Ingres (Picasso, 1919–23) and to the Gobelins of the sixteenth century (Braque, etc.). This was not an outlet but a retreat. Our generation did not need to follow them since it has found a new concept of the world represented by the Constructive idea.

The Constructive idea is not a programmatic one. It is not a technical scheme for an artistic manner, nor a rebellious demonstration of an artistic sect; it is a general concept of the world, or better, a spiritual state of a generation, an ideology caused by life, bound up with it and directed to influence its course. It is not concerned with only one discipline in Art (painting, sculpture or architecture) it does not even remain solely in the sphere of Art. This idea can be discerned in all domains of the new culture now in construction. This idea has not come with finished and dry formulas, it does not establish immutable laws or schemes, it grows organically along with the growth of our century. It is as young as our century and as old as the human desire to create.

The basis of the Constructive idea in Art lies in an entirely new approach to the nature of Art and its functions in life. In it lies a complete reconstruction of the means in the different domains of Art, in the relations between them, in their methods and in their aims. It embraces those two fundamental elements on which Art is built up, namely, the Content and the Form. These two elements are from the Constructive point of view one and the same thing. It does not separate Content from Form—on the contrary, it does not see as possible their separated and independent existence. The thought that Form could have one designation and Content another cannot be incorporated in the concept of the Constructive idea. In a work of art they have to live and act as a unit, proceed in the same direction and produce the same effect. I say "have to" because never before in Art have they acted in such a way in spite of the obvious necessity of this condition. It has always been so in Art that either one or the other predominated, conditioning and predetermining the other.

This was because in all our previous Art concepts of the world a work of art could not have been conceived without the representation of the external aspect of the world. Whichever way the artist presented the outside world, either as it is or as seen through his personal perceptions, the external aspect remained as the point of de-

parture and the kernel of its content. Even in those cases where the artist tried to concentrate his attention only on the inner world of his perceptions and emotions, he could not imagine the picture of this inner world without the images of the outer one. The most that he could dare in such cases was the more or less individual distortions of the external images of Nature; that is, he altered only the scale of the relations between the two worlds, always keeping to the main system of its content, but did not attack the fact of their dependence; and this indestructible content in a work of art always predicted the forms which Art has followed down to our own time.

The apparently ideal companionship between Form and Content in the old Art was indeed an unequal division of rights and was based on the obedience of the Form to the Content. This obedience is explained by the fact that all formalistic movements in the history of Art, whenever they appeared, never went so far as to presume the possibility of an independent existence of a work of art apart from the naturalistic content, nor to suspect that there might be a concept of the world which could reveal a Content in a Form.

This was the main obstacle to the rejuvenation of Art, and it was at this point that the Constructive idea laid the cornerstone of its foundation. It has revealed an universal law that the elements of a visual art such as lines, colours, shapes, possess their own forces of expression independent of any association with the external aspects of the world; that their life and their action are self-conditioned psychological phenomena rooted in human nature; that those elements are not chosen by convention for any utilitarian or other reason as words and figures are, they are not merely abstract signs, but they are immediately and organically bound up with human emotions. The revelation of this fundamental law has opened up a vast new field in art giving the possibility of expression to those human impulses and emotions which have been neglected. Heretofore these elements have been abused by being used to express all sorts of associative images which might have been expressed otherwise, for instance, in literature and poetry.

But this point was only one link in the ideological chain of the constructive concept, being bound up with the new conception of Art as a whole and of its functions in life. The Constructive idea sees and values Art only as a creative act. By a creative act it means every

material or spiritual work which is destined to stimulate or perfect the substance of material or spiritual life. Thus the creative genius of Mankind obtains the most important and singular place. In the light of the Constructive idea the creative mind of Man has the last and decisive word in the definite construction of the whole of our culture. To be sure, the creative genius of Man is only a part of Nature, but from this part alone derives all the energy necessary to construct his spiritual and material edifice. Being a result of Nature it has every right to be considered as a further cause of its growth. Obedient to Nature, it intends to become its master; attentive to the laws of Nature it intends to make its own laws, following the forms of Nature it re-forms them. We do not need to look for the origin of this activity, it is enough for us to state it and to feel its reality continually acting on us. Life without creative effort is unthinkable, and the whole course of human culture is one continuous effort of the creative will of Man. Without the presence and the control of the creative genius, Science by itself would never emerge from the state of wonder and contemplation from which it is derived and would never have achieved substantial results. Without the creative desire Science would go astray in its own schemes, losing its aim in its reasoning. No criterion could be established in any spiritual discipline without this creative will. No way could be chosen, no direction indicated without its decision. There are no truths beyond its truths. How many of them life hides in itself, how different they are and how inimical. Science is not able to resolve them. One scientist says, "The truth is here"; another says, "It is there"; while a third says, "It is neither here nor there, but somewhere else." Everyone of them has his own proof and his own reason for saying so, but the creative genius does not wait for the end of their discussion. Knowing what it wants, it makes a choice and decides for them.

The creative genius knows that truths are possible everywhere, but only those truths matter to it which correspond to its aims and which lie in the direction of its course. The way of a creative mind is always positive, it always asserts; it does not know the doubts which are so characteristic of the scientific mind. In this case it acts as Art.

The Constructive idea does not see that the function of Art is to represent the world. It does not impose on Art the function of Science. Art and Science are two different streams which rise from the same

creative source and flow into the same ocean of the common culture, but the currents of these two streams flow in different beds. Science teaches, Art asserts; Science persuades, Art acts; Science explores and apprehends, informs and proves. It does not undertake anything without first being in accord with the laws of Nature. Science cannot deal otherwise because its task is knowledge. Knowledge is bound up with things which are and things which are, are heterogeneous, changeable and contradictory. Therefore the way to the ultimate truth is so long and difficult for Science.

The force of Science lies in its authoritative reason. The force of Art lies in its immediate influence on human psychology and in its active contagiousness. Being a creation of Man it re-creates Man. Art has no need of philosophical arguments, it does not follow the signposts of philosophical systems; Art, like life, dictates systems to philosophy. It is not concerned with the meditation about what is and how it came to be. That is a task for Knowledge. Knowledge is born of the desire to know, Art derives from the necessity to communicate and to announce. The stimulus of Science is the deficiency of our knowledge. The stimulus of Art is the abundance of our emotions and our latent desires. Science is the vehicle of facts—it is indifferent, or at best tolerant, to the ideas which lie behind facts. Art is the vehicle of ideas and its attitude to facts is strictly partial. Science looks and observes, Art sees and foresees. Every great scientist has experienced a moment when the artist in him saved the scientist. "We are poets," said Pythagoras, and in the sense that a mathematician is a creator he was right.

In the light of the Constructive idea the purely philosophical wondering about real and unreal is idle. Even more idle is the intention to divide the real into super-real and sub-real, into conscious reality and sub-conscious reality. The Constructive idea knows only one reality. Nothing is unreal in Art. Whatever is touched by Art becomes reality, and we do not need to undertake remote and distant navigations in the sub-conscious in order to reveal a world which lies in our immediate vicinity. We feel its pulse continually beating in our wrists. In the same way we shall probably never have to undertake a voyage in inter-stellar space in order to feel the breath of the galactic orbits. This breath is fanning our heads within the four walls of our own rooms.

There is and there can be only one reality—existence. For the Constructive idea it is more important to know and to use the main fact that Art possesses in its own domain the means to influence the course of this existence enriching its content and stimulating its energy.

This does not mean that this idea consequently compels Art to an immediate construction of material values in life; it is sufficient when Art prepares a state of mind which will be able only to construct, co-ordinate and perfect instead of to destroy, disintegrate and deteriorate. Material values will be the inevitable result of such a state. For the same reason the Constructive idea does not expect from Art the performance of critical functions even when they are directed against the negative sides of life. What is the use of showing us what is bad without revealing what is good? The Constructive idea prefers that Art perform positive works which lead us towards the best. The measure of this perfection will not be so difficult to define when we realize that it does not lie outside us but is bound up in our desire and in our will to it. The creative human genius, which never errs and never mistakes, defines this measure. Since the beginning of Time man has been occupied with nothing else but the perfecting of his world.

To find the means for the accomplishment of this task the artist need not search in the external world of Nature; he is able to express his impulses in the language of those absolute forms which are in the substantial possession of his Art. This is the task which we constructive artists have set ourselves, which we are doing and which we hope will be continued by the future generation.

Letter from NAUM GABO to HERBERT READ (1942)

In addition to Gabo, Mondrian, Gropius, and Moholy-Nagy all lived in England for varying periods in the late 1930s. By the end of the decade, however, the latter three had left Europe for the United

First published in *Horizon* (London), vol. X, no. 53, July 1944. Reprinted by permission of the author.

States. Gropius settled at Harvard, and Moholy-Nagy founded the
New Bauhaus in Chicago in 1937, while Mondrian finally took up
residence in New York in October 1940. With the outbreak of war in
Europe, America became virtually the only place where artists could
continue to work, communicate with one another, and exhibit. The
Museum of Modern Art in New York had already demonstrated its
sympathy for the constructive tradition in such exhibitions as "Cubism
and Abstract Art" (1936) and the Bauhaus show of 1938–39; works
by Mondrian, Gabo, Pevsner, and Vantongerloo (together with Rod-
chenko and Lissitzky) were being purchased around this time.

Gabo visited the United States in 1938 but returned to England and
moved from London to Cornwall in the next year. He was finally to
leave Europe at the end of the war. The letter that follows speaks
for itself. But Herbert Read made a point deserving emphasis in his
reply, when he praised Gabo for having tackled the "problem of 'com-
munication'—the most difficult problem which the artist in a demo-
cratic society has to face." It is worth recalling at this point that the
Russian constructivists in effect discounted this particular problem,
since their program implicitly assumed a parallelism between their
own ends and those of society. The constructive artist in the West,
however, has had to face the fact that his work is, in Read's terms,
"like a foreign substance" in an "agitated sea." Read questions Gabo's
appeal for the "judgment" of the masses and suggests as the only
viable attitude: "Erect your constructions in public places . . . but
then wait and see. . . ."

DEAR HERBERT,

It is now more than a year and a half since *Horizon* asked me to
write an article about my own work. At that time I lightheartedly
promised to do it and only later did it dawn on me that I had en-
gaged myself in an adventure full of peril. When an artist ventures
to write about himself and about his work he is heading straight
into a minefield where his first mistake will be the end of him.

Many artists have walked innocently enough into that trap and
done themselves more harm than good. Not that their works have
actually suffered, but the misunderstandings and misinterpretations un-
loosed by their words were so confusing that it would have been better
had they kept silent.

On the other hand, looking back on the destiny of many works of art in their historical array, and having in view their relation to their own time and people as well as to posterity, I have come to the conclusion that a work of art, restricted to what the artist has put in it, is only a part of itself. It only attains full stature with what people and time make of it.

I realize that in making such a statement I may already have struck a mine—in fact I even sense the distant reverberations of explosions in many artistic camps, friend's and foe's.

I will therefore not walk one step further in this dangerous field without help and guidance from someone who knows the ground and who cares enough about my work and the idea it stands for. After all, my art, as all visual art, is by nature mute. Had the painter or sculptor been able to say in words what he wanted to express with pictorial and spatial means, I do not think there would have been so many pictures and sculptures for the public to look at and for the students of art to explain.

Here is where you come in. You know more than I ever will what the public ought to know in order to judge in fairness about my work. You know both my creed and my work; could you, would you, lend me a hand and lead me through this field to safety?

Ever since I began to work on my constructions, and this is now more than a quarter of a century ago, I have been persistently asked innumerable questions, some of which are constantly recurring up till the present day.

Such as "Why do I call my work 'Constructive'? Why abstract?" "If I refuse to look to Nature for my forms, where do I get my forms from?"

"What do my works contribute to society in general, and to our time in particular?"

I have often tried to answer these questions. So have you and others. Some people were satisfied, but in general the confusion is still there, and the questions still persistently recur.

I am afraid that my ultimate answer will always lie in the work itself, but I cannot help feeling that I have no right to neglect them entirely and in the following notes there may be some clue to an answer for these queries.

1) My works are what people call "Abstract." You know how in-

correct this is, still, it is true they have no visible association with the external aspects of the world. But this abstractedness is not the reason why I call my work "Constructive"; and "Abstract" is not the core of the Constructive Idea which I profess. This idea means more to me. It involves the whole complex of human relation to life. It is a mode of thinking, acting, perceiving and living. The Constructive philosophy recognizes only one stream in our existence—life (you may call it creation, it is the same). Any thing or action which enhances life, propels it and adds to it something in the direction of growth, expansion and development, is Constructive. The "how" is of secondary importance.

Therefore, to be Constructive in art does not necessarily mean to be abstract at all costs: Phidias, Leonardo da Vinci, Shakespeare, Newton, Pushkin, to name a few—all were Constructive for their time but, it would be inconsistent with the Constructive Idea to accept their way of perception and reaction to the world as an eternal and absolute measure. There is no place in a Constructive philosophy for eternal and absolute truths. All truths and values are our own constructions, subject to the changes of time and space as well as to the deliberate choice of life in its striving towards perfection. I have often used the word "perfection" and ever so often been mistaken for an ecclesiastic evangelist, which I am not. I never meant "perfection" in the sense of the superlative of good. "Perfection," in the Constructive sense, is not a state but a process; not an ultimate goal but a direction. We cannot achieve perfection by stabilizing it—we can achieve it only by being in its stream; just as we cannot catch a train by riding in it, but once in it we can increase its speed or stop it altogether; and to be in the train is what the Constructive Idea is striving for.

It may be asked: what has it all to do with art in general and with Constructive art in particular? The answer is—it has to do with art more than with all other activities of the human spirit. I believe art to be the most immediate and most effective of all means of communication between human beings. Art as a mental action is unambiguous—it does not deceive—it cannot deceive, since it is not concerned with truths. We never ask a tree whether it says the truth, being green, being fragrant. We should never search in a work of art for truth—it is verity itself.

The way in which art perceives the world is sensuous (you may call it intuitive); the way it acts in response to this perception is spontaneous, irrational and factual (you may call it creative), and this is the way of life itself. This way alone brings to us ultimate results, makes history, and moulds life in the form as we know it.

Unless and until we adopt this way of reacting to the world in all our spiritual activities (science above all included) all our achievements will rest on sand.

Unless and until we have learned to carry our morality, our science, our knowledge, our culture, with the ease we carry our heart and brain and the blood in our veins, we will have no morality, no science, no knowledge, no culture.

To this end we have to construct these activities on the foundation and in the spirit of art.

I have chosen the absoluteness and exactitude of my lines, shapes and forms in the conviction that they are the most immediate medium for my communication to others of the rhythms and the state of mind I would wish the world to be in. This is not only in the material world surrounding us but also in the mental and spiritual world we carry within us.

I think that the image they invoke is the image of good—not of evil; the image of order—not of chaos; the image of life—not of death. And that is all the content of my constructions amounts to. I should think that this is equally all that the constructive idea is driving at.

2) Again I am repeatedly and annoyingly asked—where then do I get my forms from?

The artist as a rule is particularly sensitive to such intrusion in this jealously guarded depth of his mind—but, I do not see any harm in breaking the rule. I could easily tell where I get the crude content of my forms from, provided my words be taken not metaphorically but literally.

I find them everywhere around me, where and when I want to see them. I see them, if I put my mind to it, in a torn piece of cloud carried away by the wind. I see them in the green thicket of leaves and trees. I can find them in the naked stones on hills and roads. I may discern them in a steamy trail of smoke from a passing train or on the surface of a shabby wall. I can see them often even on the blank

paper of my working-table. I look and find them in the bends of waves on the sea between the open-work of foaming crests; their apparition may be sudden, it may come and vanish in a second, but when they are over they leave with me the image of eternity's duration. I can tell you more (poetic though it may sound, it is nevertheless plain reality): sometimes a falling star, cleaving the dark, traces the breath of night on my window glass, and in that instantaneous flash I might see the very line for which I searched in vain for months and months.

These are the wells from which I draw the crude content of my forms. Of course, I don't take them as they come; the image of my perception needs an order and this order is my construction. I claim the right to do it so because this is what we all do in our mental world; this is what science does, what philosophy does, what life does. We all construct the image of the world as we wish it to be, and this spiritual world of ours will always be what and how we make it. It is Mankind alone that is shaping it in certain order out of a mass of incoherent and inimical realities. This is what it means to me to be Constructive.

3) I may be in error in presuming that these maxims are simple to explain and easy to understand. I cannot judge, but I know for certain that for me it is much more difficult to prove the social justification for my work at this time.

A world at war, it seems to me, may have the right to reject my work as irrelevant to its immediate needs. I can say but little in my defence. I can only beg to be believed that I suffer with all the world in all the misfortunes which are now fallen upon us. Day and night I carry the horror and pain of the human race with me. Will I be allowed to ask the leaders of the masses engaged in a mortal struggle of sheer survival: ". . . Must I, ought I, to keep and carry this horror through my art to the people?"—the people in the burned cities and scorched villages, the people in trenches, people in the ashes of their homes, the blinded shadows of human beings from the ruins and gibbets of devastated continents . . . "What can I tell *them* about pain and horror that they do not know?"

The human race is ill; dangerously, mortally ill—I offer my blood and flesh, for what it is worth, to help them; my life, if it is needed. But what is the worth of a single life—we all have learned to kill with ease and the road of death is made smooth and facile. The venom

of hate has become our daily bread and only nurture. Am I to be blamed when I confess that I cannot find inspiration for my art in that stage of death and desolation?

I am offering in my art what comfort I can to alleviate the pains and convulsions of our time. I try to keep our despair from assuming such proportions that nothing will remain in our devastated life to prompt us to live. I try to guard in my work the image of the morrow we left behind us in our memories and foregone aspirations and to remind us that the image of the world can be different. It may be that I don't succeed in that at all, but I would not accept blame for trying it.

Constructive art as a whole, and my work as part of it, has still a long way to go to overcome the atmosphere of controversy that surrounds it. It has been and still is deliberately kept from the masses on the grounds that the masses would not understand it, and that it is not the kind of art the masses need. It is always very difficult to argue with anybody on such obscure grounds as this; the simplest and fairest thing to do would be to allow the masses to make their own judgment about this art. I am prepared to challenge any of the representatives of public opinion and put at their disposal any work of mine they choose to be placed where it belongs—namely, where the masses come and go and live and work. I would submit to any judgment the masses would freely pronounce about it. Would any leader of the masses ever accept my challenge—I wonder!

Meantime I can do nothing but leave my work to the few and selected ones to judge and discriminate.

Yours as ever,

GABO

VII.
The Constructive Idea
in the Postwar World:
1948-65

CHARLES BIEDERMAN: From
*Art as the Evolution of
Visual Knowledge* (1948)

*Before the Second World War constructive art in Britain had developed
as a result of the contact between a small group of British artists and
an even smaller group of distinguished European exiles. It was fully
recognized at the time that the gap between, say, Ben Nicholson and
Mondrian, or Moholy-Nagy and Barbara Hepworth, was a wide one,
and one that was unlikely to be bridged. In* Circle, *this gap was ac-
centuated by the fact that such British contributors as Moore and
Nicholson preferred to restrict themselves to "Quotations," rather than
engage in theoretical argument. The individualism, avoidance of po-
lemic, and concern with traditional genres and materials that character-
ized the British artists did, in effect, set them apart from what was
most authentically constructivist in the newcomers: an awareness of
a common tradition, a concern with wide-ranging statements of be-
lief and commitment, and an impatience with traditional views of
the artist and his limitations. It is hardly surprising that the Circle
group, in spite of its vitality around 1937, did not survive the war*

*Despite their comparatively warm reception in the United States,
the constructive artists in exile stimulated no comparable movement
among younger American artists. Mondrian died in 1944, and Moholy-
Nagy spent the last years of his life, from 1937 to 1946, in a coura-
geous attempt to salvage the basic principles of the Bauhaus education
and enshrine them in an American institution. His lack of success con-
trasts acutely with the pervasive influence exerted at this time by*

Art as the Evolution of Visual Knowledge was privately published in Red
Wing, Minn., in 1948. A substantial extract from Chap. 18, "Non-Aristotelian
Art" (pp. 385–92) is reprinted here with permission.

223

surrealist artists such as André Masson, over the young abstract paint-
ers of the New York School.

The most significant new stimulus to constructive art in the early
postwar period was to come from America. But it was to be the work
of a native-born artist whose acquaintance with the constructivist tra-
dition was no more than perfunctory. Charles Biederman was born in
Cleveland, Ohio, in 1906, and since about 1942 or 1943 he has lived
in Red Wing, Minnesota. The passage that follows is taken from his
magisterial study, Art as the Evolution of Visual Knowledge, *which*
was published privately in 1948, though it was actually written be-
tween 1938 and 1946. Biederman had visited Paris in 1936–37 and
seen work by several artists of the Abstraction-Création group, but
because he was engaged in composing his study during the war, he
was unable to view relevant historical examples that would have en-
abled him to place constructivism in a more precise context. It is
worth pointing out that the label "constructionist," which is used
throughout the following excerpt, should not be equated directly with
the Russian or the international constructivist movement. Biederman
saw the new art as a derivative both of constructivism and of De Stijl,
and the fact that he viewed the relief construction as the most sig-
nificant product of these two tendencies attests that he was less di-
rectly concerned with their wider aesthetic and social implications.
At a subsequent stage, he substituted the term "structurism" for "con-
structionism," partly to avoid the danger of confusion with the earlier
movement. Biederman's notion of "structure" was profoundly in-
fluenced by a series of lectures by Alfred Korzybski that he attended
in 1938. Korzybski was the exponent of an approach to the struc-
ture of language that he termed "general semantics." His central work
in the field, published in 1933, was entitled Science and Sanity: An
Introduction to Non-Aristotelian Systems and General Semantics.

Biederman's incisive and original account of the "evolution of
vision," which was to be developed in Letters on the New Art *(1951)*
and The New Cézanne *(1952), played a crucial role in reinvigorating*
the constructive tradition in postwar Europe. Victor Pasmore, whose
own transition from painting to construction took place in the period
immediately after the publication of Biederman's first work, has
credited him with the attempt to "re-orientate the cubist constructive
outlook." Other British artists within the constructive tradition—

Kenneth and Mary Martin, Gillian Wise, and Anthony Hill—have also testified to the value of Biederman's analysis and its relevance to their own work.

Let us return now to a discussion of the significance of what may appear to have been a comparatively simple move on the part of the Constructionists—that is, putting the actual third dimension back into art by employing the three-dimensional materials of industry, etc. We shall show that in our times, men have discovered through Constructionist art something that they have unconsciously been searching for throughout their history and especially during the last 2,000 years of art; namely, the invention by the artist of his art content.

Ever since the Greeks invented the supposed superiority of man-art over nature-art, a unique difficulty has pervaded the efforts and researches of artists up to the very present. The difficulty was how to reconcile the art of man with the art of nature! Once the Greeks attained the "perfect" recording of the human form in general, there automatically came into existence two distinct objectives in man's art. On the one hand the objective was to record macro-reality ever more accurately. There was, as we have seen, a gradual development in this direction—an evolution in which more and more particulars were included, until, just over a century ago the Photographic method was perfected for recording the uniquely particular or individual characteristics of the objective world. The other objective of man's art, which was especially evident after the notion of the general or the "ideal" was *invented*, has been the effort to achieve something more than merely the literal imitation of nature. Stimulated by an inherent urge, man has tried to exert his ability to invent, i.e., to create, rather than use nature as it actually appears. In other words, although man used nature-art for his art content, some artists, rather than striving only for literal recording, wished to participate "creatively" in the final form of the result. It is no accident that the term "invention" is profusely employed in the art literature dealing with theories about the "ideal." What is this but an expression of the desire not simply to imitate, but to create, to invent? However, the 5th century Greeks, and the artists of the Renaissance, and all those who afterwards sought the "ideal," were thwarted in their effort to release the Inventive potential in man because they sought their objective by remaking na-

ture's own forms, just as the majority are still doing in our own times. This not only confined and restricted the Inventive activity of the artist to the limiting forms of nature-art, but also set him in direct competition with nature, *on its own grounds,* so to speak. This was a competition in which the cards were stacked against man!

Today the impediment to this objective to create, to invent, has been removed by the Constructionist decision; man no longer needs to copy or manipulate the art of nature. When artists of the 20th century finally realized that a mechanical recording instrument had been invented that was incomparably superior to the old primitive recording tools, it then became possible for the advanced artists to leave the recording task to the Camera artists entirely and to concentrate on the Inventive factor which had previously been frustrated by the Mimetic task demanded of art.

In our analysis of the Transitional-Period we pointed out how the dictation of the objects of nature began to lessen. Previously artists had made their medium increasingly answer to the dictates of the object, but especially with the Impressionists they began to explore the creative potentialities of their medium, particularly in the realm of paint-colors. Then we saw van Gogh do likewise with the *line* potentialities of man's medium; Gauguin with the *area* and *space* factors; Cézanne with the *three-dimensional* problem. Finally the Cubists made the great change, and with colors, lines, forms and space began to release the Inventive factor ever more until the contents of art had become almost completely invented by man and not copied from nature.

We have shown also how with the appearance of the Impressionists —significantly the period that marks the beginning of the elimination of nature copying—artists began to become conscious of the differences between the linearity of the canvas and three-dimensional reality. There was Paul Cézanne's remark that it took him forty years to realize that painting was not sculpture. And Juan Gris, who said, "For a painter . . . I insist on *flat* forms, because to consider these forms in a spatial world would be an affair for a sculptor." It is interesting to note, however, that ever since the Transitional-Period more and more Painters did Sculpture as well, e.g., Gauguin, Renoir, Gris, Braque, Picasso, Matisse, etc., while Mondrian and Léger and others were always talking about the "plastic." Few, however, have been

fully aware of the problem. Cézanne and many of the later Painters "solved" the apparent contradiction in the dimensions of reality and their medium, mainly by unconsciously assuming in such problems that the canvas, the sculptural object and nature were all individual realities, legitimate independent realities in their own right: one reality for Painting, one for Sculpture, and one for nature. Certain crucial relations between them and their significance were missed. The Painters did not see the contradiction in the fact that their interests in form-structure omitted its essential characteristic of being actually three-dimensional. We have noticed evidences of these conflicts ever since the Camera; for example, Cézanne and the Cubists destroyed the static, perspective point of view; the latter showed more than one view of the object or a separate viewpoint for each individual part of the Painting and even resorted to actual three-dimensional materials to make art. And, as we have just noted, many Painters from Post-Impressionism on dabbled in the medium of Sculpture. In short, the preoccupation of many artists was tending towards what was called a "spatial world."

In other words, as the Transitional-Period was characterized by an ever decreasing importance of the nature object and the ever increasing but largely unconscious interest in the Structural Process as the *source of abstraction,* the Painters had a tendency now and then to supplant their Painting with Sculpture. This was because, as abstraction from the macro-level decreased and abstraction from the structural-level increased, the need was unconsciously felt for realizing a proper reality for the results of these activities with the structural-level. This was a need for an actual three-dimensional factor and not an illusion of it. Consequently Sculpture, so to speak, seemed to pull every now and then at the sleeves of the Painter.

When artists removed the macroscopic level of nature from their art, it should naturally have occurred to them at the same time that the medium which belonged with the past art was just as obsolete. But outside of a few who have made the change in the medium (some of whom do not adequately recognize the significance of the change), most artists have attempted to continue in the old medium methods. There are many reasons why this is the case, but mainly it is because the medium of paint had been a traditionally dominant one for over five centuries, ever since the Renaissance. As a matter of fact, men

had been painting for many thousands of years and under these circumstances few dared to assume that Painting would ever come to an end. Artists had become so conditioned or canalized to the notion of painting illusions that when the necessity for making such illusions no longer existed, they utterly failed to recognize the fact. Consequently it never occurred to Painters to ask themselves why they painted, or why paint and canvas came into use in the first place. To be sure, many "Modern" artists frankly admitted that they painted illusions but it never seemed to occur to them to ask *why*. They simply accepted it as a matter of course. Conservatism stifles curiosity!

Since it is not understood fully enough why artists began to make illusions in the first place, non-Camera artists do not realize that there is no longer any need for making them today. Recall that during the Renaissance illusionary methods again took the *dominant role* in the evolution of art, for the good reason that this was the *best* means of continuing further the progress in the accurate recording of nature-appearances which the Sculptors had begun. Man has produced *useful* illusions of reality only where it was impossible to do otherwise or to do better with some other method, and also only where it was possible to make illusions that would satisfactorily function as such. It is apparent why humans, trees, etc., could not be depicted in the Sculptor's materials beyond a certain point. These materials were extremely limited in their possibilities for depicting nature; Painting, on the other hand, was considerably more flexible and offered the only other possibility until the incomparable method of the Camera was invented. Then just as Painting had taken over from Sculpture, the Camera took over from Painting. Each medium was an improvement over the others in the effort to reach a similar general objective. Until the invention of the Camera the artist was compelled to resort to primitive illusionistic methods, since it was the only useful way in which the realistic objective could be secured.

But today there are very decided reasons why we should not make illusions if our objective is to produce invented forms. The three-dimensional illusions of the older arts functioned satisfactorily to give a feeling of "reality," because of the mechanisms of *projection, recognition* and *identification*. We have already noted that these mechanisms could not function as satisfactorily in illusions of invented forms as was possible with the old content, since the recognition of these forms

Charles Biederman: *Teaching Model 1951–1952*. This work forms part
of a series of six "teaching models" that Biederman constructed in 1951
and 1952. As the title implies, they were intended to help young artists
to bypass the stages of Biederman's own evolution between 1937 and
1947 and to find "a course of study and evolution more direct and ap-
propriate to their generation." The purpose of the series in formal terms
was "to demonstrate the necessity of beginning with the cube and how
that could be developed into a spatial plane." (*Photo courtesy of the
artist*)

as reality could not be based on their being form-illusions of familiar things of the world of vision. These forms had never been seen until the artist invented them! Moreover in this task the artist was *not* compelled to employ illusions of the third dimension, because it was now *not* the most efficient way in which to do the job at hand. To achieve the highest degree of "reality" possible for the new art contents it was necessary that it be as similar in structure as possible to the structure of nature's reality process. In other words, *in the new kind of art, it was not only possible to return the third dimension, but it was just as crucially necessary that it be done as it once was necessary to eliminate it during the Renaissance.*

But notions of tradition and precedent are factors which exert a strong pull even on those who do break with the old, especially when we are not conscious of the fact; and more than 2,000 years of painting three-dimensional illusions is, for most artists, quite a thing to part with. It was a conservative attitude similar to this which led the Academicians to believe that man would forever *paint* nature-appearances just as he had apparently always done. Consequently, we find today that all the old types of artists and most of the "Modern" artists refuse to give up either the old content or the old mediums. Here we have the two kinds of conservatives again—those who would keep the old contents and those who would retain the mediums of the old contents. This is, of course, just one more aspect of the general confusion in the field of art. As Korzybski has pointed out: "The main semantic difficulty, for those accustomed to the old, consists in breaking the old structural linguistic habits, in becoming once more flexible and receptive in feelings, and in acquiring new *semantic reactions.*"

Thus while some succeeded in becoming aware of the uselessness of the old contents, even here, as we have seen, their awareness was far from adequate. Indeed, how could they see the latter adequately when they were conscious of only half the problem and saw nothing amiss with the function of the old primitive mediums? Even if Painters got so far as to be no longer concerned with producing an illusion of nature's form appearances, they were, unconsciously, now involved in producing two- or three-dimensional illusions of the form appearances of their inventions. And each of these Painters who did not change his medium was eventually compelled to return to the old

content, in one way or another, in order to give these illusions an adequate sense of "reality." For in that way they again put into operation the old projection mechanism, i.e., the reality of the forms of nature-appearances was projected upon the art content as had been done in the past. In brief, failing to achieve adequate reality for the new content, each was eventually compelled to return to the old reality content—a retreat, not a solution.

Thus although the Two-Dimensionalists, for example, set out in the correct direction, those who continued to use the wrong medium inevitably regressed. They performed, however, two major services for art: (1) they proved, unintentionally, of course, that Painting had come to its end; (2) likewise they offered worthwhile knowledge to the Constructionists who were going in the right direction with the right medium for the attainment of the new art. Just as Renaissance Sculptors like Ghiberti were working out problems like perspective, a problem which required the two-dimensional medium for its adequate realization; so in our times certain Painters have worked directly on problems of invented art which require three-dimensional solutions for their full realization.

So we can put it this way: some Sculptors of the Renaissance and some Painters of the 20th century were occupied with the correct direction but were frustrated because they refused to revise their medium. In fact, all *new progressive objectives* whch the Painters of our times have evolved can only find their adequate realization in the Constructionist method. The Constructionists do not paint nature-appearances; they do not make illusions either of nature or man-art! They are the artists who have succeeded in achieving the new orientation to art that is now in order.

From Impressionism on there were indications that not only the content was changing but that there was also an attempt to change the medium; but it was the Constructionists who took the final decisive step of subjecting the reality of nature to the potentialities of man's ability to create art with the materials he has invented. At last that which Monet and his friends had initiated was completed. The "oblong of pink," the "square of blue," the "streak of yellow," had been fully realized. Man was now truly a "creative" artist!

We can today see more clearly what a momentous event Impressionism was. It was the Impressionists in particular who decisively

began the transition away from dependence upon the forms and colors of nature, who began also the investigation of nature's structure. Therefore we have the highest respect for a movement in art which has been popularly regarded with contempt by the insecure "Moderns." True, the Impressionists themselves were little aware of much which they began, but at least they had the courage to walk forward while the majority stayed behind crying "verboten" to every forward step. Today we can fully realize how erroneous it is to whittle the Impressionists down to mere nature-gapers. You "Modern" critics who feel so superior to the Impressionists' understanding of art—they began something you never understood! Before they did their work, nature's objects had stated the goal of art; after them, man stated the goal of his own non-Camera art!

Less than three-quarters of a century after the appearance of the first successful Photograph, artists discovered how to invent their own art contents, independent of copying in any degree the macroscopic forms of nature. After 2,000 years of direct effort to do so, man is now able to use "invention" in his art, no longer frustrated by the Mimetic factor. *He no longer competes with nature at all,* but as we shall see, he *continues to employ nature,* in a more effective manner, to gain his desired objective of "invention."

In an early chapter where we discussed the early stages of the development of Sculpture, we remarked that the Inventive and Mimetic factors are never found isolated from each other throughout man's entire history of art; the problem always was a matter of *degrees* and *kinds* of Mimetic and Inventive behavior. This is still true as regards Constructionist art; the Constructionist, to mention only this one aspect, does not invent the notion of three-dimensional colored forms; he finds the source of this notion in the phenomena of nature. What he does invent is the *particular organization* of three-dimensional color-forms! In the past the artist "imitated" the *results* of nature-art; today the new artist only "imitates" the *method* of nature-art! This is the crux of the matter. As we have made clear in the chapter on the term "abstract," an artist, in order to avoid the Mimetic factor in any degree, would have to exclude *all* the characteristics found in nature —an impossibility.

Therefore, the prevalent notion is false that the Constructionist is concerned with the denial of nature: the Constructionist is striving to

do what all the great innovators in art have always done, *to continue the evolution of the artist's ability to abstract from the objective world around him for purposes of achieving a legitimate contemporary art.*

We have noted that the new reality level from which the artist can now abstract is the Structural Process level, the *building method of nature,* and no longer the macro-level, the form-results of nature. We have also noted that many of the Painting artists were unconsciously struggling under various handicaps to abstract from the Structural Process level rather than from the results of that level.

Naturally the first move in the direction of abstracting from the Structural Process level would be to acquire the *reality characteristics* of this level. *To accomplish this objective it was necessary to employ a medium or mediums whose structure CORRESPONDED to the structure of reality.* Here lies the solution of one of the main difficulties which faced the Two-Dimensionalists and others—"the problem of reality." By making this change in medium the new art direction of invention acquired one of the characteristics of *reality* which was lacking in the linear medium, i.e., *actual* three-dimensionality in *actual* space. Thus a correction was made from the dead-end medium of the Two-Dimensionalists to the actual space-form art of the Constructionists. It was in that change that the Constructionists achieved an adequate reality for the new art. Now a man-invented form, for example, a man-made sphere, an actual three-dimensional sphere, was just as real as an apple, but there was no need for it to be the form of an apple; and since no Painting of a sphere was made, no illusion of it was made. Here was the solution for those who *painted* two- and three-dimensional illusions of invented forms. By giving the invented contents actual three dimensions in space, the Constructionists achieved a *structure for their new art contents which was SIMILAR (NON-IDENTITY) IN STRUCTURE TO THE STRUCTURE OF ACTUAL REALITY.* As in nature—the criterion of reality—the *art of man* now possesses the three-dimensional characteristics of REALITY.

Thus, reality recognition is dependent no longer on the identification of nature objects as depicted in the old contents; in the new contents the reality factor is achieved by the direct method; there is a similarity to the reality characteristics of nature's Structural Process.

This is possible because *the particular form-RESULTS in the new art do not duplicate, in any degree, the form-RESULTS in nature.* The new art seeks only a *correspondence to the Structural Process, not to the results of that structure in nature.*

Since man is no longer compelled to imitate the forms of nature, he is thus no longer compelled to retain the limitations and restrictions of the old mediums. The old materials and tools are severely limited to doing only the job for which they were originally devised. Now that man can invent his own art, he can use the most modern materials and Machine methods of industry; with them he is free to achieve the greatest of the possibilities open to the Inventive ability of man as an artist. In brief, man can change from the old primitive Mimetic methods and materials and tools to ones that are particularly suited to the new demands of art. The building method is similar in both nature's and man's art, only now the form objectives are very different and so the materials and tools are changed—the old primitive mediums are discarded.

Naum Gabo: On Constructive Realism (1948)

It should perhaps be emphasized that, in England at any rate, Biederman's influence was as a theorist rather than as an artist: this was inevitable, since his work was not shown in Europe on any significant scale until the late 1960s. Biederman enabled the constructive artist to reassess his own position in relation to the course of modern art, and by his stress on a tradition that led directly from Monet and Cézanne he was able to present construction as an aesthetic of central importance, rather than a mere offshoot of the norm of figura-

Delivered as the Trowbridge Lecture at Yale University, 1948, and published in Katherine S. Dreier, James Johnson Sweeney, Naum Gabo, *Three Lectures on Modern Art* (New York: Philosophical Library, 1949). It is reprinted here with the permission of the author and Philosophical Library, Inc.

tion. But it was the work of Gabo that still provided the practical model for artists such as Pasmore: the constructionist group in England was to go beyond its predecessors from the 1930s and adopt Gabo's use of industrial materials such as plexiglas and aluminum, while for the most part neglecting the applied color that was a feature of Biederman's work. Nor should it be imagined that Gabo ceased to be influential as far as the ideological basis of the constructive tradition was concerned. In the lecture that follows, he reverts to a consideration of the "realism" that had been his object of inquiry in 1920 and reiterates the views on the independent role of art that had been the ground of his conflict with the Russian constructivists.

It has always been my principle to let my work speak for itself, following the maxim that a work of art does not need to be explained by its author, that it is rather the other way around: it is the author who is explained by his work of art. However, I have often been called upon to use words to supplement the mute medium of my profession. I confess that I was never happy about it. My only comfort, such as it may be, is the fact that I am not the only one who is encumbered by this overwhelming duty. All artists in all times had to do it in one way or another, and my contemporaries are certainly no exception. But it may be instructive to notice the difference of methods used by the former and by the latter. When the artist of old times was challenged to justify his work, he had an easy and simple task. He lived in a stable society, tightly knitted in a pattern of commonly accepted social, religious and moral codes; he and his society lived in accordance with a set of very well defined standards of what is good, what is bad, what is virtuous or vile, beautiful or ugly. All the artist had to do was to refer to these standards and argue that in his work he fulfilled their demands.

The artist of today, however, when called upon to justify his work, finds himself confronted with a most difficult and complex problem. Here he stands in the midst of a world shattered to its very foundation, before a totally anonymous society, deprived of all measures, for evil, beauty, ugliness, etc. . . . He has no norms to refer to. He is, in fact, an abnormal subject in an abnormal society. And there are only two ways left open to him; one is the reference to his personality.

Personality is one of those things which by some trick of our social

disorder has been left as some sort of a little straw in the maelstrom of confused values, and many an artist is grasping that straw.

They, in justification of their work, appeal to their personality; their motto roughly amounts to this: "You are asking from me my personality—here I am—this is how I see the world—I, not you. You cannot judge my work, because you are not I—I paint what I see and how I see it. I paint what pleases me and you have to take it or leave it."

We have seen that more often than not this method has proved of some advantage and for a time was useful for many artists in so far as it gave them the opportunity to carry their revolt and their contempt to that very society which, having no personality of its own, yet demanded that the artist produce one.

Although I have the greatest esteem for the work these artists have done in their time, their method is not mine.

And although it would be a false humility on my part to deny to myself what is given to me by nature and what I have acquired through the experience of my life, namely, that I too have a personality, I do not hold, however, that personality alone, without its being integrated in the main body of the society in which it lives can constitute a strong enough basis for the justification of my work or of any work of art, for that matter. I hold that personality is an attribute of which any one and every one may boast. It is there whether we want it or not. I hold that such a method of justification may only result in that very baleful end from which we are all striving to escape; namely, it will end in the vanity fair of personalities struggling to overpower each other. I see nothing but confusion and social and mental disaster on this road.

But there is something else at the artist's disposal to justify his work; and this is when the artist in his art is led by an idea of which he believes that it epitomises not only what he himself feels and looks forward to as an individual, but what the collective human mind of his time feels and aspires towards, but cannot yet express.

As such he is a fore-runner of some development in the mentality of human society and though his idea may or may not eventually prevail over other ideas of his time or of the future, it nevertheless is performing a function without which no progress is possible. This is my road and the purpose of this paper is to explain as concisely

as my time permits the fundamentals of the idea which I profess and which I would call—The Idea of Constructive Realism.

My art is commonly known as the art of Constructivism. Actually the word Constructivism is a misnomer. The word Constructivism has been appropriated by one group of constructive artists in the 1920's who demanded that art should liquidate itself. They denied any value to easel painting, to sculpture, in fine, to any work of art in which the artist's purpose was to convey ideas or emotions for their own sake. They demanded from the artist, and particularly from those who were commonly called constructivists that they should use their talents for construction of material values, namely, in building useful objects, houses, chairs, tables, stoves, etc., being materialist in their philosophy and Marxist in their politics, they could not see in a work of art anything else but a pleasurable occupation cherished in a decadent capitalistic society and totally useless, even harmful in the new society of communism. My friends and myself were strongly opposed to that peculiar trend of thought. I did not and do not share the opinion that art is just another game or another pleasure to the artist's heart. I believe that art has a specific function to perform in the mental and social structure of human life. I believe that art is the most immediate and most effective means of communication between the members of human society. I believe art has a supreme vitality equal only to the supremacy of life itself and that it, therefore, reigns over all man's creations.

It should be apparent from the foregoing that I thus ascribe to art a function of a much higher value and put it on a much broader plane than that somewhat loose and limited one we are used to when we say: painting, sculpture, music, etc. I denominate by the word Art the specific and exclusive faculty of man's mind to conceive and represent the world without and within him in form and by means of artfully constructed images. Moreover, I maintain that this faculty predominates in all the processes of our mental and physical orientation in this world, it being impossible for our minds to perceive or arrange or act upon our world in any other way but through this construction of an ever-changing and yet coherent chain of images. Furthermore, I maintain that these mentally constructed images are the very essence of the reality of the world which we are searching for.

When I say images I do not mean images in the platonic sense—not as reflections or shadows of some reality behind these constructed images of our minds and senses but the images themselves. Any talk and reference to a higher, to a purer, to a more exact reality which is supposed to be beyond these images, I take as a chase after illusions unless and until some image has been constructed by our mind about it to make it appear on the plane of our consciousness in some concrete and coherent form: tangible, visible, imageable, perceptible.

Obviously such a process as I visualize in our mental activity is manifestly a characteristic attribute of art. Consequently I go so far as to maintain that all the other constructions of our mind, be they scientific, philosophic or technical, are but arts disguised in the specific form peculiar to these particular disciplines. I see in human mind the only sovereign of this immeasurable and measurable universe of ours. It is the creator and the creation.

Since man started to think he has been persuading himself of the existence somewhere, somehow, in some form, of an external reality which we are supposed to search for, to approach, to approximate and to reproduce. Scientists as well as artists have obediently followed that persuasion. The scientists have made great strides in their search; the artists, however, stopped at the gates of our sensual world and by calling it naturalism they remain in the belief that they are reproducing the true reality. Little, it seems to me, do these artists know how shallow their image of reality must appear to the scentific mind of today; to the mind which conveys to us nowadays an image of reality where there is no difference, no boundary between a grain of sand and a drop of water; a flash of electricity and the fragrance of a tree. Both, however, claim reality and I shall be the last to deny them the truth of their assertions; both are artists and both are telling the truth. But neither of them has the right to claim exclusive truth for his image.

The external world, this higher and absolute reality, supposedly detached from us, may exist or may not—so long as our mind has not constructed a specific image about it, it may just as well be considered nonexistent. I know only one indestructible fact, here and now, that I am alive and so are you. But what this mysterious process which is called life actually is, beyond that image which you and I are constructing about it, is unknown and unknowable.

It may easily be seen that it would have been indeed a source of unbearable suffering to us, a source of hopeless despair, should the human mind resign to this ignorance of its universe leaving its destiny to that something unknown, unknowable. The history of mankind, the history of its material and mental development, reassures us, however, on that point. It shows us that mankind never has and never will resign to that state of total ignorance and inexorable fatality. Mind knows that once born we are alive, and once alive we are in the midst of a stream of creation and once in it we are not only carried by it, but we are capable to influence its course. With indefatigable perseverance man is constructing his life giving a concrete and neatly shaped image to that which is supposed to be unknown and which he alone, through his constructions, does constantly be let known. He creates the images of his world, he corrects them and he changes them in the course of years, of centuries. To that end he utilizes great plants, intricate laboratories, given to him with life; the laboratory of his senses and the laboratory of his mind; and through them he invents, construes and constructs ways and means in the form of images for his orientation in this world of his. And what is known to us as acquisition of knowledge is therefore nothing else but the acquisition of skill in constructing and improving that grandiose artifice of images which in their entirety represent to us the universe —our universe. Whatever we discover with our knowledge is not something lying outside us, not something which is a part of some higher, constant, absolute reality which is only waiting for us to discover it . . . but, we discover exactly that which we put into the place where we made the discovery. We have not discovered electricity, X rays, the atom and thousands of other phenomena and processes—we have made them. They are images of our own construction. After all, it is not long ago that electricity to us was the image of a sneezing and ferocious god—after that it became a current, later on it became a wave, today it is a particle which behaves like a wave which, in its turn, behaves like a particle—tomorrow its image will shrink to the symbol of some concise mathematical formula. What is it all if not an ever-changing chain of images, ever true and ever real so long as they are in use—both the old one which we discard and the new one which we construe; and when we discard them we do so not because they are untrue or unreal, but because at

a certain moment they lose their efficacy for our new orientation in this world and do not fit with other images, newly construed and newly created. The very question which we often ask ourselves, whether these phenomena were there before our knowing about them, or whether they are a part of some constant reality independent of our mind—such questions are themselves a product of our mind and they are characteristic for us so long as we remain in the state of being alive—they lose all sense and significance the moment we can face a state of nature where mind is not.

These are the fundamental principles of the philosophy of Constructive Realism which I profess. This philosophy is not a guidance for my work, it is a justification for it. It helps me to reconcile myself to the world around me in everyday activities and thoughts; it helps me also to disentangle the complex snarl of contemporary ideas, inimical to each other and, which is more important, it may give you the reason as it does to me for what I am doing in my art and why I am doing it in the way I do it.

But perhaps at this point I ought to be somewhat more explicit.

If you have followed me up till now you may perhaps grant me that I am thinking consequently when I claim that I, as an artist, have the right to discard images of the world which my predecessors have created before me and search for new images which touch upon other sights of life and nature, other rhythms corresponding to new mental and sensual processes living in us today and, that by representing these new images I have the right to claim that they are images of reality.

I say, indeed, with what right is the scientist allowed to discard views of the world which were so useful to mankind for so many thousands of years and replace them by new images entirely different from the old? With what right is the scientist allowed it and the artist not—and why? Take, for instance, our ancestors' anthropomorphic image of the world. For thousands of years it was serving them well in their everyday life and in their forward growth. That image of the world was populated by creatures who were replicas of ourselves. The sun and the earth and all the furniture of heaven were in the power of gods whose countenances were like our own. Accordingly their arts and their sciences (such as they were), their religions, their cosmologies, all were based on this anthropomorphic conception of

the world without and within them. Yet it was taken for granted that when the mechanistic conception of the universe replaced the anthropomorphic one, it was quite all right; and when now our contemporary sciences are developing an image of the world so entirely different from both the previous ones as to appear to us almost absurd, incomprehensible to common sense, we are again willing to take it—we have already accepted it; we have gotten familiar with a world in which forces are permitted to become mass and matter is permitted to become light; a world which is pictured to us as a conglomeration of oscillating electrons, protons, neutrons, particles which behave like waves, which in their turn behave like particles. If the scientist is permitted to picture to us an image of an electron which under certain conditions has less than zero energy (in common language, it means that it weighs less than nothing) and if he is permitted to see behind this simple common table, an image of the curvature of space—why, may I ask, is not the contemporary artist to be permitted to search for and bring forward an image of the world more in accordance with the achievements of our developed mind, even if it is different from the image presented in the paintings and sculptures of our predecessors?

I don't deny them their right to go on painting their images; I don't even deny that their images *are* real and true; the only thing I maintain is that the artists cannot go on forever painting the view from their window and pretending that this is all there is in the world, because it is not. There are many aspects in the world, unseen, unfelt and unexperienced, which have to be conveyed and we have the right to do it no less than they. It is, therefore, obvious that my question is purely rhetoric.

There is nothing whatsoever of any sense or validity to warrant the demand of some of those self-appointed public critics of ours, that unless we stick to the ancient, to the naïve, anthropomorphic representation of our emotions, we are not doing serious art; we are escapists, decorators, abstractionists, murderers of art, dead men ourselves. Little do these critics know how preposterous, naïve, their demand is in a time and in a world entirely different from what they want us to represent, and which they themselves have already meekly accepted without realizing it.

There is, however, one argument which could have been brought

up by our adversaries had they known what they were talking about and it is this:

It may be argued that when the scientist is advancing a new conception or a new image as we call it, of the universe or of life, he takes it for granted that this new image he is presenting must needs first be verified; it has to be tested by our experience as unmistakably factual. Only then may he claim validity for his image in the scientific picture of the world he is constructing. Whereas you artists, the argument may go on, in your sort of constructions, are expecting us, the public, to take your image for granted, take it as valid without reference to any given fact except that it is a construction of your mind. This is a serious argument, at least on the surface, and my answer to it is this:

First of all, the so-authoritative word verification should not be taken too seriously—after all verification is nothing else but an appeal to that very tribunal which issued the verdict in the first place. In our ordinary processes of jurisprudence we would never dream of letting the defendant be his own prosecutor but in this case, we seem to do so without noticing the trap into which we are falling. But let us leave that for the moment: I shall come back to it presently.

The reference I so often make here to science and my claim for the artist's right should not be understood as meaning that I consider visual art and science exactly the same thing. I am not claiming my work to be a work of science; I am no scientist and I do not know more of science than anyone who has gone through the routine of the usual university education. I have learned to read the scientists' books and I presume that I understand their meaning, but I certainly cannot do their job. There is no more mathematics in my work than there is anatomy in a figure of Michelangelo and I have nothing but contempt for those artists who masquerade their works as scientific by titling them with algebraic formulas. This is plain profanation of both Art and Science. I may quote from an editorial statement of mine published in *Circle* in 1937, London: "Art and Science are two different streams which rise from the same creative source and flow into the same ocean of common human culture, but the currents of these streams flow in different beds. There is a difference between the art of science and the visual or poetic arts. Science teaches, explores, comprehends, reasons and proves. Art asserts, Art acts, Art makes

believe. The force of Art lies in its immediate influence on human psychology, in its impulsive contagiousness: Art being a creation of man does recreate man." * In closing the quotation I can, of course, add that Science too does recreate man, but I maintain that it cannot do it without the help of some visual sensual or poetic art.

Science in conveying a new image or conception can but state it; it can make it cogent by its own means but it cannot, however, by its own means alone make this image an organic part of our consciousness, of our perceptions; it cannot bring that new image in the stream of our emotions and transfer it into a sensual experience. It is only through the means of our visual or poetic arts that this image can be experienced and incorporated in the frame of our attitude toward this world.

After all, the minds of our ancestors have in their time created a cosmology of their own, they have created an image of a single God in Heaven to which even some of our scientists today still adhere, but it is not the mere proclamation and reasoning about the existence of such a God that made this image into a fact. It is the prayer of the poet who made the primitive man humiliate himself in an ecstasy of propitiation to that God; it is the music of the psalms, the edifice of the temple, the choir and the holy image painted on the icon and the liturgical performance at the holy services—all acts of pure visual and poetic art; it is this which incorporates the religious images of our forefathers into their life affecting their behaviour and moulding their mentality. Science has long ago told us that the image of the sun risng in the east is sheer nonsense, that it is the earth and ourselves who are turning towards the sun, making it appear to rise; yet this new conception does not seem to have left any trace at all in the rhythm of our everyday experience even now Our poets are still chirping happily about the sun rising in the east; and why should they not? Theirs is still a valid image; it is real and it is poetic; but so is the new one no less real, no less poetic, no less worthy to serve as an image and be incorporated in our new vision.

In an age when the scientific eye of man is looking through matter into a fascinating all embracing image of space time as the very essence of our consciousness and of our universe, the old anthropo-

* Gabo here paraphrases the passage from "The Constructive Idea in Art" reproduced on pp. 212–13 [Ed.].

morphic image inherited by us from our primordial ancestry is still in full reign in the major part of our contemporary imagery. So long as our contemporary artists are incapable to see in a mountain anything but the image of some crouching naked figure, and so long as the sculptors are sweating in carving at various angles, this very graven image, keeping themselves in the state of mind almost identical with that of a Papuan or a Hottentot, the sculptor cannot claim to have acquired a new vision of the world outside him or of the world in him and science with all its achievements in advanced creations cannot possibly claim to have incorporated its new image of the world into the mentality of mankind. It is only through the new plastic vision of the coming artist, advanced in his mind, that science can ever hope to achieve this. I think that the constructive artist of today is qualified for just that task. He has found the means and the methods to create new images and to convey them as emotional manifestations in our everyday experience. This means being shapes, lines, colours, forms, are not illusory nor are they abstractions; they are a factual force and their impact on our senses is as real as the impact of light or of an electrical shock. This impact can be verified just as any natural phenomenon. Shapes, colours, and lines speak their own language. They are events in themselves and in an organized construction they become beings—the psychological force is immediate, irresistible and universal to all species of mankind; not being the result of a convention as words are, they are unambiguous and it is thus, therefore, that their impact can influence the human psyche; it can break or mould it, it exults, it depresses, elates or makes desperate; it can bring order where there was confusion and it can disturb and exasperate where there was an order. That is why I use these elemental means for my expression, but far be it from me to advocate that a constructive work of art should consist merely of an arrangement of these elemental means for no other purpose than to let them speak for themselves. I am constantly demanding from myself and keep on

Naum Gabo, *Bijenkorf Construction*, Rotterdam, 1954–57. This construction is the latest realization of Gabo's desire to work on an architectural scale, which was evident as early as his *Project for a Radio Station* of 1919–20. It also clearly demonstrates his utilization of biomorphic forms.

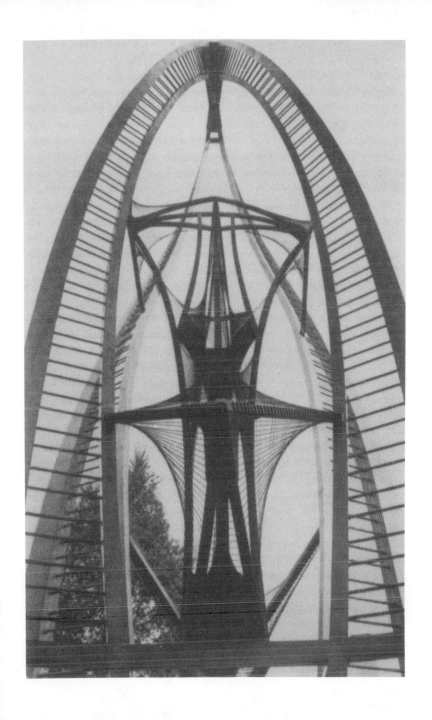

calling to my friends, not to be satisfied with that gratifying arrangement of elemental shapes, colours and lines for the mere gratification of arrangement; I demand that they shall remain only means for conveying a well-organized and clearly defined image—not just some image, any image, but a new and constructive image by which I mean that which by its very existence as a plastic vision should provoke in us the forces and the desires to enhance life, assert it and assist its further development.

I cannot help rejecting all repetitions of images already done, already worn out and ineffective. I cannot help searching for new images and this I do, not for the sake of their novelty but for the sake of finding an expression of the new outlook on the world around me and the new insight into the forces of life and nature in me.

We are living in a section of history of mankind when a new civilization is being forged. Many of us know it and more of us are talking about it, but few visualize what the image of that new civilization is. The majority of our artists and poets of today stand in a violent revolt against the new civilization. Many of them see in it a curse and a nightmare. They prefer to look for shelter in the civilization of the cave-man with all the consequences involved in a cave mentality. None of them realizes the very fact that the so-called new civilization is not here even in blue print. What we are living in is not the civilization we are striving for, and it is not a matter of our rejection or acceptance of this new civilization—it is a matter of creating it and defining its image clearly. Civilizations do not come to us from heaven in ready-made assortments to choose from. Civilizations are constructions of man; they are the result of a collective effort in which the artist has always played and still has to play, no mean part. We have to face this inevitable fact, that a new civilization must be built because the old one is going to pieces. We shall be responsible for every trait in the future structure of this new civilization—we, here and now, the artist, the scientist as well as the common man, are the builders of its edifice. How can we succeed in our task if we do not even try, nay much more, if we are not even allowed to try, to clarify to ourselves what its image shall be, what order and structure should prevail in this new civilization we are having to build.

We shall be heading straight into disaster if we take it for granted

that the main characteristic of the new civilization will consist alone in the material improvement of our surroundings; that the aeroplane and the refrigerator, the fluorescent light and the comfortable speed of our travels, the atomic clouds in our skies and the babel of our sky-scraping cities, that these are the traits of our coming civilization—we can be no further from the real image of it than by imagining it in this way. It is the man and his mentality, it is the trend of our aspirations, our ideals; it is our attitude toward mankind and the world which we have to acquire if we want to survive and to build something more propitious for the continuance of our life than what we have done up till now. It is the creation of new values, moral, social and aesthetic, which will constitute the main task in the construction of the new civilization. It is the establishment of new norms, by which I mean modes of thinking, feeling and behaving not in accordance with the wanton whim of an individual but corresponding to a constructed new image of man's relationship to mankind—it is all that, plus the reorganization of our external environment, the creation of the world we are living within our homes and in our cities; it is all this which will make our civilization.

The new forces which the human mind is placing in our power are vast and destructive as any force always is and will be; but in the command of man these same forces can be harnessed for constructive ends as always was the case since the reign of man in this world of ours began, and as it always will be. It is my firm belief that our new civilization will be constructive or it will not be at all. And as a constructive artist I believe that the former will be the case. Being satisfied that we constructive artists are capable of facing the task of building this new civilization of ours, I claim the right to participate in the construction of it; both materially and spiritually.

I could just as well have finished with that, but I hold it appropriate at this moment to add something specific in order to be heard not only by this audience, but by all who are giving so much attention, wanted or unwanted, to the so-called modern arts, to which ours also belongs. It is perhaps the only thing in all of my exposition of which I am convinced that most of my comrades will agree with me.

I want to issue a warning to all those who hold the chains of power over the world today; to the self-appointed dictators as well as to the properly elected statesmen; to the ordained commissars as well as to

the chosen heads of political departments; to the man in the street as well as to the self-appointed representatives of public opinion—I, the artist, the pushed and battered artist of today, warn them all that they will do better and will get more out of me if they leave me alone to do my work. They will never succeed, no matter how much they try, to enslave my mind without extinguishing it. I will never enlist in the suite of heralds and trumpeters of their petty glories and bestial quarrels. They may vilify my ideas, they may slander my work, they may chase me from one country to another, they may perhaps eventually succeed in starving me, but I shall never, never conform to their ignorance, to their prejudices.

We artists may dispute and argue amongst ourselves about ideologies and ideals—but nothing will more potently bind us together than the revolt against the blind forces trying to make us do what we do not believe is worth doing.

NICOLAS SCHÖFFER: Spatiodynamism, Luminodynamism, and Chronodynamism (1960)

Nicolas Schöffer was born in Kalocsa, Hungary, in 1912. He studied at the Academy of Fine Arts, Budapest, and, from 1936 on his move to Paris, at the Ecole des Beaux-Arts. His early work was considerably influenced by surrealism and expressionism. However, in 1947 he began to concentrate on spatial structures and reliefs and formulated his theory of "spatiodynamism." The article that follows traces the evolution of Schöffer's artistic theory and practice from that point. References are made to most of his major projects up to 1961: Cysp 1 (Cybernetics + Spatiodynamism), a construction that was part of a spectacle at the Théâtre Sarah-Bernhardt, Paris, in May 1956; and the two large cybernetic towers, the first of which was

From *Nicolas Schöffer* (Neuchâtel: Éditions du Griffon, 1963). Reprinted by permission of the author.

erected at the St. Cloud Park in 1954, and the second of which has stood in the Bouverie Park, Liège, since 1961.

Schöffer's work recalls the constructivism of the interwar period, even though he did not begin to work in this direction until after the Second World War. Comparisons have frequently been made between his "chronodynamic" constructions and the Light-Space Modulator *developed between 1923 and 1930 by his compatriot Moholy-Nagy. Yet it is just as necessary to point out the differences between Schöffer and his predecessors. He has little sense of belonging within a common tradition, much less a common group, and his theoretical writings are philosophical and impersonal rather than polemical. At the same time, he is able to make use of electronic devices far beyond the dreams of the early constructivists and to build structures larger and more technically sophisticated than any of theirs. He has moved, like the Russians of the 1920s, from sculpture to the architectural construction, and finally to the Utopian town planning of* La Ville cybernétique *(1969). Yet as far as completed works are concerned, his kinship would appear to be with the forms of drama and spectacle developed at the Bauhaus by such artists as Schwerdtfeger and Hirschfeld-Mack rather than with Russian architecture and planning of the same period.*

Spatiodynamism appears at the opportune moment and leads to a new plastic adventure in which the three dimensions reassume their dominant role. The essential aim of spatiodynamism is the constructive and dynamic integration of space in the plastic work. A tiny fraction of space contains very powerful energy possibilities. Its exclusion by hermetically sealed volumes deprived sculpture for a long time of possibilities of development both in the field of formal solutions and on the level of the dynamic and energy enhancement of the work.

Spatiodynamic sculpture is first of all created by a skeleton. Its function is to circumscribe and take possession of a fraction of space and to determine the rhythm of the work. On this skeleton is built another rhythm of elements, planes or volumes, elongated or transparent, serving as counterweights and giving to the marked-out space all its possibilities of energy and dynamics. Thus sculpture becomes an airy, transparent work, penetrable from all sides, achieving a pure rhythm of proportions with the logical clarity of a rational structure encom-

passing and amplifying the aesthetic and dynamic possibilities of the latter.

Its impact has no limit, it has no privileged face, it affords from every angle of vision a varied and different aspect even from within and from above. The vertical, diagonal or horizontal succession of the rhythms composed exclusively with right angles makes it possible to visualize in the space the most varied, because suggested, sinusoids.

The complex of straight angles becomes a mine rich in acute angles varying with the position of the viewer and excluding any possible repetition. The use of acute angles would be a pleonasm in spatio-dynamics and would inevitably lead to monotony. Whereas on a two-dimensional surface and the surface of a three-dimensional volume, the angles and the curves do not vary, having no relations in depth, when the structure is open there is a constant change of relation in depth according to the position of the viewer. Moreover, this constant displacement of the spectator's angle of vision on the one hand, and the transparency engendering proportional changes in relationships on the other, contribute powerfully to accentuate the dynamic effect of the work by giving it a life of its own even though it is inanimate. But this life is precisely the counterpoint of the animated life of the city that surrounds it. Naturally, spatiodynamic sculpture can be animated in its own way. Rotating axial movements on the vertical plane and on the multiple horizontal planes may be effected with rhythms carefully studied in relation to the plastic rhythm.

Spatiodynamics, which was the first stage in the research marking a break even with the immediate past, aimed at modelling space into an absolute. It constitutes a definitive break with traditional or even modern conceptions of the volumes of solids and voids. Opaque and palpable materials play only a secondary role. This conception of sculpture represented in itself, in relation to the past, such an innovation that no link could attach it to the latter, except the fundamental continuity which constitutes the characteristic activity of the creative artist, his will to go beyond.

Whereas in traditional art the material, colors, light, and their combination represented an aim in itself, spatiodynamism considers them as means which serve to produce, to determine and to dynamize a spatial fact. Here the aim is essentially one of energy, not a material one.

Nevertheless, the element of plastic revolution, that is to say the passage from matter to absolute space, is not totally realized by the processes enumerated. It is possible to foresee delimitations of space with well-nigh invisible and totally transparent materials, or with stroboscopic optical effects which will in fact make it possible to render the materials occupying the marked-out space invisible, or to immaterialize them.

In order to obtain these effects, technical means which likewise represent a new departure must be resorted to. The essential plastic aim of spatiodynamism is to transcend matter, as is done today in physics. If the plastic aim to be attained is one which relates to energy, it is logical that elements already possessing a certain energy substance should be used to this end.

These reactors, so to speak, are mechanisms adapted to purely plastic and aesthetic ends, and designed with this in view. More precisely, in the case of Cysp 1, for example, the energy-supplying element is electronic controls running on batteries, which also activate electric motors, while these in turn supply the driving power for locomotion, steering and animation. For the operation of this complex whole, electrical energy stored in these batteries is needed. The whole in operation can thus give rise to energetico-aesthetic phenomena on a very large scale. What we have, in short, is a transmutation of real energy into creative energy.

In respect to optical and stroboscopic problems, it is necessary to refer also to the use of rotating elements, having variable speeds, with a reflecting surface which is colorless on one side and polychrome on the other. When these turn, the stroboscopic effect is produced, communicating a sensation of immaterialization.

An interesting effect is obtained by reflecting surfaces in rotation which capture luminous and colored emissions, and reflect them in a great radius of action, thus considerably enlarging the spatial field of the work. The rapid displacement of the whole in movement is likewise a means of conquering adjacent spaces, and of enhancing its energetico-aesthetic power by the constant addition of elements.

The adding of sound represents another means of increasing the spatial power. Sounds derived from the work and processed electronically can be broadcast stereophonically, over considerable areas, by means of loudspeakers in a staggered series, and harmonizing

completely with the sculpture. The sounds broadcast and recomposed by the electronic brain contribute to developing the energy possibilities of the spaces surrounding the sculpture in a great radius of action. Sound, light, color, movement, electrical energy, electric motors, electronics and cybernetics represent a new technical arsenal with infinite possibilities full of unknowns.

Thus on the basis of spatiodynamic investigations, a new departure has been given leading to novel developments. After the use of space, light appeared with luminodynamism, the definition of which is simple: any space or surface delimited and differentiated into a number of *lumens,* that is to say charged with luminousness, possesses an attractive force which emphasizes the rhythm of structures. Light, whether colored or not, penetrates through the spatiodynamic work, and in lighting up the structures, the opaque or translucent surfaces, gives rise to plastic developments which liberate an immense potential of aesthetic values having a considerable energy and a great power of sensorial penetration. The light-sources may be static, mobile or intermittent, and the conveyed shadows, the colored projections, captured in their entirety or fragmentarily on appropriate screens.

Luminodynamism is thus the handling of a surface or a fraction of space of whatever size, in which are developed plastic and dynamic elements, colored or not by real or factitious movements (optical illusions). This development, if it is reflected on a surface, is accompanied by a luminous increase in relation to its surroundings, producing a differentiation measurable in a number of *lumens.* If it occurs in space, the light penetrates and passes through the spatiodynamic sculpture, increasing its luminousness, and produces on any opaque or translucent surface placed before the sculpture a supplementary luminous plastic development, thus coupling two visions which are different, but each condensed to varying degrees.

To bring about this luminous condensation and effect, a differentiation between the surface or the space singled out and its surroundings, it is necessary, of course, to have a source of light more or less strong according to the dimensions of this surface or this space, and according to the degree of illumination of the surroundings. The use of captured and directed natural (solar) light can also be envisaged.

Luminodynamism includes all investigations and all artistic (plastic) techniques which use light condensed and projected on an opaque

or translucent surface, or in a space made sufficiently opaque to give rise to a plastic visual unfolding having an aesthetic content. These projections can be cinematic or free. Cinematic projections concern cinematographic technique, and are predetermined on the visual as well as on the temporal plane. Free luminodynamic projections derive from a totally different technique without predetermination and without temporal limit. These techniques are based on the use of filters and reflectors which may be static or mobile, or both at once. The filters may be transparent, wholly or partially, colored or not, opaque or translucent, with various perforations. The surfaces receiving the projections may be opaque or translucent, fragmented or whole, perforated or continuous, smooth or having varied textures, monochrome or polychrome, fixed or mobile, artificial or natural. The objects used in the case of double development (surface or space) must be spatiodynamic, that is to say composed of structures and planes in dynamic development in space and, like the surfaces which capture the projections, integrally or partially opaque, translucent or transparent, reflecting or not, colored or not, immobile or mobile.

By integrating, in addition to color, sources of artificial light and projections which add to the three-dimensional effects supplementary two-dimensional effects, of equal importance, luminodynamism, the outgrowth of spatiodynamism, consummates the break with the past on the technical and conceptual plane, and, without sacrificing movement, achieves a real synthesis between sculpture, painting, cinematics and music. The ease with which luminodynamic works can be integrated into architecture makes it possible to add music to the components of the synthesis enumerated above.

Luminodynamic works have no place in the narrow and superannuated circuit of museums, collections, antiquities, etc., but become objects of daily use within reach of all, an article of mass consumption, a spectacle. It satisfies collectively the aesthetic needs of each, and at the same time eliminates all the harmful residues of sensorial and intellectual saturations.

The aim of luminodynamism is not to create a single, isolated object, reserved for a limited number of privileged individuals, but to create an element capable of affording spectacles on a grand scale, visible at great distances: large sculptures and their projections over thousands of square meters, whether in an urban setting or in na-

ture. On a small scale, luminodynamic works can be manufactured on a mass production basis and distributed like radios, television sets, etc., thus bringing art within the reach of everyone. Luminodynamism in itself represents a synthesis fated to become integrated in the immense mosaic of partial syntheses; it situates art in its purely human and social context, while maintaining continuity in quality and in aesthetic content.

We have now reached the last foreseeable stage of present-day evolution, in which time becomes the new raw material to be molded. Temporal architecture, or rather, the intemporalization of time, constitutes the great problem in which space, movement and light will be integrated as constructive elements.

The discontinuous materialization of time is not the exclusive apanage of motion pictures, it can bring together all sorts of disciplines having no apparent links, such as poetry, music, luminodynamic sculpture, etc. Which means that in artistic creation, thanks to this new material, a common denominator has appeared between the various expressions and techniques; it heralds a real synthesis by situating on the common plane of temporal discontinuity the auditory and visual arts by juxtaposing, superposing, mixing, counterpointing their development.

Speech, sound, movement, space, light, color, as they interconnect, will form structures with multiple counterpoints in an architecture both chiseled and flexible, without beginning or end. Their reciprocal action will engender developable series to infinity, which will burst the temporal limits imposed up to now. The chronodynamic work, in a word, is *continuous discontinuity*. The multiple visions of this whole with its perpetually varied rhythms nevertheless preserve the quality of the spatial structure determined by the will of the creator. The combined elements (spatial, luminous and optical structures) have between them relations which are predetermined but modifiable, both spatially and temporally; these initial relations, while they influence the unfolding of the general meaning, especially the aesthetic meaning, are in no sense quantitatively limiting. Thus indeterminism conditions the successive aspects whose number is infinite and whose organization is unforeseeable. In the permanent accomplishment of the chronodynamic work, change, through the medium of time, plays the role of a catalyzing agent. By this process a certainty rigorously

structured at the outset gives rise to uncertainties to which it transmits its proportional qualities. The final result is determined by the success of the initial spatial and temporal structuration.

Chance can be "directed" by the action of different natural agents (weather, the mood of crowds, etc.) which intervene in choosing a rhythm having variations predetermined to various degrees by virtue of cybernetics (see works at St. Cloud, Liège, Cysp 1), or else by the direct action of an interpreter (musiscope, luminoscope, multiphased spatiodynamic work of art). It follows: 1. that the rigorous construction of a work is qualitatively determined by its basic structure and determines it in turn; 2. that the temporal multiplication of the work is effected by the reciprocal action of the component factors, without these being transformed isolatedly as in the principle of catalysis; 3. that the organization of the component factors determines its functioning.

It is clear that any process which tends toward a temporal liberation, that is to say toward an infinitesimal multiplication of its virtual possibilities, necessitates first of all a rigorous structure. Initially, indeterminism is at the origin of all creation. The creative instinct plunges into chaos in order to extract therefrom the possible combinations among which it then chooses; it is only then that reasoning determines and develops the idea which crystallizes into a fixed form in accordance with the classic conception. We here witness the passage from the determined to the indeterminate, from a disorder to an order. But order as well as disorder crystallizes a situation. The periodic appearance of academicisms is representative of polarized orders. "Two catastrophes threaten humanity," as Valéry used to say: "order and disorder." And so an inexhaustible series of moving visions springing from a single original structure occasion constantly renewed aesthetic effects. They avoid saturation, in contrast to the conception of the static type, and correspond to the needs of a dynamic society.

Only order and organization can produce a disorder of quality, the process cannot be reversed. In artistic creation, a fugitive aspect of disorder cannot become the generator of order any more than it can enrich disorder. Yet the initial phase of investigations has a surplus value as compared to the final phase. Because of the indeterminate factors that it conceals, and the openings that it promises—although

these are not always taken advantage of—a barely organized disorder appears more precious than crystallized order. The awareness of the intrinsic value of indeterminisms makes it possible to envisage the evolution of creation in general in a constantly open and sinusoidal form. The introduction from the outset of indeterminisms latent in the "germ" prevents the coming into effect of absolute order, and by the reflection of the movement in an open angle causes it, after having reached a certain order, to return to a tendency to disorder and to swing once again toward order while avoiding the danger of the two antithetical poles.

Closed forms give way to open forms, and this opening is possible, in works having a temporal structuration, by virtue of the introduction of external parameters whether independent or not of the will of the work's creator. The intervention of an external parameter gives rise to non-predetermined optical or temporal anamorphoses, or to both simultaneously. *Optical anamorphoses are the different mutations of the basic structure, taking no account of the "time" element, that is to say that they can be grasped by elements isolable and separable from their context, capable even of becoming mutated structures, and capable of giving rise to or undergoing new anamorphoses. It is a perpetual recreation.* By anamorphosis we mean mutations, which can be extensive or restrictive, distorting or constricting, linear or spiraled, circular or angular, rounded or pointed, coloring or discoloring, harmonic or disharmonic, etc. Any constructed work lends itself the more readily to these anamorphoses as its structure is rigorous. Rigor plus indeterminism equals infinity. Any opening in form is occasioned by the reciprocal action of these antinomies.

It is possible to invent a family of forms rigorously selected and structured, to open these forms by the introduction of one or several parameters and to produce anamorphoses either in jerky rhythms, by stopping at mutated aspects, or in a rhythm continuous in time. By the fixing of different stages anamorphosis makes possible the multiplication of the object without deteriorating its value. It provides the means of industrializing the work of art. Its continual evolution renders it non-saturable and the present possibilities of distribution (motion pictures, television) can socialize it. As a result of these data we are led to examine the mechanism of the creation of a chronodynamic work. Once the sectors and the factors are chosen, it

is essentially composed of two phases, the first being one of elimination, the second one of combining. In the second as in the first the choice and the elimination occur in the second degree. The role of indeterminisms and of anamorphoses is a double one. One sets out, *a priori,* with a certain number of indeterminisms in the first phase of choice and elimination. After choice, the anamorphoses intervene to situate the latter in an even more unforeseen way and increase the degree of liberty achieved. Anamorphosis is a lever of superpower which at the outset multiplies the energy data tenfold. In the second combining phase, the indeterminisms and anamorphoses intervene, on the other hand, *a posteriori,* for the more rigorous the construction, the greater the possibility, through indeterminisms, of "opening" this structure and unveiling its hidden riches.

It is further possible to introduce factors of indeterminacy and new anamorphoses in the development of the process of creation by inverting the eliminating or combining phases and by adding still others.

In discovering a new chapter of creation, we grasp its intimate mechanism, we forge the process of creation itself, without taking account of the work (the result), which will necessarily be an open work with multiple facets, appearing at the whim of choice and anamorphoses, and at the same time being aesthetically determined. The nature of these relations of proportions, the conscious or instinctive means that govern it, will be immutable. Here we do not create a work, but a quality in constant fluctuation in time, possessing a rhythmic or modular specificity altogether its own.

The predetermined, fixed, atemporal work is a thing of the past; the artist transposes the act of creation, and situates it in himself, essentially, he detaches himself from the result of the work. What interests him is to create a quality in an open form, with a solid hold on time. He juggles with indeterminisms, with anamorphoses, he chooses and eliminates while combining and switching. He sets his work into motion in time, and the work in turn sets the creation into motion, and the creator, as well as other creators, who can find inspiration in the original work.

The work assumes multiple phases, or discards them, discovers its riches, in complex combinations or by isolated but ever significant particles; unceasingly it brings out the worth of the conceptual initiative.

The artist no longer creates one or several works. He creates creation.

VICTOR VASARELY: Planetary Folklore (1965)

Victor Vasarely, who was born in Pecs, Hungary, in 1908, has closer connections with the constructive tradition than does his compatriot Schöffer. He studied at the Hungarian Bauhaus (the Mühely) in 1928–29 and moved to Paris in 1930. From its inception in 1947 he exhibited regularly at the Salon des Réalités Nouvelles. But such a large and amorphous grouping was clearly unsuited to the growth of new tendencies and the exchange of new ideas. Vasarely was more centrally concerned with a commercial gallery, the Galerie Denise René, which he helped to found in 1944 and maintained as a stronghold against "informal" art during the subsequent years. In 1955, the gallery came of age with the "Mouvement" exhibition, to which Vasarely himself contributed two "kinetic" compositions and a group of "Notes pour un manifeste."

The fact that the "Mouvement" exhibition contained works by artists as disparate as Agam, Pol Bury, Calder, Duchamp, and Tinguely compels us to define Vasarely's relationship to constructive art more precisely. Like Schöffer, he shows clear affinities to some of the artists of the Bauhaus (e.g., Albers). Like Schöffer, his theoretical reasoning leads him from consideration of the individual art work to planning for the future of society on the widest possible scale. One step beyond the "cinétisme" of Vasarely lies the type of controlled communal experiment undertaken by the Groupe de Recherche d'Art Visuel, which both implicitly and explicitly diverges from the constructive tradition. Yet Vasarely's program, as explained in the following passages, can be plausibly seen as a solution to the I.F.d.K.'s call for a "systemization of the means of expression" according to "elementary"

From *Vasarely* (Neuchâtel: Éditions du Griffon, 1965). The text is based on notes assembled from 1960 on; the exact dates are given in his *Notes, réflexions*. This translation is by Haakon Chevalier (with emendations by Stephen Bann). Used by permission of the author.

bases, which would then permit the grounding of art and architecture upon formal constants. Vasarely revives the prospect of a modern, geometrically based classicism, which was never far from the minds of such artists as Van Doesburg and Lissitzky.

The concept "art" is a relatively recent idea. Indeed Antiquity and the Renaissance knew the master but not the artist. The statue, the fresco, were incorporated in architecture in the form of elements that were both decorative and informative. It was the excavation of archaeologists that removed torsos and ancient fragments from their places of origin and presented them in a new setting, raising them to an incomparable level. Henceforth, reanimated by the sensibility of Western man, these objects acquired a life of their own in the museums. This too was illusory! Have they not been despoiled by time and rendered unfaithful by the hands of conservators? The discovery of "savage magic" accentuated the movement in the direction of the "art object" which was no longer an integral part of architecture, but merely created for itself an atmosphere, in a capricious and wayward manner. Swept along this path, contemporary easel painting, collage, sculpture, and relief never had an architectonic function, merely a poetic and autonomous one. The divorce between painting-sculpture and architecture had been accomplished.

The work, having become an "object," detached in this way from a plastic complex, exhibited, possessed, and treasured for its own sake, has singularized itself and become congealed in obedience to this simple function, a "poetic function," in the service exclusively of a refined elite. Of this historic reduction we are the witnesses. An aesthetics of "gratification" thus replaces for a time that of an "integration" of which the possibilities are limitless. Radiating infinitely beyond the framework of the museum or collection, the work fulfills its true objective only in concrete ensembles, where it assumes multiple functions, such as cultural plastic functions, utilitarian plastic functions, urban plastic functions, and those of pure research in perpetual renewal, the only ones that can bring the work within the reach of all levels of intelligence—objective values—and all degrees of sensibility—subjective values.

The fundamental fact of "integrating" the work in the community at once justifies the adoption of techniques of distribution and

implies the idea of "gift." And indeed this idea flows naturally from the technical and conceptual transformations that have developed slowly in the works of precursors. Let us therefore offer highly faithful reproductions of the great works of the past (cultural pre-education) and of the re-creations based on constants of the decisive works closer to us (adaptation of knowledge in aesthetic matters) to educate the eye; a master plate, which is both one and one hundred thousand, is infinitely more worthwhile than those pretentious and yet mediocre "contemporary originals" that splatter the walls of galleries and homes. Let us now speak of architecture, which for its part evolves under the aegis of the discoveries of science and technology. In cement, glass, metals, coatings, synthetic plastic materials, prefabricated elements, it finds both the new construction materials that the imperatives of the period call for—hygiene, light, economy, social solution —and at the same time intrinsic aesthetic quality. The representation of biblical, historic, or anecdotal images with which it formerly adorned itself was but a supplementary and distinct adjunct intended to provide the element of information and aesthetics that the period called for. These same elements—information and aesthetics—today find their natural expression in a field which is appropriate to them: art publications and motion-picture or televised projections. The fresco no longer appears to have a *raison d'être,* even were it abstract. For in this case it would only be a matter of controversy between the figurative and the abstract. I find no fundamental difference between two approaches that use the same materials, technique, and function. At most there are divergences: whether named or unnamed objects are involved, a nonintegrated application is still in evidence: we want no more of the Renaissance! Architecture thus liberates itself from its age-old routine, breaks its ties with painting and sculpture, and inaugurates a new path, that of purely rational beauty.

The most important feature of these last decades is without doubt the advent of the new architectonic polychromy. The rigorous paths of classical abstraction (constructivism, suprematism, neoplasticism) have led, through successive eliminations, to the painting of the Mondrian type: aspatial, horizontal-vertical, with three dominants plus black and white. This is an apotheosis and a terminal threshold. The severe bidimensional principle—apart from monotonous variants— can hardly give rise to any further fundamental innovations in the

plane of the canvas, which performs an act of abdication by dissolving into the wall. With the birth of architectonic polychromy we have had the rare good fortune to witness one of the phenomenal mutations of art, so necessary to its survival. But this polychromy, capital as an idea, was in reality becoming timid and disappointing. The thin film of pigments was less and less in evidence as the mushroom blocks of houses came into being. This despite the advent of "colorist-counselors," intermediaries between the architects and the painters. Some of the latter had to think their discipline through again from the beginning in order to attune it to the imperatives of this architecture which was undergoing an expansion unprecedented in history. A population growing by leaps and bounds and a host of corollary problems (sociological, ethnic, ethical, psychological, aesthetic) designate architecture as the principal locus of plastic preoccupations. Away with the aims of yesteryear—the art of the present—if we may call it so—will stimulate the human biochemical complex and will aim to be harmonizing, balancing: a factor of well-being and of joy.

The polychrome city—polychrome especially in the sense of the diversity of its inner and outer coating materials—appears to me to be a perfect synthesis: the fundamental principle of the conjunction of the arts restores all the plastic disciplines in their "complete function." The polychrome city, indeed, proposes its most coherent application at this point of history at which we find ourselves, after Mondrian's and Malevich's revolution. That the harmonic principle is eminently called for by the factor of historic evolution should in itself be a source of satisfaction to us. But it must be added that the polychrome city achieves the only architectonic synthesis that is of such a nature as to associate the plastic value of a physical space with a real psychic dimension that implants this space-form-color in the universal consciousness. The image of such syntheses that proposed a space and its form of specific extension in a social structure was given, for example, in the Gothic period. "Gothic space" was first of all the cathedral and its plasticity, but it was above all the hold that mystical faith had on the faithful souls of the time, for which the cathedral, like a *perpetuum mobile,* manufactured mysticism. Like the syntheses of remote times, the polychrome city, today's synthesis, is in fact the concrete construction capable of essential extension: it is this that best manifests a psychic dimension of the

physical linked with its adequacy to the present-day social structure. For formerly castle and cathedral emerging from the mist signified the reign of the prince and of God, these works were unique. At the height of the human pyramid, they constituted the ideal and the style. Today the suburbs and outskirts of the big cities themselves secrete their necessary constructions which spread as far as the eye can reach. The new promotion of humanity passes first through the stage of the improvement of its living conditions, these being linked to productivity, which is itself the criterion and the *raison d'être* of our highly technical civilization. There is accordingly a slow transfer from the height of the pyramid toward its base: henceforth the princes of knowledge will serve the multitude and the work of art will be generous and the style inclusive.

In 1955 I defined the principle of the identity of two concepts which until then had been separated: that of form and that of color. Henceforth *form-color:* $1 = 2$, $2 = 1$, constitutes the *plastic unity*. The unity is composed of two constants: the kernel "form" and its complement that surrounds it: the square "background." Apart from its "biform" aspect, the Unity necessarily possesses a "bicolor" aspect which is harmonious or contrasting at the same time as positive-negative. Being thus contradictory, the resolved unity is a pure dialectical synthesis.

Every unity is proportionally reducible-extensible, which gives us the whole range of magnitudes, hence the *mobile scale* in composition. Their "square" character offers the maximum of controllability and an arithmetical reference at base. With an alphabet of thirty "form-colors" at the level of the Unity alone, we already have several thousand virtualities by simple permutation of twos. According to the number of Unities entering into the composition (for example, 4, 9, 36, or 400 . . . and more), as a result of more complex permutations (black-white, black-colors), by virtue of the use of progressive magnitudes (combination in the same composition of position of units 2, 4, 8, or 16 times bigger), finally by mirror-images, the multiple directions, the mono- and multichromatisms, the alternation of vibrating and silent areas, we can obtain a practically infinite number of possibilities.

The advent in the plastic arts of a *combinatory* of this scope offers a tool having a universal character, while at the same time permitting

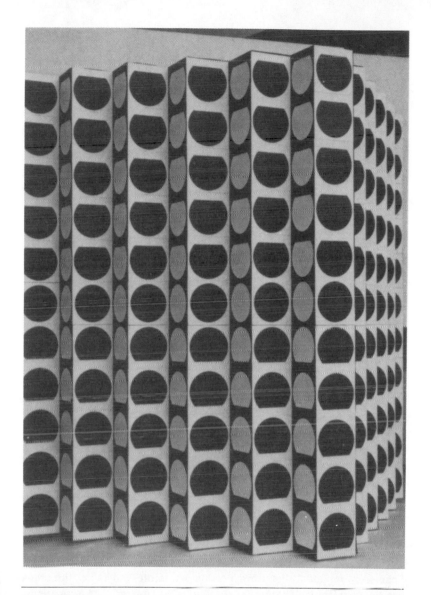

Victor Vasarely: *Relief,* 1963. Vasarely's investigations in the plastic
arts led him around 1955 to the notion of plastic unity, or the "kernel
'form' " on a square "background." As his subsequent work has shown,
there are obvious architectural implications in such a scheme of formal
constants on a rectangular grid.

the manifestation of the personality, as well as that of ethnic particularisms. We already perceive the contours of a true *planetary folklore,* modern in its idea and in its technique; unitary at the base, highly complex at its summits.

Why did I choose the square plastic unit? Because the square is the pre-eminent element of architecture. If I say square, I also say tiling or prefabricated wall, and I can accordingly enunciate the following postulate: if it is possible to manufacture neutral, commonplace, or ugly building materials (and the proof of this is provided by the cheap buildings to be found throughout the world), it is certainly possible to manufacture interesting and beautiful ones. The traditional technique of wall coating (ceramic tiling, sandstone, colored cement) and the new techniques of prefabricated elements (in glass, metals, and synthetic materials) provide us with materials constituting the outside and the inside of dwelling cells. These cells form the organic fabric of the city. Let us endow these materials *at the outset* with sensitive qualities and the perfect synthesis will be accomplished: *the unity of construction will also be the aesthetic unity giving an intrinsic, and not an added plasticity.*

A technique of embellishment intrinsic to the functional will open the era of the continually new. The "Eternal City," with its fakes, its ruins, its deterioration, will see growing round it ever-new building blocks.

Where are we in practice? At the stage of concepts, of shop experiments and of a few compromise examples. Like the viable species of nature, the viable species of consciousness must overcome all resistances, including those of time. Let us first of all kill in ourselves egocentricity. Only teams, groups, entire disciplines will henceforth be capable of creating; cooperation among scientists, engineers and technicians, manufacturers, architects, and plasticians will be the work's prime condition. More and more numerous are the artists who —either in a fumbling or a conscious way—are elaborating this "planetary folklore" that I am postulating. More and more numerous are the contacts with extrapictorial circles to concretize investigations. The art-idea is abandoning its centuries-old mists to flourish in the sunlight in the immense modern network that is being woven round the globe.

From *Structure* (1959-64)

Ten years after the end of the Second World War, the constructive tradition in Europe and America was represented by a number of small and unrelated groups. In America, Biederman was in touch with younger artists, such as Joan Saugrain, the recipient of his Letters on the New Art. *In England the group of "constructionists" who had made contact with Biederman were brought together in the publication* Nine Abstract Artists *(1954). In Paris, Vasarely and Schöffer took their individual paths while previous members of Abstraction-Création continued to exhibit, with many others, in the Salon des Réalités Nouvelles. Finally, there were still representatives of Van Doesburg's concrete tradition in Germany and Switzerland—in particular Richard Lohse, of Zurich, and Max Bill, who had left Zurich to found the Hochschule für Gestaltung at Ulm in 1950.*

The task of bringing these individual artists and small groups to a common forum was to be performed by Joost Baljeu's magazine, Structure. *Baljeu, who was born in Middelburg, Holland, in 1925, ceased easel painting in 1955 and began to work on reliefs and spatial constructions. At around this time he was a coeditor of the Dutch art magazine* Parnas, *which reflected this new interest. In 1958, he set up a new magazine that took over several of the contributors to* Parnas, *and concentrated exclusively on the constructive direction. This magazine, which was launched in collaboration with Eli Bornstein, who shared the cost with Baljeu, was called* Structure.

After the first issue, Bornstein broke away and founded his own magazine and group, The Structurist, *both of which still flourish in Canada. Baljeu continued to publish* Structure *until 1964, and as the following selections show, he managed to publish articles by a wide variety of artists. His comments on the German Zero group in "The Constructive Approach Today" and his letter to the Groupe de Recherche d'Art Visuel in* Structure, *4th ser., no. 2 show that he was also alert in castigating forms of art that appeared, on a superficial level, to be within the constructive field.*

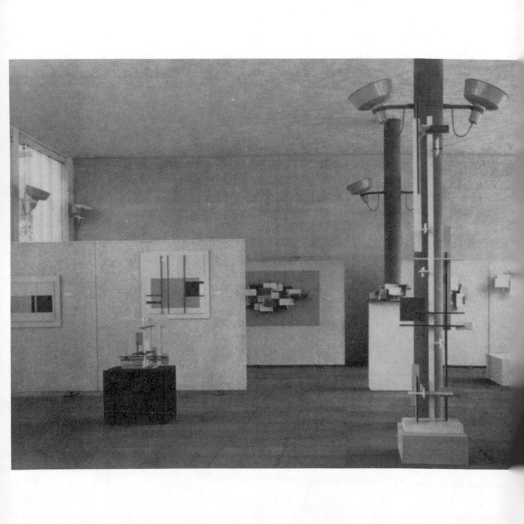

Of the contributors, Biederman was one of the most regular and wide-ranging. British artists who were acquainted with Biederman's writings also took an important part. Anthony Hill, who was born in London in 1930 and started making constructional reliefs in 1953, takes up the problem of the relationship of the art work to "Nature," which had occupied a central place in Biederman's analysis. It is worth noting that the article included here, which dates from 1959, was translated and reprinted a year later by the Yugoslav magazine Covjek i prostor, *no. 104. In view of the fact that Zagreb, the place of publication, was to be the site of the first international Nouvelle Tendance exhibition in 1961, this link between British constructivism and Yugoslavia is of particular significance. Anthony Hill has remained faithful to his early conviction that the constructive artist should promote theoretical discussion among his fellows on an international scale. His anthology* DATA—Directions in Art, Theory and Aesthetics, *published in 1968, is by far the most illuminating and comprehensive recent survey of attitudes toward the constructive tradition.*

The two other contributors quoted here both extend the notion of construction into new areas that reflect their own concerns. Lohse, who was born in Zurich in 1902, suggests that the constructive approach should be modified substantially to take account of the infinitely more complex structures that artists are now discovering and exploring. His distinctive contribution to the postwar development of constructive art has been in the systematic use of the color series from 1943 onward. His influence can be detected in the work of the British painter Jeffrey Steele and in other contributors to the Systems group exhibition (Whitechapel Gallery, London, March 1972).

Kenneth Martin, who was born in 1905 and made his first kinetic

"Experiment in Constructie" exhibition, Stedelijk Museum, Amsterdam, 1962. This exhibition consisted almost exclusively of works by contributors to *Structure:* Joost Baljeu, Charles Biederman, John Ernest, Jean Gorin, Anthony Hill, Mary Martin, and Dick van Woerkom. Later in the same year it was mounted at the Kunstgewerbemuseum, Zurich, under the title "Experiment in Plane and Space." The three works on the left and the vertical piece in the foreground right are by Gorin; the others visible in this photograph are by Baljeu.

constructions (mobiles) in 1951, is directly concerned with chance, which, he observes, has its own "strict laws." With his wife, the late Mary Martin, who was almost exclusively concerned with relief constructions, Kenneth Martin has undertaken one of the most controlled and effective investigations into the aesthetic of construction in the postwar world. Among those who have benefited directly from his teaching are two other members of the Systems group, Peter Lowe and Colin Jones.

ANTHONY HILL:
On Constructions,
Nature, and Structure

I don't think "constructions"—meaning an art work—is a term as well understood by the public as the artist who makes them realises. The cognoscenti who know about "isms" have heard about constructivism but a *form of art* which is neither painting nor sculpture and has not an invented name like "mobile" or "stabile" is at a disadvantage.

The term construction is a very general one and can be confusing like the terms "concrete" or "plastic."

We think of constructions as non-figurative and non-volumic but of course there are non-volumic constructions (sculptures) which are not abstract. A mobile is a construction par excellence and so were Moholy's "light modulators."

Much art is constructed while being two-dimensional, there is a feeling that constructed works are mathematical and that only constructed art is mathematical, this of course is not true; one need not be architectonic if one is mathematical though it might be held that

From *Structure* (Amsterdam), 2d ser., no. 1, 1959. Reprinted by permission of the author.

to be mathematical—which can mean geometric, arithmetic or topological—is to think and work *structurally* in a particular sense attaching to the process rather than to the look of the finished work.

What I have to say employs the word "construction" to refer to an art work a type of which I make—"constructional reliefs"—and for the purposes of this article I shall not go into the origins and other questions relevant to constructions as an emergent "art form." The two words "nature" and "structure" are far greater problems, the confusion that arises when they are mentioned constantly and made key words in arguments is a sign that confusion at the epistemological level is not only reflected in art but that confusion in art exists as much on account of confusion outside of art as it does because of dilemmas more peculiar to the problems of art.

Due to Charles Biederman these problems have been taken up by artists who accept the construction as the successor to the old domains of painting and sculpture.

The *"question of nature"* is the dividing issue and it would seem essential for artists to tackle the problem of "nature."

What follows is not epistemological but an attempt to analyse on the basis more of "operationalism" and "significs" with the intention of elucidating facts and the elements of the situation rather than that of propounding a credo or a system.

In 1953, before I had started making constructions, I wrote in "Nine Abstract Artists" that I considered the problems for the artist were threefold and I distinguished the syntactic: relations in the constituent structure, the internal plastic logic. Semantic: relation of the internal structure to the structure of the external—reality.

Pragmatic: the relation of the syntactic and semantic thematic issues to the integral problem of the plastic environmental realm (the total visual domain and its place in man's spiritual hierarchy).

Six years later (1959) I arrived at the following scheme:

The work as:	A	object	B	sensation	C	presentation
		physical		physiological		thematic
		technic		perceptive		mathematic

Its significs:	A	Pragmatic
	B	Semantic
	C	Syntactic

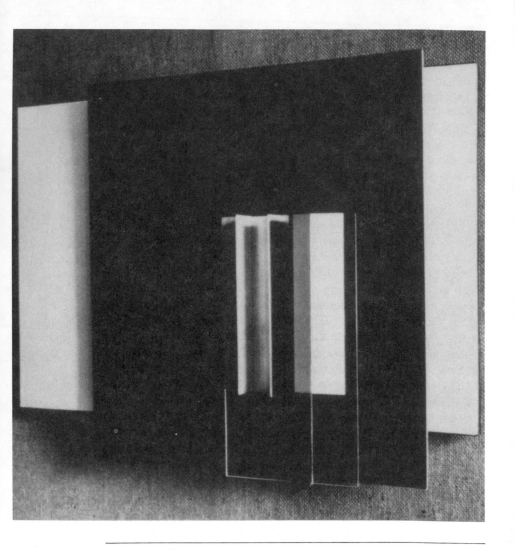

Anthony Hill: *Relief Construction,* 1959. From 1950 on Hill has investigated the problems of plastic art on three levels: the syntactic (that applicable to visible structure), the semantic (that referring to the structure of reality), and the pragmatic (that of the relation of the art work to the total visual domain). He has consistently worked toward the establishment of a unified aesthetic derived from the constructive tradition and has represented this aesthetic not only in his work but also in his writings. (*Photo Roger Mayne*)

This came about from my attempts to adopt or apply the "disciplines" of semiotic and operationalism to the situation of the work of art, how it functions and how we use it.

Before enlarging on this it might be worth while quoting from P. W. Bridgman, "The Nature of Physical Theory," even if what he says makes my attempt look all the more ineffective in the light of what he says, which is that: "Ultimately the most important thing about any theory is what it actually does, not what it says it does or what its author thinks it does, for these are often very different things" and "The most important technique of criticism is the technique of clearly apprehending and reporting just what one actually does, or what is actually happening in any situation and this is a technique which is not easy to achieve and in which one becomes more expert only by continual practice."

The questions to be answered are:

1) Why constructions?
2) What is the relationship of a construction to nature?
3) Why orthogonal planes?

These one will seek to answer by applying the analytical scheme with its three main divisions A, B and C; the scheme seems to me applicable to any work of art, while not attempting to be exhaustive.

Section A treats the work as a brute physical stimulus and as an object. A full characterisation of the object as a piece of construction would contain an account of the materials used, the enumeration and description of the parts, its weight, manner of construction, etc., in the case of the type of work we are considering—constructional reliefs—all this is very relevant and applicable.

The eye must explore and added information must come from testing by touch so that finally the object can be "known."

Section B is concerned with the scale of the object and the various thresholds relevant to its perception; this is an attempt to say "what operates."

Section C is concerned with the reasons for the particular choices in A and B and attempts to deduce its "theme."

A will deal also with the situation that the thing has a context in which it operates, a physical one, B will compare the structure of the object to that of its context and C the relevance of the theme. A also

goes all the way and asks what is the effect of this total experience on one's notions pertaining to other situations with which it is ultimately related.

Naturally each category is co-existent with the remaining ones and perhaps the scheme is both closed (in its circularity) and open because of its attempt to investigate empirically what is in one sense an empirical situation. To the extent that certain issues would appear to be (at present) settled—such as the nature of the object—there is determinism and to the extent that other issues are open it is empirical.

Concerning the nature of the object, we have already said something and laid aside a detailed account of how constructions came about, which is art history, but the question can be asked another way; constructions of the kind we are referring to are for Biederman so intimately welded to his conception of abstracting from the structural process level of nature in order to produce an invented art work which is reality orientated, that, if an artist is making constructions from any other standpoint he might seem to be merely yet another "modern artist"—an anti-nature phantasist—and not a realist.

Those of us for whom this applies are of course to be asked, "Why do you use a rigorous vocabulary of orthogonal plane structures, as Biederman does, but reject his arguments about why *he* uses it?"

One reason for this article is that I have been asked by Biederman why I do not accept his fundamental notions, why I go any way at all in his direction. The reasons I make constructions are different to those of Biederman though I do accept some of his contentions, but since I do not work by abstracting from the structural process level of nature the difference is very apparent. If I do not abstract from nature, what are my reasons for working (1) in a limited three dimensional space—that of the constructional relief; (2) with a limited form vocabulary—orthogonal planes, etc.; and (3) what is my thematic (is it mathematical?).

These questions I believe to be so closely linked that one cannot answer one without answering the others and that in answering all three one will be dealing with "the question of nature."

A construction is a piece of "pure architecture" the purpose of which is to produce excitations within the context of form elements and relations ordered by some coherent thematic.

This I would contend must be true of Neo-plastic work and suprematist work, a Gabo or Pevsner, a Biederman, in fact any work which is a purely invented abstract artifact—I take it to be an essential function intended of the work although there may be and undoubtedly are *other intentions.*

The way this idea is put to work, the special emphasis, these will depend upon what additional intentions and contentions the artist adheres to.

What could be said to be relevant factors which account for a construction taking the shape that it may have? I would answer: the practicalness of making (the possibilities of technique) relevant to the practicalness of perceiving (or appreciating) relevant to the desirability of the first two situations at the same time of that of comprehension (or apprehension) relevant to the whole experience. But in order to make the clumsiness of the above a possible intelligible explanation we must consider real examples.

Every construction presents a thematic and is likely to embody particular intentions—the artist's credo. If one was conversant with all existent credos in constructionist art then there would be no difficulty in being able to recognise these in works and being in a position to say, "This is a work by x or one of his followers and we may be sure it contains a y type theme . . ." etc.; but lacking such knowledge if we are standing in front of a work whose author or whose tendency we do not immediately recognise, there remains the question—can we deduce all the relevant factors simply by analysing the work? We now proceed to actual examples, I shall be speaking of reproductions only in the case of such artists as Biederman and Gorin, as my experience of actual works is limited to those of English artists for the most. The caption to any reproduction should inform us of the dimensions of the work and the materials and their colour, with this information we do the best we can with the evidence the reproduction avails us. With this we try to imagine what it would feel like to be looking at it, but we may be informed further of the intention of the work and its thematic if clues to this are given by it having *a title,* the date of the work is always useful too.

In AEVK [*Art as the Evolution of Visual Knowledge*] Biederman reproduces sixteen of his own constructions, these are representative of the years 1938, 1939, 1940, 1941, 1945 and 1947 and the cap-

tions give the dimensions and materials; none have specific titles.

Subsequent works of the years 1949, 1951, 1953 and 1954 appear in "Structure" 1, and "Mondrian or Miro" and here the captions omit all information save that each work is a construction—in fact a relief of course.

With these reproductions I have become as acquainted as it is possible to become with the actual *work* of Biederman while through his texts and correspondence with him I have become acquainted with his *ideas*.

What I have not become acquainted with is Biederman's operational methods and approach, the bridge one might say between the work and the ideas.

On the evidence of the illustrations in AEVK Biederman only settled for orthogonal form relationships four years before the completion of the text of his book, that is, about 1940. Since 1951 he has abandoned the use of transparent planes (glass and perspex) and also metal and plastics and has concentrated on working in wood with the addition of paint (colour), his form vocabulary has stressed the plane and orthogonal line elements (thin strips of planes, in fact parallelepipeds as are the planes but with an appropriately larger breadth).

Analysed syntactically what can we evince from a typical Biederman construction (say one of 1953)? As I have said, Biederman will not be found to have said much himself and apart from the self-evident manifestations of the over all orthogonal relations what further might we safely deduce? Rather than pursue this I shall attempt to answer the question as it might be addressed to myself. (It is to be hoped that other artists will do the same, notably Jean Gorin who appears to lean towards the mathematical and not limit himself to the relief or architectonic schemes, neither to explain his use of the orthogonal, where he uses it, and an application of the notion of abstracting from the structural process level of nature.

(There are quotations from unpublished manuscripts of Gorin in AEVK but these give us nothing in particular related to "syntactic" problems.)

As I have explained, I do not deliberately abstract from nature; what I present is a pure presentation from which nothing is to be interpreted as standing for anything or expressing anything—unlike Mondrian where the formal syntax functioned symbolically as well

as plastically. The stimulus for a work is the result of thought and experiment around the idea of the construction as an object to excite. The work ultimately effects an excitation on the whole mind-body aspect of the onlooker, through the eye, the eye and the brain and finally a complete bodily reaction which is hard to describe.

I work empirically in what could be termed a sphere of restricted improvisation. I am interested in the possibilities of the simplest form of spatial determination in conjunction with a visually comprehensible thematic all within the particular limitation of threshold and dimension relevant to the production of a plastic experience for contemplation.

An aspect of Mondrian that I feel to be important is his interest not in space expression but space determination, when Mondrian said that, "The culture of determined relations had begun" he is bound to suggest different things to different people, just as when he says, "The principal object of occidental culture is to render man conscious."

This type of statement refers to the intentions and beliefs of the artist and these will always be found to have an important role to play in determining the way the artist manipulates his material. The ambitions, predilections, conscious or unconscious are what finally count, the temperament of the artist and his desires.

Mondrian writes: "Art constructs, composes, realises. The expression of art follows the trend of life and not that of nature." We have to interpret this in the light of what we know of Mondrian but we could expect quite different types of artists to have made such a statement. I feel more sympathetic to the idea of a counterpart to the domain of sound, sensation that is music in a domain of pure visual sensation, once again relevant to the present stage of the developing convention that allows us to pursue such a thing.

I am therefore interested in the response to the special stimuli that are operating in such a thing as a purely invented abstract art work such as the construction is. I am interested in the perceptive mechanisms, that of the physical experience—sensation—and the mental, which might be described as pure thought patterns and ultimately is seen to be mathematics.

In "Consciousness, Philosophy and Mathematics" Brouwer writes: "But the fullest constructional beauty is the *introspective beauty of mathematics*, where instead of elements of playful causal acting, the

basic intuition of mathematics is left to free unfolding. This unfolding is not bound to the exterior world, and thereby to finiteness and responsibility; consequently its introspective harmonies can attain any degree of richness and clearness."

Brouwer was referring to "Constructional beauty, which sometimes appears when the activity of constructing things is exerted playfully, and, thus getting a higher degree of freedom of unfolding, creates things evoking sensations of power, balance, harmony and acquiescence with the exterior world."

In conclusion Brouwer writes, ". . . intuitionistic mathematics is inner architecture, and [that] research in foundations of mathematics is inner inquiry with revealing and liberating consequences also in non-mathematical domains of thought."

The mental concept of architecture need not have any relation to our experience of architecture as "buildings" but is more likely to be an amalgam of a strictly mental notion of the things described by Brouwer and the abstract possibilities of structural phenomena in the three-dimensional space of our experience—all of which is so much pure behavioural phenomena of man and herein lie the origin of my syntactic-thematic concerns as well as those of the semantic and pragmatic.

To summarise: space, matter and light constitute the physical context in which a work has its existence.

The work itself is a material construction organised according to structural principles.

The work is something conceived, made and finally perceived.

The perception of the work is the object of its existence.

That which is perceived is *what the work does* which in turn becomes sensations for the beholder.

The work is an organisation which in turn influences its surrounding context, the work only functions in its context.

We are dealing with the "nature" of the context, the "nature" of structure, the "nature" of stimuli, the "nature" of perception and sensation and the "nature" of order and pattern. In all this we may use the terms "nature" and "structure"—if we want to.

Richard P. Lohse: A Step Farther—New Problems in Constructive Plastic Expression

Since the first pioneering achievements the methods of plastic expression in constructive art have been fundamentally changed and developed; new possibilities, unknown until recently, come to the fore.

These pioneering achievements primarily consisted of taking the plastic means to represent parts of the picture as a whole being directly related to the picture-plane and its borders. From a structural point of view plastic forms became the elements of the picture-plane itself. For the first time in the history of art the geometric elements no longer remained the functional basis of a plastic construction essentially foreign to them, but became the theme instead. Plastic form resulted from a more or less elementary creative process in the expression of both form and color. In spite of the geometric character of the plastic elements, these were—to put it in a lapidary way—the exponents of an emotional potency parallel to a certain vision of the world rooted in the will and tending towards the change of this world.

It was incumbent on the nature of the process of development to analyse this great artistic effort if the variation of its established achievements were not to remain the permanent purpose of constructive art. Analysis is exclusive and additional. (Similar comparisons of the temporary character of artistic revolution can be made with the continuance of Cézanne's structures in Cubism, the suppression and introduction of certain plastic elements resulting from it and the establishment of a new structural law succeeding it with Analytical Cubism. As an example there is the elimination of semi-circular fragments being a remnant of painting based on perception as well as an element by its structure foreign to the shape of the picture-plane it-

From *Structure* (Bussum), 3d ser., no. 2, 1961. Reprinted by permission of the author.

self. From a dialectic point of view it is interesting to see plastic structure change through the elimination of all those elements which opposed the new still unknown structural law yet preconceived already in the future, to end finally with the structure of the horizontal—vertical.)

This new structure-reality gained from a process of development opposite to the view held by the plastic artists of structural Cubism must, through its basic attitude, set a revolutionary example for an epoch not only of painting but also of the plastic expression of our entire environment. It must represent a directive as far as structural Cubism is concerned, and provide the matter for discussion and creative analysis in future development.

From each truly spiritual explanation a new principle comes to life. This, however, undeniably possesses the characteristics of the obsolete principle. A new form of art originates from an exposition of existing and future forms, its elements and methods, however, being again subject to a new exposition. Each advance in the new realm of plastic expression always contains, to a greater or lesser degree, part of the obsolete art form. Each expression possesses moreover, indissolubly connected with its primordial conditions, an inalienable symbolic value.

To arrive at a new plastic expression it was necessary to find new methods of plastic expression. The problem arose how and in what way the emotionally created, lapidary plastic structures of early constructive art could be developed towards a new expression based on a new principle. These considerations led to the unification of the differentiated, more or less immeasurable plane and linear elements and towards the control of their sizes; to the search for a structural unity not only through the use of plastic means placed parallel to the picture-plane but also by means of parallels drawn on a more complex basis. The result was the objectivity of the elements stemming from the analytical process which, when further developed, inevitably led to a series of new fundamentals. On the one hand the objectivity and concentration of plastic means produced a change in the original character of the linear and plane elements, on the other the creation of equal elements of additional character necessarily led to solutions in which the plastic means no longer remained the exclusive means of

the will to an expression of architectural character (as was the case with earlier constructive art) but became part of a working-method. Standardization inevitably led to the equation and combination of the elements by means of groups. Thus the concept of objective rhythm came in existence. To solve the partial problems resulting from it, became one of the most complex tasks within this new method of plastic expression. The idea of creating a universal structure of plastic means had to be realized simultaneously with the principle of the greatest possible flexibility of structural law or, to put it in other words, "machine and product" so to speak had to be developed at one and the same time. The problem remained relatively easy to solve as long as the elements of a group were divided by various intervals; however, whenever the penetration of groups occurred the problem of color became of primary importance. It was obvious that its use had to be approached from an entirely new view-point and also that the solution was going to be incomparably more complicated than in earlier constructive art. A further fundamental characteristic of the new method of plastic expression can be found in the direct use of plastic means. These no longer represent a hidden principle or an expedient to the end of form and color-derivation, as was the case for instance with early Constructivism. During the realization-process the means are not reduced but constitute by themselves the expression of plastic form, thus differing essentially from other constructive methods of plastic expression.

Another characteristic typical of the plastic approach in early Constructivism and still valid with a large part of contemporary artistic achievement, consisted of a gradual realization of the process of plastic expression on the surface-plane, a formal concept which from sheer necessity changed "free space" into "background." However, it was necessary to posit these problems fundamentally anew to obtain a synthetic plastic structure.

In the course of the process of development something new came into existence: through the repetition of similar elements in the same direction a vertical and horizontal rhythm was achieved due to being based on certain intervals and a screen system. Groups of linear elements of equal size were divided over the plane in such a way as to result in an entirely new rhythm. Thus the following essential differ-

ences from the dividing lines of Mondrian as well as those of constructive art must be kept in mind:

1. The lines lose their function of separation and division and become standards of a unified extension.

2. In contradistinction with the horizontal-vertical arrangement of lines resulting in spaces of different size and direction, there now come into existence spaces of similar size and direction or those of a continuously increasing extension.

3. The standards move within a screen system—the variation of space results from certain laws of proportion (*Konkretion I*, 1945/46).

Already in 1943/44 a system of colored groups essential to a further development could be established. Twelve equal vertical bands each consisting of twelve color-elements continually extending from the top to the bottom are directed over the canvas-plane in a horizontally continued progression. Each of the twelve bands possesses another arrangement of the twelve colors, none of the color-elements repeating itself horizontally or vertically. Later on color-structures could be developed which created an infinite series of colors (*Twelve Vertical and Twelve Horizontal Progressions*, 1943/44).

In 1946 another step was made with the picture *Ten Equal Themes in Five Colors*. Ten equal themes, similar in structure-form and organized in two parallel rows the one on top of the other, are—from a horizontal point of view—based on a system of measures of the proportion values: 5 : 4 : 3 : 2 : 1. This is succeeded by the repetition of this series of proportion with vertical interval-elements of the width of proportion 5 lying in between, through which is established a second, equally horizontally orientated rhythm of 5 : 5 : 4 : 5 : 3 : 5 : 2 : 5 : 1. The diagonal rhythm is analogous to the horizontal rhythm of the second phase, achieved by turning it under 90 degrees. Phase 1 represents the basic theme, phase 2 with its intervals the basic theme reversed. The vertical interval-elements connect the upper row of the theme with the lower without any sub-division. The structure by itself is unlimited and obtains formal value only through a further plastic expression by means of color. Five colors: blue, red, yellow, black and white—the latter two representing neutral components—set the structure-form into motion.

The ten equal themes achieved by a system are now put under the

law of a termination by the five colors, in such a way as to bestow on each theme, in a horizontal movement, on top and below, an entirely new expression in no way resembling any other theme. This variety is achieved by expressing each element within a theme through a color different from all the others or, to put it in other words, each element within any theme possesses, from a horizontal point of view, a color different from the one possessed by the same element in the preceding or following themes. The main problem consisted of activating the systematic termination in such a way as to create a dynamic, artistic formulation comprising the ordering principles as the means to this aim. This represented the main artistic demand. The principles were to be arranged in such a relationship as to mutually complete and penetrate one another's character and effect. Thus, being based on the first theme, a second, a third and more theme-phases were established, each being again related to the others by a mutually effective coordination. None of the colors in one and the same element of one series being repeated, the following law is moreover established: each of the five colors partakes with an equal part, i.e., one fifth, in the total amount of color or the entire plane-surface (*Ten Equal Themes in Five Colors*, 1946/47, I).

Furthermore there were developed structures creating an unlimited series of colors through the continuous arrangement of a termination. By means of certain color-series it was possible to multiply the structure and to achieve the construction of a series with the principle of simultaneously operating laws. Each color-series contains, horizontally and vertically, the same colors, no color being repeated within the series. By means of a certain shifting a rhythmic movement is created. This principle of series, operating infinitely on its own, can be integrated in various picture-systems (*Systematic Color-Series with 15 Self-Repeating Colors*, 1950/54).

To demonstrate with two other pictures the complexity of the work in progress, these may be described here in the following condensed way:

Determination of the plastic element
Development towards standard
Identification with the picture-surface

Determination of the number of standards
Determination of the number of colors
Determination of the connection between the number of elements, their dimensions and colors
Effort to establish a module operating as a progression
Research for the possibilities of color-movement
Research for the possibilities of color-accumulation.

These problems can be solved by several themes which are either separated, partly connected or fully connected as, for instance:

additional constant progression
multiple additional constant progression
quantitative progression

based on additional, multiplying or decreasing themes. One must try to connect the various movements in order to establish a coordinated modular system.

As examples of such processes of plastic expression there are "Systematically ordered color-groups 1954/59" with 108 equal elements, as well as "Elements of a series concentrated to rhythmic groups 1949/56, 2" with 135 equal elements.

An example of another plastic principle: four cross-like arranged squares in white together with orange, red and dark-green squares of equal size create four symmetrical groups. To these are added again four groups of each five squares in the colors dark violet-blue, light violet-blue, medium-green and blue-green, which have all been symmetrically arranged with two squares on top and below and one in the center resulting in groups of five. The four squares placed in the center possess a light color through which the groups originally consisting of five become groups of four squares, producing in the center a third group of four (*Eight Color-Groups with Light Center, 1954, I*). Another example: a symmetrical system of progression consisting of two horizontally and vertically equal progressions represents the arrangement-principle of the picture which is essentially determined by color-organization. The colors are: medium-grey, light-grey, medium-green, light-green, violet-blue, light-blue, orange-red and yellow, eight colors in all which have been rhythmically arranged. The largest groups situated on all four borders with the two grey and the two green colors

produce the neutral zone, whereas four asymmetric groups of equal size in violet-blue, light-blue, orange-red and yellow penetrating them on all sides, represent the most active of the 16 color-groups. Movement is produced through the centrifugal violet-blue and orange-red cross-like groups in the left half of the picture which find their color-completion in the right half of the picture by light-blue and yellow cross-like groups of analogous form. Starting with the four cross-like centers there are three smaller cross-like groups on all sides which decrease in a diagonal direction toward the center according to the proportions 4 : 2 : 1 : 3. Each of the four cross-like groups contains an equal quantity of color (*16 Asymmetrical Color-Group Progressions within a Symmetrical System,* 1956/60, 2).

With these examples which were realized for the first time and which can be multiplied unlimitedly, we tried to explain the further development of constructive methods of plastic expression. It was demonstrated how the problems from their phase of lapidary form entered upon such complex intensifications of form and color as to demand, without doubt, particular resources of emotional strength. On the one hand the main problems consisted of establishing new thematic principles upon which a logical continuity was bestowed, on the other, however, to keep the principle as lively as possible. Thus within this realm of activity modules could be developed which through their flexibility guaranteed the greatest possible artistic freedom of plastic expression.

KENNETH MARTIN: Construction from Within

Construction stems from within. The work is the product of inner necessity and is created through an inner logic, i.e. a developing logic within the work that results in form.

From *Structure* (Amsterdam), 6th ser., no. 1, 1964. Reprinted by permission of the author.

Works of art are made of feeling, concept and material. These three can be constructed together by a logic inherent within them and their relationship. The end will be an expressive form dependent on the power of the artist.

A construction can be of any material with which it is possible to do that operation and can be in any possible dimension. Material and dimension (choice and development) are governed by the practical and the aesthetic.

Being the opposite of abstraction, construction begins in the most primitive manner, but it is dangerous for the artist to fall in love with primitivism. The elementary methods of construction are related to the elements of life, the forces of life. An example can be a band ornament drawn linear on the plane, which can be simple, subtle and dramatic, which can be directly related to life in its modulations and inevitability. Life is variable and inevitable, recurrent and developable. For the individual it is essentially tragic.

Or to re-start rather differently.

An event or a series of events may be ordered by a rhythm. The same event can be repeated varying its temporal or spatial position. An event can be inverted and take on a new, strange character A whole system can be changed by inversions. Events and systems of events considered plastically with equivalence between tangible and intangible elements can become an expressive structure. Events are changed or rhythmically related by means of kinetics. The primitive forces of kinetics are universal, they are within us and without. Therefore through their use it is possible to express life. However construction must start with the simplest and most practical means and to avoid confusion aim at the simplest results. The method is empirical and moves from ignorance to knowledge.

The spiral, the crystalline and the amorphous are primary attributes of nature used by artists from remote times to the present to express their position in and attitude towards the universe. They saw and felt the spiral, used it to express what they saw and felt, to comprehend and to feel more and to express what was beyond comprehension.

The spiral expresses dynamic and aspirational forces. The crystal has the very refinement of order from which deviations are errors. In drawings by Leonardo rocks are crystals disrupted by spiral forces.

The work of art can be a crystal formation on the plane. In a

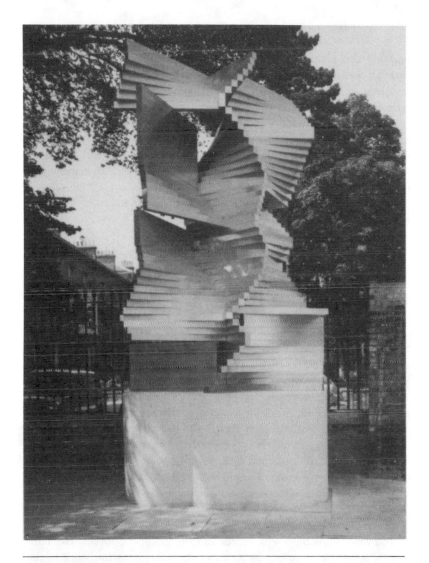

Kenneth Martin: *Construction in Aluminum,* 1967. This large and dramatically situated work was completed with the technical assistance of the Department of Engineering, Cambridge University, which also commissioned it. It reflects Martin's long-standing concern with the progressive displacement of linear elements around a central axis, clearly perceptible in his series of "screw mobiles," which he began in 1953. (*Photo Department of Engineering, Cambridge University*)

painting the canvas can seem to be such a formation, transparent, through which the perspective of a scene passes. The formation is distorted and the facets shift. And so, as in many Seurats, the work is in this sense a sum of deviations from the crystalline.

In paintings (Titian, Tintoretto, Degas, Cézanne, etc.) the spiral and the crystalline have been fused together in many ways. The writer Jay Hambidge posed a solution for the complete fusion of spiral and crystalline on the plane in his books on "dynamic symmetry."

The amorphous is ambiguity, the first transition from the void towards form or the last after disintegration.

Art corresponds with man's attitude towards nature and with the feelings of life within himself.

My work is kinetic whether the result is still or moving, therefore I am concerned with change—and with chance (which also has strict laws). If life is essentially tragic then I cannot believe in Utopia no matter how I strive for perfection. It is interesting to note here that in a society of geometric figures (*Flatland* by E. A. Abbott) the circle is a being of far higher order than a square. It is possible for a square through hereditary change, the adding of an angle each generation, to ascend the social scale towards a state of anglelessness. A moving towards perfection of asymptotic character, attaining only the semblance of it. For me each figure has its intrinsic character to be studied and used and change of character is in itself a dynamic event which can be more important than the character. For me the form is the result of the events, I work with these and become engrossed in them. The end product becomes then a matter for consideration as to what these events have achieved and then I must re-order them again towards what is for me the new.

The artist constructs with forces and the results of forces. He, himself, is a bundle of forces as is his work. Sometimes the work is the product of a slow direction (monotony is a powerful force), or it is busy with change and seeming instability (Picasso's sum of destructions).

The work of art holds opposites within itself, horizontal against vertical, acute angle against obtuse, curve against straight, open against closed and so on. Then there is the opposition against the norm within

the work. In the purely orthogonal work the deviation from a regular partitioning is expressive (Mondrian), while in cubist works expression is achieved by shifts from the vertical and horizontal. If the latter can become too confused the former can be too static. The artist limits himself by the means with which he works, the choice of means is part of his subjective nature. The norm, the powerful monotony, becomes an episode or a field which he develops, changes or interrupts through the use of slight changes or direct oppositions.

Joost Baljeu: The Constructive Approach Today

Today the constructive approach is the only direction in contemporary plastic expression which since its beginning has continued uninterruptedly for half a century, if we do not count the earliest steps towards this complete renovation which date back as far as a century ago. Mondrian, Malevich, Tatlin a.o. began this new way of plastic expression around 1914 and they developed it from basic efforts made by Monet, Cézanne and the Cubists.

Therefore one could almost speak of a constructive tradition—just as all movements or styles in the past developed a tradition when their renovating steps began to penetrate and transform the shaping of man's environment—though it has been shown that in this tradition there is progress at the same time. In fact there remain various fields in which the constructive plastic approach is as yet unexplored.

Nevertheless it is surprising to find, apart from the response in a few quarters, how much ignorance continues to surround the constructive way of plastic expression. There are a number of reasons which could explain this reaction (or one could say "fear") but as most of them are of a provincial character they are not worth considering. A much more interesting question is: how is it that new people continue to join the constructive approach? Though Tachism

From *Structure* (Amsterdam), 6th ser., no. 2, 1964.

is over, there are other possibilities such as Pop and Zero, or perhaps an entirely personal stunt—no matter what—which could be more attractive.

To someone choosing the constructive approach Pop is unacceptable because its sentiment is old. The argument that the machine produces ugliness—demonstrated in Pop-works by the piling up of countless numbers of mechanically made products of no interest— is not an argument which can be directed against the machine but one which points towards a lack of creative design as well as the ignorance of the public in general as to what really represents good design. If it is the intention of Pop to arrive at good design, the answer should be to replace bad design with good design not with junk. Since Pop does answer with junk, we are faced unavoidably with the question—does Pop lack the capacity for creative design? Another closely related aspect is Pop's fear that mechanization or automation will govern life. To fear the computer is the result of attributing to the machine a power greater than that of the man who created it. The mistake in this reasoning is self-evident. As the early machine took over and increased man's muscle power, so the modern machine, the computer, takes over and increases man's capacity to remember or such mechanical disciplines as counting, multiplying, etc. But it must not be forgotten that all data were first supplied by man with one aim—mechanically increased (re)production. The most astonishing fact in this connection is that today some people are seriously studying the problem—can the machine take over man's creative activity? Apparently they do not realise that everything creative springs from man's wish to determine things which before were determined otherwise, undetermined or unknown. The machine produces results; it can produce in a short time a calculation which otherwise would take us years. It can produce this calculation to a greater or lesser accuracy, but it can never invent the way the calculation is performed. The approach or method—the creative element—is the role of man; the final result, the calculation, is the product of the machine. The basic mistake in thinking that the machine can take over man's creative act, is the perennial error of exchanging the means for the end, the method for the result.

Automation stampeding all individuality out of man—Pop's final argument—thus forcing man to drift along uniform circumstances

created for him and to which he is fully subjected as a number, is the sentimental argument of those who lack mental resistance or creative activity no matter in what field or on what basis. Never did anyone have a dull life who did not first make it dull himself. This situation also explains why every stunt is always firmly rooted in dullness.

With Zero one is confronted with a different though related situation. Although there are various trends in Zero, they have a number of aspects in common. Zero is an attempt to suppress any subjectivity; the works must possess the highest possible degree of objectivity from an attempt to arrive at the absolute objectivity of the one and only truth that must exist in spite of the many (illusionistic) truths man continually surrounds it with. In this anonymity chance plays the divine role. Everything in existence is subjected to this common denominator, therefore man must abstain from any interference through subjective choice or will. Neither should the works exert any (magic) influence on their environment as this would disturb man's objective freedom. Black and white, the two colours predominant in Zero, foster this neutral quality.

It sounds like an echo of the Kantian "the purpose of art is its purposelessness," even though this is then reversed into "purposelessness is the purpose of art" which, when taken to its full meaning, leads one to the conclusion that, in respect of plastic expression, man's utter, objective freedom will be reached when there are no plastic, no Zero-works at all. However, here Zero is subject to the paradox inherent in all expressions of art—that is why Zero-works come into existence. Ultimately, however, one is faced with a resound of a basic tenet of one of the main philosophies behind Zero, that of Heidegger, which holds that in the end any activity or project of man leads to nothingness. There is another such paradox in Zero when it states, that, though following chance, it is controlling chance. This is done by introducing number. A Zero-work generally consists of a geometrical standard unit or a pattern which is repeated over and over again and can be seen to continue endlessly due to the lack of any centre of gravity. This automatic flow is enhanced by the use of white and black symbolizing the infinite space areas through which light must travel. (Similar characteristics, though of a less intense quality, can be found in the work of the Groupe de Recherche d'Art

Visuel.) It reflects an attitude of life based on the presupposition that man is led by circumstances and that his power to alter the constant flow of events amounts to zero. It also reveals an intrinsic desire to identify oneself with nothingness, literally taking Heidegger at his word when he states that if man arrives at any activity it is the result of his preoccupation with death. This is to deny, then, that in reality life is based on the interaction of the circumstances making man and man making the circumstances. Just as the creative act is the result of an interaction of the known and the unknown, of the something and nothingness. Not to accept this interaction means no more and no less than to eliminate man's conscious choice of acceptance or rejection, or the human situation as a whole. It need not surprise us that this cult of death, the absolute in the identification with the universe put at zero and representing the perfect example of dehumanization in plastic expression, finds most of its followers in post-war Austria and Germany.

Whereas Tachism reacted from the corrupt functioning of the world, Pop from its ugly or "cruel" functioning, Zero decides that it may function as it does but to no other end than zero. In all three the underlying current is that of a nihilism of various degrees, partly as a continued reaction from the tragedy of World War II in which a false philosophy, corrupt psychology and abused technics united with the purpose of blind destruction, and partly because it would seem that, after the war, no coherent idea has turned up to fill the void created. This situation is compensated by an attitude of romanticism which, whether vague, cheap or deep, nevertheless turns its back on reality as it is, leading to a complete withdrawal within individual man. At this point it is amazing to realize that the main argument always presented against the constructive approach is precisely that of turning its back on reality. It is often seen as representing a type of plastic expression created by a group of aesthetes possessing no view of or no tie whatsoever to life as it really is. Though the above analysis presents some reactions from a number of elements which certainly comprise a great deal of life today, the fact that the artist in the constructive realm cannot work with them, does not imply that he ignores or denies them. Let us take the above criticism of the constructive approach seriously for a while, as this is the shortest way to show how unrealistic it is. The question would

then arise: when the constructive approach cannot work with the elements presented above, can one trace any other grounds it is related to and if so, can one see these to be firmly rooted in contemporary life as a whole?

To answer this question it is necessary first to state some essentials of the constructive approach in plastic expression. The works show a limitation to the use of rectangular means which are arranged so as to describe related spaces. These spaces are interrelated in a dynamic way, i.e. they tend to expand and contract at the same time and this takes place along (a) centre(s) of gravity. Colour helps to further determine these dynamic plastic relationships. Basic in the constructive attitude to reality is the idea that nothing is inert, everything is continually in movement. However, in this concern with change it is realized that it possesses constants as well. Reality is seen as a dynamic process, that is, the constructive approach is interested in the way reality operates rather than the outer appearances of the phenomena. It has replaced the "what" of reality—the limitation to the observation of object images—by the "how" of reality: the methods or laws according to which the phenomena can be seen to come into existence. Thus it studies not only form but also counterform, i.e. the environment or the void, and in fact has observed that it is the weaker force present in environmental space which often is the stronger in the formation of matter.

These laws, representing the building method of reality, are interpreted by the constructive artist through the inner process of man which is one of elimination and addition, and it is thus that the constructive plastic work tries to achieve the synthesis of the inner working of man with the essence in the functioning of reality. Therefore the constructive plastic work, though a static entity by itself, does not wish to turn reality into something static but rather to present an instantaneous picture of a reality process which is continually on the move. It thereby distinguishes itself from the two approaches which have always governed plastic expression in Western culture, i.e. that change was either eliminated or utilized to a static end. The whole of plastic relationships constituted by the constructive work, which is of a structural nature, is therefore essentially non-Platonic and non-Aristotelian.

The principle of approaching the phenomena not as entities for and

by themselves but as interrelated, and consequently of studying their structures is one which can be found in many other human disciplines today.

For instance, as far as economy is concerned, everyone knows that to maintain a national economy today is no longer possible. Various national economies have become interrelated and in this realm one is preoccupied with the balancing of these economic interrelationships.

The same holds true of sociology. It studies smaller groups and their behaviour to one another and has also begun to draw nations into its field of interest. This step from micro- to macrosociology might eventually provide us with a clearer picture of the working of international relations. In natural science the theory of relativity, concerned with the way the phenomena are built, the equivalence of matter and energy, has profoundly modified Newton's static concept of space and time.

In the realm of technology constructive engineering is utilizing the interrelationships of the forces in the materials instead of halting at the law of gravity as the sole force governing a construction. Here one has arrived at new structures in engineering, balancing force and counterforce, which represent a new approach opening up numerous possibilities.

The world of drama has eliminated the Classical prototype, such as Molière's miser, from the stage and replaced it with the interplay of relationships between human beings which cannot be put into this or that category. A similar structurization, adding new dimensions to each person figuring in the action as a whole, has begun to develop in literature. Again in music the static quality of the time element in the Classical tone pattern was destroyed, each tone now being dynamically circumscribed by various of its time lengths. It cannot be

Joost Baljeu: *Construction—Black, White, Red,* 1964 = 1 (Collection Rijksmuseum Kröller-Müller). Baljeu's work belongs to the tradition of De Stijl rather than to that of constructivism in the narrow sense. But even his relief works are conceived in direct relation to the surrounding space, and he accepts the implications of Van Doesburg's decision to extend the principles of neoplasticism into the domain of architecture and planning.

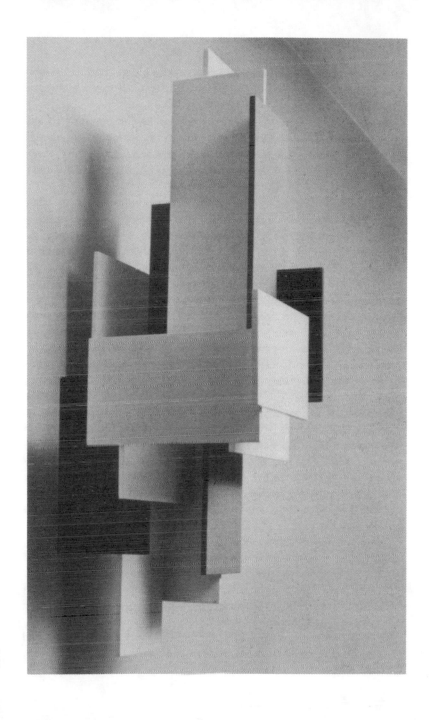

denied that in this realm, and not in this realm alone, there are doubts concerning the interpretation of certain matters, but this merely confirms that things are on the move.

In architecture static mass was opened up by the curtain-wall and an effort made to introduce more dynamics by juxtaposition, though the various spatial functions were maintained as entities by themselves, which explains why the process of renovation is still incomplete.

Philosophy is lagging behind, but this need not surprise us when one realizes that Plato and Aristotle wrote down their ideas when Classical culture had already passed its height.

The above survey shows that the ideas of men like Keynes; Einstein; Bell, Waksman; Brecht, Beckett, Sartre; Webern, Schönberg, Stockhausen; Mackintosh, Wright, Van Doesburg—to mention but a few names—reveal a similar approach in their renovation. In all these disciplines man is no longer concerned with phenomena as static entities but with phenomena that are dynamic and interrelated, revealing certain structural principles or laws in their functioning. It is thus that the constructive approach in plastic expression is firmly rooted in the new reality which has come to life and is developing today. The fact that this renovating process takes place in studies, laboratories or studios which are remote, and its results often are not widely publicized, does not effect its real presence. The above makes clear that, on the ideal side, the constructive approach possesses many more ties with contemporary reality than perhaps is realized. Just as it will be clear that it does not react against reality as it is through some nihilistic attitude, but rather that it tries to assist in shaping reality closer to its new outlook that is in the making in this and other realms of human activity.

Again, on the practical side, it is sometimes argued, mostly so in functionalist quarters, that the constructions shown between those pages are of a nonconstructive quality and the architecture of a fancy type. This to justify once more the argument that the work made in the constructive realm is produced by a group of aesthetes ignoring any aspect of its materialization in reality.

To begin with the architecture, the circumstance that "theory" and practice do not easily meet, is the result of very complex situations. It is not so much that this architecture cannot be built technically—

information from engineering circles tells that that is not the problem —but rather that industry does not follow the development in contemporary design and technics. What can one say, for instance, of the fact that at the latest steel-congress recently held, the building trade walked out because the steel producers were unable to understand one syllable of the new demands these builders had confronted them with.

As far as the constructions are concerned which need not answer the demand to be erected in order to serve as housing, it is apparently not realized that here various devices are studied with the purpose of understanding how to deal with space, time and colour. Failure to understand this can only arise when one confuses means and ends. The relief constructions are not intended as engineering constructions, but as plastic expressions which in the end could provide engineering construction with plastic form and colour. They will prove their practical value as soon as the constructive approach further advances not only in the realm of architecture but also in that of parkscaping, the building of landings, terraces and fountains, the staging of plays, ballets and operas, industrial design, typography, and so on. Apart from a few experiments at the beginning, these and other fields have so far remained virtually unexplored. Here we have another reason why the constructive approach, the oldest in modern plastic expression, is still the youngest today.

Notes

1. El Lissitzky and Hans Arp, *Die Kunstismen—Les Ismes de l'Art—The Isms of Art* (Erlenbach-Zurich: Eugen Rentsch, 1925). The paragraph on constructivism states that these artists "look at the world through the prisma of technic. They don't want to give an illusion by means of colours on canvas, but work directly in iron, wood, glass a.o. The shortsighteds see therein only the machine. Constructivism proves that the limits between mathematics and art, between a work of art and a technical invention are not to be fixed" (quoted from English version in text).
2. *De Stijl* (Amsterdam), vol. V, no. 4 (dated May 1922).
3. George Rickey, *Constructivism: Origins and Evolution* (London: Studio Vista; New York: George Braziller, 1967), p. xi.
4. Cf. *Konstruktive Kunst: Elemente und Prinzipien* (exhibition catalogue, Nuremberg Biennale, 1969).
5. Cf. Naum Gabo, "The Concepts of Russian Art," *World Review* (London), June 1942; reprinted in *Naum Gabo* (exhibition catalogue, Zurich: Kunsthaus, October 30–December 1965).
6. K. S. Malevich, *Essays on Art 1915–1933*, ed. Troels Andersen (Copenhagen: Borgen, 1968; London: Rapp and Whiting, etc., 1969–71), II, p. 74.
7. Cf. *Gabo: Constructions, Sculpture, Paintings, Drawings, Engravings* (London: Lund Humphries; Cambridge, Mass.: Harvard University Press, 1957), p. 158.
8. Alexei Gan, *Konstruktivizma* [Constructivism] (Tver, 1922). Extracts translated, pp. 33–42.
9. *Gabo*, p. 158.
10. Irving Sandler, "Gesture and Non-gesture in Recent Sculpture," originally published in *American Sculpture of the Sixties* (exhibition cata-

logue, Los Angeles County Museum of Art, 1967); reprinted in *Minimal Art—A Critical Anthology,* ed. Gregory Battcock (New York: E. P. Dutton, 1968; London: Studio Vista, 1969), p. 308.

11. Roland Barthes, "Littérature et discontinuité," *Essais critiques* (Paris: Éditions du Seuil, 1964), p. 177; translation in *Critical Essays* (Evanston, Ill., Northwestern University Press, 1972), page 173.

12. Cf. article with that title by J. Tynianov, originally published in *Problema stixovornogo jazyka* (Leningrad), 1929; reprinted in *Théorie de la littérature: Textes des formalistes russes,* ed. Tzvetan Todorov (Paris: Éditions du Seuil, 1965).

13. Nikolaus Pevsner, *Pioneers of Modern Design* (London: Penguin Books; New York: Praeger, 1960), pp. 70–71 and passim.

14. R. Longhi, "Piero dei Franceschi e lo sviluppo della pintura veneziana," *L'Arte* (Milan), 1913; reprinted in Oreste del Buono and Pier Luigi de Vecchio, *L'opera completa di Piero della Francesca* (Milan: Mondadori, 1967), p. 12.

15. "Natuurlijke en abstracte realiteit" [Natural Reality and Abstract Reality—An Essay in Dialogue Form], *De Stijl* (Leiden), no. 8–12, 1919; no. 2–3, 5–10, 1919–20; translation in Michel Seuphor, *Piet Mondrian—Life and Work* (London: Thames & Hudson; New York: Harry N. Abrams, 1956), p. 327.

16. Theo van Doesburg, *De nieuwe beweging in de schilderkunst* (Delft: J. Waltman, Jr., 1917), p. 42; text dated May–August 1916.

17. Quoted in Werner Haftmann, *Painting in the Twentieth Century* (London: Lund Humphries, 1960; New York: Praeger, 1961); I, p. 129. The examples of artists aware of this need whom Marc mentions in this piece for the *Blaue Reiter* are Cézanne and El Greco.

18. Cf. Jean Arp, *Arp on Arp* (New York: The Viking Press, 1972), p. 328.

19. Quoted in Peter Wollen, *Signs and Meaning in the Cinema* (London: Studio Vista, 1969), p. 32.

20. "Introduction to *G,*" *Form* (Cambridge, Eng.), no. 3, December 1966, p. 27.

21. Seuphor, *Piet Mondrian,* p. 317.

22. Quoted and illustrated in Marianne W. Martin, *Futurist Art and Theory, 1909–1915* (Oxford: Clarendon Press, 1968), p. 201 and plates 217, 218. Text in *Futurist Manifestos,* ed. Umbro Apollonio, The Documents of 20th-Century Art (London: Thames & Hudson; New York: Viking, 1973), pp. 197–200.

23. El Lissitzky, *Russland: Die Rekonstruktion der Architektur in der Sowjetunion* [Russia: The Reconstruction of Architecture in the Soviet Union], Neues Bauen in der Welt, I (Vienna: Schroll, 1930), p. 9.

24. Editorial, *Veshch/Gegenstand/Objet* (Berlin), no. 1–2, March–April 1922, p. 2.

25. Cf. Maurice Denis, *Théories (1890–1910): du symbolisme et de Gauguin vers un nouvel ordre classique* (Paris: Bibliothèque de l'Occident, 1912); also Denis, *Du symbolisme au classicisme: Théories,* ed. O. Revault d'Allonnes (Paris: Collection Miroirs de l'Art, 1964).

26. André Gide, *Pretexts,* ed. Justin O'Brien (New York: Dell; London: Meridian, 1959), p. 202. Gide is quoting from an anonymous correspondent of the *Times Literary Supplement.* His thoughts on the subject of classi-

cism had been stimulated by an inquiry by the magazine *La Renaissance* into the significance various writers attached to the term. It is perhaps worth noting that in 1922 the musician Busoni was proclaiming the need for a "new classicism" (quoted in *Die Form* [Bonn], vol. 15, August 1, 1929, p. 406).

27. Gide, *Pretexts*, p. 202.

28. Camilla Gray, *The Great Experiment: Russian Art 1863–1922* (London: Thames & Hudson; New York: Harry N. Abrams, 1962), p. 249.

29. See Troels Andersen, "On the Reconstruction of the Tower," in *Vladimir Tatlin* (exhibition catalogue, Stockholm: Moderna Museet, July—September 1968), p. 23.

30. Cf. *Gabo*, p. 153.

31. See Richard Sherwood, "Introduction to *Lef*," *Form*, no. 10, October 1969, p. 28.

32. See *De Stijl*, vol. V, no. 8, 1922. In this manifesto the concept "konstruktivistisch" was defined in terms of a "new formation of the life of our awareness of the age, in accordance with universal means of expression."

33. Richter, "Introduction to *G*," *Form*, no. 3, December 1966, p. 27.

34. Letters from Schwitters to Raoul Hausmann, reproduced in *Pin and the Story of Pin*, introduced by Jasia Reichardt (London: Gaberbocchus Press, 1962), p. 13. Van Doesburg's interest in the dada movement was nonetheless a cause for suspicion to some of the original dadaists. Francis Picabia wrote in the second number of his magazine *Cannibale* (May 25, 1920): "M. Théo van Doesburg, director of the magazine *De Styl* [*sic*] has just published a dadaist manifesto and a series of articles on dada in *De Nieuwe Amsterdammer*. But one asks oneself for what reason he is organizing an exhibition of the Section d'Or."

35. *A B C: Beiträge zum Bauen* (Basel), no. 2, 1926, pp. 1–2. The article is taken from Tschichold's *Typographische Mitteilungen*, no. 10, October 1925.

36. See *Gabo*, p. 153.

37. Basil Gilbert, "The 'Reflected Light Compositions' of Ludwig Hirschfeld-Mack," *Form*, no. 2, September 1966, p. 10.

38. The quotations are from Van Doesburg's own retrospective account, published in *De Stijl*, vol. VII, no. 79–84, 1927, p. 64.

39. Paul Citroën, quoted in Sibyl Moholy-Nagy, *Moholy-Nagy: Experiment in Totality* (New York: Harper, 1950), p. 32.

40. Cf. ibid., p. 43: letter to editor of *Das Kunstblatt*, dated Weimar, July 1, 1924.

41. See his article "Ismus oder Kunst?," in *A B C*, no. 2, 1926, p. 6: "The common denominator of *all* isms, from naturalism to constructivism . . . is the enduring, unconscious struggle for the acquisition of the true, primary, autonomous means of forming expression [*Ausdrucks-Gestaltungsmittel*]."

42. See p. 136.

43. *50 Years Bauhaus* (exhibition catalogue, London: Royal Academy, 1968), p. 21.

44. Design for *Asnova* illustrated in Sophie Lissitzky-Küppers, *El Lissitzky* (London: Thames & Hudson; Greenwich, Conn.: New York Graphic Society, 1968), plate 131.

45. As late as 1928, *SA* was publishing the views of Gan and others on constructivism and providing information about developments at the Bauhaus.

46. I am indebted to Peter Wollen for this reference.

47. Malevich, *Essays on Art*, II, p. 80.

48. Quoted in Lissitzky-Küppers, *El Lissitzky*, pp. 372–73.

49. Peter Blake, *Le Corbusier—Architecture and Form* (London: Pelican Books, 1953), p. 87.

50. *Architectural Design* (London), February 1970, p. 76.

51. *De Stijl*, vol. VIII, no. 87–89, 1928, pp. 19–36. The interior was designed in collaboration with Arp and Sophie Tauber-Arp.

52. *De Stijl*, final memorial number (Van Doesburg 1917–1931), January 1932, p. 26; note dated September 4, 1930.

53. *Cercle et Carré* (Paris), no. 1, March 15, 1930, p. 3.

54. Cf. Guillermo de Torre in Roberto J. Payro and Guillermo de Torre, *Torres-García* (Madrid, 1934), p. 45.

55. *Abstraction-Création—Art Non-Figuratif* (Paris), no. 1, 1932, p. 14: "We call ourselves constructivists because our pictures are no longer 'painted,' or our sculptures 'modeled,' but on the contrary constructed in space and with the aid of space."

56. Ibid., title page.

57. See account of recent exhibitions in *Circle—International Survey of Constructive Art* (London: Faber and Faber, 1937; reprinted London: Faber and Faber; New York: Praeger, 1971), pp. 279–81.

58. T. S. Eliot, *Notes towards the Definition of Culture* (London: Faber and Faber, 1967; reprint of 1st paperback ed.), p. 116.

59. Moholy-Nagy, *Moholy-Nagy*, p. 77: letter to the author dated July 29, 1932.

60. Cf. Anthony Hill, "Constructivism—The European phenomenon," *Studio International* (London), April 1966, p. 145.

61. Cf. review by Myfanwy Evans of *Telehor* (Brno), supp. 1, 1936 (issue devoted to Moholy-Nagy), in *Axis* (London), no. 6, 1936, pp. 31ff.

62. Moholy-Nagy, *Moholy-Nagy*, p. 135.

63. The *Bijenkorf Construction*, built adjacent to the store of that name in reconstructed Rotterdam, was begun in 1954 and completed in 1957. Cf. *Gabo*, plates 98–100 and commentary by Herbert Read, p. 8.

64. Ibid., p. 158.

65. *Réalités Nouvelles* (Paris), no. 1, 1947, p. 1. The same issue contains an "extract from a letter from Gabo and Anton Pevsner" (pp. 63–64).

66. Illustrated in Rickey, *Constructivism*, p. 272.

67. "A Note by Victor Pasmore," *Form*, no. 3, December 1966, p. 4.

68. *Structure* (Amsterdam) 4th ser., no. 2, 1962, p. 50. Cf. Baljeu's attack on the Zero group in "The Constructive Approach Today," reprinted on pp. 287–95.

69. Jack Burnham, *Beyond Modern Sculpture—The Effects of Science and Technology on the Sculpture of This Century* (New York: George Braziller; London: Allen Lane, 1968), p. 248. Burnham rightly includes such wholly nonconstructive artists as Fontana and Yves Klein among the precursors of the New Tendency aesthetic.

70. Max Bill, "Art as non-changeable fact," in *DATA—Directions in Art, Theory and Aesthetics*, ed. Anthony Hill (London: Faber and Faber; Greenwich, Conn.: New York Graphic Society, 1968), p. 113.

71. For further consideration of the New Tendency aesthetic, see the author's *Experimental Painting—Construction, Abstraction, Destruction, Reduction* (London: Studio Vista; New York: Universe Books, 1970), chap. 1.

72. Lawrence Alloway has convincingly shown that, for the contemporary American artist in the wake of abstract expressionism, "the systematic and the patient could be regarded as no less idiosyncratic and human than the gestural and cathartic." "Systemic painting," in *Systemic Painting* (exhibition catalogue, New York: Solomon R. Guggenheim Museum, September–November 1966); reprinted in *Minimal Art*, p. 46.

Selected Bibliography

by BERNARD KARPEL

Librarian of the Museum of Modern Art, New York

Working references employed by the author are incorporated below. Items included in the anthology proper, either in whole or in part, are coded by an asterisk (*).

Comprising 355 numbered citations, plus additional entries in the annotations, the bibliography groups *Books and Brochures*, nos. 1–83, *Selected Catalogues*, nos. 84–123, *Periodicals and Special Numbers*, nos. 124–46, *Selected Articles*, nos. 147–212, *Artists*, nos. 213–355. Many bibliographies are mentioned in the notes passim.

BOOKS AND BROCHURES

1. Alvard, Julien and Ginderlael, R. V., ed. *Témoignages pour l'art abstrait 1952. Propos recueillis* . . . Introduction by Léon Degand. [Paris] Éditions "Art d'Aujourd'hui," 1952.
 Partial contents: Naum Gabo, "L'idée du réalisme constructif," pp. 115–122.—Jean Gorin, pp. 139–142.—A. Pevsner, pp. 213–214.—V. Vasarely, p. 271.
2. Andersen, Troels, *Moderne Russisk Kunst, 1910–1925.* Copenhagen, Borgen, 1967.
3. Annenkov, Yurii. *People and Portraits. A Tragic Cycle.* New York, Interliterary Language Associates, 1966.
4. *Architects' Year Book.* No. 12. London, Elek, 1968.
 Includes Kenneth Frampton on "Notes on Soviet urbanism, 1917–1932" and "The work and influence of El Lissitsky."
5. Arp, Jean. *Jours effeuillés.* Paris, Gallimard, 1966.
 Translation: *Arp on Arp.* New York, Viking, 1972. Bibliography by Bernard Karpel.

*6. [*Art in Production*. Moscow, Narkompros 1921].
Collection of articles published by the Art-Production Council of the Visual Arts Department of the Narkompros. Includes A. Filippov, "Production Art," etc. Russian texts [bracketed] sometimes unavailable to compiler. Excerpts translated, pp. 22–25.

*7. Arvatov, B. [Art and Class. Moscow-Petrograd, 1923].
Russian text. Excerpts translated pp. 43–48.

8. Banham, Reyner. *Theory and Design in the First Machine Age*. 2. ed. New York and Washington, Praeger, 1967.
First edition: London, Architectural Press, 1960. Section on de Stijl, occasional texts and references to constructivism, especially van Doesburg and Lissitzky. Bibliography.

9. Bann, Stephen. *Experimental Painting—construction, abstraction, destruction, reduction*. London, Studio Vista; New York, Universe Books, 1970.
References to Moholy-Nagy, Lissitzky, Biederman, Baljeu, et al. Bibliography.

Bann, Stephen. See also bibl. 28, 150.

10. Barr, Alfred H., Jr. *Cubism and Abstract Art*. New York, Museum of Modern Art, 1936; also 1966.
Chapters on "abstract painting in Russia, constructivism, abstract art in Holland: de Stijl, Neo-Plasticism." Bibliography. Reprint: New York, Arno, 1966.

11. Barthes, Roland. *Essais critiques*. Paris, Éditions du Seuil, 1964.
Translation: *Critical Essays*. Evanston, Ill., Northwestern University Press, 1972.

12. Battcock, Gregory, ed. *Minimal Art. A Critical Anthology*. New York, Dutton, 1968; London, Studio Vista, 1969.
Includes "Systemic painting" by Lawrence Alloway, "Gesture and non-gesture in recent sculpture" by Irving Sandler.

13. Bayer, Herbert; Gropius, Walter; Gropius, Ise, eds. *Bauhaus 1919–1928*. New York, Museum of Modern Art, 1938; also 1972.
Publication based on major exhibition. Bibliography. Also Boston, Branford, 1952, 1959. Reprint: New York, Arno, 1972.

14. Bendien, J. and Harrenstein-Schräder, A. *Richtingen in de hedendaagsche Schilderkunst*. Rotterdam, Brusse, 1935.
Sections on neo-plasticism, constructivism, and suprematism.

14a. Berninger, Herman and Carter, Albert. *Pougny . . . Catalogue de l'oeuvre*. Tübingen, Ernst Wasmuth & Office du Livre, 1972.
"Jean Pougny (Iwan Puni) 1892–1956. Tome 1: Les années d'avant-garde, Russie-Berlin, 1910–1923." Extensive documentation includes translations of rare Russian and German documents. Illustrates and translates Tatlin manifesto, Dec. 17, 1915 (pp. 54–55, 154–155).

15. Biederman, Charles. *Art as the Evolution of Visual Knowledge*. Red Wing, Minn., The Author, 1948.
A monumental exposition from "pictographs to photographs."

16. Bjerke-Petersen, Vilhelm. *Konkret Kunst.* Stockholm, Rabén and Sjogren, 1956.
 English summary (insert). References to Gabo, Malevich, van Doesburg, Vasarely, etc.

17. Blake, Peter. *Le Corbusier—Architecture and Form.* London, Pelican Books, 1963; New York, Penguin, 1964.

18. Burnham, Jack. *Beyond Modern Sculpture. The Effects of Science and Technology on the Sculpture of This Century.* New York, Braziller; London, Allen Lane, 1968.
 Commentary on constructivism and constructivist artists.

19. Chernikov, J. and Gollerbakh, E. F. [*The Structure of Architectural and Machine Forms*]. Leningrad, 1931.
 Russian text. Variant title: *The Construction of Architectural and Mechanical Forms.* Excerpts translated pp. 149–52. Also note Sprague, bibl. 202.

*20. *Circle—International Survey of Constructive Art.* Editors: J. L. Martin, Ben Nicholson, N. Gabo. London, Faber and Faber, 1937 (reissue 1971); New York, Praeger, 1971.
 Partial contents: "Editorial."—Essays by Gabo: "The constructive idea in art."—"Sculpture: carving and construction in space." Exhibitions bibliography. For sections included here, see pp. 203–214.

21. Constantine, Mildred and Fern, Alan M. *Word and Image. Posters from the Collection of the Museum of Modern Art.* New York, Museum of Modern Art, 1968.
 Based on major exhibition; includes Bauhaus, Lissitzky, etc. Bibliography.

22. Denis, Maurice. *Théories (1890–1910). Du Symbolisme et de Gauguin vers un nouvel ordre classique.* Paris, L'Occident, 1912.
 Also *Du Symbolisme au Classicisme: Théories.* Edited by O. Revault d'Allonnes. Paris, Collection Miroirs de l'Art, 1964.

23. Egbert, Donald Drew. *Social Radicalism and the Arts—Western Europe. A Cultural History from the French Revolution to 1968.* New York, Knopf, 1970.
 Commentary on the Bolshevik Revolution, Schöffer, Vasarely, the Bauhaus, de Stijl, Constructivism. Detailed index and bibliographical notes.

24. Ehrenburg, Ilya. *People and Life, 1891–1921.* New York, Knopf, 1962.

25. Eliot, Thomas Stearns. *Notes towards the Definition of Culture.* London, Faber and Faber; New York, Harcourt, Brace and World, 1967.

26. Feo, Vittorio De. *URSS: Architettura 1917–1936.* Rome, Editori Riuniti, 1963.
 Bibliography.

27. Fitzpatrick, Sheila. *The Commissariat of Enlightenment.* Cambridge, University Press, 1971.
 "Soviet organisation of education and the arts under Lunacharsky, October 1917–1921." Reviewed: *Times Literary Supplement* (London), Mar. 5, 1971.

28. *Four Essays on Kinetic Art* [by] Stephen Bann, Reg Gadney, Frank Popper, and Philip Steadman. St. Albans, England, Motion Books, 1966.

*29. Gan, Alexei. [*Konstruktivisma*]. Kalinin-Tver, 1922.
Excerpts translated, pp. 32–42. Excerpts in Camilla Gray, 1962, pp. 284–287 (bibl. 34).

30. Gan, Alexei. *Il Costruttivismo*. Moscow-Tver, 1922–23.
Complete translation in Quilici, pp. 218–255 (bibl. 61).

31. Gertsner, Karl. *Kalte Kunst? zum Standort der heutigen Malerei.* 2.Aufl. Teufen, Niggli, 1963.
First edition, 1957. Bibliography.

32. Gide, André. *Pretexts*. Edited by Justin O'Brien. London, Meridian; New York, Dell, 1959.

33. Giedion-Welcker, Carola. *Contemporary Sculpture. An Evolution in Volume and Space.* London, Faber and Faber, 1956. Rev. and enl. ed. New York, Wittenborn, 1960.
Biographies: van Doesburg, Gabo, Hausmann, Pevsner, Rodchenko, Tatlin, et al. Bibliography by Bernard Karpel, pp. 355–394, same as first edition, 1955.

Gollerbakh, E. F. See bibl. 19.

34. Gray, Camilla. *The Great Experiment: Russian Art 1863–1922.* London, Thames and Hudson; New York, Abrams, 1962.
Especially chapter 8 (1921–1922). Artists' statements, texts, biographies. Extensive English and Russian bibliography. Reissued 1970 in reduced format (bibl. 35). Extensive review: Francine Du Plessix, "Russian art 50 years ago," *Art in America,* v. 51, no. 1, 1963.

35. Gray, Camilla. *The Russian Experiment in Art 1863–1922.* New York, Abrams; London, Thames and Hudson, 1970.
Although presented as a "re-issue" in reduced format of the 1962 edition, actually there is compression in size, modification in illustration, omission of statements and biographies, no Russian bibliography. Selected bibliography.

36. Haftmann, Werner. *Painting in the Twentieth Century*. London, Lund Humphries; New York, Praeger, 1960.
Vol. I, Text—II Plates. Popular edition, 1965. Completely revised from the German edition: Munich, Prestel, 1954–1955; 1957, Biographies, bibliographies.

37. Hamilton, George Heard. *The Art and Architecture of Russia.* Harmondsworth, Middlesex, and Baltimore, Md., Penguin Books, 1954.
Especially chap. 27. Bibliography.

38. Hamilton, George Heard. *Painting and Sculpture in Europe, 1880 to 1940.* Harmondsworth, Middlesex, and Baltimore, Md., Penguin Books, 1967.
Chap. 6: Abstract and non-objective art. Bibliography.

39. Hamilton, George Heard. *19th and 20th Century Art and Painting, Sculpture, Architecture.* New York, Abrams, 1970.
Bibliography.

40. Hiepe, Richard. *Die Fotomontage. Geschichte und Wesen einer Kunstform*. Ingolstadt, Courrier Druckhaus [1971?].
Catalogue based on exhibition (Stadt und Kunstverein Ingolstadt). Exhibitors: van Doesburg, Lissitzky, Moholy-Nagy, Rodchenko, also Soviet posters, "USSR in Bau." Bibliography. Similar coverage in bibl. 87, 139.

41. Hill, Anthony, ed. *DATA. Directions in Art, Theory and Aesthetics*. London, Faber and Faber; Greenwich, New York Graphic Society, 1968.
A cross-section of "some related movements . . . constructive, concrete, kinetic, structurist and synthesist." Contributors include Baljeu, Biederman, Gorin, Hill, Lohse, Martin, et al. Biographies; bibliographies.

42. Jaffé, Hans L. C. *De Stijl: 1917–1930. The Dutch Contribution to Modern Art*. Amsterdam, Meulenhoff; London, Tiranti, 1956.
Many translations. "Notes" constitutes index to *De Stijl*. Extensive bibliography.

43. Jaffé, Hans L. C., ed. *De Stijl*. London, Thames and Hudson, 1970; New York, Abrams, 1971.
Introduction to extensive anthology of selections from the magazine. Biographies. Partial duplication and additional extracts in his similar: *Mondrian und De Stijl*. Cologne, DuMont Schauberg, 1967 (DuMont Dokumente).

44. Kassák, Ludwig and Moholy-Nagy, László, eds. *Buch neuer Künstler*. Vienna, "MA," 1922.
"Unser Zeitalter ist das der Konstruktivität." Largely plates.

45. Kepes, Gyorgy, ed. *Structure in Art and in Science*. New York, Braziller; London, Studio Vista, 1965.
Title in 6-vol. series: "Vision and Value."

46. Kopp, Anatole. *Town and Revolution. Soviet Architecture and City Planning, 1917–1935*. New York, Braziller, 1970.
Translation: *Ville et Révolution* (Paris, Éditions Anthropos, 1967). Includes sections on "Tatlin's tower," "constructivism in architecture," excerpts from El Lissitzky's *Russland*, etc. Bibliography. Reviewed: *Architectural Design* (London), Feb. 1970, p. 108.

47. Lach, Friedhelm. *Der Merz Künstler Kurt Schwitters*. Cologne, DuMont Schauberg, 1971.
"Einfluss der Konstruktivisten," pp. 52–57.

48. Lake, Carleton and Maillard, Robert, eds. *Dictionary of Modern Painting*. New York, Paris Book Center [1955]; London, Methuen, 1956.
Translated from the French. Revised and enlarged: *Nouveau dictionnaire de la peinture moderne* (Paris, Hazan, 1963). Biographies and general articles: concrete art, suprematism, etc. Second revised English edition: New York, Tudor [1964?].

Levante, Galleria del. See bibl. 101.

48a. Leyda, Jay. *Kino: a History of the Russian and Soviet Film*. London, Allen & Unwin, 1960.

49. Lissitzky, El and Arp, Hans. *Die Kunstismen—Les Ismes de l'Art—The Isms of Art*. Erlenbach-Zurich, Munich, Leipzig, Rentsch, 1925.
Trilingual definitions, e.g., "prounismus." Also reprint: New York, Arno, 1968.

50. Lissitzky, El. *Russia, an Architecture for World Revolution*. London, Lund Humphries (1971?).
Includes both his 1929 German text (bibl. 268) and supplemental essays by others.

51. Lozowick, Louis. *Modern Russian Art*. New York, Société Anonyme, 1925.
Published by the "Museum of Modern Art—Société Anonyme—1920."

Martin, J. L., et al. *Circle*. See bibl. 20.

52. Martin, Marianne W. *Futurist Art and Theory. 1909–1915*. Oxford, Clarendon Press, 1968.
Bibliography.

53. *Metro: International Directory of Contemporary Art 1964*. Milan, Editorial Metro, 1963.
Trilingual introduction. Biography, notes, bibliography on "200 leading artists of today," e.g., Gabo, Schöffer, Vasarely.

54. Micheli, M. De, ed. *Le Avanguardie artistiche del Novecento*. Milan, Feltrinelli, 1966.
Anthology of texts of artists of the twentieth century. Frequent extracts in *L'Arte Moderna* (Milan), e.g., the Russians in no. 54, 1967 (bibl. 129).

55. Müller-Brockmann, Josef. *A History of Visual Communication*. Teufen, Niggli, 1971.
Sections on Russian constructivism, de Stijl, Bauhaus. Text also in German and French.

56. Németh, Lajos. *Modern Art in Hungary*. Budapest (?), Corvina Press, 1969.
"The constructivism of the Kassák circle," pp. 73–74, includes Kassák's statement on "picture-architecture," mentions Moholy-Nagy. Bibliography. Coverage complemented by catalogue: *Ungarische Avantgarde, 1909–1930*. Munich, Galleria del Levante, Nov. 1971–Jan. 1972. Text by Eva Körner.

57. Neumann, Eckhard. *Functional Graphic Design in the 20's*. New York, London, Reinhold, 1967.
Emphasis on European innovations, including the Russians.

58. Pellegrini, Aldo. *New Tendencies in Art*. New York, Crown; London, Elek, 1966.
Chapters on constructivist and concrete art.

59. Pevsner, Nikolaus. *Pioneers of Modern Design from William Morris to Walter Gropius*. 2. ed. New York, Museum of Modern Art, 1949.
Revision of 1936 London edition by Erwin Schaefer. Also: London, Penguin, 1960; Baltimore, Penguin, 1964; paperback editions.

60. Popper, Frank. *Origins and Development of Kinetic Art*. London, Studio Vista, 1968; New York, New York Graphic Society, 1969.
Comments on the Russians, constructivism, etc. Translated from

the French by Stephen Bann. Bibliography also in author's dissertation (University of Paris, 1966).

61. Quilici, Vieri. *L'Architettura del Costruttivismo*. Bari, Editori Laterza, 1969.
Major compilation includes introduction (p. 5ff).—essays (p. 181ff).—documents (p. 463ff).—index (p. 575ff). Largely articles and statements translated from the Russian: architects, artists, critics. Reviews early period: Vkhutemas, Inkhuk, etc. Complete text of Gan's *Il costruttivismo* (1922). Extensively and approvingly reviewed by Joseph Rykwert, *Architectural Design* (London), Feb. 1970, p. 108.

62. Rathke, Ewald. *Konstruktive Malerei 1915–1930*. Mit einem Beitrag von Eckhard Neumann. Offenbach/M, Peters Verlag, 1967.
Book edition of Frankfurt exhibition (bibl. 103). Biographies, bibliographies.

63. Read, Herbert. *The Art of Sculpture*. London, Faber and Faber, 1956 2. ed. New York, Bollingen Foundation, distributed by Pantheon Books, 1961.
Index lists constructivists, e.g., Gabo. First edition, 1956.

64. Rickey, George. *Constructivism: Origins and Evolution*. New York, Braziller; London, Studio Vista, 1967.
References to Baljeu, Biederman, van Doesburg, Eggeling, Gabo, Lissitzky, Lohse, K. Martin, Pevsner, Rodchenko, Schöffer, Tatlin, Torres-García, et al. Second printing (minor revisions), 1969. Biographies. Extensive bibliography by Bernard Karpel. Review: Camilla Gray, *Studio International*, Mar. 1968, p. 164.

65. Risselada, Max and Frampton, Kenneth. *Art & Architecture—USSR —1917–1932*. Exhibit June 3–18, 1971, at The Institute for Architecture and Urban Studies. New York, Wittenborn, 1971.
Publication based on exhibition shown at the Technische Hogeschool afd Bouwkunde, Delft (Nov. 1969–Jan. 1970), later Berlin, Harvard, and Princeton. Bibliography, important chronology, errata slip. Same as bibl. 116.

66. Ritchie, Andrew C. *Sculpture of the Twentieth Century*. New York, Museum of Modern Art; London, Thames and Hudson, 1962.
Includes "the object constructed on geometric principles." Bibliography.

67. *Russian Revolutionary Posters, 1917–1927*. New York, Grove Press, 1967.
Introduction with 40 colorplates in folio. Research: C. Garruba: notes: S. Congrat-Butlar. Also German edition with text by G. Garritano (Berlin, Gerhardt, 1966).

*68. Selvinsky, Ilya and Others. [*Gosplan for Literature*. Moscow-Leningrad, Literary Center of Constructivists]. 1924.
Russian text. Excerpt translated, pp. 123–27.

69. Seuphor, Michel. *L'Art abstrait: ses origines, ses premiers maîtres*. nouv. ed. Paris, Maeght, 1950.
Based on 1949 edition and exhibit at the Galerie Macght. Biographies include Gabo, Lissitzky, Moholy-Nagy, Pevsner, Richter, Rodchenko, Tatlin, van Doesburg. Bibliography.

70. Seuphor, Michel. *Piet Mondrian: Life and Work*. London, Thames and Hudson; New York, Abrams, 1956.
 Texts; bibliography. Note extract in bibl. 189.
71. Shvidkovsky, Oleg A., ed. *Building in the U.S.S.R., 1917–1932*. New York, Washington, Praeger; London, Studio Vista, 1971.
 Anthology of 15 essays with notes on 6 contributors. Based on material from *Architectural Design* (bibl. 125) and *Arkhitektura* including: "Creative trends 1917–1932.—Unovis.—Vkhutemas, Vkhutein.—El Lissitzky, 1890–1941," etc. Bibliography. Complements coverage in bibl. 119 (supplement).
72. Spencer, Herbert. *Pioneers of Modern Typography*. London, Lund Humphries, 1969; New York, Hastings House, 1970.
 Chapters on El Lissitzky, van Doesburg, Rodchenko, and others. Numerous examples, including color facsimiles, illustrate the influence of constructivism. Bibliography.
73. Staber, Margit. *Konkrete Kunst*. St. Gallen, Galerie Press, 1966.
 "Serielle Manifeste," Jahrgang 66, Manifest XI (Nov. 1966). Brochure also incorporated in anthology: *Gesammelte Manifeste* [1966–1967?]. Texts from van Doesburg, Bill, Lohse, et al. Bibliography.
74. Steneberg, Eberhard, ed. *Beitrag der Russen zur modernen Kunst*. Düsseldorf, Druck: H. Wintersheidt [1959].
 Biographies: Gabo, Lissitzky, Pevsner, etc. Introduction: K. vom Rath. Sponsor: Frankfurter Kulturen Arbeit.
75. Steneberg, Eberhard. *Russische Kunst: Berlin 1919–1932*. Berlin, Mann, 1969.
 Comprehensive section of biographies, chronology, bibliography. Sponsor: Deutsche Gesellschaft für Bildende Kunst (Kunstverein Berlin).
75a. Taraboukin, Nikolai. *Le dernier tableau. Écrits sur l'art et l'histoire de l'art à l'époque du constructivisme russe*. Edited by Andrei B. Nakov. Translated by Andrei B. Nakov and Michel Pétris. Paris, Éditions Champ Libre, 1972.
 Contains two essays published by Proletkult, Moscow, 1923.
76. Todorov, Tzvetan, ed. *Théorie de la littérature: Textes des formalistes russes*. Paris, Éditions du Seuil, 1965.
76a. Umanskij, Konstantin. *Neue Kunst in Russland, 1914–1919*. Potsdam, Kiepenheuer; Munich, Goltz, 1920.
77. Vollmer, Hans. *Allgemeines Lexikon der bildenden Künstler des XX. Jahrhunderts*. Leipzig, Seeman, 1953–1962.
 Comprehensive biographical notes and bibliography scattered among 5 vols. and supplement. Occasional variants, e.g., van Doesburg under Küppers; Gabo under Pevsner, N. References mention illustrations.
78. Waddington, C. H. *Behind Appearance. A Study of the Relations behind Paintings and the Natural Sciences in this Century*. Edinburgh, Edinburgh University Press, 1969.
 References to constructivism (index, p. 249).
79. Wescher, Herta. *Collage*. New York, Abrams, 1969 (?).
 Translation: *Die Collage. Geschichte eines künstlerischen Aus-*

drucksmittels. Cologne, DuMont Schauberg, 1968. Chap. 5: Russian collage and related mediums.—8: Constructivism and propaganda. Documentation.

80. Wingler, Hans Maria. *Bauhaus.* Cambridge, Mass., M.I.T. Press, 1969.
 Translation from the German edition, 1962.

81. Wollen, Peter. *Signs and Meaning in the Cinema.* London, Studio Vista; Bloomington, Indiana University Press, 1969.
 The World of Abstract Art. See bibl. 247.

82. Yale University. Art Gallery. *Collection of the Société Anonyme: Museum of Modern Art 1920.* New Haven, Associates in Fine Arts (Yale), 1950.
 Biographical and bibliographical notes on Gabo, Lissitzky, Moholy-Nagy, Pevsner, Richter, Torres-García, van Doesburg, etc.

83. Zevi, Bruno. *Poetica dell' architettura neoplastica.* Milan, Tambourini, 1953.
 Comments on the Bauhaus, de Stijl; emphasizes neoplasticism in van Doesburg and Mondrian. Bibliography.

SELECTED CATALOGUES (*By Date*)

Information on exhibitions appears in several forms, e.g., scattered as in Gray (bibl. 34), concentrated as in MacAgy (bibl. 186), or in commentary such as Bowlt (bibl. 157) and the Delft chronology (bibl. 65). However, the very early exhibits are difficult to date precisely and must wait for details from the U.S.S.R. or research in progress.

*84. Berlin. Galerie van Diemen. *Erste russische Kunstausstellung.* [Oct. Nov.?] 1922.
 "Organized for Narkompros (People's Commissariat for Education) by I. Ehrenburg and E. Lissitzky, a.o. . . . Chairman, Dept. of Fine Arts, D. Shterenberg . . . Dept. of Museums headed by A. Rodchenko." (bibl. 116). Cover design by Lissitzky. 594 exhibits in fine and applied arts. Artists: Gabo, Malevich, Pevsner, Rodchenko, Lissitzky, Tatlin, etc. Dated Jan. 1922 by Andersen (*Malevich,* 1970); dated Oct. by Hutton (bibl. 123). However, the introduction is dated Nov. 22, and the show is reviewed in *Das Kunstblatt,* Nov. 22 (bibl. 211). Also exhibited with "corrected catalog," at the Stedelijk Museum, Amsterdam (1923?). Excerpts translated, pp. 70–76.

85. Paris. Galerie Percier. *Constructivistes russes: Gabo et Pevsner, peintures, constructions.* June 19–July 5, 1924.
 Text by W. George, 12 leaves, 4 illus.

86. Paris. Galerie 23. *Cercle et Carré.* Apr. 18–May 1, 1930.
 "First international exhibition of abstract art." Organized by Michel Seuphor, introduction by Mondrian. Described in *Cercle et Carré,* no. 2, Apr. 1930. Exhibitors: Arp, Gorin, Kandinsky, Mondrian, Pevsner, Torres-García, et al.

87. Berlin. Staatliche Kunstbibliothek. *Fotomontage*. Apr. 25–May 31, 1931.
 Texts include G. Kluzio [Klutsis?]: "Fotomontage in der USSR." German and Russian sections; Moholy-Nagy, Lissitzky, Rodchenko, etc.

88. London. Lefèvre Gallery. *Abstract and Concrete*. Spring, 1936.
 First international held in London, including Gabo, Moholy-Nagy, etc. Installation view in *Circle* (bibl. 20) p. 280. Exhibition circulated to Liverpool, Oxford, Cambridge.

89. Basel. Kunsthalle. *Konstruktivisten*. Jan. 16–Feb. 14, 1937.
 Exhibitors: van Doesburg, Gabo, Lissitzky, Moholy-Nagy, Pevsner, Rodchenko, etc. Prefatory texts.

90. London. London Gallery. *Constructive Art*. [July] 1937.
 Exhibitors: Gabo, Moholy-Nagy, and others. Review by Eric Newton later reprinted in his *In My View*, pp. 56–59 (1950).

91. Basel. Kunsthalle. *Konkrete Kunst*. Mar. 18–Apr. 16, 1944.
 Texts by Bill and Arp on "art concret." Exhibitors include Lissitzky, Pevsner, van Doesburg, Gabo.

92. New York. Rose Fried Gallery. *The White Plane*. Mar. 19–Apr. 12, 1947.
 "The first pure abstract show." Artists: Albers, Bolotowsky, Malevich, Mondrian, et al. Separate mimeographed essay by Charmion von Wiegand.

93. Zurich. Kunsthaus. *Antoine Pevsner—Georges Vantongerloo—Max Bill*. Oct. 15–Nov. 13, 1949.
 Includes texts by the artists.

94. Amsterdam. Stedelijk Museum. *De Stijl*. Cat. 81, July 6–Sept. 25, 1951.
 Definitive exhibition; comprehensive multilingual texts and extracts (Dutch, English, French). Emphasis on van Doesburg and a wide circle of collaborators. Variant exhibits at the Biennale, Venice (1952), and the Museum of Modern Art, New York (catalog issued as its *Bulletin* v. 20, no. 2, Winter 1952–1953).

95. New York. Galerie Chalette. *Construction and Geometry in Painting: from Malevitch to "Tomorrow."* Mar. 1960.
 Preface by Madeleine Lejwa; introduction by Michel Seuphor. Biographies include van Doesburg, Lissitzky, Richter, Gorin, Lohse, Seuphor, et al.

96. Zurich, Kunstgesellschaft. *Konkrete Kunst: 50 Jahre Entwicklung*. June 8–Aug. 14, 1960.
 Text by M. Bill, documentation by M. Staber, manifestoes from *De Stijl*, notes on pioneers and contemporaries.

97. London. Grosvenor Gallery. *Two Decades of Experiment in Russian Art, 1902–1922*. Mar. 15–Apr. 14, 1962.

97a. Frankfurt. Göppinger Galerie. *Werbegrafik 1920–1930*. Frankfurt am Main, June 27–July 20, 1963.
 Catalog by Eckhard Neumann; bibliography.

98. Amsterdam. Stedelijk Museum. *Experiment in Constructie*. May 18–June 16, 1962.
 Bilingual English text includes Joost Baljeu: "The new plastic expression." Biographies: Baljeu, Biederman, Gorin, Hill, etc.

Variant catalog: *Experiment in Fläche und Raum.* Zurich, Kunstgewerbemuseum, Aug. 25–Sept. 30, 1962.

99. New York. American Federation of Arts. *British Constructivist Art.* Apr. 12–May 27, 1962.
 Assembled by Institute of Contemporary Art (London), circulated in America. Included Martin, Pasmore, et al. Introduction: Lawrence Alloway.

100. Hanover. Kunstverein. *Die Zwanziger Jahre in Hannover, 1916–1933.* Aug. 12–Sept. 30, 1962.
 Section on "Dorner, Lissitzky und das Kabinett der Abstraktion" (pp. 193–219). Brief biographies: van Doesburg, Lissitzky, Moholy-Nagy, etc. Text: H. Rischbieter, D. Helms.

101. Milan. Galleria del Levante. *Il contributo russo alle avanguardie plastiche.* [Winter] 1964.
 Catalog by Carlo Belloli. Exhibits; extensively illustrated; also chronology (1895–1964). Biographies.

102. Stockholm. Moderna Museet. *Den Inre och den Yttre Rymden.* [The Inner and the Outer Space: an exhibition devoted to universal art]. Dec. 26, 1965–Feb. 13, 1966.
 Partial contents: Troels Andersen, "Kasimir Malevich 1912–1935." With Malevich texts, footnotes, biography, bibliography.—K. G. Hultén, "Naum Gabo." Chronology, bibliography.

103. Frankfurt. Kunstverein. *Konstruktive Malerei 1915–1930.* Nov. 19, 1966–Jan. 8, 1967.
 Editors: Ewald Rathke and Sylvia Rathke-Köhl. Includes Malevich, Lissitzky, van Doesburg, etc. Biographies, bibliography. Also issued in book format (bibl. 62).

104. Newcastle on Tyne. University. Department of Fine Art. *Descent into the Street.* Feb. 1967.
 Russian and French exhibits. Introduction by Ronald Hunt.

105. Lund. Konsthall. *En Festival kring Konst och Teknologi i Lund.* [A Festival about Art and Technology]. Lund, Skänka Konstmuseum, Mar. 30–Apr. 21, 1967 (?).
 At head of title: Data—Urbanism—Archigram—etc.

106. New York. Gallery of Modern Art. *A Survey of Russian Painting—Fifteenth Century to the Present.* June 14–Sept. 17, 1967.
 Introduction by George Riabov. Commentary by Malevich, Tatlin, El Lissitzky, Rodchenko. Bibliography.

107. Vienna. Museum des 20. Jahrhunderts. *Kinetika.* July 7–Oct. 15, 1967.
 References to Gabo, Pevsner, Moholy-Nagy, Rodchenko, Tatlin, Vasarely, Russian architecture of the Revolution.

108. Berlin. Kunstverein und Akademie der Künste. *Avantgarde Osteuropa 1910–1930.* Ausstellung der Deutschen Gesellschaft für Bildende Kunst. Oct.–Nov. 1967.
 Text by Eberhard Roters, Hans Richter, Erich Buchholz, etc. Exhibits: Gabo, Pevsner, Rodchenko, Tatlin, et al. Extensive biographical notes: bibliography; chronology (1900–1932).

109. London. Grosvenor Gallery. *Aspects of Russian Experimental Art 1900–1925.* Oct. 24–Nov. 18, 1967.
 Exhibitors include Gabo, Lissitzky, Tatlin, et al.

110. Chicago. Museum of Contemporary Art. *Relief—Construction—Relief.* Oct. 26–Dec. 1, 1968.
 Text by Jan van der Marck. Includes Gorin, Biederman, Pasmore, Martin, Hill, Baljeu, and others. Biographies, bibliography. Also shown at Herron Museum, Cranbrook Academy, High Museum of Art, Atlanta (1968–1969).

111. Stockholm. Moderna Museet. *Transform the World: Poetry must be made by All!* Nov. 15–Dec. 21, 1969.
 Conception: Ronald Hunt. Director: Pontus Hultén. Editor: Katja Walden. Swedish and English text. Section on Malevich, Tatlin, Rodchenko, U.S.S.R. of the twenties, Lissitzky, Moholy-Nagy, etc. Bibliography.

112. New York. Museum of Modern Art. *The Machine as Seen at the End of the Mechanical Age* by K. G. Pontus Hultén. New York, Museum of Modern Art, 1968.
 Major study, which includes catalog of the exhibition. Shown New York (Nov. 25, 1968–Feb. 9, 1969), Houston (Mar. 25–May 18, 1969), San Francisco (June 23–Aug. 24, 1969). Commentary on Gabo, Hausmann, Tatlin, Lissitzky, etc. Bibliography.

113. Buffalo. Albright-Knox Art Gallery. *Plus by Minus: Today's Half-Century.* Mar. 5–Apr. 14, 1968.
 Organization and text by Douglas MacAgy. Comprehensive showing of Gabo. Exhibit illustrates range of works representing suprematism, constructivism, de Stijl, the Bauhaus, concrete art, the New Tendency.

114. Nuremberg, Biennale. *Konstruktive Kunst: Elemente + Prinzipien.* Apr. 18–Aug. 3, 1969.
 2 vols. (vol. II: "Bild-Band"). Committee: O. Bihalji-Merin, U. Apollonio, et al. Essays on Russian constructivists, de Stijl, Bauhaus, etc. Artists include Baljeu, van Doesburg, Gorin, Lissitzky, many others. Documentation. For commentary by Juliane Roh see *Werk* (Winterthur) Aug. 1969, pp. 584–587; also bibl. 203.

115. Strasbourg, Musée de la Ville. *L'Art en Europe autour de 1918.* May 8–Sept. 15, 1968.
 Commentary in German and French by Werner Hofmann on the Russians (pp. 58–61, 65–67) supplemented by biographies in catalog. Organized in association with the Council of Europe.

116. Delft. Technische Hogeschool afd Bouwkunde. *[Art & Architecture —USSR—1917–1932].* Nov. 1969–Jan. 1970.
 Exhibit assembled by Otto Das, Gerrit Oorthuys, Max Risselada (Faculty of Architecture, Technological University of Delft, Holland). Later exhibitions: Technische Hochschule, Berlin.—Carpenter Art Center, Harvard University.—School of Architecture and Urban Planning, Princeton University. For New York see bibl. 65.

117. London. Annely Juda Fine Art and Michael Tollemache Ltd. *The Non-Objective World, 1914–1924.* June 20–Sept. 30, 1970.
 Introduction by Eckhard Neumann. Biographical notes; 38 exhibitors; illus.

118. Ithaca. Andrew Dickson White Museum of Art. *Russian Art of the Revolution.* Feb. 24–Mar. 25, 1971.

Preface by Sarah Bodine. Works by Gabo, Lissitzky, Pevsner, Rodchenko, Tatlin, etc. Exhibited Brooklyn Museum of Art, June 14–July 25, 1971. Extensive chronology, 1910–1927. Detailed biographies include bibliographical references and extracts, e.g., Malevich: "Suprematism and nonobjective creation" (Tenth State Exhibition).—Tatlin, et al.: "The program of the Constructivist Group."—El Lissitzky: "The electrical-mechanical spectacle."

119. London. Hayward Gallery. *Art in Revolution: Soviet Art and Design since 1917.* Feb. 26–Apr. 18, 1971.

Organized by the Arts Council; preface by R. Campbell, N. Lynton. Introduction: Camilla Gray-Prokofieva. Main catalogue has 17 articles and statements, well illustrated; covers architecture, posters, theater, film; a revised version of "A lost avant-garde" by Kenneth Frampton (pp. 21–29). Exhibitions list includes Lissitzky, Malevich, Rodchenko, Tatlin, and others as well as film programs. *Supplemental catalog* has detailed exhibits and extensive essay by Oleg A. Shvidkovsky. Modified exhibition installed New York Cultural Center, Fall 1971. Reviewed by Hilton Kramer (bibl. 181).

120. New York. La Boétie. *Constructivist Works in Paper from the Era of the Bauhaus.* Mar. 2–Apr. 3, 1971.

Mimeographed. Lists 65 works, 14 biographical notes. Cover design: "MA."

121. New York. Institute for Architecture and Urban Studies. *Art & Architecture—USSR—1917–1932.* June 3–18, 1971.

Catalog same as bibl. 65.

122. Nuremberg, Biennale, II. *"Was die Schönheit sei, das weiss ich nicht" : Künstler—Theorie—Werk.* April 30–Aug. 1, 1971.

Major catalog (352 pp. incl. illus., 10 chapters). Chap. 6–8 includes El Lissitzky, Tatlin, Pevsner, Gabo, van Doesburg, Vasarely, and others. Bibliographies.

123. New York. Leonard Hutton Galleries. *Russian Avant-Garde, 1908–1922.* Oct. 16, 1971–[Feb. 29, 1972].

Major catalog, 120 works in varied media, 102 pp., ill. (col.). Introductions by John E. Bowlt and S. Frederick Starr. Chronology (1907–1922). List of associations with abbreviations.

PERIODICALS AND SPECIAL NUMBERS

124. *Abstraction-Création—Art Non-Figuratif* (Paris) no. 1–5, 1932–1936.

Each cahier includes brief text and illustrations. Members mentioned: Gabo, Pevsner, van Doesburg, etc. Various editorial groups, e.g., Georges Vantongerloo, Auguste Herbin, et al. Reprint edition: New York, Arno, 1968.

125. *Architectural Design* (London). Feb. 1970.

Special number, v. 40, pp. 71–107, with *AD* cover caption: "Constructivist architecture in the USSR." Contents title: "Building in the USSR, 1917–1922. Guest editor: Prof. O. A. Shvidkovsky."

Six contributors, sixteen articles including "Unovis," "Vhutemas, Vhutein," "El Lissitzky 1890–1941," "Creative trends in Russia, 1917–1932," several Soviet architects. Biographical and bibliographical references passim. Reviews (p. 108): The Constructivists: "El Lissitzky" (bibl. 272)—"Ville et Révolution" (bibl. 46) —"L'Architettura del costruttivismo" (bibl. 61). This special number also issued in book form (bibl. 71).

126. *Architecture Vivante* (Paris) no. 99, 1925.
Titled: "L'architecture vivante en Hollande.—Le groupe De Stijl." Texts: Jean Badovici: "Les constructivistes."—van Doesburg: "L'évolution de l'architecture moderne en Hollande."—Mondrian: "L'architecture future néoplasticienne."

127. *Art and Artists* (London) no. 61, Apr. 1971.
Cover-title for v. 6, no. 1: "Russian art since 1917." Includes Ronald Hunt: "The demise of constructivism."—Ivor Davies: "Red art 1916 to 1971."—N. Sokolova: "Soviet stage design."— Robert O'Rorke: "Malevich . . . and Pollock." "Censored," p. 9, by the editor, Charles Spencer, refers to the current exhibition *Art in Revolution* (bibl. 119). Note on Camilla Gray, p. 60. Colored cover: Decor sketch, 1920.

*128. *Art Concret (Paris).* Numéro d'introduction du groupe et de la revue. Apr. 1930.
Actually a collective manifesto (since only one number was published) and the first use of "concrete art." Associates: Carlsund, Doesbourg, Hélion, Tutundjian, Wantz. Contents: "Base de la peinture concrète." (p. 1); "Hélion, Commentaries sur la base de la peinture concrète" (Jan. 1930) "Les problèmes de l'art concret.—Art et mathématiques."—Doesbourg, "Vers la peinture blanche" (Dec. 1929), "Definitions de l'art selon Doesbourg." "Quelques mots . . . ," etc. Gérant: Jean Hélion. Excerpt translated, pp. 191–93.

129. *L'Arte Moderna* (Milan) nos. 44, 48, 54, 1967.
V. 5, no. 44: Maurizio Calvesi, "Il futurismo russo."—V. 6, no. 48: Guilia Veronesi. "Suprematisti e costruttivisti in Russia."— V. 6, no. 54: "Antologia critica" (selections from Malevich, Gabo, Pevsner, Lissitzky, van Doesburg, the Bauhaus, etc.). Bibliography and index, v. 6.

130. *Cahiers du Cinéma* (Paris) no. 220–221, May–June 1970.
Titled "Russie années vingt." Covers filmic, theatrical, and literary events. Chronology 1909–1930 (pp. 114–118). Bibliography.

131. *Cercle et Carré* (Paris). Editors: M. Seuphor, J. Torres-García. No. 1–3, 1930.
Facsimile edition. Turin, [Galeries d'Art Lorenzelli], 1969. "Postface" by Giuliano Martano. Also see bibl. 323. Continued by *Círculo y Cuadrado* (bibl. 133).

132. *Cimaise: Present day art and architecture* (Paris) no. 85–86, Feb.– May 1968; no. 99, Nov.–Dec. 1970.
No. 85–86: "L'art soviétique des années 20." Double number for the 50th anniversary of the October Revolution. Bilingual texts include Michel Hoog: "The situation of the avant-garde in Russia." —Miroslav Lamac: "Melevitch, the misunderstood."—*No. 99:* "De

Stijl." Bilingual texts by Seuphor, Nelly van Doesburg, César Domela, Mondrian. Also the movement, its architecture, and European art around 1925 by T. Wolters, M. Hoog, M. Ragon, H. Wescher.

133. *Círculo y Cuadrado* (Montevideo). Editor: Torres-García. No. 1–10, May 1936–Dec. 1943.
"Segunda época de *Cercle et Carré* . . . revista de la Asociacíon de Arte Constructivo."

134. *Form* (Cambridge, England). Editors: Philip Steadman, Mike Weaver, Stephen Bann. No. 1–10, 1966–1969.
Representative contents: No. 1: "Film as pure form" (van Doesburg).—no. 3: "The electrical-mechanical spectacle" (El Lissitzky).—no. 5–6: "The Stijl" index—no. 8: "Russian exhibitions, 1904 to 1922" (John E. Bowlt).—no. 10, Oct. 1969: "LEF."

135. *G* (Berlin). *Zeitschrift für Elementare Gestaltung.* Editor: Hans Richter. Associates: Werner Gräff, El Lissitzky, Mies van der Rohe, Friedrich Kiesler. July 1923–1926.
No. 1–2 in newspaper format; no. 3–5/6 in small format. Indexed by Mike Weaver in *Form*, no. 3, Dec. 1966, with extracts, e.g., bibl. 195.

*136. *LEF* [Levei Front Iskoustva] (Moscow). [Journal of the Left, Left Front in Art]. Editor: V. Mayakovsky. 1923–1925.
Revived as *Novy Lef*, edited by V. Mayakovsky and V. Tretyakov, 1927–1928. Part of no. 10, Oct. 1969 of *Form* (Cambridge, England) is devoted to "LEF, 1923–1925." Contents: Cover design by Rodchenko.—"Introduction to LEF" by R. Sherwood.—"What is LEF fighting for? Whom is LEF alerting?" by LEF Editorial Board.—"Into Production" by O. M. Brik.—"Materialized Utopia" by B. Arvatov.—"Our literary work" by V. V. Mayakovsky and O. M. Brik.—"The so-called 'formal method'" by O. M. Brik. Excerpts translated, pp. 80–89.

*137. *Mécano* (The Hague-Paris). Editor: Théo van Doesburg. 4 parts, 1922 (?).
I. K. Bonset, literary director, was van Doesburg. No. 1: Yellow.
—2: Blue.—3: Red.—4–5: White. For partial translations and full index, see *Form* (Cambridge, England) no. 4, pp. 30–32, Apr. 15, 1967, where *Mécano* 4–5 white is listed as 1923. In bibl. 237, all four numbers: blue, yellow, white, red (C25–C28) are dated 1922. Excerpts translated, pp. 109–112.

138. *Paletten* (Göteborg) no. 4, 1963.
Titled "Konstruktiv Konst," with partial English summary. Quotes Gabo's Realistic Manifesto; essay on "Open form" by Olle Baertling; mentions Vasarely, Schöffer, etc. Articles by F. Edwards, G. Hellinas, E. Johansson, and others.

139. *Social Kunst* (Copenhagen) no. 9, 1932.
"Fotomontage" number, includes El Lissitzky, Moholy-Nagy, H. Richter, Rodchenko, and others.

140. *De Stijl* (Delft, Leiden, Meudon) Editor: Theo van Doesburg. No. 1–[90], 1917–1932.
Outstanding issues included no. 79–84: "10 Jahren 1917–1928."—no. 87–89: "Aubette Number." "Dernier numéro [i.e. 90], Van

Doesburg 1917–1931" (Jan. 1932). *De Stijl* also sponsored *Mécano* (bibl. 137). Author index to *De Stijl* published by Mike Weaver in *Form* (Cambridge, England) no. 6, Dec. 1967 (part I), no. 7, Mar. 1968 (part II). Important selections published in Jaffé (bibl. 43).

141. *Structure* (Amsterdam). Editors: Eli Bornstein and Joost Baljeu, 1958; Joost Baljeu, 1959–1964.
Vol. 1, 1958 (Toronto), "Annual on the New Art" (Bornstein and Baljeu).—Ser. 2, no. 1, 1959–Ser. 6, no. 2, 1964 (Baljeu), on "constructionist and synthesist" art. Biographical notes.

142. *The Structurist* (Saskatoon, Canada). Editor: Eli Bornstein. No. 1, 1960–61—current.
No. 8: "Light-Color-Space-Structure in Art and Nature," texts on De Stijl, van Doesburg; a new translation of the "Realistic Manifesto" by Camilla Gray.—no. 9: "On the Oblique in Art" (dedicated to van Doesburg).—no. 10 (1970) has cumulative index (1–10).

143. *Studio International* (London) no. 876, Apr. 1966.
Special issue on "Naum Gabo and the Constructivist Tradition." Contributions by Gabo, D. Thompson, A. Hill, J. Ernest. Includes "The Realistic Manifesto, 1920," p. 126, and Gabo's comment, p. 125. Also "Naum Gabo talks about his work," pp. 127–131.

144. *20th Century Studies* (Canterbury) no. 7–8, Dec. 1972.
Special issue on "Russian Formalism." Includes "Russian Formalism and the visual arts" by John Bowlt (pp. 131–146) and "The Rationalist movement in Soviet architecture in the 1920's" by Milka Bliznakov (pp. 147–161).

*145. *Veshch—Gegenstand—Objet* (Berlin) No. 1–2, 3. Editors: Ilya Ehrenburg and El Lissitzky. 1922.
No. 1–2 (Mar.–Apr. 1922) includes editorial: "The blockade of Russia is coming to an end." Trilingual texts: Russian, German, and French. Cover design by El Lissitzky. Excerpts translated, pp. 53–57 and 63–64.

146. *Vytvarne Uměni* [Fine Arts] (Prague) no. 8–9, 1967.
Special issue on the revolutionary era in Russia, dealing with suprematism, constructivism, and kineticism. Inserted translations in Russian, German, and English refer to Malevich, Tatlin, Lissitzky, etc. Numerous scarce illustrations.

For other magazines and special numbers relevant to this period see Steneberg (1969), pp. 83–84 (bibl. 75).

SELECTED ARTICLES

147. Abramsky, Chimen. Does art relate to revolution?—the Russian experience. *Art and Artists* (London) no. 5, Aug. 1969.
148. Alloway, Lawrence, Systemic painting. *In* Solomon R. Guggenheim Museum. *Systemic Painting*. New York, Sept.–Nov. 1966.
Reprinted in: *Minimal Art. A Critical Anthology* (bibl. 12).

149. Badovici, Jean. Le mouvement constructif russe. *Architecture Vivante* (Paris) no. 11, Spring 1926.
150. Bann, Stephen. Introduction. *In* Systems. London, Arts Council, 1972. Group exhibition catalog with commentary and chart on constructivism. Circulated Mar. 8–Apr. 8 (Whitechapel Art Gallery) until Apr. 28–May 27, 1973 (Oxford Museum of Art).
151. Barr, Alfred H., Jr. The "Lef" and Soviet art. *Transition* (Paris) no. 14, 1928.
152. Barr, Alfred H., Jr. Notes on Russian architecture. *The Arts* (New York) no. 1, 1929.
153. Bill, Max. Art as non-changeable fact. *In* DATA: Directions in Art, Theory and Aesthetics. London, 1968 (bibl. 41).
154. Bill, Max. Ueber konkrete Kunst. *Das Werk* (Zurich) Aug. 1938.
155. Bourgeois, Victor. Salut au constructivisme. *Zodiac* (Milan) no. 1, 1957.
156. Bowlt, John E. The failed Utopia: Russian art 1917–1932. *Art in America* (New York) no. 4, 1971. Bibliographical sources.
157. Bowlt, John E. Russian exhibitions, 1904 to 1922. *Form* (Cambridge, England) no. 8, 1968.
158. Canaday, John. The revolution that couldn't in a show that doesn't. *New York Times,* Sec. D, Art, p. 23, June 27, 1971. Review of "Russian Art of the Revolution" (bibl. 118) shown at the Brooklyn Museum.
159. Constructing art and society: the role of the "God-builders." *Times Literary Supplement* (London) Mar. 5, 1971. Cultural and literary aspects of the Russian revolution (pp. 257–258). Reviews of relevant art books (pp. 259–260).
160. Del Marle, Félix. Le suprématisme, le néoplasticisme, le constructivisme . . . et son influence. *Art d'Aujourd'hui* (Boulogne-sur-Seine) ser. 2, no. 3, Jan. 1951.
*161. [Editorial: Picture]. *Disk* (Prague) no. 1, 1923. For translation, see pp. 97–102.
*162. [Editorial: What Constructivism Is]. *Blok* (Warsaw) no. 6–7, 1924. For translation, see pp. 103–106.
163. Elderfield, John. Constructivism and the objective world. *Studio International* (London) Sept. 1970. "An essay on production art and proletarian culture." Bibliography.
164. Engelien, Egon. Konstruktivismus. *De Stijl* (Leiden) v. 5, no. 12, Dec. 1922.
165. Ernest, John. Constructivism and content. *Studio International* (London) Apr. 1966.
*166. Filippov, A. [Production art. *From* Art in Production. Moscow, 1921] (bibl. 6). For translation, see pp. 22–25.
167. Frampton, Kenneth. Notes on a lost avant-garde. *In* Art in Revolution (bibl. 119). Earlier version: Notes on a lost avant-garde: architecture, U.S.S.R., 1920–1930. *Art News Annual* (New York) no. 34, 1969.

168. Gan, Alexei. Constructivism [extracts]. *In* Camilla Gray. The Great Experiment: Russian Art. London, New York, 1962 (bibl. 34).

*169. Gan, Alexei. Constructivism in the cinema. *S.A.* [Contemporary Architecture] (Moscow?) no. 3?, 1928.
For translation, see pp. 127–32.

170. Gilbert, Basil. The "reflected light compositions" of Ludwig Hirschfeld-Mack. *Form* (Cambridge, England) no. 2, Sept. 1966.

171. Graeff, Werner. The Bauhaus, the De Stijl Group in Weimar and the Constructivist Congress of 1922. *In* Bauhaus People. New York, etc., Van Nostrand Reinhold, 1970.
Biographical note, p. 73.

172. Habasque, Guy. Documents inédits sur les débuts de Suprématisme. *Aujourd'hui* (Boulogne-sur-Seine) no. 4, 1955.

173. Higgens, Andrew. Art and politics in the Russian revolution. *Studio International* (London) part I Nov. 1970; part II Dec. 1970.

*174. Hilberseimer, Ludwig. Konstruktion und Form. *G* (Berlin) no. 3, June, 1924.
For translation, see pp. 118–23.

175. Hill, Anthony. Constructivism—the European phenomenon. *Studio International* (London) Apr. 1966.
Excellent summary of objectives and evolution.

176. Jelenski, K. A. Avant-garde and revolution. *Arts* (New York) Oct. 1960.
"Modernist art in the U.S.S.R" translated from the Polish *Kultura* (Paris). Constructivist illustrations, 1921–1923.

177. Jelenski, K. A. Russian art: evolution and revolution. *Arts* (New York) Nov. 1962.
Largely a review of Gray's *The Great Experiment* (bibl. 34).

178. Jenks, Charles. "Art in Revolution" [French text]. *L'Oeil* (Paris) Mar.–Apr. 1971.
On the Russian show in London (bibl. 119).

179. Kállai, Ernst. Konstruktivismus. *Jahrbuch der Jungen Kunst* (Leipzig) v. 5, 1924.

*180. [Kemal's constructive program]. *Blok* (Warsaw) no. 5, 1924.
A photomontage, illustrated p. 105.

181. Kramer, Hilton. Art: Soviet avant-garde. *New York Times* p. 44, Sept. 10, 1971.
Review of London show, "Art in Revolution" (bibl. 119), installed in the New York Cultural Center, Sept. 9. Includes 2 sections closed in London: El Lissitzky's Proun room and Tatlin's sculpture.

182. Lawrence, Stuart. Russian unofficial art: "a fairy tale about a firm road." *Form* (Cambridge, England) no. 6, Dec. 1967.
Bibliography.

183. Lohse, Richard P. The influence of modern art on contemporary graphic design. *New Graphic Design* (Zurich) no. 1, Sept. 1958.
Constructivism as major influence; bibliography; German and French text.

184. Longhi, R. Piero dei Franceschi e lo sviluppo della pintura veneziana (from *L'Arte* [Rome] 1913). *In* Oreste del Buono and Pier Luigi de Vecchio, L'Opera completa di Piero della Francesca. Milan, 1967.

185. Lozowick, Louis. A note on modern Russian art. *Broom* (Berlin-New York) Feb. 1923.
 Cover by El Lissitzky.
186. MacAgy, Douglas. The Russian desert: a note on our state of knowledge. *Aspen* (New York) no. 5 + 6, sect. 14, Fall and Winter 1967.
 References passim including exhibitions data.
187. Moholy-Nagy, László. Ismus oder Kunst. *ABC* (Basel) no. 2, 1926.
 Also *Vivos Voco* (Leipzig) no. 8–9, 1926.
188. Moholy-Nagy, Sibyl. Constructivism from Malevich to Moholy-Nagy. *Arts and Architecture* (Los Angeles) June 1966.
189. Mondrian, Piet. Natuurlijke en abstracte realiteit. *De Stijl* (Leiden) no. 8–12, 1919; no. 2–3, 5–10, 1919–1920.
 Translation: Natural reality and abstract reality—an essay in dialogue form. *In* Michel Seuphor. Piet Mondrian. pp. 301–352 (bibl. 70).
190. Nakov, A. B. Destination l'infini: la théorie du suprématisme. *XXe Siècle* (Paris) no. 33, Dec. 1969.
191. Prampolini, Enrico. The aesthetic of the machine and mechanical introspection in art. *Broom* (Berlin-New York) Oct. 1922.
 Refers in part to the "Constructionists" at the "Artists Congress of Düsseldorf."
*192. The Program of the Productivist Group (from *Egyseg*, Vienna, 1922). *In* Naum Gabo, p. 153. London, 1957 (bibl. 242).
 Document issued by a Constructivist group led by Tatlin and translated for a Hungarian magazine. Published in catalogue "for an exhibition organized by Roschenko [sic] and Stepanova and signed by them." For translation, see pp. 18–20.
193. Rathke, Ewald and Neumann, Eckhard. Constructivism 1914–1924. *Art and Artists* (London) July 1970.
194. Richards, J. M. Construction—dead and alive. *Transition* (New York) no. 26, 1937.
 Recent English architecture in a constructivist phase.
195. Richter, Hans. Introduction to "G." *Form* (Cambridge, England) no. 3, Dec. 1966.
196. Roditi, Edouard. The background of modern Russian art. *Arts Magazine* (New York) Oct. 1960.
 "The Peredvizhniki, ancestors of the Socialist Realists, are no less the founders of the whole Russian avant-garde movement."
197. Rosenberg, Léonce. Parlons peinture. *De Stijl* (Leiden) Jan. 1921, Mar. 1921.
198. Sandler, Irving. Gesture and non-gesture in recent sculpture. *In* Minimal Art. New York, 1968 (bibl. 12).
199. Seuphor, Michel. Art construit. *XXe Siècle* (Paris) no. 19, June, 1962.
200. Seuphor, Michel. Constructivist painting. *In* The Selective Eye IV: Modern Art Yesterday and Tomorrow. New York, Reynal [1960].
 Previously published in *L'Oeil* (Paris), Oct. 1959.
201. Seuphor, Michel. Russia and the avant-garde. *In* The Selective Eye, 1956–1957. New York, Reynal, 1956.
 Originally published in *L'Oeil* (Paris) Nov. 1955.

202. Sprague, Arthur. Chernikov and constructivism. *Survey* (London) no. 39, Dec. 1961.
203. Staber, Margit. Biennale Nürnberg: idee, organisation und realität. *Art International* (Lugano) Nov. 1969.
 Bibliography. Catalog listed as bibl. 114.
204. Steneberg, Eberhard. Die Ungeduldigen: zum verständnis der École Russe. *Das Kunstwerk* (Baden-Baden) Aug.–Sept. 1959.
 "Das Tatlinische Manifest, 1914–1915 . . . Bühnenmodell 1919–1920 . . . Puni im "Sturm" 1921 . . . Mansouroff, Leningrad, 1923," etc. Illustrations. English summary. Also supplementation Apr.–May 1961: "Der revolutionäre Grossvater" [USSR].
*205. Toporkov, A. [Technological and artistic form. *From* Art in Production. Moscow, 1921] (bibl. 6).
 For translation, see pp. 26–32.
206. Tynianov, J. [The notion of construction]. *In* Problema stixvoronogo jazyka (Leningrad), 1929.
 Also in Théorie de la littérature (bibl. 76).
207. Vallier, Dora. L'art abstrait en Russie: ses origines, ses premiéres manifestations. *Cahiers d'Art* (Paris) v. 33–35, 1960.
208. Veronesi, Giulia. Suprematisti e costruttivisti in Russia. *L'Arte Moderna* (Milan) no. 48, 1967.
209. Weaver, Mike, ed. Great little magazines. *Form* (Cambridge, England) nos. 1–10, 1966–1969.
 An indexing, commentary, and extracts series which covered *G* (no. 3, 1966), *Mécano* (no. 4, 1967), *De Stijl* (no. 6–7, 1967–1968), and others.
210. Wescher, Herta. Collages constructivistes et successeurs. *Art d'Aujourd'hui* (Paris) no. 2–3, Apr. 1954.
211. Westheim, Paul. Die Ausstellung der Russen. *Das Kunstblatt* (Berlin) no. 11, Nov. 1922.
 Review of bibl. 84.
212. Wollen, Peter. Art in Revolution: Russian art in the twenties. *Studio International* (London) no. 932, Apr. 1971.
 On the occasion of the current show (bibl. 119).

ARTISTS: *Selected Contributors to the Anthology*

BALJEU

213. Baljeu, Joost. *Attempt at a Theory of Synthesist Plastic Expression.* London, Tiranti, 1963.
 Important theoretical work reprinted from *Structure* (Amsterdam), ser. 5, no. 2, 1963.
*214. ——— The constructive approach today. *Structure* (Amsterdam) ser. 6, no. 2, 1964.
 For text, see pp. 287–95.
215. ——— The fourth dimension in neoplasticism. *Form* (Cambridge, England) no. 9, Apr. 1969.
 References to van Doesburg, van Eesteren, Mondrian, etc. Notes.

216. ———— Open letter to the Groupe de Recherche d'Art Visuel. *Structure* (Amsterdam) ser. 4, no. 2, 1962.

217. ———— The problem of reality with suprematism, constructivism, Proun, neoplasticism and elementarism. *Lugano Review* (Zurich) no. 1, 1965.

BIEDERMAN

*218. Biederman, Charles. *Art as the Evolution of Visual Knowledge.* Red Wing, Minn., The Author, 1948.
Extensive text (710 pp.) and illustrations. Includes "Non-Aristotelian art." Emphasizes potentialities arising from a science-machine culture. Bibliography. For sections included here, see pp. 225–34.

219. ———— *Letters on the New Art.* Red Wing, Minn., The Author, 1951. Also *The New Cézanne* (1952). Additional imprints under "Art History Publishers."

220. Arts Council of Great Britain. *Charles Biederman.* A retrospective exhibition with especial emphasis on the structurist works of 1936–1969. London, 1969.
Texts by Robyn Denny, Jan van der Marck. Chronology, bibliography. Exhibited Hayward Gallery, Sept. 18–Oct. 23, 1969; Leicester Museum Nov. 29–Jan. 11, 1970.

221. Bann, Stephen. The centrality of Charles Biederman. *Studio International* (London) no. 914, Sept. 1969.

222. Charles Biederman. *Form* (Cambridge, England) no. 3, Dec. 1966. Includes "A note by Victor Pasmore" on bibl. 218, articles by Biederman, "Letter to Michael Wilson."

223. Walker Art Center. *Charles Biederman: the Structurist Relief, 1935–1964.* Minneapolis, Mar. 30–May 2, 1965.
Introduction by Jan van der Marck. Chronology, glossary, bibliography.

VAN DOESBURG

*224. Van Doesburg, Theo. Manifesto on concrete art (Paris, 1930). *The Structurist* (Saskatoon, Canada) no. 9, p. 42, 1969.
"The manifesto, the original of which was written by me, is signed by the new avant-garde painters" refers to *Art Concret* (bibl. 128). Doesburg contributions usually listed as: "Base de la peinture concrète" (a collective statement) and "Vers la peinture blanche." Excerpt translated, p. 193.

225. ———— L'Élémentarisme et son origine. *De Stijl* (Leiden) no. 87–89, 1928.
In special Aubette (Strasbourg) number.

226. ———— Van Doesburg's Elementarism: new translations of his essays and manifesto originally published in De Stijl, by Donald McNamee. *The Structurist* (Saskatoon) no. 9, 1969.
Three of four essays on the theme (pp. 22–29). Another, described as "the second manifesto fragment, 1926–27" is translated in Hans L. C. Jaffé's article (pp. 16–17).

*227. ————Erklärung der internationalen Fraktion der Konstruktivisten des ersten internationalen Kongresses der fortschrittlichen Künstler.

De Stijl (Leiden) Apr., 1922.
Signed: "Théo van Doesburg, El Lissitzky, Hans Richter. Düsseldorf, 30. Mai, 1922." In special number devoted to the International Congress of Progressive Artists. For translation, see pp. 68–69.

228. ——— *Grundbegriffe der neuen gestaltenden Kunst.* Munich, Langen, 1925. (Bauhausbücher 6).
"Dutch notes collected 1915, manuscript completed 1917, published in *Het Tijdschrift voor Winsbegeerte* 1919, German translation revised and simplified with help of Max Burchartz" (Donald McNamee). Facsimile edition, Mainz, Kupferberg, 1966. English edition, bibl. 229.

*229. ——— *Principles of Neo-Plastic Art.* London, Lund Humphries; New York, New York Graphic Society, 1968.
Translation of bibl. 228. Introduction: Hans M. Wingler; postscript: Hans L. C. Jaffé. Includes "Report of the De Stijl Group," Düsseldorf Conference, May 29–31, 1922. Fragment from van Doesburg's text, *De Stijl,* v. 5, p. 59, 1921–1922. Excerpts translated, pp. 64–66.

230. ——— *De Nieuwe beweging in de schilderkunst.* Delft, 1927.
Other early texts: *Drie voordrachten over de nieuwe beeldende kunst,* Amsterdam, 1919.—*Klassiek, Barok, Modern.* Antwerp, 1920 (translation: *Classique—Baroque—Moderne.* Antwerp and Paris, 1921).

*231. ——— Tot een constructieve Dichtkunst. *Mécano* (Leiden) no. 4–5, 1922–23(?).
"By I. K. Bonset." Translated: Towards a constructive poetry. *Form* (Cambridge, England) no. 4, Apr. 1967. For translation, see pp. 109–112.

*232. ——— Vers une construction collective. *De Stijl* (Leiden) no. 6–7, 1924.
Signed: Théo van Doesburg, Cor van Eesteren, Rietveld. Also in *L'Effort moderne* (Paris) Nov. 1924. Translation: Banham *Theory and Design* pp. 196–197 (bibl. 8).—*Form* (Cambridge, England) no. 9, Apr. 1969, *Studio International* (bibl. 234). For translation, see pp. 115–18.

*233. ——— Zur elementaren Gestaltung. *G* (Berlin) no. 1, July, 1923.
Translation: Elemental formation. *Form* (Cambridge, England) no. 3, Dec. 1966. For translation, see pp. 91–93.

234. Aggis, Maurice and Jones, Peter. Van Doesburg: a continuing inspiration. *Studio International* (London) no. 909, Mar. 1969.
Includes texts by van Doesburg: "Collective construction" (1923). —"Towards a plastic architecture" (1924).

235. Bornstein, Eli, ed. [On the oblique in art]. *The Structurist* (Saskatoon) no. 9, 1969.
Special issue dedicated to van Doesburg, his writings on art and literature, as well as related concepts by others. Contributors include Donald McNamee, Jean Gorin, Victor Pasmore, Naum Gabo. Hans Jaffé's essay includes translation of van Doesburg text from De Stijl: "Painting and plastics, fragments of a manifesto."

No. 8 (1968) includes McNamee's "Van Doesburg's Cow" with translated excerpts.

236. Doesburg, Pétro van, ed. Van Doesburg, 1917–1931. *De Stijl* (Meudon) Dernier numéro, Jan. 1932.
Texts, testimonials, illus., biography, bibliography.

237. Eindhoven. Stedelijk van Abbemuseum. *Théo van Doesburg 1883–1931.* Eindhoven, The Museum, 1968.
Comprehensive catalog of major exhibition held Dec. 13, 1968–Jan. 26, 1969; Gemeentemuseum Den Haag Feb. 17–Mar. 23, 1969; Kunsthalle Basel June–July 1969. Essays by J. Leering, Joost Baljeu, et al. Numerous Dutch, German, French texts by the artist.

238. Jaffé, Hans L. C. *De Stijl.* London, Thames and Hudson, 1970; New York, Abrams, 1971.
Translations from the magazine include sixteen van Doesburg articles: pp. 99–103; 107–108, 117; 127–130; 143; 148–156; 159–163; 177–178; 180–183; 185–188; 190–192; 201–206; 206–212; 212–213; 213–217; 218–225; 232–237; 238.

GABO

239. Gabo, Naum. The concepts of Russian art. *World Review* (London) June 1942.
Also in bibl. 250.

*240. ———— Constructive art: an exchange of letters [with Herbert Read]. *Horizon* (London) no. 53, July 1944.
Also in Read's *The Philosophy of Modern Art* (bibl. 249). For text, see pp. 215–20.

*241. ———— Editorial. *In* Circle. London, Faber and Faber, 1937 (bibl. 20).
By Gabo, Martin, and Nicholson, editors. For sections included here, see pp. 203–204.

*242. ———— Gabo: Constructions, Sculpture, Drawings, Engravings. Introductory Essays by Herbert Read and Leslie Martin. London, Lund Humphries; Cambridge, Harvard University Press, 1957.
Contents: The Realistic Manifesto, 1920 (in reproduction and translation).—The Program of the Productivist Group.—Excerpts from foreword by David Sternberg [sic] to Catalogue of the First Russian Exhibition, Berlin, 1922.—Russia and constructivism, an interview (from bibl. 247).—The constructive idea in art (from *Circle*, bibl. 20).—Toward a unity of the constructive arts (from *Plus* and *Architectural Forum*).—Sculpture: carving and construction in space (from *Circle*, bibl. 20).—An exchange of letters between Naum Gabo and Herbert Read (from *Horizon*, bibl. 240). —On constructive realism (from bibl. 243).—Image, explanatory note.—Art and science (from *The New Landscape*, ed. by G. Kepes, 1956). Also French edition: *Naum Gabo*. Neuchâtel, Éditions du Griffon, 1961. Bibliographies by Bernard Karpel. For sections included here, see pp. 3–11, 18–20, and 204–214.

*243. ——— On constructive realism. *In* Three Lectures on Modern Art by Katherine S. Dreier, James Johnson Sweeney, Naum Gabo. New York, Philosophical Library, 1949.

> Also referred to as "A retrospective view of constructive art." The Trowbridge lecture, Yale University, 1948. Also published in Architects' Year Book, London, Elek, 1952, and *Témoignages pour l'art abstrait* (bibl. 1). For text, see pp. 234–48.

*244. ——— - *The Realistic Manifesto*. Moscow, Aug. 5, 1920.

> Reproduction and *authorized* translation in Gabo monograph (bibl. 242). Other citations noted in bibliographies (bibl. 242, 248). Recently *Studio International* (bibl. 143), Gray (bibl. 246). For text, see pp. 3–11.

245. ——— *The Realistic Manifesto (1920). Naum Gabo—Noton Pevsner. Read by Gabo. Posted in Moscow, Aug. 5, 1920.* Monaural recording (16⅔ rpm), recorded by Aspen, Nov. 1967, in London. [Actual insert]. *Aspen* (New York) no. 5 + 6, sect. 4, Fall and Winter 1967.

246. ——— A new translation of the Realistic Manifesto by Camilla Gray. *The Structurist* (Saskatoon) no. 8, 1968.

> Foldout with brief comment, pp. 43–47. Protested by Naum Gabo in no. 9 (1969), p. 64 with response by the editor.

247. American Abstract Artists, ed. *The World of Abstract Art*. New York, Wittenborn, 1957.

> Includes "Russia and constructivism," an interview with Naum Gabo by Ibram Lassaw and Ilya Bolotowsky, Mar. 1956. Also in bibl. 242.

248. New York. Museum of Modern Art. *Naum Gabo—Antòine Pevsner*. Introduction by Herbert Read; text by Ruth Olson and Abraham Chanin. New York, Museum of Modern Art, 1948.

> Catalog and bibliography on each artist in separate sections. Read's essay also published as chap. 13 of bibl. 249.

249. Read, Herbert. *The Philosophy of Modern Art*. London, New York: Horizon Press, 1953.

> Chap. 13: Constructivism: the art of Naum Gabo and Antoine Pevsner.—13a: Appendix to the essay on Constructivism: an exchange of letters between Naum Gabo and Herbert Read (from *Horizon* no. 53, July 1944).

250. Zurich. Kunsthaus. *Naum Gabo*. Oct. 30–Dec. 1965.

> Includes "The concepts of Russian art by Naum Gabo" (*World Review,* London, June 1942, p. 48).—"Das Realistische Manifest 1920." Chronology, bibliography.

Also see bibl. 102, 113, 138.

GORIN

*251. Gorin, Jean. But de la plastique constructive. *Abstraction-Création— Art Non-Figuratif* no. 5, 1936.

> Additional texts in 1932, 1935. For translation, see pp. 199–200.

252. ——— Nature and art in the 20th century. *Structure* (Amsterdam) ser. 2, no. 1, 1959.

> Additional texts in 1961, 1962, 1963, etc.

253. —— Plastique constructive de l'espace-temps architectural. *Leonardo* (London), no. 3, July 1969.
English abstract. "References" to 16 articles by Gorin.

254. —— Where is pure plastic art leading? *In* DATA. London, 1968 (bibl. 41).
Biographical notice, p. 294.

255. Paris. Centre National d'Art Contemporain. *Jean Gorin: peintures, reliefs, constructions dans l'espace, documents, 1922–1968.* Paris, 1969.
Letters, texts, chronology, bibliography.

HAUSMANN
*256. Hausmann, Raoul. Aufruf zur elementaren Kunst. *De Stijl* (Leiden) v. 4, no. 10, 1921.
Signed: Berlin, Okt. 1921. R. Hausmann, Hans Arp, Iwan Puni, Moholy-Nagy. "Seems to be earliest record of the word [Elementarism]." Banham, p. 189 (bibl. 8). For translation, see pp. 51–52.

257. —— Pin and the Story of Pin. Introduced by Jasia Reichardt. London, Gaberbocchus Press, 1962.
In collaboration with Kurt Schwitters.

258. —— Motherwell, Robert, ed. *The Dada Painters and Poets.* New York, Wittenborn, Schultz, 1967.
Second printing of first edition, 1951. Extracts, bibliography. Index (p. 386). Viking paperback edition in progress (1974).

259. Stockholm. Moderna Museet. *Raoul Hausmann.* Stockholm, Oct. 21–Nov. 19, 1967.
Cover: "Tatlin at home." Catalogue by Beate Sydhoff. Includes some early abstract and collage works. Extensive bibliography.

HILL
260. Hill, Anthony. Art and mathesis—Mondrian's structures. *Leonardo* (London) no. 1, 1968.

261. —— The constructionist idea and architecture. *Ark* (London) no. 18, 1956.

*262. —— On constructions, nature and structure. *Structure* (Amsterdam) ser. 2, no. 1, 1959.
Additional essays in no. 2 (1960), etc. For text, see pp. 268–76.

263. —— Programme: paragram: structure. *In* DATA. London and Greenwich, 1968 (bibl. 41).

Also note bibl. 175.

LISSITZKY
*264. Lissitzky, El and Ehrenburg, Ilya. Die Blockade russlands geht ihrem ende entgegen. *Veshch—Gegenstand—Objet* (Berlin) no. 1–2, 1922.
For translation of trilingual text, see pp. 53–57.

265. —— The electrical-mechanical spectacle. *Form* (Cambridge, England) no. 3, 1966.
Indicates textual variations from 1923 text in *MA* (Vienna, 1924): the "Musik und Theater Nummer." Notes. Also note bibl. 118.

266. —— *Die Kunstismen* . . . von El Lissitzky und Hans Arp. Erlenbach-Zurich, Munich, Leipzig, Rentsch Verlag, 1925.
Colored cover by Lissitzky, lettered "Kunstism 1914–1924." Text also in French and English. Reprint: New York, Arno, 1968.

*267. —— *Russland: Die Rekonstruktion der Architektur in der Sowjetunion.* Vienna, Schroll, 1930.
"Neues Bauen in der Welt, I." Text dated Moscow, Oct. 1929. Revised edition, 1965. Excerpts translated, pp. 137–47.

268. —— *Russland: Architektur für eine Weltrevolution.* Berlin, Ullstein, 1965.
"Bauwelt Fundamente 14"; hrsg. Ulrich Conrads et al. Anhang: Lissitzky: Biographie, Programmatische Texte und Werkkommentare 1921–1926. Berichte über Architektur und Städtbau in der USSR 1928–1933, p. 135ff. English edition, bibl. 50.

269. —— *Proun.* [Folge von 6 Blatt farbigen Lithographien und Titel]. Hanover, Ludwig Ey, 1923.
1. Kestnermappe. Suprematist designs, Moscow-Berlin (1919–1923). Edition: 50 numbered and signed folios.

270. Birnholz, Alan. El Lissitzky's writings on art. *Studio International* (London) no. 942, Mar. 1972.
Bibliographical footnotes.

271. Leering-van Moorsel, L. The typography of El Lissitzky. *Journal of Typographic Research* (Cleveland) no. 4, Oct. 1968.
Comprehensive illustrated article. Summarizes *Merz* no. 4, July 1923 (Lissitzky on "Topographie der Typographie"). Relevant references: Jan Tschichold in *Imprimatur* v. 3, 1930; Camilla Gray in *Typographica* no. 16, 1959; Tschichold in *Typographische Monatsblätter* Dec. 1970 (with bibliography).

272. Lissitzky-Küppers, Sophie. *El Lissitzky: Maler, Arthitect, Typograf, Fotograf. Erinnerungen, Briefe, Schriften.* Dresden, VEB Verlag der Kunst, 1967.
Monumental monograph, lavishly illustrated and documented. Reprints of texts by and on the artist. *English edition:* London, Thames and Hudson; Greenwich, Conn., New York Graphic Society, 1968.

273. Lozowick, Louis. El Lissitzky. *Transition* (Paris) no. 18, 1929.
Also commentary in his *Modern Russian Art* (bibl. 51).

274. Lueddeckens, Ernst. The "abstract cabinet" of El Lissitzky. *Art Journal* (New York) no. 3, Spring 1971.
Refers to the 1968 reconstruction of the "Abstrakte Kabinett," Landesmuseum, Hanover, 1927. For account by Alexander Dorner see *Die Form* no. 4, Apr. 1928, and bibl. 100.

275. Richter, Horst. *El Lissitzky: Sieg über die Sonne. Zur Kunst des Konstruktivismus.* Cologne, Czwiklitzer, 1958.
Comprehensive bibliography. Documentation extended by Richter in catalog: *El Lissitzky.* Eindhoven, Stedelijk van Abbemuseum, 1965.

LOHSE
276. Lohse, Richard P. A revised thematics for progressive art. *Trans/formation* (New York) no. 3, 1952.

*277. —— A step farther: new problems in constructive plastic expression. *Structure* (Amsterdam) ser. 3, no. 2, 1961.
 For text, see pp. 277–83.
278. Martin, Kenneth. Richard Paul Lohse: an appreciation. *Studio International* (London) Feb. 1968.
279. Newbery, Hans and Lohse, Ida Alis, ed. *Richard P. Lohse.* Teufen, Niggli [1962].
 An anthology of international contributions. English texts by Anthony Hill, Kenneth and Mary Martin, Victor Pasmore. Chronology (1902–1961); exhibitions (1930–1962).
280. René, Denise, Galerie. *Richard Paul Lohse.* Paris, Nov. 3–Dec. 4, 1967.
 Texts: Jean Clay, Carola Giedion-Welcker, H. L. C. Jaffé, Eduard Pluss. Exhibitions, bibliography.
281. Stockholm. Moderna Museet. *Richard Paul Lohse.* Mar. 13–Apr. 18, 1971.
 Comprehensive retrospective; exhibitions list; bibliography.

MARTIN
282. Martin, Kenneth. Construction and change. Notes on a group of works made between 1965 and 1967. *Leonardo* (London) no. 4, Oct. 1968.
 References. French résumé.
*283. —— Construction from within. *Structure* (Amsterdam) ser. 6, no. 1, 1964.
 For text, see pp. 283–87.
284. Ernest, John. Constructivism and content. *Studio International* (London) Apr. 1966.
285. Forge, Andrew. Some recent works of Kenneth Martin. *Studio International* (London) Dec. 1966.
286. Overy, Paul. Mary Martin and Kenneth Martin. *Art and Artists* (London) Nov. 1970.
 Bibliography.
287. Rickey, George. *Constructivism: Origins and Evolution.* New York, Braziller; London, Studio Vista, 1967.
 Documentation, pp. 238, 288, 304. Second revised printing, 1969.

MOHOLY-NAGY
288. [A call for elementarist art]. See bibl. 256.
289. Moholy-Nagy, László. Dynamisch-konstruktives Kraftsystem von Moholy-Nagy und Alfred Kemény. *Der Sturm* (Berlin) Dec. 1922.
 "Manifesto der Kinetischen Plastik" (Galerie der Sturm). Translation in bibl. 293.
290. —— *6 Konstruktionen (Kestnermappe 6).* Hanover, Verlag Ludwig Ey, 1923.
 Six lithos (2 colored) in signed edition of 50 folios.
291. —— *The New Vision [1928] and Abstract of an Artist.* 4. rev. ed. New York, Wittenborn, Schultz, 1949.
 Translation of Bauhausbücher 14: *Vom Material zum Architektur.* Munich, Langen, 1929.

292. Chicago. Museum of Contemporary Art. *Moholy-Nagy.* Chicago, Museum of Contemporary Art; New York, Solomon R. Guggenheim Museum, 1969.

Comprehensive exhibition organized by Jan van der Marck. Essay by Sibyl Moholy-Nagy. Biography, chronology, extensive bibliography.

293. Kostelanetz, Richard, ed. *Moholy-Nagy.* New York-Washington, Praeger, 1970.

"Documentary monographs in modern art." Extensive chronology of classified writings, critiques on his art and philosophy, comprehensive bibliography. Includes "Dynamic-constructive energy-system (Berlin, 1922)," p. 29.—"Constructivism and the proletariat" (*MA,* May 1922), pp. 185–186.—"Position statement of the Group MA in Vienna to the First Congress of Progressive Artists in Düsseldorf, Germany (1921)," pp. 186–187.

*294. Moholy-Nagy, Sibyl. *Moholy-Nagy: Experiment in Totality.* New York, Harper, 1950; 2. ed. Cambridge, Mass., and London, M.I.T. Press, 1969.

Introduction by Walter Gropius. Important "introduction to the second edition" discusses constructivism. Moholy's letter of resignation from the Bauhaus, dated Jan. 17, 1928, pp. 46–47. Bibliography. For section included here, see pp. 135–37.

295. Moholy-Nagy, Sibyl. Moholy-Nagy und die Idee des Konstruktivismus. *Die Kunst und das Schöne Heim* (Munich) June 1959.

PEVSNER

296. Pevsner, Antoine. Extrait d'une lettre de Gabo et Anton Pevsner. *Réalités Nouvelles* (Paris) no. 1, 1947.

297. ——— [La plus précieuse découverte . . .] *Abstraction-Création— Art Non-Figuratif* no. 2, 1933.

Untitled statement, p. 35.

298. Massat, Réne. *Antoine Pevsner et le constructivisme.* Paris, Caractères, 1956.

Preface by Jean Cassou.

299. Read, Herbert, Olson, Ruth and Chanin, Abraham. *Naum Gabo— Antoine Pevsner.* New York, 1948.

Bibliography, 1920–1947. See bibl. 248 for details.

300. Peissi, Pierre. *Antoine Pevsner: Tribute by a Friend* [with] *Antoine Pevsner's Spatial Imagination by Carola Giedion-Welcker.* Neuchâtel, Éditions du Griffon, 1961.

Catalog, biography, bibliography.

301. Pevsner, Alexei. *A Biographical Sketch of My Brothers Naum Gabo and Antoine Pevsner.* Amsterdam, Augustin and Schooman, 1964.

New, intimate, and corrective comments.

302. Soby, James T. The constructivist brotherhood. *Art News* (New York) Mar. 1948.

"Early experiments and new works" at the Museum of Modern Art exhibition.

RICHTER

303. Richter, Hans. An den Konstruktivismus. *G* (Berlin) no. 3, June 1924.
*304. ───── [Editorial]. *G* (Berlin) no. 3, June 1924.
Also note bibl. 135, 195. For translation, see pp. 93–96.
305. ───── Fragment Filmkompositie Zwaar-licht. *De Stijl* (Leiden) no. 2 Feb. 1922.
Similarly "Filmmoment," illus. and text, no. 5, 1923.
306. ───── Principles of the art of motion. *In* De Stijl. pp. 144–146 (bibl. 43).
From the magazine, no. 7, July 1921.
307. ───── A history of the avantgarde. *In* Art in Cinema. Edited by Frank Stauffacher. San Francisco, San Francisco Museum of Art, 1947.
308. Grey, Cleve. *Richter on Richter.* New York, Holt, 1971.
Bibliography.
309. Jaffé, Hans L. C. [Articles by Richter]. *In his* Mondrian und De Stijl. Cologne, DuMont Schauberg, 1967.
Includes: "Prinzipielles zur Bewegungskunst" (pp. 135–137), "Film" (pp. 171–173), "Film" (pp. 188–189).

RODCHENKO

*310. Brik, Osip. From 'LEF': Into production! *Form* (Cambridge, England) no. 10, Oct. 1969.
Cover design: Project for "cine-car" by Alexander Rodchenko. For translation, see pp. 83–85.
311. Gray, Camilla. Alexander Rodchenko: a constructivist designer. *Typographica* (London) no. 11, 1965.
312. Gray, Camilla. *The Great Experiment: Russian Art 1863–1922.* London, New York, 1962 (bibl. 34).
Chronology, pp. 292–294. Index (p. 326). Also bibl. 35.
313. London. Hayward Gallery. *Art in Revolution: Soviet Art and Design since 1917.* Arts Council, 1971 (bibl. 119).
Two parts. Text and exhibitors include Rodchenko.
314. New York. Museum of Modern Art. *Alexander Rodchenko, 1891–1956.* Feb. 7–Apr. 11, 1971.
Folded brochure with checklist. Introduction by director of exhibit, Jennifer Licht, expanded in bibl. 315.
315. Licht, Jennifer. Rodchenko, practicing constructivist. *Art News* (New York) Apr. 1971.
Bibliography.

SCHÖFFER

316. Schöffer, Nicolas. Notes on a new trend: multi-dimensional animated works. *Yale French Studies* no. 19–20, 1957–1958.
317. ───── *La Ville cybernétique.* Paris, Éditions Tchou, 1969.
318. Gadney, Reg. Nicolas Schöffer. *In* Four Essays on Kinetic Art, pp. 31–36, St. Albans, England, Motion Books, 1966.
*319. Habasque, Guy and Ménétrier, Jacques. *Nicolas Schöffer.* Neuchâtel, Éditions du Griffon, 1963.
Introduction by Jean Cassou. Texts by the artist include: "The

three stages of dynamic sculpture," a recording: "Spatiodynamism."
For section included here, see pp. 248–57.

320. New York. Jewish Museum. *Nicolas Schöffer and Jean Tinguely: 2 Kinetic Sculptors.* Nov. 23–Jan. 2, 1966.
Essays by Jean Cassou, K. G. Hultén, Sam Hunter. With a statement by Schöffer. Extensive bibliographies list articles by the artist.

321. Schneede, Clive M. Nicolas Schöffer: vom Konstruktivismus Mondrians zum Mobil en Eiffelturm. *Die Kunst und das Schöne Heim* (Munich) Oct. 1968.

322. Sers, Philippe. *Entretiens avec Nicolas Schöffer.* Paris, Éditions Pierre Belfond, 1971.
Chronology, 1912–1970 (pp. 183–185).

SEUPHOR

323. Seuphor, Michel, *Cercle et Carré.* Paris, Pierre Belfond, 1971.
Introduction with illustrations followed by letterpress resetting of issues of *Cercle et Carré* (no. 1, Mar. 15.—no. 2, Apr. 15.—no. 3, June 30, 1930). Includes catalog of group exhibition, Paris, Apr. 18–May 1, 1930. Bibliography. Also see bibl. 131.

*324. ———— Pour la défense d'une architecture. *Cercle et Carré* no. 1, Mar. 15, 1930.
For translation, see pp. 177–91.

325. ———— Sens et permanence de la peinture construite. *Quadrum* (Brussels) no. 8, 1960.
With English translation.

326. St. Étienne. Musée d'Art et d'Industrie. *Michel Seuphor.* Mar.–Apr. 1971.
Brief texts. Extensive chronology and bibliography.

Also note bibl. 69–70, 199–201.

TATLIN

*327. Tatlin, Vladimir. [Art out into technology]. *In* Vystavka rabot zasluzhennogo deyatelya iskusstv. V. E. Tatlina. Moscow, Leningrad, 1933.
Dated 1932. Also in *Vladimir Tatlin* Stockholm, Moderna Museet, 1968. For translation, see pp. 170–74.

*328. ———— The work ahead of us. *In* Vladimir Tatlin. Stockholm, Moderna Museet, 1968.
Dated Moscow, Dec. 31, 1920. Signed by Tatlin, Shapiro, Meyerzon, Vinogradov. For translation, see pp. 11–14.

*329. ———— [and others]. The program of the Productivist group. *Egyseg* (Vienna) 1922. *In* Gabo. London and Cambridge, 1957 (bibl. 242).
For translation, see pp. 18–20. Also note bibl. 118.

*330. ———— On Zangezi. *Zhizn' iskusstva* (Petrograd) no. 18, May 1923.
For translation, see pp. 112–15.

331. Andersen, Troels. *Vladimir Tatlin.* Stockholm, Moderna Museet, July–Sept. 1968.
Texts by the artist. Contemporaneous comments on the Tower;

also Andersen: "On the reconstruction of the Tower." Editors: K. B. Lindegren, K. G. P. Hultén, D. Feuk. Exhibition: Hultén, Carlo Derkert. Biography, exhibitions list, bibliography.

332. Chalk, Martyn. Two lost corner reliefs of Tatlin: notes on reconstructions made in 1966. *The Structurist* (Saskatoon) no. 9, 1969. Thesis project on two 1915 works actually assembled and illustrated.

333. Ehrenburg, Ilya. Ein Entwurf Tatlins. *Frühlicht* (Magdeburg) Mar. 1922.

334. Elderfield, John. The line of free men: Tatlin's "towers" and the age of invention. *Studio International* (London) Nov. 1969.

335. Lozowick, Louis. Tatlin's monument to the Third International. *Broom* (Berlin-New York) Oct. 1922.

336. Punin, Nikolai. *Protiv Kubizma: Tatlin*. Petrograd, Gosudartsvennoe izdatelistvo, 1921. Pamphlet ["Against Cubism"], 26 pp., 16 ill. (port.); ascribed to the Visual Arts Department under Narkompros (Petrograd).

337. Rodchenko, Alexander. Vladimir Tatlin. *Opus International* (Paris) no. 4, 1967.

338. Stockholm. Moderna Museet. *Vladimir Tatlin*. July–Sept. 1968. See bibl. 331.

339. Umanskij, Konstantin. Der Tatlinismus oder die Maschinenkunst. *Der Ararat* (Munich) Jan. 1920, Feb.–Mar. 1920.

340. Volavková-Skorepova, Zdenka. Vladimir Jergreafovič Tatlin. *Výtvarne Umění* [Fine Arts] (Prague) no. 8–9, 1967. Insert includes complete English translation.

TORRES-GARCÍA

341. Torres García, Joaquín. La regla abstracta. *In* Nueva Escuela de Arte del Uruguay—Pintura y arte constructivos . . . p. 28. [Montevideo, 1946] Also reprint with English and French translation (Buenos Aires, 1967).

*341a. ——— Grupo de arte constructivo. *Guiones* (Madrid), no. 3, July 30, 1933. Excerpts translated, pp. 194–99.

342. ——— *Historia de mi Vida*. Montevideo, Asociación de Arte Constructivo, 1939. English translation prepared by Sr. Emilio Ellena of Santiago, Chile, planned for "the near future" (197?).

343. ——— *Universalismo Constructivo*. Buenos Aires, Poseidon, 1944. Massive work (1011 pp., illus.) with chapters on constructive art, abstract art, neo-plasticism, Mondrian, Arp, etc.

344. Catlin, Stanton L. and Grieder, Terence. *Art in Latin America since Independence*. rev. ed. New Haven, Yale University Art Gallery and The University of Texas Art Museum, 1966. Torres García, p. 245 (index). Biography, bibliography. Exhibit shown Yale (Jan. 27–Mar. 15), Texas (Apr. 17–May 15), San Francisco (July 2–Aug. 7), La Jolla (Aug. 27–Sept. 30), New Orleans (Oct. 29–Nov. 27).

345. *Cercle et Carré* and *Círculo y Cuadrado*. See bibl. 131, 133.
The former in association with Michel Seuphor in Paris; the latter independently in Montevideo.

346. Austin. University of Texas. Art Museum. *Joaquín Torres-García.* Dec. 1, 1971–Jan. 16, 1972.
Guest Curator: Barbara Duncan. Text by Monroe Wheeler, Donald B. Goodall. Lists 46 works (1917–1948).

347. Fried, Rose, Gallery. *Joaquín Torres-García, 1874–1947* (15th memorial exhibition). New York, Jan. 6–Feb. 13, 1965.
Text by Dario Suro (similar to *Américas* Mar. 1965). Illustrations include reduced facsimile of Torres-García's *Raison et nature*, Paris, Imán, 1932; actually published Montevideo, 1954.

348. Rhode Island School of Design. Museum of Art. *Joaquín Torres-García, 1874–1949.* Providence, R.I., Feb. 18–Mar. 21, 1971.
Text by Daniel Robbins. Extensive catalog. Comprehensive bibliography (pp. 121–137). Also exhibited at the National Gallery of Canada, Oct. 2–Nov. 1, 1970; Solomon R. Guggenheim Museum, N.Y., Dec. 12, 1970–Jan. 31, 1971.

349. Suro, Dario. Torres-García of Uruguay, universal constructionist. *Américas* (Washington, D.C.) Mar. 1965.

VASARELY
350. Vasarely, Victor. *Notes, réflexions.* Paris, Bureau Culturel de l'École Nationale Supérieure des Beaux-Arts [1962].
Mimeographed. Also in *Vasarely II.*

*351. ——— *Vasarely II.* Neuchâtel, Éditions du Griffon, 1970.
Miscellaneous writings. Preface by Marcel Joray. Exhibitions, biography, bibliography (1947–1969). A sequel to *Vasarely* [I], 1965, with similar documentation. For section included here, see pp. 258–64.

352. Clay, Jean. Victor Vasarely: a study of his work. *Studio International* (London) May 1969.

353. Ferrier, Jean-Louis. *Entretiens avec Victor Vasarely.* Paris, Éditions Pierre Belford, 1969.

354. Moles, Abraham A. Vasarely and the triumph of structuralism. *Form* (Cambridge, England) no. 7, 1968.

355. Spies, Werner. *Vasarely.* London, Thames and Hudson; New York, Abrams, 1971.
Translated from the German (DuMont Schauberg, Cologne). Bibliography.

The Story of Genesis and Exodus,

AN EARLY ENGLISH SONG,

ABOUT A.D. 1250.

BERLIN: ASHER & CO., 53 MOHRENSTRASSE.
NEW YORK: C. SCRIBNER & CO.; LEYPOLDT & HOLT.
PHILADELPHIA: J. B. LIPPINCOTT & CO.

The
Story of Genesis and Exodus,

AN EARLY ENGLISH SONG,
ABOUT A.D. 1250.

EDITED

FROM A UNIQUE MS. IN THE LIBRARY OF CORPUS CHRISTI COLLEGE, CAMBRIDGE,

WITH INTRODUCTION, NOTES, AND GLOSSARY,

BY THE

REV. RICHARD MORRIS, LL.D.,

AUTHOR OF "HISTORICAL OUTLINES OF ENGLISH ACCIDENCE;"
EDITOR OF "HAMPOLE'S PRICKE OF CONSCIENCE;" "EARLY ENGLISH ALLITERATIVE POEMS,"
ETC. ETC.;
ONE OF THE VICE-PRESIDENTS OF THE PHILOLOGICAL SOCIETY.

[Second and Revised Edition, 1873.]

LONDON:
PUBLISHED FOR THE EARLY ENGLISH TEXT SOCIETY,
BY N. TRÜBNER & CO., 57 & 59, LUDGATE HILL.
MDCCCLXV.

7

JOHN CHILDS AND SON, PRINTERS.

PREFACE.

DESCRIPTION OF THE MANUSCRIPT, ETC.

THE Editor of the present valuable and interesting record of our old English speech will, no doubt, both astonish and alarm his readers by informing them that he has never seen the manuscript from which the work he professes to edit has been transcribed.

But, while the truth must be told, the reader need not entertain the slightest doubt or distrust as to the accuracy and faithfulness of the present edition; for, in the first place, the text was copied by Mr F. J. Furnivall, an experienced editor and a zealous lover of Old English lore; and, secondly, the proof sheets have been most carefully read with the manuscript by the Rev. W. W. Skeat, who has spared no pains to render the text an accurate copy of the original.[1] I have not been satisfied with merely the general accuracy of the text, but all *doubtful* or *difficult* passages have been most carefully referred to, and compared with the manuscript, so that the more questionable a word may appear, either as regards its *form* or *meaning*, the more may the reader rest assured of its correctness, so that he may be under no apprehension that he is perplexed by any typographical error, but

[1] My obligations to Mr Skeat (in whose accuracy and judgment I have the fullest confidence) are numerous; and I am indebted to him, among other obligations, for the description of the manuscript, and for some interesting remarks upon the metre of the poem. My thanks are also due to the Rev. J. R. Lumby, who most kindly and readily re-collated the text with the manuscript.

feel confident that he is dealing with the reading of the
original copy.

The editorial portion of the present work includes the
punctuation, marginal analysis, conjectural readings, a some-
what large body of annotations on the text of the poem, and
a Glossarial Index, which, it is hoped, will be found to be
complete, as well as useful for reference.

The Corpus manuscript[1] is a small volume (about 8 in. ×
4½ in.), bound in vellum, written on parchment in a hand of
about 1300 A.D., with several final long f's, and consisting of
eighty-one leaves. Genesis ends on fol. 49*b*; Exodus has the
last two lines at the top of fol. 81*a*.

The writing is clear and regular; the letters are large,
but the words are often very close together. Every initial
letter has a little dab of red on it, and they are mostly
capitals, except the *b*, the *f*, the ᷎ð, and sometimes other
letters. Very rarely, however, B, F, and Đ are found as
initial letters.

The illuminated letters are simply large vermilion letters
without ornament, and are of an earlier form than the writing
of the rest of the manuscript. Every line ends with a full
stop (or metrical point), except, very rarely, when omitted
by accident. Whenever this stop occurs in the middle of a
line it has been marked thus (.) in the text.

DESCRIPTION OF THE POEM.

Our author, of whom, unfortunately, we know nothing,
introduces his subject to his readers by telling them that
they ought to love a rhyming story which teaches the "lay-
man" (though he be learned in no books) how to love and
serve God, and to live peaceably and amicably with his fellow

[1] It is thus described—wrongly, of course, as to age—in the printed catalogue
of the Corpus manuscripts:—"ccccxliv. A parchment book in 8vo., written in the
xv. century, containing the history of Genesis and Exodus in Old English verse."

Christians. His poem, or "song," as he calls it, is, he says, turned out of Latin into English speech ; and as birds are joyful to see the dawning, so ought Christians to rejoice to hear the "true tale" of man's fall and subsequent redemption related in the vulgar tongue ("land's speech"), and in easy language ("small words").

So eschewing a "high style" and all profane subjects, he declares that he will undertake to sing no other song, although his present task should prove unsuccessful.[1] Our poet next invokes the aid of the Deity for his song in the following terms :—

> "Fader god of alle Shinge,
> Almigtin louerd, hegeſt kinge,
> Ðu giue me ſeli timinge
> To thaunen Ðis werdes biginninge,
> Ðe, leuerd god, to wurÐinge,
> QueÐer ſo hic rede or ſinge !"[2]

Then follows the Bible narrative of Genesis and Exodus, here and there varied by the introduction of a few of those sacred legends so common in the mediæval ages, but in the use of which, however, our author is far less bold than many subsequent writers, who, seeking to make their works attractive to the "lewed," did not scruple to mix up with the sacred history the most absurd and childish stories, which must have rendered such compilations more amusing than instructive. It seems to have been the object of the author of the present work to present to his readers, in as few words as possible, the most important facts contained in the Books of Genesis and Exodus without any elaboration or comment, and he has, therefore, omitted such facts as were not essenti-

[1] From lines 19-26 we might infer that our author intended to include in his song much more of the Bible narrative than we have in the present work.

[2] Father, God of all things, Almighty Lord, highest of kings, Give thou me a propitious season (enable thou me successfully), to show this world's beginning, Thee, Lord God, to honour, whetherso I read or sing.

ally necessary to the completeness of his narrative;[1] while, on the other hand, he has included certain portions of the Books of Numbers and Deuteronomy,[2] so as to present to his readers a complete history of the wanderings of the Israelites, and the life of Moses their leader.

In order to excite the reader's curiosity, we subjoin a few passages, with a literal translation :—

LAMECH'S BIGAMY.

Lamech is at ðe sexte kne,	*Lamech is at the sixth degree,*
ðe feuende man after adam,	*The seventh man after Adam,*
ðat of caymes kinde cam.	*That of Cain's kin came.*
ðif lamech waf ðe firme man,	*This Lamech was the first man*
ðe bigamie firft bi-gan.	*Who bigamy first began.*
Bigamie is unkinde ðing,	*Bigamy is unnatural thing,*
On engleis tale, twie-wifing ;	*In English speech, twi-wiving ;*
for ai was rigt and kire bi-forn,	*For aye was right and purity before,*
On man, on wif, til he was boren.	*One man, one wife, till he was born.*
Lamech him two wifes nam,	*Lamech to him two wives took,*
On adda, an noðer wif fellam.	*One Adah, another wife Zillah.*
Adda bar him fune Iobal,	*Adah bare him a son Jubal,*
He was hirde wittere and wal ;	*He was a [shep-]herd wise and able ;*
Of merke, and kinde, and helde, & ble,	*Of mark,[3] breed, age, and colour,*
fundring and fameni[n]g tagte he ;	*Separating and assembling taught he ;*
Iobal if broðer fong and glew,	*Jubal his brother poetry and music,*
Wit of mufike, wel he knew ;	*Craft of music, well he knew ;*
On two tablef of tigel and braf	*On two tables of tile and brass,*
wrot he ðat wiftom, wif he was,	*Wrote he that wisdom, wise he was,*
ðat it ne fulde ben undon	*That it should not be effaced*

[1] The following are the chief omissions :—1. Genesis, chapters ii. 10-14 ; ix. 20-27 ; x. 2-7, 10-32 ; xxiii. 3-20 ; xxx. 1-5, 14-16, 37-43 ; xxxi. 1-17 ; xxxvi. ; xxxviii. ; xlviii. ; xlix. 1-27. 2. Exodus, chapters xii. 40-51 ; xiii. 1-16 ; xx. 20-26 ; xxi. ; xxii. ; xxiii. ; xxv. ; xxvi. ; xxvii. ; xxviii. ; xxix. ; xxx. ; xxxi. ; xxxiii. 12-23 ; xxxiv. 1-32 ; xxxv. ; xxxvi. ; xxxvii. ; xxxviii. ; xxxix. ; xl.

[2] Numbers, chapters xi. ; xii. ; xiii. ; xiv. ; xvi. ; xvii. ; xix. ; xx. ; xxi. ; xxii. ; xxiii. ; xxiv. ; xxv. ; xxvi. ; xxvii. ; xxxi. Deut. xxxiv.

[3] Natural marks ?

If fier or water come ꝺor-on.

If fire or water came thereon.

Sella wuneꝺ oc lamech wiꝺ,

Zillah dwelleth also Lamech with,

ghe bar tubal, a fellic fmiꝺ ;

She bare Tubal, a wonderful smith ;

Of irin, of golde, filuer, and bras

Of iron, of gold, silver, and brass

To fundren and mengen wif he was;

To separate and mix, wise he was ;

Wopen of wigte and tol of griꝺ,

Weapon of war and tool of peace,

Wel cuꝺe egte and fafgte wiꝺ.

Well could he hurt and heal with.

—(ll. 444-470.)

DEATH OF CAIN.

Lamech ledde long lif til ꝺan

Lamech led long life till then

ꝺat he wurꝺ bifne, and haued a
 man

That he became blind and had a
 man

ꝺat ledde him ofte wudef ner,

That led him oft to woods near,

To fcheten after ꝺo wilde der ;

To shoot after the wild deer
 (animals) ;

Al-so he miftagte, alfo he fchet,

As he mistaught, so he shot,

And caim in ꝺe wude if let ;

And Cain in the wood is let ;

His knape wende it were a der,

His knave (servant) weened it were
 a deer,

An lamech droge if arwe ner,

And Lamech drew his arrow near

And letet flegen of ꝺe ftreng,

And let it fly off the string,

Caim unwar[n]de it under-feng,

Cain unwarned it received,

Grufnede, and ftrekede, and ftarf
 wiꝺ-ꝺan.

Groaned, fell prostrate (stretched)
 and died with-that.

Lamech wiꝺ wreꝺe if knape nam,

Lamech with wrath his knave seized,

Vn-bente if boge, and bet, and slog,

Unbent his bow, and beat and slew,

Til he fel dun on dedef fwog.

Till he fell down in death's swoon.

Twin-wifing and twin-manflagt,

Twi-wiving (bigamy) and twi-
 slaughter (double homicide)

Of his foule beꝺ mikel hagt.

On his soul is great trouble
 (anxiety).

—(ll. 471-486.)

HOW THE CHILD MOSES BEHAVED BEFORE PHARAOH.

Ghe brogte him bi-foren pharaon,

She (Thermutis) brought him
 (Moses) before Pharaoh,

And ꝺif king wurꝺ him in herte
 mild,

And this king became to him in
 heart mild,

So fwide faiger was ꝺif child ;

So very fair was this child ;

And he toc him on funes ftede,

And he took him on son's stead
 (instead of a son),

And hif corune on his heued he dede,
And let it ftonden ayne ftund;
Ꝥe child it warp dun to Ꝥe grund.

And his crown on his head he did (placed),
And let it stand a stound (while);
The child threw it down to the ground.

Hamonef likenef was Ꝥor-on;
Ꝥif crune is broken, Ꝥif if mifdon.

Hamon's likeness was thereon;
This crown is broken, this is misdone.

Biffop Eliopoleos
fag Ꝥif timing, & up he rof;

The Bishop of Heliopolis
Saw this circumstance, and up he rose;

"If Ꝥif child," quad he, "mote Ꝥen,
He fal egyptes bale ben."
If Ꝥor ne wore helpe twen lopen,
Ꝥif childe adde Ꝥan fone be dropen;
Ꝥe king wiꝥ-ftod & an wif man,
He feide, "Ꝥe child doꝥ alf he can;
We fulen nu witen for it dede
Ꝥif witterlike, or in child-hede;"
He bad Ꝥis child brennen to colen

If this child, quoth he; might thrive (grow up),
He shall Egypt's bale be.
If there had not helpers' tween leapt,
This child had then soon been killed;
The king with-stood and a wise man,
He said, The child doth as he can (knows);
We should now learn whether it did
This wittingly, or in childishness;
He offered this child two burning coals

And he toc is (hu migt he it Ꝥolen),
And in hife muth fo depe he if dede
Hife tunges ende if brent Ꝥor-mide;
Ꝥor-fore feide Ꝥe ebru witterlike,
Ꝥat he fpäc fiꝥen miferlike.

And he took them (how might he bear them?)
And in his mouth so deep (far) he them did (placed)
His tongue's end is burnt therewith;
Therefore said the Hebrew truly,
That he spake afterwards indistinctly.
—(ll. 2634-2658.)

HOW MOSES DEFEATED THE ETHIOPIANS.

Bi Ꝥat time Ꝥat he was guꝥ,

By that time that he was a youth (young man),

Wiꝥ faigered and ftrengthe kuꝥ,
folc ethiopienes on egipte cam,
And brende, & flug, & wreche nam,

For beauty and strength renowned,
Ethiopian folk on Egypt came,
And burnt, and slew, and vengeance took,

Al to memphin ðat riche cite,
And a-non to ðe reade fe ;
ðo·was egipte folc in dred,
And afkeden here godes red ;
And hem feiden wið anfweren,
ðat on ebru cude hem wel weren.

All to Memphis that rich city,
And anon to the Red Sea ;
Then was Egypt's folk in dread,
And asked their gods' advice ;
And they said to them in answer,
That one Hebrew could them well
defend.

.

Moyfes was louered of ðat here,

Moses became leader of that
(Egyptian) army,

ðor he wurð ðane egyptes were ;

There he became then Egypt's
protector ;

Bi a lond weige he wente rigt,
And brogte vn-warnede on hem
fgt ;

By a land-way he went right,
And brought unwarned on them
fight ;

He hadden don egipte wrong,
He bi-loc hem & fmette a-mong,

They had done Egypt wrong,
He compassed them and smote
among, .

And flug ðor manige ; oc fumme
flen,
Into faba to borgen ben.

And slew there many ; but some
fled
Into Sheba to be saved.

Moyfes bi-fette al ðat burg,
Oc it was riche & ftrong ut-ðhurg ;

Moses beset all that borough (city),
But it was rich and strong out-
thorough (throughout) ;

Ethiopienes kinges dowter tarbis,

Tarbis, the Ethiopian king's
daughter,

Riche maiden of michel prif,
Gaf ðif riche burg moyfi ;
Luue-bonde hire ghe it dede for-ði.

Rich maiden of great renown,
Gave this rich city to Moses ;
As love-bond's hire she did it,
therefore.

ðor ife fon he leide in bonde,
And he wurð al-migt-ful in ðat
lond ;
He bi-lef ðor(.) tarbis him fcroð,

There his foes he laid in bond,
And he became all-powerful in
that land ;
He remained there, Tarbis him
urged,

ðog was him ðat furgerun ful loð ;

Yet was to him that sojourn full
loath ;

Mai he no leue at hire taken
but-if he it mai wið crafte
maken :

May he no leave of her take
Unless he it may with craft
make :

He waſ of an ſtrong migt [&] wiſ, *He was of a strong might and wise,*

He carſ in two gummes of priſ *He carved in two gems (stones) precious,*

Two likeneſſes, ſo grauen & meten, *Two likenesses alike carved and depicted,*

Ðis doð ðenken, & ðoðer for-geten; *This one causes to remember, and the other to forget;*

He feſt is in two ringes of gold, *He fastened them in two rings of gold,*

Gaf hire ðe ton, he was hire hold; *Gave her the one, he was dear to her;*

[And quan awei nimen he wolde *[And when depart he would*

Gaf hire ðe toðer, he was hire colde] *Gave her the other, and was distasteful to her]*

Ghe it bered and ðiſ luue iſ for-geten, *She it beareth and this love is forgotten,*

Moyſes ðus haued him leue bi-geten; *Moses thus hath for himself leave begotten;*

Sone it migte wið leue ben, *Soon it might with leave be,*

Into egypte e wente a-gen. *Into Egypt he went again.*

—(ll. 2665-2708.)

THE PLAGUE OF FROGS.

And aaron held up his hond *And Aaron held up his hand*

to ðe water and ðe more lond; *To the water and the greater land;*

Ðo cam ðor up ſwilc froſkes here *Then came there up such host of frogs*

Ðe dede al folc egipte dere; *That did all Egypt's folk harm;*

Summe woren wilde, and ſumme tame, *Some were wild, and some tame,*

And ðo hem deden ðe moſte ſame; *And those caused them the most (greatest) shame;*

In huſe, in drinc, in metes, in bed, *In house, in drink, in meats, in bed,*

It cropen and maden hem for-dred; *They crept and made them in great dread;*

Summe ſtoruen and gouen ſtinc, *Some died and gave (out) stink,*

And vn-hileden mete and drinc; *And (others) uncovered meat and drink;*

Polheuedes, and froſkes, & podes ſpile *Tadpoles and frogs, and toad's venom*

Bond harde egipte folc un-ſile.[1] *Bound hard Egypt's sorrowful folk.*

[1] MS. in-sile. —(ll. 2967-2978.)

The reader must not be disappointed if he fails to find many traces in this work of our pious author's poetic skill; he must consider that the interest attaching to so early an *English* version of Old Testament History, as well as the philological value of the poem, fully compensates him for the absence of great literary merit, which is hardly to be expected in a work of this kind. And, moreover, we must recollect that it is to the patriotism, as well as piety, of such men as our author, that we owe the preservation of our noble language. The number of religious treatises written in English during the thirteenth and fourteenth centuries proves that the dialect of religion approached more closely to the speech of the people than did the language of history or romance. And it is a curious fact that the most valuable monuments of our language are mostly theological, composed for the lewed and unlearned, who knew no other language than the one spoken by their forefathers, and who clung most tenaciously to their mother tongue, notwithstanding the changes consequent upon the Norman invasion, and the oppression of Norman rule, which, inasmuch as it fostered and kept up a patriotic spirit, exercised a most important and beneficial influence upon Early English literary culture and civilization.

DATE AND DIALECT OF THE POEM.

The mere examination of an Early English work with respect to its vocabulary and grammatical forms, will not enable us (as Price asserts) to settle satisfactorily the date at which it was written. The place of composition must also be taken into consideration, and a comparison, if possible, must be made with other works in the same dialect, the date of which is known with some degree of certainty. The date of the text before us must not, therefore, be confounded with that of the manuscript, which is, perhaps, a few years earlier

than A.D. 1300. A careful comparison of the poem with the
Bestiary, written in the same dialect, and most probably by
the same author[1] (and printed by Mr Wright in the Reliquiæ
Antiquæ, p. 208, and by myself in an Old English Miscellany),
leads me to think that the present poem is not later than
A.D. 1250.[2]

The vocabulary, which contains very few words of
Romance origin,[3] is not that of Robert of Gloucester, or of
Robert of Brunne, but such as is found in Laʒamon's Brut, or
Orm's paraphrases, and other works illustrating the second
period of our language, i. e. the twelfth and earlier part of
the thirteenth centuries.

The employment of a *dual* for the pronouns of the first
and second persons marks an *early* date (certainly not much
later than the time of Henry III.) even in works composed in
the Southern dialect, which, it is well known, retained to a
comparatively late period those Anglo-Saxon inflections that
had long previously been disused in more Northern dialects.

The Corpus manuscript is evidently the work of a scribe,
to whom the language was more or less archaic, which
accounts for such blunders as *ðrosing* for *ðrosem*, *waspene* for
wastme, *lage* for *vn-lage*, *insile* for *vn-sile*, *grauen* for *ðrauen*,
etc.

The original copy of Genesis most probably terminated
with ll. 2521-4 :

[1] The Bestiary presents not only the same *grammatical* and *verbal* forms which
distinguish the Genesis and Exodus from other Early English compositions, but also
its *orthographical* peculiarities, *e.g.* f for *sch ;* ð for *th ; g* for *y* and ʒ (*gh*), etc. The
editor assigns this poem to the *early* part of the thirteenth century.

[2] Warton assigned it to the reign of Henry II. or Richard I. ; Sir F. Madden
to the time of Henry III. (1216-1272).

[3] Those employed (about *fifty* altogether) are more or less technical—*aucter,
auter, astronomige, arsmetrike, bigamie, bissop, crisme, charité, canticle, circumcis,
corune, crune, desert, graunte, gruchede, holocaust, hostel, iurnee* (journey), *iusted*
(allied), *lecherie, lepre, mount, mester, meister, neve* (nephew), *offiz, pais, plente, pore,
present, prest, pris, prisun, promissioun, prophet, roche, sacrede, scité* (city), *spirit,
spices, suriurn* (sojourn), *swinacie* (quinsy), *serue, seruice, ydeles, ydolatrie.*

> " And here ended completely
> The book which is called Genesis,
> Which Moses, through God's help,
> Wrote for precious souls' need."

The concluding lines, in which both the author and scribe are mentioned, seem to me to be the work of a subsequent transcriber :

> " God shield his soul from hell-bale,
> Who made it thus in English tale (speech) !
> And he that these letters wrote,
> May God help him blissfully,
> And preserve his soul from sorrow and tears,
> Of hell-pain, cold and hot ! "

The Ormulum is the earliest[1] printed Early English work which has come down to us that exhibits the uniform employment of the termination -*en* (-*n*) as the inflection of the plural number, present tense, indicative mood; or, in other words, it is the earliest printed example we have of a *Midland* dialect. I say *a* Midland dialect, because the work of Orm is, after all, only a specimen of *one* variety of the Midland speech, most probably of that spoken in the northern part of the eastern counties of England, including what is commonly called the district of East Anglia.

Next in antiquity to the Ormulum come the Bestiary, already mentioned, and the present poem, both of which uniformly employ the Midland affix -*en*, to the exclusion of all others, as the inflection of the present plural indicative.

There are other peculiarities which these works have in common ; and a careful comparison of them with the Ormulum induces me to assign them to the East Midland area; but there are certain peculiarities, to be noticed hereafter, which induce me to believe that the work of Orm represents

[1] Since writing the above I have printed for the Early English Text Society "Old English Homilies, 2nd Series," which are earlier than the Ormulum, and contain many East Midland peculiarities. "The Wooing of Our Lord" in Old English Homilies, 1st Series, contains some peculiarities of the West Midland dialect.

a dialect spoken in the northern part of this district, while the Story of Genesis and Exodus, together with the Bestiary, exhibits the speech of the more southern counties of the East Midland district.[1] Thus, if the former be in the dialect of *Lincoln*, the latter is in that of *Suffolk*.[2]

The chief points in which the present poem and the Bestiary agree with the Ormulum are the following :—

I. The absence of compound vowels.

In the Southern dialects we find the compound vowels *ue, eo, ie, ea* (*yea*). In the Ormulum *eo* occurs, but with the sound of *e*, and *ea* in Genesis and Exodus is written for *e*.

II. The change of an initial ð (th) into *t* after words ending in *d, t, n, s*, that is to say, after a dental or a sibilant.[3]

> "ðanne if *tis* fruit wel fwiðe good."—(*Gen. and Ex.*, 1. 334.)
> " ðe firſt moned and *te* firſt dai,
> He ſag erðe drie & *te* water awai."—(*Ibid.*, ll. 615-6.)
> " ðin berg and *tin* werger ic ham."—(*Ibid.*, 1. 926.)
> "at *te* welle[n]."—(*Ibid.*, 1. 2756.)

This practice is much more frequent in the Bestiary, which is a proof, perhaps, that the present poem has suffered somewhat in the course of transcription.

> neddre is *te* name."—(*O.E. Miscellany*, p. 5.)
> " it is *te* ned."—(*Ibid.*, p. 6.)
> " ðis lif bitokneð ðe sti
> ðat *te* neddre gangeð bi,
> and *tis* is ðe ðirl of ðe ston,
> ðat *tu* salt ðurg gon."—(*Ibid.*, p. 7.)
> " at *tin* herte."—(*Ibid.*, p. 7.)

III. Simplicity of grammatical structure and construction of sentences.[4]

[1] See Preface to O.E. Hom., 2nd Series.

[2] It must be recollected that the Ormulum is much earlier than the Story of Genesis and Exodus.

[3] See Ormulum, Introduction, p. lxxviii., note 105 ; lxxxi., note 112.

[4] While agreeing with the editor of the Ormulum, that the simplicity of gram-

1. The neglect of *gender* and *number* in nouns.

2. The genitive singular of substantives end in *-es* in all genders.[1]

3. The absence of the gen. pl. of substantives in *-ene*.

4. The employment of an uninflected article.[2]

5. The use of ðat (that) as a demonstrative adjective, and not as the neuter of the article. The form ðas (those), common enough in the fourteenth century, does not occur in this poem or in the Ormulum.

6. No inflection of the adjective in the accusative singular. The phrase ' *godun* dai,' good day, in l. 1430, p. 41, contains a solitary instance of the accusative of the adjective, but it is, no doubt, a mere remnant of the older speech, just like our ' for *the* nonce' (= for *then* once), and is no proof that the writer or his readers employed it as a common inflection. The form *godun* is a corruption of *godne*, as it is more properly written in works in the Southern dialects as late as the middle of the fourteenth century.

7. Adjectives and adverbs with the termination *-like*.

The Southern form is, for adjectives, *-lich* (sing.), *-liche*

matical forms may fairly be considered as indicating a less artificial, and therefore advanced, stage of the language, I cannot adopt his theory, that " the strict rules of grammar " were therefore abandoned, and thereby was anticipated, to a certain extent, a later phraseology and structure; or that Orm, or any other O.E. writer, ever sacrificed " the more regular for a simpler, though more corrupt, structure and style." It must always be borne in mind that our earlier writers always speak of their language as English; but it was the English of the district in which they lived. In some districts, as in the Northumbrian, for instance, the language underwent certain changes at a very early period, which more Southern dialects did not adopt for more than a century afterwards : thus, in works of the 14th century, we find the Midland more archaic than the Northumbrian, and the Southern more archaic than either. Authors seeking to become popular would write in the dialect best understood by their readers, without considering whether it was simple or complex. Thus the Ayenbite of Inwyt (A.D. 1340), written for the men of Kent, contains far more of the older inflectional forms than the Ormulum of the twelfth century.

[1] Southern writers before 1340 formed the g.s. of fem. nouns in *-e* and not in *-es.*

[2] In the Southern dialect the article had separate forms for the nominative fem. (*theo, tho*), and neuter (*thet, that*); the fem. gen. sing. (*thar, ther*), and the masc. acc. (*than, then*).

(pl.); for adverbs -*liche*. Thus the adoption of this affix really (though at first it appears a matter of no importance) marks a *stage* in the language when the distinction between the sing. and pl. form of adjectives was not very strictly observed, and was, moreover, a step towards our modern -*ly*, which is adjectival as well as adverbial.

Even in this poem adjectives occur in -*li*, as *reuli* = piteous, which is the earliest example I have met with. Orm employs double forms in -*like* and -*liȝȝ* (= *ly*?). -*ly* has arisen not out of -*lich* or -*liche* (which would have become *lidge* or *litch*), but out of some such softened form as *liȝ*.

8. The tendency to drop the initial *y, i* (A.S. *ge*) of the passive participles of strong verbs.

The Ormulum has two or three examples of this prefixal element, and in our poem it occurs but seldom.

IV. A tendency to drop the *t* of the second person of verbs, as *as*, hast; *beas*, beëst; *findes*, findest.

Examples of this practice are very common in the Bestiary and Genesis and Exodus, but it occurs only four times in the Ormulum.[1] It was very common for the West-Midland to drop the -*e* of 2nd person in strong verbs. See Preface to O.E. Homilies, 1st Series.

V. The use of *arn, aren*, for *ben* of the Midland dialect, or *beð* of the Southern dialect.[2]

VI. The employment of the adverbs *thethen, hethen, quethen* (of Scandinavian origin),[3] instead of the Southern *thenne* (*thennen*), thence; *henne* (*hennen*), hence; *whanne* (*whanene*), whence.

VII. The use of *oc, ok* (also, and), a form which does not occur in any specimen of a Southern, West-Midland, or Northern dialect that has come under my notice. The use of

[1] See Ormulum, Introduction, p. lxxviii., note 105.

[2] *Sinden*, are, occurs in the Ormulum and the Bestiary, but is not employed in the present poem.

[3] These forms occur in O.E. Hom., 2nd Series.

on, o, for the Southern *an* or *a,* as *onlike, olike,* alike, *on-rum,* apart, *on-sunder,* asunder, is also worth noticing.

VIII. The coalition of the pronoun *it* with pronouns and verbs, as *get* (Bestiary) = she it (ȝhŏt in Ormulum; cf. þüt = *thu itt,* thou it); *tellet* = tell it; *wuldet* = would it; *ist* = is it, is there; *wast,* was it, was there, etc. þ*it* = þ*e* + *hit* = who it, occurs in O.E. Homilies, 2nd Series.

The Ormulum, the Bestiary, and Genesis and Exodus have some few other points of agreement which will be found noticed in the Grammatical Details and Glossary. There are, however, grammatical forms in the latter works which do not present themselves in the former, and which, in my opinion, seem to indicate a more Southern origin. (See Preface to O.E. Homilies, 2nd Series.)

I. Plurals in *n.*

I do not recollect any examples of plurals in *n* in the Ormulum, except *ehne,* eyes; in this poem we have *colen,* coals; *deden,* deeds; *fon,* foes; *siðen,* sides; *son,* shoes; *steden,* places; *sunen,* sons; *tren,* trees; *teten,* teats; *wunen,* laws, abilities, etc. (see p. xxii.)

II. The pronoun *is* (*es*) = them.[1] In the fourteenth century we only find this form *is* (*hise*) in pure *Southern* writers.[2]

"Diep he *if* dalf under an ooc."[3]—(*Gen. and Ex.,* l. 1873, p. 54.)

"For falamon findin *if* fal."[4]—(*Ibid.,* l. 1877, p. 54.)

"He toc *if.*"[5]—(*Ibid.,* l. 2654, p. 76.)

"Alle hise fet steppes ðer he steppeð,
After him he filleð, Oðer dust oðer deu,
Drageð dust wið his stert ðat he ne cunne *is* finden."[6]

 (*O.E. Miscell.,* p. 1.)

[1] In O.E. Hom., 2nd Series, we find *hes* = them. See Moral Ode, l. 186, O.E. Hom., 2nd Series : "wel diere he *hes* bohte."

[2] Robt. of Gloucester, Shoreham, Dan. Michel's Ayenbite of Inwyt.

[3] Deep he *them* buried under an oak.

[4] For Solomon find *them* shall. [5] He took *them.*

[6] All his *footsteps* after him he filleth, draweth dust with his tail where he steppeth, or dust or dew (moisture), that they are not able to find *them.*

Our author, however, employs this curious pronoun in a way quite peculiar to himself, for he constantly joins it to a *pronoun* or a *verb*,[1] and the compound was at first rather perplexing. *Hes = he + is*, he, them ; *wes = we + is*, we, them ;[2] *caldes*, called them ; *dedis*, did (placed) them ; *settes*, set them ; *wroutis*, wrought them, etc.

"Alle *hes* hadde wiꝺ migte bi-geten."[3]—(*Gen. and Ex.*, l. 911, p. 26.)

"Vndelt *hef* leide quor-so *hef* tok."[4]—(*Ibid.*, l. 943, p. 27.)

"Ðe culuer haueꝺ costes gode,
alle *wes* ogen to hauen in mode."[5]—(*O.E. Miscell.*, p. 25.)

"Bala two childre bar bi him,
Rachel *caldes* dan(.) neptalim ;
And zelfa two sunes him ber,
Lia *calde is*(.) Gad(.) and asser."[6]
—(*Gen. and Ex.*, l. 1700, p. 49.)

"ꝺe tabernacle he *dedis* in."[7]—(*Ibid.*, l. 3830, p. 109.)

"He *settes* in ꝺe firmament."[8]—(*Ibid.*, l. 135, p. 5.)

In the Kentish Ayenbite of 1340 *he* never coalesces with *hise* (them), *e.g.* :—

"He (the devil) is lyeӡere and vader of leazinges, ase he þet made þe verste leazinge, and yet *he hise* makeþ and tekþ eche daye."— (Ayenbite of Inwyt, p. 47.)

(He is a liar and the father of leasings, as he that made the first leasing, and yet *he them*, i.e. lies, maketh and teacheth each day.)

[1] I have in one case taken the liberty of separating the pronoun from the verb (for the convenience of the reader), giving the MS. reading in the margin ; but I am sorry now that I did not let them stand as in the original copy.

[2] *Mes = me + es =* one, them, occurs in O.E. Hom., 2nd Series.

[3] All *he them* had (he had them all) with might begotten (obtained).

[4] Undealt (undivided) *he them* laid, whereso *he them* brought.

[5] The dove hath habits good,
All *we them* ought to have in mind
(*i.e.* we ought to have them all in mind).

[6] Bilhah two children bore by him,
Rachel *called them* Dan, Naphtali ;
And Zilpah two sons to him bore,
Leah *called them* Gad and Asher.

[7] The tabernacle he *put them* in. [8] He *set them* in the firmament.

In Old Kentish Sermons (Old Eng. Miscell. p. 28) *has* = *ha* + *es* = he them.

III. The pronoun *he*, they (Southern *hii*, *heo*; Northumbrian *thay*). Orm uses *þeȝȝ*, as well as *þeȝȝer* (their), *þeȝȝm* (them).[1]

IV. *hine*, *hin*, *in* = him. This form occurs as late as 1340, and still exists under the form *en*, *un*, in the modern dialects of the South of England, but is not employed by Orm; nor do we find any traces of *whan* (whom), another very common example of the -*n* accusative inflection, either in the Ormulum or the present work.

V. The substitution of *n* for a vowel-ending in nouns. Dr Guest has noticed this peculiarity, but he confines this substitution to the *nominative* case of nouns of the *n* declension,[2] and to the definite form of the adjective, which has, no doubt, given rise to the O.E. *himseluen*, etc., *bothen* (both), as well as, perhaps, to *ouren* (ours), *heren* (theirs), etc.

In the present poem, however, the *n* seems added to the vowel-ending of all cases except the possessive, in order to rhyme with a verb in the infinitive, a passive participle, or an adverb terminating in -*en*, and is not always limited to nouns of the -*n* declension, but represents in A.S. an *a* or *e*: 'on *boken*,'[3] on book, l. 4; 'on *soðe-sagen*,' on sooth-saw, l. 14; *meten*, (acc.) meat, l. 2255, (nom.) 2079; *sunen*, (nom.) son, l. 1656; 'of *luuen*,' of love, 635; 'after ðe *wunen*' (after the custom), l. 688; *steden*, (nom.) place, 1114; 'for *on-sagen*,' for reproach, 2045; *wliten*, (nom.) face, 3614, (acc.) 2289; 'wið *answeren*,' in answer, 2673; *bileuen*, (acc.) remainder, 3154; *uuerslagen*, (acc.) lintel, 3155.

Dr Guest considers this curious nunnation to be a

[1] ðei occurs *once* only in the present poem, *þeȝȝr*, *þeȝȝm*, not at all; it occurs twice in O.E. Hom., 2nd Series.

[2] Philolog. Soc. Proceedings, vol. i. pp. 73, 261. *Almigtin*, almighty, p. 2, l. 30, is the only *adjective* I find with this termination.

[3] The dative of the A.S. *bóc* was *béc*.

Northern peculiarity, but as we do not meet with it (as far as I know) in any Northumbrian work, his statement is rather doubtful. On the other hand, it is well known that the plurals *bretheren* (*broðeren*[1] in Shoreham), *calveren*[2] (calves), *children*,[3] *doren* (doors),[4] *eyren* (eggs),[5] *honden* (hands),[6] *kine*,[7] *lambren* (lambs),[8] *soulen* (souls)—very common forms in the *Southern* dialects in the thirteenth and fourteenth centuries— are examples of the substitution of *n* for, or in addition to, the vowel-ending, and were unknown in the Northern dialect.

The Southern dialect could drop or retain, at pleasure, the *n* final in the past participles, the preterite plurals, and infinitive mood of verbs.

VI. A very small Norse element in the vocabulary.

The only words of undoubtedly Norse element that occur in the present poem, and were unknown to Southern English, are—*fro* (from), *ille* (bad), *for-sweðen* (to burn), *flitten* (to remove), *laðe* (barn), *lowe* (flame), *mirk* (dark), *ransaken* (to search), *swaðe* (flame), *til* (to), *uglike* (horrible), *werre* (worse).[9]

The Ormulum, being more Northern, contains a *larger* number of words that must be referred to one of the Scandinavian idioms:[10]—*afell* (strength), *afledd* (begotten), *beʒʒsc* (bitter), **blunnt* (blunt, dull), *bracc* (noise), **braþ* (angry), **braþþe* (anger), **brodd* (shoot), *brodden* (to sprout), *broþþfall* (fit), **bun* (ready, bound), **clake* (accusation), **croc* (device), **derf* (bold), **dill* (sluggish), **eggenn* (to urge, egg on), **egginng* (urging), **ettle*, **flittenn* (to remove, flit), **flitting*

[1] *gebroðeren* (A.S. *broðru*) occurs in the Semi-Sax. Gospels. [2] A.S. *cealfru*.
[3] *cildru*. [4] *dura*. [5] *ægru*. [6] *handa*. [7] *cý*. [8] *lambru*.
[9] *greiðe* (prepare), *kipte* (seized), *lit* (stain), *liðe* (listen), *mal* (speech), *witterlike* (truly), are found in Southern English, and may be the remains of the Anglian element in the A.Saxon.
[10] Those marked * thus constantly occur in Northumbrian and Midland works (with Northern peculiarities) of the 14th century.

(change, removal), *forrgart (opposed, condemned), *forr-gloppned (disturbed with fear, astonishment), *gate (way), gowesst (watchest), *haʒherr (dexterous), haʒherleʒʒc (skill), *haʒherrlike (fitly), hof (moderation), hofelæs (immoderately), *ille (bad), *immess (variously), *kinndlenn (to kindle), *lasst (crime, fault), leʒhe (hire, pay), *leʒʒtenn (O.E. layle, inquire, seek), o-loft (aloft), *loʒhe (fire), *mune (must, will), naþe (grace), nowwt (cattle, O.N. naut; the Southern form is neet, nete, A.S. neát), *ploh (plough), *radd (afraid), *ros (praise), *rosen (to boast), *rosinng (boast), rowwst (voice), *scaldess (poets, O.E. scald, a great talker, boaster, E. scold), *sit (pain), *sket (quickly), *skirpeþþ (rejecteth), *sloþ (track, path), smikerr (beautiful, Eng. smug), sowwþess (sheep), stoff-nedd (generated, O.E. stoven, trunk, stem), *summ (as), *till (to), *tór (hard, difficult), *trigg (true), uppbriæle (object of reproach, O.E. briæle, reproach), usell (wretched), *wand (rod), *wandraþ, O.E. wandreth (trouble), *werre (worse).

As most, if not all, of the words in the foregoing list are not found in works written in the Southern dialect,—so far as we at present know them—we may reasonably suppose that they indicate fairly the Danish element in the English litera-ture of the 12th and 13th centuries. In the Northumbrian, and the West, and East-Midland productions of a century later this element prevails to a much larger extent, and Herbert Coleridge's list of such words may be largely in-creased (Phil. Soc. Trans., 1859, p. 26-30).

GRAMMATICAL DETAILS.

I. Nouns.

1. *Number.*—The plural is generally formed by adding -es to the singular. Some few nouns make the plural in -en, as feren[1] (companions), fon (foes), goren (spears), loten (features),

[1] fere occurs for feren, so senwe = sinews (A.S. sinu, sing., sina, pl.).

sunen (sons), *teten* (teats), *tren* (trees), *weden* (garments), *wunen* (laws). The plurals of *brother* and *child* are *brethere* and *childere*. *Der* (deer), *erf, orf* (cattle), *got* (goat), *neat* (oxen), *sep* (sheep), *scrud* (garbs), *wrim* (reptiles), of the neuter gender, are uninflected in the plural. *Winter, ger* (year), and *nigt* (night), are plural as in Anglo-Saxon.

2. *Gender.*—As a general rule the names of inanimate things are of the neuter gender. The names of towns, however, are considered as masculine.

3. *Case.*—The genitive singular and plural of masculine and feminine nouns end in -*es*. Occasionally proper nouns form the genitive in -*is*. The means or instrument occasionally stands in the genitive without the preposition : ' *deades* driuen,' influenced by death ; ' *swerdes* slagen,' slain of the sword ; ' *teres* wet,' wet with tears. Cf. ' *floures bred,*' bread made with flour ; ' *bredes* mel,' meal consisting of bread ; ' *wines* drinc,' drink consisting of wine.

Corresponding to the modern word *kinsmen* we have such forms as ' *daiges-ligt* ' (daylight), ' *hines-folk* ' (servants), ' *wifeskin* ' (women). The genitive is used adverbially, as *newes*, anew ; *liues*, alive.

We have a few traces of the genitive in -*e* in the following examples : ' *helle* nigt,' l. 89 (hell's night) ; ' *helle* bale,' l. 2525 (hell's bale) ; ' *sterre* name,' l. 134 (star's name) ; ' *safte* same,' l. 349 (shame of form) ; '*werlde* nigt,' l. 1318 (world's night).[1]

The genitive of *fader* and *moder* is, as is very seldom the case in Early English writers, *fadres* and *modres*.

An *n* is often added to the final -*e* (representing an A.Sax.

[1] As a rule fem. nouns, and nouns of the *n* declension, take the inflexion -*es ;* as, ' *sinnes* same' (sin's shame), ' *sowles* frame ' (soul's profit), ' *helles* male ' (hell's mail), ' *werldes* drof' (world's assembly). The Bestiary contains the following genitives in -*e* :—' *nese* smel' (O.E. Miscell., p. 1), '*welle* grund' (*Ib.*, p. 3), ' *kirke* dure' (*Ib.*, p. 6), ' *soule* drink ' (*Ib.*, p. 7), ' *soule* spuse' (*Ib.*, p. 23), ' *helle* pine' (*Ib.*, p 24).

vowel-ending) in the nom., dat., and acc. of nouns. For examples, see p. xxi.

II. ADJECTIVES.

1. Adjectives have a definite and an indefinite form; the former is used when the adjective is preceded by the definite article, a demonstrative adjective, or possessive pronoun.

Indef. *wis* (wise),	*god* (good).
Def. *wise,*	*gode.*

2. *Number.*—The plural is formed by the addition of *e* to the singular.

SINGULAR.	PLURAL.
fet (fat),	*fette.*
gret (great)	*grete.*
other,	*othere.*
tother,	*tothere.*

But the -*e* (pl.) is seldom added to the past participle of irregular verbs. *This* forms the plurals *thes* (oblique cases *these*), *this* (*thise*). *Tho* is the plural of *that.*

Cases.—*One* makes the genitive *ones;* as, ʻ*ones* bles,ʼ of one colour. The gen. pl. -*re* occurs in *ald-re* (= *alre*), of all; as, ʻhure *aldre* bale,ʼ the bale of us all; ʻhere *aldre* heuedes,ʼ the heads of them all.

Degrees of comparison.—The comparative ends in -*ere* (-*er*), the superlative in -*este* (*est*).[1] Very few irregular forms occur in the present poem.

POSITIVE.	COMPARATIVE.	SUPERLATIVE.
ille,	werre.	——
lite,	lesse,	leist.
long,	{ leng. lengere. }	——

[1] The forms in -*er*, -*est*, are properly adverbial and not adjectival.

POSITIVE.	COMPARATIVE.	SUPERLATIVE.
mikel,	$\begin{cases} mo, \\ mor, \end{cases}$	moste.
neg,	——	neste.
old,	eldere,	eldeste.

Numerals.—The Northumbrian forms in -*nde* have super-seded the Southern ones in -*the*; as, *seuende* (seventh), *egtende* (eighth), *tende* (tenth).[1]

III. Pronouns.

1. The first personal pronoun *Ic* is never found softened into *Ich* as in Laȝamon's Brut, the Ancren Riwle, and other Southern works. *I* is found only once or twice throughout the poem.

2. The first and second personal pronouns have a *dual* as well as a plural number; as, *wit*, we two; *unc*, us two; *gunc*, you two; *gunker*, of you two.

3. *Hine* (*hin*, *in*) (acc.) occasionally occurs, but more frequently *him* (dat.) does duty for it.

4. *Ge*, *ghe*,[2] she, represents the A.Sax. *héo* (O.E. *heo*, *ho*, and *hi*). The curious form *sge* (= *sye*), as well as *sche*, occurs for she, the earliest instance of which is *scæ* in the A.Sax. Chronicle.

5. The neuter pronoun is written *it* and not *hit*, and is frequently used as a plural. It coalesces with the pronoun *ge*, *ghe*[3] (she), and with the preterite of verbs terminating in -*de* or -*te*,[4] and with some few irregular verbs; as, *sagt* (saw there), p. 37, l. 1301. The curious form *negt* (in l. 3964, p. 112) = *neg* + *it* = nigh it.

[1] *tigðe* = *tithe*, tenth, occurs in l. 895, and *tigðes* in l. 1628.

[2] Orm uses the more Northern ȝ*ho* (Northumbrian *sco*).

[3] *get* = she it: "al *get* bit otwinne," she biteth it all in two (Bestiary, O.E. Miscell., p. 9).

[4] See p. xix.

6. The A.Sax. *hi* (they) is represented by *he* = *hie*.[1] *He* is common enough in the Romance of Havelok the Dane.[2]

The pronouns, as has already been shown, coalesce with the plural (acc.) *is* (them), and give us the compounds *hes*, he + them; *wes*, we + them;[3] mes = *me* + *hes* = one + them.[4]

Not satisfied with joining *he* (they) to the pronoun *is*, the author of this poem occasionally employs the more perplexing combination *hem* = *he* + *hem*, he, them.

> bred kaluef fleif, and flures bred,
> *Roasted calves' flesh, and flour-bread,*
> And buttere, *hem* ðo sondes bed,
> *And butter, he them the messengers offered.*—(l. 1014.)
> In fichem feld ne fonde *hem* nogt,
> *In Shechem field found he them not.*—(l. 1933.)
> Ðo fette fundri *hem* to waken,
> *Then set sundry he them to watch.*—(l. 2551.)
> Ðo feide ðuf quanne *hem* cam dun,
> *Then said thus when he to them came down.*—(l. 4022.)

In l. 2673 *hem* seems to stand for *he* + *hem*, they + them.

> And *hem* feiden wið anfweren,[5]
> *And they to them said in answer.*

The Southern *me*, one (Fr. *on*), is absent from this poem as well as from the Ormulum; its place is supplied by *man* and *men*[6] used with a verb in the singular number. Ðe is frequently used as a relative pronoun as well as ðat, but uninflected; *quo* (who), *quat* (what), are interrogative; *whether* signifies which of two.

[1] Ðei occurs but once only. [2] O.E. Hom., 2nd Series.

[3] See pp. xix, xx.

[4] See Preface to O.E. Hom., 2nd Series.

[5] If *godes* = god's, *seiden* (pl.) may be an error for *seide* (sing.), and *hem* will then = *he* + *hem*, he them.

[6] Chaucer constantly uses *men* with a *verb* in the *singular* number, third person. See Notes and Queries for Feb. 8th, 1873, where I have shown that the West-Midland substituted *men* for the Southern *me*.

TABLE OF PRONOUNS.

SINGULAR.

Nom.	Ic, I	ðu
Gen.	min	ðin
Dat.	me	ðe
Acc.	me	ðe

	DUAL.	PLURAL.		DUAL.	PLURAL.
Nom.	wit	we		——	ge
Gen.	——	ure		gunker	gure
Dat.	——	us		——	gu
Acc.	unc	us		gunc	gu

SINGULAR.

Nom.	He	ge, ghe (sge, sche)	It
Gen.	His	Hire	Is, His
Dat.	Him	Hire	It
Acc. { Hin / Him }		Hire	It

PLURAL.

	Masc.	Neut.		Interrogative.
Nom.	He	It		Quo
Gen.	Here	Here		Quase } Was }
Dat.	Hem	It		——
Acc.	Hem	It		Quam

The third personal pronoun is occasionally used reflexively; as *him* = himself. *Self* is used adjectively in the sense of own, very, and the form *selven* (from the A.Sax. *sylfa*) is joined to the personal pronouns; as ðeselven, himselven, etc.

The independent possessives are *min*, ðin, his (*hise*), *hire* (hers), *ure* (ours), *gure* (yours), *here* (theirs).

IV. VERBS.

Infinitive Mood.—The infinitive terminates in -*en,* which is seldom dropped.

[1] The genitive and possessive are denoted by one form; as, *ure,* of us; *gure,* of you; *here,* of them.

There are no infinitives in -*y* or -*ie,* as in Southern English writers, nor do we find them in the Ormulum, or in Robert of Brunne's "Handlyng Synne," and they were, most probably, wholly unknown to the East Midland district.

The *t* in the 2nd pers. sing. pres. is occasionally dropped, as *beas* (=*best*), art, *betes,* beatest, *findes,* findest, etc.; but not in the preterite of regular verbs.

There are no instances of the 3rd pers. sing. present in -*es* in this poem.

The final *e* of the first and third persons (sing.) of the preterite tense is often dropped before a vowel or an *h,*[1] and, in a few cases, through the carelessness of the scribe,[2] it is unwritten before a consonant, where we should expect to, and do, find it in the majority of instances.

Some few strong verbs have become weak, as *grapte* (grasped, felt), *gette* (poured), *smette* (smote).

Imperative Mood.—Verbs forming the past tense in *de* or *te* take no inflexion in the 2nd pers. sing. imperative.

Participles.—1. The active or imperfect participle ends in -*ende* or -*ande,* the former being the Midland and the latter the Northumbrian form. The Southern affix is -*inde,* from which we have the modern -*ing* (O.E. -*inge*).

Our author rhymes *specande* with *lockende,* and in the Bestiary we find that the participle in -*ande* rhymes with an infinitive in -*en,*[3] and this accounts for such forms as *stinken* = *stinkende, brennen* = *brennende,* in the present poem.

2. The passive or perfect participle of regular or weak verbs terminates in -*ed;* of irregular or strong verbs in -*en.* In *bigote* (begotten), *funde* (found), *geue* (given), the absence of the *n* is probably an error of the scribe.

3. The prefix *i-* or *y-* (A.S. *ge-*) is not of frequent occur-

[1] Because elided in these cases.
[2] The Bestiary is far more accurate in this respect.
[3] *gangande* rhymes with *standen* (O.E. Miscell., p. 21, ll. 654, 655).

rence either in this poem or in the Bestiary; in the former
we have *i-wreken* (avenged), *i-wrogt* (wrought), *ybiried*
(buried), *y-oten* (called); and in the latter we find *i-digt*
(arranged).

There are two conjugations of verbs, regular (weak) and
irregular (strong). The regular verbs form their past tense
in -*ede*, -*de*, or -*te*; the past participle ends in -*ed*, -*d*, or -*t*.
Irregular verbs form their past tense by a change of vowel,
and the past participle terminates in -*en*.

CONJUGATION OF REGULAR VERBS.

I. CLASS. INFINITIVE MOOD—*Loven*, love.

INDICATIVE MOOD.

PRESENT.

Singular.	Plural.
1. love,	1. loven,
2. lovest,	2. loven,
3. loveð.	3. loven.

PAST TENSE.

Singular.	Plural.
1. lovede,	1. loveden,
2. lovedest,	2. loveden,
3. lovede.	3. loveden.

SUBJUNCTIVE MOOD.

PRESENT.		PAST.	
Singular.	Plural.	Singular.	Plural.
love,	loven.	lovede,	loveden.

IMPERATIVE MOOD.

Singular.	Plural.	
	1st form.	2nd form.
2. love.	loveð,	love.[1]

PARTICIPLES.

PRESENT OR ACTIVE.	PAST OR PASSIVE.
lovande, ⎫ lovende, ⎭	loved.

[1] This form is used when the pronoun follows.

II. CLASS. INFINITIVE MOOD—*Heren*, hear.

INDICATIVE MOOD.

PRESENT.			PAST.	
Singular.	Plural.		Singular.	Plural.
1. here,	heren,		1. herde,	herden,
2. herest,	heren,		2. herdest,	herden,
3. hereð.	heren.		3. herde.	herden.

SUBJUNCTIVE MOOD.

PRESENT.		PAST.
Singular.	Plural.	
here.	heren.	(Like the Indicative.)

IMPERATIVE MOOD.

Singular.	Plural.	
	1st form.	2nd form.
2. her.	hereð.	here.[1]

PARTICIPLES.

PRESENT.	PAST.
herande, ⎱	
herende. ⎰	herd.

III. CLASS. INFINITIVE MOOD—*Seken*, seek.

INDICATIVE MOOD.

PRESENT.			PAST.	
Singular.	Plural.		Singular.	Plural.
1. seke,	seken,		1. sogte,	sogten,
2. sekest,	seken,		2. sogtest,	sogten,
3. sekeð.	seken.		3. sogte.	sogten.

SUBJUNCTIVE MOOD.

PRESENT.		PAST.
Singular.	Plural.	
seke.	seken.	(Like the Indicative.)

IMPERATIVE MOOD.

Singular.	Plural.	
	1st form.	2nd form.
2. sek.	sekeð.	seke.

PARTICIPLES.

PRESENT.	PAST.
sekande, ⎱	
sekende. ⎰	sogt.

[1] *Followed* by the pronoun.

CONJUGATION OF IRREGULAR VERBS.

A. (no change of vowel in the plural preterite.)

Infinitive Mood—*Holden*, hold.

INDICATIVE MOOD.

PRESENT.		PAST.	
Singular.	Plural.	Singular.	Plural.
1. holde,	holden,	1. held,	helden,
2. holdest,	holden,	2. helde,[1]	helden,
3. holdeð.	holden.	3. held,	helden.

SUBJUNCTIVE MOOD.

PRESENT.		PAST.	
Singular.	Plural.	Singular.	Plural.
holde.	holden.	helde.	helden.

IMPERATIVE MOOD.

Singular.		Plural.	
	1st form.		2nd form.
2. hold.	holdeð.		holde.

PARTICIPLES.

PRESENT.	PAST.
holdande, ⎱ holdand. ⎰	holden.

B. (change of vowel in the preterite plural.)

Infinitive Mood—*Helpen*, help; *singen*, sing.

INDICATIVE MOOD.

PRESENT TENSE.

Singular.		Plural.
1. helpe,	singe, ⎱	
2. helpest,	singest, ⎬	helpen, singen.
3. helpeð.	singeð. ⎰	

PAST.

Singular.		Plural.
1. halp,	sang, ⎱	
2. holpe,[2]	sunge,[2] ⎬	holpen, sungen.
3. halp.	sang. ⎰	

[1] The second person of irregular verbs (pret.) does not occur in the poem. In the Ormulum the inflection is -*e*, which is occasionally dropped.

[2] These forms do not occur in the poem.

SUBJUNCTIVE MOOD.

PRESENT.		PAST.
Singular.		Plural.
helpe,	singe.	holpen, sungen.

IMPERATIVE MOOD.

Singular.		Plural.	
		1st form.	2nd form.
2. help,	sing.	helpeð, singeð.	helpe, singe.

PARTICIPLES.

PRESENT.		PAST.
helpande,	singande, ⎱	
helpendo,	singende, ⎰	holpen, sungen.

TABLE OF VERBS.

A.—REGULAR.

	Present.	Preterite.	Passive Participle.
Class I.	Loven (to love),	lovede,	loved.
	etc.	etc.	etc.
Class II. (a)	Callen (call),	calde,	cald.
	Feden (feed),	fedde,	fed.
	Greden (cry),	gredde,	gred.
	Heren (hear),	herde,	herd.
	Leden (lead),	ledde,	led.
	Sriden (clothe),	sridde,	srid.
	Wenen (think),	wende,	wend.
	etc.	etc.	etc.
(b)	Bimenen (lament),	bimente	biment.
	Bitiden (betide),	bitidde,	bitid.
	Delen (divide),	delte,	delt.
	Demen (judge),	dempte,	dempt.
	Kepen (keep),	kepte,	kept.
	Wenden (go),	wente,	went.
Class III.	Bigen (buy),	bogte,	bogt.
	Biseken (beseech),	bisogte,	bisogt.
	Biteche (assign),	bitagte,	bitagt.

Present.	Preterite.	Passive Participle.
Cachen (drive),	kagte,	kagt.
Lachen (seize),	lagte,	lagt.
Sellen (sell),	solde,	sold.
Tellen (tell),	tolde,	told.
Worchen (work),	wrogte,	wrogt.

B.—IRREGULAR VERBS.

DIVISION I.

	Present.	Preterite.	Passive Participle.
Class I. (a)	Beren (bear),	{ bar, bor, }	boren.
	Bidden (bid),	bad,	beden.
	Bi-speken (speak),	bi-spac,	bi-speken.
	Bigeten (beget),	bigat,	{ bigeten. bigoten. }
	Breken (break),	brac,	broken.
	Cumen (come),	cam,	{ cumen. comen. }
	Eten (eat),	at,	eten.
	Forgeten (forget),	forgat,	forgeten.
	Giuen (give),	gaf,	{ geven. given. }
	Nimen (take, go),	nam,	{ nomen. numen. }
	Seren (shear),	——	soren.
	Stelen (steal),	stal,	stolen.
	Sweren (swear),	swor,	sworen.
	Beten (beat),	bet,	beten.
Class II.	Bidden (ask, entreat),	bed,	boden.
	Biheten } (promise),	{ bihet, het, }	bihoten.
	Heten }		hoten.
	Drepen (slay),	——	dropen.
	Fallen (fall),	fel,	fallen.
	Forhelen (hide),	——	forholen.
	Hingen (hang),	heng,	hangen.

Present.	Preterite.	Passive Participle
Holden (hold),	held,	holden.
Lepen (leap),	lep,	lopen.
Leten (leave),	let,	leten.
Slepen (sleep),	slep,	slepen.
Wepen (weep),	wep,	wepen.
Wassen (wash),	weis,	wassen.
Waxen (wax),	wex,	waxen.
Wreken (avenge),	wrek,	{ wroken. wreken. }

Class III.

Present.	Preterite.	Passive Participle
Dragen (draw),	{ drog, drug, }	dragen. drogen.
Faren (go),	for,	faren.
Forsaken (forsake),	forsoc,	forsaken.
Graven (bury),	——	graven.
Slon (slay),	{ slog, slug, }	slagen.
Standen (stand),	stod,	standen.
Taken (take),	toc,	taken.
Waken (wake),	woc,	waken.

DIVISION II.

Class I.

Present.	Preterite.	Passive Participle
At-winden (depart),	at-wond.	——
Abreden (awake),	abraid.	——
Bergen (protect),	barg,	{ borgen. borwen. }
Binden (bind),	bond,	bunden.
Bresten (burst),	brast,	{ brusten. brosten. }
Biginnen (begin),	bigan,	bigunnen.
Delven (buy),	dalf,	dolven.
Drinken (drink),	dranc,	drunken.
Figten (fight),	fagt,	fogten.
Finden (find),	{ fand, fond, }	funden.

Present.	Preterite.	Passive Participle.
Gelden (requite),	{ gald, geald,	golden. gulden.
Helpen (help),	halp,	holpen.
Melten (melt),	malt,	molten.
Scriðen (invite),	scroð.	——
Singen (sing),	sang,	sungen.
Sinken (sink),	sanc,	sunken.
Springen (spring),	sprong,	sprungen.
Sterfen (die),	starf,	storven.
Stingen (sting),	stong,	stungen.
Wergen (defend),	warg.	——
Werpen (throw),	warp,	worpen.
Đresten (thrust),	ðrast.	——
Class II. At-witen (go, depart),	atwot.	——
Biten (bite),	bot,	biten.
Driven (drive),	drof,	driven.
Gliden (glide),	glod,	gliden.
Risen (rise),	ros,	risen.
Sinen (shine),	son,	sinen.
Smiten (smite),	smot,	smiten.
Writen (write),	wrot,	writen.
Class III. Beden (offer),	{ bed, bead,	boden.
Crepen (creep),	crep,	cropen.
Chesen (choose),	ches,	chosen.
Dregen (suffer),	dreg,	drogen.
Flegen (fly),	{ fleg, flew,	flogen.
Fleten (float),	flet,	floten.
Forlese (lose),	{ forles, forleas,	forloren.
Scheten (shoot),	schet.	——
Segen (see),	{ seg, sag,	sogen. sowen.

Present.	Preterite.	Passive Participle.
Seðen (boil),	seð,	soden.
Stigen (ascend),	steg,	stigen.
Ten (go),	teg,	togen.
Ðen (thrive),	ðeg,	ðogen.

Anomalous Verbs.

Cunen (can), 3 *pers. sing.* can, *pl.* cunen, *pret.* cuðe, *p.p.* cuð.

Daren (dare), *pres. pl.* duren, *pret.* durste.

Mogen (may), 3 *pers. sing.* mai, *pl.* mogen, mowen, *pret.* migte (2 *pers. pret.* migt).

Mot (may), *pret.* muste.

Ogen (owe, ought), 3 *pers. sing.* og, *pl.* ogen, *pret.* ogte.

Sal (shall), 2 *pers. sing.* salt, *pl.* sulen, *pret.* sulde, *pret. pl.* sulden.

Witen (know), 3 *pers. sing.* wot, *pret.* wiste.

Wilen (will), *pret.* wulde; nile = will not; nolde = would not.

The verb *ben*, 'to be,' is conjugated after the following manner :—

INDICATIVE MOOD.

PRESENT.

Singular.		Plural.
1. am,		
2. art, beas, best,	}	ben, arn[1] (aren).
3. is, beð,		

PAST.

Singular.		Plural.
1. was,		
2. wore,	}	weren, worn (woren, wore).
3. was,		

[1] *Sinden* = are, occurs in the Bestiary and the Ormulum. *Sinde* and *senden* in O.E. Hom., 2nd Series.

V. Adverbs.

The adverbs *hence, thence, whence,* do not occur, being superseded by the Norse forms *heðen, ðeðen, queðen.*

Adverbial Terminations.—Adverbs are formed from adjectives by the addition of *e;* as *long* (adj.), *longe* (adv.).

-um (dative) occurs in *whilum* and *seldum.*

-es (gen.) in *lives,* alive, *newes,* anew.

-en in *abouten, aboven, binnen, biforen* (*foren*), *bisiden, uten, wiðouten.*

VI. Prepositions.

Fro (Northumbrian *fra*) takes the place of the Southern *fram* (from), and *til* (unknown to Southern writers) occurs frequently for *to.*

THE METRE OF THE POEM.

THE essence of the system of versification which the poet has adopted is, briefly, that every line shall have *four accented* syllables in it; the *unaccented* syllables being left in some measure, as it were, to take care of themselves.

The words which Coleridge prefixed to his poem of "Christabel" are by no means inapplicable here. He says, "I have only to add, that the metre of the 'Christabel' is not, properly speaking, irregular, though it may seem to be so from its being founded on a new (?) principle: namely, that of counting in each line the accents, not the syllables. Though the latter may vary from seven to twelve, yet in each line the accents will be found to be only four."

The normal form of the line of the present poem is that simple one of eight syllables, consisting of four (so-called) iambics, which is so common in English poetry. But it should be remembered that this line is at all times convertible with one of *seven* syllables, generally described as consisting of three trochees and a long syllable. This is easily exemplified by taking the first two lines of the Conclusion to the Second Part of Coleridge's "Christabel."

A ⏑ līt | tle chīld | a lĭm | ber ēlf ‖
Sīnging | dāncing | to ĭt | sēlf ‖

This is adopting the common form of scansion given in English prosodies, which is far from being a very correct method; since to make *trochaic* and *iambic* metres convertible is to introduce all sorts of confusion.

The fact is, that the *seven-syllable* line, though *trochaic* to the *ear*, is really an *iambic* line, of which the *first* syllable is *deficient*, i.e., supplied by a *pause;* and the truer scansion is,

A lit | tle child | a lim | ber elf ‖
— Sing | ing danc | ing to | itself ‖

At any rate, to adopt this latter method (of beginning to mark off the feet from the *end*, instead of from the *beginning* of the line) will be found to be far more convenient in practice; since the accented

syllables, instead of drifting about, will thus always be placed at the end of a foot. We should thus, for instance, introduce the same marking off of syllables in the line,

　　　Ánd | ẟe séx | te dá | is ligt ‖　l. 167,

as we have in the line,

　　　ẟo cám | ẟe fíf | te dá | is ligt ‖　l. 158.

Examples of couplets containing a line of each kind are not uncommon; thus, ll. 29, 30 :—

　　　Fá | der gód | of ál | le ẟhínge ‖
　　　Almíg | tin lóu | erd hég | est kínge ‖

Also lines 289, 290.

　　　And gét | ne kú | ẟe hé | nogt blínne ‖
　　　Fór | to dón | an óẟ | er fínne ‖

See also ll. 309, 310 ; 439, 440, etc.

The introduction of these seven-syllable lines, far from being a defect, is a natural and agreeable variation, adopted by all our best poets.

The next chief variation to be noted is that two very rapid syllables are often (as in other English metres) substituted for an unaccented one, as in l. 88 :—

　　　Ór | ẟe nígt | and áf | ter ẟe dáy ‖

Again, in l. 93 :—

　　　On an óẟ | er daí | ẟis míd | del érd ‖

and in l. 474 :—

　　　To schɔ | ten áf | ter ẟe wíl | de dér ‖

See also ll. 321, 503, 505, 656, etc. ; and compare the line from "Christabel :"

　　　"That shá | dowy in | the moon | light shone ‖ "

The syllables thus most frequently *slurred over*—the term *elided* is but weak and improper, explaining nothing—are the final syllables *-en, -er, -et*, etc., as in ll. 96 and 116 :—

　　　Ál | abú | ten ẟis wálk | ne sént ‖
　　　Was wá | ter and érẟe | o fún | der fád ‖

Some lines—and these sound rather harshly—require a little *forcing* to make them conform to the strict type; as, *e.g.*, l. 66, which, to make it agree with the rest, must be written,

　　　Iń | to ẟis ẟhíf | terneffe hér | bi-néẟen ‖

A poet's business is, in fact, to take care that the syllables which *are* to be rapidly pronounced are such as easily *can* be so ; and that the syllables which are to be heavily accented are naturally those that *ought* to be. If he gives attention to this it does not much matter whether each foot has *two* or *three* syllables in it.

A man is master of his art when he can write—

> Come in | to the gar | den, Maud ‖
> For the black | bat, night, | has flown ‖
> And the wood | bine spi | ces are waf | ted abroad ‖
> And the musk | of the rose | is blown ‖

With respect to the final -en, it should be further noted—
(1) That it is sometimes fully pronounced, as in ll. 87 and 91—

> fró | ðat tíme | we tél | len áy ‖
> ðo gán | hem dá | gen wél | iwíſſe ‖

(2) That it is sometimes rapidly slurred over, as in l. 96, already cited ; and
(3) That (especially after an r) it is often so pronounced as to be incorporated with the syllable preceding it, so that the whole word, supposing it a dissyllable in appearance, becomes monosyllabic in pronunciation ; as in l. 514—

> Matú | ſalé | was bóren | if fúne ‖

and, again, in l. 655 —

> Wóren | ſtalwúr | ði bóren | bi tále ‖

Thus, we may find the same word written and pronounced as a dissyllable—

> Wó | ren ðáne | don fóne | a-nón ‖ l. 3591 ;

and, in another place, written and pronounced as a monosyllable—

> In geu | eléngðh | e wórn | it mád ‖ l. 147.

Thus, the n must have been *very slightly* touched, as is shewn also by the riming of e and en. Examples, ll. 11 12 ; 363, 364, etc.

As to the final -e, it may be observed that it is most frequently pronounced just when it is most essential, viz., when it marks a grammatical inflexion, or an adverbial form, as, *e g.* : -

> Til ihé | sus beð | on Ró | dè dón ‖ l. 386 ;

and,

> Wél | he fei | den and fwí | ðè wél ‖ l. 1645.

In the second place, it is very liable to be slurred over before a vowel following, as in l. 148—

> In Ré | ke-fíl | le on fún | der ſhád ‖

and, thirdly, it is frequently added to words without cause, and is therefore mute, as in l. 60—

> ðat éu | ere ſpróng | in wérld | wíd ‖

It seems to be sometimes mute after -ed, when -ede forms part of a verb. See ll. 1396, 1433, etc.

Attention to the metre may detect errors in the text. Thus, in l. 75, the word *dais* is missing :—

> forð glód | ðat fír | me [dá | is] lígt ‖

See l. 113, which proves the point.

In l. 1846 the definite form of the adjective is required, and *strong* should be *stronge*—

> ꝺe stróng | e gód | of ýs | raél ‖

It has been noted that the first foot of a line sometimes consists of *one* syllable only, and that one *accented*. By a bolder license, this is sometimes the case not only with the *first* foot, but with *other* feet, *e.g.* with the *third* foot. Line 2572 :—

> Quan é | bru chíld | fúld | be bóren ‖

Again, with the *last* foot, as in l. 3580, unless we read *duste* :—

> And ftíred | it ál | to dúft | fír ‖

Very many other curious variations occur, which the reader will probably observe for himself with some interest. Thus, in l. 60, just above cited, the question arises whether or not the *r* in *werld* was pronounced with so strong a *burr* as to render the word *dissyllabic*, as is often the case in Scotch poetry with words containing *rl*, *rn*, etc.

CONTRACTIONS USED IN THE GLOSSARY.

A.S. Anglo-Saxon.
Da. Danish.
Du. Dutch.
Allit. Poems, Early English Alliterative Poems (Ed. Morris).
O.E. Old English.
Prov. E. Provincial English.
Fr. French.
Fris. Frisian.
Ger. German.
Goth. Gothic.
M.H.Ger. Middle High German.

O.H.Ger. Old High German.
Laȝ. Laȝamon's Brut (Ed. Sir F. Madden).
Met. Hom. Metrical Homilies (Ed. Small).
O.N. Old Norse.
Orm. Ormulum.
P. of C. Hampole's Pricke of Conscience (Ed. Morris).
Prompt. Parv. Promptorium Parvulorum (Ed. Way).
S.Sax. Semi-Saxon.
Sw. Swedish.

THE STORY OF GENESIS, EXODUS, ETC.

MAn og to luuen ðat rimes ren,
 ðe Wiſſeð wel ðe logede men,
hu man may him wel loken
ðog he ne be lered on no boken, 4
Luuen god and feruen him ay,
For he it hem wel gelden may,
And to alle criftenei men
beren paiſ and luue bi-twen; 8
ðan fal him almightin luuen,
Her bi-neðen and ðund¹ abuuen, [¹ *read* gund ?]
And giuen him bliſſe and foules reſte[n]
ðat him fal earuermor² leften. [² So in MS.] 12

Ut of latin ðis fong is dragen
 on engleis ſpeche, on foðe fagen;
Cristene men ogen ben ſo fagen
ſo fueles arn quan he it ſen dagen, 16
ðan man hem telled soðe tale
Wid³ londes ſpeche and wordes ſmale, [³ *read* wið]
Of bliſſes dune, of forwes dale;
Quhu lucifer, ðat deuel dwale, 20
[Brogte mankinde in sinne and bale]
And held hem ſperd in helles male
til god frid him in manliched,
dede mankinde bote and red, 24
And unſpered al ðe fendes ſped,
And halp ðor he ſag mikel ned.

GENESIS. 1

[Fol. 1.]
Man ought to love those who instruct the lewd,

so that he who is not book-learned may love and serve God.

God shall love all Christian men, and give them soul-rest

that shall last evermore.

Out of Latin is this song turned into English speech.

Christian men ought to be as glad as birds are of dawn to hear the story

of man's bliss and sorrow,

and how salvation came through Christ,

and destroyed the power of Satan.

Biddi[1] hic ſingen non oðer led, [¹ *read* bidde]

ðog[2] hic folgen idel-hed. 28

FAder god of alle ðhinge,

 Almigtin louerd, hegeſt kinge,

ðu giue me ſeli timinge

To thaunen ðis werdes biginninge, 32

ðe, leuerd god, to wurðinge,

Queðer ſo hic rede or ſinge !

Wit, and wisdam, and luue godd,

 And ſer ear biðohte al in his modd, 36

In his wiſdom was al biðogt

Ear ðanne it was on werlde brogt.

In firme bigini[n]g, of nogt

Was heuene and erðe ſamen wrogt ; 40

ðo bad god wurðen ſtund and ſtede,

ðis middes werld ðor-inne[3] he dede, [³ MS. ime.]

Al was ðat firme ðroſing in nigt,

Til he wit hiſe word made ligt ; 44

Of hiſe word, ðu wiſſike mune,

Hiſe word, ðat is, hiſe wiſe ſune,

ðe was of hin ſer ear bi-foren

Or ani werldes time boren; 48

And of hem two ðat leue luuen,

ðe welden al her and abuuen,

ðat heli luue, ða[t] wiſe wil,

ðat weldet alle ðinge wit rigt and [ſ]kil ; 52

Migt bat wit word wurðen ligt,

(Hali froure welt oc ðat migt ;

for ðhre perſones and on reed,

On migt and on godfulhed.) 56

ðo ſo wurð ligt ſo god it bad,

fro ðiſterneſſe o ſunde[r] ſad ;

ðat waſ ðe firme morgen tid,

ðat euere ſprong in werld[e] wid. 60

² 'may' is inserted between 'ðog' and 'hic' in a later hand.

wid Ꝺat ligt worn angles wrogt,

And in-to newe heuene brogt,

Ꝺat if ouer dis¹ walkenes turn, [¹ *read* Ꝺis]

God hem quuad Ꝺor feli furiurn ; 64

Summe for pride fellen ꝺeꝺen,

In-to Ꝺis Ꝺhifterneffe her bi-neꝺen ;

Pride made angel deuel dwale,

Ꝺat made ilc forge, and euerilc bale, 68

And euerilc wunder, and euerilc wo,

Ꝺat if, or fal ben euere mo.

He was mad on Ꝺe funedai,

He fel out on Ꝺe munendai ; 72

(Ꝺis ik wort in ebriffe wen,

He witen Ꝺe foꝺe Ꝺat if fen.)

forꝺ glod Ꝺat firme [dais] ligt,

And after glod Ꝺat firme nigt ; 76

Ꝺe daigoning cam eft ² a-gon, [² *read* eft]

His firme kinde dci was a-gon,

On walkenes turn wid dai and nigt

Of foure and twenti time rigt ; 80

Ꝺes frenkis men o france moal,

it nemnen " un iur natural ; "

And euoro gode Ꝺe dai biforn,

fiꝺon Ꝺat newe werld was boren, 84

Til ihesus crift fro helle nam,

Hif quemed wid ³ eue and adam; [³ *read* wiꝺ]

fro Ꝺat time we tellen ay,

Or Ꝺe nigt and after Ꝺe day, 88

for god ledde hem fro helle nigt

to paradises leue ligt ;

Ꝺo gan hem dagen wel iwiffe,

Quan god hem ledde in-to bliffe. 92

On an oꝺer dai Ꝺif middel-erd,

 waf al luken and a-buten fperd ;

Ꝺo god bad ben Ꝺe firmament,

Al abuten Ꝺis walkne fent, 96

Side glosses:

With that light were angels made,

and brought into a new heaven.

Some for pride fell thence into nether darkness.

Pride turned angels into devils, who became the source of every sorrow, bale, and woe.

The devil was made on the Sunday and fell out on the Monday.

Forth glided the first light, and afterwards the first night. The dawning came again.

Thus in the welkin's course comes day and night "of twenty-four hours right." [Fol. 2b.]

So ever came the day first,

till Christ brought his saints from hell.

From that time we ever reckon first the night and then the day.

For God led them from Hell's might into Paradise's bright light.

On the second day the earth was enclosed by the firmament,

by frozen waters and wall of ice.

Of watres froren, of yfef wal,
ðis middel werld it luket al ;—

No fire has ever yet melted this ice.

May no fir get melten ðat yf ;
He ðe it made if migtful and wis,— 100

This enclosure may be called Heaven-roof.

It mai ben hoten heuene-Rof ;
It hiled[1] al ðis werldes drof, [¹ read hileð]
And fier, and walkne, and water, and lond,
Al if bi-luken in godes hond, 104

It shall last until Doomsday.

Til domef-dai ne fal it troken.
Al middel-erd ðer-inne is loken,

[Fol. 3.]

watres ben her ðer-under fuuen,
And watres ðor a-buuen ; 108

Above this is another heaven full of bliss and life.

And ouer ðat fo ful i-wis,
An oðer heuene ful o blis,
And ful o lif ðe lefted oo,
wo may him ben ðe fel ðor-fro. 112

Thus passed this second day's night.
Then came the third day's light.

Forð glod ðis oðer daif nigt,
 ðo cam ðe ðridde dais ligt :
ðe ðridde dai, fo god it bad,

Water and earth became separated.

was water and erðe o funder fad ; 116
God bi-quuad watres here ftede,

The earth did bring forth grass, herb, and fruit tree.

And erðe brimen and beren dede ;
Ilk gres, ilc wurt, ilc birðheltre,
Hif owen fed beren bad he ; 120

Thus was earth made mother of wealth.

Of euerilc ougt, of euerilc fed,
Waf erðe mad moder of fped.
ðe ðridde dai was al ðis wrogt,
And erðes fodme on werldes brogt ; 124
An euerilc fodme his kinde quuemeðen.

Then was all fair here below.
God saw that it was so, and blessed it.

ðo was it her fair bi-neðen,
God fag his fafte fair and good,
And blifcede it wid[2] milde mood. [² read wið] 128

Forð glod ðis ðridde daif nigt,
 ðo cam ðe ferðe daif ligt.

Then came the fourth day's light, and Might made the sun and moon and each bright star.

ðe ferðe dai made migt
Sunne, and mone, and ilc fterre brigt, 132

walknes wurðinge, and erdes frame, [Fol. 3b.]
He knowned[1] one ilc fterre name, [[1] *read* knoweð]
He fettes in ðe firmament, God set them in
 the firmament.
Al abuten ðis walkne went ; 136 He let them be
ðe feuene he bad on fligte faren,
And toknes ben, and times garen. for signs and for
 seasons.
Sunne and mone ðe mofte ben Sun and moon
 are the greatest
Of alle ðe toknes ðat men her fen ; 140 of all these
 tokens.
ðe mone if more bi mannes tale, The moon is
 greater than the
ðan al ðis erðe in werldes dale ; earth.
And egeft fwilc ðe funnes brigt, The sun's bright-
 ness is greater
If more ðanne ðe mones ligt. 144 than the moon's
 light.
ðe mones ligt is moneð met, The moon's light
 is the measure of
ðor-after if ðe funne fet ; a month.
In geuelengðhe worn it mad, In the equinox
 was it made.
In Reke-fille, on funder fhad ; 148
Two geuelengðhes timen her, Two equinoxes
 and two solstices
And two folftices *in* ðe ger. are in the year.
On four doles delen he In four parts the
 year is divided,
ðe ger, ilc dole of moneð ðhre ; 152 each part being of
 three months.
Euere fchinen ðo toknes brigt,
And often giuen if on erðe ligt ;
wel wurðe his migt letful ay,
ðe wroutis on ðe ferðe day ! 156
Forð glod ðis ferðe daif nigt,
 ðo cam ðe fifte dais ligt ; On the fifth day,
ðe fifte day god made ywis [Fol. 4.]
 God made of
of water, ilc fuel and eruerilc[2] fif, [[2] So in MS.] 160 water each fowl
 and fish,
And tagte fuel on walkene his fligt,
Ilc fif on water his flotes migt,
And blifced hem, and bad hem ðen
 and bad them
And tuderande on werld[e] ben. 164 multiply.
ðif fifte dai held forð his fligt, This fifth day
 took its flight,
 And forð endede ðat fifte nigt ; and on the sixth
 day God made all
And [cam] ðe fexte dais ligt, cattle, reptiles,
 and wild deer
So made god wið[3] witter migt, [[3] *read* wið] 168 (beasts).

Al erue, and wrim, and wilde der,

Qwel [1] man mai fen on werlde her. [¹ qwilc ?]

God fag bi-fore quat after cam,

Ꝺat fingen fulde firme adam, 172

And him to fremen and do [2] frame, [² to ?]

He made on werlde al erue tame,

Ꝺe fulde him her, in fwinkes ftrif,

to fode, and frud, to helpen Ꝺe lif; 176

And him to pine, and loar her,

God made wirme *and* wilde der.

He pine man wid [3] forwe and dred, [³ *read* wiꝺ]

And don hem [4] monen hif finfulhed, [⁴ him ?] 180

Ꝺat if him loar quan he feꝺ,

Ꝺan he for finne *in* forwe beꝺ.

Ilk kinnes erf, and wrim, and der

Was mad of erꝺe on werlde her, 184

And euerilc on in kinde good,

Ꝺor quiles adam fro finne ftod;

Oc der and wrim it deren man

fro Ꝺan Ꝺat he fingen bi-gan; 188

In Ꝺe mofte and *in* Ꝺe lefte he forlef

Hif louerd-hed [5] quuanne he mif-chef;

Leunes and beres him wile to-dragen,

And fleges fen on him non agen; 192

Hadde he wel loked him wiꝺ fkil,

Ilc befte fulde don hif wil;

Erf helpeꝺ him Ꝺurg godes meꝺ,

Hif lordehed [6] Ꝺor-onne he feꝺ. 196

And for hife finne oc he to munen,

Ꝺat mofte and leifte *him* ben binumen.

Ðif fexte dai god made Adam,

And his licham of erꝺe he nam, 200

And blew Ꝺor-in a liues blaft,

A likneffe of his hali gaft,

⁵ louerd-hel in MS. ⁶ *read* louerd-hed

A ſpirit ful of wit and ſckil ;

Ðor quiles it folgede heli wil, 204

God ſelf Ðor quile liket iſ,

An un-lif quuanne it wile miſ.

[I]N feld damaske adam was mad,

And Ðeðen fer on londe ſad ; 208

God bar him in-to paradiſ,

An erd al ful of ſwete bliſ ;

fol wel he wid¹ him Ðor dede, [¹ read wið]

bi-tagte him al Ðat mirie ſtede ; 212

Oc an bodeword Ðer he him forbed,

if he wulde him ſilden fro Ðe ded,

Ðat he ſulde him Ðer loken fro

A fruit, Ðe kenned wel and wo, 216

And hiegt him ded he ſulde ben

If he Ðat bode-word ne gunne ſlen.

God brogt adam Ðor bi-forn

Ilc kinnes beſte of erðe boren, 220

and fugel, an fiſ, wilde and tame,

Ðor gaf adam ilc here iſ name ;

Ne was Ðor non lik adam.

God dede dat²he on ſweuene cam, [² read Ðat] 224

And in Ðat ſweuene he let him ſen

Mikel Ðat after ſulde ben.

Ut of his ſide he toc a rib,

And made a wimman him ful ſib, 228

And heled him Ðat ſide wel

Ðat it ne wrocte him neuere a del.

Adam abraid, and ſag Ðat wif,

Name he gaf hire dat³ iſ ful Rif ; [³ read Ðat] 232

Iſſa waſ hire firſte name,

Ðor-of Ðurte hire Ðinken no ſame ;

Mayden, for ſche was mad of man,

Hire firſt name Ðor bi-gan ; 236

Siðen ghe brocte us to woa,

Adam gaf hire name eua.

a spirit full of wit and skill."

In Damascus field Adam was made.

God bore him into Paradise, an abode full of sweet bliss.

[Fol. 5.]

He intrusted to him all that pleasant place.

But forbad him to touch the fruit which taught "weal and woe."

Dead should he be if he broke this command.

God brought all beasts of the earth, fowl, and fish unto Adam,

who gave to each a name.

God caused a sleep to come upon Adam, and in that sleep he saw much that should hereafter be.

Out of his side God took a rib, and out of it made a woman.

Adam awoke and saw his wife.

Issa was her first name,

because she was made of man.

After she brought [Fol. 5b.] us to woe Adam called her Eva.

Adden he folged godes red,
Al man-kin adde feli fped ; 240

For sin they lost the bliss of Paradise. for finne he ðat bliffe for-loren,
ðat derede al ðat of hem was boren ;
It is her-after in ðe fong,
Hu adam fel in pine ftrong. 244

The sixth day passed and Forð glod ðif fexte dais lig[t],
 After glod ðe fexte nig[t] ;

the seventh morning sprung. That day betokened long rest. ðe feuendai morgen fpro[n]g,
ðat dai tokenede refte long ; 248
ðis dai waf forð in refte wrogt,
Ilc kinde newes ear waf brog[t] ;

God ordained this day a day of bliss and rest. God fette ðis dai folk bitwen,
Dai of bliffe and off refte ben, 252
for ðat time ear fear bi-forn,

So it remained until Christ rose from the cold rock. Til ihesus was on werlde boren,
And til he was on ðe rode-wold,
And biried in ðe roche cold. 256
And reftede him after ðe ded,
ðat ilke dai god aligen bed.

Then the Sunday from that time forth became hallowed for ever. Siðen for-lef ðat dai if prif,
 for ihesus,[1] god and man fo wis, [[1] MS. ihc.] 260
Rof fro ded on ðe funenday,

[Fol. 6.] ðat is forð fiðen worðed ay ;

So shall it remain until Doomsday. And it fal ben ðe lafte tid,
Quan al man-kinde, on werlde wid, 264
Sal ben fro dede to liue brogt,
And feli fad fro ðe forwrogt,
An ben don in bliffe and in lif,
fro fwinc, and forwe, and deades ftrif. 268

Wisdom made each thing of nought. Wifdom ðe made ilc ðing of nogt,
 quuat-fo-euere on heuone or her if wrogt.

Lucifer waxed proud, Ligber he fridde a dere frud,
An he wurðe in him-feluen prud, 272

and with that pride came envy. An wid ðat pride him wex a nyð,
ðat iwel weldeð al his fið ;

Ðo ne migte he non louerd ðhauen,
Ðat him fulde ðhinge grauen :[1] [[1] *read* þrauen ?] 276
" Min fligt," he feide, "ic wile up-taken, "My flight," he says, "I will up take,
Min fete norð on heuene maken, and make my seat north of heaven,
And ðor ic wile fitten and fen and therein will
Al ðe ðhinges ðe in wer[l]de ben, 280 I sit and see all things.
Twen heuone hil and helle dik,
And ben min louerd geuelic."
Ðo wurð he drake ðat ear was knigt, Then became he dragon that ere
Ðo wurð he mirc ðat ear was ligt, 284 was knight ;
And euerilc on ðat helden wid[2] him, [[2] *read* wið] all that held with him became dark,
Ðo wurðen mirc, and fwart, and dim, dim, and black,
And fellen ut of heuones ligt and fell out of heaven's light.
In-to ðis middil walknes nigt ; 288
And get ne kuðe he nogt blinne [Fol. 6*b*.] Yet would Satan
for to don an oðer finne. not cease to commit sin.
Eften[2] he fag in paradif [[2] *read* eften] He saw Adam and Eve in Paradise
Adam and eue in mike[l] prif, 292 in great bliss and honour.
Newelike he was of erðe wrogt,
And to ðat mirie bliffe brogt ;
Ðowgte ðis quead, " hu ma it ben, How may it be, thought he, that
Adam ben king and eue quuen 296 Adam is king and Eve queen of all
Of alle ðe ðinge in werlde ben. things in the world,
Hu mai it hauen, hu mai it fen,
Of fif, of fugel, of wrim, of der,
Of alle ðhinge ðe wunen her, 300
Euerilc ðhing haued he geue name,
Me to forge, fcaðe, and fame ; while I am in sorrow, scathe, and shame.
for adam ful ðus and his wif
In bliffe ðus leden lefteful lif ; 304
for alle ðo, ðe of hem fule cumen,
fulen ermor in bliffe wunen, Evermore shall they remain in bliss,
And we ðe ben fro heuene driuen,
fulen ðuffe one in forwe liuen ; 308 while we must live in sorrow.
Get ic wene I can a red, Yet I think I know of a plan
Ðat hem fal þringen iwel fped ; to bring them into sin,

For if they do
what God forbid-
deth they shall
die.

This I will with-
out delay bring
about to-day.

[Fol. 7.]
I think that Eve
and I shall de-
prive Adam of his
life."

Thus he thought,
and up he went,
and to the earth
he came.

He went into a
" worm " and told
Eve a tale.

"Eve," he said,
" what meaneth
it that a tree is
forbidden you,

a tree that sur-
passes all others,

which shall teach
you evil and good,

and make you as
wise as those who
dwell above in
heaven?"

When Eve saw
that it was fair
to the sight and
soft to the hand,

she ate thereof,
and took some
and brought it to
Adam.

[Fol. 7b.]

He ate that fruit
and did foolishly.

Then death's two
bonds came upon
them.

for gef he don ðad ¹ god for-bead, [¹ read ðat]
ðat fal hem bringen to ðo dead, 312
And fal get ðis ilke dai,
ðor buten hunte if ic mai
Ic wene ðat ic and eue hife wif
fulen adam bilirten of hife lif. 316
Ic wene ðat ic and eue
fulen alle is bliffe dreue."

Dus he ðhogte, and up he fteg,
 And eften ² til dat ³ erð he teg, 320
Wente in to a wirme, and tolde eue a tale ;
And fenkede hire hure aldre bale.

" Eue," feide he, ðat neddre bold,
" Quat oget nu ðat for-bode o-wold, 324
ðat a tre gu forboden is,
ðat ouer alle oðre bered pris ?
for if fruit fired mannes mood,
To witen boðen iwel and good, 328
Sone ge it ðor-of hauen eten,
Al ge it fulen witent ⁴ and nogt forgeten,
And ben fo wife alle euene
So ðo ðe wunen a-buuen in heuone." 332

Danne ðogte eue on hire mod,
 ðanne if tif fruit wel fwiðe good,
fair on figðhe and fofte on hond,
Of ðif fruit wile ic hauen fond. 336
Sum ghe ðer at, and fum ghe nam,
And bar it to her fere adam ;
So manie times ghe him fcroðt,
Queðer so him was lef or loðt, 340
for to forðen if fendes wil,
At he dat ³ fruit, and dede unskil ;
Sone it was under breft numen ;
Dedes two bondes on hem ben comen ; 344

² read eften ³ read ðat ⁴ witen ?

Vn-buxumhed he hauen hem don,
Vn-buxumhed if hem cumen on ;
Vn-welde woren and in win,
Here owen limes hem wið-in. 348 Weakness and sorrow troubled their limbs.

fleſſes fremcðe and fafte fame They were ashamed of their nakedness,
boðen he felten on here lichame ;
ðo gunen he fame friden,
And limes in leues hiden. 352 and shrouded themselves in leaves.
Nu wot adam fum-del o wo,
Her-after fal he leren mo.

A fter ðiſ dede a fteuone cam, After this deed a voice came, saying, "Where art thou, Adam ?"
 " ðu, nu, quor art, adam, adam ? " 356
" Louerd, quat fame if me bi-tid, Quoth Adam, "I am naked, and hid myself."
for ic am naked and haue me hid ? "
" Quo feide ðe dat gu¹ wer[e] naked ;
ðu haues ðe forges figðhe waked, 360
for ðhu min bode-word haues broken, Then said God, "Because thou hast broken my command,
ðhu falt ben ut in forge luken,
In fwinc ðu falt tilen ði mete[n], thou shalt till thy meat with toil,
ðin bred wid fwotes teres eten, 364 and eat thy bread with sweat and tears,
Til gu¹ beas eft in to erðe cumen, until thou come again to the earth.
Quer-of gu¹ beaf to manne numen ; [¹ read ðu ?]
And wif fal under were wunen, [Fol. 8.]
 Woman shall be under man, and have sorrow in every birth.
In heuerilc birðhe forge numen ; 368

A nd niðful neddre, loð an liðer, The adder shall glide on his breast and eat earth.
 fal gliden on hife breſt neðer
And erðe freten wile he mai liuen,
And atter on is tunge cliuen ; 372 Poison shall cleave to his tongue.
And nið, and ftrif, and ate, and fan, Envy, strife, hate, and shame shall be between the adder and the woman."
Sal ben bi-twen neddre and wimman ;
And get fal wimman ouercumen,
His heued under fote bi-numen." 376

T wo pilches weren ðurg engeles wrogt, Two pilches the angels wrought for Adam and Eve,
 And to adam and to eue brogt,
ðor-wið he ben nu boðen frid, so that their shame might be hid.
And here fame fumdel is hid. 380

He ben don ut of paradif,

 Ðat erd al ful of fwete blif;

He ben don ut of bliffes erd,

Cherubin hauet Ðe gatef fperd; 384

Ne fulen it neuere ben un-don,

Til ihesus beÐ on Rode don;

Ne fulen it neuermore ben opened,

Til ihesus beÐ on rode dead. 388

Iff mikel is forge, and more care,

 Adam and eue it wite ful gare;

Of paradif hem Ðinkeð fwem,

Of iwel and dead hem ftondeð greim. 392

On fundri Ðhenken he to ben,

And neiðere on oðer fen,

Til angel brogte adam bode,

bodeword and tiding fro gode :— 396

" Adam, Ðhu knowe eue Ðin wif,

And leded famen gunker lif;

Summe fulen of gu to kumen,

Sulen ben in to refte numen; 400

Summe fulen folwen fendes red,

And ben in forwe after Ðe dead;

And get fal godef dere fune

In gure kin in werlde wunen, 404

And he fal bringen man a-gen

In paradif to wunen and ben."

Swilc tiding Ðhugte adam god,

And fumdel quemeð it his feri mood. 408

Đif angel is to heuone numen,

 And adam if to eue cumen,

More for ernefte dan [1] for gamen; [¹ read Ðan]

Adam and eue wunen famen, 412

And hadden childre manige i-wif,

Mo Ðan of telleð de genefis;

for fiftene ger hadde adam,

Ðan caim of eue cam, 416

Side notes:

They were turned out of Paradise.

Cherubim closed the gates. Never shall they be undone till Christ is crucified.

Thus Adam and Eve became acquainted with sorrow and care.

[Fol. 8b.] Evil and death troubled them. They thought that they must never look upon one another.

Message came from God, "Adam, know Eve, thy wife, and live together.

Some that shall be born of you shall come to bliss, others shall be in sorrow after their death.

God's dear Son shall bring man again into Paradise."

These tidings partly softened Adam's sorry mood.

Adam and Eve lived together.

Children had they, many more than Genesis tells of.

After fifteen years Cain was born,

And oðer fiftene al fwilc fel,

Quane eue bar rigt-wife abel.[1]

Abel an hundred ger waf hold,

ðan he was of if broðer wold ; 420

An hundred ger after if dead,

Adam fro eue in frifte abead.

To hundred ger and .xxx.[ti] mo

was adam hold and eue ðo, 424

ðan bor ghe feht in ðe ftede

Of caym ðat abel for-dede ;

Or or midleft, or after ðo

Bar eue of adam manige moo. 428

Ðor quiles ðat adam forge dreg

 for abel, caym fro him fleg,

wið wif and hagte, and wurð ut-lage,

wið dead him ftood hinke and age. 432

He ches a ftede toward eden,

And to him[2] fameden oðer men,

wallede a burg, e-no bi name ;

ðeft and reflac ðhugte him no fame, 436

for ðat he made him manige fon,

ðor he ðhogte he ftonden agon.

Met of corn, and wigto of fo,

And merke of felde, firft fond he. 440

Tellen ic wile fo birðe bad,

 Adam, caym, enos, iraab,

Malaleel, matusale ;

Lamech is at ðe sexte kne, 444

ðe feuende man after adam,

ðat of caymes kindo cam.

ðif lamech waf ðe firme man,

ðo bigamie firft bi-gan. 448

Bigamie is unkinde ðing,

On engleis tale, twie-wifing ;

[1] At the bottom of fol. 8b is the catchword—Abel a hundred.

 [2] *him* is by a later hand.

for ai was rigt and kire bi-forn,

On man, on wif, til he was boren. 452

Two wives he took—Adah and Zillah. Lamech him two wifes nam,

On adda, an noðer wif fellam.

Adah bare Jabal.

He was a cunning shepherd. Adda bar him fune Iobal,

He was hirde witt*e*re and wal ; 456

Of merke, and kinde, and helde, & ble,

He taught separation and assembling. fundring and fameni[n]g tagte he ;

Jubal, his brother, wise in song and glee, Iobal if broðer fong and glew,

Wit of mufike, wel he knew ; 460

wrote on tile and brass. On two tablef of tigel and braf

wrot he ðat wiftom, wif he was,

ðat it ne fulde ben undon

If fier or water come ðor-on. 464

Zillah bare Tubal, a mighty smith. Sella wuneð oc lamech wið,

ghe bar tubal, a fellic fmið ;

Iron, gold, silver, and brass he well knew how to separate and to mix. Of irin, of golde, filuer, and bras

To fundren and mengen wif he was ; 468

He was skilled in making weapons of war and household tools. Wopen of wigte and tol of grið,

wel cuðe ¹egte and fafgte¹ wið. [¹ *read* fegte and sagte ?]

[Fol. 10.]

Lamech at last became blind. He had a man to lead him to the woods in search of wild deer. Lamech ledde long lif til ðan

ðat he wurð bifne, and haued a man 472

ðat ledde him ofte wudes ner,

To fcheten after ðe wilde der ;

Al-so he miftagte, alfo he fchet,

And caim in ðe wude if let ; 476

The knave mistook Cain for a deer. His knape wende it were a der,

An lamech droge if arwe ner,

Lamech let fly an arrow, And letet flegen of ðe ftre*n*g,

Caim u*n*warde it under-feng, 480

which struck Cain and killed him. Grufnede, and ftrekede, and ftarf wið-ðan.

Lamech wið wreðe if knape nam,

Lamech beat and slew his servant. Vn-bente if boge, and bet, and slog,

Til he fel dun on dedef fwog. 484

Thus was he guilty of twi-wiving and twin-slaughter. Twin-wifing ant twin-manflagt

Of his foule beð mikel hagt.

Of hife endinge ne wot ic nogt,

oc of if kinde woren brogt 488

On werlde feue and feuenti ðhufant men,

Or or flum noe fpredde hif fen ;

Queðer fo it ðhogte hem iuel or good,

Alle he drinkilden in ðat flood. 492

Of feth, ðe waf adam-if fune,
 cam enos ; he gan ali wune

Of bedes, and of godefrigtihed,

for liucs hclpc and foules red. 496

Ic wile rigt tellen, if ic can,

Adam, feth, enos, caynan,

Malaleel, iareth, enoch,

for alied¹ god felf him toch [¹ *read* halihed] 500

fro mannes mene in to ðat ftede

ðat adam forles for iuel dede ;

gct liucð enoch wið-vten ftrif,

In paradif in fwete lif ; 504

Get he fal cumen or domef-day,

And wenden iewes, if he may,

To ðe witteneffe of iefus crift,

And tholen dead vnder antecrift ; 508

Siðen fal antccrift ben flagen,

And man and angeles wurðen fagen.

chirches ben wurfiped mor and mor,

And fendes dregen forge and for. 512

Or enoch wente [fro] werldes wune,

Matufale waf boren if fune,

And lamech of matufale,

And of lamech rigt-wife noe. 516

Metodius, ali martyr,
 Adde in his herte fighe ² fir ; [² *read* sigðhe]

Alfo he god adde ofte bi-fogte,

Wiflike was him in herte brogt 520

ðis midelerdes biginning,

And middel-hed, and if ending :

Marginal notes:

Of his death we know nothing.

His descendants were all destroyed by Noah's flood.

Of Seth came Enos, who was prayerful and God-fearing.

[Fol. 10b.]

God took Enoch to Himself,

to dwell with Him in Paradise.

Enoch shall come before Doomsday to turn the Jews to Christ.

Before Enoch went from the world Methuselah was born.

Lamech came of Methuselah.

Lamech begat Noah.

Methodius, holy martyr, knew much of this world's beginning, middle, and ending.

[Fol. 11.]
He wrote a book,
well known to
many.

He wrot a boc dat manige witen,

Manige tiding ðor-on if writen ; 524

ðor if writen qŭat agte awold,

dat ¹ ðif werld waf watͬ wold. [¹ *read* ðat]

Fif hundred ger of ðat ðufent

ðat mankin was on werlde fent, 528

Cain's kind
wrought against
law.

Caymes funes wrogten vn-lage,

Wið breðere wifes hore-plage ;

And on ðe fexte hundred ger

Women waxed
evil, unchaste,
and unnatural.

Wimmen welten weref mefter, 532

And fwilc woded wenten ² on, [² wentem MS.]

Golhed hunkinde he gunnen don ;

And ðe fifte hundred ger,

Men began to ad-
dict themselves
to wretched
practices.

wapmen bi-guñnen qŭad mefter, 536

bi-twen hem-feluen hun-wrefte plage,

A ðefis kinde, a-genes lage.

Two hundred ger after ðo wunes,

Seth's sons made
marriages con-
trary to Adam's
commands.

Mis-wiuen hem guñnen feðes funes, 540

Agenes ðat adam fͬr-bead,

And leten godef frigti-hed ;

They chose wives
of Cain's seed,
and mixed with
the accursed kind.

He chofen hem wiwes of caym,

And mengten wið waried kin ; 544

Of hem woren ðe getenes boren,

Of them were
giants born who
wrought many
evils.

Migti men, and figti, [and] for-loren ;

He wrogten manige [sinne] and bale,

Of ðat migt [nu] is litel tale ; 548

[Fol. 11b.]

for ðat he god ne luueden nogt,

ðat migt if al to forge brogt ;

For their great sin
there came wrath
and vengeance
upon the world.

for fwilc finful dedes fake,

fo cam on werlde wreche and wrake 552

for to bliffen fwilc finnes fame,

ðat it ne wexe at more huñ-frame.

A flood drowned
man and beast.

Do wex a flod ðis werlde wid-hin,

and [o]uer-flowged men & deres kin, 556

Noah and his
family were saved
in an ark.

wið-vten noe and hise ðre funen,

Sem, Cam, Iaphet, if we rigt munen,

And here foure wifes woren hem wið;

ðise .viij. hadden in ðe arche grið.[1] 560

Ðat arche was a feteles good,
 fet and limed a-gen ðe flood;

 The ark was a good vessel.

Ðhre hundred elne waf it long,

Naild and fperd, ðig and ftrong, 564

And .l.^{ti} elne wid, and .xxx.^{ti} heg;

 Three hundred ells was it long,

 fifty wide, and thirty high.

ðor butcn noe (.) long fwing he dreg,

An hundred winter, euerilc del,

welken or it was ended wel; 568

 A hundred winters was Noah in building it.

Of alle der ðe on werlde wunen,

And foueles weren ðer-inne cumen

Bi feuene and feuene, or bi two & two,

Al-migtin god him bad it fo, 572

And mete quorhi ðei migten liuen,

ðor quiles he woren on water driuen.

 Clean animals entered the ark by seven and seven, unclean by two and two.

Sexe hundred ger noe was hold

Quan he dede him in ðe arche-wold; 576

 [Fol. 12.]
 Six hundred years old was Noah when he entered the ark.

Two ðhufant ger, fex hundred mo,
 And fex and fifti forð to ðo,

weren of werldes elde numen

ðan noe waf in to ðe arche cumen. 580

Ilc wateref fpringe here ftrengðo undede,

And Reyn gette dun on ouerilk ftede

fowerti daif and fowerti nigt,

So wex water wið magti migt; 584

 The water springs undid their strength. Rain poured down on every place.

So wunderlike it wex & get

ðat fiftene elne it ouer-flet,

Ouer ilk dune, and ouer ilc hil,

ðhurge godes migt and godes wil; 588

 Fifteen ells it overflowed, over every hill and vale.

And oðer fowerti ðore-to,

Daif and nigtes ftodet fo;

ðo waf ilc fleif on wer[l]de flagen,

ðo gunnen ðe wateres hem wið-dragen. 592

 Then was all flesh destroyed.

[1] *At the end of the line in the margin* 'Se archa Nœe.'

In the seventh
month and the
twenty-seventh
day the ark stood
in Armenia.

Ðe feuend moned¹ waſ in cumen, [¹ *read* moneð]
 And feuene and .xx.ᵗⁱ dais numen,
IN armenie ðat arche ſtod,
 Ðo waſ wið-dragen ðat ilc flod. 596

When the tenth
month came the
waters withdrew.

Ðo ðe tende moned¹ cam in,
 So wurð dragen ðe watreſ win ;
Dunes wexen, ðe flod wið-drog,
It adde lefted longe a-nog 600

[Fol. 12b.]
Forty days after
this the ark's
window is un-
done, the raven
out flew, and
came not again
to the ark.

Fowerti daiſ after ðiſ,
 Arches windoge undon it iſ,
Ðe Rauen ut-fleg, hu ſo it gan ben,
Ne cam he nogt to ðe arche a-gen ; 604

The dove found
no clean place,
and came again
to the ark.

Ðe duue fond no clene ſtede,
And wente a-gen and wel it dede ;

After seven days
the dove left the
ark and returned
with an olive
bough.

Ðe feuendai eft ut it tog,
And brogt a grene oliues bog ; 608
Seue nigt ſiðen euerilc on

Seven nights
after all are let
out of the ark.

He is let ut flegen, crepen, and gon,
wið-uten ilc feuend clene der
 Ðe he facrede on an aucter. 612
Sex hundred ger and on dan² olde [² *read* ðan]
 Noe ſag ut of ðe arche-wolde ;

Noah looked out
of the ark and
saw that the earth
was dry.

Ðe firſt moned¹ and te firſt dai,
He ſag erðe drie & te water awai ; 616
get he waſ wiſ and nogt to rad,

Yet went he not
out till he was
bidden by God.

Gede he nogt ut, til god him bad.
Ðe toðer moneð was in cumen,
 And feuene and twenti dais numen, 620
Ðo herde Noe wol bliðe bode

At God's com-
mand he and his
family left the
ark.

Of a ſteuene, ðe cam fro gode ;
He and hiſe wif wenten ut fre,
Hiſe ſunes and here wifes ðre ; 624

Noah made an
altar and sacri-
ficed thereon.

He made an aucter on godeſ name,
And ſacrede he ðor-on, for fowleſ frame,

[Fol. 13.]
The seventh deer
was offered up,

Ilc feuende der of clene kin,
Ðe waſ holden in arche wið-hin, 628

And leten ðe oðre to liue gon, *the others were allowed to escape alive.*

of hem ben tudered manigon.

Often he [bad] wid[1] frigti bede, [[1] *read* wið] *Noah besought God that he*

ðat fwiulc wreche fo god ðo dede 632 *would no more send such destruction upon mankind.*

Ne fulde more on werlde cumen,

Quat wreche fo ðor wurðe numen.

God gat it a token of luuen, *God granted his request, and*

Taunede him in ðe wa[l]kene a-buuen 636 *shewed him the rain-bow as a token of His love.*

Rein-bowe, men cleped[2] reed and blo ; [[2] *read* clepeð] *The rain-bow is called red and blue.*

ðe blo tokeneð de[3] wateres wo, [[3] *read* ðe] *The blue denotes the water that drowned all flesh.*

ðat if wið-uten and is gon ;

ðe rede wid-innen[4] toknet on 640 *The red betokeneth the destruction of the world by fire.*

wreche ðat fal get wurðen fent,

wan al ðif werld wurðe brent ;

And al-fo hege ðe lowe fal gon,

So ðe flod flet de dunes on ; 644

fowerti ger or domef-dai,

ðif token no man ne fen mai.

Of[5] noe fiðen an if ðre funen, *From Noah and his three sons all*

ben boren alle ðe in werlde wunen, 648 *mankind have come.*

And or he waf on werlde led, *Before his death his family were widely spread.*

His kinde waf wel wide fpred ;

Al it if writen ic tellen mai

Of his kin bi hif liue dai ; 652

vten childre and vten wimmen, [Fol. 13b.] *They numbered, excluding women and children, 24,000 stalworth men.*

wel fowre and .xx. ðhufent men

woren ftalwurði boren bi tale,

wið-uten wif-kin and childre fmale ; 656

.ix. hundred ger and fifti told,

or or he ftarf, noe waf old.

Nembrot gat hife feres red, *Nimrod had dread of water,*

 for ðat he hadde of water dred, 660 *so he advised his followers to make a tower high and strong.*

To maken a tur, wel heg & ftrong,

Of tigel and ter, for water-gong ;

Twelwe and fexti men woren ðor-to, *Seventy-two men were employed about it.*

 [4] *read* wið-innen. [5] Of MS.

Meiſter men for to maken it ſo. 664

All spoke one speech before.
Al waſ on ſpeche ðor bi-foren,

Now sundry tongues arose and sorely terri-fied the workmen.
ðor woren ſundri ſpeches boren ;

ðo wurðen he frigti and a-griſen,

for dor¹ waſ ſundri ſpecheſ riſen, [¹ read ðor] 668

Seventy-two land-speeches were then spoken.
Sexti lond-ſpeches and .xii. mo,

weren delt ðane in werlde ðo.

That tower was called Babel.
Babel, ðat tur, bi-lef un-mad,

The folk became scattered afar upon the earth.
ðat folc if wide on lon[de] ſad ; 672

Nembrot nam wið ſtrengðhe ðat lond,

And helde ðe tur o babel in hiſ hond.

Belus was Nim-rod's son, and after him reigned Nilus, who set up an image in re-membrance of his father.
Beluſ king waſ nembrot ſune,

Nilus hiſ ſune gan ille wune ; 676

Belus wurð dead, and nilus king

Made likeneſſe, for muni[gin]g¹ [¹ see l. 1623]

[Fol. 14.]
After hiſ fader, and he ſo dede,

He it ſetten on an mirie ſtede ; 680

Nilus rewarded all that honoured this likeness.
Euerilc man he gaf lif and frið

ðat to ðat likeneſſe ſogte grið ;

for ðat frið ðat hem [gaf] ðe king,

He boren ðat likneſſe wurðing, 684

They called it Bel, after Belum.
Calden it bel, after belum ;

After ðis cam ſwilc oðer ſum,

Many made like-nesses of their friends.
Manie man, if frend for to munen,

Made likneſſe after ðe wunen, 688

Bel was the first, and hence the names Bal or Balim.
Bel was ðe firſte, and after him

Sum higte beland, fum balim,

And fum bel, and fum bal ;

fendes fleiðing wex wið-al, 692

To wenden men fro godes reed,

To newe luue and to newe dred ;

Thus was idolatry introduced, by which many are destroyed.
Ydolatrie ðuſ waſ boren,

for quuam mani man if for-loren. 696

Of ſem, and of ðe folc ðe of him cam,

luue and dred under gode nam ;

Of ðis kinge wil we leden ſong,

Cristes helpe be us amonge ! 700

Noe, fem, arfaxath, fale, *The family of Shem.*

Heber, phaleth, ðe fexte if he,

Reu, faruch, nacor, thare,

ðif if ðe tende fro noe. 704

Dis oðer werldes elde if fo, [Fol. 14*b*.]

 A ðhufent ger feuenti and two.

ðe ðridde werldef elde cam, *The third age of the world began when Terah begat Abram.*

Quanne thare bi-gat abram ; 708

for he bi-gat a fune aram,

Nachor midleft, laft abram ;

Aram bi-gat loth, and farray, *Haran begat Lot and Sarai and Milcah.*

And melcham, and waf fort leui 712

In lond caldea, hur hicte ðe tun, *They dwelt in Ur of the Chaldees.*

Quor deades ftrenge warp him dun ;

ðor fader, and breðere, and childre, and wif, *Much strife was there between father and brother, children and wife.*

Him bi-ftoden wið forwes ftrif ; 716

ðo ðogte thare on hif mod,

long bigging if here nogt god. *Terah did not care to remain long in this town.*

Nachor he gaf wif melcam,

And trewe farray abram. 720

Quanne abram wurð wif and war *Abram having no children adopted Lot as his son.*

ðat farray non childre ne bar,

He toc him loth on funes ftede ;

He waf hife neve, wol wel he dede. 724

Thare let hur, and ðeðen he nam, *Terah left Ur and came to Haran in Mesopotamia.*

And wulde to lond canahan,

Cam into a burgt [1] ðat het aram, [1 *read* burg]

In londe mefopothaniam. 728

Wið him ledde he nachor, melcam, *With him he took his sons and daughters.*

Sarray, loth, and abram.

Tho [2] hundred ger and fifue mo, [2 *read* two] [Fol. 15.]

Thare waf old, ftarf he ðo. 732 *Terah died when he was two hundred and five years old.*

Teref gliden for hertef for

fro loth, and abram, and nachor ;

Thare lið biried in aram. *He lies buried in Haran.*

God feide wurd to abram :— 736

God then com-
manded Abram
to leave Haran.

" Abram, ðu fare ut of lond and kin

To a lond ic ðe fal bringen hin."

Sex ger and fiftene mo,

Adde Abram on if elde ðo. 740

He departed,
taking with him
Lot and Sarai.

Abram tok loth wið farray,

Hife agte, and erue he ledde him bi,

For in to lond cananeam,

First he came to
Sichem,

And in-to fichem, a burgt, he nam, 744

And ðeðen he nam to mirie dale ;

fif burgef were ðor-inne bi tale,

and afterwards
to Pentapolis (the
five cities of the
plain),

ðer-fore it higte pentapolis,

Of weledef[1] fulfum and of blif, [1 werldes ?] 748

Nov ift a water of loðlic ble,

where now stands
the Dead Sea.

Men callið it ðe dede fe ;

Ilc ðing deieð ðor-inne if driuen ;

Ne may no fif ðor-inne liuen ; 752

The cities were
destroyed for
man's sin.

for mannes finne ðus it if went,

brent wið brimfir, funken and fhent.

God quad to abram, " al ðif lond

fal cumen in to if kinnef hond." 756

[Fol. 15b.]

ðor god him taunede, made habram

An alter, and fro ðeðen he nam.

Abram raised an
altar between
Bethel and Ai.

An oðer alter abram feli

Made bi-twen betel and ai. 760

Damascus was
the third place
where Abram
dwelt.

At damafke if ðe ðridde ftede,

Quer abram if bigging dede,

And ðeden for he, for hunger bond,

Famine drove
him to Egypt.

feger ut in to egipte lond ; 764

ðor he feide ðat farrai

To save his life
he said that Sarai
was his sister.

waf hif fifter, al for-ði

for he dredde him to leten if lif

If he wiften ghe wore if wif ; 768

Sarai was fair
and Egypt's folk
were lecherous.

for ghe waf fai[ge]r witter-like,

And ðat folc luuede lecherlike.

Quan abram was to egipte cumen,

Sone him waſ ſarrai binumen;

Sone him waſ ſarray bi-lagt,

And ¹pharaon ðe kinge bi-tagt ;

God ſente on him ſekeneſſe & care,

And lettede al his lecher-ſare.

Sarray liuede in clene lif,

And ðe king ðholede ſorges ſtrif

Til he wiſte al ðat ſtrif

Cam him on for abram wiſ ;

ðo ſente he after abram,

And bi-tagte he him if leman,

And gaf him lond, and agte, and fe,

And leue, ðor quiles his wille be,

To wune egipte folc among,

And friðen him wel fro cuerilc wrong,

Bad him to god hiſ erdne beren,

ðat ywel him ſulde nunmor deren.

ðor wunede abram in welðe and in frið,

Egipte clerkes woren him wið,

And hem lerede, witterlike,

Aſtronomige and arſmetike ;

He was hem lef, he woren him hold.

God gaf him ðor ſiluer and gold,

And hird, and orf, and ſrud, and ſat,

Vn achteled welðe he ðor bi-gat.

Vt of egipte, riche man,

Wente abram in to lond canaan ;

And loth hiſe neue and ſarray

bileften bi-twen betel and ay,

ðor he quilum her wiſten wunen,

Or he weren to egipte cumen.

So wex here erue, and ſo gan ðen

An twen here hirdeſ ſtriuing gan ben ;

Loth him cheſ, bi leue of abram,

ðat herðe hende ðe ſlum iurdan ;

772

776

780

784

788

792

796

800

804

Soon was Saraı taken from Abram, and brought to king Pharaoh.

God plagued the king with sickness.

Pharaoh at last became aware that all this strife was on account of Sarai,

so he restored her to her husband,

[Fol. 16.]
and gave Abram land and cattle.

In Egypt the patriarch abode in security.

Egypt's clerks held him in high honour.

God greatly increased his riches.

Out of Egypt Abram went to Canaan, and abode between Bethel and Ai.

Strife arose between Abram and Lot's herdsmen.

Lot, by leave of his uncle, chose the plains of the

¹ *w* in MS. But the *w* is much like *p*.

In mirie dale hife bigginge he ches,

ᚧat he fiᚧen twie for-les. 808

A bram let loth in welᚧe and wale,
 And ferde a-wei to mambre dale;

ᚧor wunede abram henden ebron,

ᚧat burge an oᚧer man liᚧ on, 812

It atteᚧ cariatharbe,

On engle fpeche fowre cite;

fowre arbe cariatht arn in,

for ᚧat fowre biried ᚧor ben; 816

ᚧor waf leid adam and eua,

Abram fiᚧen and farra;

ᚧor yfaac and rebecca,

And iacob and hife wif lia. 820

M Ambre, wiᚧ excol and anel,
 ᚧor luueden Abram ful wel;

He woren breᚧere of kinde boren,

And abram woren he breᚧre fworen. 824

Quor abram wunede, ᚧor wex bi

An ok' ᚧat waf of gibi,

ᚧer het god abre ᚧat tagte lond

Sal cumen al in hif kinnef hond, 828

And eft and weft, and fuᚧ and norᚧ;

Al ᚧat god wile fal wel gon forᚧ.

D o wurᚧen waxen fo wide and fpred,
 pride and gifcinge of louerd-hed; 832

Neg ilc burge hadde ife louereding,

Sum waf king, and fum kumeling;

Sum waf wiᚧ migte¹ fo forᚧ gon,

ᚧat hadden he under hem mani on. 836

F if burges of pentapolif,
 Adama, bala, Seboyf,

And fodoma wiᚧ gomorra,

ᚧe kinges welten burges ᚧoa, 840

¹ The MS. has migt; but migte is at the bottom of p. 16 *b* in
the catchwords—" Sū waf wiᚧ migte."

Marginal notes:

Jordan for his dwelling-place.

[Fol. 16*b*.]

Abram dwelt in Mamre-dale, towards Ebron.

This city is called Kirjatharba, *i. e.* four cities.

Four lie buried there.

There was laid Adam and Eve, Abram and Sarai, Jacob and Leah.

Mamre, Eschol, and Aner were sworn brothers with Abram.

God promised that Abram's seed should possess the land wherein he was a stranger.

Then was pride widely spread, and desire of sovereignty.

Nearly every city had its ruler.

[Fol. 17.]

The five cities of Pentapolis, ruled over by their own kings,

On-kumen was cadalamor,

king of elam, wiꝼ ferding ſtor ;

.xij. ger he weren under iſ hond,

And gouen him gouel of here lond ; 844

.xiij. ger gan ſo forꝼ gon

wulde he giuen him gouel non ;

ꝼre kinges haued he wiꝼ him brogt,

wiꝼ here-gonge hiſe gouel ſogt ; 848

He ben cumen to mirie dale,

An ꝼere he werken ſckaꝼe and bale;

fowre on-ſeken and fifue weren,

Oc ꝼe fowre ꝼe fiue deren ; 852

wunded ꝼor waſ gret folc and ſlagen,

ꝼe fifwe ſlen, ꝼe fowre ben ſagen;

ꝼe fifwe up to ꝼe dunes ſlen,

ꝼe fowre in to ꝼe tuneſ ten ; 856

wiſwes, and childre, and agte, and ſrud,

He ledden a-wei wiꝼ herte prud.

Loth and iſ agte, childre and wif,

ben led a-wei bunden wiꝼ ſtrif; 860

oc on of hem, ꝼe flogen a-wei

Told it abram ꝼat ilke deai.

ꝼre hundred men and .xiij. wigt,

Alle ſtalwurꝼi and witter of ſigt, 864

wiꝼ mambre, and excol, and anel,

Abram let him tunde wel ;

ꝼat hird he folged[1] alſ to ꝼan,

On heued-welle of flum iordan, 868

ꝼor he wenden ben ſiker on nigt ;

Abram he brogte wel newe ſigt.

He woren drunken and ſlepi,

Abram[2] folc made hem dredi ; 872

ſo heg, ſo long, ne ſpared hem nogt,

Alle he ben ꝼor to gronde brogt,

wiꝼ-ꝼuten ꝼo ꝼe cuden ſlen ;

 [2] An *is* is inserted by a later hand.

Marginal notes:

were conquered by Chedorlaomer, and paid him tribute.

Twelve years they were under his hand.

In the thirteenth they rebelled,

Chedorlaomer and other three kings made war upon the cities.

Much sorrow they wrought. The four kings conquered the five.

The five flee to the hills, and the four to the cities of the plain.

They led away with them Lot, his goods, children, and wife.

[Fol. 17*b*.]

But one escaped and told Abram, who armed 313 servants and pursued the enemy.

[1 folgel in MS.]

Abram found them drunk and sleepy.

He brought them all to ground.

get ne migten he fiker ben, 876

He pursued them unto Hoba, near Damascus.
for magnie[1] of ðo woren ouer-taken, [¹ *read* manige]

Abram cude hem to forwe maken.

Henden damafk, til burgt oba,

Abram hem folwede and wrogte woa; 880

Much spoil he took.
wifes, and childre, and frud, and fat,

He brogte agen and mikel he bat;

And tol, and takel, and orf, he dede

wenden hom to here ogen ftede, 884

All this he did for love of Lot.
for lotef luue fel him ðuf rigt,

Borwen he ben wel of dat[2] figt. [² *read* ðat]

[Fol. 18.]
The king of Sodom went out to meet Abram.
Sodomes king in kinge dale,

Mette abram wið feres wale, 888

In ðe weie ðe ligið to falem,

ðe fiðen if cald ierufalem.

Melchizedek brought him bread and wine.
Melchifedech, falamef king,

dede abram ðor mikel wurðing; 892

He froðer[ed]e him, after if fwinc,

wið bredef fode and wines drinc;

Abram gave him a tenth of the spoil.
Habram gaf him ðe tigðe del

Of alle if bigete, and dede ðor wel, 896

And blifcede dor[3] godef migt, [³ *read* ðor]

ðat bargt abram wel of ðat figt;

Melchizedek was both priest and king.
for he waf boðen king and preft,

of elde moft, of wit hegest; 900

None knew from what family he sprung.
wifte no man of werlðe ðo,

Quat kinde he waf kumen fro;

Some said that this king of Salem was Shem,
Oc fumme feiden ðat it waf fem,

ðif preft and [oc] king of falem, 904

or or ðe flod waf long bi-forn

of noe bi-geten, of[4] if wif born, [⁴ MS. of.]

who lived until the birth of Isaac.
And fro fo longe ðor bi-foren

Liuede til yfaac waf boren. 908

The king of Sodom offered Abram the goods and cattle taken from the enemy.
Sodomes king bed dor[5] abram [⁵ *read* ðor]

Al agte and erf, wið-uten man,[6] [⁶ ? nam]

Alle hef hadde wið migte bi-geten,

wolde he nogt him hif fwinc for-geten, 912

oc abram dede ðor meðelike wel, [Fol. 18b.]
The patriarch
wid-held he ðor-of neu[er]e on del, would accept of
nothing.

oc al ðat euere fel him to,

Sac-les he let hin welden it fo. 916 Then first began
the custom of
Ebruif feigen, wune hem wex her keeping the 15th
year holy
To algen ilk fiftene ger,

for loth waf fifti winter hold,

Quan abram him bi-told. 920

A bel primicef firft bi-gan, Abel first began
first-fruit.
And decimas first abram; Abram tithes.

Nu ift fo boden and fo bitagt,

Quo-fo hif alt him bi agt. 924

After ðif fpac god to abram :— After this God
spake to Abram,
"ðin berg and tin werger ic ham. saying,
"I am thy safety
ðin fwinc ðe fal ben gulden wel, and thy defence,
thy toil shall be
wid[1] michel welðe in good[e] fel." [1 read wið] 928 requited."

Quad he, "quat fal me welðes ware, Quoth Abram,
"What avails
Quane ic child-lef of werlde fare; wealth, seeing
that I am child-
Damak eliezeref fune, less,
and that Eliezer's
In al min welðe fal he wunen?" 932 son shall inherit
my wealth?"
Quat god, "fo fal it nogt ben, God said, "Of
thyself shall
Of ðe felf fal ðin erward ten." thine heir come."

Abram leuede ðif hot in fped,

dat[2] waf him [told] to rigt-wifhed. [2 read ðat] 936

ðre der he toc, ilc ðre ger hold, Abram took
three deer each
And facrede god on an wold; three years old
and offered them
of godef bode he nam god kep, as a sacrifice.
[Fol. 19.]
A net, and a got, and a fep; 940 An heifer, a goat,
and a sheep he
Euerilc of ðefe he delte on two, took, and divided
them in two and
And let hem lin on funder fo, set them apart.

Vndelt hef leide quor-fo hef tok;

And ðor a duue and a turtul ok 944 The dove and the
turtle he divided
Sat up on-rum til heuene he tok, not.

And of ðo doles kep he nam

Gredi fouelcs fellen ðor-on, Greedy fowls fell
upon the carcases.

Abram drove
them away.
Then came on
him fear and
fright.
A great and
bright fire he saw
glide down be-
tween the pieces.
In a dream God
showed Abram
the future con-
dition of his de-
scendants.

Ꝺat Ꝺogte abram wel iwel don, 948

kagte if wei, quan it waf nigt,

Ꝺo cam on him vgging and frigt;

A michel fier he fag, and an brigt,

gliden Ꝺor twen Ꝺo doles rigt. 952

God feide him Ꝺor a foꝺe drem

Ꝺe timinge of if beren-tem,

And hu he fulde in pine ben,

And uten erdes forge fen; 956

fowre hundred ger fulden ben gon,

Canaan is pro-
mised as his in-
heritance.

Hor he fulden wel cumen a-gon,

oc fiꝺen fulde in here hond,

bi-cumen Ꝺat hotene lond. 960

Then knew
Abram much
more of what was
to come than he
ever knew before.
Sarai, being bar-
ren, gives Hagar
to Abram.

Ꝺo wifte abram wel michel mor

Quat waf to cumen Ꝺan he wifte or.

Siꝺen bi-fel Ꝺat farrai,

for ghe waf longe untuderi, 964

[Fol. 19b.]

Ghe bitagte abre maiden agar;

Ghe wurꝺ wiꝺ childe and hem two bar;

forꝺ fiꝺen ghe bi abram flep,

Hagar having
conceived,
despised her
mistress.

Of hire leuedi nam ghe no kep; 968

And farrai wuldet nogt Ꝺolen

Ꝺat agar wore Ꝺuf to-bolen;

Sarai afflicts her
thrall.

Ghe held hire hard in Ꝺrallef wune,

And dede hire forge and anger mune; 972

Hagar flees from
Sarai into the
desert homeless
and weary.

Ꝺo fleg agar fro farray,

wimman wiꝺ childe, one and fori,

In Ꝺe diferd, wil and weri,

And an angel cam Ꝺor hire bi, 976

wifte hire drogen fori for Ꝺrift,

An angel com-
mands her to
return and be
buxom to her
lady.

At a welle quemede hire lift,

And bad hire fone wenden agen,

And to hire leuedi buxum ben; 980

He tells her of
her child.

And feide ghe fulde funen wel

And timen, and clepen it fmael,[1]

¹ A metrical licence for "ifmael."

And he ſulde ben man migti,

And of him kumen folc frigti ; 984

Ghe wente agen, and bar ðat child,

And abram wurð wið hire milde.

> Hagar returns, and Ishmael is born.

lxxx. gere and ſexe mo

Hadde abram on hiſ elde ðo, 988

> Abram was then fourscore and six years old.

And .xiii. ger ðor after told,

ix. and nigneti[1] ger he waſ old, [¹ *read* nigenti]

Qwanne him cam bode in ſunder run,

fro gode of circumcicioun. 992

> When Abram was ninety-nine [Fol. 20.] years old God changed his name to Abraham.

His name ðo wurð a lettre mor,

Hiſ wiueſ leſſe ðan it waſ or,

for ðo wurd abram abraham,

And ſarray ſarra bi-cam ; 996

> Sarai's name is also changed to Sarah.

And al ðat euere ðe louered bad,

dede abraham redi and rad.

He him ſelf wurð ðanne circumciſ,

> Circumcision is instituted.

And yſmael hiſ ſune iwiſ ; 1000

And of iſ hird euerilc wapman

wurð circumciſ, al-ſo he it bi-gan,

Quuo ne bar ðanne iſ merk him on

fro godes folc ſulde he be don. 1004

> Whoso bore not this mark upon him was to be cut off from God's folk. Afterwards in the dale of Mamre Abraham saw figures three, seemly messengers from God.

Sıðen, ın ðe dale of mambre,

ſag abraham figures ðre,

Sondes ſemlike kumen fro gode;

Abraham he broghten wel bliðe bode. 1008

Abraham he[m] ran wel ſwiðe agon,

And of ðe ðre he wurðede ðe ton,

ðe god him dede in herte ſen,

ðe waſ wurði wurðed to ben ; 1012

> Abraham enter-tains the angels.

bred, kalueſ ﬂeiſ, and ﬂures bred,

And buttere, hem ðo sondes bed;

for ðat he bad wið herte fre,

He it nomen in charite ; 1016

So malt ðat mete in hem to nogt,

So a watreſ drope in a fier brogt.

> He set before them calves flesh) bread and flour and butter.
> What he offered with a free heart his guests took in charity,
> [Fol. 20b.] though it was but as a drop of water in a fire.

Abraham ſtod and qᴜamede hem wel,

Hiſ good[e] wil was hem good mel. 1020

Qᴜuad ðiſ on, " ðiſ time oðer ger,

Sal ic me to ðe taunen her ;

Bi ðan ſal farra felðe timen,

ðat ge ſal of a ſune trimen." 1024

ðanne herde farra ſwilc tiding,

And it hire ðogte a felli ðhing,

for ghe waf nigenti winter hold,

Abraham on wane of an hundred told ; 1028

Ghe glente and ðhogte, migte it nogt ben,

And ghe ðat fulde her wið childe be ſen ;

And Abraham trewid it ful wel,

And it wurð foð binnen ſwilc ſel. 1032

Fro mambre dale wente ðo ðre,

 to-ward ſodome geden he ;

Qᴜad ðe louered, "wile ic nogt ſtelen,

Ne min dede abraham helen ; 1036

Ic cume to ſen ðat ſinne dwale

ðat iſ me told of mirieſ dale."

ðo adde abram iſ herte for,

for loth hiſ newe wunede ðor. 1040

" Louerd," qᴜad he, " hu faltu don,

If ðu ſalt nimen wreche ðor on ;

Salt ðu nogt ðe rigt-wiſe weren,

Or for hem ðe toðere með beren ? " 1044

Qᴜad god, " find ic ðor ten or mo,

Ic ſal meðen ðe ſtede for ðo."

Durſte Abraham freinen nu␯mor,

Oc wente agen wið herte for ; 1048

And god at-wot in-to hiſe ligt,

ðo to gon to ſodome rigt.

Sunne iſ weſt under erðe numen,

Qᴜuan␯ne he ben to ſodome cumen ; 1052

Get ſat loth at ðe burges gate,

After ſum geſte ſtod him quake ; ¹ [¹ read quate]

He rof, and lutte, and ſcroð him wel,

And bead hem hom to if oftel 1056 he invited them to his home to stay with him that night.

To herbergen wið him ðat nigt,

ðo ſwete angeles, faier and brigt ;

And he ſo deden alf he hem bead,

He wiften him bergen fro ðe dead ; 1060

And loth hem ſerued faire and wel, Lot served his guests fair and well.

And he him gulden it euerilc del.

Oc al ðat burgt folc ðat helde waf on,

ðe migte lecher crafte don, 1064

To lothes huf he cumen ðat nigt The wicked So-domites beset Lot's house.

And bi-fetten it redi to figt ;

He boden him bringen ut o-non, They bade him bring out the strangers.

ðo men ðat woren ðidir in-gon. 1068

Loth hem bead if dogtres two, [Fol. 21b.] Lot offered them his daughters.

for to friðen hiſe gefte fwo ;

Oc he ne wulden hif dogtres nogt,

for wicke and feble waf here ðogt. 1072 The wicked folk sought to harm Lot.

ðat folc vn feli, finne wod,

ðo fori wrecches of yuel blod

wulden him ðor gret ſtrengðe don,

Til wreche and letting cam hem on. 1076

ðis angels two drogen loth in, The angels drew Lot in.

And fhetten to ðe dure-pin.

Wil fiðen cam on euerilc on, Blindness came upon the Sodom-

ðo wrecches ðe wið-vten gon, 1080 ites,

for al ðat nigt he fogten ðor

ðe dure, and fundend[1] neuere mor. [1 So in MS.] and they sought the door in vain.

ðo feiden ðif angeles to loth wið fped,

If ðu frend haueft and wi[l]t don red, 1084 Lot is command-ed to leave the city with his friends before daybreak.

Bid him, or day, redi ben,

And fwiðe ut ðif burgef flen,

elles fulen he brennen and for-faren,

If he ne bi time heðe[n] waren. 1088

Two ðor werren quam him ðogte ear

To wedden hif two dogtres ðear ;[2] [2 read dear]

Lot warned his sons-in-law in vain.

Loth hem warnede, wiſlike and wel,
Oc he ne troweden him neuere a del. 1092

The angels led Lot and his family out of Sodom,

On morgen quan day cam hem to,
Loth and hiſ dogtres two

[Fol. 22.]

Ledden ðiſ angeles ut in ſel,

and bade them turn not back.

And boden hem and tagten wel, 1096
ðat here non wente agen,
for non ðhing he migte ſen.

Lot thought the way to the hills hard and strong.

Loth waſ wanſum, and ðugte long
vp to ðo dunes ðe weie hard and ſtrong; 1100

He intreated that he might dwell in Segor.

"Louerd," quat he, "gunde under dun,
mot hic ben borgen in ðat tun!"
ðo angeles ſeiden, "we ſulen it fren,[1] [1 ? fren]
ðor quile ðu wilt ðor-inne ben; 1104

This city was safe while Lot abode there;

Ai waſ borgen bala-ſegor
ðor quile ðat loth dwelledde ðor;

when he left it, it was destroyed.

Oc fiðen loth wente ut of hine,
brende it ðhunder, fanc it erðe-dine. 1108
Sone ſo loth ut of ſodome cam,

Sodom was destroyed by fire,

brend-fier-rein ðe burge bi-nam;
Hardere wreche ðor waſ cumen
ðan ear was vnder flode numen; 1112

for sin and "unkind deeds."

for men ðor ſinne un-kinde deden,
ſo for-ſanc and brente ðat ſteden;
So bitter-like iſ it for-don,
Ne mai non dain waſſen ðor-on; 1116
So for-ſanc ðat folc ſinful ðor,
ſwilc ſinful ſinne wex ðer nummor.

Lot's wife turned back, and "went into a stone."

Do lotes wif wente hire a-gon,
Sone ghe ſtod, wente in to a ſton; 1120

[Fol. 22b.]
Thus is this "merry dale turned into a swarthy lake.

So iſt nu forwent mirie dale
In to dririhed and in to bale,
ðe ſwarte flum, ðe dede ſe,
Non fiſ, non fuel ðor-inne mai be. 1124
ðat water iſ ſo deades driuen,

Nothing may live therein.

Non ðing ne mai ðor-inne liuen;

Men feið ðe treen ðat ðor henden ben

Waxen in time, and brimen, and ðen, 1128 Trees on its banks produce apples,

Oc qwane here apples ripe ben,

fier-iſles man mai ðor-inne fen ; which contain ashes only.

ðat erd if oten faltes dale,

Maniman ðor-of holdet litel tale. 1132

L oth wuned litel in fegor, Lot soon left Segor.

for he dredde him for to forfare ðor ;

Wið hife two dowtres ut he teg,

And for dred to ðo dunes he fleg ; 1136 For fear he fled to the hills, and dwelt in a cave.

And ðor he biggede in a caue[n],

ðe waf ðor in roche grauen.

ðo meidenes herden qwilum feien, Lot's daughters thought *all mankind* had perished, and that, unless they had children, the world would come to an end.

ðat fier fulde al ðis werld forfweðen, 1140

And wenden wel ðat it were cumen,

And fieref wreche on werld numen,

And ðat man-kinde wore al for-loren

but of hem ðre wore man boren. 1144

ðis maidenes redden fone [1] on on [[1] MS. fono.] They consulted as to what was best to be done.

Qwat hem two wore beft to don,

Hu he migten vnder-gon [Fol. 23.]

Here fader, ðat he ne [2] wore ðor gon ; [[2] MS. hene.] They made their father drunk so that he wrought the deed, and each begot a child.

Wið winef drinc he wenten if ðhogt,

So ðat he haueð ðe dede wrogt,

And on eiðer here a knaue bi-geten,

ðif ne mai nogt ben for-geten. 1152

ðif maidenes deden it in god dhogt,[3] [[3] read ðogt.]

ðe fader oc drunken ne wifte he it nogt.

ðe firfte him bar moab ðat fune, The first bore Moab, the other Ammon.

Of him beð folc, [in] moab it wune ; 1156

ðe leffe him bar a fune amon,

Amonit folces fader on.

N V bi-oueð uf to wenden a-gen, Now turn we to Abraham.

And of abraham fong under-gon. 1160

Abraham up on morgen ftod, On the morrow he looked toward Sodom,

Wið reuli lote and frigti mod ;

GENESIS. 3

and saw that the
city had been
destroyed.
To-ward fodome he fag ðe roke

And ðe brinfires ftinken¹ fmoke, [¹ _for_ ftinkende] 1164

For sorrow he left
Mamre's dale.
And wente a-wei fro mambre dale,

So fore him reu of ðat bale.

and went and
abode in Gerar.
Suðen he wente & wunede _in_ geraris,

bi-twen cade and vr, y-wis; 1168

There he said
Sarah was his
sister.
ðor he feide eft, for luue of lif,

ðat fifter wore farra his wif.

Q_u_ilu_m_ of² er ³pharraon hire toc, [² _read_ af? ³ MS. w]

Nu takeð abimalech hire oc; 1172

[Fol. 23 b.]
Abimelech took
her to wife.
Sene it was ðat ghe waf fair wif,

Quan ghe waf luued in fo long lif.

Abimalech wurð fek on-on,

Sickness fell on
him and on his
folk.
And oðer wreche if folc cam on; 1176

Nogt wif-kinnes non birðe ne nam,

ðor q_u_iles he ðor wið-helð faram.

On dreme him cam tiding for-q_u_at

The cause of this
evil was made
known to him in
a dream.
He ðrowede and ðolede un-timing ðat; 1180

Al it waf for abraham-if wif,

ðat he hire held ðor wið ftrif;

ðo bi-ðhogte him ful wel,

And fente after abraha_m_ ðat ilc fel, 1184

He sent back
Sarah,
And bi-tagte him hif wif a-non,

And hif yuel fort⁴ waf ouer-gon. [⁴ fort in MS.]

his wife and
others bore chil-
dren,
and the quinsy
no more troubled
him.
His wif and oðere birðe beren,

ða ðe fwinacie gan him nu_n_mor deren. 1188

Abimalech gaf abraham

Gold, and filuer, and lond for-ðan;

Plates of silver he
gave to Sarah.
A ðhufant plates of filue_r_ god

Gaf he farra ðat faire blod, 1192

Bad hire ðor hir wið⁵ heuod ben hid, [⁵ _read_ ðor wið hir]

for fwilc timing was hire bi-tid.

Ðo wulde god bi-fewen fo

of olde abraha_m_ and o farra fo. 1196

Ghe wurd wið child, on elde wac,

The birth of
Isaac.
And trimede and cleped it yfaac.

Ðe egtende dai ðat he waſ boren, [Fol. 24.]

Circumciſed he waſ, a-buten ſchoren ; 1200 He was circum-
 ciſed on the
Ðor-of holden ðe ieuwes lay, eighth day,

Circumciſed on ðe egtende day.

Arabit folc of yſmael,

After him don he it al ſwilk ſel, 1204 which custom the
 Jews follow.
Quane he .xiii. ger ben old ;

Of yſmael here time iſ told.

Ðre ger woren yſaac on, When Isaac was
 three years old
 Quane he waſ fro teding don ; 1208 Abraham made a
 great feast.
Michel geſtninge made abraham

Quane he ðat ſune to borde nam.

Wintres forð-wexen on yſaac,

And yſmael waſ him vn-ſwac ; 1212 Ishmael often
 mocked Isaac,
Of-ten it gan yſaac un-framen,

And yſmael pleide hard gamen ;

Sarra waſ ðor-fore often wroð, which caused
 Sarah to be very
Hir waſ yſmaeles anger loð ; 1216 wroth.

Ghe bi-mente hire to abraham, She complains to
 Abraham.
And ſumdel ligtlike he it nam

Til god him bad iſ wiues tale

Liſten, and don a-wei ðat dwale. 1220

Abraham rapede him ſone in ſped

for to fulfillen godeſ reed ;

He flemede agar and yſmael Abraham ban-
 ishes Hagar and
In ſumertid, In egeſt ſel ; 1224 her son.

Bred, and a fetles wið water fild, [Fol. 24b.]

Bar agar wið hire and wið ðe child ;

Bi ðe deſert a-wei che nam, By the desert
 they took their
In ard weie and hete gram ; 1228 way.

Wið ſwinc and hete hem wexon ðrift,

Ðe water fleckede ðe childeſ liſt ; They became
 very thirsty.
Tid-like hem gan ðat water laken,

Ðo gan agareſ ſorwe waken ; 1232 The water in the
 bottle became
Wantede ðit child ſaierneſſe and migt, spent.

Hiſ moder wurð neg dead for ſrigt.

<table>
<tr><td>Hagar placed her child under a tree,</td><td>Ghe leide ðe child under a tre,</td><td></td></tr>
<tr><td></td><td>fer ðeðen ghe gede, fo it gan be,</td><td>1236</td></tr>
<tr><td></td><td>ðe child ne mai ghe for forge fen ;</td><td></td></tr>
<tr><td></td><td>Bi al-fo fer fo a boge mai ten,</td><td></td></tr>
<tr><td>and sat as far as a bow-shot off. She thought it could not re-cover.</td><td>ðor fat hif moder in fik and for, wende ghe it coueren neuere mor.</td><td>1240</td></tr>
<tr><td></td><td>Goddef merci dede hire reed,</td><td></td></tr>
<tr><td>An angel showed her a well-spring,</td><td>An angel meðede hire ðat ned, Tagte hire ðor a welle fpring,</td><td></td></tr>
<tr><td></td><td>ðat waf hire ðor feli timing ;</td><td>1244</td></tr>
<tr><td>and she gave the lad drink and bread.</td><td>ðor ghe gan fremen yfmael Wið watref drinc and bredef mel,</td><td></td></tr>
<tr><td>Forth they went and dwelt in Paran.</td><td>filt hire fetelef, and nam fro ðan forð to ðe defert of ¹pharan ;</td><td>[¹ w MS.] 1248</td></tr>
<tr><td>Ishmael married an Egyptian woman.</td><td>ðor wunede yfmael and agar. Ghe chef him a wif ðe childre bar ;</td><td></td></tr>
<tr><td>[Fol. 25.] Twelve sons he had, of whom sprang great na-tions.</td><td>.xii. funef he auede bi hif wif, Of him cam kinde mikil and rif.</td><td>1252</td></tr>
<tr><td></td><td>Nabachot waf hif firft fune,</td><td></td></tr>
<tr><td>In Arabia they dwelt.</td><td>In arabie hif kinde wune fro ðe riche flod eufrate,</td><td></td></tr>
<tr><td></td><td>Wid and fer to ðe rede fe ;</td><td>1256</td></tr>
<tr><td>Kedar gave name to a kingdom.</td><td>Of hif oðer fune cedar, A ku[n]griche hif name bar ;</td><td></td></tr>
<tr><td>From Dumah came the king-dom of Dirima.</td><td>And of duma hif fexte fune, A ku[n]gdom dirima ðu mune ;</td><td>1260</td></tr>
<tr><td></td><td>Hif .ix. waf tema for-ðan,</td><td></td></tr>
<tr><td>Teman gets its name from Tema.</td><td>If ðor a ku[n]glond teman ; And .xii. of ðe cedima,</td><td></td></tr>
<tr><td></td><td>Het a guglond² eften fro ða. [² read kunglond]</td><td>1264</td></tr>
</table>

Flemd waf agar and yfmael,
 and yfaac wex and ðehg wol wel.

<table>
<tr><td>Abimelech makes a covenant with Abraham,</td><td>Abimalech fag abraham, Hu welðe him wex and migte cam,</td><td>1268</td></tr>
<tr><td></td><td>He bad him maken fiker pligt Of luue and trewðe, in frendef rigt,</td><td></td></tr>
</table>

Ðat ne fulde him nogwer deren,
Oc him and hiſe helpen and weren ; 1272
He gaf him a welle and a lond fre,
Abraham it clepede berſabe ;
Ðor ben he boðen feren pligt
Ðat here neiðer ſal don oðer un-rigt. 1276

Abraham gan ðor longe ben,
And tillede corn and ſette treen,
Ðog [it] waſ nogt if kinde lond ;
Richere he it leet ðan he it fond. 1280

Iff ioſephus ne legeð me,
 Ðor quiles he wunede in berſabe,
ſo waſ yſaaceſ eld told
xx. and fiwe winter old ; 1284
Ðo herde abraham ſteuene fro gode,
Newe tiding, and ſelkuð bode :—
"Tac ðin ſune yſaac in hond,
And far wið him to ſiðhingeſ lond, 1288
And ðor ðu ſalt him offren me
On an hil ðor ic ſal taunen ðe."
fro berſabe iurneſ two
Waſ ðat lond ðat he bed him two ; [¹ read to] 1292
And morie, men ſeið, waſ ðat hil,
Ðat god him tawne[de] in his wil ;
Men ſeið ðat dune-if ſiðen on
Was mad temple ſalamon, 1296
And ðe auter mad on ðat ſtede
Ðor abraham he² offrande dede. [² read ðe]

Abraham waſ buxum o rigt,
Hiſe weie he tok ſone bi nigt ; 1300
Ðe ðrid[d]e day he ſagt ðe ſtede
Ðe god him witen in herte dede ;
Ðan he cam dun to ðo duneſ fot,
Non of hiſ men forðere ne mot, 1304
But yſaac iſ dere childe,
He bar ðe wude wið herte mild,

and gives him the well of Beersheba.

[Fol. 25b.]

Abraham left the land much richer than he found it.

When Isaac was twenty-five years old,

God's word came to Abraham,—

"Take Isaac thy son,

and offer him on a hill that I shall show thee."

Moriah that hill was called.

Upon this hill was afterwards built Solomon's temple.

Abraham was obedient to God's commands.

[Fol. 26.] He came to the hill and sent his servants away.

Isaac bare the wood,

and Abraham the fire and the sword.

And abraham ðe fier and ðe fwerd bar ;

ðo wurð ðe child witter and war 1308

ðat ðor fal offrende ben don,

Oc ne wifte he quuat, ne quor-on ;

"Where," quoth Isaac, "is the offering that thou wilt make?"

" fader," quað he, " quar fal ben taken

ðe offrende ðat ðu wilt maken ? " 1312

Quoth Abraham, "God will provide the offering.

Quat abraham, " god fal bi-fen

Quor-of ðe ofrende fal ben ;

In a wonderful manner thou camest into the world, and so shalt thou depart hence.

Sellik ðu art on wer[l]de cumen,

Sellic ðu falt ben heðen numen ; 1316

Wið-uten long ðhrowing and figt,

God wile ðe taken of werlde nigt,

God requires thee as an offering."

And of ðe seluen holocaustum hauen,

ðanc it him ðat he it wulde crauen." 1320

Isaac was ready to be sacrificed.

Yfaac waf redi mildelike,

Quan ðat he it wifte witterlike.

Oc abraham it wulde wel

quat-fo god bad, ðwerted he it neuer a del; 1324

Isaac was placed upon the altar.

Yfaac waf leid ðat auter on,

So men fulden holocauft don ;

Abraham drew out his sword to slay his son, but an angel forbad him to harm the child. [Fol. 26b.]

And abraham ðat fwerd ut-drog,

And waf redi to flon him nuge,[1] [¹ read nog ?] 1328

Oc angel it him for-bed,

And barg ðe child fro ðe dead ;

ðo wurð abraham frigti fagen,

for yfaac bi-leaf un-flagen ; 1332

Bi-aften bak, af he nam kep,

A ram is offered instead of Isaac.

fafte in ðornes he fag a fep,

ðat an angel ðor-inne dede ;

It waf brent on yfaac ftede. 1336

Ere Abraham departed God swore to him that his seed should inherit the land.

And, or abraham ðeðen for,

God him ðor bi him-feluen fwor

ðat he fal michil hif kinde maken,

And ðat lond hem to honde taken ; 1340

Good felðhe fal him cumen on,

for he ðif dede wulde don.

He wente bliðe and fagen agen,

To berſabe he gunne teen, 1344 Abraham went home joyful and glad.

Sarra waſ fagen in kindes wune,

ðat [hire] [1] bileſ ðat dere ſune.

Dor quiles abraham wunede ðor, While at Beersheba he heard good tidings of Nahor.

Him cam good tiding of nachor, 1348

ðat melca bar him egte ſunen ;

Huſ waſ eldeſt, if we rigt munen. Huz was Nahor's first-born.

Rigt-wiſ iob cam of hiſ kin, Job came of his kin.

Hus lond he waſ riche wid-hin ; [2] [2 *read* wið-hin] 1352

Of [3] buz, hiſ broðeres kin, cam [3 MS. "Ob."] Of Buz came the Buzites, Eliv and Balaam.

Buzites, Eliv, Balaam.

Abraham, riche of welðe and wale, [Fol. 27.] Abraham went again to Mamre.

wente a-gen in to manbre dale ; 1356

Sarra ðo ſtarf, an hundred ger old Sarah died being 127 years old.

And ſeuene and .xx. winter told.

Abraham ſente eliezer Abraham sent Eliezer to Mesopotamia,

to lond meſopotanie fer, 1360

To caram ðor iſ fader lay,

(Or he cam ðor waſ manie day)

To ſechen yſaac hom a wif, to fetch a wife for Isaac.

Of hiſ kinde ðe ðor waſ in liſ. 1364

Ten kameles ſemeð [4] forð he nam, [4 *read* ſemede ?] Ten camels he took with him.

Wið michel ſwinc he ðider cam Eliezer came to a well without the city.

At a welle wið-uten ðe tun ;

ðor he leide hiſe ſemes dun, 1368

ðor he wulde him reſten and ben, He there prayed to God to send him good speed.

Sum good tiding heren or ſen.

" Louerd god," quað he mildelike, He offered his prayer in a good time.

" min erdne ðu forðe felðhelike, 1372

ðif dai me lene hire to ſen,

ðat ſal yſaaces leman ben."

He bad hiſe bede on good ſel. He offered his prayer in a good time.

Rebecca, bi-geten of batuel, 1376

[1] MS. hire is written over in the later hand.

Rebekah came to
that well,
Of nachor bi-geten, of melca boren,

Cam to ðat welle ðor him bi-foren,

and she gave him
and his camel
water to drink.
And him and ilc-on his kamel

Wið watres drinc ghe quemede wel. 1380

[Fol. 27b.]
Oðere maidenes wið hire cumen,

Ne wor nogt so forð ðeuwe numen.

Eliezer learned
that she was of
the family of
Nahor.
Eliezer lerede ðor

ðat batuel cam of nachor ; 1384

Of batuel ðis maiden cam

ghe was forð nifte of abraham ;

Thought he, this
maiden will I
have as a wife
for Isaac.
ðogte he, ðif maiden wile ic hauen

And to min louerdes bofte bi-crauen ; [1] 1388

for kindes luue he was hire hold,

He gave her ear-
rings and brace-
lets of gold.
Wið beges and ringes boðen of gold,

Afkede here if ghe migte taken

Herberge for hire frendes fake[n]. 1392

Maiden rebecca ðanne ran,

 And kiddit to hire broðer laban,

Laban came to
the well, invited
him home, and
entertained him
well.
And laban cam to ðat welle ner,

faiger welcumede he ðer eliezer, 1396

And[2] fond good grið and good hostel, [2 Anð MS.]

Him, and hise men, and hise kamel.

Eliezer would not
eat till he had
told his errand;
Eliezer, or he wulde eten,

Wulde he nogt hise erdene for-geten ; 1400

Al he tolde hem fro queðen he cam,

And for quat erdene he ðider nam ;

Tolde hem tiding of abraham,

Quilc selðe and welðhe him wel bi-cam, 1404

how he had been
sent by Abraham
to seek a wife for
Isaac.
Sent he was ðider, for kinde wune,

After a wif to ysaac hif sune.

[Fol. 28.]
seide he, " rebecca wile ic hauen,

To ysac-if bi-ofte wile ic crauen. 1408

Laban and the
mother were well
pleased with the
messenger.
Laban and hif moder wið-ðan

fagneden wel ðif sondere man ;

[1] *read* bi-ofte crauen ? r. l. 1408.

(Quan god haueð it ſo bi-ſen,
Alſe he ſendet, alſ it ſal ben.) 1412

Wið gold, and ſiluer, and wið frud,
ðiſ ſonde made ðe mayden prud ;

 With gold and silver and raiment Eliezer made the maiden proud.

ðe broðer and de[1] moder oc [¹ *read* ðe]
Riche gifteſ eliezer ðe[2] toc. [² *read* ðo?] 1416

 Gifts also he gave to the brother and mother.

Sone o-morwen he gan him garen,
And crauede hiſ erdene, and wolde hom faren,

 No longer than one night would he delay his errand.

for ſcrið, ne mede, ne wold he ðor
Ouer on nigt drechen nunmor ; 1420
And ðo gan ðat moder and laban
Rebecca freinen ðor for-ðan,

 Rebekah's consent was first asked and obtained.

And ghe it grantede mildelike,
And he hire bi-tagten bliðelike. 1424

Siðen men hauen holden ſkil,

 For this reason men ask the woman's will before she is given in marriage.

firſt to freinen ðe wimmaneſ wil,
Or or men hire to louerd giue,
for wedding or for morgen-giwe. 1428

Eliezer iſ went hiſ wei
And haueð hem boden godun dai.

 Eliezer takes his departure, wishing all a good day.

Or he wel homward cumen was,
Yſaac waſ cume to geraſis, 1432
And wunode ðor in ðogt and care,

 [Fol. 28b.] Isaac mourned for the death of his mother.

for moderes dead and fondeo fare.
In a weie an time he cam,
And to a welle, ſigande, he nam, 1436
ðohgteful he waſ on felde gon ;
Eliezer him cam a-gon,
Eððede hiſ ſorge, brogt him a wif

 Eliezer brought him a wife by whom he was comforted.

Of faiger waspene,[3] of clene liſ. 1440
He fagnede hire wið milde mod,
Here ſameni[n]g was clene and god ;
He luuede hire on-like and wel,

 Isaac loved Rebekah well, and she never contradicted him.

And ſge ne bi-ſpac him neuere a del. 1444

 ³ An error for wasteme.

Get men seyn¹ ðat abraham,
fiðen calde agar ceturam,

And ſge bar him fiðen ſex ſunen ;
Abraham dede hem fiðen ſundri wunen ; 1448
fer eſt fro cratonidé,
Weren he ſpred to ðe rede ſe.
Yſaac he let ål hiſ god,
for he waſ bi-geten of kinde blod. 1452

An hundred ger hold and ſeuenti
And .v. he waſ leid ſarram bi.
boðen yſaac and yſmael
Him bi-ſtoden wurlike and wel. 1456

On hundred ger and .xxxvij.
Liuede yſmael and waſ ðor bi.

Yſaac waſ hold .xl. ger
Quanne rebecca cam him ner ; 1460
Longe it waſ or ghe him child bar,

And he bad god, quanne he it wurð war,
ðat he ſulde fillen ðat quede
ðat he² abraham quilum dede. 1464

ðo wurð rebecca childre bere,
ðat ghe felte ful time in gere ;
At on burdene ghe under-stod
two ðe weren hire ſibbe blod ; 1468
Alſe ðhute hire day and nigt,

Alſe he wrogten and³ figt, [³ read an ?]
Queðer here ſulde birðen bi-foren.

Oc eſau waſ firmeſt boren, 1472
And iacob ſone after, ic wot,
for ðat he heldim bi ðe fot.

Sexti ger yſaac waſ old,
Quan ðiſ tidi[n]g him waſ told ; 1476
Ghe⁴ was abraham liues her, [⁴ read get]
After ðiſ, fiftene ger.

¹ seyn is at the side in a later hand.
² In a later hand at the side.

Wexen boden yſaac ſunes,
 And Ꝥhogen, and adden ſundri wunes ; 1480

Isaac's sons grew up and had different occupations.

Eſau wilde man huntere,
And Iacob tame man tiliere.

Esau was a hunter, and Jacob a husbandman.

Ꝥe fader luuede eſau wel,
for firme birꝺe & ſwete mel ; 1484

Isaac loved Esau for that he was the eldest.

Ꝥe moder, iacob for tamehed,
And for Ꝥe ali gaſteſ red.

*[Fol. 29b.]
Rebekah loved Jacob because of his peaceful disposition.*

Iacob An time him ſeꝺ a mete
Ꝥat man callen lentil gete, 1488

Jacob sod pottage.

And eſau fro felde cam,
Sag Ꝥis pulment, hunger him nam.

Esau came from the field hungry.

" Broꝺer iacob," quat eſau,
" Of Ꝥiſ warme mete Ꝥu gif me nu, 1492
for ic ham mattilike weri."

"Brother," said he, "give me of this warm meat, for I am weary."

Iacob wurꝺ war he waſ gredi ;
" Broꝺer," quad he, " ſel me Ꝥo wunes,
Ꝥe queꝺen ben Ꝥe ſirme ſunes, 1496
Ꝥat ic Ꝥin firme birꝺehe gete,
If ic Ꝥe fille wiꝺ Ꝥiſ mete."

Jacob said, "Sell me thy birthright, and I will fill thee with meat."

Quad eſau, " ful bliꝺelike,"
And gafe it him wel ſikerlike. 1500

Esau consented full blithely.

firme birꝺe waſ wurꝺi wune
Ꝥe fader dede Ꝥe firme ſune ;

The eldest son was highly honoured.

Ꝥe firme ſune at offrende ſel
Waſ wune ben ſcrid ſemelike and wel, 1504
And ſulde auen Ꝥe bliſcing

At his father's death he had the blessing.

Or or Ꝥe fader dede hiſ endinġ ;
And at heg tide and at geſtninġ,
Ꝥe gungere¹ ſune geuen Ꝥe bliſcing, 1508

And hauen mete Ꝥan at iſ mel,
More or Ꝥe gungere twinne del ;

At meat he had a double portion.

And quanne Ꝥe fader were grauen,
two doles of ereward riche auen. 1512

*[Fol. 30.]
His inheritance was twice as much as the younger's share.*

¹ An error for eldere.

A famine banish-
ed Isaac to Gerar.

An time dede hunger yſaac flen,
And he wulde to egipte then,[1] [1 *read* ten ?]
Oc god him ſente reed in wis
ꝺat he bi-lef in geraſis ; 1516

For his father's
sake he was
highly esteemed.

ꝺor he was for hiſ fadreſ luue[n]
Holden wurꝺelike a wel a-buuen.
An hundred ſo mikel wex hiſ tile,
So may god friꝺe ꝺor he wile. 1520

The folk of Gerar
envied Isaac, so
he left them and
went to Beer-
sheba.

Niꝺede ꝺat folk him fel wel
And deden him flitten hiſe oftel.
At berſabe he wunede beſt,
And ꝺor wurꝺ wiꝺ him trewꝺe feſt 1524

Abimelech made
a covenant with
Isaac.

Abimalech, and luue ſworen,
So he waſ or iſ fader bi-foren.
And helde gede on yſaac,

Isaac became old
and sightless.

Wurꝺede fightelſ and elde ſwac ;[2] 1528
He bad eſau, hiſ firme ſune,

He sends Esau
for venison,

fechin him ſode, aſ he waſ wune ;
If he toke him ꝺat he wulde eten,

and promises him
his blessing.

Hiſ ſeli bliſcing ſulde he bi-geten. 1532

Rebekah in-
structs Jacob
how to obtain
the blessing.

Ꝺor q*u*iles eſau ſogte and ran,
Rebecca iacob reden gan ;
Two kides he fette and brogtes hire,
And ghe knew wel ꝺe faderes kire,[3] 1536

[Fol. 30*b*.]

And made ſwiꝺe on ſele ꝺat mete,
ſwilc ghe wiſte he wulde eten ;

She made him
rough like Esau.

Sridde ghe iacob and made him ru
ꝺor he was bare(.) nu lik eſau ; 1540
And he ſeruede hiſ fader wel

Jacob obtained
the blessing from
his father.

Wiꝺ wines drinc and ſeles mel.
Yſaac wende it were eſau,
for he grapte him and fond hi*m* ru ; 1544
ꝺanne he wiſte him on gode ſel,
He him bliſcede holdelike and wel ;

2 *read* eldes wac 3 Glossed *wune* in later hand.

"Heuene dew, and erðeſ fetthed,

Of win and olie fulſum-hed," 1548

And bad him of hiſ kindes louerd ben,

In welðe and migt wurðinge ðen.

Wel bliðe and fagen was iacob ðo,

for bliſced he wente hiſ fader fro. 1552

Quan yſaac it under-nam

ðat eſau to late cam,

And ðat iſ broðer, af-ter boren,

Waſ kumen and hadde iſ bliſcing bi-foren, 1556

Wel ſelkuðlike he wurð for-dred ;

And in ðat dred hiſ ðogt waſ led

In to ligtneſſe for to ſen

Quow god wulde it fulde ben. 1560

ðo ſeide yſaac to eſau,

"ðin broðer iacob waſ her nu,

And toc ðin bliſcing liðer-like,

And he wurð bliſced witterlike." 1564

Quad eſau, "rigt iſ hiſ name

hoten iacob, to min un-frame ;

Or he min firme birðe toc,

Nu haued[1] he ſtolen min bliſcing oc; [¹ read haueð]

ðog, fader dere, bidde ic ðe,

ðat ſum bliſcing giſ ðu mo."

ðo gan eſau ðengen[2] and ſen [² read ðenken]

Quilc iſ bliſcing migte ben ; 1572

In heuene deu, and erðes ſmere,

Gatte him bliſcing ðat him waſ gere ;

for ydumea, ðat fulſum lond,

Of lewſe god, was in hiſe hond. 1576

Quad eſau, "grot ſal bi-cumen,

And wreche of iacob ſal binumen."

Oc rebecca wiſte ðat ðhogt,

ðat hate waſ in hiſe herte brogt, 1580

for-ði gho iacob warnen gan,

And ſente him to hiſ broðer laban ;

The dew of heuven, the fatness of the earth, plenty of corn and wine, and the lordship over his brethren.

When Isaac understood that Esau came too late he was seized with great fear.

In his dread he saw how God would that it should so be.

To Esau thus he spoke: "Thy brother was here just [Fol. 31.] now, and has taken thy blessing, and he shall be blessed."

Esau intreats for one blessing.

Isaac promises him that his dwelling shall be of the fatness of the earth and of the dew of heaven.

Idumea became Esau's inheritance.

Esau threatens Jacob.

Rebekah warns Jacob of his brother's intentions.

"be ðu ðer," quat ghe, "til efau

Eðe moðed [be], ðe wreðed nu, 1584

And ðu falt ðe betre fped,

If it beð bi ðin faderes red."

Quad rebecca to hire were,

"Efau wifuede uf to dere 1588

Quan he iufted & beð fo mat,

Toc of kin ðe canaan bi-gat,

For-ði he maked him ftið & ftrong,

For he beð mengt ðat kin among; 1592

If iacob toke her alfo a wif,

Ne bode ic no lengere werldef lif.

Yfaac bad iacob him garen,

And forð fwiðe to laban faren; 1596

Iacob liftenede ðo frendes red,

Fro berfabe he ferde wið fped;

Long weie he gan to-ward aram,

bi cananeam forð he nam, 1600

And wulde nogt ðat folc bi-twen

Herberged in here hufes ben.

He lay bi luzan ut on nigt,

A fton under hife heued rigt, 1604

And flep and fag, an foðe drem,

fro ðe erðe up til heuene bem,

A leddre ftonden, and ðor-on

Angeles dun-cumen and up-gon, 1608

And ðe louerd ðor uppe a-buuen

Lened[1] ðor-on; and [Jacob] wurð ut-fuuen,

Herde ðat he quad, "god ic am

ðe luued yfaac and abraham; 1612

And ðis lond ic fal giuen ðin fed,

And in ðis weige don ðe red;

And i fal bringen ðe a-gen,

And of ðin kinde blifced ðu falt ben." 1616

[1] *read* leued = remained?

Iacob abraid, & ſeide frigtilike :—

" God in ðis ſtede iſ wittirlike,

Her, dredful ſtede, her, godeſ hus,

Her, heuenegate amonguſ¹ us ; [¹ So in MS.] 1620

Louerd, if ic mote a-gen cumen,

Of ðis ſtede ic ſal in herte munen ; "

(Sette he up ðat ſton for muniging,

And get on olige for tok-ning) 1624

" He ſal euere min louerd ben,

ðat dede me her ðis figt[e] ſen,

Her ic ſal offrendes here don

And tigðes wel gelden her-up-on ; 1628

And wel ſal luz wurðed ben,

for ic gan her ðis figðhe ſen."

Iacob calde ðat ſtede betel ;

Quor-fore he it dede, he wiſte wel. 1632

Longe weie he fiðen ouer-cam,

And longe time or he ſag tharam.

Quane he cam ner, fond he ðor-on

A welle wel helid under a ſton, 1636

And ðre flockes of ſep dor-bi,² [² read ðor-bi]

ðat ðor abiden al for-ði ;

ðor waſ nogt wune on & on,

ðat orf ðor to water gon, 1640

Oc at ſet time he ſulden ſamen,

ðor hem-ſelf & here orf framen.

Iacob ðes hirdes freinen gan,

Hu fer iſt heðen to laban ; 1644

Wel he ſeiden and ſwiðe wel,

" loc ! her hiſ dogter rachel."

Sep he driuen ðiſ welle ner,

for ghe hem wulde wattre ðer. 1648

Iacob wið hire wente ðat ſton,

And let hire ſep to water gon ;

And kidde he was hire mouies ſune,

And kiſte hire aftre kindes wune ; 1652

Jacob awoke. "Surely," he said, " here is God's house.

If I may come again to my father's house,

the lord shall be my God,

here I shall brake offerings, and yield tithes."

Jacob called the place Bethel.

Jacob pursues his journey.

He finds a well at Haran ; three flocks of sheep were lying by it.

The cattle did not go to water one by one, but were all collected together at one time.

[Fol. 32b.]

Jacob asks the herdsmen the way to Laban's house.

They answered, " Here is Rachel his daughter." She came to bring the sheep to the well.

Jacob rolled the stone from the well's mouth.

He made known his relationship to Rachel.

Rachel was bliðe and forð ghe nam,
And kiddit to hire fader laban.

Laban welcomes his nephew and brings him to his house.
Laban fagnede him in frendes wune,
feren fwunken yfaaces funen. 1656
Iacob tolde him for quat he fwanc
So fer, and laban herte ranc ;
He cuðe him ðer-of wel gret ðhanc,

He entertains him well.
And dede him eten and to him dranc, 1660
And feide to him, " bi min blod,
ðin come if me leflike and good."

Jacob abode with Laban for one month,
Laban bi-tagte him, fiðen to fen,
Hif hirdeneffe ðat it wel ben. 1664

after which time Laban said to him,
And quanne a moneð was ouer-meten,
" Iacob," wað he, " quat wiltu bi-geten ?

[Fol. 33.] " Tell me what shall thy wages be."
Quat-fo [2][ðu] wilt for hire crauen,
Afke it wið fkil and ðu falt hauen." 1668

Jacob covenanted for Rachel.
Quat iacob, " ic fal, for rachel,
Seruen ðe feuene winter wel."
Luue wel michil it agte a wold,
Swilc feruife and fo longe told. 1672

Seven years passed away and Laban made a feast.
forð geden feuene ger bi tale,
And laban made him hif bridale ;

When even came Jacob was deceived with Leah.
Iacob wurð drunken, and euen cam,
Laban bi nigt tog him liam ; 1676
And a maiden waf hire bi-tagt,
Zelfa bi name, ðat ilke nagt.
Iacob gan hire under-fon,

Laban says that it was not the custom to marry the younger before the firstborn.
O morgen ðugte it him mif-don. 1680
Quat laban, " long wune if her driuen,
firmeft on elde, firft ben giuen :
And loð me waf fenden rachel
So fer, for ic luuede her wel ; 1684

Jacob agrees to serve other seven years for Rachel.
Oc ferf me feuene oðer ger,
If ðu falt rachel feruen her ;

[2] At bottom of Fol. 32b is the catchword—" quat fo ðu wilt."

Seue nigt fiðen forð ben numen
Or rachel beð to iacob cumen, 1688
And laban made a fefte oc
Quanne iacob wid[1] rachel toc ; [1 wið ?] Jacob marries Rachel.
And for ghe ðanne cam him ner,
feruede he him fiðen feuene ger. 1692
Rachel adde, after londes kire,[2] [Fol. 33b.]
maiden balaam to feruen hire.

L Ia moder of fowre was, Leah was the mother of four
 Ruben, fymeon, leui, iudas ; 1696 sons.
for rachel non birðe ne nam, Rachel was barren.
Sge[3] bi-tagte iacob balaam ; [3 she ?]
bala two childre bar bi him, Bilhah, her hand-maid, bare Dan
Rachel cald es[4] dan(.) neptalim ; [4 caldes MS.] 1700 and Naphtali.
And zelfa two funes him ber, Zilpah bare Gad and Asher.
Lia calde if(.) Gad(.) and affer ;
Lia fiðen two funes bar, Leah afterwards bare Zebulun,
Zabulon(.) laft(.) or yfakar ; 1704 Issachar, and Dinah.
Lia bar laft dowter dinam,
Sichem, fiðen, hire ille bi-nam.
Last of rachel iosep was boren, At last Joseph was born of
Beft of alle ðe oðere bi-foren. 1708 Rachel.

I onge haued[5] nu iacob bon her, [5 haueð ?]
 wið laban fulle .xiii. ger ,
Leue afkede hem hom to faren, Jacob desires
Wið wiues and childre ðeðen charen, 1712 leave of Laban to depart.
But-if laban him ðelde bet Laban would not let him depart.
Hife feruife, and wið-holde him get ;
ferue he fcriðed ðat .vij. ger,
ðat he bi-leue and ferue him her ; 1716
Wel he feið him ðat he fal hauen He promises him to give him for
for hire, quat-fo he wile crauen. hire whatever he shall ask.
forward if mad of alle fep, [Fol. 34.]
Of onef bles[6] iacob nim kep, [6 fles MS.] 1720
And if of ðo fpotted cumen, Jacob is to have all the speckled

[2] Glossed *wune* in a later hand.

GENESIS. 4

and spotted cattle for his hire.	Ðo fulen him ben for hire numen ;
	Sep or got, hafwed, arled, or grei,
	Ben don fro iacob fer a-wei ; 1724
The flocks produced many speckled and spotted.	Ðog him boren ðes onef bles
	Vn-like manige and likeles.
Laban was greatly displeased.	Ðo fag laban ðat iacob bi-gat
	Michil, and him miflikede ðat ; 1728
He changed Jacob's hire.	bi-tagte him ðo ðe funder bles,
	And it him boren ones bles.
Ten times within six.years he shifted the cattle.	Ten fiðes ðus binnen .vi. ger,
	Shiftede iacob hirdeneffe her, 1732
	And ai was labanef herte for,
	for hif agte wex mor & mor.
Jacob saw that Laban was un-friendly towards him,	Ðo fag iacob laban wurð wroð,
	Vnder him ben leng if him loð, 1736
so he determined to leave Padan-aram.	And wið if wiues he takeð red,
	And greiðet him deðenward¹ wið fped.
Laban had left Haran to shear his sheep.	Laban ferde to nimen kep,
	In clipping time to hife fep, 1740
	fro caram in-to vten ftede,
	Ðor quiles iacob ðif dede dede ;
	Wið wiues, and childre, & orf he nam,
Jacob came to mount Gilead, [Fol. 34b.]	And to ðe munt galaad he bi-cam ; 1744
and drew towards Canaan.	Ðanne fleg he to mefopotaniam,
	And drog to-ward cananeam.
Rachel had stolen her father's gods.	And Rachel adde hid and for-olen
	Hire faderes godes of gold, & ftolen. 1748
	Laban it wifte on ðe ðridde dai
Laban, hearing of Jacob's flight, pursues him.	Ðat iacob waf ðus flogen a-wei ;
	He toc, and wente, and folwede on,
	And ðhogt in mod iacob to flon, 1752
God, in a dream, forbids Laban to harm Jacob.	Oc god in fweuene fpac him to,
	Ðat he fulde iacob non yuel do.
Laban overtakes Jacob on the seventh day.	vij. nigt forð-geden and dais oe,
	Or laban iacob ouer-toc ; 1756

¹ ðeðenward?

So waſ he frig[t]ed ear in drem,

ðus meðelike ſpac ðiſ em :

"Qꭒi wore ðu fro me for-holen,

And qꭒi aſ ðu min godeſ ſtolen? 1760

Min mog, min neue, and felage,

Me ne agteſ ðu don ſwilc [vn-]lage."

"[I]c was for-dred ðe migte timen,

fro me ðine doutres bi-nimen, 1764

fro here childre ðhogt hem for,

mor for me bi-leuen ðor ;

ſtalðe ic for-ſake, ðat iſ min red,

wið qꭒam ðu iſ findes, ðat he be dead." 1768

Of al ðat laban haued¹ iſ ſogt, [¹ haueð ?]

So woren it hid, ne fond he is nogt.

Ðo [q]wáð iacob, "yuel iſt bi-togen, [Fol. 35.]

Min ſwinc a-buten ðin holðe drogen ; 1772

ðu me ranſakes alſ an ðef,

And me was ðin wurðing lef."

ðo qꭒat laban, "frend ſule wit ben,

And trewðe pligt² nu unc bi-twen, [² wligt MS.] 1776

And make we it her an hil oſ ſton,

Name of witneſſe be ðer-on ;"

ðor-on he eten bliðe and glað,³ [³ glad ?]

ðat hil iſ hoten galaað ; 1780

Laban hem bliſcede, & on nigt

wente a-gen-ward, or it waſ ligt ;

And iacob waſ of weie rad,

Raðe he was fer fro laban ſad. 1784

Alſ he cam ner cananeam,

Engel wirð a-gen him cam,

Als it were wopnede here,

Redi to ſilden him fro were ; 1788

ðat ſtede he calde manaim,

ðor ðis wird of engeles metten him.

ðor he bi-lef, and ſente ðeden⁴ [⁴ ðeðen ?]

Sondere men to freinen and queðen 1792

If eſau wulde him ogt deren,

Ðog wiſte wel god ſulde him weren ;

Ðor him cam bode him for to ſen,

Ðat eſau him cam a-gen ; 1796

And iacob ſente fer bi-foren
him riche loac, and fundri boren,

And iordan he dede ouer waden,

Orf & men, wiÐ welÐe laden ; 1800

And he bi-lef Ðor on Ðe nigt

to bidden helpe of godeſ migt.

And Ðor wreſtelede an engel wiÐ,
Senwe ſprungen fro Ðe liÐ ; 1804

(wulde he non ſenwe fiÐen eten,

Self his kinde nile Ðat wune forgeten.)

Get held he wiÐ Ðis angel faſt,

Til Ðe daning up eſten it braſt ; 1808

Ðo ſeide Ðe engel, " let me get ben,

Ðe daining her nu men mai ſen."

Quad iacob, " Ðe ne leate ic nogt,

Til Ðin bliſcing on me beÐ wrogt." 1812

Ðo quad Ðe angel, " ſal tu nummor
ben cald iacob, ſo Ðu wore or,

Oc Ðu ſal ben hoten iſrael,

for Ðu Ðe weries ſwiÐe wel ; 1816

Quan Ðe Ðe migt wiÐ angel weren,

Hu ſal ani man Ðe mugen deren ?

Ear iacob and nu iſrael."

Ðat ſte[de] was cald phanuel, 1820

for he nam ouer phanuel ;

And it wurÐ ligt and he ſag wel

Quor eſau a-gen him cam,

And bi-foren a-gen him nam ; 1824

And feue fiÐes he fell him bi-foren,

And wurÐe him ſo firmeſt boren ;

And eſau Ðo ran him to,

And kiſſede, and wept, Ðo rew Lim ſo. 1828

" Broðer," quad he, " ðu and ðin trume
ben here in ðif place to me welcume ; Esau welcomes Jacob,
Haue and bruc wel al ðin prefent,
ðat ðu to me bringeft and haueft fent." 1832
Iacob was wo ðat he if for-foc,
And feroð him fo(.) ðat fum he ðor tok. accepts his present,
Here luue ðo wurð hol and fchir,
And efau ferde forð ðeden[1] to feyr ; [¹ ðeðen ?] 1836 and departs unto Seir.
ðat newe burg waf him to frame,
Mad and cald of if owen name.
Iacob fro ðeðen wente, ic wot, From thence Jacob went to Succoth,
tgelt on a ftede, and cald it[2] fochot ; [² caldit MS.] 1840
fro fochot fiðen to fichem,
And wune ðor-inne falem, and afterwards to Shalem,
ðor him folde an lond kinge emor, where he bought a piece of land
And he drog ðider and wunede ðor ; 1844 from Hamor.
wið newe alter wurðed he wel
ðe ftrong god of yfrael.

Hif dowter dina ðor mif-dede, Here his daughter Dinah "misdid."
 ghe nam leueles fro ðat ftede, 1848
To fen de werld ðhugte hire god, [Fol. 36b.] She went out to see the world.
ðat made hire fiðen feri-mod,
for-liftede hire owen red ;
Sichem tok hire maiden-hed ; 1852 Shechem took her maidenhead.
Emor his fader, fiðen for-ði,
And hif burge-folc fellen in wi ;
Symeon and leui it bi-fpeken, Simeon and Levi slew the Shechemites and
And hauen here fifter ðor i-wreken ; 1856 spoiled the city.
folc of falem ðor-fore waf flagen,
wiwes, and childre, and agte up-dragen ;
Oc iacob ne wifte it nogt,
Til ðat wreche to bale was wrogt, 1860 Jacob reproved Simeon and Levi
Oc michil he frigtede for-ði, for their cruelty.
boðen fymeon and leui.

Henden fichem ne durften he wunen, They durft not dwell longer at
 ðat folkes kin god bad him funon, 1861 Shechem, but went to Bethel.

And ðeden[1] faren to betel, [1 ðeðen ?]
And he folgede if red on fel ;

Their unclean goods they bore not with them.
Agte unclene ne wulde he beren,
for he dredde him it fulde him deren ; 1868
Godes ðat rachel hadde ftolen,
And ay til ðan wið him for-holen,

Their idols and gold rings they buried under an oak.
And oðre ydeles brogt fro fichem,
Gol prenes and ringef wið hem, 1872
Diep he if dalf under an ooc,
Made him non gifcing in herte wooc.

[Fol. 37.]
Long they remained buried, until Solomon found them and decked his temple with them.
Longe it weren ðor for-hid ;
Men feið for-ði waf fo bi-tid, 1876
for falamon findin if fal,
And hif temple friðen wið-al.

Iacob wente fro ðeden[2] in fped, [2 ðeðen ?]
God sent a fear upon the folk round about, so they did no hurt to the sons of Jacob.
God fente on ðat erdfolc fwilc dred, 1880
ðan[3] here non iacob fcaðe ne dede ; [3 ðat ?]
Quane he wente a-wei fro ðat ftede,
Jacob makes an altar at Bethel.
He made an alter at betel,
Alf he god bi-het, ðor he geld wel. 1884

Benjamin is born.
Siðen ðo beniamin was boren,
Rachel dies.
Rachel adde ðe life for-loren ;
Iacob dalf hire and merke dede,
ðat if get fene on ðat ftede. 1888

At Edar Reuben "misdid" and lay with his father's concubine.
Jacob arrives at Hebron, and finds his mother gone from this world.
Dor quiles he wunede at tur ader,
 Ruben mifdede wid[4] bala ðer. [4 wið ?]
Siðen cam iacob to ebron,
And fond his moder of werlde gon ; 1892
Starf ysaac quan he waf hold
Isaac dies at the age of nine score years.
.ix. fcore ger and fiue told,
And was doluen on ðat ftede,
ðor man adam and eue dede. 1896
So riche were growen hife funen,
ðat he ne migte to-gider wunen ;
Esau dwells in Edom,
Oc efau, feyr [and] edon
Lond ydumeam wunede on ; 1900

Of edon ſo it higte ða,

for it was hoten ear bozra.

Hear haued[1] moyſes ouer-gon,

　ðor-fore he wended eft a-gon.　　1904

xii. ger or yſaac waſ dead

Iacobes ſunes deden un-red ;

FOr ſextene ger ioſeph was old,

　Quane he was in-to egipte ſold ;　　1908

He was iacobes gunkeſte ſune,

Bricteſt of waſpene,[2] and of witter wune,

If he ſag hiſe breðere miſ-faren,

Hiſ fader he it gan vn-hillen & baren ;　　1912

He wulde ðat he ſulde hem ten

ðat he wel-ðewed ſulde ben ;

for-ði wexem[3] wið gret nið

And hate, for it in ille [herte] lið.　　1916

ðo wex her hertes niðful & bold

Quanne he hem adde iſ dremeſ told,

ðat hiſ handful ſtod rigt up foren,

And here it leigen alle hem bi-foren ;　　1920

And ſunne, & mone, & ſterres .xi°.[4]

wurðeden him wið frigti luue ;

ðo ſeide hiſ fader, "hu mai ðis ſen

ðat ðu ſalt ðuſ wurðed ben,　　1924

ðat ðine breðere, and ic, and ſhe

ðat ðe bar, ſulen luten ðe ?"

ðuſ he chidden hem bi-twen,

ðoge ðhogte iacob ſiðe it ſulde ben.　　1928

Hiſe breðere kepten at ſichem

Hirdneſſe, & iacob to ſen hem

ſente ioſeph to dalen ebron ;

And he was redi his wil to don.　　1932

In ſichem feld ne fonde hem nogt,

In dotayin he fond hem ſogt ;

He knewen him fro feren kumen,

　　[Fol. 37b.]

which was before
called Bozra.

[¹ haueð ?]

Jacob's sons did
wickedly.

Joseph was six-
teen when sold
into Egypt.

Joseph informed
his father of his
brethren's mis-
deeds.

His brethren en-
vied him on ac-
count of his
dreams.

The vision of the
sun, moon, and
eleven stars.

Jacob reproached
his son, yet he
believed it should
be so.

　　[Fol. 38.]

The sons of
Jacob kept flocks
at Shechem.

Joseph was sent
to see how they
fared.

His brethren
knew him from
afar,

² wasteme ?　　³ So in MS.　　⁴ For endluue ?

Hate hem on ros, in herte numen; 1936

Swilc niꝥ & hate rof hem on,

and took counsel
to slay him. He redden alle him for to flon.

"Nai," quad ruben, "flo we him nogt,

Reuben advised
them to throw
Joseph into an
old and deep pit. Oꝥer finne may ben wrogt, 1940

Quat-fo him drempte ꝥor quiles he flep,

In ꝥif ꝥifterneffe,¹ old and dep,

Get wurꝥe² worpen naked and cold,

Quat-fo hif dremef owen a-wold." 1944

ꝥif dede waf don wid³ herte for,

Reuben left his
brethren to seek
better pasture for
his cattle. Ne wulde ruben nogt drechen ꝥor;

He gede and fogte an oꝥer ftede,

Hif erue in bettre lewfe he dede; 1948

Judah gave them
bad advice, Vdas dor⁴ quiles gaf hem red,

ꝥat was fulfilt of derne fped;

fro galaad men wiꝥ chafare

Sag he ꝥor kumen wid fpices ware; 1952

[Fol. 38b.] To-warde egipte he gunne ten.

Iudas tagte hu it fulde ben,

and Joseph was
sold for thirty
pieces of silver. Ioseph folde ꝥe breꝥere ten,

for .xxx. plates to ꝥe chapmen; 1956

Get waft bettre he ꝥuf waf fold,

dan⁵ he ꝥor ftorue in here wold.

Reuben came
thither again and
found Joseph
gone. Ðan ruben cam ꝥider a-gen,

to ꝥat cifterneffe⁶ he ran to fen; 1960

He miffed Ioseph and ꝥhogte fwem,

Great was his
outcry, which
did not cease
until he was
assured that
Joseph lived. wende him flagen, fet up an rem;

Nile he blinnen, fwilc forwe he cliued,

Til him he fweren ꝥat he liued. 1964

ꝥo nomen he ꝥe childes frud,

ꝥe iacob hadde mad im⁷ in prud;

Joseph's coat was
dipt in kid's
blood, In kides blod he wenten it,

ꝥo waf ꝥor-on an rewli lit. 1968

Sondere men he it leiden on,

¹ cisterneffe? ² he is inserted in the later hand. ³ wiꝥ?
⁴ ꝥor? ⁵ ꝥan? ⁶ MS. cifterneffe. ⁷ madim in MS.

And ſenten it iacob in-to ebron,

And ſhewed it him, and boden him ſen

If hiſ childes wede it migte ben ; 1972

Senten him bode he funden it.

Ꝺo iacob ſag dat[1] ſori writ, [1 Ꝺat ?]

He gret, and ſeide Ꝺat "wilde der

Hauen min ſune ſwolgen her." 1976

Hiſ cloꝺes rent, in haigre frid,

Long grot and ſorge is him bi-tid.

His ſunes comen him to ſen,

And hertedin him if it migte ben ; 1980

"Nai ! nai !" quat he, "helped it nogt,

Mai non herting on me ben wrogt ;

ic ſal ligten til helle dale,

And groten Ꝺor min ſunes bale." 1984

(Ꝺor was in helle a ſundri ſtede,

wor Ꝺe ſeli folc reſte dede ;

Ꝺor he ſtunden til helpe cam,

Til iheſu crist fro Ꝺeden[2] he nam.) [2 Ꝺeꝺen ?] 1988

Ꝺe chapmen ſkiuden here fare,

In-to egipte ledden Ꝺat ware ;

wiꝺ putifar Ꝺe kinges ſtiward,

He maden ſwiꝺe bigetel forward, 1992

So michel ſe Ꝺor iſ hem told,

He hauen him bogt, he hauen ſold.

Putifar waſ wol riche man,

And he bogte ioſeph al forꝺan 1996

He wulde don iſ lechur-hed

wiꝺ ioſeph, for hiſe faire-hed,

Oc he wurꝺ Ꝺo ſo kinde cold,

To don ſwilc dede adde he no wold ; 2000

ſwilc ſelꝺe cam him fro a-buuen,

God dede it al for ioſeph luue[n].

Biſſop in eliopoli[3]

Men ſeiꝺ he was ſiꝺen for-ꝺi, 2004

[3 In [H]Eliopolis ; the words are run together.]

Marginal glosses:

and sent to Jacob at Hebron.

"Evil beasts," said Jacob, "have swallowed my son."

Long was his lamentation and sorrow.

[Fol. 39.]

Jacob would not be comforted for the loss of Joseph.

In hell was a separate abode where the righteous rested,

till Christ took them from thence.

The merchants took their ware to Egypt.

Potiphar bought Joseph.

He entertained impure desires towards him,

but Joseph was strengthened from above.

[Fol. 39*b*.] Ꝺog had he Ꝺo wif(.) and bi-foren
Childre of him bi-geten and of hire boren,
Oc after Ꝺis it fo bi-cam,
Ioseph if dowter to wiue nam. 2008

Potiphar loved Joseph well.

Putifar luuede iofeph wel,
 bi-tagte him hif huf euerilc del,
And he wurꝺede riche man an heg,

His wealth prospered under Joseph's care.

vnder iofeph hif welꝺe Ꝺeg. 2012

His wife sought to lead Joseph astray.

Hif wif wurꝺ wilde, and nam in Ꝺogt
vn-rigt-wif luue, and fwanc for nogt,
One and ftille Ꝺogt hire gamen
wiꝺ iofeph fpeken and plaigen famen ; 2016

For gold nor for wealth of any kind would he "forget his chastity."

Ghe bed him gold, and agte, and fe,
To maken him riche man and fre,
wiꝺ-Ꝺhan Ꝺat he wiꝺ here wile ;
Oc him mislikede Ꝺat ghe wile ; 2020
for fcriꝺ, ne Ꝺret, ne mai ghe bi-geten
for to don him chafthed for-geten ;

Neither threats nor intreaties prevailed.

Often ghe Ꝺrette, often ghe fcroꝺ,
Oc al it was him o-like loꝺ. 2024
An time he was at hire tgeld,
Ꝺo ghe him his mentel for-held ;

Wherefore she sought to be revenged upon Joseph.

for he wiꝺ hire ne wulde fpeken,
Ghe Ꝺhenkeꝺ on him for to ben wreken ; 2028
Sone ghe mai hire louerd[1] fen, [1 MS. loruerd.]
Ghe god him bitterlike a-gen,

[Fol. 40.]
She accused him falsely to Potiphar,

And feiꝺ iofeph hire wulde don,
Ꝺat ghe ne migte him bringen on ; 2032
" Ꝺif mentel ic wiꝺ-held for-Ꝺi,
To tawnen [Ꝺe] Ꝺe foꝺe her-bi."
Ꝺe wite if hife(.) Ꝺe right if hire,
God al-migtin Ꝺe foꝺe fhire. 2036

who, believing his wife's tale,

Pvtifar trewiꝺ hife wiwes tale,
 And haued[2] dempt iofep to bale ; [2 ? haueꝺ.]
He bad [him] ben fperd faft dun,

threw Joseph into prison.

And holden harde in prifun. 2040

An litel ſtund, quile he waſ ðer,

So gan him luuen ðe priſuner,

And him de¹ chartre haueð bi-tagt, [¹ ðe ?]

wið ðo priſunes to liuen in hagt. 2044

Or for miſdede, or for on-ſagen,

ðor woren to ðat priſun dragen,

On ðat ðe kingeſ kuppe bed,

And on ðe made ðe kingeſ bred ; 2048

Hem drempte dremcs boðen onigt,

And he wurðen ſwiðe ſore o-frigt ;

Ioſeph hem ſeruede ðor on ſel,

At here drink and at here mel, 2052

He herde hem murnen(.) he hem freinde for-quat ;

Harde dremcs ogen awold ðat.

ðo ſeide he to ðe butuler,

"Tel me ðin drem, mi broðer her. 2056

Queðer-ſo it wurðe ſofte or ſtrong,

ðe reching wurð on god bi-long."

"Me drempte, ic ſtod at a win-tre,

ðat adde waxen buges ðre, 2060

Oreſt it blomede, and fiðen bar

ðe beries ripe wurð ic war ;

ðe kinges [kuppe] ic hadde on hond,

ðe beries ðor-inne me ðhugte ic wrong, 2064

And bar it drinken to pharaon,

Me drempte, alſ ic waſ wune to don."

"Good is," quað Ioſeph, "to dremen of win,

heilneſſe an bliſſe if ðer-in ; 2068

ðre daies ben get for to cumen,

ðu ſalt ben ut of priſun numen,

And on ðin offiz ſet agen ;

Of me ðu ðhenke ðan it ſal ben, 2072

Bed min herdne to pharaon,

ða[t] ic ut of priſun wurðe don,

for ic am ſtolen of kinde lond,

and her wrigteleſlike holden in bond." 2076

The gaoler loved Joseph.

In this prison, either for misdeed or bad words,

were placed the chief butler and baker.

Both dreamt dreams in one night,

which caused them to become very sorrowful.

Joseph inquired the reason of their grief.

[Fol. 40b.]

The butler's dream.

A vine with three branches

bore grapes ;

the juice the butler squeezed into Pharaoh's cup, and gave him to drink as he was wont.

"Good it is," said Joseph, "to dream of wine.

In three days thou shalt be restored to thy office,

then think of me and bear my errand to Pharaoh,

for I am here wrongfully held in prison."

The "bread-
wright's" dream.

Quað ðis bred-wrigte, "liðeð nu me,
 me drempte ic bar bread-lepes ðre,
And ðor-in bread and oðer meten,
Quilke ben wune ðe kinges to eten ; 2080

Fowls seized on
the baskets of
bread intended
for the king,

And fugeles hauen ðor-on lagt,
ðor-fore ic am in forge and hagt,

[Fol. 41.]

for ic ne migte me nogt weren,

and he could not
keep the meat
from them.

Ne ðat mete fro hem beren." 2084

"Me wore leuere," quad Iofeph,
 "Of eddi dremes rechen fwep ;

"In three days,"
said Joseph,
"thou shalt be
hanged, and
fowls shall tear
thy flesh in
pieces."

ðu falt, after ðe ðridde dei,
ben do on rode, weila-wei ! 2088
And fugeles fulen ði fleis to-teren,
ðat fal non agte mugen ðe weren."
Soð wurð fo iofeph feide ðat,

The butler soon
forgat Joseph.

ðis buteler Iofeph fone for-gat. 2092

After two years,

Two ger fiðen was Iofeph fperd
ðor in prifun wið-uten erd ;

Pharaoh dreamt
a dream.
He stood by the
river, and there
came seven
"neat" fat and
great, and seven
lean after,

Do drempte pharaon king a drem,
 ðat he ftod bi ðe flodes ftrem, 2096
And ðeden[1] ut-comen .vii. neet, [1 ðeðen?]
Euerilc wel fwiðe fet and gret,
And .vii. lene after ðo,
ðe deden ðe .vii. fette wo, 2100

which ate up the
fat ones.

ðe lene hauen ðe fette freten ;
ðif drem ne mai ðe king for-geten.
An oðer drem cam him bi-foren,

Seven full ears of
corn sprang up
"on a rank
bush," and then
came seven
withered ears,

.vii. eares wexen fette of coren, 2104
On an busk ranc and wel tidi,
And .vii. lene rigt ðor-bi,
welkede, and fmale, and drugte numen,
ðe ranc he hauen ðo ouer-cumen, 2108

[Fol. 41b.]
which smote the
others to the
ground.

To-famen it fmiten and, on a ftund,
ðe fette ðrift hem to ðo grund.
ðe king abraid and woc in ðhogt,
ðei dremes fwep ne wot he nogt, 2112

Ne was non ſo wis man in al hiſ lond,

Ðe kude vn-don ðis dremes bond ;

Ðo him bi-ðhogte ðat buteler

Of ðat him drempte in priſun ðer, 2116

And of ioſeph in ðe priſun,

And he it tolde ðe king pharaun.

Ioſeph waſ ſone in priſun ðo hogt,

And ſhauen, & clad, & to him brogt ; 2120

Ðe king him bad ben hardi & bold,

If he can rechen ðis dremeſ wold ;

He told him quat him drempte o nigt,

And ioſep rechede his drem wel rigt. 2124

" Ðis two dremes boðen ben on,

God wile ðe tawnen, king pharaon ;

Ðo .vij. ger ben get to cumen,

In al fulſum-hed ſulen it ben numen, 2128

And .vij. oðere ſulen after ben,

Sori and nedful men ſulen iſ ſen ;

Al ðat ðiſe firſt .vii. maken,

Sulen ðiſ oðere vii. roſpen & raken ; 2132

Ic rede ðe king, nu her bi-ſoren,

To maken laðes and gaderen coren,

Ðat ðin folc ne wurð vnder-numen,

Quan ðo hungri gere ben forð-cumen." 2136

King pharaon liftnede hiſe red,

Ðat wurð him ſiðen ſeli ſped.

He bi-tagte ioſep hiſ ring,

And his bege of gold for wurðing, 2140

And bad him al hiſ lond bi-ſen,

And under him hegeſt for to ben,

And bad him welden in hiſ hond

His folc, and agte, & al his lond ; 2144

Ðo waſ vnder him ðanne putifar,

And hiſ wif ðat hem ſo to-bar.

Ioſep to wiue his dowter nam,

Oðer is nu quan ear bi-cam ; 2148

Marginal notes:

None were found able to interpret the dreams.

The butler bethought him of Joseph.

Joseph is taken from prison,

and brought before Pharaoh,

who related to him his dreams.

" The two dreams," answered Joseph, " are one."

" Seven years of plenty

shall be followed by seven years of famine.

I advise thee to make barns and store up corn, that thy folk perish not." [Fol. 42.]

Pharaoh gave Joseph his ring,

and bad him rule the whole land.

Then were Potiphar and his wife under him.

And ghe ðer him two childer bar,

Before the famine came two sons were born to Joseph.

Or men wurð of ðat hunger war,

first manaſſen and effraym ;

He luueden god, he geld it hem. 2152

The years of plenty pass away.

Ðe .vii. fulſum geres faren,

Ioſep cuðe him bi-foren waren ;

ðan coren wantede in oðer lond,

ðo ynug [was] vnder his hond. 2156

The famine was felt in Canaan.

Hvnger wex in lond chanaan,
 And his .x. ſunes iacob for-ðan

Jacob sent his ten sons to Egypt to buy corn.

Sente in-to egipt to bringen coren ;

He bilef at hom ðe was gungeſt boren. 2160

[Fol. 42b.]

Ðe .x. comen, for nede ſogt,

To Ioſep, and he ne knewen him nogt,

Though they honoured Joseph,

And ðog he lutten him frigtilike,

Anð ſeiden to him mildelike, 2164

" We ben fondes for nede driuen

To bigen coren ðor-bi to liuen."

yet he pretended not to know them.

(Ioſep hem knew al in his ðhogt,

Alf he let he knew hem nogt.) 2168

" It ſemet wel ðat ge ſpies ben,

He accused them of being spies.

And in-to ðif lond cumen to ſen,

And cume ge for non oðer ðing,

but for to ſpien ur lord ðe king." 2172

" Nai," he ſeiden euerilc on,

They declared that they were true men, the sons of one father.

" Spies were we neuer non,

Oc alle we ben on faderes ſunen,

For hunger doð es[1] hider cumen." [1 doðes MS.] 2176

" Oc nu ic wot ge ſpieſ ben,

for bi gure bering men mai it ſen ;

"Only kings," said Joseph, "had so many sons."

Hu fulde oni man[2] poure for-geten,

fwilke and ſo manige ſunes bigeten ? 2180

for feldum bi-tid ſelf ani king

fwilc men to ſen of hiſe offpring."

2 MS. Hu suld sulde oninan.

"A louerd, merci! get if ðor on
 migt he nogt fro his fader gon ; 2184
He if gungeft, hoten beniamin,
for we ben alle of ebriffe kin."

"Nu, bi ðe feið ic og to king pharaon,
fule ge nogt alle eðen gon, 2188
Til ge me bringen beniamin,
ða gungefte broðer of porc¹ kin." [¹ gure ?]

For ðo waf Iofep fore for-dred
ðat he wore oc ðhurg hem for-red ; 2192
He dede hem binden, and leden dun,
And fperen fafte in his prifun ;
ðe ðridde dai he let hem gon,
Al but ðe ton broðer fymeon ; 2196
ðif fymeon bi-lef ðor in bond,
To wedde under Iofepes hond.

ðes oðere breðere, fone on-on,
Token leue and wenten hom ; 2200
And fone he weren ðeden² went, [² ðeðen ?]
Wel fore he hauen hem bi-ment,
And feiden hem ðan ðor bi-twen,
"Wrigtful we in forwe ben, 2204
for we finigeden quilum or
On hure broðer michil mor,
for we werneden him merci,
Nu drege we forge al for-ði." 2208
Wende here non it on hif mod,
Oc Iofep al it under-ftod.

Iofepes men ðor quiles deden
 Al-fo Iofep hem adde beden ; 2212
ðo breðere feckes hauen he filt,
And in euerilc ðe filuer pilt
ðat ðor was paid for ðe coren,
And bunden ðe muðes ðor bi-foren ; 2216
Oc ðe breðere ne wiften it nogt
Hu ðis dede wurðe wrogt ;

Side notes:
"One," the brethren said, "is at home with his father."

[Fol. 43.]
Quoth Joseph, "Ye shall not all go hence, until ye bring me Benjamin."

He kept them in prison, and on the third day let them all go except Simeon.

The others bemoaned their ill-luck.

They thought of their sin towards Joseph.

Joseph's men did, meanwhile, as they were commanded,

[Fol. 43b.]
and filled the brothers' sacks, and placed in them the money paid for the corn.

Unopened they brought them to Jacob and told him how they had sped.

Oc alle he weren ou*er*-ðogt,

And hauen it fo to iacob brogt, 2220

And tolden him fo of here fped,

And al he it liftnede i*n* frigtihed ;

Great was their fear when they saw the money in the sack's mouth.

And q*ua*n men ðo feckes ðor un-bond,

And in ðe coren ðo agtes fond, 2224

Alle he woren ðanne[1] fori ofrigt. [¹ MS. ðanno]

Iacob ðus him bi-meneð o-rigt,

"Much sorrow," says Jacob, "is come upon me,

" Wel michel forge is me bi-cumen,

ðat min two childre aren me for-nume*n* ; 2228

since my two children are taken from me.

Of Iofep wot ic ending non,

And bondes ben leid on fymeon ;

If ge beniamin fro me don,

Dead and forge me fegeð on ; 2232

Benjamin shall remain with me."

Ai fal beniamin wið me bi-lewen

ðor q*ui*les ic fal on werlde liuen."

ðo q*ua*ð iudas, " us fal ben hard,

'If we no[2] holden him non forward." [² ne ?] 2236

The corn is soon consumed, and Jacob bids them go to Egypt for more. [Fol. 44.]

Wex derke,[3] ðis coren if gon, [³ derðe ?]

 Iacob eft[4] bit hem faren agon, [⁴ eft ?]

Oc he ne duren ðe weie cumen in,

Jacob is persuaded to send Benjamin.

" but ge wið uf fenden beniamin ; " 2240

ðo q*ua*ð he, " q*ua*n it if ned,

And ne can no bettre red,

He sends back the silver,

Bereð dat[5] filu*er* hol agon, [⁵ ðat ?]

ðat hem ðor-of ne wante non, 2244

and other corn-money,

And oðer filuer ðor bi-foren,

for to bigen wið oðer coren ;

together with a present of fruit and spices for Joseph.

fruit and fpices of dere prif,

Bereð ðat man ðat if fo wif ; 2248

God hunne him eði-modes ben,

And fende me min childre agen."

The brethren come again to Egypt.

ðo nomen he forð weie rigt,

Til he ben cumen i*n*-to egypte ligt ; 2252

Joseph treats them kindly,

And q*ua*nne Iofep hem alle fag,

Kinde ðogt i*n* his herte was [ðag].

He bad hiſ ſtiward gerken iſ meten,

He ſeide he ſulden wiծ him alle eten ; 2256 *and bids his steward prepare a feast for them.*

He ledde hem alle to Ioſepes biri,

Her non hadden ծo loten miri.

" Louerd," he ſeiden ծo euerilc on,

" Gur ſiluer iſ gu brogt a-gon, 2260 *They tell Joseph that they have brought back the silver which they found in their sacks.*

It was in ure ſeckes don,

Ne wiſte ur non gilt ծor-on."

" Beծ nu ſtille," quad ſtiward,

" for ic nu haue min forward." 2264

ծor cam ծat broծer ſymeon *[Fol. 44b.]*

And kiſte iſ breծere on and on ; *Simeon was brought out unto them.*

Wel fagen he was of here come,

for he was numen ծor to nome. 2268

It was vndren time or more, *Joseph came home about noon,*

Om cam ծat riche louerd ծore ;

And al ծo briծere, of frigti mod,

fellen bi-forn ծat louerd-iſ fot, 2272 *and the brethren offered him their present.*

And bedden him riche preſent

ծat here fader hi[m] adde ſent ;

And he leuelike it under-ſtod,

for alle he weren of kinde blod. 2276

" Lueծ," quad he, " ծat fader get, *He inquires after his father.*

 ծat ծus manige funes bi-gat ? "

" louerd," he ſeiden, " get he liueծ, *They answer that Jacob is well,*

Wot ic ծor non ծat he ne biueծ ; 2280

And ծiſ iſ gunge beniamin, *and that Benjamin stands before him.*

Hider brogt after bode-word ծin."

ծo Ioſep ſag him ծor bi-foren,

Bi fader & moder broծer boren, 2284

Him ouer-wente his herte on-on, *Joseph was overcome.*

Kinde luue gan him ouer-gon ;

Sone he gede ut and ſtille he gret, *He went out and wept secretly.*

ծat al his wlite wurծ teres wet. 2288

After ծat grot, ho weiſ iſ wliten, *After a while he returned to them and bade them eat.*

And cam ծan in and bad hem eten

GENESIS. 5

[Fol. 45.]

He dede hem waſſen and him bi-foren,
And ſette hem af he weren boren ; 2292
Get he ðhogte of hiſ faderes wunes
Hu he ſette at ðe mete hiſe ſunes ;
Of euerilc ſonde, of euerilc win,
moſt and beſt he gaf beniamin. 2296
In fulſum-hed he wurðen glaðe,[1] [1 = glade.]
Ioſep ne ðoht ðor-of no ſcaðe,
Oc it him likede ſwiðe wel,
And hem lerede and tagte wel, 2300
And hu he ſulden hem beſt leden,
Quene he comen in vnkinde ðeden ;
"And al ðe bettre ſule ge ſpeden,
If ge wilen gu wið treweiðe leden." 2304
Eft on morwen quan it waſ dai,
Or or ðe breðere ferden a-wei,
Here ſeckes woren alle filt wið coren,
And ðe filuer ðor-in bi-foren ; 2308
And ðe feck ðat agte beniamin
Ioſepes cuppe hid was ðor-in ;
And quuan he weren ut tune went,
Ioſep haueð hem after ſent. 2312
ðis fonde hem ouertakeð raðe,
And bi-calleð of harme and ſcaðe ;
"Vn-ſeli men, quat haue ge don?
Gret vn-ſelðehe iſ gu cumen on, 2316
for iſ it nogt min lord for-holen,
ða[t] gure on haueð iſ cuppe ſtolen."
ð[o] ſeiden ðe breðere fikerlike,
"Vp quam ðu it findes witterlike, 2320
He flagen and we agen driuen
In-to ðraldom, euermor to liuen."
He gan hem ranſaken on and on,
And fond it ðor ſone a-non, 2324
And nam ðo breðere euerilk on,
And ledde hem ſorful a-gon,

He made his brethren sit before him according to their age.

Of meat and wine, the best he gave to Benjamin.

Joseph gave them good counsel,

and advised them to act truthfully.

On the morrow they depart.

Joseph's cup is hid in Benjamin's sack.

Joseph's messenger overtakes them,

and accuses them of theft.

[Fol. 45b.]

The brethren assert their innocence.

They are ransacked one by one,

And brogte hem bi-for iofep

Wid reweli lote, and forwe, and wep.　　　　2328 　*and brought be-fore Joseph,*

Ðo quat iofep, " ne wifte ge nogt

Ðat ic am o wol witter ðogt?　　　　　　　　　　*who reproaches them for their crime.*

Mai nogt longe me ben for-holen

Quat-fo-euere on londe wurð ftolen."　　　　2332

" Louerd !" quad Iudas, " do wið me　　　　　*Judah tells Joseph of his promise to his father.*

Quat-fo ði wille on werlde be,

Wið-ðan-ðat ðu friðe beniamin ;

ic ledde [him] ut on trewthe min,　　　　　2336

ðat he fulde ef¹ cumen a-gen　　　　　　　　[¹ eft ?]

to hife fader, and wið him ben."

Ðo cam iofep fwilc rewðe up-on,　　　　　　*Joseph commands all, except his brethren, to leave him, and makes himself known to them.*

he dede halle ut ðe toðere gon,　　　　　　2340

And fpac un-eðes, fo e gret,

ðat alle hife wlite wurð teref wet.

" Ic am iofep, dredeð gu nogt,　　　　　　　[Fol. 46.]

for gure helðe or hider brogt ;　　　　　　2344

Two ger ben nu ðat derke² if cumen,　　　　[² derðe ?]

Get fulen .v. fulle ben numen,

ðat men ne fulen fowen ne fheren,

So fal drugte ðe feldes deren.　　　　　　　2348

Ɍapeð gu to min fader a-gen,　　　　　　　*Tells them to hasten to his father,*

And feið him quilke min bliffes ben,

And doð him to me cumen hider,

And ge and gure orf al to-gider ;　　　　　2352 *and return with their cattle to Egypt.*

Of lewfe god in lond gerfen

fulen ge fundri riche ben."

Euerilc he kifte, on ilc he gret,

Ilc here was of if teres wet.　　　　　　　2356

Sone it was king pharaon kid　　　　　　　*Soon did Pharaoh learn the new tidings.*

Ꜳ Hu ðis newe tiding wurð bi-tid ;

And he was bliðe, in herte fagen,

ðat Iofep wulde him ðider dragen,　　　　　2360

for luue of Iofep migte he timen.

He bad cartes and waines nimen,　　　　　　*He bad them take carts and*

wains and fetch
their wives and
children.
And fechen wiues, and childre, and men,

And gaf hem ðor al lond gerfen, 2364

And het hem ðat he fulden hauen

More and bet ðan he kude crauen.

Joseph gave them
changes of rai-
ment.
Iofep gaf ilc here twinne frud,

Beniamin moft he[1] made prud; [1 MS. be.] 2368

[Fol. 46b.]
fif weden beft bar beniamin,

Ðre hundred plates of filuer fin,

Al-fo fele oðre ðor-til,

He bad them
take presents for
Jacob,
He bad ben in is faderes wil, 2372

And .x. affes wið femes feft;

Of alle egiptes welðhe beft

Gaf he if breðere, wið herte bliðe,

and hasten home-
ward.
And bad hem rapen hem homward fwiðe; 2376

And he fo deden wið herte fagen.

Toward here fader he gunen dragen,

When they came
home, Jacob
scarcely recog-
nized them.
And quane he comen him bi-foren,

Ne wifte he nogt quat he woren. 2380

"Lord Israel,"
they said,
"Joseph liveth
and greeteth thee
well."
" Louerd," he feiden, " ifrael,

Iofep ðin fune greteð ðe wel,

And fendeð ðe bode ðat he liueð,

Al egipte in hif wil cliueð." 2384

Jacob believed
not till he saw the
presents.
Iacob a-braid, and trewed it nogt,

Til he fag al ðat welðe brogt.

" Wel me," quað he, " wel if me wel,

ðat ic aue abiden ðuf fwil[c] fel ! 2388

Then he said, "I
shall go to my son
ere I turn from
the world."
And ic fal to min fune fare

And fen, or ic of werlde chare."

Jacob and his fa-
mily left Canaan.
[I]Acob wente ut of lond chanaan,

And of if kinde wel manie a man; 2392

Iofep wel faire him vnder-ftod,

And pharaon ðogte it ful good;

[Fol. 47.]
for ðat he weren hirde-men,

Pharaoh gives
them the land of
Goshen to live in.
Jacob is brought
before Pharaoh,
He bad hem ben in lond gerfen. 2396

Iacob waf brogt bi-foren ðe king

for to geuen him hif blifcing.

"fader derer," quað pharaon,

"hu fele ger be ðe on ?"　　　　　　　　2400

" An hundred ger and .xxx. mo　　　　　*and tells him of his age,*

Haue ic her drogen in werlde wo,

ðog ðinkeð me ðor-offen fo,

ðog ic if haue drogen in wo,　　　　　2404　*of his many sorrows,*

fiðen ic gan on werlde ben,

Her vten erd, man-kin bi-twen ;

So ðinked[1] euerilc wif man,　　　　　[1 ðinkeð ?]

ðe wot quor-of man-kin bi-gan,　　　　2408　*and how all suffer for the sin of Adam.*

And ðe of adames gilte muneð,

ðat he her uten herdes wuneð."

Pharaon bad him wurðen wel　　　　　*Pharaoh bad him rest in peace.*

　　in fofte refte and feli mel ;　　　　2412

He and hife funes in refte dede

In lond gerfen, on fundri ftede ;

Siðen ðor waf mad on fcité,

ðe waf y-oten Ramefé.　　　　　　　2416

Iacob on liue wuncde ðor　　　　　　*Jacob lived one hundred and forty-four years.*

In refte fulle .xiiij. ger ;

And god him let bi-foren fen　　　　　*God showed him the time of his death.*

Quilc time hife ending fulde ben ;　　2420

He bad iofep hife leue fune,　　　　　[Fol. 47b.]

On ðhing ðat[2] offe wel mune,　　　　[2 ðar ?]　*Jacob bad Joseph promise*

ðat quan it wurð mid him don,

He fulde him birien in ebron ;　　　　2424　*to bury him in Hebron,*

And witterlike he it aueð him feid,

ðe ftede ðor abraham was leid ;　　　　*where Abraham was laid,*

So was him lif[3] to wurðen leid,　　　[3 lcf ?]

Quuor ali gaft ftille hadde feid　　　　2428

Him and hife eldere(.) fer ear bi-foren,　*and his elders before him.*

Quuor iefu crift wulde ben boren,

And quuor ben dead, and quuor ben grauen ;

He ðogt wið hem refte to hauen.　　　2432

Iofep fwor him al-fo he bad,　　　　　*Joseph swore to do as his father wished.*

And he ðor-of wurð bliðe & glad.

Before he died
Jacob called his
sons before him,
and "said what
of them should
be."
Or ðan he wiſte off werlde faren,
He bade hiſe kinde to him charen, 2436
And ſeide qwat of hem ſulde ben,
Hali gaſt dede it him ſeen ;
In clene ending and ali lif,
So he for-let ðis werldes ſtrif. 2440

Joseph caused his
father's body to
be embalmed.
[I]Oſep dede hiſe lich faire geren,
Waſſen, and riche-like ſmeren,
And ſpice-like ſwete ſmaken ;

Egypt's folk "be-
waked" Jacob
for forty nights
and forty days.
And egipte folc him bi-waken 2444
xl. nigtes and .xl. daiges,
ſwilc woren egipte lages.

[Fol. 48.]
The first nine
nights they
bathe, anoint,
etc., the body.
firſt .ix. nigt ðe liches beðen,
And ſmeren, and winden, and bi-queðen, 2448
And waken if ſiðen .xl. nigt ;
ðo men ſo deden ðe adden migt.

The Hebrews had
a different cus-
tom ;
And ebriſſe folc adden an kire,
Nogt ſone deluen it wið yre, 2452

they wash the
body,
and keep it un-
anointed for
seven nights.
Oc waſſen it and kepen it rigt,
Wið-ven ſmerles, ſeuene nigt,
And ſiden[1] ſmered .xxx. daiges. [1 ſiðen ?]
Criſtene folc haueð oðer laiges, 2456
He ben ſmered ðor qwiles he liuen,

Christian folks
are anointed with
chrism and oil in
eir life-time.
Wið criſme and olie, in trewðe geuen ;
for trewðe and gode dedes mide,
ðon[2] ben ðan al ðat wech-dede ; [2 don ?] 2460
Sum on. ſum. ðre. sum .vii. nigt,
Sum .xxx., ſum .xii. moneð rigt ;
And ſum euerilc wurðen ger,
ðor qwiles ðat he wunen her, 2464

For the dead they
perform alms-
gift and mass-
song.
don for ðe dede chirche-gong,
elmeſſe-gifte, and meſſe-ſong,
And ðat if on ðe weches ſtede ;
Wel him mai ben dat[3] wel it dede ! [3 ðat ?] 2468

Jacob's sons kept
a "wake" of
thirty days.
Egipte folc aueð him waked
xl. nigt, and feſte maked,

And hife funes .xxx. daiges,

In clene lif and ali daiges ; [1] 2472

So woren forð .x. wukes gon,

get adde Iacob birigeles non.

And pharaon king cam bode bi-foren,

ðat Iofep haueð his fader fworen ; 2476

And he it him gatte ðor he wel dede,

And bad him nimen him feres mide,

Wel wopnede men and wif of here[n],

dat[2] noman hem bi weie deren ; 2480

ðat bere if led, ðif folc if rad,

he foren a-buten bi adad ;

ful feuene nigt he ðer abiden,

And bi-mening for iacob deden ; 2484

So longe he hauen ðeðen numen,

To flum iurdon ðat he ben cumen,

And ouer pharan til ebron ;

ðor if ðat liche in biriele don, 2488

And Iofep in-to egipte went,

Wið[3] al if folc ut wið him [s]ent.

Hife breðere comen him ðanne to,

And gunnen him bi-feken alle fo ; 2492

" Vre fader," he feiden, " or he was dead,

Vs he ðif bodewurd feigen bead,

Hure finne ðu him for-giue,

Wið-ðanne-ðat we vnder ðe liuen." 2496

Alle he fellen him ðor to fot,

To beðen meðe and bedden oc ;

And he it for-gaf[4] hem mildelike,

And luuede hem alle kinde-like. 2500

[I]Ofep an hundred ger waf hold,

And hif kin wexen manige-fold ;

He bad fibbe cumen him bi-foren,

Or he waf ut of werlde boren ; 2504

[Fol. 48b.]
So ten weeks passed away and Jacob had no burial.

Pharaoh heard of Joseph's oath to his father,

and gave him leave to bury his father, and to take with him "weaponed" men.

They crossed the Jordan, and laid the body in a tomb, and Joseph returned to Egypt.

His brethren came to him to seek forgiveness,

and fell down there before his feet, and he forgave and loved them kindly.
[Fol. 49.]

Joseph waxed old ;

he had his relations come before him ere he died,

¹ laiges ? ² ðat ? ³ wið ?
⁴ At the bottom of fol. 48b is the catchword—"And he it for-gaff."

"It fal," quað he, "ben foð, bi-foren

and told them of God's promise to their elders.

ðat god hað ure eldere fworen;
He fal gu leden in hif hond
Heðen to ðat hotene lond; 2508
for godef luue get bid ic gu,
Lefted it ðanne, hoteð it nu,

He asks them to bear his bones with them, when they leave Egypt.

ðat mine bene ne be for-loren,
wið gu ben mine bones boren." 2512
He it him gatten and wurð he dead,
God do ðe foule feli red!

The death of Joseph.

Hife liche waf fpice-like maked,
And longe egipte-like waked, 2516
And ðo biried hem bi-foren,
And fiðen late of londe boren.
Hife oðre breðere, on and on,
Woren ybiried at ebron. 2520

Here endeth the book called Genesis, written by Moses, through God's counsel.

An her endede to ful, in wif,
ðe boc ðe if hoten genefis,
ðe moyfes, ðurg godes red,
Wrot for lefful foules ned. 2524

[Fol. 49b.] God shield his soul from hell-bale, who translated it into English! May God help and protect him from hell-pain, cold and hot!

God fchilde hife fowle fro helle bale,
ðe made it ðus on engel tale!
And he ðat ðife lettres wrot,
God him helpe weli mot, 2528
And berge if fowle fro forge & grot
Of helle pine, cold & hot!
And alle men, ðe it heren wilen,[1] [1 MS. welin.]

And all men who will hear it, God grant that they may dwell in bliss among angels for ever!

God leue hem in hif bliffe fpilen 2532
Among engeles & feli men,
Wiðuten ende in refte ben,
And luue & pais uf bi-twen,
And god fo graunte, amen, ameN! 2536

G Odes bliſcing be wið vs,
 Her nu bi-ginned[1] exodus.

Pharao kinges rigte name

Vephres, he dede ðe ebriſ frame ;

And bi oðere ſeuene kinges ſel,

Wexen he ðore & ðogen wel.

ðe egtenede king amonaphis,

Agenes ðis folc hatel is ;

And egipte folc adden nið,

for ebriſ adden ſeli ſið.

Quuað ðis ging[2] wið hem ſtille *in* red,

" ðis ebris waxen michil ſped,

Bute if we craflike[3] hem for-don,

Ne ſulen he non eige ſen uſ on."

D o ſette ſundri hem to waken
 His tigel and lim, and walles maken,

burges feten ; a*n*d rameſen

ðurge here ſwinc it walled ben ;

Summe he deden in vn-ðewed ſwinc,

for it was fugel and ful o ſtinc,

Muc and fen ut of burgeſ beren,

ðuſ bitterlike he gun he*m* deren ;

ðe ðridde ſwinc was eui and ſtron[g],

He deden hem crepen dikes long,

And wide a-buten burges gon,

And cumen ðer ear waſ non ;

And if ðat folc hem wulde deren,

ðe dikeſ comb he*m* ſulde weren.

for al ðat ſwinc heui & for,

Ay wex ðat kinde, mor & mor,

And ðhogen, & ſpredden *in* londe ðor,

ðat made ðe kinges herte ful for.

D o bad monophis pharaun
 wimmen ben ſet *in* euerilc tun,

And ðat he weren redi bi-foren,

Quan ebru child ſuld be boren,

[1 bi-ginneð ?]

2540

2544

[2 king ?]

2548

[3 craftlike ?]

2552

2556

2560

2564

2568

2572

Here beginneth Exodus.

Under Pharaoh, and the seven kings who succeeded him,

the Israelites increased and prospered.

The eighth king treated them harshly,

and the Egyptians became jealous of them.

[Fol. 50.]

They made slaves of them, and set them to build walls.

Some they made to do foul work,

to carry " muck and fen out of the city,"

and to creep along dikes.

The comb of the dike serves them as protection against their enemies.

For all that labour, the folk increased and spread.

Then bad Pharaoh,

that every Hebrew male child should be put to death as soon as it was born.

And ðe knapes to deade giuen,

And leten ðe mayden childre liuen.

[Fol. 50b.]
The midwives
saved the chil-
dren's lives,

Oc he it leten fro godef dred ;

Get ðo childre wexen in fped, 2576

And quane he komen to ðe king,

and lied to the
king, saying,

He wereden hem wið lefing ;

He feiden ðe childre weren boren

that the children
were born ere
they arrived.

Or he migten ben hem bi-foren. 2580

God it geald ðefe wifes wel,

On hom, on hagte, eddi fel !

Pharaoh then
bad that every
"knave child"
should be drown-
ed.

Ðo bad ðis king al opelike,

In alle burges modilike, 2584

Euerilc knape child of ðat kin

ben a-non don ðe flod wið-in.

By that time was
Moses born.

BI ðat time waf moyfes boren,

So het abraham dor¹ bi-foren ; [¹ ðor ?] 2588

And his moder het Iacabeð,

Ghe was for him dreful and bleð,

His mother hid
him for three
months.

wel is hire of bird² bi-tid. [² birð ?]

ðre moneð haueð ghe him hid, 2592

durfte ghe non lengere him for-helen,

Ne ghe ne cuðe ðe wateres ftelen ;

Then she made
an ark,

In an fetles, of rigeffes wrogt,

Terred, ðat water dered it nogt, 2596

placed the child
in it,

ðif child wunden ghe wulde don,

and set it on the
water.
Miriam was sent
to watch what
[Fol. 51.]
became of it.

And fetten it fo ðe water on ;

Ghe adde or hire dowter fent,

To loken quider it fulde ben went ; 2600

Maria dowter ful feren ftod,

And ghe nam kep to-ward ðif flod.

The king's
daughter came
and saw the child
on the water.

Teremuth kinkes³ dowter ðor cam, [³ kinges ?]

ðor ðis child on ðe water nam ; 2604

Ghe bad it ben to hire brogt,

And fag ðis child wol fair[e] wrogt,

She wist it was of
Hebrew kin,

Ghe wifte it was of ebrius kin,

And ðog cam hire rewde⁴ wið-in ; [⁴ rewðe ?] 2608

God haued[1] fwilc fair-hed him geuen, [¹ haueð ?]

ðat felf ðe fon it leten liuen.

Egipte wimmen comen ner,

And boden ðe childe letten ðer, 2612

Oc he wente it awei wið rem,

Of here bode nam he no gem.

ĐO quad maria to teremuth,

"wilt ðu, leuedi, ic go fear out, 2616

And take fum wimman of ðat kin

ðor he waf bi-gote & foftred in ?"

Teremuth fo bad, & fche forð-ran,

And brogt hire a foftre wimman, 2620

On waf tette he fone aueð lagt,

And teremuth haueð hire him bi-tagt.

Iakabeð wente bliðe agen,

ðat ghe ðe gildef[2] foftre mufte ben; [² cildef ?] 2624

Ghe kepte it wel in foftre wune,

Ghe knew it for hire owen fune;

And quane it fulde fundred ben,

Ghe bar it teremuth for to fen; 2628

Teremuth toc it on funes ftede,

And fedde it wel and cloðen dede;

And ghe it clepit moyfen,

Ghe wifte of water it boren ben 2632

An time after ðat ðif was don,

Ghe brogte him bi-foren pharaon,

And ðif king wurð him in herte mild,

So fwide[3] faiger was ðif child; [³ fwiðe ?] 2636

And he toc him on funes ftede,

And hif corune on his heued he dede,

And let it ftonden ayne ftund;

ðe child it warp dun to de grund. 2640

Hamonel[4] likenef was ðor-on; [⁴ Hamonef ?]

ðis crune is broken, ðif if mifdon.

Biffop Eliopoleos

fag ðif timing, & up he rof; 2644

Side notes:

but let it live for its beauty.

Egyptians wanted her to destroy the child.

Miriam, at Teremuth's bidding,

fetches a "foster woman" for the child.

Teremuth consigned Moses to Jochabed, who returned home blithely.

[Fol. 51b.]
When old enough, the child was adopted by Teremuth, who called it Moses.

She brought him before Pharaoh, who placed the royal crown on his head.

The child soon threw it to the ground. Hamons' likeness was thereon.

The Bishop of Heliopolis saw this, and said,

"If this child be allowed to thrive, he shall become Egypt's bale."

"If ðif child," q*u*ad he, "mote ðen,
He fal egyptes bale ben."
If ðor ne wore helpe twen lopen,
ðif child adde ðan fone be dropen; 2648
ðe king wið-ftod & an wif man,
He feide, "ðe child doð alf he can;
We fulen nu witen for it dede
ðif witterlike, or in child-hede;" 2652

[Fol. 52.]
The king offered the child two burning coals (to eat), and he put them in his mouth, and burnt the end of his tongue therewith, and spake indistinctly.

He bad ðis child brennen to colen
And he toc is hu migt he it ðolen,
And in hife muth fo depe he if dede
Hife tunges ende if brent ðor-mide; 2656
ðor-fore feide de[1] ebru witterlike, [1 ðe ?]
ðat he fpac fiðen miferlike;

So fair was he to look upon, that none might be angry with him.

Oc fo faiger he waf on to fen,
ðat migte non man modi ben. 2660
ðor q*u*iles he feweden him up-on,
Mani dede b[i]leph un-don
In ðat burg folc bi-twen,
So waf hem lef on him to fen. 2664

By the time that he became renowned for beauty and strength, the Ethiopians invaded Egypt, and burnt and slew as far as the Red Sea.

Bi dat[2] time ðat he was guð, [2 ðat ?]
Wið faigered and ftrengthe kuð,
folc ethiopienes on egipte cam,
And brende, & flug, & wreche nam, 2668
Al to memphin dat[3] riche cite, [3 ðat ?]
And a-non to ðe reade fe;

The Egyptians ask counsel of their gods, who tell them that a Hebrew shall deliver them.

ðo was egipte folc in dred,
And afkeden here godes red; 2672
And hem feiden wið anfweren,
ðat on ebru cude hem wel weren;
Teremuth un-eðes migte timen

Moses is permitted by Teremuth

ðat moyfes fal wið hire forð-nimen, 2676
Or haue he hire pligt & fworen,
ðat him fal feið wurðful ben boren.

[Fol. 52b.]

Moyfes was louered of ðat here,
ðor he wurð ðane egyptes were; 2680

Bi a lond weige he wente rigt,

And brogte vn-warnede on he*m* figt ;

He hadden don egipte wrong,

He bi-loc hem & fmette a-mong, 2684

And flug ðor manige ; oc fu*m*me flen,

Into faba to borgen ben.

Moyfes bi-fette al ðat burg,

Oc it was riche & ftrong ut-ðhurg ; 2688

Ethiopienes kinges dowt*er* tarbis,

Riche maiden of michel prif,

Gaf ðif riche burg moyfi ;

Luue-bonde hire ghe it dede for-ði. 2692

Ꝧor ife fou he leide i*n* bonde,

And he wurð al-migt-ful in ðat lond ;

He bi-lef ðor(.) tarbis him fcroð,

ðog was him ðat furgerun ful loð ; 2696

Mai he no leue at hire taken

but-if he it mai wið crafte maken :

He waf of an ftrong migt wif,

He carf i*n* two gummes of prif 2700

Two likeneffes, fo grauen & meten,

ðif doð ðenken, & ðoð[1] forgeten ; [1 ðoðer ?]

He feft is i*n* two ringes of gold,

Gaf hire ðe ton, he was hire hold ; 2704

Ghe it bered[2] and ðif luue if for-geten, [2 bereð ?]

Moyfes ðus haued[3] him leue bi-geten ; [3 haueð ?]

Sone it migte wið leue ben,

Into egypte e[4] wente a-gen. [4 MS. cwente.] 2708

A N time he for to lond gerfen,

to fpeken wið hife kinnes men ;

And fone he cam in-to ðat lond,

A modi ftiward he ðor fond, 2712

Betende a man wid[5] hife wond ; [5 wið ?]

ðat ðhugte moyfes michel fond,

And hente ðe cherl wið hife wond,

And he fel dun in dedes bond ; 2716

to lead the Egyptians against their enemies.

He smote and slew them. Many fled to Sheba.

The king of Ethiopia's daughter, for love,

gave this rich city to Moses.

who waxed mighty in the land.

His sojourn there was distasteful to him,

but by craft he brought it to an end.

He carved upon two gems two likenesses ;

the one caused remembrance, the other forgetfulness.

Moses gave her the one which

[Fol. 53.] caused her to forget her love,

and so he came again to Egypt.

On a time he went to Goshen, and found a "moody steward" beating a Hebrew.

He seized the churl, slew him, and buried him in the sand.

And moyfes drug him to ðe ftrond,

And ftille[1] he dalf him [in] ðe fond;

He thought that none had wist it.
wende he ðat non egipcien

ðat hadde it wift, ne fulde a fen; 2720

On the second day he saw two men chiding, and reproved them.
Til after ðif on oðer day,

He fag chiden in ðe wey

two egypcienis, modi & ftrong,

ðif on wulde don ðe toðer wrong; 2724

And moyfes nam ðer-of kep,

And to hemward fwide[2] he lep, [² fwiðe ?]

And vndernam him ðat it agte awold.

The wrong-doer thus answered him, " Moses, who made thee master ?
And he him anfwerede modi & bold; 2728

" Meifter(.) moyfes, quo haueð ðe mad?

ðu art of dede and o word to rad.

[Fol. 53b.]
We know well how yesterday one was slain and hid.
we witen wel quat if bi-tid,

Quuow gifter-dai waf flagen and hid; 2732

ðe bode if cumen to pharaun,[3] [³ MS. pharaum.]

Soon shall thy pride fall down."
Then Moses fled
Get fal ðin pride fallen dun."

Do bi-thowte him moyfes,

 And his weige ðeðen ches; 2736

ðurg ðe deferd a-wei he nam,

and came to Midian,
And to burge madian he cam,

And fette hi[m] ðor vten ðe town,

where dwelt Jethro,
Bi a welle ðo fprong ðor dun. 2740

Raguel Ietro ðat riche man,

Was wuniende in madian,

who had seven daughters.
He hadde feuene dowtref bi-geten;

ðor he comen water to feten, 2744

And for to wattren here fep;

These maidens took care of cattle.
(Wimmen ðo nomen of here erf kep,

Pride was not so great then as now.
Pride ne cuðe bi ðat dai

Nogt fo michel fo it nu mai). 2748

Hirdes wulden ðe maidenes deren,

Moses helped the maidens to water the flocks.
 Oc moyfes ðor hem gan weren,

And wattrede here erue euerilc on,

And dede hem tidelike to tune gon; 2752

 [1] MS. ftalle, *corrected to* ftille.

And ben ſone hom numen ;

And b[i]foren here fader cumen,

They told their father

And gunen him ðore tellen,

Hu a gunge man, at te welle[n], 2756 [Fol. 54.]

how a young man at the well had protected them.

ðewe and wurſipe hem dede ;

And ietro geld it him in eſtdede,

Jethro sent after him and kept him in his house,

Sente after him, freinede hiſ kin,

Helde him wurðelike iſ huſ wið-in ; 2760

Of ali kinde he wiſte him boren,

And bad him ðor wunen him bi-foren,

Gaf him iſ dowter ſephoram ;

and gave him his daughter to wife,

To wife in lage he hire nam, 2764

who bore him two sons.

And bi-gat two ſunes on hire ðer,

firſt gerlon, ſiðen eliezer.

Egipte king to late waſ dead,

ðe ðe childre ſo drinkelen bead. 2768

And moyſes waſ numen an ſel

On a time Moses went into the desert with his flocks, for rich men then kept such ware.

In ðe deſerd depe ſumdel,

for te loken hirdneſſe fare ;

Riche men ðo kepten ſwilc ware. 2772

ðo ſag moyſes, at munt ſynay,

By Mount Sinai he sees a wondrous sight,

An ſwiðe ferli ſigt ðor-bi,

fier brennen on ðe grene leaf,

And ðog grene and hol bi-leaf ; 2776

a bush burning, and nevertheless green and whole.

forð he nam to ſen witterlike,

Hu ðat fier brende milde-like ;

Vt of ðat buſk, ðe brende and ðheg,

Out of that bush God's voice was heard, clear and high,

God ſente an ſteuene, brigt and. heg ; 2780

" Moyſes, moyſes, do of ðin ſon,

' Moses, Moses, take off thy shoes, for thou standest on holy ground.

ðu ſtondes ſeli ſtede up-on ;

Hic am god ðe in min geming nam

[Fol. 54b.] I am the God of Jacob, Isaac, and Abraham.

Iacob, yſaac, and abraham ; 2784

ic haue min folkes pine ſogen,

I have seen the affliction of my people,

ðat he nu longe hauen drogen ;

Nu am ic ligt to fren hem ðeðen,

and have come down to deliver them,

And milche and hunige lond hem queðen ; 2788

and to bring them into the land of seven kingdoms.	An .vii. kinge-riches lond Ic fal hem bringen al on hond.
Come, thou shalt be my messenger,	Cum, ðu falt ben min fondere man, Ic fal ðe techen wel to ðan ; 2792
and bid Pharaoh release my people.	ðu falt min folc bringen a-gen, And her ðu falt min migte fen ; And ðu falt feien to faraon, ðat he lete min folc ut-gon ; 2796
If he refuse, I shall work great marvels,	If he it werne and be ðor-gen, Ic fal ðe techen hu it fal ben ; for ic fal werken ferlike ftrong,
and cause my people to go out freely.	And maken min folc frelike ut-gong ; 2800 Ge fulen cumen wið feteles & frud,
As a sign, throw down thy wand." The wand then became an ugly snake.	And reuen egipte ðat if nu prud. Werp nu to token dun ðat wond." And it warp vt of hife hond, 2804 And wurð fone an uglike fnake, And moyfes fleg for dredes fake ;
God bade Moses take it by the tail, and anon it became a wand. [Fol. 55.] He put his hand into his bosom and it became leprous. He put it in again and it became whole and sound.	God him bad, bi ðe tail he it nam, And it a-non a wond it bi-cam, 2808 And in hife bofum he dede his hond, Quit and al unfer he it fond ; And fone he dede it eft agen, Al hol and fer he wifte it fen. 2812
"If they believe not these tokens, pour out the water of the flood on the earth, and it shall become blood."	" If he for ðife tokenes two Ne lifteðe ne troweð to, Go, get ðe water of de[1] flod [1 ðe ?] On ðe erðe, and it fal wurðen blod." 2816
"Lord! I am not eloquent, and cannot speak well," said Moses.	"Louerd, ic am wanmol, vn-reken Of wurdes, and may ic Iuel fpeken. Nu if forð gon ðe ðridde dai, Sende an oðer ; bettre he mai." 2820
Quoth God, "Who made the dumb, the speaking, the blind, and the seeing ? "	" Quo made domme, and quo fpecande ? Quo made bisne, and quo lockende ? Quo but ic, ðat haue al wrogt ? Of me fal fultum ben ðe brogt." 2824

" Louerd, ſent him ðat if to cumen,
Vgging and dred me haueð¹ numen." [¹ MS. haued.]

" Aaron ðin broðer can wel ſpeken,

Aaron, thy bro-
ther can speak

Ðu ſalt him meten and vnſteken 2828

well, thou shalt
meet him, and
make known to

Him bodeword min, and ic ſal red

him my words."

Gunc boðen bringen read and ſped."

Moyſes, frigti, ðo funden gan

Moses asks leave
of Jethro to visit

to ſpeken wið ietro ðat riche man, 2832

his brethren.

And afkede him leue to faren and ſen,

If hiſe breðere of liues ben ;

ðog drechede he til god eſ[t] bad,

[Fol. 55b.]
Moses delayed

And brogte him bode ðe made him glad, 2836

until God's mes-
sage again came
to him.

ðat pharaun, ðe wulde him ſ[l]en,

Waſ dead and hadde iſ werkes len.

Moyſes and hiſe wif ſephoram,

Then he departed
with his wife and

And hiſe childre wið him nam ; 2840

children.

And ðat on waſ vncircumciſ.

He nam ſo forð, ſoð it is ;

One child was
uncircumcised,

An angel, wið an dragen ſwerd,

and the angel in
the way sought

In ðe weie made him offerd, 2844

to slay him.

for ðat he ledden feren ſwike,

ðe fulden him deren witterlike ;

Sephora toc ðiſ gunge knaue,

Zipporah circum-
cised her son.

And dede circumciſe haue, 2848

And gret, and wente frigti a gen,

And let moyſes forð one ten.

Moses pursued
his way alone.

He bar hiſe gerde forð in iſ hond,

And nam a weie² bi deſerd lond ; [² MS. aweie.] 2852

To mount fynai forð he nam,

At Mount Sinai
he meets with

Aaron hiſe broðer a-gen him cam ;

Aaron.

Eyðer [h]ere was of oðer fagen ;

Moyſes him haueð iſ herte³ vt-dragen, [³ MS. herðe.]

And he ben in-to egypte numen, 2857

They come into
Egypt.

And a-mong folc ebriſſe ben cumen ;

Moyſes tolde hem ðat bliðe bode,

And let hem ſen tockenes fro gode ; 2860

The people be-
lieve them.

GENESIS. 6

[Fol. 56.]

He redden famen he fulden gon
wið¹ wife men to pharaon. [¹ MS. wid.]

Moses and Aaron come before Pharaoh,

"God," he feiden, "of ifrael
ðe bode fente, and greteð wel, 2864

and deliver their message.

ðat, bi ði leue, hife folc vt-fare,
ðre daiges gon and ben ðor gare,
In ðe deferd an ftede up-on,
Hif leue facrififc to don." 2868

Quad pharaun, "knowe ic² him nogt, [² MS. ic hic.]
Bi quafe read haue ge ðif fowt?"

Moses says that he is well known to the Egyptians,

Seide moyfes, "ic am fonder man,
Egipte folc mc knowen can, 2872
for ic am ðat ilc moyfes,

having delivered them from the Ethiopians,

ðe egypte folc of forge les,
ðan ethiops woren her cumen;
ic warc al ðat ðu was binumen, 2876
And fwanc and michel forwe dreg,

and that he brings God's message from Mount Sinai.

Get ift vnfene hu ic it bi-teg?
Ic haue ben fiðen at munt fyna,
Godes bode-wurd bringe ic ðor-fra." 2880

Pharaoh chides Moses,

Qvað pharaun, "ðu art min ðral,
ðat hidel-like min lond vt-ftal;
Sum fwike-dom doð it nu ben,
ðat ðu beft cumen nu eft agen; 2884

and declares that the Israelites shall suffer still greater woe.

ðif folc, ðat ðu wilt me leden fro,
fal ben luken in more wo."

[Fol. 56b.]

De king it bad, and [it] wurð don;
More fwinc ðo was hem leid on. 2888

More labour is laid upon the Israelites.

Hem-feluen he fetchden ðe chaf
ðe men ðor hem to gode gaf,
And ðog holden ðe tigeles tale, [³ ? eldren and children?]
And elten and eilden,³ grete & fmale. 2892

Moses complains to God.

Do fleg ðif folc wið moyfen,
And [he] to god made hife bimen.
"Louered, qui waf ic hider fent?
ðin folc if more in forwe went." 2896

God quað, "ic fal hem lefen fro,
 And here fon weren wið wo ;
Abraham, yfac, and hife funen
Woren to min ðhunerg wunen, 2900
ðog ne tagte ic hem nogt for-ði
Min mig[t]ful name adonay ;
Min milche witter name eley
He knewen wel, and ely ; 2904
ðat ic ðe haue hoten wel,
Ic it fal leften euerilc del."
Moyfes told hem ðif tidding ;
ðog woren he get in ftrong murni[n]g. 2908
Sið en fpac god to moyfen,
 and tagte him hu it fulde ben.
fowre fcore ger he waf hold,
And aaron ðre more told,[1] 2912
Quanne he ðat[2] bodewurd fpoken,
And deden ðe firme token.
Aron ðor warp vt of hif hond
 Moyfeses migtful wond, 2916
And it wurð bi-foren pharaon
An Iglic fnake fone on-on ;
ðe king fente after wiches kire,
Wapmen ðe weren in fowles lire, 2920
ðe ferden al bi fendes red,
fendef hem gouen finful fped ;
And worpen he ðor wondes dun,
fro euerilc ðor crep a dragun ; 2924
Oc moyfes wirm hem alle fmot,
And here aldre heuedes he of bot ;
ðog deden wichef ðo men to fen
On oðere wife or foðe ben ; 2928
for ðo fendes or he[m] bi-foren
Hadden ðo neddres ðider boren ;

God renews his
promise by his
name Adonai,

which was un-
known to Abra-
ham, Isaac, and
Jacob.

Moses told the
Hebrews these
tidings, and yet
were they in
great anguish.

Moses was now
fourscore years
old.

[Fol. 57.]

Aaron cast down
his rod before
Pharaoh.

It became an
ugly snake.

The sorcerers, by
the devil's help,
did the like.

Each of their rods
became a dragon.

Moses's serpent
bit off their
heads.

[1] At the bottom of this page is the catchword—"Quanne he ðat bodewurd." [2] MS. dat ; see the catchword.

Pharaoh would
not let the Is-
raelites go.
And pharaon ſtirte up a-non,

And for-bed ðif folc to gon. 2932

DO feide moyſes to araon,
 "Quat redeſ tu, broder, fule wit don?

ðif king him his¹ wel wiðer-ward [¹ *read* is.]

Agen ðis folc, and herte hard ; 2936

Moses and Aaron
again came be-
fore Pharaoh.
Go we and ſpeken wið hem get,

And fonden wið ðif token bet."

[Fol. 57b.]
And ſo deden [he] ſone a-non,

And comen bi-foren pharaon, 2940

Quad aaron, "nu ſaltu ſen

Quilc godes migtful ſtrongðes ben."

Aaron smote on
the flood with his
wand;
soon anon it be-
came blood,
and the fish in it
died.
He ſmot on ðat flod wið ðat wond,

Sone anon blod men al it fond ; 2944

And ðe fiffes, in al ðat blod read,

floten a-buuen and wurðeden dead ;

In every well and
pool blood was
found,
In euerilc welle, in euerilc trike,

men funden blod al witterlike, 2948

except in Goshen.
But-if it were in ðe lond gerſen,

ðor-inne woree² ðe ebriſſe men. [² woren ?]

ðis wreche, in al egypte rigt,

This plague lasted
seven nights.
Leſtede fulle ſeuene nigt ; 2952

ðo waſ ðif king ſumdel for-dred,

Pharaoh then
promised that
the Hebrews
should depart.
And het hem he ſulden vt ben led ;

And moyſes ðif pine vn-dede,

And water wurð on blodeſ ſtede. 2956

When the plague
was removed he
would not release
them.
ðan pharaon wurð war ðis bot,

ðif folc of londe funden ne mot ;

Iannes and mambres, wicheſ wod,

Him ðhugte he maden water blod ; 2960

Mad sorcerers
misled the king.
It waſ on fendes wiſe wrogt,

for to bi-tournen³ ðe kingeſ ðogt. [³ MS. bitoueren.]

Moyſes lerede god, ſpac him mide,
 Al ðat iſ broðer aaron dede. 2964

[Fol. 58.]
Eft he comen to pharaon,

And he wernede ðif folc ut-gon.

And aaron held up his hond,

to ðe water and ðe more lond ;　　2968　Aaron held up his hand towards the water, and up came a host of frogs.

 So cam ðor up ſwilc frofkes here

ðe dede[1] al folc egipte dere ;　　[1 MS. ðede.]

Summe woren wilde, and ſumme tame,　Some were wild and some tame.

And ðo hem deden ðe[2] moſte ſame ;　[2 MS. de.]

In huſe, in drinc, in metes, in bed,　2973　Some crept into houses, drink, meat, and bed.

It cropen and maden hem for-dred ;

Summe ſtoruen and gouen ſtinc,　Some died and stank.

And vn-hileden mete and drinc ;　2976

Polheuedes, and frofkes, & podes ſpile　Tadpoles, frogs, and toads afflicted Egypt's folk.

Bond harde egipte folc [3 ?un-sile.]

ðif king bad moyſes and aaron,

ðat he ſulden god bone don ;　2980

And ſone ſo moyſes bad if bede,　The frogs died,

ðif wirmes ſtoruen in ðe ſtede ;

And quane ðe king wurð war ðis dead,　but the king forbad the departure of the Hebrews.

Anon ðis folc fore he for-bead.　2984

De ðridde wreche dede aaron

　Bi-foren ðe king pharaon ;

He ſmot wið ðat gerde on ðe lond,　The third plague, of gnats, small to look at, but sharp in biting.

And gnattes hird ðor ðicke up-wond,　2988

ſmale to ſen, and ſarp on bite,

In al egypte fleg ðif ſmite.

And ðo dede men and herf wo,　[Fol. 58b.]

Anger and tene, ſorge and wo.　2992

Quoðen ðo wiches clerkes(.) " ðif　The sorcerers said, "This is token of God's ghost,"

fortoken godeſ gaſtes is."

Her hem wantede migt and ſped,　for they lacked might to do this.

to ſwilc ðing cuðen he non red ;　2996

ðif toknes dede aaron.

God ſente ſiðen hem oðere on,　Pharaoh remained obstinate,

for euere eld ðif king on-on,

And wernede ðif folc vt to gon.　3000

Do ſeide god to moyſen,

　" Go ðu gund pharaon agen ;

Sei him, if min folc ne mote gon,

fleges kin fal hin ouer-gon, 3004

And al hif lond to forge ten ;

Qc in lond gerfen ne fal non ben."

And ðuf¹ it was, and al ðif for [¹ MS. duf.]

Sag pharaun, and dredde him ðor. 3008

He gaf hem leue ðo vt to faren

wið-ðanne-ðat he to londe ef[t] charen ;

And moyfes bad meðe here on,

And ðif fleges fligt vt if don ; 3012

And pharaon wroð² herte on hard, [² worð ?]

And vn-dede hem ðat³ forward. [³ MS. dat.]

Moyfes fpac fiðen wið gode,

And he brogte pharaun ðif bode ; 3016

" To-morgen, bute he mugen vt-pharen,

Egyptes erf fal al for-faren."

He wið-held⁴ hem and, al-fo he it b[e]ad, [⁴ MS. wid-held.]

Al ðe erf of egipt wurð dead ; 3020

And get ne migte ðif folc vt-gon,

fwilc har[d]neffe if on pharaon.

After ðif time, it fo bi-cam,

ðat moyfes afkes up-nam, 3024

And warpes vt til heuene-ward ;

ðo wex vn-felðe on hem wel hard,

dolc, for, and blein on erue and man ;

ðe wicches hidden hem for-ðan, 3028

Bi-foren pharaun nolden he ben,

So woren he lodelike on to fen ;

At laft, quan it waf ouer-gon,

Hadde moyfes ðo leue non. 3032

Siðen fente ðe louerd gode,

bi moyfes, to ðif king bode ;

" for-ði lete ic ðe king her ben,

Men fal, ðurg ðe, min migte fen, 3036

And knowen fal ben, ðe to un-frame,

In euerilc lond min migte name.

ſwilc hail was her or neuere nomen
So fal ðiſ ſel to-morgen cumen ; 3040 He threatens
the king with
hail-storm.
Do men and erue in huſe ben,
If ðu wilt more hem liues ſen."
ðo men, ðe weren in eige and dred, [Fol. 59b.]
ben borwen, and erue, ðurg ðiſ red. 3044
O morgen, al ſwilc time al ſir, On the morrow
came thunder,
hail, and light-
ning.
ðhunder, and hail, and leuenes ſir,
Cam wel vnghere ; al ðat it fond
Bergles, it ſloge in ðat lond ; 3048 It slew many
men, broke down
trees, grass, and
corn.
Treeſ it for-brac, and greſ, and corn,
ðat waſ up-ſprungen ðor bi-foren ;
Oc ðe ebrius in lond gerſen
ne derede it, coren, ne erf, ne men ; 3052
ðo ſeide ðe folc to pharaon,
" Nu ic wot we haue miſ-don ; The Egyptians
beseech Moses to
remove this
plague.
Moyſes, do ðiſ weder charen,
And gu ſal [ic] leten ut-faren." 3056
Moyſes gede vt, helde up iſ hond,
And al ðiſ vnweder ðor atwond,
And wurð ðiſ weder ſone al ſtille, The storm
ceased,
And al after ðe kinges wille. 3060
ðiſ weder iſ ſofte, And ðiſ king hard, but though the
weather was soft,
the king's heart
was hard.
And brokeð him eft ðat forward.

MOyſes ſiðen, and aaron,
Seiden bi-foren pharaon, 3064 Then said Moses,
" To-morgen ſulen greſſeoppes cumen, "To-morrow shall
the grasshoppers
come into the
land."
And ðat ail ða bileaf ſal al ben numen ;
So ſal ðin hardneſſe ben wreken,
ðat men ſulen longe ðor-after ſpeken." 3068
" Goð vt," quað he, " red ic ſal taken, [Fol. 60.]
And gu ſiðen i ſal anſwer maken."

Qvað ðiſ folc, " beter iſt laten hem vt-pharen, The Egyptians
advise the king
to let the Israel-
ites go.
Al ſal egipte elles for-faren." 3072
He calde hem in ; quad pharaon, Pharaoh is at
first inclined to
let them go,
" Quilc ben ðo ðe ſulen vt-gon ?"

Qua𝛿 moyfes, "but alle wapmen,
wi𝛿 erf, and childre, and wimmen." 3076

"Hu! haue ge wrong," quad pharaon,
"Gu wapmen giue Ic leue to gon ;
Of erf and wimmen leue ic nogt,
Ear one of wapmen waf bi-fogt." 3080
Ef[t] 𝛿if andfwere, ben vt-gon
moyfes for𝛿 and aaron ;

MOyfes held up hif hond,
A fu𝛿en wind if flig[t] up-wond, 3084
And blew 𝛿at day and al 𝛿at nigt
And brogte egipte an newe figt ;

𝛿if wind hem brogte 𝛿e fkipperes,
He deden on gref and coren deres. 3088

𝛿at lond was ful, and 𝛿if king wo,
He fente after 𝛿e bre𝛿ere 𝛿o.

Quad pharaon, "ic haue mif-numen,

Wreche if on vs wi𝛿 rigte cumen ; 3092
Bi-fek get god, 𝛿is one fi𝛿e,
𝛿at he vs of 𝛿if pine fri𝛿e."

And fo [he] dede, and on wind cam
fro weften, and 𝛿o opperes nam, 3096
And warpes ouer in-to 𝛿e fe ;
𝛿o pharaun fag if lond al fre,

Hif herte 𝛿o wur𝛿 𝛿wert and hard,
And al he brac hem [𝛿at] forward. 3100

MOyfes fi𝛿en held up if hond,
And 𝛿hikke 𝛿herkneffe cam on 𝛿at lond,

𝛿at migte non egipcien
Abuten him for mirkneffe fen ; 3104
Manige 𝛿or forge on liue bead,

And manige weren rewlike dead ;
Quor-fo 𝛿e folc waf of yfrael,

He adden ligt and fowen wel. 3108
𝛿o quad pharaon to moyfen,

"Led vt al 𝛿at if boren of man,

And let her ben boden erf & fep,

ic wile ðor-on[1] nimen kep." [1 MS. dor-on.] 3112

to leave their flocks and herds behind.

Quad moyfes, "la! god it wot,

fal ðe[r]-of bi-leuen non fot,

Al we fulen if wið vs hauen;

Moses will not consent to this arrangement.

'Wold,' quad god, 'wile ðor-of crauen.'" 3116

Quað pharaon to moyfen,

"Nu ic rede ðat ge flen;

for fe ic gu more-ouer nu,

Moses and Aaron are driven out from the presence of Pharaoh.

dead fal be[2] wreken ouer gu." [2 MS. me.] 3120

Moyfes fleg to lond gerfen,

ðor wuneden hif kinnes men.

[Fol. 61.]

Quað god, "get ic fal pharaon,

Or ge gon vt, don an wreche on, 3124

(Nu fal ic in-to egipte gon,)

Swilc wreche waf ear neuere non;

God tells Moses of his final vengeance upon the Egyptians.

Deigon ðor fal ilc firmc bigoten

Or men and erf, non forgeten; 3128

Each first-born shall be destroyed.

Oc among gu, dredeð gu nogt,

to gu ne fal non iuel ben fogt,

Ne fal ic gu nog[t] loten

Of ðat ic haue gu bi-hoten." 3132

Siðen quað god to moyfen,

"ðif fal gurc firmcft moncð[3] ben, [3 MS. moncd.]

ðoo gunc mon ðo mono fon

The year shall begin,

In april Reke-fille ben." 3136

ðanne he lereden hem newe wunen;

when in April the new moon is seen.

"Euerilc ger, more to munen,

Euerilc huf-folc ðe mai it ðauen

The institution of the Passover.

On ger fep oðer on kide hauen; 3140

ðe tende dai it fulde ben lagt,

And ho[l]den in ðe tende nagt,

And [slagen] on ðe fowrtende dai;

A lamb or kid of the first year is to be taken and slain by each household on the fourteenth day of the month,

So mikil hird fo it noten mai, 3144

Ben at euen folc fum to famen,

And ilc folc if to fode framen,

and to be roasted whole.

[Fol. 61b.]

And eten it bred, and non bon breken,

None of it is to be taken out of the house.

And nogt ðor-of vt hufe wreken, 3148

Oc fod and girt, ftondende, and ftaf on hond,

It is to be roasted whole,

Ilc man after his owen fond,

and eaten with bitter herbs, and unleavened bread.

Heued and fet, and in rew mete[n],

lefen fro ðe bones and eten, 3152

Wið [1] wriðel and vn-lif bread ;" [1 MS. wid.]

The remainder is to be burnt, and the blood is to be sprinkled upon the door-posts.

ðe bi-leuen brennen he bead.

" ðe dure-tren and ðe uuerflagen,

wið yfope ðe blod ben dragen ; 3156

ðat nigt fal ben feft pafche,"

forð-for, on engle tunge, it be.

Vengeance came upon the Egyptians.

ON midel fel, ðat [2] ilc nigt, [2 MS. dat.]

So cam wreche on egipte rigt ; 3160

The first-born of man and beast were slain.

Ilc firme bigeten, of erf and man,

was ftoruen on morwen and dead forðan ;

ðo waf non biging of al egipte

lich-lef, fo manige dead ðor kipte.[3] [3 caught.] 3164

Pharaoh consented to let Israel go.

ðo wurð phara[o]n nede driuen

And haueð [4] hem ðane leue giuen ; [4 MS. haued.]

And egipte folc bad hem faren,

And fwiðe a-weiward hem garen. 3168

The Egyptians gave the Hebrews whatever they asked.

Quat-fo he boden, frud [5] or fat, [5 MS. fruð.]

Egipte folc hem lenen ðat ;

Waf hem nogt werned ðat he crauen,

for here fwinc-hire he nu hauen ; 3172

[Fol. 62.]

Gold and filuer he hauen vt-brogt,

The Israelites numbered 600,000 men.

ðe tabernacle ðor[6]-wið wurð [7] wrogt ; [6 MS. dor.]
[7 MS. wurd.]

He woren fexe hundred ðhufent men,

wið-vten childre and wimmen ; 3176

Al erf-kin hauen he ut-led,

Egipte folc hem hauen ut-fped.

Moses thought of the oath sworn to Joseph.

Almoft redi waf here fare,

moyfes bi-ðogt him ful gare 3180

Of ðat ðe if kin haueð fworen,

Joseph's grave could not be found.

Iofepes bones fulen ben boren ;

Oc ðe ail haueð¹ ſo wide ſpiled, [¹ MS. haued.]

ðat hiſ graue iſ ðor vnder hiled, 3184

On an gold gad ðe name god

Iſ grauen, and leid up-on ðe flod ;

Moyſes it folwede ðider it flet,

And ſtod ðor ðe graue under let ; 3188

ðor he doluen, and hauen ſogt,

And funden, and hauen up-brogt

ðe bones ut of ðe erðe wroken,

Summe hole, & ſumme broken ; 3192

He dede iſ binden & faire loken

Alle ðe bones ðe he ðor token.

Quane he geden egipte fro,

It wurð erðe-dine, and fellen ðo 3196

fele chirches and ideles mide,

Miracle it was ðat god ðor dede.

Gon woren .vii. ſcore ger

Siðen² ioſep waſ doluen ðer ;³ [² MS. Siden.] 3200

And .xxiii. ſcore fro ðan [³ MS. der.]

ðat god it ſpac wið⁴ abrahram. [⁴ MS. wid.]

fro Rameſe to ſokoht ſtede

Non man on hem letting dede, 3204

For ſwinc and murning hem was on,

fro ðo lichos in to ðo orðo don ;

And manige of ðo greten forði

ðat he adden ben hard hem bi. 3208

To burg ethan fer fro ſokoth,

And ðeðen he ten to pharaoth ;⁵ [⁵ MS. pharaofh.]

ðor he ſtunden for to ſen

quilc pharaon wið hem ſal ben. 3212

Pharaon bannede vt hiſ here,

 Iſrael he ðhogte to don dere ;

Sex hundred carte-hird i-wrogt⁶ [⁶ MS. hirdi wrogt.]

vt of egipte he haueð⁷ brogt ; [⁷ MS. haued.] 3216

On horſe fifiti ðhuſent men,

x ſcore ðhuſent of fote ren ;

Marginal glosses:

A golden rod with the name of God upon it was laid upon the flood. Moses followed its course, and thus discovered the grave.

Some of the bones were whole and some broken.

When Israel left Egypt there was an earthquake.

Many temples fell down.

[Fol. 62b.] Seven score years were gone since Joseph was buried.

The Israelites journey from Rameses to Succoth.

From Succoth they go to Etham, and thence to Pi-hahiroth.

Pharaoh called out his army.

Six hundred chariots he brought out of Egypt, fifty thousand horsemen, and ten score thousand men of foot.

Alle he ledde hem vt forði
ðat folc ebru to werchen wi. 3220

Ðif godes folc waf under-numen,
 Quan he fegen ðif hird al cumen,
Sore he gunen for-dredde ben,
for ne cuðen ne¹ gate flen, [¹ ? he no-gate] 3224

And if he ðore ben bi-fet,

Ille he fulen ben hunger gret ;
He ne mogen figten a-gen,

for [he] wið-vten wopen ben ; 3228
ðanne he ðuf woren alle in dred,
On moyfen he fetten a gred.
" Beð nu ftille," quað moyfes,

" ðor god wile(.) if non helpeles ; 3232
Ge fulen fen ðif ilke dai
Quat godes migt for gu mai."
He bad ðif folc dregen wið fkil,
And he bi-fogte godes wil. 3236

Qvað god, " quor-at calles ðu me ?
 Hold up ðin gerde to ðe fe
And del it fo on fundri del,
ðat gu ben garknede weigef wel." 3240

ðo moyfes helde up hif hond,

A wind blew ðe fe fro ðe fond ;
On twel[fe] doles delt ift ðe fe,

xii. weiges ðer-in ben faiger and fre, 3244
ðat euerilc kinde of ifrael
Mai ðor hif weige finden wel.

ðe water up-ftod, ðurg godes migt,
On twinne half, alfo a wal up-rigt ; 3248
Moyfes bad hem, alfo he ben boren,
ðe eldeft kindes gon bi-foren ;

Oc moyfes gede in bi-foren,
And ðo ðe kinde of iuda boren ; 3252
On and on kin, alf herte hem cam,
ðat folc ilc in his weige nam ;

Bi-foren hem fleg an ſkige brigt

Ðat nigt hem made ðe weige ligt ; 3256

Egiptes folc gunnen ðif ſen,

And wenden ðat he wode ben.

Ðis bode herde king pharaon

And him ðuhte ſellic ðer-on, 3260

Garkede his hird & after nam,

And to ðe ſe bi nigte he cam ;

In ferde ðif hird after ðif king,

And ðo ſprong ðe daiening. 3264

Ðhunder, and leuene, and rein ðor-mong

God ſente on ðat hird, ſtið and ſtrong ;

Ðo quoðen ho, " wende we a-gen,

An[d] iſrael folc lete we ben." 3268

Ðor-quiles ben ðo kinges¹ cumen [¹ kindes ?]

Ouer, and hauen ðe londes numen ;

Egipcienes woren in twired wen

 queðer he ſulden folgen or flen ; 3272

And moyſes ſtod up-on ðe ſond,

God him bad helden up hif hond

to-ward ðif water, in a morgen quile

Ðe ſe luked, ſo god it wile,² 3276

And on and on, ſwiðe litel ſtund,

Egypcienes fellen to ðe grund ;³ [³ MS. grunð.]

Of hem alle bi-leaf non fot

Vn-drincled in ðat ſalte ſpot.⁴ [⁴ MS. ſwot.] 3280

Ðvs if iſrael of hem wreken,

 And here welðe if to londe weken,

Wepen, and ſrud, ſiluer, and gold ;

wel hem mai ben ðe god beð hold ! 3284

Moyſes ðor made a newe ſong,

And tag[t]e it al ðat folc a-mong ;

And ilke dai ðat ſeuen nigt,

Ones he ðor it ſungen rigt ; 3288

Side notes:

A cloud went before them.

Pharaoh pursued the Israelites,

and to the Red Sea he came. In went this host after the king.

Some were for going back.

The Israelites reached the land,

and God bade Moses stretch his rod over the sea.

[Fol. 64.]. The sea covered the Egyptians,

and not one remained un-drowned in that salt spot.

Moses made a new song, and taught it to the people.

Each day for a week was it sung over.

² At the bottom of this page is the catchword—" And on and on."

In memory of which are we wont to come seven times to the font at Easter-tide.

Ðor-of in efterne be we wunen

Seuene fiðes to funt cumen.

Ðor quiles he weren in ðe defert,

 God tagte hem weie, wis and pert; 3292

A fair piler fon hem on o nigt,

And a fkie¹ euere on daiges ligt. [¹ MS. afkie.]

The fifth sojourn was in the wil-derness of Shur;

Ðe fifte furiuren ðat he deden,

 In ðe defert fur, on drie ftede; 3296

three days the people were with-out water.

Ðre dages weren he ðider gon,

Ðat he ne funden water non;

At Marah the waters were bitter, but

A welle he funde at marath,² [² read marach.]

Ðe water was biter and al wlath;³ [³ read wlach.] 3300

A funden trew ðor-inne dede

a tree rendered them sweet.
[Fol. 64b.]
The sixth sojourn was at Elim,

Moyfes, and it wurð fwet on ðe ftede.

Ðe fexte furiuren at elim,

 xij welle-fpringes weren on him, 3304

An[d] then⁴ and fexti palme tren [⁴ ten ?]

bi ðo welles men migte fen;

He maden fiðen, fro elim,

and from thence to Sin.

Mani furiuren in ðe defert fin. 3308

Bi-twen elim and finay,

Bread fails them.

 bred wantede, hem was wo forði;

Ðat was on ðe ðrittiðe⁵ dai, [⁵ MS. ðrittide.]

Ðat here wei fro egypte lay, 3312

Ðor he woren hungur for-dred;

They murmur against Moses.

"Ille," he feiden, "haue we fped,

Bet uf were in egipte ben,

Bred and fles ðer⁶ we muwen fen." [⁶ MS. der.] 3316

Moyfes wurð war ðe folc was wroð,

And here gruching ðo god was loð.

"ftille," quað he, "and on-dreg,

Godef fulfum-hed if gu ful neg." 3320

God sends them a flight of fowls,

At euen cam a fugel-fligt,

fro-ward arabie to hem rigt;

Ðor migte euerilc man fugeles taken,

So fele so he wulden raken; 3324

On morgen fel hem a dew a-gein.
firſt he wenden it were a rein,
knewen he nogt ðiſ dewes coſt ;

It lai ðor, quit als a rim[1] froſt, [1 MS. rin.] 3328

He ðe it fogen,[2] feiden, " man hu," [2 MS. logen.]
Manna for-ði men clepeð it nu.

Quad moyſes, " loc ! her nu [iſ] bread,
Ille gruching iſ[3] gu for-bead." [3 ? ic.] 3332

A met ðor was, it het Gomor,
Ile man iſ he bead, and nummor,
Him gaderen or ðe funne-fine,
Elles he fulden miſſen hine. 3336

for it malt at ðe funne-fine,
Oc oðer fir for-hadede hine.

To duſt he it grunden and maden bread,
ðat liuni and olies ðef he bead ; 3340
Quo-fo nome up forbone mor,
it wirmede, bredde, and rotede ðor.

Moyſen dede ful ðe gomor,
In a gold pot, for muning ðor. 3344
Held it fundri in clene ſtede,
And in ðe tabernacle he it dede.

Wið ðiſ mete weren he fed,
fowerti winter vten leð,[4] [4 led ?] 3348
Til he to lond canaan
Comen(.) ðat god hem giuen gan.

Forð nam ðiſ folc, ſo god tagte him,
 to ðe deſert of rafadim ;[5] [5 MS. rafaclim.] 3352

Tidlike hem waſ ðat water wane,
ðor he grucheden for ðriſt hane ;[6] [6 MS. haue.]

Harde he bi-haluen ðer moyſes,
And to god he made is bi-men. 3356

"Louered," quad he, " quat ſal ic don ?
He fulen me werpen ſtones on."

Quað god, " go ðu to erebiſ ſton,
And ſmit wið ðin gerde ðor-on." 3360

Marginal glosses:

and on the morrow a dew,

like rime froſt ;

" Man-hu," said they, wherefore they called it Manna.

[Fol. 65.]

Each man gathered an omer of it before the sun shone,

for it melted at the sunshine.

When ground and made into bread, it tasted like wafers made with honey.

Moses filled an omer of the manna,

and placed it in the tabernacle.

Forth came this folk, and came to Rephidim,

where they murmured for thirst, and did chide with Moses.

[Fol. 65b.]

God sent him for water to a rock in Horeb.

It was a ſtede henden ðor-bi,

Moses smote the rock,
On a ſyde of munt ſynay ;

And he ſmot wið his wond ðor-on,

And water gan ðor-vten gon ;　　　　3364

and the people had enough to drink without toiling for it.
Anog adden he ðanne drinc,

Redi funden wið litel ſwinc ;

This place was called Temptation.
ðat ſtede waſ cald temptatio,

for he ðo god fondeden so.　　　　3368

Amalek comes to war against Israel.
A malec, yſmaeles ſune,

Was ðor hende rafadim [1] wune,　　[¹ MS. rafaclim.]

He welte ðor ſtone and iaboch,

ðat herdes folc him louerd toch ;　　　　3372

Wopened he ben a-gen iſrael.

Moses sends Joshua with the army to fight with Amalek.
Moyſes ear it wiſte wel,

And ſente agen hem king ihesum,

wið folc iſrael wopened ſum ;　　　　3376

He let bi-aften ðe [2] more del,　　[² MS. de.]

Moses, accompanied by Aaron and Hur, goes up to the top of a hill, and prays for the folk of Israel.
[Fol. 66.]
To kepen here ðing al wel.

He, and aaron, and hur ben gon,

Heg up to a dune ſone o-non ;　　　　3380

Moyſes bad [for] folc yſrael,

And hiſe benes hem holpen wel ;

Ai quiles he up iſ hondes bead,

Amalek is overcome by the holding up of Moses' hands.
Amalechkes folc fledde for agte of dead,　3384

And quane he let [3] iſ hondes niðer,　　[³ MS. leth.]

Amalech folc fagt hard and wiðer ;

Quane it wurð war, vr [4] and aaron　　[⁴ MS. ut.]

He iſ under-leiden wið an ſton,　　　　3388

Til ſunne him feilede in ðe weſt ;

Thus Moses fought best of all.
ðus fagt Moyſes ðor alðer-beſt.

Amalech fleg, and iſrael

Hadde hegere hond, and timede wel.　　3392

ðo ſente god to moyſen,

wið ðis timing to muning ben,

The future destruction of Amalek.
" Get ſal ðe kinde of amalech

Ben al fled dun in deades wrech."　　　　3396

Moyſes made ðor alter on,

" Min blif" iſ name ðor-one don.

Ð^O cam ietro to moyſen,

 To ſpeken him and ðo kinnes-men, 3400

And ſephora, moyſes wif,

And hire two ſunes of faiger lif ;

Ietro liſtnede moyſes tale,

Of him and pharaon ðe dwale, 3404

And ðhankede¹ it almigten wel, [¹ MS. ðahankede.]

ðat waſ bi-tid for iſrael ;

And at wið moyſen feſtelike, [Fol. 66b.]

And tagte him fiðen witterlike 3408

Vnder him helpes oðere don,

ðat folc ſtering to ſtreng[t]hen on.

Al bi ðhuſenz ðiſ folc was told,

Ilc ðhuſent adde a meiſter wold ; 3412

And vnder ðiſ tgen ² ſteres ben, [² ten ?]

Ilc here on hundred to bi-ſen ;

Vnder ðis ilc two ſteres wunen,

And vnder hem fif oðere numen ; 3416

Ilc of ðe .v. ſteres-men

Vnder hem welden in ſtere tgen.²

If ymong .x. wurð ogt miſ-don,

Here ſtere rigten [fulde] ðor-on, 3420

And if he ne mai it rigten wel,

Taunet iſ meiſter euerilc del ;

And if he rigten it ne can,

He taune it al hiſ ouer-man, 3424

Ai ſo forð fro man to man,

Til he it here, ðe rigten can ;

If it ne mai or rigted ben,

ſo ſal it cumen to moyſen. 3428

He bad him cheſen ſtereſ-men

Migti, ðe gode-frigti ben,

ðe ſoð-faſtneſſe lef ben,

And ðe niðing [and] giſcing flen. 3432

GENESIS. 7

Moses raises an altar.

Jethro visits Moses,

bringing with him Zipporah and her two sons.

Moses relates to him the destruction of Pharaoh.

Jethro counsels Moses to appoint rulers of the people,

rulers of thousands,

rulers of hundreds,

rulers of fifties,

and rulers of tens.

An appeal to be made from the ruler of ten,

to the ruler of hundreds,

and thence to the superior ruler.

The final appeal to be made to Moses.

These rulers were to be able men, god-fearing, lovers of truth, and haters of covetousness.

[Fol. 67.]
Moses accepts the counsel.

Ðif red ðhugte moyfes ful god,

And leuelike it under-ftod.

Ietro wente in-to his lond a-gen ;

Al[f] he redde, al-fo gan it ben. 3436

In the third month of the year Exodus, and in the forty-seventh day after they left Egypt,

De ðridde moneð in if cumen,

 To fynay ðif folc if numen ;

ðe feuene and forwerti dai

ðat he nomen fro egipte awei, 3440

the people come to the desert of Sinai.

Vnder ðif munt he funden fteden,

And here teldes ðor he deden.

On oðer daiges morgen quile,

God tauned[1] moyli quat he wile. [1 ? tauneð.] 3444

" Sei ðif folc ðat nu ðolen,

God's message by Moses unto the people out of the mount.

for if here ðhogt nogt me for-holen ;

' If ye liften lefful to me,

Ic wile min folc owen be.' " 3448

And moyfes tolde ðif ifrael,

And him heten euerilc del,

ðat hem bideð, fulen he don.

God dede moyfes ðif bodeword on, 3452

The people are to be prepared against the third day.

" Clenfe ðif folc wel ðif to daiges,

And bidde hem leden clene la[i]ges ;

Abute ðif munt ðu merke make,[2] [2 MS. made.]

If erf or man ðor-one take, 3456

The mountain must not be touched.

It dead ðolen, wið ftones flagen,

Or to dead wið goren dragen ;

[Fol. 67b.]

ðif frig[t]ful [folc] ðus a-biden,

Quiles ðif daiges for[ð] ben gliden." 3460

On the third day there were thunders and lightning and a thick cloud upon the mount.

De ðridde daiges morge quile,

 ðunder and leuene made fpile,

On ðif munt ftod, and fkies caft,

And dinede an migtful hornes blast ; 3464

Smoke up reeked and the mount quaked.

Smoke up-rekeð and munt quakeð,

Slep ðor non ðe[2] ðane up-wakeð ; [2 MS. de.]

Ai was mofes one in ðis dine,

ðif folc wende hauen for-loren hine ;[3] [3 MS. himine.]

Oc he cam faiger and ſer him to,

And gan wiðr hem ſpeken ſo ;

 Moses addresses the people.

" Ilc gure wel in herte mune,

Ne iſt nogt moyſes, amrame ſune, 3472

Ꝺe ge ſulen to dai here ſpeken ; *He reminds them of their deliver-*

Oc he ðe ſlog, gu for to wreken, *ance from the Egyptians,*

Egypte, an weige made in ðe ſe,

And let adam fonden ðe tre 3476

Ꝺe noe barg, and abraham

Ledde vt in-to lond canaan ; *and of God's kindness to their*

Of olde abraham and of ſarra bigeten *ancestors, to Abraham, to*

Dede yſaac, of olde teten ; 3480 *Isaac, and Jo- seph.*

Ꝺe gaf yſaac ſo manige ſunen,

Ꝺe Ioſep dede ſo riche wunen ;

His word gu wurðe digere[1] al-ſo lif, [1 = dgere = diere

Digere[1] or eiðer child or wif. = dere.]

Cumeð her forð, and beð alle reken, [Fol. 68.]

And lereð wel quat he ſal ſpeken."

He ledde hem to ðe muntes fot, *Moses leadeth the people to the*

Non but non[2] forðere ne mot, [2 ? Nun.] 3488 *foot of the mount.*

And on if broðer aaron ;

God bad hem ðat merke ouer-gon ;

Ꝺo ſo ſpac god ſo brigt like,

Ꝺat alle he it herden witterlike. 3492 *The Ten Com-mandments. First Command-ment.*

L Oke ðat ðu god oðer ne make,
 Ne oðer ðan me ðat ðu ne take.

for ic am god, gelus and ſtrong,

Min wreche if hard, min ðole if long. 3496

T ac ðu nogt in idel min name[n], *Third Command-ment.*
 Ne fwer it les to folo in gamen,

Ne let ðu nogt min wurðfulhed

for faren in ðe fendes red. 3500

M in hali dai ðu halge wel, *Fourth Com-mandment.*
 An do ðin dede on oðer fel.

W urð ðin fader and moder ſo, *Fifth Command-ment.*
 Ꝺat ðu hem drede and helpe do. 3504

Sixth Commandment.

Ne flo ðu nogt wið hond ne wil,
 Ne rend, ne beat nogt wið vn-fkil;
Help de nedful, ðat he ne be dead
 for truke of ðin helpe an[d] read. 3508

Seventh Commandment.

Oc horedom ðat ðu ne do,
 Ne wend no lecherie to.

[Fol. 68b.]
Eighth Commandment.

Loke ðe wel ðat ðu ne ftele,
 Ne reflac, ne ðefte, for-hele.[1] 3512

Ninth Commandment.

Falfe witneffe ðat[2] ðu ne bere, [2 MS. dat.]
 Ne wið ðe lefe non ma[n][3] ne dere.

Tenth Commandment.

Ne gifce ðu nóg[t] ðin neftes ðing,
 Huf, ne agte, ne wif, in ðin gifcing; 3516
For if ðu it gernes and giffe,
 ðu tines vn-ended blifce."

The Israelites at the foot of the mount are in great dread and fear.

Dif for-frigted folc figeren ftod,
 dredful, and bleð, and fori mod; 3520
Herden ðat dredful beames blaft,
Sogen ðat figer, dred held hem faft.
ðo feiden he to moyfen,

They intreat Moses to stand between them and God.

"Be ðu nu god and us bi-twen, 3524
Her nu quat god fal more queðen,
And tellet uf fiðen her bi-neðen."
And moyfes fteg up a-non,

God gave to Moses many commandments and laws,

God hem bad bodes manige on 3528
And lages; and hu he fulen maken
ðe tabernacle, and wor-of taken

instructed him concerning the making of the Tabernacle,

ðe gold, and filuer, and ðe bras,
ðe fyðen don ðor-on[4] was, [4 MS. dor-on.] 3532
And nemeld it befeel,

and gave him two tables of stone upon which were written the Ten Commandments.

And two oðere to maken it wel;
And gaf to[5] tabeles of fton, [5 two ?]
And .x. bodeword writen ðor-on. 3536

[Fol. 69.]

Dor quiles moyfes was up wið gode,
 And liftenede al ðat leue bode,

¹ MS. for for hele. ³ MS. ma.

Swilc wod-hed ðif folc [1] cam on,

ðat he feiden to aaraon, 3540

" Mac vs godes foren us to gon,

of moyfes haue we helpe non."

Aaron and vr ftoden a-gen,

And boden hem fwilc ðhowtes leten ; 3544

ðat wod folc ðor ur of dage

Brogten, and deden aaron in age ;

Here faigere ringes hc boden taken,

And don in fier, and geten, and maken 3548

An calf of gold, and [an] alter

Made ðat folc, and lutten it ðer,

And ðat calf ofrendes deden,

And made gret feft in ðat ftede[n]. 3552

Ðo fcide god to moyfen,

" Go ðu nu dun ðin folc to fen,

He hauen fineged and mifdon,

Let me taken wreche ðer-on." 3556

" Loruerd,[2] merci ! " quad moyfes,

" get ne let hem nogt helpe-les ;

If he nu her wurðen flagen,

Egipte folc fal ðor-of ben fagen, 3560

And feyen ðat he ben bi-fwiken,

In ðe defert wel liðerlike ;[3]

And ðenk, louerd,[2] quat hen bi-foren

Abram, and yfaac, and iacob fworen." 3564

God liftnede wel [4] al ðis anfwere ;

ðat he ðis folc al ðer [5] ne dere.

And moyfes gan neðer-ten,

And Iofu cam him a-gen, 3568

Alf he was ilc dai wune to don,

quil moyfes ðat munt was on.

Quat Iofue to moyfi,

" Ic wene he figten dun her-bi," 3572

The people, in the absence of Moses, said unto Aaron,

" Make us gods to go before us,"

and compelled him to make a molten calf,

which they worshipped.

God is angered thereby.

[2 MS. louerð.] Moses intreateth for them.

[3 MS. liðerlike.]

[Fol. 69b.]

God listeneth to Moses, and is appeased.

[5 MS. alðer.]

3568 Moses came down with the tables,

[1] MS. has " ðif folc " twice over.
[4] MS. wel and wel.

"Nai, for gode," quad moyſes,

"It if a ſong wikke and redles."

and seeing the idolatry of the people, he brake them in pieces.
Moyſes cam ner and ſag ðif plages,[1] [1 MS. wlages.]

And ðif calf, and ðif ille lages; 3576

So wurð he wroð, o mode ſarp,

Hif tables broken dun he if warp,

The calf he burnt and ground to powder, and mixed it with the water they drank.
And dede ðat calf melten in ſir,

And ſtired it al to duſt ſir, 3580

And mengde in water and forð it of,

And gaf ðat folc drinken ðat drof.

ðo wiſte he wel quilc hauen it don,

Sene it was here berdes on. 3584

ðo gredde he lude, "goð me to,

Alle ðe god luuen so."

Moses caused the idolaters to be put to death.
Frend ne broðer ne ſpared he nogt

On of hem ðat haued ðif wunder wrogt; 3588

[Fol. 70.]
Of ðo ðe weren to ðif red,

The number slain were about 3000.
.xxx. hundred to ðe dead

woren ðane don ſone a-non,

ðurg ſtrengðe of moyſes and aaron; 3592

On oðer ſtede men writen ſen,

xxiii. ðhuſent ðat ðor ben;

On the morrow, Moses reminded the people of their sin.
Do woren on liue ſumdel les.

 On oðer dai quad moyſes, 3596

"Michel ſinne haue ðe [2] don,[3] [2 ge ?]

Ic ſal gon ſeken bote her on."

He returned to Mount Sinai to seek God's mercy.
Eft he ſteg up to munt ſynay,

for to bi-ſeken god merci. 3600

"Louerd," quad he, "ðin meðe if god,

Merci get for ðin milde mod![4] [4 ? milde-hod.]

Or ðu ðif folc wið milche mod,[5] [5 MS. moð.]

Or do min name ut of ðin boc." 3604

God promises to send his angel before the people.
God anſwerede, "of ſal ic don

 Hem, ðe arn nogt to ben ðor-on;

Go, led ðif folc, min engel on

[3 MS. Michel ſinne quað haue ðe don.]

Sal ic don ðe bi-foren gon." 3608
Ebrus feigen it waf michael
Engel ðe fiðen ledde hem wel.
Moyfes faftede fiðen to pligt
xl. daiges and xl. nigt; 3612
Oðere tables he brogte eft(.) writen, *Moses received other tables.*
And funne-bem brigt fon if wliten
ðat folc on him ne migte fen [Fol. 70b.]
But a veil wore hem bi-twen. 3616
Ðo waf ðif folc frigti and rad *The Israelites offer Moses gold and silver for the tabernacle.*
To don al ðat moyfes hem bad ;
Offreden him filuer and golde,
And oðer metal fwilc he wolde ; 3620
He it bi-tagte beffeleel, *Bezaleel and Aholiab are appointed for the work of the tabernacle.*
And eliab, he maden wel
ðe tabernacle alf hem was tagt,
Goten and grauen wið witter dragt ; 3624
.vii. moneð ðor-buten he ben, *Seven months they were about it.*
And here fwinc wel he bi-ten ;
for fwilc huf was ear neuere wrogt,
Ne fwilc fafte her on werlde brogt ; 3628
God it tagte al ear moyfen *God taught Moses the fashion of it.*
Wiflike hu it wrogt fulde ben,
Quilc frud, quat offrende, quilc [1] lage, [1 MS. qu[i]l.]
And quat for lune, and quat for age. 3632
Aaron biffop, oðere of ðat kin, *Aaron and others of his kin were appointed to serve in the tabernacle.*
Sette he hem for to feruen ðor-in.
Bokes he wrot of lore wal,
Hu ðif folc hem rigt leden fal, 3636
Betten mif-dedes, and clene lif
Leden, wið-uten [h]ate and ftrif.

Twelf moneð forð ben alle cumen, *Twelve months passed ere the people departed from Sinai.*
 Or he fro fynay ben forð numen ; 3640
On ðat oðer twenti'ðe [2] dai, [2 MS. twentide.] [Fol. 71.]
of ðe oðe[r] moneð [3] tagte he wei ; [3 MS. moned.] *On the twentieth day of the second month (in the second year),*
ðat brigte fkie bi-foren hem fleg,[4] [4 MS. flegt.]

the Israelites de-
parted from Sinai,

And ðif folc ðor after teg. 3644

Ðre dages and nigtes faren it gan

and came into the
wilderness of
Paran.

And wið-ftod in ðe deferd pharan ;

Ðif folc if after fofte togen,

For their com-
plaining,

And hauen fwinc in weige drogen ; 3648

for ðat fwinc he grucheden ðor,

Ðor-fore hem cam on more for.

the fire of the
Lord consumed
them,

fier if on hem bi-fiden ligt,

fele it brende and made o-frigt, 3652

but is quenched
by the prayers of
Moses.

Moyfes it bleff[ed]e wið his bede,

And brenninge he calde ðat ftede.

Here hine-folc ðe waf hem mide,

 And fumme of hem ðor ille dede, 3656

The people lust
for flesh and
loathe manna.

He gerneden after oðer mete[n],

Of manna he ben for-hirked to eten ;

He greten up-on moyfen,

And he to god made his bi-men. 3660

Moses complains
of his charge.

" Loruerd !" quad he, " ðif folc if ðin,

And al ðis forge nu if min ;

But ic haue an oðer [1] read, [1 MS. oder.]

Ðu falt me raðe don [2] ðolen dead." [2 MS. ðon.] 3664

God commands
him to choose
seventy wise
men to help him
 [Fol. 71b.]
in the govern-
ment of the
people.

Quað god, " ches ðe nu her feuenti

Wife men to ftonden ðe bi,

And ic fal hem geuen witter-hed,

And he ðe fulen don helpe at ned ; 3668

And ðin folc fal to-morgen bi-geten

ynog fles(.) into a moneð [3] for to eten." [3 MS. moned.]

Moyfes was bliðe an glad [4] of ðis, [4 MS. glað.]

The appointment
of seventy elders.

 And ches ðo men [ðe] god made wif; 3672

waf here non of herte dim,

prophetis he weren and holpen him.

Fro lond ortigie cam a wind,

 And brogte turles michel mind ; 3676

Quails are sent in
wrath at Kibroth-
Hattaavah.

It flogen longe, and ðikke, and wel

Abuten ðe folc of yfrael ;

For two days the
fowls came.

Two daiges hem ben fugeles cumen,

So fele he wilen, he [h]auen numen, 3680
And dried and holden to eten ;
Oc god ne wile¹ it nogt for-geten ; [¹ MS. wile he.]
Ðat gruching hauen he derre bogt, The Lord smote the people with a plague because of their murmuring.
fier haueð² on hem ðe wreche wrogt, [² MS. haued.]
Brend and doluen waſ ðat folc ſoth ; 3685
Ðat ſtede beð cald ðor-fore cabroth.

FOrð he nomen to aſſaroth, The people come to Hazaroth.
 Ðor wurð maria ſumdel ſoth,³ [³ ? sot.] 3688 Miriam speaks against Moses,
for ſche ðor haueð wið moyſes fliten ;
ðor wurð ghe ðanne wið lepre ſmiten, and is smitten with leprosy.
And vten ſundred .vii. nigt,
In grot and in ſrifte, ſore offrigt ;⁴ 3692
Moyſes bi-ſogte, and ſche wurð ſer [Fol. 72.]
And frend, and cam ðat⁵ broðer ner. [⁵ MS. dat.]

FOrð nam ðiſ folc ſiðen fro ðan The people remove from Hazaroth and come to Paran.
 fele iurnes in-to pharan ; 3696
Forð waſ gon al ðeſe oðer ger,
ðo he woren at ſyon-gaber ;
Fro ðeðen⁶ he ſente forð to ſen, [⁶ MS. ðeden.] Men are sent to search the Land of Promise.
Quilc ðo riche londes ben, 3700
ðat god hem ſulde bringen in ;
On man he ſente of ilc kin. One is sent from each tribe.
xii. ſondere men ðor vte faren,
ðiſ hoten lond ðurg-vt he charen, 3704
xl. daigeſ faren ben ; The spies having been away forty days,
Bi ðanne quanne he wenten a-gen,
In-to cades ðe folc was ſogt.
ðeſ .xii. ðider hem hauen brogt 3708
Of ðe plenteð ðe god ðor gaf,
An win-grape on an cuuel-ſtaf, return bringing with them of the plenty of the land.
And tolden hem ðe lond iſ god,
ful of erf and of netes brod ; 3712
Oc burges ſtronge and folc v[n-]frigt, In Hebron they found walled cities, stalworth men, and giants.
ftalwurði to weren here rigt ;

⁴ At the bottom of the page is the catchword—"Moyſes bi-ſogte, &."

And geteniſſe men ben in ebron,

Quile men mai get wundren on.　　3716

The Israelites murmur at the news.

Ðiſ folc ðo ſette up grot and gred,

And ſeiden he folwen iuel red;

[Fol. 72b.] " Betre iſ vs get we wenden agen

And in egipte ðralles ben,　　3720

Ðan we wurðen her ſwerdeſ ſlagen,

" A captain," said they, " we will make, and return into Egypt."

And ure kin to forge dragen;[1]　　[1 MS. ðragen.]

An loder-man we wilen us ſen,

And wenden in-to egipte agen;　　3724

Joshua and Caleb endeavour to still them.

Ðo quad Ioſue and calef,

" Leateð ben ſwilc wurdes ref,

And doð nogt god almigten wrong,

If milce iſ mikel, iſ ſtrenge iſ ſtrong."　　3728

God threatens them.

Ðor ðrette god hem alle to ſlen,

If moyſes ne wore ðor agen;

For Moses' sake he spareth them.

Oc for iſ benes and for iſ ſake[n],

got he ſal wið hem milche maken,　　3732

The murmurers are deprived of entering the land.

Oc alle he ſulen wenden a-gen,

And in ðe deſert longe ben;

And on ðe .xx. winter hold

or mor ut of egipte told,　　3736

Ðat hauen ðuſ often fand,

Ne ſulden welden ðat leue land,

Joshua and Caleb are excepted.

Wið-vten Ioſue & calef,

Here rigt-wiſed waſ gode lef.　　3740

Much sorrow came upon the people.

Moyſes told hem al ðis anſwere,

And he ben ſmiten in forweſ dere;

Yet thirty-seven years shall they be in the desert.

Get he ſulen .xxx.vii. ger

In ðe deſert ben vten her.　　3744

[Fol. 73.] Agen he maden here dragt,

Al-ſo ðat ſkie haueð[2] tagt.　　[2 MS. haued.]

Oſwas was moyſes eam,[3]　　[3 MS. cam.]

And chore was iſ bernteam;　　3748

Korah, with two hundred and fifty princes, rebel against Moses.

Ille nið iſ herte wexe on

A-gen moyſen and aaron,

Hem two .ii. hundred men,
And two¹ ðo .xl. and ten ; [¹ to ?] 3752
He feiden he weren wurði bet
to ðat feruife to ben fet ;
And two migtful he hauen taken,
Meiftres princes he wolden hem maken, 3756
On dathan(.) an oðer Abiron.
Moyfes it herde and feide a-non,
"To-morwen beð her alle redi,
And ile gure oðer ftonde bi ; 3760
And ilc gure hife reklefat,
And fier ðor-inne and timinge on ðat,
And ðan fuldo wo brigte fon,
Quile gure fal god quemest ben." 3764

And ðuf it waf on morgen don,
 Ne wulde he, dathan(.) ne abiron,
For orgel pride forð ðor cumen ;
Moyfes wið² folc if to hem numen, [² MS. wid.]
In here teld he ftonden a-gen 3769
Moyfes and vr, [&] ne wulde gon ;
Moyfes ðor gret and bad if bede,
And erðe denede³ fone in ðat ftede, [³ MS. deuede.]
And opnede vnder [h]ere fet ;
Held up neiðer fton ne gret,
Alle he funken ðe erðe wið-in,
Wið wifes, and childre, and hines-kin, 3776
Swilc endefið vn-bi-wen hauen ;
darð⁴ noman fwinken hem to grauen, [⁴ MS. ðarð.]
ðif erðe if to-gidere luken,
Als it ne were neuere or to-broken. 3780

For chore wel wifte ðat
 Gret fier wond vt of is reclefat,
And of if fere on and on,
And for-brende hem ðor euerilck on ; 3784
Oc aaron al hol and fer,
Cam him no fieres fwaðe ner ;

They said they
were more worthy
to perform the
services of the
Tabernacle.

Dathan and
Abiram were
joined to Korah.

Moses' directions
to the company of
Korah.

Dathan and
Abiram would not
obey the com-
mand of Moses.

The earth swal-
lowed up Korah.

None had need to
toil in burying
them.

A fire came from
God,

and burnt the two
hundred and fifty
men.

Of the censers were made crowns for the altar of brass.

Of ðo Reklefates for wurðing,
Woren mad, and for muning, 3788
Corunes at ðe alter of bras,
ðe at here tabernacle was.

On the morrow the people murmured against Moses and Aaron, who fled to the Tabernacle.

For al ðis, oðer day ðor waſ neſt,
 Agenes moyſes and iſ preſt 3792
Gan al ðiſ folc wið wreðe gon,
And wulden hem werpen ſtones on;
To ðe tabernacle he ben flogen,
ðor [h]aueth a ſkie hem wel bi-togen; 3796

[Fol. 74.] A fire slew many of the people.

A fier magti ðat folc ſeſt on,
And haueð manige ðor for-don.
ðan bad moyſes aaron,
wið hiſe Rekelefat, to ðat fir gon; 3800
And he it dede[1] alſ he him b[e]ad, [1 MS. ðede.]

Aaron stays the plague.

Ran and ſtod tuen[2] liues and dead, [2 MS. tiren.]
And ðiſ fier bleſſede and wið-drog,
It [h]adde or ſlagen manige ynog; 3804

Fourteen thousand and eighty were thus slain.

.xiiii. ðhuſent it haueð ſlagen,
And .iiii. ſcore of liue dragen.

The Israelites do not recognise Aaron's authority,

Dog ðiſ folc miðe a ſtund for-dred,
 ðog he ben get in ſunder red, 3808
Get he aglen on here red(.) and wen
ðat it mai loked betre ben;
ðog ðiſe brende ben for-ſaken,
ðog he wenen ðat god ſal taken 3812

but think that others are fitted for the service of God.

Of ðo .xii. tribuz ſumme mo,
To ben ðor he for-hu-gede ðo,
Or ynog raðe of euerilc kin,
He wile ðat ſumme ſerue ðor-in. 3816

Moses addresses the people,

"Childre," qat moyſes, "gure ſtrif
dereð ðe fowle and greueð ðe lif;
Do we uſ alle in godes red,

and directs each prince of the tribes to take a rod, and to write every man his name upon it.

Vs ſal timen ðe betre ſped; 3820
Ilc prince me take hiſe wond,
And do we us here in godes hond;

And on [ilc] wond writen sal ben [Fol. 74b.]
Ðe kindes name ðe ðor to tgen ; 3824
God sal to-morgen token don,
Quilc kinde he wile ðis mester on.
Ðus it was don, and on a wond
Wið-uten¹ ðo wrot he wið hond [¹ MS. wid-uten.]
Ðe twelfte names of ðat kin ;
Ðe tabernacle he dedis in,
And ðor he is haued god bi-tagt,
And let is ben ðor al ðat nagt. 3832

O morgen quan he com a-gen,
 Quat was bitid he let hem sen ;
Ilc wond he fond of euerilc kin
Alf swilc alf he is dede ðor-in ; 3836
Oc on, ðe was of aaron,
(Writen was name leui ðor-on),
It was grene and leaued bi-cumen,
And nutes amigdeles ðor-onne numen ; 3840
Ðo wisten he ðat² aaron [² MS. dat.]
Was hem bissop ðurg god don ;
To sen gode witnesse ðor-on,
Ðat wond was in ðat arche don. 3844
[I]N ðe desert he wuneden ðor
.xxx.vii. winter and mor ;
Longe abuten munt seyr,
folgede hem ðat skie scir, 3848
And often to ðe se ðor-bi,
And often to ðe munt fynay ;
Ier and gund ðor he biried lin,
Alle he³ olde deden ðor fin. [³ ðhe ?] 3852
And at ðe laste ne-ðe-les,
Eft he come sone to cades,
Ðor was moyses sister dead ;
Ðat folc ðor .xxx. daiges a-bead, 3856
And after wune faire hire bi-stod,
wið teres, rem, and frigti mod ;

The rods were
written upon,

and laid before
the Lord in the
Tabernacle.

On the morrow
the rods were
examined,

and Aaron's rod,
of the house of
Levi, had budded,
blossomed, and
brought forth
almonds,

so it was seen
that God had
appointed Aaron
as bishop.

Thirty-seven
years and more
the people abode
in the desert,

[Fol. 75.]
wandering about
from place to
place,

and all the old
ones died.

At Kadesh
Miriam died,

and her body was buried in Mount Zin.

Hire lich if biried in munt ſin,

Hire ſowle if reſted ſtede wið-in. 3860

It bi-tidde after hire dead

The people murmur for water.

Ðat ðis folc forge in ðriſte abead.

And ðer rof wreððe and ſtrif a-non

Agen moyſen and aaron ; 3864

Moses is commanded to gather the people before the rock at Meribah.

God [bad] femelen folc and gon,

And foren hem ſmiten on ðe ſton

And ſeide, ut of ðe ſmiten ſton

Ynog hem fulde water gon ; 3868

He and hiſ folc comen ðer-to,

Ic wene frigtlike ðat he do ;

Ones he ſmot ðor on ðe ſton,

Moses smote the rock twice, and the water flowed forth,

And miſte, and ſag ðe water gon ; 3872

An oðer ſiðe he went if ðogt

Betre and ſoftere, and ne miſte nogt,

[Fol. 75b.]
and the folk and cattle had enough.

Ðo flew ðor[1] water michil and ſtrong, [[1] MS. dor.]

Al folc and erue a-nog a-mong. 3876

The people are denied a passage through Edom.

Ðvrg lond edom ne migten he faren,

 Ðor-fore he fulen a-buten charen

Bi ðe deſert of arabie lond ;

Long weige and coſtful he ðor fond, 3880

forð bi archim ðat meiſter burg ;

Ðe deſert aren he walkeden ðurg,

They come to Mount Hor,

Til ðat[2] he comen to munt hor ; [[2] MS. dat.]

Aaron ðo wente of liwe ðor, 3884

where Aaron dies.

Eleazar, if ſune, him neſt

Was mad biſſop and meiſter preſt.

Thirty days the folk mourned for him.

xxx. daiges ðat folc in wep

Wið bedes, and gret, and teres wep ; 3888

Get iſt ſene, on ðe munt on ðat ſtede,

Quor men aaron in birieles dede ;

The age of Aaron.

vii. ſcore ger and .iii. told,

Ðor he lið doluen on ðat wold. 3892

Forð ðeðen he comen to ſalmona,

The people murmur,

 for-weried grucheden he ðoa,

Ðor-fore hem cam wrim-kin among,

Ðat hem wel bitterlike ftong ; 3896 and are plagued
 with serpents.

Non oðer red ðor don ne waf,

Moyfes ðor made a wirme of bras, They, repenting,
 are healed by a
And henget hege up-on a faft, serpent of brass,

Ðurg godes bode and godes craf[t] ; 3900

Quat ftungen man so fag ðor-on, [Fol. 76.]

Ðat werk him fone al was vn-don ;

Digere it was al ðat berem-tem,[1] [¹ beren-tem ?] which long after-
 wards was wor-
figer fiðen in-to ierusalem ; 3904 shipped in Jeru-
 salem.

oc fiðen it waf to dufte don,

for ðat folc mifleuede ðor-on.[2]

Frigti nam forð ðis folc and bleð, The people come
 to Zered.
 Til he comen to flum iareth ; 3908

Ðif water him on-funder drog,

And let hem ouer, drige ynog ;

King ouer(.) amor(.) reos(.) feon, Sihon, king of the
 Amorites, comes
for to figten cam hem ageon ; 3912 out against Israel
 and is overcome.

Ðif folc him flog and hif lond tok,

Suð fro arnon, norð to iabok,

And weften al to flum iordan ;

Oc he flugen king of bafaan. 3916 The king of Ba-
 shan is slain.
To lond moab drugen he fo,

Ðor nu if a burg, ierico.

Balaac king was for-dred for-ðan,

 And fente in to lond madian, 3920

To hife frend ðe ben him neft ;

And fente after balaam ðe preft, Balak sends after
 Balaam,
Wið riche men an[d] giftes oc,

for to ftillen hife [vn-]eðe mod, 3924

And bad him cumen for to don

fol[c] of yfrael hif curfing on. to curse the folk
 of Israel.
Balaam wið-[h]eld him ðor ðat nagt [Fol. 76b.]

To witen quat him fal wurðen tagt ; 3928 The failure of the
 first message.
Al waf if fultum and hif fped

 ² For this see 2 Kings, xviii. 4.

Bi-luken ille, in fendes red.

On nigt him cam fonde fro gode, 3931

Agen ðif kinges [¹ MS. ginges.] red for-bode, [¹ MS. ginges.]

God forbids Balaam to curse the Israelites.

And ðat he ne curfe non del

ðif folc ðat god blifcede wel.

O morgen feide he, " fare ic nogt,

for bode if me fro gode brogt." 3936

Balak's second message to the prophet.

Balaac fente richere an[d] mo

Medes, and oðer men to ðo.

" Sondes, fondes," quað balaam,

Or he ðefe oðere medes nam, 3940

Balaam's answer to the messengers.

" Ðog balaac king me goue hold,

Hif huf ful of filuer and of gold,

Ne mai ic wenden her bi-neðen ;"

Godes wurd if cumen alf it if queðen ;² 3944

Oc or or ge wenden agen,

ðif nigt ic fal fonden and fen."

Quat tiding so it cam on ðe nigt,

On morgen, at ðe daiges ligt, 3948

He consents to go with the princes of Moab,

Vp-on hife affe hif fadel he dede,

To madian lond wente he hif ride,

And wente if herte on werre ðhogt ;

Wicke gifcing it haueð³ al wrogt. 3952

being influenced by covetousness. [Fol. 77.] An angel meets him in the way. The ass is frightened,

ðuf rideð forð ðif man for-loren,

An angel drog an fwerd him bi-foren,

ðif affe wurð fo fore of-dred,

Vt of ðe weige it haueð him led. 3956

Sellic ðogte balaam for-ði,

And bet and wente it to ðe fti

Bi-twen two walles of fton ;

and turns aside to the wall,

Eft ftod ðif angel him a-gon,⁴ [⁴ ? agen.] 3960

ðif affe if eft of weige ftired,⁵ [⁵ ? ftirt.]

So ðat balames fot if hird ;⁶ [⁶ ? hirt.]

so that Balaam's foot is crushed.

And he wurð ðo for anger wroð,

And ðif prikeð and negt floð ; 3964

² MS. queden. [³ MS. haued.]

forð and narwere ðif affe him bar,

And ðe ðridde fiðe wurð ðe angel war.

ðo ne migte ðes affe flen,

Ne he ne durfte forðere ten,

Oc fel ðor dun(.) ðan ðis was don,

Balaam it fpureð and fmit ðor-on ;

And god vndede ðif affes muð,

So foð it if(.) fo it is felcuð.

Quuað ðif affe ðus wið vn-miðe,

" Qui betes ðu me ðis ðridde fiðe ? "

Quað balaam, " for ðu tregeft me ;

Had ic an fwerd, ic fluge ðe."

So was ðis were to wunder brogt,

ðhog ðe affe fpac, frigtede he nogt ;

ðe let god¹ him ðat angel fen,

wið ðe fwerd dragen him agen.

Quað ðe angel, " ðin weige if me loð,

ðor-fore am ic wið ðe ðuf loð ; ²

If ðin affe ne were wið-dragen,

Her fuldes ðu nu wurðen flagen."

Quað balaam, " quane ic haue mif-faren,

If ðu wilt, ic agen fal charen."

" far forð," quað ðe angel, " oc loc ðe wel,

for-bi min red, quað ðu non del."

forð-nam balaam, and balaac king

Cam him a-gen for wurðing,

Gaf him giftes of mikil prif ;

And balaam feide him to wif,

" Sal ic non wurd ³ mugen forð don,

Vten ðat god me leið on."

Balaac him leddede ⁴ heg on an hil,

And .vii. alteres wrogte in his wil,

On ilc alter fier alðerneðer,

And ðor-on an calf and a weðer,

And he bad balaac ftonden ðor-bi,

And gede on-rum qui ⁵ bute for-ði,

GENESIS. 8

3968

3972

3976

3980

3984

3988

3992

3996

[¹ MS. goð.]

[² wroð ?]

[³ MS. wurð.]

[⁴ ledde ?]

[⁵ quile ?]

The angel went further, and stood in a narrow place,

and the ass fell down under Balaam,

who smote her with his staff.

God opened the mouth of the ass, and she spoke to her master.

Nevertheless this infatuated man was not frightened.

[Fol. 77b.]

The angel tells Balaam,

that but for the ass he would have slain him.

The prophet offers to return.

He is cautioned by the angel.

Balak entertains Balaam.

Balak causes seven altars to be built.

On each altar was offered a bullock and a wether.

fro abuuen cam to him bi-neðen,

Word in herte ðat [1] he ſal queðen ; [[1] MS. dat.]

Quan he cam to balaac a-gen,

Swilc wurdes he let vt-ten. 4004

" Hu mai ic ðat folc curſen on,

ðor louerd haueð [2] bliſcing don ? [[2] MS. haued.]

ðif folk ſal waxen wel and ðen,

And ouer al oðer migtful ben, 4008

Hif lif beð bliðe, hif ending ſal,

ðe timeð al-ſo ðif timen ſal."

Balaac miſliked al ðif queðe,[3] [[3] quede ?]

And ledde hem ðeðen on oðer ſtede, 4012

To munt faga, for to ſen wel

Of folc iſrael ðe oðer del.

He wente on oðer ſtund or ſtede,

Betre timing ðor-fore he it dede, 4016

And wende wenden godes ðogt,

Oc al he ſwinked him for nogt.

Hef[t] haueð he mad her .vii. alter,

And on ilc brend eft twin der. 4020

Gede eft balaam up on-rum,

ðo ſeide ðuſ quanne hem cam dun,

" ðis folc, ſprungen of iſrael,

If vnder god timed wel ; 4024

Al-ſo leun iſ migtful der,

So ſal ðif folc ben migtful her ;

ðif leun ſal oðer folc freten,

Lond canaan al preige bi-geten." 4028

Ille liked ðanne balaac

Euerilc word ðe preſt balaam ſpac.

Get he ledde him to munt fegor,

 And efte he ſacrede deres mor ; 4032

ðor [4] ſpac balaam mikel mor [[4] MS. dor.]

Of ðif folckes migt, or he dede or.

" folc ebru," quað he, " ðat ic ſe,

Bliſced ſal ben ðe bliſcede ðe ; 4036

And quuo-ſo wile curſing maken,
Ille curſing ſal him taken ;
Of ðe ſal riſen ſterre brigt,

-and prophesies their future happiness and greatness.

And a wond ðe ſal ſmiten rigt 4040
Moab kinges, and under-don
Al ſedes-kin ðiſ werld up-on."

Manie tiding quad balaam ðor,
Ðe made balakes herte for ; 4044

Such tidings made Balak's heart sore.

Oc ðan balaam wente a-gen,
Tagte he balaam quat migte ben
Ðiſ folc to dere, and gaf him red

Balaam teaches Balak how to injure the Israelites,

Ðat brogt iſrael iwel ſped. 4048
" Ðo gingo wimmen oſ ðin lond,
faiger on ſigte an[d] ſofte on hond,

by sending out young women fair of face and soft of speech,

And brigte on howe, on ſpeche glad,
Wið ðgere[1] ſal ic ſondes ſad, [1 gere ?] 4052
ðe ðu ten vt gen ðiſ men,
ðe cunen[2] brewen herte-bren, [2 MS. cumen.]

who should "brew heart-burning and love,"

wið win, and wlite, & bodi, & dwale,
Luue[li]ke and wið ſpeche ſmale, 4056
To wenden hem fro godes age

[Fol. 79.] and so turn the people from God.

To ði londe godes and vre lage ;
Bute-if ðu migt forðen ðiſ red,
And hem fro godes luue led, 4060
And fonde to wenden ðuſ here ðhogt,

For war nor weapon had no power to harm them.

for wi ne wopen ne helpeð[3] nogt." [3 MS. helped.]
forð-nam balaam, ðat ille qu[e]ad
ðe gaf ðiſ read of ſoules dead. 4064
ðuſ it was don, and bi ðat ſel
In ſichin ſingede iſrael,

This counsel was followed, and thus it fell that Israel sinned in Shittim,

And for luue of ðiſ hore-plage
Manie for-leten godes lage, 4068
And wrogten ðor ſwilc ſoules ſor
ðat he ðor lutten belphegor.

and worshipped Baal-peor.

Ðo ſeide god to moyſen,
" Ðe me[i]ſtres of ðiſe hore-men, 4072

Ðe fendes folgen and me flen,

Ðe bidde ic hangen ðat he ben ;

Ben ðefe hangen ðe funne agen,

God commands the chief men to be hanged.

Ðise oðer [1] folc fal meðe fen." [1 MS. oder.] 4076

Twenty-three thousand were slain.

Godes wreche ðor haueð of-flagen

xx.iii. ðufent of dagen. [2] [2 MS. ðagen.]

Phinehas kills Zimri and Cozbi

finees waf a feli man,

Ðe godes wreche forðen gan ; 4080

He flug Zabri for godef luuen,

Hife hore bi-neðe and him abuuen ;

[Fol. 79b.] with his long and sharp pike.

Ðurg and ðurg boðen he ftong

wið hife gifarme farp & long. 4084

God commands Moses to take the sum of the people above twenty.

God moysen nemnen bead

Hif folc ðe was firmeft fro dead,

Or .xx. winter or more hold,

Ðe in egypte or ne weren told ; 4088

It was found to be 601,720.

On and .vi. hundred ðufent ðor,

And .vii. hundred and .xx. mor

Moyfes fond and eliazar ;

Was non of hem told in tale or, 4092

Of those who were numbered at Sinai, all died except Joshua and Caleb.

Ðo moyfes tolde hem and aaron,

Ðan [h]e gunnen fro egipte gon.

Vten iofue and caleph,

Alle elles he driuen in deades weph ; 4096

Alle ðife wapmen ðor [3] god let liwen, [3 MS. dor.]

Ðe lond hoten fal hem ben giuen.

Moses being told of his death,

God moyfes clepede and quad to him,

"ftig hege up to munt Abarim, 4100

And ic fal don ðe ðeðen [4] fen [4 MS. ðeden.]

Ðe lond ðe fal ðif folc[e]s ben ;

Ðer ðu falt ben of werlde numen.

In to ðat lond falt ðu nogt cumen." 4104

" Louerd, merci !" quad moyfes,

intreats God not to let the people be "helpless."

" Let ðu ðin folc nogt helpe-les,

And good let oc ðu hem bi-fe,

Alfwilc alf hem bi-hu[f]lik bee." 4108

God hem andſwerede, "ioſue
 Ic wile ben loder-man afŧer ðe ;
Tac him bi-foren eleazar,
ðat al ðin folc wurð war, 4112
And ðine hondes ley him on,
Sey him on ðin ſtede to gon."
Alſ it is boden, alſo he dede,
Ioſue wurð ſet on hiſe ſtede. 4116

Do moyſes was on abarim,
 ðat lond hoten god tawned him.
ðor quiles him leften liue dages,
Hiſ he tagte leue lages, 4120
And writen hem, hauuð [1] if hem bitagt, [1 MS. haued.]
Bute-if he iſ loken hem beð agt,[2]
Erðe and heuene he wittneſſe tooc,
And wrot an canticle on ðat booc, 4124
ðat ðreated ðo men bitter-like
ðe god ne ſeruen luue-like.
ðo .xii. twelue kindcrodes, on and on,
He gaf bliſcing bi-leue gon ; 4128
At munt nemboc on ðat knol faſga,
Wane he was ſtigen ðeðen ðoa,
Sag ðe lond of promiſſion,
ðurg god [3] him was fiðen ðat on. [3 MS. goð.] 4132
ðer he ſtarf inne. ðe moab lond,
His bodi was biried wið angeles hond,
ðer non man fiðen it ne fond, 4136
In to lef reſte hiſ ſowle wond.
Ebrius ſeigen, ðuſ waſ bi-tid,
ðat moyſes waſ hem ðuſ hid,
ſor, migten he finden ðe ſtede, 4140
Quor engel-wird hiſ liche dede,
ſele ſulden him leuen on,
And leten god ; ðat were miſ-don.

[2 MS. beð beð agt.]

[Fol. 80.]
Joshua is appointed to succeed him.

When Moses was on Abarim, God showed him the promised land.

Moses' song, setting forth God's vengeance upon those who would not serve Him truly.

The blessings of the twelve tribes.

Moses dies in Moab, and is buried by angels' hands.
[Fol. 80b.]
No man ever found his body.

It was thus hid,

that the people might not afterwards worship it.

Ydolatrie, ꝺat waſ hem lef,
ofte vt-wrogte hem forges dref. 4144

MOyſes iſ faren, on elde told
 fulle ſex ſcore winter old ;

And ꝺog him leſtede hiſe ſigte brigt,
And euerilc toꝺ bi tale rigt. 4148

.xxx. daiges wep iſrael
for hiſ dead(.) and bi-ment it wel.

Swilc prophete in folc of iſrael
Roſ non, ne ſpac wiꝺ god ſo wel ; 4152
Eſdras iſ witneſſe of [hiſ] ſage,
He was wel wiſ of ꝺe olde lage.

Bi-ſeke we nu godes migt,
 ꝺat he make ure ſowles brigt, 4156
And ſhilde us fro elles nigt,
And lede us to bliſſe and in-to ligt ;
In ſwilc ꝺewes lene[1] us to cumen,[2] [1 ? leue. 2 MS. cunen.]
ꝺurg qwat we ben to liue numen, 4160
And in-to bliſſe wiꝺ ſeli men ;
Wiꝺ muꝺ and herte ſey we, Amen !

EXPLICIT LIBer EXODUS.

Marginal notes:

Although Moses was 120 years old,

yet his eyesight remained bright, and every tooth was "by tale right."

Such a prophet in Israel rose none.

Beseech we now God's might,

that he shield us from Hell's night,

[Fol. 81.] and bring us all into bliss. Amen!

NOTES.

P. 1. ll. 1-2 *Man og to luuen ðat rimes ren,*
 ðe Wisseð wel ðe logede men.

og, another form of *agh*, = *ow* = ought. *ren* = *run* = *rune*, song, story.
 "Nalde ha nane *runes*
 Ne nane luue *runes*
 leornen ne lustnen."—(St. Kath. 108.)

logede = lay. It is not necessarily unlearned, ignorant, etc., for O.E.
writers frequently use the term in contradistinction to clergy. See Ayen-
bite, p. 197. "Vor all manere of volk studieþ in avarice, and (both)
great and smale, kinges, prelates, clerkes, an *lewede* and religious."—
—(Ayenbite, p. 34.)
 "And bathe klerk and *laued* man
 Englis understand kan,
 That was born in Ingeland."—(Met. Hom. p. 4.)

3 *loken*, to take care of oneself, to direct one's course of life, keep from
sin. See Ayenbite of Inwyt, pp. 1, 197, 199, 201.
 " Ac alneway hit is nyed to leawede men
 that hi ham *loki* vram þise zenne (avarice)."—Ayenbite, p. 31.

10 *ðund* is evidently an error for *gund* = yond, yonder, over. Cp. gu for
ðu, ll. 365, 366.
 " & *þeond* þat lond he heom to-draf (B. & ouer al þat lond he drof heom) "
 —(Laȝ. i. 68.)

12 *earuermor* = *eauermor* = evermore. 14 *soðe-sagen* = *soðe-sage* =
sooth-saw = sooth-saying, true saying.

15-16 *Cristene men ogen ben so fagen,*
 so fueles arn quan he it sen dagen.
 Christian men ought to be as fain (glad)
 As fowls (birds) are when they see it dawn.

17 *telled* = *telleð* = telleth. 20 *devil-dwale* = devil-deceiver, devil-
heretic = arch-deceiver, arch-heretic. See l. 67. Cf. *maȝȝstredwale* =
master heretic = arch-heretic, in the following passage:—

" Off all þis laþe læredd follc Of all this loathsome learned folk
 þat we nu mælenn ummbe That we now talk about
 Wass *maȝȝstredwale*, an defless þeww, Was an arch-heretic, a devil's serf
 þat Arrius was nemmnedd." That Arius was named.
 —(Orm. i. p. 258, l. 7454.)

23 *til god srid him in manliched,*
 till god shrouded (clothed) himself in manhood.
 srid = *sridde*.

24 *bote and red,* salvation and counsel. 25 *And unspered al ꝥe fendes sped* = undid all the fiend's successful work (luck). 26 *halp* = Old and Middle Eng. *holp* = helped, assisted.

P. 2. l. 27 *Biddi,* an error for *bidde ?*

31-34 ꝥu giue me seli timinge,
 To thaunen ꝥis wer[l]des biginninge,
 ꝥe, leuerd god, to wurꝥinge,
 Queꝥer so hic rede or singe !

 Give Thou me a propitious opportunity
 To show (declare) this world's beginning,
 Thee, Lord God, for honour,
 Whether-so-ever I read or sing!

thaunen = *taunen,* show, exhibit.

 " Ful wel he [Crist] *taunede* his luue to man,
 Wan he ꝥurg holi spel him wan."
 —Bestiary (O.E. Miscell. p. 24, l. 767.)

The word is very uncommon in O.E. writers. Cp. O.Du. *tónen,* to show. See ll. 1022, 2034. *wurꝥinge* = for worship, honour. *wurꝥinge* is a noun, not a participle or gerund. See l. 133. 38 *Ear ꝥanne* = ere that.

41 ꝥo bad god wurꝥen stund and stede,
 When God bad exist time and space.

43 *ꝥrosing* seems to be an error for *ꝥrosim* or *ꝥrosem* = fog, mist, chaos. Cf. *waspene* in l. 1440, p. 41, where the correct form is *wasteme.* *aꝥrusemen,* to suffocate, occurs in Ancren Riwle, p. 40.

wite þoliaꝥ	torment they suffer
hátne heaꝥo-welm	burning heat intense
helle to-middes	amidst hell,
brand & bráde lígas	fire, and broad flames;
swilce eác þa biteran récas,	so also the bitter reeks
þrosm and þystro,	smoke and darkness.

 (Caedmon, p. 21, 18.)

45 *ꝥu wislike mune* = do thou wisely bear in mind. 47 *hin* = *hine* = him. 48 *or,* another form of *ar,* = ere, before. 49-56 The meaning of these lines may be expressed as follows :—" And of them two [God the Father and God the Son] that dearly love, who wield all here and above, *proceeds* that holy love, that wise will [the Holy Ghost], that wieldeth all things with right and skill [reason]. Might bad with word light exist; also that might [the Holy Ghost] wieldeth *holy consolation,* for there are three persons and one counsel, one might, and one godhead." 54 *Hali froure* = holy comfort, an allusion to the office of Holy Ghost as the comforter.

 " Hire uoster moder wes an þe *frourede* hire."

= Her foster mother was one who comforted her.—(St. Marherete, p. 8.) 58 *o sunde[r] sad* = on sunder shad, i. e. a-sunder shed = divided apart, separated. It still exists in *water-shed,* Ger. *wasser-scheide.* Cf. l. 116. See Hampole's Pricke of Conscience, p. 271, l. 32. Cp. " the *schedynge* of tonges." (Trevisa's Translation of Higden's Polychron., p. 251. " The longages & tonges were *ischad* & to-schift."—Ib. p. 251.

P. 3. 1. 63 ꝺis *walkenes turn* = this welkin's course. See 1. 79. 64 *quuad* =
biquuad = bequeathed, ordained. See 1. 117.
 69 *And euerile wunder, and euerile wo.*
 And every evil and every woe.
Wunder = misfortune, evil. S.Saxon *wundre*, mischief, hurt.
 " hare lust leadeꝺ ham to wurchen to *wundre*."
 = their lust leadeth them to work to mischief. —(St. Marh. p. 14.)
(See Sir Gawaine and the Green Knyght. Ed. Morris, 1. 16.)
71-72 Our ancestors had some strange chronological theories. In the
Cursor Mundi we read that Adam was made at *undern-tide*, at *mid-day*
Eve was drawn from his side, and at *noon* they both ate the apple, and
were thus only three *tides* in bliss.[1]
 73 . ꝺis ik (ilk ?) *wort in ebrisse wen.*
This same word is in Hebrew opinion (tradition). The true form is *wene*,
" *a wene* " = in supposition. See LaꝈ. 1. 18752; Orm. 1. 4326; Owl and
Nightingale, 1. 237.
77 *a-qon — agen* = again. 78 *a-gon* = gone It is our word *ago*. Gram-
marians, therefore, altogether err in making the *a* in *ago* = the prefixal
element *ge* (y) as in yclept. *agon* and *ago* = the A.Saxon *agán* =
af-gán, gone by, past. We have abundant examples in O.E. writers of
the verb *agon* (ago) = to go. The past participle is *agon* or *ago*, in con-
formity to the rule that the past participles of verbs with this prefix do
not take the initial *y*. 81 *o france moal ;* in French speech ; *moal* =
mel = speech. S.Saxon *mælenn*, to speak. See Orm. vol. i. 1. 99, 253.
mol also signifies tribute. See O.E. Hom. 2 S. p. 179 ; O.E. Miscell. p.
151, 1. 161. 87 *tellen* = reckon. 88 *or* = *ar* = first.
P. 4. 1. 102 It *hiled* [= hileꝺ] *al ꝺis werldes drof.*
 — It surrounds (encloses) all this world's drove (assemblage).
 drof = A.S. *dráf*, company.
 105 *Til domes-dai ne sal it troken.*
 Till doomsday it shall not fail.
troken = S.Saxon *truken*, O.E. *trokie.*
 " Ah for nauer nare teonen But never for no injury
 Nullo wo þo *trukion*." Will we fail thee.
 —(LaꝈ. i. p. 186.)
 " Ah nauest þu neuere nenne mon. But thou hast neuer no [any] man

 þe cunne wærc makien. Who can make a work,
 þe nauere nulle *trukien*." That never will fail.
The later copy reads " þat neuere nolle *trokie*." See St. Kath. 1814.
107 *suuen* = *shoven*, i. e. thrust, prest, driven.
111 *oo* = O.E. *aa* = *ai* = ever.
119 *birꝺheltre*, fruit tree, from *birꝺel*, fruitbearing. Adjectives in *-el, -ol*,
are not uncommon in O.E. See O.E. Hom. 2 S. p. 131.
 Cp. " ꝺare bwys bowys all for *byrtht*."
 Their boughs bend all for fruit.—(Wyntown, i. p. 14.)
124-5 *fodme.* When we find, as on p. 2, 1. 43, ꝺrosing for ꝺrosim,

[1] See " The History of Our Lord," vol. i. p. 53.

we must not be surprised at learning that *fodme* is an error for *fodinge*, production; A.S. *fadung*, dispensation, order, production, from *fadian*, *gefadian*, to dispose, order, produce. "Hwæt is se Sunu? He is þæs Fæder Wisdom, and his Word, and his Miht, þurh þone se Fæder gesceop ealle þing and *gefadode*."—(Ælfric—"De Fide Catholica"—Thorpe's Analecta, p. 65.) "An Scyppend is ealra þinga, gesewenlicra and un-gesewenlicra; and we sceolon on hine gelyfan, forþon þe hé is soð God and ána Aelmihtig, seðe næfre ne ongann ne anginn næfde, ac hé sylf is anginn, and hé eallum gesceaftum anginn and ordfruman forgeaf, þaet hí beon mihton, and þæt hí hæfdon agen gecynd, swa swa hit þære god-cundlican *fadunge* gelicode."—(Ibid. p. 63.)

125 *quuemeðen* = *quemeden*, pleased. See l. 86.

P. 5. l. 133 *walknes wurðinge, and erdes* [*erðes ?*] *frame.*
 welkin's glory and earth's advantage.

frame = advantage, gain, profit. See Handlyng Synne, ll. 5, 4249.

 "Twifold forbisne in ðis der [the fox]
 To *frame* we mugen finden her."—(O.E. Miscell. p. 14, l. 425.)
 " Summwhatt icc habbe shæwedd ȝuw
 till ȝure sawle nede,
 ȝiff þat ȝe willenn follȝhenn itt
 & ȝuw till *frame* turrnenn."—(Orm. vol. i. p. 31.)
 "*Manne frame* = men's advantage."—(O.E. Miscell. p. 2, l. 39.)
 " Jhesu, do me that for thi name
 Me liketh to dreȝe pyne ant shame
 That is thy (the ?) soule note ant *frame,*
 Ant make myn herte milde ant tame."—(Lyric Poetry, p. 71.)

 134 *He knowned (* = *knoweð) one ilc sterre name.*
 He alone knoweth each star's name.

135 *He settes* = He set (placed) *them.* Cf. l. 156, where *wroutis* = wrought *them.* The pronoun *is* or *es* = them. See Prefaces to Ayenbite of Inwyt, O.E. Hom. 1st and 2nd SS. 136 *ðis walkne went* = this welkin's course. See l. 63. 141 *bi mannes tale* = by man's reckoning. 143 *egest* = *hegest* = highest. *ðe sunnes brigt* = the sun's brightness. 145 *moneð met*, measure of a month. Cp. O.E. *metwand.* 148 *Reke-fille* (see l. 3136) = *reke-filleð* (cp. O.E. *winter-fylleð* = October. See Me-nologium, p. 62, ed. Fox), April (the vapoury or watery month).

 155 *wel wurðe his migt lefful ay.*
 Well worth his might ever holy !

Cf. "*wo worth* the day !" etc. *lefful* = O.E. *geleáfful*, faithful, holy. O.E. Miscell. p. 23, l. 713. 160 *eruerilc* = *eauerilc* = every. 162 *his flotes migt* = his floating (swimming) power. Cp. "*a flote*," *a float*, Rob. of Brunne, p. 169, l. 13. 163 *ðvn* = to prosper, be successful. Cf. the O.E. phrase, "so mot I *the.*" 164 *tuderande* = propagating, fruitful.

 "Þa gyt drihten cwæð Again the Lord spake

 wórd to Noe words to Noah :—
 tymað nu & *tiedrað.*" Teem now and propagate.
 —(Cæd. p. 91.)

" I was borenn her
Off faderr & off moder.

.

Þa þeȝȝre time wass all gan
To *tiddrenn* & to tæmenn."

I was born here
Of father and mother.

.

When their time was all gone
To propagate and to teem.
—(Orm. ii. p. 284.)

See O.E. Hom. 2nd S. p. 177, where *tuder* = offspring.
168 *So*, an error for *ðo* ?

P. 6. l. 169 *wrim* = *wirm* = reptiles. 170 *Qwel* = *qwele; quile* = which.
172 *singen*, to sin. It is not an error for *sinnen*, but a genuine form
(contracted from *sinigen*), and not uncommon in O.E. writers. See
sineged in l. 3555, p. 101.

" He su[n]ggeden and sorgeden and weren in ðogt."
They sinned and sorrowed and were in thought.
(O.E. Miscell. p. 22, l. 682.)

" Þe verþe manere to zeneȝi in chapare is to zelle to tyme."
—(Ayenbite, p. 33.)

" Alsuo may he mid his oȝene wyue zeneȝi dyadliche."—(Ibid. p. 36.)

Sunegi = to sin, occurs in the " Owl and Nightingale," 926.
See *Sunegie, sunehi*, in O.E. Miscell. pp. 67, 68, 78, 79, 193.

173 *to fremen and do frame*,
to serve and do good.—(See l. 133.)

" Hoo scullen mo mon-radenc mid mo[n]scipe *fremmen*."
They shall me homage with honour perform.—(Laȝ. ii. 586.)

See St. Kath. 288; Anc. Riwle, p. 284.

Freme and *frame* are radically the same words, the former being of
A.Saxon and the latter of Norse origin. In the Ayenbite, p. 91, *vreme*
= *freme* = *frame* is used exactly in the sense of *frame :* " We wylleþ
wel þet we be yvonded (tempted) vor hit is oure *vreme* ine vele maneres,
vor we byeþ þe more ymylded and þe dredvoller and þe more wys ine alle
þinges and þe more worþ and þe more asayd." 197 *oo* = *og* = *ow*, ought.

P. 7. ll. 204-6 Whilst it (the soul) followed holy will,
God's self the while is pleased,
And displeased when it loves sin.

un-lif is evidently an error for *un-lief* = displeased = O.E. *unleóf*. In
the MS. the *f* has a long tail, and might almost stand for an incomplete
k. 217 *hiegt* = *hight* = threatened, literally promised. 222 *ilc here* =
each of them. Cf. the expressions *her non, non her* = none of them. 228
sib = akin, related; still preserved in *gossip*, originally *godsib*. See
Ayenbite, p. 36. 230 *wrocte* = *wrogte* = pret. of *worken*, to *ache, pain,
hurt*. Cf. A.S. *rop-weorc* = stomach-ache; *weoresum*, irksome. In the
Reliq. Antiq., p. 51, a receipt is given " for evel and *werke* in þe bledder."
On p. 54 of the same work we have a receipt for the " seke man" whose
" heved *werkes*." 231 *ðurte*, an abbreviated form of *ðurfte* = behoved.
This verb is used with the *dative* of the pronoun. (See Handlynge Synne,
l. 5826.)

" Whyne had God made us swa
Þat us *thurt* never haf feled wele ne wa."
—(Hampole's P. of C. 6229.)

P. 8. l. 240 *seli sped* may be regarded as a compound, and printed *seli-sped* = good speed, prosperity. Cf. l. 310, where *iwel sped* = *iwel-sped* = misfortune. Cf. O.E. *gode-happe*, prosperity, and *ille-happe*, mishap. 247 *seuendai* = *seuend dai* = seventh day. 250 *newes* = *a-new*, a genitival adjective used adverbially. Cf. our modern adverb *needs*, O.E. *nedes*, of necessity ; *lives*, alive. (R. of Gloucester, 301, 376. Owl and Nightingale, 1632.) *deathes* = dead. (R. of Gl., 375, 382. Owl and Nightingale, 1630.) 255 *rode-wold* = rode tree. I have printed *rode-wold* and not *rode wold*, because the two expressions are widely different in meaning. In the latter phrase the word *wold* = put to death, slain ; in the former it is a suffix = -tree, -beam ; so that *rode-wold* corresponds exactly to the O.E. *rode-tre* = *rood-tre* = the cross.

> " Þe ille men in manhed sal hym [Christ] se,
> Anly als he henged on þe *rode-tre*," etc.
> —(Hampole's P. of C., l. 5260.)

Cf. *dore-tree*, Piers Pl. 833, and the phrases " hanged on a *tree*," " the gallows *tree*," etc. O.E. *Tre* = *tree* = wood, beam (and *treen* = wooden), still existing in *axle-tree*, *saddle-tree*, etc. The *-wold* in *rode-wold* must therefore = *-tre* = wood, beam, which we still preserve in *threshold*. O.E. *threshwald*, *threshwold* (A.S. *thersc-wald*, *thyrscwold*). The affix *-wold* fortunately occurs again in lines 576 and 614 in the word *arche-wold* = ark-board.

> Sexe hundred ger noe was hold,
> Quan he dede him in ðe *arche-wold*.—(l. 576.)

> Sex hundred ger and on dan olde
> Noe fag ut of ðe *arche-wolde*.—(l. 614.)

A passage in Cædmon's poems furnishes us with the very term *ark-board* by which we have rendered *arche-wold*.

> " Læd swa ic ðe hate Lead so I thee hete (command)
> under *earce-bord* under the ark-board
> eaforan þine." thy progeny.
> —(l. 23, p. 80.)

> " Him þa Noe gewat Noah then departed
> swa hine nergand het as him the preserver bad,
> under *earce-bord*." under the ark board.
> —(l. 4, p. 82.)

259 *Siðen for-les ðat dai is pris*
 Afterwards lost that day its honour.

266 *And seli sad fro ðe forwrogt.*
 And *the* righteous separated from the wicked (accursed).
Seli constantly occurs in O.E. writers in the sense of *good*, and *unseli*, with the opposite meaning of *bad*, *wicked*. At first sight it would appear that the *for* in *forwrogt* is the same prefix which we have in *forbid*, *forsake*, O.E. *for-worth*, " good for nothing ; " but *forwrogt* in O.E. = over-worked, and, hence, fatigued. *Forwrogt* seems to be connected with the O.H.Ger. *foruuerget*, cursed ; O.E. *weried*, cursed. The first interpretation, however, is supported by the Goth. verb *fra-vaurkjan ;* Ger. *ver-wirken*, sündigen.

271 *Ligber he sridde a dere srud.*

Lucifer he shrouded (clothed) in dear (precious) shrouds (vestments). *Ligber* is evidently *Ligtber* = Lucifer. It occurs in the Ayenbite, p. 10 : —" And verst we willeþ zigge of þe zenne of prede, vor þet wes þe verste zenne and þe aginninge of alle kueade, for prede brek verst velaȝrede and ordre, huanne *Liȝtbere* the angel for his greate vayrhede and his greate wyt wolde by above þe oþre angeles and him wolde emni to God þet hine zo vayr an zuo guod hedde ymad."

272-276 And he became in himself proud,
 And with that pride upon him waxed envy
 That evilly influenced all his conduct ;
 Then might he no lord tolerate,
 That should in any wise control him.

P. 9. 1. 275 ðhauen = suffer, endure, tolerate. S.Saxon ðafen, iðeuen ; O.E. *thave.*

" Þe sexte bȝde þatt mann bitt The sixth petition that one prayeth
Uppo þe Paterr Nossterr in the Pater Noster is that God should
Þatt iss, þatt Godd ne þole nohht not suffer nor permit loathsome spirits
Ne þafe laþe gastess. to gain the upperhand of us
To winnenn oferrhand off uss through their loathsome wiles.
Þurrh heore laþe wiless." —(Orm. i. p. 188.)

 " & Hengest hine gon werien. And Hengest gan him defend
 & nalde it noht iþeuen [þolie]." And would not suffer it.
 —(Laȝ. vol. ii. p. 215.)

276 ðhinge = place, office, duty ; it seems to be here used adverbially in the sense of " any wise," " at all." 276 *grauen* is perhaps an error for þrauen, to compel, control. Cf. *gu* for ðu, p. 11, ll. 365, 366, and ðund for *gund*. If *grauen* be the original reading then it is equivalent to *greven*. O.F. *grever*, Lat. *gravare*, to injure, grieve.

278 *Min sete norð on heuene maken.*

 " Sette," he (Lucifer) said, " mi sete I sal
 Gain him þat heist es of alle ;
 In þe *north* side it sal be sette,
 O me seruis sal he non gette."—(Cursor Mundi, fol. 4b.)

282 *geuelic* = *geuenlic* = like. Cf. the A.S. *ge-efenlæcan*, to be like, to imitate. O.E. *euening* = equal.

 " And ðeðen he sal cumen eft,
 and thence he shall come again,

 for to demen alle men,
 for to judge all men,
 oc nout *on-geuelike.*
 but not a-like."—(O.E. Miscell. p. 23.)

" It (the law) fet ðe licham and te gost It feedeth the body and the
 oc nowt o *geuelike.*" spirit but not alike.
 —(Ibid. p. 10.)

295 ꝺis quead = this wicked one. In Early English writers we meet with several derivatives of this word, as kueadliche, wickedly, kueadvol, sinful. (See Ayenbite of Inwyt, p. 4, and extract in Note to l. 271, p. 125.)

301 *Euerilc ꝺhing haued [haueꝺ] he geue name,*
 To everything hath he given name.

309-310 Yet I ween I know of a device, that shall bring them misfortune.

P. 10. l. 314 ꝺor buten hunte, there without search, or hunting, without delay; or thereabout to hunt or search. 316 bilirten, to deprive of by treachery, to cheat a person out of a thing.

 " ꝺa herodes gesægh for-ꝺon bisuicen
 [& bilyrtet] wæs from dryum, [& tungul
 cræftgum] uraꝺ wæs suiꝺe."
 (Matthew ii. 16, Northumbrian version.)

" Listneꝺ nu a wunder,	Listeneth now to a wonder,
ꝺat tis der doꝺ for hunger:	That this deer (fox) doth for hunger:
goꝺ o felde to a furg,	Goeth a-field to a furrow,
and falleꝺ ꝺar-inne,	And falleth therein,
in eried lond er in erꝺ-chine,	In eared land or in earth-chink,
forto bilirten fugeles."	For to deceive fowls.

 —(O.E. Miscell. p. 13, l. 403.)

318 dreue = trouble, disturb. Cf. O.E. drove, to trouble, droving, tribulation. " Þa Herodes þæt gehyrde, þa wearꝺ he gedrefed,[1] & eal Hierosolimwaru mid him."—Matt. ii. 3.

 " & for-þi þatt he sahh þatt ȝho
 Was dræfedd of his spæche
 He toc to froffrenn hire anann."—(Orm. i. p. 74.)

"And because that he saw that she was troubled at his word, he took to comfort her anon." Southern writers, by metathesis, formed from dreuen (dreue) the vb. deruen (derue), thereby confounding it with another vb. deruen or derue, pret. dorue, p.p. doruen (A.Sax. deorfan, pret. dearf, p.p. dorfen), to labour, perish, be in trouble. Dreue is a transitive vb. of the weak conjugation, while derue is intransitive and of the strong conjugation, nevertheless we find derue (pret. dorue), taking the signification of dreue. " Stute nu earme steorue ant swic nuꝺe lanhure swikele swarte deouel, þat tu ne derue me na mare."—(Seinte Marherete, p. 12.) " Stop now, poor stern one, and cease now at once, deceitful swart devil, that thou harm me no more." In Laȝamon we find not only pret. drof = distressed, but derfde, and the p.p. iderued. In the Owl and Nightingale (ed. Wright), p. 40, we find the p.p. idorve = troubled, injured.

 " Other thou bodest cualm of oreve (orve),
 Other that lond-folc wurth i-dorve."

322 *And senkede hire hure aldre bale*
 = And poured out to her the bale of us all,

i. e. gave her the cup of sorrow, of which we all drink; senkede = schenkede, to pour out, to give to drink, to skink. See Orm. ii. 181. Laȝ. ii. 202, 431; Alys. 7581; Owl and Nightingale, p. 70.

[1] The Northumbrian version reads gedroefed, from which the O.E. vb. drove.

324 *Quat oget nu ðat for-bode o-wold*
 = What does now that prohibition signify ?

i. e. What is the meaning of the prohibition ; *oget* = has, possesses
o wold = *a wold* = in force, in signification. Cp.

 Quat-so his dremes owen a wold
 = What-soever his dreams do mean.

In ll. 1671, 2122 *wold* occurs as a noun = interpretation, meaning.
The connection between the idea of *power*, and *meaning, interpretation*, is
not, after all, so very remote. Do we not speak of the *force* of a word,
its *power, use,* etc., in an expression ? See Ormulum, p. 56, l. 11815.

327 *for is fruit sired* [*sireð* ?] *mannes mood,*
 = for its fruit enlighteneth (cleareth) man's mind.

330 *witent* for *witen it* = know it. 333 *on hire mod* = in her mind.
339 *scroðt* = *scroð* = solicited; the pret. of *scriðe.* The original
meaning of the verb is, (1) to go ; (2) to cause to go, to urge ; (3) to solicit.

341 *for to forðen is fendes wil,*
 for to further (do) his foe's will.

 " For up he rigteð him
 redi to deren,
 to deren er to ded maken
 if he it muge forðen."—(O.E. Miscell. pp. 5, 6.)

342 *At he ðat fruit, and dede unskil,*
 Ate he that fruit and committed sin.

unskil, literally, signifies indiscretion, folly, and by an easy transition, sin,
crime. (See Ormulum, vol. i. p. 12. Cf. O.E. *unskilwis* = irrational.)

P. 11. l. 345 *Vn-buxumhed* = disobedience ; but in line 346 it signifies weakness,
un-lithesomeness.

347-8 *Vn-welde woren and in win* Their own limbs within them
 Here owen limes hem wið-in. Were powerless and in strife.

vnwelde = unwieldy = the S. Saxon *vniwælde,* heavy.—(Gower i. 312.)

 "——hise limes arn *unwelde.*"—(O.E. Miscell. p. 3.)

(*i. e.* weak with age) ; *in win,* in strife, conflict.

 " and wið al mankin
 he (the devil) haueð nið and *win* " (envy and strife).
 (O.E. Miscell. p. 8.)

 " ðis fis wuneð wið ðe se grund,
 and liueð ðer eure heil and sund,
 til it cumeð ðe time
 ðat storm stireð al ðe se,
 ðanne sumer and winter *winnen* (strive)."
 (O.E. Miscell. pp. 16, 17.)

 " Þar aros wale and *win.*"
 There arose slaughter and strife.—(Laȝ. i. 18.)

349 *flesses fremeðe and safte same* Lust of flesh, and shame of form
 boðen he felten on here lichame. both they felt in their bodies.

fremeðe seems connected with *fremen* and *frame.* In the translation I
have connected *fremeðe* with O.E. *frim,* vigorous ; but it may be another
form of O.E. *frumðe,* beginning. Then the translation of l. 349 would
be ' the beginning of flesh and shame of form.'

360 *Þu haues Þe sorges sigÞhe waked.*
 Thou hast for thyself a sight of sorrow roused.

sigÞhe = sight, but if it be an error for *siÞhe* it will signify adversity, mishap. 362 *ut luken* = shut out. 363 *tilen Þi mete*[*n*] = earn thy food. *tilen* (till), earn, procure.

 " Ne maig he *tilen* him non fode."
 He is not able to procure food for himself.
 (O.E. Miscell. p. 3.)

364 *wid* = *wiÞ*, with. *swotes teres* = tears of sweat, *i. e.* drops of sweat. We may, however, by spoiling the metre, read *swotes & teres*, for in O.E. writers *swot* is frequently used in the singular and makes the plural *swotes*.

365, 366 *Til gu beas eft into erÞe cumen,*
 Till thou art again into earth come.

beas = *be'st* = art. The present has also a future signification.
369 *niÞful* = envious.

 " O *nyth* þare springes mani bogh,
 Þat ledes man to mikel wogh,
 for *nithful* man he luuves lest,
 Þe quilk he wat es dughtiest."
 —(Cursor Mundi, MS. Cott. Vesp. A iii. fol. 153*b*.)

loÞ an liÞer, loathsome and vile.

372 *And atter on is tunge cliuen,*
 And poison on his tongue shall cleave.

373 *san* = *schand*, disgrace, shame. Did the scribe originally write *sam* = shame? 377 *pilches*. This word answers to the "coats of skin" in our English version of the Scriptures. In modern English *pilch* is merely the flannel swathe of an infant, but it formerly signified a fur garment. Cf. Ital. *pellicia*, *pelizza*, any kind of fur; also Fr. *pelisse* (pelice), a furred garment.

 " Here kirtle, here *pilche* of ermine,
 Here keuerchefs of silk, here smok o line,
 Al-togidere, with both fest,
 Sche to-rent binethen here brest."—(Seven Sages, 473.)

P. 12. l. 384. *Cherubin hauet* [*haueÞ*] *Þe gates sperd,*
 Cherubim have the gates bolted (barred, fastened).

391 *swem* = sorrow, grief. See Gloss. to Allit. Poems, s.v. *swemande.* Legends of Holy Rood, pp. 135, 201.

392 *Of iwel and dead hem stondeÞ greim*
 Of evil and death they stand in awe.

A similar phrase occurs in l. 432, p. 13. The phrase *stande awe* is not uncommon in O.E. writers.

 " Than sal be herd the blast of bem,
 The demster sal com to dem,
 That al thing of *standes awe*."
 (*i. e.* stands *in* awe of.)—(Met. Hom. p. xii.)

 " For Crist com sal be sa bright
 Þat thoru þat mikel lauerd might
 Him sal of *stand sa mikel au*,
 Þat alle þe filthes of his maugh

Sal brist ute at his hindwin,
For dred he sal haf of drightin."

—(Antichrist and the Signs of the Doom, in *Jahrbuch für Romanische und Englische Literatur*, 1863, p. 203, l. 408.)

" Thereof ne *stod him non owe*."—(Seven Sages, 1887.)

See Havelok the Dane, p. 9, l. 277.

393 *on sundri* = *asunder* = apart, separate.

398 *And leded* (ledeð) *samen gunker lif.*
And lead (pass) together your (two) lives.

leded = *ledeð*, is a verb in the imperative mood; *gunker*, the A.S. *incer* (*dual*) = your two, of you two. Cf. ӡ*unkerr baþre* = of you both.—(Orm. i. 214.)

408 *And sumdel quemeð it his seri mood*
And somewhat it cheereth his sorry mood.

411 *More for erneste dan [ðan] for gamen,*
More for necessity than for pleasure.

P. 13. l. 417 *ul swilc sel* = all such time.

420 ð*an he was of is broðer wold,*
When he was by his brother killed.

421, 422 *An hundred ger after is dead,*
 Adam fro eue in srifte abead.
A hundred years after his death,
Adam from Eve in shrift (penance) abode.

(*i. e.* on account of the death of Abel.)

" A hundred winter of his liue
fra þan forbar Adam his wiue,
for soru of Abel þat was slayn."—(Cursor Mundi, fol. 8.)

See Legends of the Holy Rood, pp. 20, 21.

431 *and wurð ut-lage* = and became an outlaw.

432 *wið dead him stood hinke and age.*
Of death he stood *in* dread and fear.

hinke — inke, doubt, dread. See note on l. 392.

436 ð*eft and reflac ðhugte him no same,*
 theft and robbery appeared to him no shame.

Reflac = robbery with violence, rapine. (See Laӡ. i. 172, 272, 424; ii. 526.)

" Þe first sin is o covatise
Þat revis mani man þair praise,
O þis cumes blindnes and tresun,
Reuelaic, theft, extorsiun."

—(The Seven Deadly Sins: *Cursor Mundi, Cott. MS. Vesp. A* iii.)

438 *stonden agon* = withstand, oppose. Cf. O.E. *again-stande*, to oppose.

439 *Met of corn, and wigte of fe,*
Measure of corn, and weight of goods.

The only objection against explaining *fe* by goods or money is that in the poem it signifies cattle, the proper term for goods, etc., being *agte*. In Laӡamon *fe*, however, has the meaning of goods, money.

440 *And merke of felde, first fond he,*
And he first devised division (boundary) of fields (lands).

GENESIS. 9

444 *at ðe sexte kne* = at the sixth degree. *Kne* in this sense is used by Robert of Gloucester, p. 228 :—" He come of Woden þe olde louerd, as in teþe kne " (*i. e.* tenth generation). 450 *On engleis tale* = in English speech. P. 14. l. 451 *kire,* modesty, purity. See Laȝ. l. 8077. K. Horn, l. 1446.

456 *He was hirde wittere and wal.*

He was herdsman wise and experienced (skilful). See Gloss. to Allit. Poems, s.v. *wale.*

457-8 *Of merke, and kinde, and helde, & ble,*
 sundring and sameni[n]g tagte he.

He taught of (concerning) the character, breed, age, colour [of cattle], the keeping them asunder, and the matching them together. *merke* refers, perhaps, to the *form, shape,* etc., of the cattle, and *kinde* to their *pedigree.* 459 *glew,* music, still exists in glee, *gleeman,* etc., O.E. *gleowinge* = singing. *gleu,* to amuse by singing.

 " Bi a piler was he þar sett
 To *gleu* þaa gomes at þair mete."—(Cursor Mundi, fol. 40*b.*)

Cf. *gleo,* music.—(Laȝ. i. 298.) *gleo-cræften* = glee-crafts, arts of music. —(Ibid. i. 299.) *gleo-dreme* = glee-sound.—(Ibid. i. 77.) *gleowen, gleowien,* to chant, play.—(Ibid. ii. 382, 429.) 466 *a sellic smið,* a wonderful (rare) smith. 468 *To sundren and mengen* = to separate (the ore from the dross) and to mix (alloy).

469 *Wopen of wigte and tol of grið*
 = weapon of war and tool of peace.

wigte = *wig* = war. *Wigte* may signify sharpness ; it usually = strong, brave.

470 *wel cuðe egte and safgte wið.*

This line seems to be very corrupt and to stand in need of some emendation. I would propose to read as follows :—

 wel cuðe he fegte and sagte wið

= well could he *fight* [*i. e.* with the *wopen* of *wigte*] and *heal* with [the *tol* of *grið*]. If this interpretation be right *tol of grið* would refer to some curative agents. 472 *wurð bisne,* became blind.

 " Þis Lamech was called Lamech þe blind,
 Caym he slogh wit chaunce we find."—(Cursor Mundi, fol. 10.)

475 *Al-so he mistagte, also he schet,*
 As he mistaught, so he shot.

477 *wende* = *weened,* thought. 480-481 Cain unwarned, received it (the arrow), groaned, and stretched (fell prostrate), and died with that (immediately). *unwarde* may be an error for *unwarnde* = unwarned, or for *unwared* = A.S. *unwered* = unprotected. 484 *dedes swog* = death's swoon. *Swog* = O.E. *swowe, swoughe.*

 " *Aswogh* (in swoon) he fell adoun
 An his hynder arsoun (rise of the saddle),
 As man that was mate."—(Lybeaus Disconus, 1171.)

The verb to *swoon* occurs often in English under the form *swoghen* (p.p. *yswowe*),

 " The king *swoghened* for that wounde."—(Kyng Alys., 5857.)

Cf. Laȝ. 130, " *he fel iswowen* ;" i. 192, *stille he was iswoȝen* (the later copy reads *iswoȝe*).

486 *Of his soule beð mikel hagt.*

On his soul is much sorrow.—(See l. 2044, p. 59.)

The literal signification seems to be thought, care. (See *Agte* in l. 3384.)

P. 15. l. 490 *or or*, etc. = first ere, etc. = first before, etc. *fen* = mud, dirt.

 " Man here is nathyng elles

 Bot a foule slyme, wlatsom til men,

 And a sekful of stynkand *fen*."

 —(Hampole's P. of C., l. 566.

See R. of Gloucester, 6 ; Ps. (in Surtees' Psalter) xvii. 43. 492 *drinkilden* = were drowned ; *drinkil* is a derivative of O.E. *drinke*, to drown, a softer form of which is *drenche*, which often signifies in O.E. a drink, potion (R. of Gl., p. 151 ; Ayenbite, p. 151, *deaþes drenche*), as well as to drink and to drown. See Laȝ. i. 64.

 " & att te lattste *drunncnenn* þeȝȝ

 þa wrecchess, þat hemm trowwenn.

 And at the last drown they

 The wretches who them trow (believe)."—(Orm. ii. 181.)

 " The see him gon *adrynke*

 That Rymenil may of-thinke."—(Kyng Horn, 978.)

494 he began holy custom

 Of prayers, and of god-fearing-ness,

 for life's help and soul's comfort (counsel).

500 *alied* = *halihed* = holiness ; *toch* = *toc* = took. 501 *fro mannes mene*, from man's fellowship, society. The usual form of *mene* in O.E. is *ymene, ymono* = common, general. 503-510 From Hampole's Pricke of Conscience, pp. 122-126, we learn that both Enoch and Hely (Elijah) shall come before doomsday to turn the Jews from following Antichrist to the Christian law :—" For 1260 days, or three years, shall they continue to preach. Antichrist, in great wrath, shall put the two prophets to death in Jerusalem, where their bodies shall lie in the streets for three days and a half, after which they shall ascend to heaven in a cloud. After their death Antichrist shall only reign fifteen days, at the end of which time he shall be slain before the Mount of Olivet." Some " clerks " affirm that he shall be slain by St Michael in Babylon, " that great hill." (See " *Antichrist and the Signs before the Doom*," in Jahrbuch für Romanische und Englische Literatur, 1863.) 517 *Metodius*. In the " Polychronicon Ranulphi Higdeni," p. 23, ed. by Churchill Babington, 1865, amongst the " auctores names" we find mention made of " Methodius etiam martyr et episcopus, cui incarcerato revelavit angelus de mundi statu principio et fine." 518 *sighe sir* = *sigðhe sir* = *sheer insight*, clear fore-knowledge.

P. 16. l. 525 *quat agte awold* = what should happen. 526 *water wold*, destroyed by water. *wold* may = *walled*, flooded, from *wallen*. 530 *hore-plage*, whore-play, whoredom. Cf. O.Sax. *hor-uuilo* ; O.H.G. *huorgilust*. In O.E. *hore* (not *whore*) was an epithet applicable to men as well as women. It occasionally signifies adultery. It is found in combination as a qualifying term in *hore-cop, horesone*, a bastard ; *hore-hous*, a brothel. The O.E. *horwed*, defiled, unclean ; *horowe*, foul (Chaucer) ; *hori, ouri*, dirty ; Provincial E. *horry* (Devonshire), seem to belong to another family of words.

532 *Wimmen welten weres mester*
 Women wielded a man's art.—(See Rom. i. 26.)
See Allit. Poems, p. 46, ll. 269-272.

533 *And swilc woded wenten on,*
 And such madness (folly) went on.
woded = *wodhed*, Cf. *alied* = *alihed* = holiness (l. 500, p. 15). " Þe
oþer ontreuþe þet comþ of prede is *wodhede*, me halt ane man *wod* þet is
out of his wytte, in huam skele is miswent."—(Ayenbite, p. 12.)

534 *Golhed hunkinde he gunnen don,*
 Unnatural lust they did commit.
Golnes = lust, lasciviousness, occurs in the Owl and Nightingale, l. 492.
Ancren Riwle, p. 198. Ps. lxvii. 14.
 " Non lest (listen) on man do amys
 Thorȝ hys oȝene *gale* (lust)."—(Shoreham, p. 107.)
hunkinde = *unkinde*, unlawful, unnatural. 536 *quad mester*, wicked
craft (practices). See Allit. Poems, p. 46, ll. 265-268. *Quad* takes
several forms and meanings in O.E.; as *qued*, wicked (Kyng Alys.,
5619; evil, 4237) ; the devil (R. of Gl., 314) ; *quead*, wickedness (Ayen-
bite, p. 4) ; *quathe, wothe, wathe*, evil, harm (Hampole's P. of C., 2102,
4558; Allit. Poems, B. 885).
 " De *quât* deit, de schuwet gêrn dat licht."—(Reynard the Fox.)
537 *hun-wreste plage*, wicked lust; *hun-wreste* = *unwreste*, weak, frail,
and hence wicked.
 " Mærling *vnwærste* [*onwreste*] man
 Whu hæuest þu me þus idon."—(Laȝ. ii. 228.)
 " Þenne þat hæfd (leader) is *unwræst* [*onwrest*]
 Þe hæp (host) is þæ wurse."—(*Ibid.* vol. ii. 259.)
 " Thanne aȝte men here wyves love,
 Ase God doth holy cherche ;
 And wyves nauȝt aȝens men
 Non *onwrestnesse* werche,
 Ac tholye,
 And nauȝt *onwrest* opsechen hy
 Ne tounge of hefede holye."—(Shoreham, p. 57.)
See Orm. i. 168-9. A.Sax. Chron., 1052. Wright's Lyric Poems, 37.
Kyng Alys., 878. Owl and Night., 178. 538 *A ðefis kinde* = in thief's
kind, in sodomy. *thief* in O.E. was a general term of reproach. Perhaps
in *ðefis* we have an allusion to *Cain.*
542 *And leten godes frigti-hed* And forsook the fear of God.
544 *And mengten wið waried kin* And intermixed with accursed
kin.
545 *Of hem woren ðe getenes boren* Of them were the giants born.
 —(See Genesis vi. 4.)
546 *Migti men, and figti, for-loren*
 = *Migti men, figti and forloren,*
 Mighty men, warlike and forlorn (doomed).
548 *litel tale*, little account (worth). 553 *blissen* = *lessen* = *be-lessen* (?)
or *bi* + *leschen*, to soften. Cf. *blinnen* and *linnen* = to cease. See ll.
3653, 3803.

554 *Ꝺat it ne wexe at more hun-frame*
 lest it should grow to greater evil.

hun-frame = *unframe*, loss, disadvantage. 556 *deres kin* = animals.

P. 17. 1. 560 *griꝺ*, protection, safety.

 " he wuneden (dwelt) seoꝺꝺen (afterwards) here
 inne *griꝺe* and inne friꝺe (peace)."—(Laȝ. ii. 50.)

 " Lauerd, lauerd, ȝef (give) me *griꝺ*."—(Ibid. iii. 35.)

Cf. *greth*, quarter (Sir Cleges, 292). *grith-bruch*, breach of the peace
(Owl and Nightingale, 1043). *grith-sergeant* (Havelok, 267). 561 *feteles*,
a vessel, a *fat* or *vat*.

 " þe firrste *fetless* wass
 Brerdfull off waterr filledd."—(Orm. ii. 148.)

 " Sex *feteles* of stan war thar stan[d]and,
 Als than was cumand in the land
 And Crist bad thaim thir *feteles* fille
 Wit water, and thai did son his wille."
 —(Met. Hom. p. 120.)

562 *set*, made, formed. *limed*, daubed, pitched. 564 *sperd*, *sparred*, barred.
See Orm. D. 261; H. i. 142, ii. 68; Havelok, 448. *spere* or *sparre*
signifies also to lock, shut up. *Chaucer*, Troilus and Creseide, v. 455;
Bone Florence, 1774. *ꝺig* = *ꝺic*, thick.

566 *ꝺor buten noe(.) long swing he dreg.*
 Thereabout Noah endured long toil.

swing = *swinc*, toil, labour. 568 *welken*, pass away, literally to fade,
wither; and usually applied to plants and flowers.

 " It wites als gresse areli at dai,
 Areli blomes and fares awai;
 At euen doun es it brogt,
 Un-lastes, and *welkes*, and gas to noght."—(Ps. lxxxix. 6.)

See Hampole's P. of C. l. 707. 576 *arche-wold*. See note to l. 255.
582 *gette* or *get*, poured down. *gette* is the preterite of *geten* or *gete*.
See l. 585. Cf. O.E. *yhete* (ȝete); pret. *yhet*; p.p. *yhoten* (iȝote).

 " *Yhet* over þam þi wreth."—(Ps. lxviii. 25.)

See Ps. xli. 5, lxxiii. 21. Percy's Reliq. vol. ii. 81. Cf. "a metal *geoter*,"
a metal caster, Kyng Alys. 6725. *out-yhetted*, poured out, Hampole's P.
of C. 7119. See Gloss. to Allit. Poems, s.v. *Gote*. 592 *moned* = *moneꝺ*
= month.

P. 18. 1. 598 *dragen* by metrical license for *wiꝺ-dragen*, withdrawn. *ꝺe watres
win* = the water's force (strife). *Winne* in O.E. has the signification of
to fight, contend with, strive, and hence to get. Cf. O.E. *wunne*, victory;
wan, contrivance, remedy. See l. 317.

 " Alle we atter dragen off ure eldere,
 ꝺe broken drigtinnes word ꝺurg ꝺe neddre;
 ꝺer-ꝺurg haueꝺ mankin
 boꝺen niꝺ and *win*."—(O.E. Miscell. p. 11.)

607 *est* = east. Probably only an error for *eft* = again. 614 *arche-
wolde*. See note to l. 255. 617 *Rad* = hasty, rash. Literally it signi-
fies ready, and frequently occurs in O.E. writers with this meaning. Cf.
O.E. *gerád*, *rædlice*, *rædliche*, *radely*, *radly*, promptly, quickly, suddenly.

See l. 2481, and Owl and Nightingale, ll. 423, 1041, 1279 ; Laȝ. 25603 ;
St Marh. p. 10 ; Avow. Arth. xix. 6.

P. 19. l. 630 *tudered* (see note to l. 164).

631-637 Often he prayed with timid prayer,
 That such vengeance as God then did
 Should no more on the world come,
 What vengeance so *ever* there should be taken.
 God granted it in token of love,
 Showed him in the welkin above
 A rainbow, they call it, red and blue.

so after *swiulc* is a true relative, as in the oldest period.

635 *gat* = granted. It is the preterite of a verb *gate*, to grant.

 " Fourti dais he sal [tham] *yate*
 Þat fallen ar ute o þair state
 Þoru foluing o þat fals prophet,
 Þat þai mai þam wit penance bete."

—(*Antichrist*, in Jahrbuch für Romanische und Englische Literatur,
1863, p. 204, l. 428.)

gate or *yate*, pret. *yatte*, is the Northern form of the word, the correspond-
ing southern term is ȝ*ete*, pret. ȝ*ette*.

 " & ȝho ne wass nohht tær onnȝæn,
 Acc ȝ*atte* hemm hĕre wille
 & ȝ*atte* þatt ȝho wollde ben
 Rihht laȝhelike fesstnedd
 Wiþþ macche, swa summ i þat ald
 Wass laȝhe to ben fesstnedd."—(Orm. i. 80.)

 " & þe king him ȝ*ette*
 swa Hengist hit wolde."—(Laȝ. ii. 172.)

 " & þe king him ȝ*ette*
 al þat he ȝirnde."—(Laȝ. i. 189.)

See Seinte Marherete, p. 18. Allit. Poems, p. 17, l. 557. *a* = *an* = in.

637 *men cleped* = one calleth it ; *cleped* = *clepet* = *clepe* + *et* ; *et* = it.
We have a similar construction in l. 1082 :

 " for al ðat nigt he sogten ðor
 ðe dure, and *fundend* neuere mor."

fundend = *funden* + *ed* = *founden* + *et* = found it. The author of the
poem constantly joins the pronoun *et* = *it* to the preterite of weak verbs.
See line 479, where *letet* = let it. 590 *stodet* = *stod it* = it stood.
1654 *kiddit* = *kidd it* = showed it. As the plurals of the present indic-
ative do not end in -*eþ* or -*et* in the poem, but in -*en* (-*n*), *cleped* may be
an error for *clepeð* or *clepeth* — calls, and *men* = O.E. *me* = one. See
line 750.

643-644 And as high the flame shall go,
 As the flood flowed on the downs (hill).

lowe, a northern term (of Norse origin) for flame, the southern form
(of A. Sax. origin) is *leie*. Religious Songs in Old Eng. Miscell., pp. 67,
182.

 " Of his neose-þurles
 cumeð þe rede *leie*."

See also Legend of St Brandan, 512.

> " Þair throtes sal ay be filled omang
> Of alle thyng þat es bitter and strang,
> Of *lowe* and reke with stormes melled,
> Of pyk and brunstane togyder welled."
>
> —(Hampole's P. of. C., l. 9431.)

653 *vten = wiÐ-vten*, without, besides. See l. 656. Cf. l. 596, with l. 598. 655 *bi tale*, in number.

P. 20. l. 676 *gan ille wune*, began wicked practices. 678 *muni[gin]g* = remembrance. 692 *fendes fleiÐing*, fiends' strife. Probably *fleiÐing — flitting*, contention, strife. The phrase *fendes fleathe* = ? *fendes fleiÐing*, occurs in Shoreham's poems, p. 97.

> " ȝyf thou rewardest thyne eldrynges nauȝt
> A-lyve and eke a-dethe,
> That were wel besy to brynge the forthe,
>
>
>
> ȝyf thou hy gnaȝst and flagȝst eke,
> Ryȝt hys that *fendes fleathe*."

P. 21. l. 713 *hicte = higte*, was called, named. 724 *wol wel = wel wel* = very well, extremely well. Cf. the O.E. expressions *wel ald, wel lang*, etc., very old, very long, etc.; *wol wel* corresponds exactly to the O.H.G. and M.H.G. *vil wol;* Mod. Ger. *sehr wohl*. See Erec. (ed. Haupt. 1839), 2017.

> 725 *Thare let hur, and ÐeÐen he nam,*
> Terah left Ur, and thence he went.

let (pret. of *lete*) = left ; *nam*, literally took, and hence took the way, departed, went. See ll. 744, 745. 727 *burgt*, an error for *burg*.

P. 22. l. 743 *for*, went. See l. 763.

748 *Of weledes fulsum and of blis* Rich of (in) wealth and of (in) bliss. *weledes* is an error for *welÐes ;* it may = *werldes* = world's ; *fulsum* = rich, plenteous, bountiful, occurs in O.E. *fulsumhed* (see l. 1548), *fulsumly*. 749 *ist = is it*, is there.

> 751 Each thing dieth that therein is cast.

753 *Ðus it is went* = thus is it turned *or* changed. 754 *brimfir*, if not an error for *brin-fire* (burning fire ; see l. 1164), signifies wild-fire, *i.e.* brimstone. Cf. A.Sax. *cwic-fyr* = fire of brimstone. 763 *hunger bond*. We ought, perhaps, to read *hunger-bond*, corresponding to the German *hungers-noth*, famine, dearth. Cf. luue-bond, l. 2692, force of love. 764 *feger = feyer*, far. 767 *to leten —* to lose.

P. 23. l. 787 *erdne = ernde*, errand, prayer, petition, message.

> " Ih seal in sagen imbot,
> gibot ther himilisgo Got,
> Ouh nist ther er gihorti
> so fronsig *arunti*."—(Otfried's Evangelienbuch.)

to god erdne beren = to intercede with God. *Ernde* occurs in Lyric Poetry, p. 62, in the sense of to intercede. 792 *arsmetike = arsmet[r]ike* = arithmetic.

> 793 *He was hem lef, he woren him hold,*
> He was dear to them, they were true to him.

795 *sat* = *schat*, treasure, still existing in *scot, shot*. 796 *vn-achteled*, unestimated, immense; from *achtel*, to estimate, reckon. See Stratmann, s.v. *ahtlien*.

801 ðor he quilum her wisten wunen,
 Where they formerly wished to dwell.

P. 24. l. 813 *atteð* = *hatteð*, is called.

827 ðer het god abre ðat tagte lond, etc.
 There God promised Abraham that promised land, etc.

tagte = *bitagte*, literally, assigned, appointed. 832 *giscinge of louerd-hed* = desire of lordship, greed of dominion. *Giscinge* = covetousness; the correct form is *gitsing* (*ʒitsung, ʒittsung*), but *ʒissinge* is found in Laʒ. ii. 227. Cp. *yssing*, O.E. Miscell. p. 38. *icinge*, Ayenbite, p. 16, and see Orm. i. 157.

 " Al his motinge (talk)
 was ful of ʒitsinge."—(Laʒ. i. 280.)

833 Neg ilc burge hadde ise louereding,
 Nigh each borough (city) had its lord.

834 *kumeling* is literally a stranger, foreigner, but here signifies a king or ruler not of native blood, one of foreign extraction. See *Comeling* in Prompt. Parv. p. 89.

 " For I am a *commelyng* toward þe
 And pilgrym, als alle my faders was."
 —(Hampole's P. of C., 1385.)

" Wande ein *chomelinch* ih bin mit dir unde ellente also alle uatere mine."
—(Wendb. Ps. xxxviii. 22.)

P. 25. l. 842 *ferding stor*, a great army. See O.E. Hom. 2nd S. p. 189.

844 *gouel*, tribute, tax. Later writers use the word *gauel* or *gouel* in the sense of usury. See Ayenbite, p. 35; O.E. Miscell. p. 46. Cf. *gaueler*, usurer. Ayenbite, p. 35; Ps. cviii. 11. 847 *haued* = *haueð*, hath. 848 *here-gonge*, invasion.

 " For ich am witi ful iwis,
 And wot (knoweth) al that to cumen is:
 Ich wot of hunger [and] of *hergonge*."
 —(Owl and Nightingale, l. 1189.)

851 *fowre on-seken and fifue weren* = four attack and five defend. *on-seken* = attack.

" heo wenden to beon sikere. They weened to be secure
 þeo Belin heom *on-sohte*." when Belin attacked them.
 —(Laʒ. i. 241.)

864 *witter of fygt* = skilled in fighting. See Gloss. to Allit. Poems, s.v. *wyter*, and Laʒ. i. 260, 409; ii. 247.

866 Abram let him tunde wel,
 Abram caused himself to be well surrounded (well guarded).

869 *wenden*, thought.

875 wið-ðuten [= wiðð-uten] ðo ðe cuden flen
 = except those who could flee.

P. 26. l. 882 *bat* = *bad* = *bead* = literally offered, and hence restored. *bat* = *bette* occurs in Legends of Holy Rood for *amended*, restored, p. 210, l. 6.

886 *Borwen*, delivered, rescued, the p.p. of *bergen* (O.E. *berʒe, berwen*).

"Þis boc is ymad vor lewede men
vor vader and vor moder and vor oþer ken
Ham ver to berȝe vram alle manyere zen
þet in hare inwytte ne bleve no voul wen."
—(Ayenbite, p. 211.)

"And huo þat agelt ine enie of þe ilke hestes him ssel þer-of vor-þench, and him ssrive, and bidde God merci yef he wyle by yborȝe."—(Ibid. p. 1.) Orm uses berrȝhenn, to save, preserve, from which he forms the derivative berrhless, salvation. 888 feres wale, brave companions (allies). Wale signifies select, choice, worthy, and hence brave. See Gloss. to Allit. Poems, s.v. Wale.

893 He froðer[ed]e him after is swinc.
He comforted him after his toil.

Herbert Coleridge (Gloss. Index, p. 33) connects froðere with the A.Sax. frofrian, to comfort. Of course there is nothing to be said against the interchange of f and th (cf. afurst, thirsty; afyngred, hungry, etc.); but the A.S. freoðian, to protect, render secure, is nearer in form, and there is the O.E. vreþie (Ayenbite) to prove that this verb had not gone out of use. 895 ðe tigðe del = the tenth part. tigðe = tithe = tenth. 898 bargt = barg (the pret. of bergen) preserved. 910 wið-uten man = except the men. The rhyme seems to require us to read nam; the meaning would then be "without exception or reserve."

911 Alle hes hadde wið migte bi-geten.
He had them all with might begotten (obtained).

hes = he + es = he + them. The combination hes occurs again in l. 943. es or is = them, as in l. 949. See Note to l. 135, and Preface to O.E. Miscell. p. xv, and O.E. Hom. 2nd S. p. xii.

P. 27. l. 913 meðoliko wol, with great moderation, very meetly. Cf. unmeaðeliche in Seinte Marherete, p. 10. meðeliche in O.E. Hom. 2nd S. p. 7. meðleas, Ancren Riwle, p. 96. 918 algen = halgen = hallow. 920 bi-told (rescued) should be the pret. of a vb. bitellen, but no such word occurs in the poem. See O.E. Hom. 1st S. p. 205. Owl and Night. l. 263. Laȝamon uses bi-tellen, to win.
"Ac wih him we scullen ure frooscipe (freedom)
mid fehte bitellen."—(Vol. i. p. 328.)
"Bi-ðencheð eow ohte (bold) cnihtes
to bi-tellen eoweore rihtes."—(i. 337.)
The editor explains bitellen by to win, but regain would suit the context.
"Nu þu hauest Brutlond,
Al bi-tald to þire hond."—(Vol. ii. p. 335.)
"Nu ich mi lond habben bi-tald."—(Vol. iii. p. 258.)

924 Quo-so his alt him bi-agt
= Whoso them (goods) holdeth, him it behoveth (yield as tithes). His = is = es, them. 927 gulden wel, requited well.

934 Of ðe-self sal ðin erward ten, Of thyself shall thine heir come. erward = eruweard, heir. 939 nam god kep = took good heed to, attended carefully to. kep = care. See R. of Gl. 177, 191. Owl and Night. l. 1226. Hampole's P. of C. ll. 381, 597. 941 Euerilc, each, every one. euerilc is the same as the O.E. euerich, Mod. Eng. every.

943 *Vndelt hes leide quor-so hes tok,*
 Undivided he laid them where-so he took (brought) them.
 This line refers to the "*duue and a turtul,*" in the following line. See
 Genesis xv. 10. 945 *on-rum* the same as *a-rum,* apart, aside.
 " Tho Alisaundre sygh this,
 Aroum anon he drow, ywis,
 And suththe he renneth to his muthe (army)."
 —(Kyng Alys., 1637.)
946 *And of ꝺo doles kep he nam.*
 And of the pieces care he took.
P. 28. l. 949 *kagte is wei,* drove them away. *kagte* is the pret. of *kache,* to drive.
 " And he ansuered als he war medde,
 And said, Allas and wailewaye.
 That ever I com at yon abbaye,
 For in na chaffar may I winne
 Of tha lurdanes that won tharinne
 For likes nan of thaim my play,
 Bot alle thar *kache* me away."—(Met. Hom. p. 151.)
 953-954 God said to him in true dream, the *future* condition of his seed.
 beren-tem = *barn-teem,* offspring, descendants.
 " We are alle a (one) man *barn-teme.*"—(Cursor Mundi, fol. 27b.)
956 *And uten erdes sorge sen.*
 And in foreign lands sorrow see (experience).
 Cp. " *Outen* sones to me lighed þai,
 Outen sones elded er þai."—(Ps. xvii. 46.)
 " Filii alieni mentiti sunt mihi, filii alieni inveteraverunt."
 Cf. *uten stede,* l. 1741. O.E. *utenlande,* a foreigner. Havelok, l. 2153.
 958 *Hor* = *or,* before. 960 ꝺat *hotene lond,* that promised land. 964
 untuderi, barren. The usual O.E. term is *unberand,* unbearing. See
 O.E. Hom. 2nd S. p. 177. 965 *abre* = to Abram. 969-971 And Sarai
 would not suffer it, that Hagar were thus swollen (with pride). She
 held her hard in thrall's wise (treated her as a slave). 974 *one and sori,*
 solitary and sad. 975 *wil and weri,* lonely and weary. *Wil* literally
 signifies astray, *wild,* from the verb *wille,* to go astray. See Gloss. to
 Allit. Poems, s.v. *Wyl.*
 " He is hirde, we ben sep ;
 Silden he us wille,
 If we heren to his word
 ꝺat we ne gon nowor *wille.*"—(O.E. Miscell. p. 2.)
 " And child Jesus *willed* them fra."—(Met. Hom. p. 108.)
977 *wiste hire drogen sori for ꝺrist.*
 Knew her to be suffering sorely for thirst.
 drogen may be an error for *drogende* = suffering. *sori* as an adjective is
 not sorrowful, as most editors interpret the word, but heavy, painful, and
 hence anxious, etc. See l. 974.
 " Quen thai him (Jesus) missed, thai him soht
 Imang thair kith and fand him noht,
 And forthi Joseph and Mari
 War for him sorful and *sari.*"—(Met. Hom. 108.)

978 *quemede hire list*, satisfied her desire.

P. 29.　l. 984 *folc frigti*, formidable folk. *frigti* does not here signify, as in other parts of the poem, *afraid*, but *to be feared*. 991 *in sunder run*, secret speech or secret communing, private conversation. See O.E. Hom. 2nd S. p. 29. 1010 ꝺe *ton* = the one. *ton* = that one the first; *to*ꝺ*er* = that other, the second.

P. 30.　l. 1019 *quamede* = *quemede*, pleased.

1021-1024　　Quoth this one, "this time next year,
　　　　　　Shall I appear to thee here;
　　　　　　By that time shall bliss befall Sarah,
　　　　　　That she shall of a son conceive."

1026　　　　*And it hire* ꝺ*ogte a selli* ꝺ*hing*,
　　　　　　And it appeared to her a marvellous thing.

1028 *on wane*, wanting one, *i.e.* one less. "In þis burh was wuniende a meiden swiꝺe ȝung of ȝeres, *two wone* of twenti."—(St. Kath. 69.)

1032　　　　*And it wur*ꝺ *so*ꝺ *binnen swilc sel*,
　　　　　　And it became so (came to pass) within such time.

1035 *stelen* = go away stealthily or secretly.

1036 *Ne min dede abraham helen*,　　Nor my deed from Abraham hide.

1037 *sinne dwale* = complaint of sin (see l. 1220); *dwale* may be taken as an adj. = grievous, mischievous. 1038 *miries dale*, an error for *mirie dale* = pleasant dale. See l. 1121.

1039-40　　　　ꝺ*o adde abram-is herte sor*,
　　　　　　for loth his newe wunede ꝺ*or*,
　　　　　　Then had Abraham's heart grief,
　　　　　　For Lot, his nephew, dwelt there.

1041-4 "Lord," quoth he, "how shalt thou do (this), if thou shalt take vengeance thereon; shalt thou not the righteous protect (spare), or for them (for their sake) to the others mercy bear (show)?" *me*ꝺ *beren* = to bear mercy, to show mercy to. See ll. 1046, 1242.

1046　　　　*Ic sal me*ꝺ*en* ꝺ*e stede for* ꝺ*o*,
　　　　　　I shall have mercy upon the place for those (for their sake).

*Me*ꝺ*en* signifies to use gently, act with moderation towards any one, to compassionate, to show mercy to. (See Allit. Poems, p. 45, l. 247; p. 51, l. 436; p. 54, l. 565; O.E. Hom. 2nd S. p. 153.) 1049 *at-wot*, departed. There is no such verb as *æt-witan*, to depart, in Bosworth's A.Sax. Dict. The only meaning given to *atwiten* by Stratmann is to reproach, twit. *At-wot* may be a blunder for *at-wond*, departed. See l. 3058. Laȝ. l. 87. We have the O.E. *at-flegen*, *at-gon*, *at-scape*, etc. The simple verb *wite* is not uncommon in Early English authors.

　　　　　　" The first dai sal al the se
　　　　　　Boln and ris, and heyer be
　　　　　　Than ani fel of al the land,
　　　　　　.
　　　　　　And als mikel the tother day
　　　　　　Sal it sattel and *wit* away."—(Met. Hom., p. 25.)

　　　" When this was sayd, scho *wyte* away."—(*Ibid.*, p. 169.)

1054 *quake* is evidently an error for *quate* = wait, look for.

P. 31. l. 1055 *He ros, and lutte, and scroꝺ him [hem?] wel.*
 He rose, and bowed, and urged (invited) them well.
 1060 *He wisten him bergen fro ꝺe dead.*
 They wished to preserve him from death.
 bergen is literally to preserve, but it may be here used passively, as the
 infinitive often is by O.E. writers, and we must then render the line as
 follows :—" They wished him to be preserved from death."
 1062 *And he him gulden it euerilc del.*
 And they him requited it every whit.
 1063 *Oc al ꝺat burgt folc ꝺat helde was on.*
 But all that townsfolk that were old enough.
 1073 *ꝺat folc vn-seli, sinne wod.*
 That wretched folk, mad with sin.
 1076 *wreche and letting* = vengeance and failure.
 1079 *Wil siꝺen cum on euerilc on.*
 Blindness *or* bewilderment afterwards came on every one.
 1082 *fundend* = *funden* + *id* = *funden* + *it* = found it. 1084 *don
 red* = do (obey) counsel, i.e. take advice.
P. 32. l. 1095 *in sel* = in time, timely, opportunely.
 1097 *ꝺat here non wente agen.*
 That none of them should turn back.
 1101 *gunde under dun*, under yond hill. 1103 *sren*, if correct, might
 signify *screen*, but it seems to be an error for *fren*, to set free, and hence
 to save.
 1105 · *Ai was borgen bala-segor.*
 Aye was saved Bela Zoar (little Bela).
 See Gen. xiv. 2 ; xix. 20, 22. 1107 *hine* = him, the name of the
 town being regarded as of the masculine gender. 1108 *erꝺe-dine* = earth-
 quake.
 " Á hundyr á thowsand and sewyntene yhere
 Frá þe byrth of our Lord dere,
 Erddyn gret in Ytaly
 And hugsum fell all suddanly,
 And fourty dayis frá þine lestand."—(Wyntown, p. i. 289.)
 The verb *dinne* in O.E. has not only the sense of to *din*, but to shake,
 quake. See Seinte Marherete, p. 20.
 " Þe erth quok and *dind* again."
 —(Cursor Mundi ; Cott. MS. Vesp. A. iii. fol. 11 *b*.)
 1109 *Sone so*, as soon as. 1110 *brend-fier-rein*, rain of burning fire.
 1116 *Ne mai non dain wassen ꝺor-on,*
 None may dare to wash therein.
 dain, if not an error for *darin* = *daren*, dare, venture, may = ꝺ*ain*, a
 man, a servant, or = *duen*, avail. 1119 *wente hire a-gon*, turned her
 aback. See l. 1097. 1120 *wente in to a ston*, turned into a stone.
 1121 *So ist nu forwent mirie dale,*
 So is there now changed merry (pleasant) dale.
 ist = *is* + *it*, is it, there is. 1125 *deades driuen*, held (influenced) of
 (by) death.
P. 33. l. 1127 They say the trees that are near it, come to maturity in time, and

bring forth fruit and thrive, but when their apples are ripe, fire-ashes one may see therein. *fier-isles*, fire-ashes. For the meaning of *isle*, see Gloss. to Allit. Poems, s.v. *Vsle*. 1131-2 That land is called dale of salt, many a one taketh thereof little heed (account).

> " Of thair schepe thai gif na *tale*,
>> Whether thai be seke or hale."—(MS. Harl. 4196, fol. 92.)

1137 *biggede*, dwelt. It signifies more properly to *build*. 1139-40 Here is an allusion to the destruction of the world by fire mentioned in lines 640-644, p. 19. Those maidens erewhile heard some say that fire should all this world consume. 1140 *forswethen*, to burn up entirely, from the O.E. *swethe* or *swithe*, to burn, scorch. See Ancren Riwle, p. 306 (footnote). Gloss. to Allit. Poems, s.v. *swythe*. 1142 *fieres wreche*, vengeance (plague) of fire. 1143-4 The Cursor Mundi says that Lot's daughters seeing only their father, thought that all men had perished.

> " Bot Loth him held þat cave wit-in,
> He and his doghtres tuin ;
> For þai nan bot þair fadre san,
> Þai wend alle men war don odau,
> Thoru þat ilk waful wrak ;
> Þe elder to þe yonger spak :
> ' Sister to þe in dern I sai,
> Þou seis þe folk er alle awai ;
> Bot Loth our fador es carman (male) nan,
> Bot we twa left es na womman ;
> I think mankind sal perist be,
> Bot it be stord wit me and þe.' "—(fol. 18.)

1147 *vnder-gon*, (1) to go under, (2) to cheat, deceive. In line 1160 *under gon* — to undertake, take up again.

Cp. " 3et our by leave wole *onder-gon*,
> That thyse thre (Persons of the Trinity) beth ry3t al on."
>> —(Shoreham, p. 142.)

> " Ope the he3e e3tynde day
>> He *onder-3ede* the Gywen lay."—(Ibid. p. 122.)

> " And tus adam he [Christ] *under-yede*,
>> reisede him up, and al mankin,
>> ðat was fallen to helle dim."—(O.E. Miscell. p. 22.)

1151 *eiðer here*, each of them. Cf. O.E. *eiðer e3e*, each eye, both eyes. 1159-60 Now behoveth us to turn back and take up *the* song concerning Abraham.

1162 *Wið reuli lote and frigti mod.*
> With mournful cheer and frightened mood (mind).

reuli = sad, rueful, from the verb *rue*, to pity, compassionate, grieve for. Cf. O.E. *rueness*, compassion ; *Ruer*, a merciful person ; *reuthe*, pity.

> " He saith ' we ben ybore euerichone
>> Making sorwe and *reuly* mone.' "—(MS. Addit. 11305.)

lote, fare, cheer.

> " Þis isah þe leodking The king saw this,
>> grimme heore *lates*." their grim gestures.
>> —(La3. ii., 245.)

"Þat freond sæiðe to freonde, That friend saieth to his friena
mid fæire *loten* hende, With fair comely looks,
'Leofue freond, wæs hail!'" "Dear friend, wassail!"
 —(*Ibid.* ii., 175.)

P. 34. l. 1163 *Roke*, East Anglian for *reke*, smoke. See Prompt. Parv. p. 436
Beve's, l. 2471.

1164 *And ðe brinfires stinken smoke,*
 And the sulphur's stinking smoke.

stinken = *stinkende*, stinking. 1166 *him reu*. The verb *rewe* is used
impersonally in O.E. 1167 *suðen* = southwards. (See Gen. xx. 1.)
1171-2 Erewhile as first Pharaoh her took, now taketh Abimelech her
also. 1177 *wif-kinnes*, womankind. 1178 *wið-helð* = *wið-held*.
1179-80 In dream to him came tidings why he suffered and underwent
that misfortune. 1180 *untiming* is literally that which is unseasonable.
We have the same notion expressed in O.E. *unhap* (mishap), misfortune;
E. *happen*, happy, and E. *hap*, happen, etc. Cp. *untime*, in Ancren
Riwle, p. 344. 1184 *ðat il sel*, that same time, immediately.

1186 *And his yuel sort was ouer-gon,*
 And his evil lot was passed.

1188 *ða ðe swinacie gan him nunmor deren,*
 When the quinsy did him no more vex (annoy).

Our author or his transcriber is certainly wrong about the "*swinacie;*" for
the punishment of "*lecher-craft*" was *meselry* (leprosy), the quinsy being
the penalty for *gluttony*. The seven deadly sins were thus to be punished
in Purgatory:—

 1. Pride, by a daily fever.
 2. Covetousness, ,, the dropsy.
 3. Sloth, ,, the gout.
 4. Envy, ,, boils, ulcers, and blains.
 5. Wrath, ,, the palsy.
 6. Gluttony, ,, the quinsy.
 7. Lechery, ,, meselry or leprosy.

1192 *ðat faire blod*, that fair woman. *blod* in O.E. was used as a term of
the common gender, as also were such words as *girl*, *maid*, etc. See
Gloss. to Allit. Poems, s.v. *blod*.

1193 · *Bad hire ðor hir við heuod ben hid*
 = *Bad hire ðor-við hir heuod ben hid?*
 Bad her there-with her head to be hid,
 (That is, she was to buy a veil for her head).

1194 *timing*, good-fortune, happiness. See note to line 1180. 1195 *bi-
sewen*, be seen. *so* in this line seems an unnecessary addition of the
scribe's. 1197 *wurd* = *wurð*, became; *on elde wac*, in age weak (feeble).
Woc = weak; the older form is *wac*. See Laȝ. ii. 24, 195, 411.

 "Forr icc amm i me sellfenn *wac*,
 & full off unntrummnesse."—(Orm. ii. 285.)
"Vor nout makeð hire *woc* but sunne one."
For nought maketh hir weak but sin only.
 —(Ancren Riwle, p. 4.)

See O.E. Miscell. p. 135; ll. 581, 595.

1198 *trimede* is, perhaps, for *timede* = *teemed* = brought forth; if not it must be referred to O.E. *trumen*. See *trimen* in l. 1024.

P. 35. l. 1200 *a-buten schoren* = about shorn, is merely the explanation of circum-cized.

> " O thritte yeir fra he was born,
>
> was ysmael wen he was *schorn.*"—(Cursor Mundi, fol. 16 b.)

1201 *lay* is another form of *law.* Cf. O.E. *daye* and *dawe.* 1204 *al swilk sel*, even at such time. 1206 *is told*, is reckoned. 1208 *fro teding don*, removed from his mother's care (?). *teding* = *tending* (?), nursing, care, not *teŏing* = *teething.* "*fro teding don*" in the Cursor Mundi is expressed by the phrase *spaned fra the pap* = weaned from the breast.

1209 *Michel gestninge made abraham,*

> great feasting *or* entertainment made Abraham.

gestninge (feasting) seems to be the same as the S.Saxon *gistninge*, a ban-quet. The original meaning is hospitality; O.E. *gesten*, to entertain a guest; S.Sax. *gistnen*, to lodge. See Ancren Riwle, p. 288 a, 414. La3. ii. 172.

1212 *And ysmael was him vn-swac,*

> And Ishmael was to him (Isaac) disagreeable.

vn-swac, displeasing, distasteful. There is no such word as *un-swæc* to be found in the A.Sax. glossaries, but we have *swæc*, savour, taste, from which I have deduced the meaning here given to *un-swac*. See Ancren Riwle, p. 48, where *spekung* = *swekung*, and cp. *swæe*, stenc, and hrepung, in Ælfric's Hom. i. 138.

1213 *un-framen*, to annoy, from O.E. *frame*, to benefit, to profit.

1216 *Hir was ysmaeles anger loŏ*, To her was Ishmael's anger displeasing.

1217 *Ghe bi-mente hire to abraham*, She bemoaned her to Abraham.

bimente = pret. of *bimene*, to complain, lament.

> " *bimene* we us, we hauen don wrong."—(O.E. Miscell. p. 25 ; see R. of Gloucester, p. 490.) 1220 *dwale*, complaint, grief. See l. 1037.

> " Be þu neuere to bold, to chiden agen oni scold,
>
> ne mid mani tales to chiden agen alle *dwales.*"

> (O.E. Miscell., p. 127. See p. 126, l. 414.)

1221 *rapede*, hastened, hurried away. See Rich. Cœur de Lion, 2206.

> " The wretche stiward ne might nowt slape ;
>
> Ac in the morewing he gan up *rape.*"—(Seven Sages, l. 1620.)

> " The king saide, ' I ne have no *rape* (I am in no hurry)
>
> For me lest yit ful wel slape.' "—(Ibid. l. 1631.)

1224 *In sumertid, In egest sel,*

In summer time, in the highest time (the hottest season) of the year. Cp. 'in a *hy3* seysoun.'—Allit. Poems, p. 2, l. 39. 1228 *hete gram*, fierce heat. 1229 *waxim ŏrist.* The sense requires us to read *wex on ŏrist*, with fatigue and heat thirst waxed on them.

1231 *Tid-like hem gan ŏat water laken*, Soon did that water fail them.

P. 36. l. 1238 *Bi al-so fer so a boge mai ten*, By as far as a bow may reach.

1239 *sik and sor*, sighing and sadness. 1241 *dede hire reed*, brought her help.

1242 *An angel meŏede hire ŏat ned*, An angel alleviated her distress. *hire* is the dative of the personal pronoun. 1244 *seli timing*, a fortunate occurrence. See note to l. 1180. 1247 *nam fro ŏan*, went from that

place. *fro ðan* = Sc. *fra thine*, from thence. 1252 *mikil and rif*, great (powerful) and wide-spread. 1254 In Arabia his kin dwell. 1258 *kung-riche = kineriche*, kingdom. Cf. *kungdom = kunedon =* kingdom, l. 1260. *kunglond, kunelond = kinglond*, kingdom, l. 1262. *guglond = kunglond*, kingdom, l. 1264.

1261-2 His ninth son was Tema,
 Wherefore is there a kingdom called Teman.
1264 *Het a guglond esten* (eften ?) *fro ða,*
 Was called a kingdom afterwards from that time.
esten fro ða = eastwards from those *other kingdoms.* 1269 *siker pligt,* firm, sure pledge.

P. 37. l. 1275 *feren pligt,* pledged fellows.
1279 *ðog* [*it*] *was nogt is kinde lond,*
 Nevertheless it was not his native land.
1280 *Richere he it leet ðan he it fond,* richer he left it than he found it.
1290 *On an hil ðor ic sal taunen ðe,* on a hill where I shall show thee.
1292 *ðat he bed him two* [to ?], that he commanded him to go to. *two,* an error for *to.* See l. 3752. 1295-6 They say on that hill's side was made the temple of Solomon. 1295 *dune-is siðen = dune-is siden,* down's (hill's) sides. 1299 *buxum o rigt,* rightly obedient. 1301 *sagt,* an error for *sag* (saw). See l. 1334.

P. 38. l. 1308 *ðo wurð ðe child witter and war,*
 Then became the child wise and wary.
1315-20 Wonderfully art thou in the world come,
 Wonderfully shalt thou be hence taken ;
 Without long suffering and fight (struggle)
 God will thee take from world's night,
 And of thyself holocaust have,
 Thank Him that He would it crave (demand).
1317 *ðhrowing = throe,* suffering, agony.
 " *ðrowwinge* and pine."—(Orm. ii. 174.)
" Vor soð wisdom is don euere soule-hele biuoren flesches hele : and hwon me ne mei nout boðe holden somed, cheosen er licomes hurt þen þuruh to stronge vondunges, soule *þrowunge.*"—(Ancren Riwle, p. 372.) For true wisdom is ever to put soul-health before flesh-health, and when one may not hold both together, to choose rather bodily hurt than, through too strong trials, soul-agony (death). 1323 Supply *don* after *wulde.* 1328 *nuge = nog,* now, 1331 *frigti fagen* may be either *frigti and fagen,* timid *and* glad, or else *frigti-fagen,* timidly glad.
1332 *for ysaac bi-leaf un-slagen,* for Isaac remained unslain.
1333 *Bi-aften,* behind, abaft.
 " Tacc þær an shep *bafftenn* þin bacc
 and offre itt forr þe wennchell."—(Orm. ii. 156.)
1336 *on ysaac stede,* instead of Isaac.

P. 39. l. 1345 *Sarra was fagen in kindes wune,* Sarah was naturally glad.
in kindes wune = after the manner of kinde (nature) ; *kindes wune =* kind-wise, kin-wise. 1365 *semeð* is an error for *semes,* burdens, loads, or for *semed,* burdened, loaded. See l. 1368. *seme* is properly a load for a pack-horse.

"An hors is strengur than a mon,
 Ac for hit non i-wit ne kon,
 Hit berth on rugge grete *semes*,
 And dra3th bi-vore grete temes."
 —(Owl and Nightingale, ed. Wright, p. 27.)

1372 *min erdne ðu forðe selðhelike*, mine errand do thou perform, accomplish successfully. *forðe* = *forðen*. See Orm. 1. 1834; Ancren Riwle, p. 408; La3. l. 31561. 1373 *lene*, grant, still exists in *lend*, *loan*, etc.

1375 *He had hise bede on good sel*,
 He offered his prayer (in good time) opportunely.

P. 40. l. 1379 *ilc on* = each one.

1382 *Ne wor nogt so forð ðeuwe numen*,
 The custom had not been so forth (up to that time) practised.

1388 *bofte* = *bi-ofte*, behoof; cf. O.E. *byefþe*, *bi-ofþe*. See l. 1408. 1390 *beges* = bracelets, armlets, probably from A.Sax. *bugan* (= *beogan*), to bow, to bend. The original meaning of *beg* is crown. In Piers Ploughman 346, *beighe* signifies a collar. In the Middle High German version of the Book of Genesis (ed. Diemer) it is stated that Eliezer, for love, gave Rebekah

 "Zwêne ðringe
 und zuêne arm-*pouge*
 ûz alrôteme golde."

1391 *ghe* seems to be an error for *he*. 1394 *kiddit* = made it known, showed it. 1397 *good grið* = good entertainment. 1398 *Him* (the dative of the personal pronoun), for him.

1404 *Quile selðo and welðhe him wel bi-cum*,
 What prosperity and wealth had well befallen him.

1409 *wið-ðan*, with that, thereupon.

1410 *fagneden wel ðis sondere man*, welcomed well this messenger. *fagnen* is literally to make *fain* or glad, to welcome, entertain; *sondere man*. The proper form is *sondes-man*. Ancren Riwle, p. 190. Cf. *loder-man* for *lodes-man*, l. 4110, p. 117; and *sander-bodes*, O.E. Hom. 2nd S. p. 89.

P. 41. ll. 1411-12 When God hath it so ordained,
 As he sendeth so it shall be.

1417 *garen*, to prepare (to set out), to make *yare*, to get ready.

1419-20 For entreaty nor meed not would he there.
 Over one night delay no (any) more.

drechen is (1) to trouble, annoy, (2) to hinder, delay.

 (1) "Sir Pilates wife dame Porcula
 Tille hir Lord thus gan say—
 'Deme 3e noght Ihesus tille ne fra,
 Bot menske him that 3e may
 I have bene *drechid* with dremes swa,
 This ilk night als I lay.'"
 —(Gospel of Nichodemus, Harl. MS. 4196.)

 (2) "Quhen Claudius þe manhed kend
 Of þe Brettownys, he message send
 Tyl Arwyra3us, þan þe kyng

þat Brettayne had in governyng,
For til amese all were and stryfe,
And tak his dochtyr til his wyfe,
And to Rowme þat Tribwte pay
Wycht-owtyn *drychyng* or delay."—(Wyntown, vol. i. p. 92.)
In the Cursor Mundi we are told that *wanhope* (despair) causes
" Lathnes to kirc at sermon here
 Dreching o scrift (delay of shrift)," etc.—(Cott. MS. Vesp. A. iii.)
1427 *Or or* first ere, i.e. before. 1428 *morgen-giwe* = *morgen-giue*, nuptial
gift, the morning gift, the gift of the husband presented to the wife on the
morning after marriage. See Ancren Riwle, p. 94. Hali Meid. p. 39.
1430 *godun dai*, good day. *godun* = *godne*, the accusative of the ad-
jective.
 " He let clipie þe saterday :
 Þe freres bifore him alle
 And bed alle *godne* day."—(St Dunstan, l. 200.)
1434 *sondes fare*, the journey of the messenger (Eliezer). 1437 *on felde*
= the O.E. *afelde*. 1439 *Eðõede* = *eõede*, alleviated, is connected with
the O.E. *eþe* (*eaõ*), easy, and literally signifies softened. 1440 *Of faiger
waspene*, of fair form ; *waspene* is evidently an error for *wasteme* or *wastene*.
" He seh þeos seli meiden marherete. þe schimede ant
schan al of wlite (face) ant of *wastum* (form)."—(Seinte Marherete, p. 2.)
" In þis burh was wuniende a meiden swiõe ȝung of ȝeres, two wone of
twenti, feir ant freolich o wlite & o *westum*."—(St Kath. p. 69.) 1442
Here samening, their union, intercourse.
1444 *And sge ne bi-spac him neuere a del.*
 And she contradicted him never a whit.
bispeke in O.E. also signifies to threaten. See Castle of Love, l. 221.
P. 42. l. 1448 *Abraham dede hem siõen sundri wunen,*
 Abraham assigned them afterwards sundry abodes.
 1456 *Him bi-stoden wurlike and wel,*
 Mourned for (bewailed) him worthily and well.
See ll. 716, 3857. *wurlike* = *wurõlike*, worthily. 1461-4 Long it was
ere she him child bare, And he entreated God, when he became aware of it
(*i.e.* that Rebekah was barren), That he should fulfil that promise, That he
to Abraham erewhile made. 1463 *fillen*, to fulfil, accomplish. See Orm.
i. 91. *quede*, promise, saying, is the same as the O.E. *quede*, a bequest,
quide, a saying, from *queõe*, to say, still existing in *quoth*. See Laȝ. i.
38, 43 ; ii. 151, 197, 613 ; iii. 3 ; Orm. ii. 321.
1467-8 At one burden she bore
 Two, who were to her akin of blood.
sibbe blod = O.H.G. *sippe-bluot*, blood relatives. Perhaps this line was
inserted by the author on account of the popular belief at this time, that
the birth of twins was an indication of unfaithfulness on the part of the
woman to her husband. 1469-71 Also it seemed to her day and night,
As (though) they wrought in fight (struggling, conflict), Which of them
should first be born. 1470 " And the children struggled together within
her."—(Gen. xxv. 22.) The following curious paraphrase of this passage
occurs in the Cursor Mundi, fol. 20*b* :—

" His wiif (Rebekah) þat lang had child forgane,
Now sco bredes tua for ane,
Tuinlinges þat hir thoght na gamen,
Þat in hir womb oft faght samen.
Swa hard wit-in hir wamb þai faght,
Þat sco ne might rest dai ne naght;
At pray to Godd ai was sco prest,
To rede hir quat þat hir was best;
Þat hir war best he wald hir rede.
Hir liif was likest to þe ded (death).
Strang weird was giuen to þam o were,
Þat þai moght noght þair strif forbere
Til þai had o þaim-seluen might
To se quarfor þat þai suld fight.
Fra biginning o þe werld
O suilk a wer was never herd,
Ne suilk a striif o childer tuin
Þat lai þer moder wamb wit-in.
Þair strut it was vn-stern stith,
Wit wrathli wrestes aiþer writh.
Bituix unborn a batel blind,
Suilk an was ferli to find.
He þat on þe right side lai
Þe tother him wraisted oft awai;
And he þat lay upon þe left,
Þe tother oft his sted him reft."

1470 *and* = *an* = in; or else *figt* must be an error for *fagt* = fought; and *nigt* = *nagt*. 1477 *Ghe* is evidently an error for *ghet* or *get*, yet. *liues* = alive. Cf. *newes*, anew, etc.

P. 43. l. 1484 *swete mel*, sweet meal (food), not sweet speech. " And Isaac loved Esau, because he did eat of his venison."—(Gen. xxv. 28.) 1487 *seð a mete*, sod a meat. " sod pottage."—(Gen. xxv. 29.) 1493 *mattilike weri* = *mattilike and weri*, overcome (faint) and weary. *Mattilike* is connected with the O.E. *mat*, *mote*, faint, half dead. See Allit. Poems, p. 12, l. 386.

1494 *Iacob wurð war he was gredi*,
Jacob became aware that he (Esau) was hungry.

—(See Gloss. s.v. *Gredi*.)
1495-6 "Brother," quoth he, " sell me those privileges Which are said to be the first (eldest) son's." 1499 *bliðelike*, quickly; *blithelike* has often this sense in O.E. writers. 1501 *wurði wune*, a worthy (high, great) privilege. 1503 *offrende sel*, offering time.

1504 *Was wune ben scrid semelike and wel*,
Was wont to be clothed seemly and well.

1506 *dede his ending*, came to his end (died). 1507 *heg tide*, hey (high) days. 1510 *twinne del*, two-fold. 1511-12 And when the father were (should be) buried, to have two portions of hereditary property. *ereward* = *erfeward*, is properly the guardian, keeper of the *erfe* or inheritance, and hence the heir, so that instead of *ereward riche* we ought to read

ereward-riche, corresponding to the A.Sax. *yrfe-land,* hereditary land. The *-riche* is the affix found in O.E. *heven-riche,* heaven kingdom; *kineriche,* a kingdom; E. *bishoprick.* The *-ward* (in *ereward*) = *warder,* keeper, is found in O.E. *gate-ward, dore-ward* (door-keeper), *bat-ward* (boat-keeper); *hey-ward* (farm-yard keeper); *sti-ward* (steward, the officer who originally had care of the highways or *sties*?).

P. 44.　l. 1514 *then,* an error for *ten,* to go.　1515 *in wis,* in wise, so that; but may we not read *in-wis = i-wis,* indeed, truly? See l. 2521.　1518 *Holden wurδelike,* esteemed honourably, held in honour, respect; *a* may be for *and,* or for *aa = aye,* ever.

1519-20　　A hundred times as much waxed his honour,
　　　　　　So may God prosper where he will.
1521　　*Niδede δat folk* [δat] *him fel wel,*
　　　　　　That folk envied him because he prospered.
1522 And made him change his abode; *flitten* is to remove, to *flit.*

　　　　" O land he (Noe) had ful grette plenté,
　　　　For him and for his sons thre;
　　　　Mast to tilth he gave him þan,
　　　　To *flitt* þe breres he bigan;
　　　　Sua lang wit *flitting* he þam sloght,
　　　　Þat wine-treis he þam wroght."
　　　　　　　　　　　—(Cursor Mundi, fol. 13.)

1524 *trewδe fest, troth-fast,* pledged by troth or plighted faith; *fest* has usually the sense of confirming, pledging, in O.E.

　　　　" Þis neu forward (covenant) was *festened* þan."
　　　　　　　　　　　—(Cursor Mundi, fol. 23.)

1527-28　　And age came upon Isaac,
　　　　　　He became sightless and weak of (with) age.
elde swac = eldes wac, weak of (with) age.　1531 *δat,* what.　1535 *brogtes,* brought them.　1536 And she well knew the father's choice; *kire* answers exactly to the later gloss, *wune =* what is chosen, selected; S. Sax. *cure,* choice.

　　　　" Þer stoden in þere temple
　　　　ten þusend monnen
　　　　þet wes þe bezste *cure*
　　　　Of al Brut-londe."—Laȝ. i. 345.

1537 And made exceedingly good, or very opportunely, that meat; *on sele = on-sele,* good, literally timely, opportunely; S.Sax. *on sele,* safely. See note on l. 1542.

　　　　" Cnihtes fuseδ me mid
　　　　leteδ slæpen þene king
　　　　And fare we *on sele.*"—Laȝ. i. 32.

sæ-men æfter　　　　　　*The* sea men after
fóron flód-wége　　　　marched the flood way
folc wæs *on salum.*　　*the* folk prospered (was in prosperity).
　　　　　　　　　　　—(Cædmon, 184, 13.)

1539 Clothed she Jacob and made him rough.　1542 *seles mel,* an error for *selie mel,* good (timely) meal? Cf. *miries dale* for *mirie dale,* l. 1038, p. 30. See Laȝ. i. 75; ii. 173.

" And þas word saide

Brutus þe *sele* (the good)."—Laȝ. i. 30.

' " haueð mi fader bi þære sæ

Castel swiðe *sæle*."—(*Ibid*. ii. 14.)

1544 For he handled him and found him rough. **1545** When he knew him, opportunely he blessed him, faithfully and well. *on gode sel*, in good time, opportunely. See note to l. 1542.

P. 45. ll. 1547-8 Heaven's dew and earth's fatness,

Abundance of wine and oil.

1550 Supply *and* after *migt*.

1565-6 Quoth Esau, "right is his name

Called Jacob, to my disadvantage."

1569-70 Nevertheless, dear father, intreat I thee

That thou give me some blessing.

1573 *erðes smere*, earth's fatness; *smere* is properly *fat*, grease, butter. In the Orm. ii. 106 it is used in the sense of ointment. **1574** granted him blessing that was precious to him; *gere* is evidently an error for *dere*, beloved, dear, precious.

1575-6 For Idumea, that rich land,

Of pasture good, was in his hand.

lewse, cf. O.E. *leswen*, to pasture; *lezzer*[1] (Shropshire), a pasture-land. (Wicliffe, 1 Kings xvi. 11; 1 Cor. ix. 7; Luke viii. 34.) "If ony man schal entre by me, he schal be saved; and he schal go yn, and schal go out, and he schal fynde *lesewis*." (Wicliffe, St John x. 9.) "Egipte aȝenst kynde of oþer londes haþ plenté of corn; he is bareyne of *lesue*, and whan he haþ plenté of *lesue* it is bareyne of corn." (Trevisa's translation of Higden's Polychronicon, vol. 1, p. 131.)

1577-8 Quoth Esau, "*The time of* mourning shall pass away,

And *I* shall take vengeance of (on) Jacob."

1577 *grot* is a noun formed from the vb. to *grete* (to weep, mourn), just as *wop* is from *wepe* (weep). It is the same as the O.E. *gret*, *grete*, cry, outcry.

P. 46. ll. 1583-4 " Be thou there," quoth she, " till Esau

Appeased be, who rages now."

Eðe-moðed (= *eðe-moded*) is literally easy-minded, humble, mild, and hence soft-mooded, appeased. S. Sax. *edmod*, *eadmodied*, *edmodie*. See Laȝ. ii. 554; Ancren Riwle, 246, 278. The insertion of *be* is necessary to the metre as well as to the sense.

1588-9 Esau married *in order* to annoy us

When he allied (himself to kin of Canaan) and is so foolish.

1591-2 Wherefore he maketh him stubborn and strong,

For he is mixed amongst that kin.

1594 *Ne bude ic no lengere werldes lif*,

I could endure (abide) no longer world's life.

1605 *an soðe drem*, in true dream. **1606** *heuene bem* = heaven-beam (?), the sun (?). **1610** *Lened* = leaned; but the MS. also sanctions *leued* = remained; *and* [*Jacob*] *wurð ut-suuen*, and Jacob became cast out of

[1] Written *leasowe*.

(aroused from) *his sleep*. 1615 *i* = *ic*, I. It is common to find *i* before *sal*, instead of the fuller *ic*.

P. 47. l. 1620 *amongus* = *amonges* = amongst. 1621 *a-gen cumen* = *agen-cumen*, return. 1623 *for muniging* = for *a* memorial. 1624 *And get on olige* = and poured on oil ; *olige* = the O.E. *olie*, *elye* = oil ; *anelye*, to anoint. 1636 A well well-covered under a stone. 1638 *abiden* (= abode) is the pret. pl. of *abide*. 1641 *sulden samen* = should assemble.

1649 Iacob *wi𐌔 hire wente 𐌔at ston*,
 Jacob for her removed that stone.

wi𐌔 in O.E. signifies in, for, against, etc.

1651-2 And he made known he was her aunt's son,
 And kissed her after kins-wise (as a relative).

mouies is properly a female relative ; S.Sax. *mawe*, *mo𐌣e*, *mowe*, and must be distinguished from *mæi*, *mey*, *may*, etc., a male relative. "*Þis 𐌣et þunche𐌔 me wurst þæt tu þe ane hauest ouergan þi feder ant ti moder, meies ba ant mehen*." (St Marherete, p. 16.)

 "Nu is afered of þe
 þi *mei* and þi *mowe* ;
 Alle heo were𐌔 þe weden
 þat er weren þin owe."—(O.E. Miscell. p. 178.)

We occasionally, as in this instance, meet with the word in a more limited sense. "Annd hire *me𐌣he* Elysabaeþ
 Wass gladd inoh & bliþe
 Off hire dere child Iohan,
 And lefli𐌣 𐌣ho himm fedd."—(Orm. i. 109.)

 "Has þou her," þai said, "ani man,
 Sun or dogter, mik or *mau*
 To þe langand, or hei or lau."—(Cursor Mundi, fol. 17.)

We even find a confusion between the two terms, as in l. 1761, p. 51, and in the following passage :

 "Loth went and til his *maues* (sons-in-law) spak."
 —(Cursor Mundi, fol. 17.)

P. 48. ll. 1655-6 Laban welcomed him (Isaac's son travelled from afar) in friend's wise (friendly) ; *feren* = S.Sax. *feorren*, afar, far, from a distance. (See Ancren Riwle, p. 70, l. 3888.)

 "The sonne, and monne, and many sterren
 By easte aryseth swythe *ferren*."—(Shoreham, p. 137.)

1658 *and laban herte ranc* = and Laban's heart was wrung (with pity) ? for *ranc* read *wranc* = wrang. 1666 *wa𐌔* = *qua𐌔*, quoth, spoke. 1668 *wi𐌔 skil*, in reason, reasonably.

1671 *Luue wel michil it agte a-wold*
 Love so great it ought prevail.

agte awold, have in power, prevail, avail. Cp. "Þerfore everyche Romayn overcomeþ oþer is overcome wiþ flaterynge and wiþ faire wordes; and 𐌣if wordes failleþ, 𐌣iftes schal hym *awelde*." (Trevisa's translation of Higden's Polychronicum, vol. i. p. 253.) 1676 *tog* = *toc* = took.

1681 *long wune is her driuen*, long custom is here held (practised).

P. 49. l. 1693 *londes kire*, custom of the land (country). 1700 *caldes*, called them. Cf. *calde is* in l. 1702. 1706 *ille bi-nam*, foully ravished. 1712 *charen*,

to depart, literally to turn. 1713 *ðelde* an error for *gelde* = should re-
quite.

1713-14 Unless Laban should reward better
 His service, and withhold (retain) him yet.

1715 *serue he scriðed* = he entreated *him* to serve.

1719-26 Covenant is made of all sheep,
 Jacob should take charge *of those* of one colour,
 And if of those, spotted *ones* came,
 Those should be taken for hire (wages).
 Sheep or goat, speckled, streaked, or gray,
 Are placed from Jacob far away ;
 Nevertheless those of one colour
 Bore many unlike and dissimilar.

P. 50. l. 1723 *haswed* = *haswe*, "livid, a sad colour mixed with blue." It also
signifies rugged, shaggy. 1726 *vn-like* = unlike in colour. It may be,
however, an error for *on-like* = alike; *likeles*, unlike, dissimilar in form.
1729 *ðe sunder bles*, the diverse coloured ones. 1736 To be under him
longer is displeasing to him. 1740 *clipping time*, shearing time. See
Allit. Poems, A. 802. 1717 *for-olen* = *for-holen*, secreted.

P. 51. l. 1758 *ðus meðelike spac ðis em,*
 thus kindly (mildly) spake this uncle.

1761-2 My relative, my nephew, my fellow (companion)
 Thou oughtest not to do me such unlawfulness (wrong).

mog. See note to l. 1651.

1763-4 I was afraid it might occur to thee
 To take thy daughters from me.

1765 *fro* an error for *for* (?).

1767 Theft I deny, that is my advice,
 That he be dead (put to death) with whom thou findest them (thy
 gods).

1768-9 *is* — them. 1771 *yuel ist bi-togen*, evil is there accused =
wrongfully has accusation been made, i. e. I am accused of a crime. *bito-
gen*, the p.p. of *biteon*, signifies also *befallen. bitogen* may be an error for
bilogen. 1772 My labour about thy property is drawn (taken up), i. e.
I am troubled about thy property. 1774 And to me was thine honour
dear; *wurðing* = honour, respect, good opinion. 1775 *frend sule wit
ben*, friends shall *we two* be. 1776 And troth plight (pledge) now *us two* be-
tween. 1779 *glað* = glad. 1782 Turned backward ere it was light.
1783 *of weie rad*, quickly away. *of liues* = alive; *of kin* = akin.
1784 Soon was he far from Laban separated. 1786 *Engel-wirð* = *engel-
wird*, a troop, multitude of angels.
 " Þer wes Bruttene *weored*
 baldeliche isomned."—(Laȝ. ii. 412.)

1787 *wopnede here, a* weaponed (armed) host.
 " *iwepned* wel alle
 heo wenden to þan walle."—(Laȝ. i. 401.)
 " & sone anan se þiss wass seȝȝd
 Þurrh an off Godess enngless,
 A mikell *here* off cnngleþeod

Wass cumenn ut of heoffne,
& all þatt hirdeflocc hemm sahh
& herrde whatt te33 sungenn."—(Orm. i. 115.)
" He comuth with so gret *here*
Wondur is the ground may heom beore."—(Kyng Alys., p. 91, l. 2101.)

P. 52. l. 1797-8 And Jacob sent far before
 Him rich gifts, and sundry bearers.
1798 *loac* = *lac*, *loc*, a gift, present.
 " ðe riche reoðeren
 & scheop & bule,
 hwa se mihte
 brohten to *lake*."—(St. Kath. 63.)
 " And bi þatt allterr wass þe *lac*
 O fele wise 3arkedd."—(Orm. i. 34.)
 " Alle hii nemen þat *lock*."—(La3., later copy, ii. 320.)
boren = bearers. A.S. *bora*. 1804 The sinews sprang from the limb.
lið — member, limb. See Hampole's P. of C. 1917.
1805-6 Would they (Jacob's kin) no sinews thenceforth eat,
 His own kin will not forget that usage.
1808 Till the dawning up from the east burst. 1811 *leate* = *lete*,
relinquish. 1818 How shall any man be able to hurt thee ? 1826 And
honoured him as the first-born ; *wurðe* should be *wurð[ed]e*. 1828 ðo
rew him so, then had he such compassion upon Jacob.

P. 53. l. 1829 *trume*, host. (See Guy of Warwick, p. 291 ; La3. iii. 73, 107.)
 " And he arayeth hare *trome*
 As me (one) areyt men in fy3t."—(Shoreham, p. 108.)
Cp. *shel-ter* = or *scheltron* = *schild-trume*. 1833 Jacob was sorrowful
that he forsook (refused) them (the presents). 1835 *hol and schir* =
whole and sound ; *schir* = sheer, pure, undefiled. 1837 *him to frame* =
for his own use. 1840 *tgelt* = *tyelt* = encamped. Cf. Ger. *zelt* ; Eng.
tilt. 1843 There King Emor sold him a *piece of* ground. 1848 She de-
parted leave-less (without permission) from that place. 1851 Her own
counsel misled (ruined) her. We might read
 for hire listede hire owen red, for her own counsel pleased her.
1854 *And his burge-folc fellen in wi*,
 And his people (borough-folk) fell in war.
wi = *wig* = war. Cf. Semi-Sax. *wi3e*, battle, conflict. (La3. i. 201 ; ii.
260 ; iii. 5.) *wi-ax*, *wi-eax*, a battle-axe. (La3. i. 67, 96, 166, 286.)
1855 *bi-speken*, blamed. Cf. *bi-spac*, l. 1444, p. 41.

P. 54. l. 1872 *Gol prenes* = *golde prenes* = gold brooches. *Prene* is connected
with O.E. *preonne*, to sew up. (See O.E. Miscell., p. 172, l. 68.) Sc.
prin, a pin.
1873-4 Deep he them buried under an oak,
 No covetousness made him weak (disobedient) in heart.
1877-8 For Solomon shall find them,
 And his temple deck withal.
1887 *merke dede*, set up a mark (monument).

P. 55. ll. 1901-2 Of Edom so it was named then,
 For it was before called Bozra.

1906 *deden un-red* = committed sin ; *unred,* want of wisdom, miscounsel, folly, wickedness. (See Owl and Nightingale, 161.)

"For *unræd* is swiðe ræh (rash)."—(Laȝ. i. 278.)

1910 *Brictest of waspene* (*wasteme*), brightest of form; *witter wune* = skillwise, skilful, of good abilities. 1912 *vn-hillen & baren,* discover and lay bare (disclose) ; *vnhillen* = O.E. *unhelen.* (See Surtees, Ps. xxviii. 9.) 1914 *wel-ðewed,* well conducted, well behaved.

1915 *for-ði wexem wið gret nið ;* unless *wexem* = *wex hem,* we should perhaps read,

 for-ði he wexen wið gret nið,

Wherefore they increased in great envy (jealousy).

wið = in. 1919 *soren* = *shorn* = reaped. *Shear* is still an E.Anglian term for to reap.

"And I sal say til men *scherande,*
Gaderes the darnel first in bande,
And brennes it opon the land,
And *scheres* sithen the corn rathe,
And bringes it unto my lathe."
—(Met. Hom. p. 146.)

1920 *here* = theirs. Cf. *ure* = ours. 1923 *hu mai ðis sen,* how may this appear (be seen). 1928 *siðe* = *siðen* = afterwards. 1934 In Dothan he found them come. *sogt* = sought = como, arrived ? 1935 *fro feren* = from afar.

P 56. l. 1942 *ðisternesse* = *cisternesse* = cistern. (See l. 1960.) Cistern occurs in the Middle High German Book of Genesis and Exodus, ed. Diemer, p. 75.

"Nu sehet ze dem trômære, er bringet nivmare
Slahen wir den selben hunt,
Werfen in in der *zisterne* grunt."

1942-4 In this pit, old and deep,
Yet shall he be cast, naked and cold,
What-so(ever) his dreams may signify.

1943 *wurðe* = *wurð e* = *wurð he* (?) = he shall be. 1950 *derne sped* = secret haste. I should prefer *derue sped* = *derfe sped,* bold (wicked) haste. 1952 *spices ware* = *spices-ware* = spicery. 1958 Than he should there die in their power. 1961 *ðhogte swem* = appeared grieved = was sorrowful.

1962-3 Believed him to be slain, set up a cry
He will not cease, such sorrow he endured.

1962 *rem,* cry, outcry.

"ðanne *remen* he alle a *rem,*
so hornes blast oðer belles drem (noise)."
—(O.E. Miscell., p. 21.)

1967-8 In kid's blood they turned it,
Then was there-on a piteous stain.

1968 *lit* = stain.

"Ah wið se swiðe lufsume leores
Ha leien, se rudie

& se reade *i-litet* (coloured)
eauereach leor
as lilie i-leid to rose,
Þæt nawhit ne þuhte hit
Þæt ha weren deade."—(St. Kath. l. 1432.)
" Saide Laverd of Basan torne, torne sal I,
In depnesse of þe se for-þi ;
Þat þi fote be *lited* in blode o lim,
Þe tunge of þi hundes fra faas of him."—(Ps. lxvii. 24.)

P. 57. lr. 1975-8 He wept, and said that " wild beasts
Have my son swallowed here."
His clothes rent, in hair (cloth) shrouded,
Long mourning and sorrow is him befallen.

1977 *haigre.* " Þai sal be, als þe appocalips spekes,
In harde *hayres* clende and in sekkes."
—(Hampole's P. of C., 4530.)
1980 *hertedin,* consoled ; literally encouraged him (to hope that his son was
still alive). 1982 *herting* = consolation. 1989 *skiuden* for *skinden* = went.
1992 They made quickly a gainful covenant. 1995 *wol* = *wel* = very.
1999, 2000 But he became then so naturally cold,
To do such deed had he no power.
2004 The author of the poem seems to have confounded Potiphar with
Poti-pherah, the priest of On. (See Gen. xli. 45.)

P. 58. l. 2011 *an heg* for *and heg* = and high. 2015 *One and stille,* alone and
secretly. 2019 Provided that he would with her wanton ; *wile* seems to
be the same as *wigele,* to play, sport. May we not supply *plaige,* play,
before *wile ?* 2020 But what she desired was displeasing to him. 2024
But it was to him all alike displeasing. 2025 *tgeld* = *teyld* = tent. Cf.
tilt (of a cart). 2030 *god* = *goð* = goes.

2031-2 And saith Joseph would do to her,
What she might not prove (or bring) against him.
2031 *seið,* says.
2035-6 The blame is his, the right is hers,
May God almighty discern the truth.
wite, blame, still exists in *twit ;* O.E. *at-wite.*

P. 59. l. 2043 *chartre* for *cwartre* = prison.
" Forr nass nohht Sannt Johan ȝët ta
Intill *cwarrterrne* worrpenn."—(Orm. ii. 270.)
2044 *in hagt,* in sorrow. We might translate ll. 2042-4 as follows :—
"The gaoler did love him, and hath entrusted him the prison to live in
care with the prisoners." 2045 *on-sagen* = *un-sagen* = O.E. *mis-saw,*
opprobrious language. 2047 One that the king's cup presented (the
butler). 2049-50 *onigt* = *anigt,* by night ; *o-frigt* = *afrigt,* in fright,
affrighted. 2054 Hard (troublesome) dreams would cause that (*i. e.*
cause them to mourn). 2057 *softe or strong* = pleasant or un-
pleasant. 2058 The interpretation will on (to) God belong. 2059 *win-
tre,* a vine.
" Me thoght I sagh a *win-tre,*
A bogh þar was wit branches thre ;

O þis tre apon ilk bogh,

 Me thoght hang *winberis* inogh."--(Cursor Mundi, fol. 26.)
2060 That had full grown boughs three; *waxen* = full grown, explains Shakespear's *man of wax*. 2061 First it bloomed, and afterwards bore. 2062 Of the berries ripe became I aware. 2073 Present my petition (intercede for me) to Pharaoh; *herdne* = *ernde*. Cf. O.E. *wordle* = world.

 " Bute heore almesdede But their alms-deed

 heore *ernde* schal bere." Shall intercede for them.

 —(O.E. Miscell. p. 164.)

2075 *kinde lond*, native land. 2076 And here wrongfully held in bond; *wrigteleslike* = *wrigte-les-like*, fault-less-ly; *wrigte* = *wrihhte*, a fault, crime.

 " For niss nohht Godess griþþ wiþþ þa

 Þatt wiþþrenn Godd onnȝæness,

 Acc helle-wawenn iss till þa

 All affterr þeȝȝre *wrihhte*."—(Orm. i. 136.)

P. 60. l. 2077 *liðeð nu me*, listen now to me. 2078 *bread-lepes* = bread-baskets. Cf. O.E. *bar-lepe*, a basket for keeping barley in. See Townley Myst., p. 329; Wicliffe, Exod. ii. 3. *Leep*, or baskett (lepp. K). Sporta, calathus, corbis.—(Prompt. Parv.)

 2085-6 It were preferable to me (I had rather) quoth Joseph,

 Tell the meaning of pleasant dreams.

2086 *rechen* = *recken* = to tell, explain; *swep* = force, stroke. Cf. the use of *bond*, *wold*, ll. 2114, 2122. 2088 *ben do[n] on rode*, be put on the cross (be crucified).

 2089-90 And fowls shall tear away thy flesh,

 That no wealth shall be able to save thee.

2094 *wið-uten erd*, in a foreign land. 2105 On a bush full grown and very beautiful (seasonable ? well-seasoned, prime ?). 2107 *welkede* = withered. *drugte numen*, seized with drought (dryness).

P. 61. l. 2114 Who could explain the meaning of these dreams. 2119 *ðu hogt*. Is *hogt* an error for *logt* = *lagt*, taken, or for *sogt* = sought ? 2122 *ðis dremes wold* = this dream's meaning. *Wold* signifies (1) power, (2) force, (3) meaning. 2130 *nedful* = grievous; the O.E. *ned* often signifies grief, trouble. 2132 *rospen and raken*, rasp and rake, diminish and scatter. The Swedish *raka* signifies to clip, shave, shear. 2134 *laðes*, barns. (See note to l. 1919.) Chaucer uses the word in the Reve's Tale. "Berne or *lathe*, Horreum."—(Prompt. Parv.) 2136 *hungri gere*, famine years. 2146 *so to-har*, so *falsely* accused him. (See *baren* in l. 1912.) In the Castle of Love *to-beren* = disagree; *to-boren*, at enmity, l. 49.

P. 62. l. 2153 The seven years of plenty pass away.

 Joseph himself knew how to provide beforehand.

2161 *for nede sogt*, sought, come by compulsion. (See l. 2165.) 2163 *he lutten him*, they did obeisance to him.

 2167-8 Joseph knew them all in his thought (mind),

 He made as *if* he knew them not.

2176 For hunger doth (causes) them (Jacob's sons) hither to come.

2178 *bi gure bering*, by your behaviour. 2181 For seldom betideth even
any king.

P. 63. 1. 2190 ꝺa = ꝺat ; *pore* is evidently an error for *gure* = your.

2191-2 For then was Joseph sore afraid
 That he were also through them deceived.

2196 ꝺe ton = the one. 2198 *to wedde* = in pledge, as hostage.
 " He said, ' Forsothe, a tokyne *to wedde*
 Salle thou lefe with me.' "—(Sir Perceval of Galles, p. 19.)
2204 *Wrigtful* = sinful. (See note to l. 2076.) 2209 For we denied
him mercy ; *werneden* = denied, refused.

 " God schewes in his godspelle
 Of þe riche man and laȝarus,
 How þat he *warned* him almus,
 Þarfor God *warned* him agayne
 A drope of water, to sloken his payne
 In þe fire of helle when he was þan."
 —(Cott. MS. Tib. E. vii., fol. 37.)

2214 *pilt* = O.E. *pult*, thrown, placed (R. of Gloucester, 3376, 459 ; Lay
le Freine, 136).

P. 64. 1. 2219 *ouer-ꝺogt*, over-anxious. 2224 ꝺo *agtes* = the monies. 2232
Death and sorrow come on me ; *segeꝺ* = *sigeꝺ*, cometh, alighteth,
falleth.

 " & þi wracche (wretched) saule
 [Scal] *siȝen* to helle."—(Laȝ. ii. 186.)

2233 *bi-lewen* = *bi-liuen* = remain.

2235-8 Then quoth Judah, " It will go hard with us,
 If we do not keep our agreement with him."
 Famine increased, this corn is gone,
 Jacob again biddeth them go again (to Egypt).

2241-2 Then quoth he, " When (since) it is necessary,
 And *I* know no better plan."

2249 God grant that he may be kindly disposed (towards you) ; *eꝺi-modes*
= *eꝺe-moded* (see note to l. 1584). 2252 *ligt* = soon ; literally easily,
without difficulty. 2254 Kind thought (natural affection) was in his
heart then ; ꝺag = ꝺa = ꝺo = then, is necessary for the sense and the
rhyme.

P. 65. 1. 2255 *gerken* = O.E. ȝarke, Mod. Eng. *yark*, prepare, get ready.
 " He lætte bi sæ flode
 ȝearkien scipen gode."—(Laȝ. i. 111.)

2258 None of them had then merry cheers (countenances). 2262 *ur non*,
none of us ; *ur* should be properly *ure*. Cf. l. 2260, where we have *gur*
for *gure*.

2267-8 Very glad (fain) he was of their coming,
 For he was held there as a prisoner.

to nome may have the same signification as the phrase *to wedde* = as
hostage, as security ; *nome* (*nom ?*), derived from *nimen*, to take, capture,
signifies seizure. Cf. *wop* from *wepe* (weep), *grot* from *grete* (lament, cry),
lop (flee) from *lepe* (leap, run), etc. 2269 *vndren time* = A.Sax. *undern-
tid ;* *vndren* is the Prov. *aandorn, oandurth, orndorn*. It literally denotes

" the intervening period, which accounts for its sometimes denoting a part of the forenoon, or a meal taken at that time, and sometimes a period between noon and sunset."—(Garnett.) 2275 And he willingly accepted it. 2279 Know I that none of them but what trembles.

2287-9 Soon he went out, and secretly he wept,
 That all his face became wet with tears.
 After that weeping, he washed his face.

P. 66. l. 2295 *of euerilc sonde*, of every dish, of every mess ; *sond* signifies a dish, mess, meal. S.Sax. *sonden, sunde*, viands.

> " wanliche (bad) weoren þa *sonden*."—(Laȝ. iii. 32.)
> " þas beorn þa *sunde*
> (þes beare þe *sondes*)
> from kuchene to þan kinge."—(Laȝ. ii. 611.)
> " Hwer beoð þine disches
> midd þine swete *sonde ?* "—(O.E. Miscell., p. 174.)

2297 In abundance they became glad. 2302 ðeden — peoples. 2311 *weren . . . went* = had gone. 2316 *vn-selðehe* = *vnselðe*, misfortune, evil.

> " Her waas *unnseollþe* unnride inoh
> Till an mann forr to dreȝhenn."—(Orm. i. 165.)
> " Ah ich heom singe, for ich wolde
> That hi wel understonde schulde
> That sum *unselthe* heom is i-hende (near)."
> —(Owl and Nightingale, p. 43.)

Later writers use the word in the sense of wickedness. (See Shoreham's Poems, p. 43.) 2314 *bi-calleð*, accuses. See Ywain and Gawin, p. 21, l. 491. 2318 *gure on* = one of you. 2320 *vp* = *vpe* = upon.

> " Moni of þisse riche
> þat wereden foh and grei,
> An rideþ *uppe* stede
> and uppen palefrai,
> Heo schulen atte dome,
> suggen weilawei."—(O.E. Miscell., p. 164.)

P. 67. l. 2335 Provided that thou spare Benjamin. 2341 *so e gret* = *so he gret*, so he wept. 2342 That all his face became wet of (with) tears. See l. 2356. 2354 *sundri* = *on-sundri*, apart. 2356 *Ilc here*, each of them.

P. 68. l. 2367 *twinne srud*, two *changes of* raiment. 2369 *fif weden*, five garments. 2373 *wið semes fest*, with burdens loaded. 2380 He knew not who they were (on account of their princely garments). 2384 All Egypt in his power is placed (fixed). 2390 *or ic of werlde chare*, ere I from the world go (turn) = ere I die.

P. 69. l. 2399 *derer*, an error for *derë* = beloved. 2400 How many years are on thee. 2403 *fo* = few ; O.E. *fowe*. Cp. Northern *fon*, few, in Hampole's P. of C. 2404 Although I have passed (suffered) them in woe. 2406 *her vten erd* = here in foreign lands. See l. 2410. 2412 *seli mel*, good sustenance (food). Cf. l. 1542. 2416 *y-oten* = *y-hoten*, called.

2427-31 So was it pleasing to him to be laid,
 Where the Holy Ghost secretly had said

To him and his elders, far ere before,
Where Jesus Christ would be born,
And where be dead, and where be buried.

P. 70. l. 2435 *Or ðan* = ere that.

2441-3 Joseph caused his body to be honourably prepared (for burial),
To be washed, richly anointed,
And with spices to be scented.

Smaken usually signifies to taste, savour, but here means to scent, to be scented. *Smac* in the Owl and Night., 821, is used for scent, while in the Ayenbite of Inwyt it has the sense of flavour.

"Zalt yefþ *smac* to þe mete."

See Gloss. to Allit. Poems, s. v. *Smach*.

2444-9 And Egypt's folk him bewaked,
Forty nights and forty days,
Such were Egypt's laws;
The first nine nights the bodies they bathe,
And anoint, and shroud, and bewail
And watch them afterwards forty nights.

2451-5 And Hebrew folk had a custom,
Not immediately to bury it with iron,
But to wash it (the corpse) and keep it right,
Without anointing, seven nights,
And afterwards (keep it) anointed thirty days.

2452 *yre* = iron; O.E. *ire, iren* (Owl and Night. 1028). The form *ize*, iron, is also met with in O.E. writers. (See Ayenbite, pp. 110, 133.) 2454 *smerles*, ointment, belongs to the same class of words as *feteles*, a vessel, *reckeles*, incense, etc. "þe *smeryels* ne is naȝt worþ to hele þe wonde ne non oþer þing þer huile þet þet yzen is þerinne."—(Ayenbite, p. 174.)

2459-60 For truth and with good deeds,
Done is then all that watch-deed.

2460 *wech-dede*, vigils. 2463 And some every year as it happens or comes round. 2465 Do for the dead church-going; *chirche-gong* = church-going.

"Þe gret cyte of Medes suþþe afure he (William) sette,
Vor me (one) ne myȝte non *chyrche gong* wyþ out lyȝte do."
—(R. of Gloucester, p. 380.)

2467 And that is instead of the vigils.

P. 71. l. 2472 *daiges* is evidently an error for *laiges*, laws. See l. 2456. 2479 *wis of here*[*n*], skilful in arms. 2487 *ouer-pharan* = *ouer-faren*, pass over or beyond Pharan. 2488 *in biriele don*, put into the tomb. "And whanne Jhesus hadde comen over the water at the cuntre of men of Genazereth, twey men havynge develis runnen to him, goynge out fro *birielis* (tombs), ful feerse, *or wickid*, so that no man miȝte passe by that way."—(Wicliffe, St. Matt. viii. 28.) 2498 *To beðen meðe*, to supplicate for mercy; *beðen* may be an error for *beden*, to entreat. *bedden oc* = *beoden oth* = to offer oath [of obedience].

P. 72. l. 2505-12 "It shall," quoth he, "be fulfilled
What God before hath to our elders sworn;

He shall lead you in his hand
Hence to that promised land ;
For God's love I yet entreat you ;
Perform it (my prayer) then, promise it now
That my petition shall not be lost (sight of) ;
With you let my bones be borne.

2510 *Lested* = *lesteð*, perform. 2514 God bring the soul into bliss.
2516 *egipte-like*, after the custom of the Egyptians. 2521 *to ful in wis*
= *to ful-iwis*, very full (completely), indeed. See l. 109. Orm uses the
word *fuliwis, ful iwiss, fuliȝwiss*, in the sense of certainly, truly See
Gloss. to Orm, s. v. *fuliwis*. 2524 *for lefful soules ned*, for the need of
faithful souls. 2528 May God help him kindly (joyfully). For the
meaning of *weli* see Gloss. to Allit. Poems, s. v. *wely*. 2529 And preserve
his soul from sorrow and tears. 2532 God grant them in his bliss to have
pleasure ; *spilen* signifies to sport, live pleasantly.

" Þan was Uortigerne þa king
in Cantuarie-buri.
Þer he mid his hirede,
hæhliche *spilede* (nobly diverted themselves).''
—(Laȝ. ii. 153.)

" dâ was *spil* unde wunne
under wîben unde manne.
vone benche ze benche
hiez man allûteren wîn scenchen ;
Si *spilten* and trunchan
unz in iz der slâf binam,''
—(M.H.G. version of Genesis and Exodus, ed. Deimer.)

P. 73 1. 2544 *hatel*, severe, cruel. See Gloss. to Allit. Poems, s. v. *Hatel*. 2546
seli við, prosperity. 2547 Quoth (spoke) this king with them, secretly,
in council. 2548 *michil sped* = great speed, rapidly. 2553 *feten* seems
to be an error for *ooton*, made. 2555 *vn-ðewed swine*, unaccustomed
(extraordinary) labour ; *vn-ðewed* also signifies immoral, wicked. See
Orm. i. 74, Allit. Poems, B, l. 190. 2556 *fugel* = *ful*, foul, loathsome.
2560 They caused them to creep along (or through) dikes ; *dikes* = O.E.
diches, may here signify subterraneous passages, burrows ; or perhaps
dikes = sewers, from the allusion to *mue* and *fen*. " And Jhesus said to
him, Foxes han *dichis*, or *borowis*, and briddis of the eir han nestis, but
mannes sone hath not where he reste his heued.''—(Wicliffe, St. Matt.
viii. 20.)

2561-2 And wide about (through) the cities to go,
And come where none had been before.

2564 *comb*, crest or top (?). 2567 *ðhogen* = *ðogen*, throve. See l. 2542.

P. 74. l. 2575 But they disobeyed from fear of God. 2578 They defended them-
selves with lies.

2581-2 God requited it these women well,
On *their* homes, *their* wealth, *a* happy time.

eddi sel is, literally, pleasant time, but may here denote prosperity, success,
etc. 2583 *opelike* = openlike, openly. 2588 *Abraham* is an error for
Amram, i.e. Amram was Moses' first name. 2590 *dreful and bleð*, sorrow-

ful and afraid; *bleð*. In A.Sax. *bleað* = gentle, slow; *blæt* = miserable; the S.Sax. *blæð* = destitute, poor; *bliðere*, cowardlier. 2594 Nor could she take him stealthily (secretly) of (from) the water; or *stelen* may signify to still, to quiet. 2595 *rigesses* = rushes. Cf. Sc. *reesk, reyss.* 2596 *terred* = tarred, pitched.

P. 75. l. 2609-10 God had such beauty him given,
 That the very foes let him live.

 2611-5 Egypt's women came near,
 And bad *her* leave the child there,
 But she took it away with a cry (scream);
 Of their command took she no heed.

2613-4 *he* = *ghe* = she. It cannot be the plural *he* = they, for this would require *namen* instead of *nam.* 2621 On whose *teat* (paps) he soon hath seized. 2629 *on sunes stede*, instead of a son. See l. 2637. 2639 *ayne* [= *ane*] *stund*, one minute. 2644 *ðis timing* = this occurrence, this timely assistance.

P. 76. l. 2647-8 If help had not run between
 This child had then soon been killed.

2650-8 He said, "The child doth as he knows (*i. e.* acts according to the extent of his knowledge); we shall now learn whether it did this wittingly, or in childishness." He offered this child two burning coals, and he took them; how was he able to bear it? and in his mouth so deep he placed them, that his tongue's end is burnt therewith; therefore said the Hebrews truly that he afterwards spake indistinctly. This legend is thus given in Lady Eastlake's Life of Our Lord:— "Therefore when he (Moses) was three years of age she (Thermutis) brought him to Pharaoh, who caressed him, and in sport, put the crown on his head, when the child eagerly pulled it off, and dashed it to the ground; for it is said that the crown was engraved within with figures of idols, which Moses instinctively abominated. Those around Pharaoh looked upon it as a bad omen, and they counselled the king that he should be slain; but another counsellor said that he should be pardoned, because he was too young to know right from wrong; and a third counsellor said, 'There is in this child something miraculous and uncommon. Cause, therefore, a burning coal and a ruby ring to be set before him; and if he take the ring it will show that he knows right from wrong, and then let him be destroyed, lest he spoil the kingdom of Egypt. But if he take up the burning coal, it will show that he is too young to know right from wrong, and then let his life be spared.' Then the king said, 'Let the hot burning coal and the king's signet ring (which was a large shining ruby) be placed side by side, and we shall see what he will do.' And immediately the child stretched out his hand to take the signet ring; but the angel Gabriel (who instantly took the form of one of the attendants) turned his hand aside, and the child Moses took up the burning coal, and put it to his mouth, and his tongue was burnt therewith, so that he was unable afterwards to speak distinctly, even to the end of his days." 2652 *childhede;* "ac zeþþe ich com to elde of vol man, ich vorlet alle mine *childhedes.*"—(Ayenbite, p. 208.) 2653 *brennen* = brennende*, burning; *to* = two. 2654-5 *is* = them. 2658 *miserlike* =

S.Sax. *misliche*, variously, differently; and, hence, thickly, indistinctly. The form *miser-like* may be a corruption of the A.Sax. *missen-lic*, dissimilar. *Misliche* in Owl and Nightingale, l. 1771, signifies erroneously. 2662 *b[i]leph = bi-lef*, remained.

2665-8 By that time that he was a youth (young man)
 With (for) beauty and strength renowned,
 The Ethiopian folk on Egypt came,
 And burnt, and slew, and vengeance took.

2675-8 Teremuth scarcely might bring it about (prevail)
 That Moses shall with them forth-go,
 Ere she have her pledged and sworn,
 That to him shall be borne (kept) honourable faith.

2676 *hire*, an error for *hem*, them. 2677 *ho = ghe = she*. 2680 *were* (a substantive from *weren*, to defend), a defender, protector. Cf. *dere*, harm, from *deren*, to hurt.

P. 77. l. 2682 *vn-warnede*, unexpected. This enables us to correct the reading *unwarde* in l. 480. 2688 *ut-ðhurg* = out-through, throughout. Cf. O.E. *ut-with*, without, *in-witð*, within, etc. 2696 Nevertheless that sojourn was very distasteful to him. 2701 *meten* is the p.p. of *mete*, to measure. 2702 *This* causes remembrance, *the other* causes forgetfulness. 2703 *He fest is* = he fixed them. 2704 Gave her the first *gem ;* he was kind to her. Two lines seem missing after this line. We might supply the following :—

 And quan awei nimen [faren] he wolde
 Gaf hire ðe toðer, he was hire colde.

And when he would go away, he gave her the other gem, and was distasteful to her. 2708 *e* = he. 2712 *a modi stiward*, a moody (proud) steward. 2714 That seemed to Moses *a* great shame.

P. 78. ll. 2718-20 And secretly he buried him in the sand,
 He weened that no Egyptian
 Had known it, or should have seen it.

2720 *a sen* may signify 'have seen.' Northumbrian *ha*, to have; but more probably we should read *a-sen*, to see, the infinitive being required after *sulde*, so that *sulde u-sen* = should see. In the Romans of King Alysaundre *asen* occurs as the p.p. of *a-see*, to see. Cf. our modern words *wake* and *awake*, *rise* and *arise*, etc. These double forms were far more common in O.E. writers than in the modern stage of our language. 2727 And enquired *of* him what it should mean. 2730 *to rad*, too hasty. 2736 *his weige ðeðen ches* = chose (took) his way thence.

P. 79. l. 2757 *ðewe and wursipe*, courtesy and honour. 2758 *estdede*, kindly deed (actions). (See Owl and Nightingale, l. 997.) *Esste mete* occurs in the Ormulum for delicate meat (food), etc.

 " Ac thar lond is bothe *este* and god."
 —(Owl and Nightingale, p. 36, l. 1029.)

2764 To wife in law he her took; *in luye* = in law, in marriage, is an early use of a common phrase. 2769 And Moses had gone on a time. 2771 To look after the condition of the herds. 2775 *brennen = brennende*. See l. 2653. 2776 And nevertheless green and whole remained.

2783 *in min geming*, under my care (protection). 2788 *milche*, milk; *queðen*, to promise.

P. 80. l. 2789 *an* = *in*. 2790 *on hond* = *on-hond*, soon, speedily. Ger. *in die hand*. (See Laȝ. vol. ii. pp. 96, 106, 251, 264.) 2792 *to ðan*, to that = for that purpose. 2797 If he refuse it and be there-*to* contrary. 2803 *to token*, for a token (sign). Cf. *to wedde*, for a pledge, etc. 2812 *fer*, sound, and hence *unfer* (l. 2810), diseased. (See Sir Gawayne and the Green Knight, l. 103; Ormulum, i. 41, 153, 212. 2815 *get* = pour (see l. 582). 2817 *wanmol* = un-eloquent; *wan* occurs in O.E. *wan-hope*, despair; *wan-trauthe*, disbelief; *mol* is the same as *moal* (speech) in l. 81, p. 3; *vn-reken* = un-ready, slow. (See Gloss. to Allit. Poems, s. v. *reken*.) 2822 Who made the blind, and who the looking (seeing)? 2824 *fultum*, aid, assistance.

Þa cristine liðen after,	The Christians pursued after,
and heom on læiden,	and laid on them,
& cleopeden Crist, godes sune,	and called Christ, God's Son,
beon heom a *fultume*.	To be to them in aid (to help them).

—(Laȝ. ii. 264.)

P. 81. l. 2828 *vnsteken*, disclose. See Gloss. to Allit. Poems, s. v. *Steke*. 2830 *Gunc* = you two. See Orm. i. 301; ii. 98. 2831 *funden ;* O.E. *founde*, to go, occurs in Allit. Poems, p. 63, l. 903. 2834 *of liues* = alive. 2838 *is werkes len*, reward of his works. 2845 *feren swike*, unfaithful companions, that is, his two sons who were uncircumcised. *he* = they, refers to Moses and his wife. 2847-50 Zipporah took this young lad, and made him to have circumcision, and wept, and turned back frightened, and let Moses forth alone proceed. 2855 *Eyðer [h]ere* = each of them. 2856 *haueð is herte vt-dragen* = hath his heart out-drawn. Cf. our expression, to unbosom oneself, with the Ger. *sein herz anschütten*.

P. 82. l. 2876-78
I defended so that thou wast rescued,
And laboured, and great sorrow endured,
Yet is it unseen (is it a secret) how I accomplished it?

2882 *hidel-like* (= hidingly), secretly. Cf. O.E. *hidel*, a hiding place (Ps. xxvi. 5). 2890 *to gode*, for good, gratuitously. 2891-2 And yet they hold (keep up) the number of the tiles (bricks), and knead and bake (them), great and small. 2894 And to God he made his complaint (bemoaning).

P. 83. l. 2900 *ðhunerg* = *ðuner ;* O.E. *thoner*, thunder. 2903 *Min milche witter name* may signify (1) my great wise name, or (2) my merciful wise name. In (1) *milche* = *michel* = *mikel*, great ; but in (2) it = *milce*, mild, merciful. See l. 3603. 2918 *Iglic* = *uglic*, ugly, horrible. 2919 *wiches kire*, select (choice) witches. 2920 *in sowles lire*, in soul's loss. 2926 And the heads of them all he bit off.

P. 84. l. 2934 *wit* = we two. See Orm. vii. 73, H. i. 4, 300. 2935-6 This king himself is very bitter against this folk, and of heart hard. 2938 And try better with this token. 2947 *trike*, a rivulet, small stream, evidently connected with the verb *trick-le*. 2951 *wreche* = *wreke*, vengeance, plague. Cf. *michel* and *mikel*, *dike* and *diche*, etc. 2857 *bot* = *boot*, release, deliverance, is connected with O.E. *bete*, to amend, to alleviate. 2962 *bitournen* = *biturnen*, turn, change.

P. 85. l. 2969 *froskes here* = host of frogs.

 2977-8 Pole-heads (tadpoles) and frogs, and sport of podes (toads),
 Bound hard Egypt's wretched folk.

in sile = *vn-sile* = *vn-sele*, miserable, wretched. Stratmann says that *sile* = *sele*, epirhedium. *Polheuedes* (Provincial Eng. *pole head*), a tadpole. Palsgrave has *polet*. *Polly-wigs*, tadpoles. " Tadpoles, *pole-wigges*, young frogs." (Florio, p. 212.) *Pol-wygle*, wyrme, occurs in the Prompt. Parv. (Hall.) ; *pode* = Prov. E. *pode, paddock*, a toad (Shakespeare) ; W. Prov. E. *padstool* = toadstool. (See King Alis. 6124.)

 " ꝺare nakyn best of wenym may
 Lywe, or lest atoure a day ;
 As ask, or eddyre, táde or *pade*,
 Suppos þat þai be þiddyr hade."—(Wyntown, i. p. 15.)

2988 *up-wond* = up-went, but literally up-wound. 2989 *on bite*, in *their* bite. 2990 *smite*, a blight, plague.

P. 86. l. 3011 *bad meꝺe*, entreated for mercy. 3013 *wroꝺ* = *worꝺ* = *wurꝺ*, became. 3014 And broke them that promise (see l. 3062). 3027 *dolc* = O.E. *dolg*, wound, ulcer. O.E. *dolc* = pin, tongue. 3037 ꝺe *to un-frame*, to thy sorrow.

P. 87. l. 3045 *al sir* = *all sheer*, clearly, openly. 3047 *vnghere* may be an error for *undere* = badly, or, what is more probable, for *vngere* = unready, unexpectedly, *gere* being the same as *gare, yare*, ready, prepared. 3048 *bergles* = unprotected, shelterless, from *bergen*, to protect.

 3055-6 Moses, cause this weather to turn,
 And I shall let you out fare (go).

3058 *vnweder*, storm. See ll. 3059, 3061. *Weder* in O.E. is often used for a tempest, storm. See Ywaine and Gawin, 411 ; Wyntown, i. 387 ; Romaunt of the Rose, 72, 4302. *atwond*, departed = away-wound, or away winded. Cf. *at* in *at-wot*, departed, p. 30, l. 1049. 3065 *gresseopp-e*, grasshopp-e-r, locust. Cf. O.E. *hunt-e*, a hunt-e-r, etc.

 " And to lefe-worm þar fruit gaf he,
 And þai swynkes (labours) to *gress-hope* to be."

 (Ps. lxxvii. 46.)

3066 And what the hail then left (untouched) shall all be consumed.

P. 88. l. 3075 *but*, without exception (?). 3077 *Hu* = how ? 3080 Erewhile alone of men was *leave* besought. 3086 *an newe figt*, in *a* new conflict. 3087 *skipperes*, the grasshoppers. See l. 3096, where *opperes* is similarly used. 3088 They did on grass and corn injuries. 3102 ꝺ*herk-nesse* = *derknesse*, darkness, is a genuine form, and occurs in the Coventry Mysteries :—" *Therknesse*, or derknesse, tenebre, caligo."—(Prompt. Parv.) 3105 Many there suffered sorrow in life ; *bead* = *abead*, suffered. 3108 *sowen* = *sogen*, saw. See l. 3329.

P. 89. l. 3111 *boden* = both. See *bothen* in Glossary to Morte Arthure, ed. E. Brock. 3120 Death shall be avenged over you.

 3123-6 Said God, " Yet I shall on Pharaoh,
 Ere ye go out, put a plague
 (Now I shall into Egypt go)—
 Such a plague was never any before."

3131-2 I shall not fail you
 Of what I have promised you.
3139 Every house-folk (family) that may permit of it.
3141-3 The tenth day it should be taken,
 And kept on the tenth night,
 And slain on the fourteenth day.
3144 *so it noten mai,* as may partake of it; *noten* = O.E. *note, naite,* to
make use of, enjoy, eat.

P. 90. l. 3147 *bred* = O.E. *brad,* roasted. (See Sir Gawayne and the Green
Knight, l. 891.) 3148 *wreken,* taken, thrown out. "God nele naʒt þet
me make, his hous marcat ne boþe, huerout he *wrek* þo þet zyalde and
boʒte in þe temple."—(Ayenbite, p. 172.) 3150 *his owen fond,* his own
wants (need). 3153 *wriðel;* can it mean *haste?* (see Ex. xii. 11.) At
first sight it seems to be a derivative of *wirt* (by metathesis *writ*), an
herb; but the mention of *rew mete*⌊*n*] in l. 3151 renders this rather
doubtful. 3154 *bi-leuen,* the remainder. O.E. *lave, leve,* the remainder.
3155 *dure-tren* = door-trees, posts.
 " For James the gentile
 Jugged in hise bokes
 That feith withouten the feet
 Is right nothyng worthi
 And as ded as a *dore-tre*
 But if the dedes folwe."
 —(Piers Ploughman, 833.)
uuerslagen = *overslagen, ouerslage,* over-piece, lintel. " *Ovyrslay* of a
doore. superliminare."—(Prompt. Parv.) 3172 For their toil they now
have hire.

P. 91. l. 3206 *fro* = *for,* on account of. 3211 *stunden* does not mean stood, but
is a vb. (formed from the sb. *stund,* a stound, a short space of time) signify-
ing to delay awhile, to wait. 3212 How Pharaoh should act toward
them. 3213 Pharaoh summoned (assembled) out his army; *bannen* = to
call to arms.
 " Þa bleou Brutus Then blew Brutus his horn
 & *bonnede* [*bannede*] his ferde." And assembled his forces.
 —(Laʒ. i. 75.)
3218 *of fote ren* = swift of foot.

P. 92. l. 3220 *to werchen wi,* to work war, to make war upon. 3224 *ne gate* =
no gate, no ways; *gate* is often used by Northern writers as an affix =
-wise or -ways; as *al-gate, thus-gate,* etc. 3230 On (against) Moses
they set *up* a cry. 3234 Supply *don* after *gu.* 3235 *dregen wið skil,*
endure with patience. 3240 That for you ways (paths) may be well
prepared.

P. 93. l. 3255 *an skige,* a cloud. Cf. Milton's ' *sky-tinctured* ' (Paradise Lost,
Book V.). " it ne left not a *skie*
 In al the welkin long and brode."
 —(House of Fame, iii. 508-511.)
3264 *daiening* = *daigening,* dawning. 3271 *in twired wen,* in perplexing
doubt; *twired* signifies two-fold (doubtful) counsel.

" and [Bruttes] duden swiðe vnwrastc And Brutus did very evilly
 alle his haste, all his behests,
 and weoren alle *twiræde*." and all were of two counsels.
 —(Laȝ. ii. 392.)

3274 *helden*, an error for *holden*. 3275 *a morgen quile*, a morrow while, a minute. 3282 *weken* seems to be an error for *wreken*, taken (see l. 3148.)

P. 94. l. 3292 *pert = apert*, open, clear. 3300 *wlath*, the reading of the MS., = *laȝ*, loathsome. But *wlach* = brackish, properly *warm ;* cp. *luke*-warm. 3301 *a funden* (discovered) *trew* = a tree *which he* found. 3310 *bred wantede*, bread failed.

3315 *Bet us were in egipte ben,*
 It were better for us in Egypt to be.

3319 *on-dreg* = 'bear up,' endure patiently. 3324 *so fele so*, as many as.

P. 95. l. 3327 *ðis dewes cost*, the nature of this dew. For the meaning of *cost* see O.E. Miscell., pp. 12, 25 ; Allit. Poems, p. 66 ; Chaucer's Knight's Tale. 3328 *rim frost = rime frost*, hoar frost. 3338 *for-hadede*. Read ? *for-hardede*, hardened. 3340 That it gave a flavour of honey and oil. 3341 *forbone mor*, more *than* was bidden ; *forbone* may be an error for *forbode*, prohibition, command ; or we may read (and the MS. will admit of it) *forboue*, above. Cf. *bi* and *for-bi*, etc. 3345 Kept it apart in *a* clean place. 3348 *vten leð* = in a foreign land ; *withouten let* = without cessation. 3353 Soon was that water wanting to them. 3354 MS. *haue ;* the rhyme requires *hane ; ðrist hane* signifies torment of thirst.

P. 96. l. 3378 *here ðing*, their affairs. 3381 Moses prayed for the folk *of* Israel. 3385 For *leth is* read *let his*. 3388 They supported them with a stone. 3393 *bode* seems wanting after *sente*. 3394 Of this occurrence to have a memorial.

P. 97. l. 3398 *min blis*. Jehovah-nissi is generally explained as "The Lord is my banner." 3410 *stering*, government, rule ; *stere* in ll. 3418, 3420, rule ; *steres*, rulers, ll. 3413, 3415 ; *steres-men*, rulers, ll. 3417, 3429. 3412 *a meister wold*, a master (head) ruler, the same as *ouer-man*, l. 3424. 3413 *tgen = tyen*, ten. See l. 3418. 3414 *Ile here*, each of them. 3429-32 He bad them choose rulers, mighty, who are God-fearing, truth-loving, and who strife and covetousness forsake. 3432 *niðing* signifies not only strife, but niggardliness, wickedness, slaughter, etc. O.E. writers usually employ the word in the sense of a coward, villain, miser, etc.

P. 98. l. 3434 And willingly (gladly) *he* received (accepted) it. 3438 *is numen*, has gone. 3448 May we not read *Ic wile min folc cnowen be* — I will be known to my people ?

3449-51 And Moses told this to Israel,
 And they promised him every whit
 What he biddeth them they will do.

3152 *ðis to daiges* = these two days. 3458 *wið goren dragen* = pierced with darts. " heo beoren on heore honde
 gares [speres], swiðe stronge."
 —(Laȝ. iii. 44.)

3459-60 These *people* fearful thus abode,
 While these days forth have passed.
3462 *Spile*, ravage, destruction (see l. 2977). 3463 On this mount stood
a cloud's shadow; *and* = *an* = *a* (see l. 3475).

P. 99. l. 3471-84 Each of you bear in mind, that it is not Moses, Amram's son,
whom ye shall to-day hear speak, but He who slew Egypt (you for to
avenge), and a path made in the sea; and who let Adam discover the
tree which preserved Noah, and led Abraham out into the land of Canaan;
who caused Isaac to be begotten of old Abraham and of Sarah (of old
teats); who gave Isaac (Jacob?) so many sons, and who gave Joseph
such rich gifts (abilities); let His word be to you as precious as life,
dearer than either child or wife.

3488-9 None might go further except Nun,
 And also his brother Aaron.
3489 *on* = *one*. It may be an error for *oc* = also. 3496 My vengeance
is severe, my forbearance is long. 3497 *in idel*, in vain; *idel* in O.E.
signifies *empty, void*. 3498-3500 Nor swear it lyingly to defile in sport,
Nor let thou my honour be lost in the fiend's tempting (*i. e.* in yielding
to the devil's advice).

P. 100. l. 3508 *for truke of* = for failure of, for want of. 3515 Covet not thy
neighbour's thing. 3518 Thou losest everlasting bliss. 3519 *figeren*
= *fiyeren* = *feren*, afar. 3533 *nemeld* = *nemend* = *nemned*, named,
appointed (?).

P. 101. l. 3545-6 That mad folk there of day brought Hur (*i. e.* put Hur to
death) and put Aaron in fear; 'to don of dawe' = to bringen of dage =
put to death. (See Legend of St. Beket, l. 622; Allit. Poems, p. 9, l.
282.)
 " For quen the childe es born, sal I
 Do it of daw sa priuely,
 That na wiht sal the squeling here,
 And delf it sithen in our herbere."—(Met. Hom. p. 167.)

P. 102. l. 3573 *for gode* is frequently employed by Chaucer. 3574 It is a song
wicked and foolish.
3581-2 And mixed *it* in *the* water and poured it off,
 And gave that folk that draff (dregs) to drink.
Cf. O.E. *draff*, chaff. "*Draffe* or drosse, or mater stampyd, pilumen."
(Prompt. Parv.) Cf. "*draf-sak*." (Chaucer.)
3583-4 Then wist he well who had done it (committed idolatry),
 Seen it (the dregs) was on their beards.
3603 *milche moð* = *milce mod*, mild (merciful) mood.
3605-6 God answered, " Off shall I take them,
 Who are not *worthy* to be placed thereon."
3607 *min engel on*, my angel alone.

P. 103. l. 3611 *to pligt*, for *their* sin. 3614 And as sun-beam bright shone his
features. 3624 *wið witter dragt*, with skilful device. 3626 And their
labour they well apply. 3635 *of lore wal*, of choice lore. 3637 *betten* =
beten, amend, from *bet*, better. 3640 Ere they from Sinai forth have
passed. 3642 *ðe oðer*, the second.

P. 104. l. 3647 This folk has after pleasure gone. 3653 Moses caused it to cease

with his prayer. See note on *blissen*, p. 132. 3658 *for-hirked* = *for-irked*, tired. 3661 *Loruerd* = *louerd*, lord. 3664 Thou shalt cause me quickly to suffer death. 3676 And brought a great mint of quails; but *turles* = *turtles*, doves. See Ayenbite of Inwyt, p. 181.

P. 105. l. 3688 There became Miriam somewhat foolish; *soth* = *sott*, a fool (see l. 3685). 3710 A bunch of grapes on a long pole; O.E. *cowele, cowle*, a coop, tub, etc.; Prov.E. *cowl; cuuel-staf* signifies the staff or pole upon which the people carried their kneading troughs. This interpretation is supported by the form *cowle-tre* or *soo-tree*. Falanga, vectatorium. (Prompt. Parv.) "Phalanga est hasta, vel quidam baculus ad portandas cupas, Anglice a stang, or a *culstaffe*."—(Ortus.) "*Courge*, a stang, pale-staffe, or *cole-staffe*, carried on the shoulder, and notched for the hanging of a pale at both ends."—(Cotgrave.) In Caxton's Mirrour of the World, c. 10, A.D. 1481, it is related that in Ynde "the clusters of grapes ben so grete and so fulle of muste, that two men ben gretly charged to bere one of them only upon a *cole-staff*." In Hoole's translation of the Orbis sensualium, by Comenius, 1658, is given a representation of the *cole-staff* (*ærumna*), used for bearing a burden between two persons, p. 135; and again, at p. 113, where it appears as used by brewers to carry to the cellar the new-made beer in "soes," or tubs with two handles (*labra*), called also *cowls*. In Brand's "Popular Antiquities," ii. 107, will be found an account of the local custom of riding the *cowl-staff* or *stang* (Way in Prompt. Parv.)

P. 106. l. 3721 *swerdes slagen*, slain of (with) sword. 3723 *loder-man* = *lodes-man*, leader. A leader we will choose (take); *sen* = *bi-sen*. 3730 If Moses were not opposed there-*to*. 3732 *milche* = *milce*, mercy, pity. See l. 3728, where the correct form occurs. 3740 Their righteousness was pleasing to God. 3742 *sorwes dere* = sorrow's hurt.

 3745-6 Again (backwards) they made their course,
 As that cloud had taught.

P. 107. l. 3755 *migtful* qualifies *meistres* in l. 3756. 3760-61 *ilc gure*, each of you. Cf. *quilc gure*, which of you, l. 3764. 3761 *reklefat*, incense vat, the vessel holding the incense, censer. See Orm. i. 2, 35, 58. 3762 *timinge* seems to be an error for *time ge*, wait ye. 3767 *orgel pride*, arrogant pride. Cf. *orȝhellmod*, pride (Orm. i. 216). "Ichabbe ischen his ouergart, ant his egede *orhel* ferliche afallet."—(St. Marh. p. 11.) I have seen his presumption and his arrogance fearfully felled. 3770 Instead of the reading in the text substitute the following : *Moyses, and vt ne wulde gon; vr* seems to be an error for *vt* = out. See Numbers xvi. 12. 3774 Held up neither stone nor grit. I do not think *ston ne gret* = strong *ne gret* = strong nor great.

 3777-80 Such destruction they have unexpectedly
 No man need labour to bury them
 This earth is together closed
 As it were never ere broken up.

 3786 *fieres swaðe*, flame (burning) of fire.

P. 108. l. 3796 There hath a cloud them well girded. 3802 Ran and stood be-tween the living and the dead; *tiren* seems, from the way it is written in the MS., to be an error for *tuen* = *twen*, between. 3807-14 Though this folk, much frightened, remained quiet for a time, nevertheless they

are yet in diverse counsels (*i. e.* of conflicting opinions). Moreover, they vacillate in purpose, and think that it may be decided better. Though these burnt (*i. e.* those destroyed by fire) are refused, yet they ween that God shall take of the twelve tribes some more to be in the place of those whom he had despised (rejected). *miðe* is the pret. subj. of *miðen* = A.S. *miðan* (pret. *mád*, pl. *midon ;* pret. subj. *mide*), to lie hid, to avoid, omit, hide, dissemble. 3809 *aglen* = *aylen* = *ail*, become weak or foolish. 3814 *for-hugede*, despised, rejected.

" Ah Gurmund hit *for-hoȝede*
And habbe he heo nolde."—(Laȝ. iii. 156.)
" For niss nan mann þatt uss birrþ att
Forrhoȝhenn god to lernenn."—(Orm. ii. 107.)

P. 109. l. 3824. The name of the tribe which *shall* thereto belong. 3826 Which tribe he desires this service *to be* on.

3851-2 Here and there (yonder) there they buried lie,
 All the old (ones) did there end (i. e. died).

P. 110. l. 3865-6 God bad assemble the folk and go,
 And before them smite on the stone.

3880 *costful*, dangerous. See Met. Hom. p. xix, where *far-cost* = a dangerous voyage. 3884 *wente of liwe* = turned from life = died. 3887 *in* = *hin* = *hine*, him.

P. 111. l. 3924 The sense requires us to read, *for to stillen his vn-eðe mod*, for to quiet his uneasy (disturbed) mind.

P. 112. ll. 3931-2 In the night a message came to him from God,
 And a prohibition against this king's counsel.

3941 *me goue hold* = should give me faithfully ; *hold* = *holde* = faithfully, truly. 3945 *Oc or or* = but first ere. 3951 And turned his heart on worse thought. 3958 And beat and turned it to the path ; *sti*, path, way. " ðes is forðon ðeðe gecuoeden wæs ðerh esaias ðone witgo cuoeðende : stefn cliopende in woestern gearuas woeg drihtnes, ræhta doeð [wyrcas] *stiga* his." (Matt. iii. 3. Northumbrian Version.) 3964 *negt* = *neg* + *it* = nigh it.

P. 113. ll. 2972-3 It is as true as it is marvellous.
 Said this ass thus with anger.

3976-7 Had I a sword, I would slay thee.
 So was this man to mischief (grief) brought.

3985-6 Quoth Balaam, " since I have mis-fared,
 If thou wilt, I will turn back."

3988 Against my counsel speak thou nought.

3993-4 Shall I no word be able to forth-do (utter),
 Except what God layeth on me.

4000-1 And went apart ; why ? but because from above, etc.

P. 114. ll. 4009-10 His life is blithe (joyful), so shall be his ending (death),
 Who prospereth as this (one) shall prosper.

4015 For *or* read *and* (?). 4016 He did it for better success. 4022 *hem*, if not an error for *he*, stands for *he* + *hem*.

P. 115. l. 4049 " The young women of thy land, fair of sight, and soft of hand, and bright of hue (complexion), of speech glad (joyous), in haste shall I set apart *as* messengers ; do thou send out against these men those who

can brew (produce) heart-burning with joy, with features, and with body and sin, pleasantly, with speech small (flattery), to turn them from God's fear to thy land gods and our laws; unless thou canst follow this advice and lead them from God's love, and seek to turn thus their thought, for war nor weapon helpeth not. 4052 ðgere = gere = haste. At first I was inclined to take ðgere for dere, so that wið ðgere = for harm. 4053 ten = te (?). Or should we read, ðe do ten vt = cause those to go out. 4056 Luueke may be an error for luue-like = pleasantly; or it may = luue-leke = love; -lec being a not uncommon ending of abstract nouns, as in O.E. feirlec, fairness, beauty. 4063 quad. The rhyme seems to require quead; ðat ille quad = that wickedly spoke (advised); ðat ille quead = that wicked wretch.

P. 116. ll. 4085-88 God bad Moses number
His folk who were first preserved from death
Either twenty winters or more old,
Who in Egypt were not before numbered.

4096 All others were driven in death's web. 4106-8 Leave thou not thy folk helpless, and do thou, O God, cause them to be governed just as it may be advantageous for them.

P. 117. l. 4110 loder-man. See note on l. 3723.

4119-22 Whilst to him lasted life-days,
Them he taught precious laws,
And written hath committed them to them,
Unless they them keep, on them shall be sorrow (misfortune shall befall them).

In line 4121 the first hem should be omitted.

P. 118. l. 4143-4 Idolatry, that was pleasing to them, oft out-wrought (effected) for them sorrow's trouble, i. e. brought sorrow and trouble upon them.

4159-60 In such virtues grant us to come;
Through which we shall be to everlasting life taken.

GLOSSARIAL INDEX.

A, in, 271, 538, 635, 953.
A, have, 2720.
Abead = abad, abode, 422, 3856,
3862. A.S. *abídan*, pret. *abád*,
p.p. *abiden.*
Abiden, (*pl. pret.*) abode, 1638,
2483, 3459.
Abiden, (*p.p.*) abided, remained,
2388.
Abraid, awoke, arose, started up,
231, 1617, 2111, 2385. A.S.
abredan (pret. *abræd*).
Abute, about, 3455.
Abuten, about, 94, 1772, 2482.
A.S. *abútan.*
Abuten - schoren, circumcised,
1200. See *Schoren.*
Abuuen, above, 10, 108, 332,
636, 1518. A.S. *abufan.*
Adde = hadde, had (3 *pers.
sing.*), 240, 518, 519, 600,
1039, 1693, 1747, 2274.
Adden = hadden, had (3 *pers.
pl.*), 239, 1480, 2451, 2545,
2546.
Aftre, after, 1652.
Age, awe, 432, 3546, 3632. A.S.
ege, fear, terror, dread. Dan.
ave, O.E. *age, awe*, is a northern
form corresponding to the
southern *eige* or *eie.*
Agen, awe, (*acc.*) 192.

Agen, (*a*) again, 405, 604, 606,
979, 985 ; (*b*) against, 562,
3373, 3375 ; (*c*) adverse, op-
posed to, 3730; (*d*) backwards,
back, 1097, 3267; (*e*) towards,
1786, 1796, 1823, 1824 ; (*f*)
for, 562. A.S. *ongean, agen.*
See *Agon.*
Agenes, against, 538, 541.
Agenward, back, 1782.
Ageon, against, 3912. A.S. *agean.*
Aglen, to become weak, foolish,
3809. A.S. *eglian*, to ail, *egle*,
troublesome ; Goth. *aglo*, afflic-
tion, *aglus*, difficult.
Agon, gone, 78. A.S. *agán.*
Agon, again, 77, 958 ; against,
438 ; backwards, 1119 ; to-
wards, 1009, 1438.
Agrisen, terrified, alarmed, 667.
A.S. *agrýsan.*
Agt, ⎫ property, possession,
Agte, ⎭ wealth, 742, 783, 857,
910, 924, 1858, 1867, 2017,
2090. A.S. *ágan*, (pret. *ahte,
áhte*) to own, possess. A.S.
œht, property.
Agte, owned, 2309.
Agte, ought, should, 525, 1671,
2727.
Agte, fear, 3384. It literally
signifies thought, anxiety, sor-

row. A.S. *eaht*, estimation, *eahtian*, to meditate, devise. Ger. *acht*, care, attention, *achten*, to mind, regard. See *Hagt*.

Agtes, oughtest, 1762.

Agtes, moneys, 2224.

Ai, ever, aye, 451, 1105.

Ail, hail, 3066, 3183.

Al, all, 36, 37 ; entirely, quite, 3059, 3098.

Al abuten, all about, 96, 136.

Aldre, of all; 'hure *aldre* bale,' the bale of us all, 322 ; 'here *aldre* heuedes,' the heads of them all, 2926.

Algen — halgen, to hallow, keep holy, 918. A.S. *halgian*.

Alle, all, 874, 896.

Al-migt-ful, powerful, 2694.

Almigten,) almighty, (*sb*.) 9,
Almigtin,) 3405, (*adj*.) 30, 572, 3727.

Als,) also, 867 ; as, 1773, 1785,
Alse,) 1787, 2650 ; so, 1412.

Also, as, 475, 643, 1238, 2212 ; so, 3436. A.S. *alswá*.

Alswilc,) even as, 4108. A.S.
Alsswilc,) *alswilc = eallswilc*, even as, likewise.

Alt = halt, holdeth (?), 924.

Alter, altar, 758.

Alðer-best, the best of all, 3390.

Alðerneðer, beneath all, 3997.

Amigdeles, almonds, 3840. Gr. *αμυγδαλη* ; Lat. *amygdala*.

Amonge, among, 700.

Amongus, amonges, amongst, 1620.

An (before a cons.), a, 680, 938, 951 ; '*an* time,' 1435, 1487 ; '*an* busk,' 2105 ; '*an* kire,' 2451 ; '*an* wis man,' 2649 ; '*an* sel,' 2769 ; '*an* steuene,' 2780 ; '*an* dragen swerd,' 2843.

An, in, 1605, 2789, 3086. A.S. and O.S. *an* ; South Prov. E. *an*.

An, and, 206, 221, 647.

And = an, a, 3463.

And = an, in, 1470.

Andswere, answer, 3081.

Andswerede, answered, 4109. A.S. *andswerian*, to answer.

Anger, grief, 972.

Ani, any, 48, 2181.

Anog, enough, 600, 3365, 3876.

Answerede, answered, 2728, 3605.

Answeren, (*sb*.) answer, 2673.

Ant, and, 485.

Apples, 1129.

Arche, ark, 560, 561, 580.

Arche wold, ark board, 576, 614.

Arches, ark's, 602.

Ard, hard, 1228.

Arled, ring-streaked, 1723. A.S. *orl*, rim, welt, border.

Arn,) are, (*pl*.) 16, 815, 3606,
Aren,) 3882.

Arsmetike = arsmetrike, arithmetic, 792.

Arwe, arrow, 478.

As, hast, 1760.

Aske, ask, 1668.

Askede, asked, 1391.

Askeden, (*pl*.) asked, 2672.

Askes, ashes, 3024.

Astronomige, astronomy, 792.

At, to, 554 ; of, 2697 ; in, 3790.

At, ate, did eat, 337, 342, 3407.

Ate, hate, 373, 3638.

Atter, poison, venom, 372. A.S. *áter, atter*.

Atteð = hatteð, is called, 813.

At-wond, ceased, 3058. A.S. *ætwíndan*, to wind off, escape, flee away (pret. *ætwánd*, p.p. *ætwunden*).

At-wot, disappeared, departed, 1049. A.S. *wítan*, to depart ; *at* = A.S. *æt*, as in *at-wond*, etc.

Aucter, altar, 612, 625.

Auter, altar, 1297, 1325.

Aue, have, 2388.

Auede = hauede, had, 1251.

Auen = hauen, have (*inf.*), 1505, 1512; (*pl.*) 3680.

Aueð = haueð, hath, 2425, 2469.

Awai,) away, 616, 810, 858, 860,
Awei,) 861.

Aweiward, away, 3168.

Awold, avail, be successful, 1671; signify, 1944, 2727; cause, 2054. A.S. *walden*, to rule, *wealdan*, to govern (p. *weold*, p.p. *wealden*).

Ay, ever, always, 5, 87, 155.

Ayne = ane, one, a, 2639.

Bad, commanded, 41, 57, 441, 572, 618; prayed, 1462; '*bad* meðe,' besought mercy, 3011. A.S. *biddan* (prct. *bæd*, p.p. *beden*), to ask, pray, command.

Bad, offered, gave, 2653; '*bad* bede,' offered prayer, 1375, 2981. A.S. *beódan* (pret. *beád*, p.p. *boden*).

Bade, bad, 2436.

Bak, back, 1333.

Bale, sorrow, misery, calamity, destruction, 68, 322, 850, 1122, 1166; death, 1984. A.S. *bealu*.

Bannede, summoned, assembled, 3213. A.S. *bannan*, *bonnan*, to proclaim.

Bar, bore, took, 209, 338; gave birth to, 418, 428, 722; carried, 2078.

Baren, to disclose, 1912.

Barg, (pret. of *bergen*) preserved, 1330, 3477.

Bargt = barg, preserved, 898.

Bat, bad, 53; restored, 882; offered, gave, 1015. See *Bad*.

Be, shall be, 784.

Bead, bad, 1059, 2494, 2768;
invited, 1056; offered, 1069; presented, 3340.

Bead = abead, endured, suffered, 3105.

Beames, trumpet's, 3521. A.S. *byme*, a trumpet.

Beas = beast = beëst, art, 365, 366.

Bed, (pret. of *bidden*) commanded, bad, 258, 1292. See *Bad*.

Bed, (pret. of *beden*) offered, gave, presented, 909, 1014, 2017, 2047; (*imp.*) present, 2073.

Bedden, (*pl. pret.*) offered, 2273; prayed to, 2498.

Bede, prayer, 631, 1375, 2981. A.S. *béd*.

Beden, (*p.p.*) commanded, 2212.

Bedes, prayers, 495, 3888.

Bege, ring, 2140. A.S. *beah*, *béh*, *beág* (g. *beáges*), a crown, bracelet, ring.

Beges, bracelets, 1390. A.S. *beágas*.

Bem, beam, 'heuene-*bem*' = the sun (?), 1606.

Ben, to be, 15, 101, 164; are, 107, 139, 630.

Bene, prayer, petition, 2511. A.S. *bén*.

Ber, bore, 1701.

Berdes, beards, 3584.

Bere, bier, 2481.

Bere, (*inf.*) bear, 1465; (*subj.*) 3513.

Bered = bereð, beareth, 326, 2705.

Berem-tem = bern-tem, family, race, 3903.

Beren, (*inf.*) bear, carry, 8, 118, 120, 787, 2084; (*pl. pret.*) 1187, 2557; to show, 1044.

Beren-tem, family, descendants, 954.

Beres, (*sb.*) bears, 191.

Bereð, bear, (*imp.*) 2243, 2248.

Berg, *(sb.)* defence, protector, 926, A.S. *beorh.*

Berge, } to protect, 1060 ; *(opt.)*
Bergen, } 2529. A.S. *beorgan* (pret. *bearh*, p.p. *borgen*).

Bergles, shelterless, unprotected, 3048.

Beries, berries, 2062, 2064.

Bering, bearing, behaviour, 2178.

Bernteam, descendant, 3748. A.S. *bearn-team*, posterity,· from *bearn*, a child, and *teamian*, to generate.

Best, art, 2884.

Beste, beast, 194.

Bet, beat, *(pret.)* 483, 3958. A.S. *beót.*

Bet, better, 1713, 2366, 2938, 3753. A.S.

Betende, beating, 2713.

Betes, beatest, 3974.

Betre, } better, 1585, 1957, 2820.
Bettre, }

Betten = beten, amend, 3637. A.S. *bétan.*

Beð, is, 182, 1156, 1589 ; shall be, 386, 4122 ; *(imp.)* 2263, 3231.

Beðen, bathe, 2447. A.S. *beþian.*

Beðen, pray, entreat, 2498. O.N. *heiða*, to pray.

Bi, by, 141, 1586.

Bi-aften, behind, 1333, 3377. A.S. *be-æftan.*

Bi-agt, ought, should, 924.

Bicalleð, calls after, accuses, 2314.

Bicam, became, befell, happened, 996, 1404, 2007, 2148 ; went, 1744.

Bicrauen, *(inf.)* ask, crave, 1388.

Bicumen, *(inf.)* become, pass, come into, 960, 1577 ; *(p.p.)* befallen, 2227 ; become, 3839.

Bid, intreat, pray, 2509.

Bidde, intreat, 1569 ; command, 3454.

Bidden, *(inf.)* pray, beseech, 1802.

Biddi = bidde, offer, 27.

Bideð, biddeth, 3451.

Bifel, befell, 963.

Biforen, } before, 47, 219, 253,
Biforn, } 451, 665, 905, 907, 2272.

Bigan, began, 188, 236, 448, 921.

Bigamie, 448, 449.

Bigat, begot, 708, 709, 711, 1590 ; obtained, 796.

Bigen, to buy, 2166, 2246. A.S. *bygan, bycgan.*

Bigete, winnings, spoil, 896.

Bigetel, advantageous, 1992.

Bigeten, *(inf.)* obtain, 1532 ; beget, 2180 ; require, 1666 ; prevail, 2021 ; *(p.p.)* begotten, 906, 1151, 1376, 1377, 2006 ; acquired, obtained, 911, 2706.

Biggede, dwelt, 1137. A.S. *byggan*, to build ; Icel. *byggia ;* O.Sw. *bygga*, to build, inhabit.

Bigging, } sojourn, abode, dwell-
Bigginge, } ing, 718, 762, 807 ;
Biging, } house, 3163.

Biginned = biginneð, beginneth, 2538.

Biginning, } beginning, 32, 39,
Biginninge, } 521.

Bigote, begotten, 2618.

Bigunnen, *(pl. pret.)* began, 536.

Bihaluen = surround, 3355. See Havelok, l. 1834.

Bihet, (pret. of *bihete*) promised. A.S. *behátan*, (pret. *behét ;* p.p. *beháten*) to promise.

Bihoten, promised, 3132.

Bi-hu[f]lik (?), needful, necessary, 4108. A.S. *behóflíc.*

Bilagt, taken away, 773. A.S. *ge-læccan* (pret. *gelæhte*), take, catch, seize.

Bileaf, remained, 1332, 2776 ; left, 3066.

Bilef, remained, 671, 1346, 1516, 1791, 1801. A.S. *belífan* (pret. *belaf*).

Bileften, (*pl. pret.*) dwelt, abode, 800.

Bileph = bilef, remained, 2662.

Bileue, should remain, 1716.

Bileue, quickly, 4128.

Bileuen, to remain, stay, 1766, 3114.

Bileuen, remainder, 3154.

Bilewen, to remain, 2233.

Bilirten, deprive of by fraud, 316.

Biloc, surrounded, 2684. See *Biluken.*

Bilong, along of, *not* belong, 2058.

Biluken, enclosed, shut up, 104. A.S. *belúcan* (pret. *beleác ;* p.p. *belocen*).

Bimen, complaint, cry, 2894.

Bimeneð, bemoaneth, 2226.

Bimening, mourning, bemoaning, 2484.

Biment,) complained, 1217; be-
Bimente,) wailed, bemoaned, 2202, 4150. A.S. *bemǽnan* (pret. *bimǽnde*).

Binam, used, 1706. See *Bini-men.*

Binden, to bind, 2193, 3193.

Bineðe,) beneath, below, 10,
Bineðen,) 66, 126, 3526, 4082. A.S. *benyðan.*

Binimen, to take away, 1764. A.S. *beniman* (pret. *benám,* p.p. *benumen*).

Binnen, within, 1032, 1731. A.S. *binnan.*

Binumen = be taken, 1578.

Binumen, bereft, taken away, 198, 772 ; rescued, 2876 ; placed, 376.

Biofte, behoof, 1408. A.S. *be-hofian,* to behove.

Bioueð, behoveth, 1159.

Biquuad, ordered, appointed, 117. See *Quuad.*

Biqueðen, bewail, 2448. See *Queðe.*

Bird, birth, 2591.

Biri, city, 2257. A.S. *burh* (pl. *byrig*).

Biried, buried, 256, 735, 2517, 3851.

Biriele, tomb, sepulchre, 2488. A.S. *byrgels.*

Birien, to bury, 2424.

Birigeles, burial, interment, 2474.

Birðe,) birth, 441, 1177, 1187,
Birðehe,) 1484, 1497.

Birðen, to be born, 1471.

Birðhe, birth, 368.

Birðheltre, fruit-bearing tree, 119.

Bise, rule, govern, 4107.·

Bisek, (*imp.*) beseech, 3093.

Biseke, (*imp.*) beseech, 4155.

Biseken, to beseech, 2492, 3600.

Bisen, to provide, 1313 ; ordained, 1411 ; govern, direct, 2141, 3414. A.S. *beseon.*

Biset, (*p.p.*) beset, surrounded, 3225.

Bisctte, (*pret.*) beset, compassed, 2687.

Bisetten, surrounded, encompassed, 1066.

Bisne, blind, 472, 2822. A.S. *bisen.*

Bisogt, (*p.p.*) besought, asked, 3080.

Bisogte, (*pret.*) besought, 3236 ; interceded, 3693.

Bispac (= bespoke), gain-said, contradicted, 1444.

Bispeken, to blame, condemn, 1855. A.S. *besprécan,* to accuse, blame.

Bistod, lamented, 3857.

Bistoden, (*pl.*) bewailed, wept for, 716, 1456. A.S. *bestanden,* to stand by.

Biswiken, betrayed, deceived, 3561. A.S. *beswícan.*

Bit, biddeth, 2238.

Bitagt, (*p.p.*) delivered, given over, assigned, 774, 1677.

Bitagte, (pret. of *bitaken* or *bi-*

techen) gave, 212, 782, 1185; appointed, assigned, 923, 965, 1663, 2622, 3621. A.S. *betæcan* (pret. *betǽhte*).

Bitagten, (*pl.*) delivered, consigned, 1424.

Biteg, accomplished, 2878. See *Ten*.

Biten, (*pl.*) accomplish, 3626. See *Ten*.

Biter, bitter, 3300.

Bithowte, bethought, 2735.

Bitid, befallen, 357, 1194, 1876, 1978, 2358, 3406.

Bitidde, befell, 3861.

Bitime, betimes, 1088.

Bitogen, bestowed, applied, 1771; guided, directed, 3796. See *Ten*.

Bitold, rescued, 920; from *bitellan*, to defend, rescue. See Orm. l. 2405, and O.E. Hom. 1st S. p. 205.

Bitterlike, bitterly, 1115; angrily, 2030; severely, sharply, 3896.

Biðhogte, ⎫ bethought, devised,
Biðogt, ⎬ 36, 37, 1183. A.S.
Biðohte, ⎭ *beþencan*, to consider, bethink.

Bitwen, between, 8, 251, 760, 1168, 1601, 2406.

Biueð, trembleth, 2280. A.S. *bifian*, *beofian*.

Biwaken, (*pl.*) keep a wake (or vigil) for the dead, 2444. A.S. *wǽcan*, to watch, wake.

Blast; (*ph.*) 'liues *blast*,' 201; 'hornes *blast*,' 3464.

Ble, colour, hue, 457; appearance, 749. A.S. *bleo*.

Blein, blain, 3027.

Bles, (*g. sing.* of *ble*) of colour, hue, 1725.

Blessede, turned aside, ceased, 3653, 3803. See *Blissen*.

Bleð, timid, fearful, 2590, 3520, 3907. A.S. *bleáð*, gentle, timid. O.N. *blauðr*.

Blinne, ⎫ to cease, 289, 1963.
Blinnen, ⎬ A.S. *blinnan*.

Blis, ⎫ bliss, 382, 748, 3518.
Blisce, ⎬

Blisced, (*p.p.*) blessed, 1552, 1616.

Bliscede, (*pret.*) blessed, 163, 897, 1546.

Bliscing, blessing, 1508, 1532, 1556, 1563, 1568, 2398.

Blisse, bliss, 11, 241, 2068.

Blissen, to lessen, 553. Du. *bleschen*, to quench.

Blisses, (*g. sing.*) of bliss, 19,383; *pl.* happiness, joys, 2350.

Bliðe, blithe, joyful, 1343, 1653.

Bliðelike, blithely, joyfully, 1424, 1499.

Blo, blue, 637, 638. A.S. *bleo*; O.Du. *bla*.

Blod, blood, 1074, 1452, 1661, 2816.

Blod, woman, 1192. See Gloss. to Allit. Poems, s.v. *Blod*.

Blodes, of blood, 2956.

Blomede, bloomed, flowered, 2061.

Boc, book, 523, 2522.

Bode, (*subj.*) should tolerate, endure, 1594.

Bode, word, message, command, 395, 621, 939, 991, 1008, 1286, 1973, 2383, 2859. A.S. *bod*, *gebod*, a command, message; *beódan*, to command, order, bid.

Boden, (*pl. pret.*) bad, commanded, 1067, 1096, 1971, 3544; asked for, 3169; *p.p.* bidden, 1430, 3111, 4115.

Bodes, commands, rules, 3528.

Bodeword, ⎫ commandment, pro-
Bodewurd, ⎬ hibition, 213, 218, 361, 2282; message, 396, 2494, 2880, 2913. See *Bode*.

Bofte = Bihofte, behoof, 1388. A.S. *be-hófian*, to behove.

Bog, bough, 608.

Boge, bow, 483, 1238.

Bogt, (*p.p.*) bought, 1994, 3683.

Bogte, (*pret.*) bought, 1996.

Boken, book; *ph.* 'on no *boken*,' 4.

Bokes, books, 3635.

Bold, bad, 323 ; stubborn, 1917 ; boldly, 2728.

Bolen. See *To-bollen.*

Bond,) bond, prison, 2076,
Bonde,) 2693 ; force, power, 763, 2114, 2716.

Bondes, bonds, 344, 2230.

Bone, prayer, petition, *boon*, 2980. O.N. *bón ;* A.S. *bén.*

Booc, book, 4124.

Bor, (pret. of *beren*) bore, 425.

Borde, table, *board*, 1210.

Boren, *s. pl.* bearers, 1798.

Boren, (pl. pret. of *beren*, to bear) bore, 684, 1725, 1730 ; *p.p.* born, 84, 220, 648, 655, 666, 1144 ; borne, 2512, 2518.

Borgen, (p.p. of *bergen*) protected, saved, 1102, 1105, 2686. See *Bergen.*

Borwen, (p.p. of *berge*) preserved, saved, 886, 3044.

Bosum, bosom, 2809.

Bot, (pret. of *biten*) bit, 2926.

Bot,) salvation, deliverance
Bote,) from evil, forgiveness, atonement, 24, 2957, 3598. A.S. *bót, bótu; bétan*, to amend.

Boðen, both, 328, 350, 899, 1275, 1390.

Brac, broke, 3100.

Bras, brass, 467.

Brast, (pret. of *bresten*) burst, 1808.

Bread-lepes, bread-baskets, 2078. A.S. *leap*, a basket, hamper.

Bred,) bread, 364, 1013, 1225,
Bread,) 2079.

Bred, (*p.p.*) roasted, 1013, 3147. A.S. *brǽdan*, (p. *brǽdde ;* p.p. *gebrǽd*) to melt, roast.

Bredde, (*pret.*) melted, 3342.

Bredes, of bread, 894, 1246.

Bred-wrigte, baker, 2077.

Breken, break, 3147.

Brekeð, breaketh, 3062.

Brend, (*p.p.*) burnt, 3685.

Brende, (*pret.*) burnt, 1108, 2668, 2778, 2779.

Brend-fier-rein, rain of burning fire, 1110.

Brennen, to burn, 1087, 2775, 3154.

Brennen = brennende, burning, 2653.

Brenninge, (*sb.*) burning, 3654.

Brent,) burnt, 754, 1114, 1336,
Brente,) 2656.

Brest, breast, 343, 370.

Brewen, to brew, produce, 4054.

Breðere, brethren, 823, 1911, 2217 ; brothers', 530, 2213.

Brictest, brightest, 1910.

Bridale, wedding, 1674.

Brigt, (*adj.*) bright, 132, 951 ; beautiful, 1058 ; clear, 2780 ; (*sb.*) brightness, 143.

Brigte, (*adv.*) clearly, 3763.

Brigtlike, clearly, brightly, 3491.

Brimen, to become fertile, teem, 118 ; bear fruit, 1128. A.S. *breman*, to have in honour.

Brimfir, burning-fire, brimstone, 754.

Brinfires, burning-fires, brimstones, 1164.

Bringen, to bring, 312, 738, 1067 ; 'bringen on' = to bring against, 2032.

Briðere = breðere, brethren, 2271.

Brocte, brought, 237.

Brod, brood, 3712. A.S. *bród.*

Brogt, (*p.p.*)) brought, 62, 124,
Brogte, (*pret.*)) 219, 608, 847, 870, 874, 882, 2634.

Brogten, (*pl. pret.*) brought, 3546.

Broðer, brother, 420, 1394.

Bruc, (*imp.*) enjoy, 1831. A.S.

brúcan, (p. *bréac;* p.p. *gebrocen*) use, enjoy, eat.

Buges, boughs, 2060.

Bunden, (*p.p.*) bound, 2216.

Burdene, burden, birth, 1467.

Burg, ⎫ city, 812, 833, 1110,
Burge, ⎭ 1837. A.S. *burh, burg.*

Burge-folc, townsfolk, 1854.

Burges, cities, 746, 840.

Burges, (*g. sing.*) of the city, 1053, 1086.

Burgt = burg, city, 727, 744, 879.

Burgt-folk = burg-folc, townsfolc, people, 1063.

Busk, bush, 2779.

But, send out (?), 3075. It may represent the A.S. *búte, bútu*, both.

But, ⎫ unless, 3017, 3616 ; only,
Bute, ⎭ 4000. A.S. *búte.*

Bute if, unless, 4059.

Buteler, butler, 2092, 2115.

Buten, about, 566. A.S. *bútan.*

But-if, unless, 1713, 2698, 2949.

Buttere, butter, 1014.

Buxum, obedient, 980, 1299. A.S. *bocsum*, from *búgan*, to bend.

Cald, (*p.p.*) called, 3367, 3686.

Calde, (*pret.*) called, 1446, 1631, 1702.

Calden, (*pl.pret.*) called, 685.

Calles, callest, 3237.

Cam, came, 114, 158, 416.

Can, know, 309 ; did, 2872.

Canticle, 4124.

Care, sorrow, 775. A.S. *cáru.*

Carf, cut, carved, 2700. A.S. *ceorfan*, (pret. *cearf;* p.p. *corfen*) to cut, engrave.

Carte-hird, collection of carts (chariots), 3215.

Cartes, carts, 2362.

Cast, a shadow (?), 3463.

Caue[n], a cave, 1137.

Chaf, chaff, 2889.

Chafare, chaffer, 1951.

Chare, turn, go, 2390.

Charen, to turn, depart, journey, 1712, 2436, 3010, 3055, 3704, 3986. A.S. *cérran, círran*, to turn, pass over or by.

Charite, charity, 1016.

Chartre, prison, 2043. A.S. *cwartern*, a prison.

Chasthed, chastity, 2022.

Che, she, 1227.

Cherl, churl, man, fellow, 2715.

Ches, (pret. of *chesen*) chose, selected, 433, 805, 807, 1250, 2736, 3672 ; (*imp.*) 3665.

Chesen, to choose, 3429. A.S. *ceósan*, (pret. *ceás*, p.p. *córen*) to choose, select.

Chidden, (*pret. pl.*) chided, rebuked, 1927.

Chiden, to chide, 2722.

Childe, child, 966, 974.

Childes, child's, 1965, 1972.

Childhede, childishness, 2652.

Childles, childless, 930.

Childre, children, 656, 715, 722.

Chirche-gong, church-going, 2465.

Chirches, churches, 511, 3197.

Chosen, (*pl.*) chose, 543.

Circumcicioun, circumcision, 992.

Circumcis, circumcised, 999, 1002.

Circumcise, circumcision, 2848.

Circumcised, circumcised, 1200, 1202.

Cisternesse, pit, cistern, 1960.

Clene, clean, pure, 605, 611, 627, 777, 3454, 3637.

Clense, cleanse, 3453.

Cleped, ⎫ called, 1198, 1274,
Clepede, ⎬ 2631, 4099. A.S.
Clepit, ⎭ *cleopian*, to cry, call.

Clepeð, calleth, 3330.

Clerkes, clerks, learned men, 2993.

Clipping-time, shearing time, 1740.

Cliued, 'he *cliued*' = *him cliueð* = cleaves to him, 1963.

Cliuen, to stick, fasten, 372. A.S. *clifian.*

Cliueð, adheres, remains, 2384.

Cloðen, to clothe, 2630.

Colen, coals, 2653.

Comb, top, crest, 2564. Du. *kam.*

Come, coming, arrival, 2267.

Come, should come, 464.

Comen, (*p.p.*) come, 344.

Comen, (*pret. pl.*) came, 1979, 2611, 2940.

Coren, corn, 2104, 2237.

Corune, crown, 2638.

Corunes, crowns, 3789.

Cost, nature, kind, 3327. A.S. *cost.* Icel. *kostr*, habits, character.

Costful, trying, dangerous, 3880. A.S. *costian*, to try.

Craflik, craftily.

Crauede, craved, asked, 1418.

Craueu, to crave, ask, demand, 1320, 1408, 1667, 1718, 2366, 3171.

Crep, (pret. of *crepen*) crept, 2924. A.S. *creópan*, to creep (pret. *creáp*, p.p. *cropen*).

Crepen, to creep, 610, 2560.

Crisme, chrisom, the anointing oil, 2458. O.Fr. *cresme*, from χρισμα.

Cristene, } Christian, 7, 15.
Cristenei, }

Cropen, crept, 2974.

Crune, crown, 2642.

Cude = cuðe, could, knew how to, 878, 2674.

Cuden = cuðen, (*pl.*) could, 875. A.S. *cunnan*, to ken, know (pret. *cúðe*, p.p. *cúð*).

Cum, (*imp.*) come, 2791.

Cume. (1*st pers. sing.*) come, 1037.

Cume, (*p.p.*) come, 1432.

Cume, (*pl.*) come, 2171.

Cumen, (*inf.*) come, 305, 505, 2337.

Cumen, (*pl. pret.*) came, 1065.

Cumen, (*p.p.*) come, 365, 410, 570, 1141, 2316.

Cumeð, (*imp. pl.*) come, 3485.

Cunen, (*pl.*) can, are able, 4054.

Cuppe, cup, 2310, 2318.

Cursen, to curse, 4005.

Cursing, (*sb.*) curse, 3926, 4037, 4038.

Cuðe, could, 470, 2594, 2747; showed, 1659.

Cuðen, could, 3224; knew, 2996.

Cuuel-staf, a cowl-staff, a pole for carrying two-handled vessels, 3710. A.S. *ceofl, cawel*, a basket.

Dage, days, 'of *dage* brogten,' put to death, 3545.

Dagen, to dawn, 16, 91. A.S. *dæg*, a day; *dægian*, to shine; *dagian*, to dawn; *dagung*, a dawning, daybreak.

Dages, days, 3297.

Dai, day, 83, 88, 93.

Daiening, } dawn, 77, 1808,
Daigening, } 3264.
Daning, }

Daiges, day's, 3294.

Daiges, days, 2455, 2471.

Dain = ðain (?), a man, 1116.

Dais, day's, 113, 114, 157, 158.

Dais, days, 590.

Dale, dale, vale, 'sorwes *dale*,' 19; 'werldes *dale*,' 142.

Dalen, dale, 1931.

Dalf, buried, 2718. See *Deluen.*

Dan = ðan, then, 411, 613, *et passim.*

Daning, dawn, 1808. See *Daiening* and *Dagen.*

Dat = ðat, 224, 232, 342.

Dead, } death, 312, 392, 402,
Deade, } 421, 2573, 3120.

Dead, deed, 2983.

Deades, death's, 268, 714, 3396.

Deai, day, 862.

Ded, } death, 214, 257, 261,
Dede, } 265.

Ded, }
Dede, } dead, 217, 750, 2465.

Dede, deed, 355, 502, 1150, 2662.

Dede, did, 24, 118, 224 ; put, placed, 42, 576 ; made, 762, 2291 ; showed, 2757.

Deden, (*pl. pret.*) did, 1059, 1153 ; made, caused, 1522, 2100, 2560 ; put, 2555 ; fixed, 3442 ; gave, 3551.

Dedes, death's, 344, 484, 2716.

Dedes, deeds, 2459.

Dedes, deeds', 551.

Dedis = put them, 3830.

Dei, day, 78.

Deieð, dieth, 751.

Deigen, to die, 3127.

Del, a part, a whit, bit, 230, 1092, 567, 1062 ; -what, -thing, 353 ; parts, 3239. A.S. *dæl*, a part.

Del, (*imp.*) divide, 3239. A.S. *dælan*, to divide, distribute.

Delen, (*pl. pres.*) divide, 151.

Delt, divided, scattered, 670, 3243.

Delte, (*pret.*) divided, 941.

Deluen, to bury, 2452. A.S. *delfan*, to dig, delve (pret. *dealf*, p.p. *dolfen*).

Dempt, doomed, condemned, 2038. A.S. *dèman*, to deem, doom.

Denede = dinede, shook, quaked, 3772. A.S. *dynian*, to din.

Dep, deep, 1942.

Depe, }
Diep, } deeply, 1873, 2655, 2770.

Der, *deer*, animal, 169, 178, 187, 299, 4020, 4025.

Dere, noble, precious, 271, 2247 ; dear, beloved, 403, 1569.

Dere, to harm, annoy, 1588, 3514 ; to injure, 4047 ; destroy, 3566. A.S. *derian.*

Dere, (*sb.*) harm, hurt, 2970, 3214, 3742. A.S. *dere, dar, daru,* hurt, damage.

Dered, } harmed, hurt, 242,
Derede, } 2596, 3052.

Deren, to hurt, annoy, 788, 1188, 1271, 2348.

Deren, (*pl. pres.*) hurt, annoy, 187, 852.

Derer = dere, dear, beloved, 2399.

Deres, injuries, 3088.

Deres, animals, 4032.

Deres-kin, animals, 556.

Dereð, harms, hurts, 3818.

Derke = derðe, dearth, famine, 2237, 2345.

Derne, secret, 1950. A.S. *dearn.*

Derre = dearly, 3683.

Deserd, } desert, 1227, 2737,
Desert, } 2770.

Dew, 3325.

Dhogt = ðhogt, thought, care, 1153.

Dewes, dew's, 3327.

Digere = diyere, dear, precious, 3483, 3484 ; dearer, 3903.

Dik, dike, ditch, pit, 281.

Dikes, ditches, 2560.

Dim, dull, 286 ; ignorant, 3673.

Dine, din, noise, 3467.

Dinede, sounded, 3464.

Dis = ðis, 63.

Diserd, desert, 975.

Do, take, put, 2781, 3604, 3819, 3822.

Dogtres, daughters, 1090, 1094.

Dole, part, 152.

Doles, parts, 151, 3243 ; pieces, 952 ; shares, 1512. See *Del.*

Doluen, (*p.p.*) buried, 1895, 3200, 3685.

Doluen, (*pret. pl.*) dug, 3189.

Domesdai, } doomsday, 105, 505,
Domesday, } 645.

Domme, dumb, 2821.

Don, (*inf.*) to do, cause, 194, 534, 1146, 3608.

Don, (*pl. pres.*) do, 311 ; cause, 180.

Don, (*p.p.*) done, 345, 3012; placed, put, 267, 381, 383, 2586, 3206.

Dor = ᚦor, there, 668, 897.

Dor-bi = ᚦor-bi, thereby, 1637.

Doᚦ, (*imp.*) cause, 2351; do, 3727.

Doᚦ, doth, causes, 2702, 2883.

Dowter, daughter, 1847, 2147, 2599, 2601, 2603.

Dowtres, daughters, 2743.

Dragen,(*p.p.*) drawn, 3980; compiled, 13; 'to dead *dragen*,' put to death, 3458; 'of liue *dragen*,' slain, 3806; withdrawn, 598; led, drawn, 2046; sprinkled, 3156.

Dragen, (*inf*) to draw near to, 2360, 2378.

Dragen, (*adj.*) drawn, 2843.

Dragt, plan, 3624; way, course, 3745.

Dragun, dragon, serpent, 2924.

Drake, dragon, 283.

Dranc, drank, 1660.

Drechede, delayed, 2835.

Drechen, delay, 1420, 1946. A.S. *drécan*, to trouble, oppress.

Dred, dread, fear, 179, 660, 694, 698.

Dredde, dreaded, feared, 767, 1868, 3008.

Dredes, dread's, 2806.

Dredeᚦ, (*imp.*) dread, 2343,3129.

Dredful, fearful, 3520; dreadful, 3521.

Dredi, afraid, 872.

Dref, trouble, 4144. See *Dreue*.

Dreful, sorrowful, 2590. See *Dregen*.

Dreg, suffered, endured, 429, 566, 2877.

Drege,) (*pl.*) endure,suffer,bear,
Dregen,) 512, 2208.

Dregen, (*inf.*) to suffer, 3235. A.S. *dreógan* (pret. *dreag*, p.p. *drogen*), to suffer, bear.

Drem,) dream, 953, 2095; 'on
Dreme,) *dreme*,'in dream,1179.

Dremen, to dream, 2067.

Drempte, (*vb. impers.*) dreamt, 1941, 2049, 2059, 2078, 2095.

Dremes, (*pl.*) dreams, 1918, 2086; (*gen.*) 2112, 2114.

Dreue, to trouble, 318. A.S. *dréfan*, to trouble, disturb.

Drie, dry, 616.

Dried, 3681.

Drige, dry, 3910.

Drinc, drink, 1149, 1246.

Drinkelen, to drown, 2768.

Drinken, to drink, 2065, 3582.

Drinkilden, (*pl.*) drowned, 492.

Dririhed, dreariness, 1122.

Driuen, (*pres. pl.*) drive, 1647; (*pret. pl.*) drove, fell, 4096; (*p.p.*) driuen, 307, 574, 1125; practised, 1681.

Drof, draff, dregs, 3582. O.Du. *dᵣᵤf.* Dan. *drav;* Icel. *draf*, dregs. "*Draffe* or drosse, or matter stamped, pilumen."— (Prompt. Parv.)

Drof, assemblage, 102. A.S. *dráf*.

Drog,) drew, 478, 1746, 1844,
Droge,) 3909.

Drogen, (*pl.*) drew, 1077.

Drogen = ?drogende, suffering, 977.

Drogen, (*p.p.*) suffered, 1772, 2402, 2404, 2786, 3648. See *Dregen*.

Drope, drop, 1018.

Dropen, killed, 2648. A.S.*drepan* (pret. *dræp*, p.p. *drepen*), to strike, wound.

Drug, drew, 2717.

Drugen, (*pl.*) drew.

Drugte, drought, dryness, 2107, 2348. A.S. *drugoᚦ*.

Drunken, drunk, 871, 1154.

Dun, down, 484, 714, 1303.

Dun, } hill, 19, 587, 1101, 1295,
Dune, } 3380. A.S. *dún.*

Dun-cumen, to descend, 1608.

Dunes, hills, 599, 644, 855, 1100.

Dune-is, down's, hill's, 1295.

Dure, door, 1082.

Duren, dare, 2239.

Dure-pin, door pin, bolt of the door, 1078.

Dure-tren, door-posts, 3155.

Durste, durst, 2593, 3968.

Dursten, (*pl.*) durst, 1863.

Duue, dove, 605, 944.

Dwale, heretic, apostate, 20, 67 ; deceit, fraud, 4055. A.S. *dwala*, an error ; *dwelian*, to deceive.

Dwale, grief, complaint, 1037, 1220 ; strife, contest, 3404. O.E. *dule, dole.* Sc. *dool.*

Dwelledde, dwelt, 1100.

E = he, 2341, 2708.

E = *he*, they, 4094.

Ear, ere, before, formerly, 36, 47, 250, 284, 1089, 1757, 2562, 3080 ; ' *ear* ðanne,' ere that. A.S. *ear, ær.*

Eares, ears (of corn), 2104.

Earuermor = eauermor, evermore, 12.

Ebrisse, Hebrew, 73.

Eddi, pleasant, good, 2086. A.S. *eadig.*

Eddi-sel = happy (pleasant) time, prosperity, 2582. A.S. *eádig*, happy, blessed ; *sæl*, time.

Ef = eft, again, 2337.

Eft, } again, 77, 365, 1169,
Efte, } 1032.

Egest = hegest, highest, 143, 1224.

Egte, probably miswritten for *fegte*, 470.

Egte, eight, 1349.

Egtende, } eighth, 1199, 1202,
Egtenede, } 2543.

Eige, awe, fear, 2550, 3043. A.S. *ége*, fear, terror.

Eilden, ? bake, 2892. Stratmann proposes to derive it from O.N. *elda*, to make a fire.

Eld, } age, 579, 705, 707, 740,
Elde, } 900, 1283 ; *on elde*, in age, 1197. A.S. *eld, yld*, age.

Eldes, of age, 1528.

Eld = held, 2999.

Elles, Hell's, 4157.

Elles, else, 3072 ; besides, 4096.

Elmesse-gifte, alms-gift, 2466.

Elne, ella, 563, 565, 586.

Elten, knead, 2892. O.N. *elta.* (Stratmann.)

Em, uncle, 1758. A.S. *eám.*

Endede, ended, 166.

Endesið, destruction, death, 3777. A.S. *ende*, end, *sið*, adversity. *Endesið* may be an error for *unsið*, from. A.S. *unsið*, mishap.

Ending, } death, 487, 1506,
Endinge, } 2420, 2439.

Engle, } English, 14, 450, 814.
Engleis, }

Erd, } land, abode, 210, 383,
Erde, } 1131, 2094, 2406. A.S. *eard*, province, country.

Erdes, abodes, lands, 956.

Erdfolc, people, 1880.

Erdne, } = *ernde*, errand, peti-
Erdene, } tion, 787, 1372, 1400, 1402. A.S. *ærend, ærende*, message, news.

Ere — here, of them, 2855, 3773.

Ereward-riche, inheritance, 1512. Du. *erfrijk.* See *Erward.*

Erf, cattle, 183, 195, 910, 2746, 3018. A.S. *ærfe, erfe, orfe, yrfe.*

Erf-kin, cattle, 3177.

Ermor = eauermor, evermore, 306.

Erneste, necessity, 411.
Erðe, earth, 40, 116, 118, 122.
Erðe-dine, earthquake, 1108, 3196. A.S. *eorð-dýne*.
Erðes, earth's, 124, 1547, 1573.
Erue, cattle, 169, 174, 803, 1948, 2751. See *Erf*.
Eruerilc = *euerilc*, every, 160.
Erward = erf-ward, heir, 934. A.S. *yrfe-weard*, an heir.
Es = *is*, them, 135, 1535, 1700, 2176, 3025, 3097.
Est, an error for *eft*, 607.
Est, east, 829, 1449.
Estdede, kindness, 2758. A.S. *este*, mild, favouring.
Esterne, Easter, 3289.
Et, it, 590, 3899.
Eten, (*p.p.*) eaten, 329 ; (*inf.*) to eat, 364, 1531, 1538 ; (*pl. pres.*) eat, 1779.
Eðe-moðed = *eðe-moded*, appeased, 1584.
Eðen = *heðen*, hence, 2188.
Eði-modes = *eðe-moded* (easy minded), kind, gentle, 2249. A.S. *eáð*, easy, gentle, mild ; *eáð-mód*, easy-minded, humble.
Eððede, softened, alleviated, 1439.
Euen, evening, 1675.
Euene, even, equally, 331.
Eui, heavy, 2559.
Euerilc, every, 68, 69, 121, 2407 ; each, every one, 2214, 2355.
Euerilc del, every whit, 567.
Euerilc on, every one, 185, 609.
Euerilk, every, 582.

Fader, father, 29, 1148.
Faderes, father's, 1536, 1586, 1748, 2293.
Fagen, glad, joyful, 15, 510, 854, 1331, 1343, 1551. A.S. *fægn, fægen*, glad ; *fægnian*, to rejoice, be delighted with.

Fagnede, welcomed, 1441, 1655.
Fagneden, (*pl.*) welcomed, 1410.
Fagt, fought, 3386, 3390.
Faier,) (*adj.*) fair, beautiful, 126,
Fair, } 127, 769, 1058, 1192 ;
Faire,) (*adv.*) 1061.
Faiernesse, fairness, colour, 1233.
Faiger, (*adj.*) fair, beautiful, 1440, 2636, 2659 ; good, 3244; (*adv.*) 1396. A.S. *fæger*.
Faigere, (*pl.*) fair, 3547.
Faigered, *fairhood*, beauty, 2666.
Faire, (*adv.*) decently, honourably, 2393, 3193.
Faire-hed,) beauty, 1998, 2609.
Fair-hed, }
Fallen, to fall, 2734.
Fand, temptation, strife, 3737. See *Fonden*.
Far,) (*imp.*) fare, go, 737,
Farc, } 1288.
Fare, course, journey, 1434, 1989 ; departure, 3179; welfare, 2771. A.S. *fær, faru*.
Fare, (*inf.*) to go, 2389.
Fare, (1*st pers. sing.*) go, 930.
Faren, (*inf.*) to go, 137, 1418, 1596, 2238 ; (*pl. pres.*) pass away, 2153 ; (*p.p.*) gone, 3705, 4145. A.S. *faran*, to go (pret. *fór*, p.p. *gefaren*).
Fastede, fasted, 3611.
Fe, goods, 439; cattle, 783. A.S. *feoh*, cattle, money, goods.
Fear, far, 253, 2616.
Feble, weak, bad, 1072.
Fechen,) (*inf.*) to fetch, 1363,
Fechin, } 1530, 2363.
Fedde, fed, 2630.
Feið, faith, 2187, 2678.
Feger, far, 764.
Fel, fell, 72, 484; '*fel* wel,' prospered, 1521.
Felage, fellow, companion, 1761.
Felde, field, 440, 1437.
Fele, many, 2371, 2400, 3197.

Fele, defile, dishonour, A.S. *fœ́-lan*, to defile ; ? or 'to fele ' = too much, 3498.

Fellen, (*pl.*) fell, 65, 287, 1854, 2272.

Felte, felt, 1466.

Felten, (*pl.*) felt, 350.

Fen, mud, dirt, 490, 2557.

Fendes, fiend's, devil's, 25, 401.

Fendes, devils, 512, 2922, 2929.

Fendes wise, devil wise, 2961.

Fer, far, 36, 47, 1238, 1256.

Fer, sound, whole, 2812, 3469. Dan. *fór;* O.N. *foerr*. See Sir Gawaine and the Green Knight, l. 103.

Ferde, went, 810, 1598, 1739, 3263.

Ferden, (*pl.*) went, 2306 ; acted, 2921. A.S. *féran*, to go.

Ferding, army, 842. A.S. *ferd*, army ; *fyrding*, an army, expedition.

Fere, companion, 338 ; companions, 3783. A.S. *fera, gefera*, a companion.

Feren, companions, fellows, 1275, 2845.

Feren, afar, 2601. A.S. *feorran*, far from.

Feres, companions, 659, 888, 2478.

Ferli, wondrous, 2774. A.S. *fœ́rlíc*, sudden ; *fœ́rlíce*, suddenly, from *fœ́r*, sudden, fearful, strange.

Ferlike, marvellously, 2799.

Ferðe, fourth, 130, 131, 156, 157.

Fest, fastened, 2703, 3797.

Fest, } feast, 1689, 2470, 3552.
Feste, }

Festelike, convivially, 3407.

Fet, feet, 3151.

Fet, (*sing.*) } fat, 2098, 2100,
Fette, (*pl.*) } 2101, 2104, 2110.

Fetchden, (*pl.*) fetched, 2889.

Feteles, } vessel,561,1225,1247,
Fetles, } 2595,2801. A.S.*fetels*.

Feten, an error for *feten*, set, built, 2553 (?). It may = *fettle*. O.Fris. *fitia ;* Goth. *fetjan*, to adorn.

Feten, fetch, 2744. A.S. *fettan*.

Fette, fetched, 1535.

Fetthed, fatness, abundance, 1547.

Fier, fire, 103, 464, 1140.

Fier-isles, fire ashes, 1130. A.S. *ysla*, ashes.

Fieres, fire's, 1142, 3786.

Fif, five, 527, 746.

Fifte, fifth, 158, 159, 165, 166.

Fiftene, fifteen, 415, 417.

Fifti, fifty, 578, 657.

Fifue, }
Fifwe, } five, 731, 852, 854, 855.
Fiue, }

Figer, fire, 3522.

Figer, } far, 3519, 3904.
Figeren, }

Figt, fight, 870, 886 ; struggle, 1317, 1470.

Figten, (*inf.*) fight, 3227 ; (*pl.*) 3572.

Figti, warlike, 546.

Figures, forms, 1006.

Fild, filled, 1225.

Fillen, fulfil, perform, 1463.

Filt, filled, 1247, 2213, 2307.

Fin, ending, death, 3852.

Finden, } to find, 1877, 3246.
Findin, }

Findes, findest, 1768.

Fir, fire, 99, 3338.

Firmament, 95, 135.

Firme, first, 39, 43, 59, 75, 76, 78, 172.

Firmest, first, 1472, 1682, 1826, 4086.

Fis, fish, 162, 221, 299, 752.

Fisses, fishes, 2945.

Fled, put to flight, subdued, 3396.

Fledde, fled, 3384.

Fleg, fled, 430, 1136, 1745, 2806.

Flegen, to fly, 479, 610.

Fleges, flies, 192.

Fleges, flies', 3012.

Fleges-kin, flies, 3004.

Flegt = fleg, fled, 3643.

Fleis, flesh, 591, 1013, 2089.

Fleiðing, instigation, 692. A.S. *flít*, strife, offence.

Flemd, banished, 1265.

Flemede, banished, 1223. A.S. *flyman*, to banish.

Flen, (*inf.*) to flee, 1086, 1513, (*pl.*) 2685.

Fles, flesh, 3316.

Flesses, flesh's, 349.

Flet, flowed, 644 ; floated, 3187. A.S. *fleótan*, to flow.

Fligt, ⎱ flight, 137, 161, 277,
Fligte, ⎰ 3012.

Fliten, striven, 3689. A.S. *flítan*, to strive (pret. *flát*, p.p. *gefliten*).

Flitten, to remove, 1522. Dan. *flytte*, to remove.

Flod, ⎱ flood, 596, 644, 1112,
Flode, ⎰ 3186.

Flodes, flood's, 2096.

Flogen, (*pl.*) flew, 861, 3677; (*p.p.*) fled, flown, 1750, 3795.

Flotes, swimming's, floating's, 162. A.S. *flótan*, to swim, float ; *flót*, a float, raft. Stratmann compares *flote* with O.H. Germ. *floza* pinna.

Floten, (*pl.*) floated, 2946.

Flum, flood, 490 ; river, 806, 2486 ; sea, 1123.

Flures, flour's, 1013.

Fo, few, 2403. A.S. *feáw, feá*.

Fode, food, 176, 894, 3146.

Fodme, productions, 124, 125. A.S. *fadung*, setting in order. disposition.

Fol, full, 211.

Folc, folk, people, 697, 770, 894.

Folckes, folk's, 4034.

Folged, (*p.p.*) followed, 239.

Folgede, (*pret.*) followed, 204, 1866.

Folgen, to follow, 28, 3272.

Folkes, folk's, people's, 2785.

Folkes-kin, people, 1864.

Folwede, followed, pursued, 880, 3187.

Folwede on, pursued, 1751.

Folwen, to follow, 401.

Fon, foes, 2610, 2693.

Fond, trial, 336 ; need, want, 3150. Cf. Du. *vond*, scheme, device. See *Fonden*.

Fond, ⎱ found, 440, 1280, 1397,
Fonde, ⎰ 1933, 2324.

Fondeden, (*pl.*) tempted, 3368.

Fonden, to try, 2938 ; to seek, 3476, 3946. A.S. *fandian*, to try, tempt, seek, search out.

For, (*pret.* of *fare*) went, 743, 763, 1337, 2709.

For, whether, 2651.

Forbead, ⎱ forbad, 213, 311,
Forbed, ⎰ 1329, 2932, 2984.

Forbi, against, 3988.

Forbode, prohibition, 324.

Forboden, forbidden, 325. A.S. *forbeódan*, to forbid, prohibit.

Forbone, an error for *forbode*, command, law, 3341.

Forbrac, broke down, 3049. A.S. *for-brecan*, to break in two.

Forbrende, burnt up, consumed, 3784.

Fordede, killed, 426. A.S. *fordón*, to destroy.

Fordred, afraid, 1557, 1763, 2191.

Fore, departure, 2984. A.S. *fór, fóru, faru*, a way, journey.

Foren, before, 3541, 3866. A.S. *fóran*, before.

Foren, (*pl.*) went, 2482. See *Fare*.

For-fare, ⎱ to perish, 1087, 1134,
For-faren, ⎰ 3018. A.S. *forfaran*.

Forfrigted, afraid, frightened, 3519.

Forgaf, forgave, 2499.

Forgat, forgot, 2092.

Forgeten, (*inf.*) to forget, 912, 1400, 1806; (*p.p.*) forgotten, 1152, 2179, 3128.

For-hadede, consecrated (by burning), 3338. A.S. *hadian*, to consecrate. ? for-ha[r]dede, hardened.

For-held, withheld, 2026.

For-hele, (*subj.*) hide, 3512.

For-helen, (*inf.*) to hide, 2593. A.S. *for-hélan*, to hide, conceal.

For-hid, hidden, concealed, 1875.

For-hirked, tired of, 3658. A.S. *earg*, slothful, dull, timid; *yrhð*, sloth, fear.

For-holen,) (*p.p.*) concealed, hid-
For-olen,) den, 1747, 1759, 1870, 2317, 2331, 3446.

For-hugede, rejected, 3814. A.S. *for-hugian*, to despise.

Forles, lost, 189, 259, 502, 808. A.S. *for-leósan*, to lose.

For-leten, (*pl.*) forsook, 4068.

For-listede, from *forlisten*, to desire greatly, yearn for (see Orm. l. 11475); or does forlistede = deceived (?), 1851. Cf. Ger. *list*, craft, deceit.

For-loren, (*pret. pl.*) lost, 241; (*p.p.*) 1886, 2511, 3468; accursed, reprobate, 546; destroyed, 1143.

For-numen, taken away, 2228. See *Nimen.*

For-quat, wherefore, 1657, 2053.

For-red, deceived, 2192. A.S. *forrœdan*, to mislead, deceive.

For-sake, deny, 1767.

For-saken, refused, 3811.

For-sanc, sank entirely, 1114, 1117.

For-soc, refused, 1833.

For-sweðen, burn up, consume,

1140. O.N. *sviða*, to burn, consume.

Forð, forth, away, forward, 249, 262, 578.

For-ðan, therefore, 1190, 1261; because, 1996; thereupon, 3162.

Forð-do, utter, 3993.

Forðe, perform, 1372.

Forðen, to promote, further, accomplish, 341, 4080; follow, 4059. A.S. *fyrðrian*, to further, support.

Forðere, further, 1304, 3488.

Forð-for, departure, exodus, 3158. A.S. *forð-faru.*

Forð-geden, (*pl.*) passed, 1755. See *Gede.*

Forð-glod, passed away, 113, 129, 157. See *Glod.*

Forð gon, extended, 835; pass, 845; gone, 2819.

Forði, therefore, wherefore, 1581, 1591. A.S. *forði.*

Forð-nam, forth went, 3351. See *Nimen.*

Forð-nimen, proceed, 2676.

Forð-numen, passed, 3640.

Forð-wexen, (*pl.*) passed, 1211.

For token, token, sign, 2994.

Forward, covenant, agreement, 1719, 1992, 3014. A.S. *forweard.*

Forwerti *fowertieðe*, fortieth, 3439.

For-went, changed, 1121. See *Wente.*

For-weried, fatigued, 3894.

For-wrogt, accursed, 266.

Fostre, foster, nurse, 2620, 2624, 2625.

Fostred, fostered, brought up, 2618.

Fot,) foot, 376, 1303, 1474;
Fote,) 'to fot,' at the feet, 2497.

Foueles, fowls, birds, 570, 947.

Gad, a rod, 3185. A.S. *gád*, goad.

Gaderen, gather, 2134, 3335.

Gaf, ⎫ gave, 232, 238, 681,
Gafe, ⎭ 1500.

Gamen, pleasure, 411, 2015; sport, 3498; tricks, 1214. A.S. *gamen*.

Gan, did, 91, 1417, 1421.

Gare = *yare*, soon, quickly, 390, 2866, 3180. A.S. *gare, gearo*.

Garen, prepare, get ready for a journey, 1417, 1595; exhibit, show, 138; to hasten, 3168. A.S. *gearwan, gyrwan*, to make ready, prepare.

Garkede, arrayed, 3261.

Garknede, prepared, 3240. O.E. *yark;* A.S. *gearcian*, to prepare, make ready.

Gast, ghost, 202, 2428. A.S. *gást*.

Gastes, ghost's, 1486, 2994.

Gat, ⎫ granted, 635, 1574,
Gatte, ⎬ 2477, 2513; gave, 659.
Gatten, ⎭ A.S. *geatan*, to grant. O.N. *geta*.

Ge = ghe, she, 1024.

Ge, ye, 329, 330.

Geald, requited, 2581. See *Gelden*.

Gede, went, 618, 1236, 1947, 3057.

Geden, (*pl.*) went, 1034, 3195; passed away, 1673.

Gef, if, 311.

Geld, (*pret.*) performed, 1884; requited, 2758; (*imp.*) requite, 2152.

Gelden, to requite, reward, 6; pay, 1628. A.S. *geldan*, to pay, yield, restore (pret. *geald*, p.p. *golden*).

Gelus, jealous, 3495.

Gem, heed, 2614. A.S. *geame, gyme*, care.

Geming, care, protection, 2783.

A.S. *gýman*, to take care of, preserve.

Ger, year, 150, 152.

Ger, years, 415, 419.

Gerde = *yard*, rod, 2851, 2987. A.S. *geard*.

Gere, an error for *dere*, precious, 1574.

Geren, set in order (for burial,) 2441. See *Garen*.

Geres, years, 2153.

Gerken, prepare, 2255. See *Garknede*.

Gerneden, (*pl.*) yearned, 3657.

Geste, guest, 1054; guests, 1070.

Gestning, feast, festival, 1507. A.S. *gyst*, a guest; *gystenlíc*, hospitable.

Get, (*pret.*) poured, flowed, 585; (*imp.*) pour, 2815. A.S. *geótan*, to pour, pour out, shed (pret. *geát*, p.p. *gegoten*).

Get, ⎫ yet, 313, 375, 503, 1488.
Gete, ⎭

Gete, obtain, get, 1497.

Geten, melt, cast, 3548. See *Get*.

Getenes = *yetenes*, giants, 545. A.S. *eóten*, a giant.

Getenisse, gigantic, 3715.

Getle, poured, 582.

Geue, given, 301.

Geuelic, like, 282. A.S. *geefenlécan*, to be like.

Geuelengóhe (even length), equinox, 147, 149.

Geuen, to give, 1508, 2398; given, 2458.

Ghe = she, 237, 337, 339.

Ghe = *ghet*, yet, 1477.

Gif, (*imp.*) give, 1492.

Giftes, gifts, 1416.

Gildes = *cildes*, child's, 2624.

Gilt, ⎫ guilt, 2262, 2409.
Gilte, ⎭

Ging, king, 2547.

Ginge, young, 4049. A.S. *ging*.

Ginges, king's, 3932.

Girt, girded, 3149.

Gisarme, pike, axe, 4084.

Gisce, covet, 3515.

Giscing, covetousness, 1874, 3432, 3516. A.S. *gítsung*, desire.

Gisse, covetest, 3517. A.S. *gít-* *sian*, to desire.

Gister-dai, yesterday, 2732.

Giuen, to give, 11, 1613.

Glaꝺ, ⎱ = *glade;* glad, 1779 ;
Glaꝺe, ⎰ 2297, 3671.

Glente, looked affrighted, stared in astonishment, 1029. It signifies originally merely to shine, look.

" Þys persone lay and lokede furth
Vntyl a cofre yn þe florthe ;
Þar-to þe frere gaf gode tente
Whyderwarde hys eyȝen *glente.*"
—(Robt. of Brunne's Handlyng Synne.)

Glew, music, 459. A.S. *gleó.*

Gliden, (*inf.*) to glide, go, 370, 952 ; flowed, (*pret. pl.*) 733; (*p.p.*) passed, 3460.

Glod, glided, passed, 76, 113, 129.

Gnattes, gnats', 2988.

God, ⎱ good, 1191, 1545, 1576.
Gode, ⎰

God, goeth, 2030.

Gode, ' *to gode,*' gratuitously, 2890.

Gode-frigtihed, ⎱ god-fearing-
Godes-frigtihed, ⎰ ness, the fear of God, 495, 542.

Godfulhed, godhead, 56.

Gol = gold, 1872.

Godun, (*acc.*) good, 1430.

Golhed, lust, 534. A.S. *gál,* wanton ; *gálnes,* lust.

Gon, (*inf.*) to go, 643, 845, 2561 ; (*pl.*) go, 3124 ; (*p.p.*) gone, 639, 835 ; departed, 4128.

Goren, darts, 3458. A.S. *gár,* a dart, javelin.

Got, goat, 940.

Goꝺ, (*imp.*) come, 3585.

Goꝺ, God, 4132.

Goue, should give, 3941.

Gouel, tax, tribute, 844, 846, 848. A.S. *gafel, gafol,* tax, tribute.

Gouen, (*pl.*) gave, 844, 2922, 2975.

Grantede, consented, 1423.

Grapte, felt, grasped, 1544. A.S. *grápian,* to feel, grope.

Gram, fierce, 1228. A.S. *gram,* furious, fierce.

Grauen, (*inf.*) to bury, 3778 ; (*p.p.*) dug, 1138; buried, 2431; carved, 2701, 3186, 3624.

Grauen, an error for *þrauen,* control, 276. A.S. *þrafian,* to urge, compel.

Graunte, grant, 2536.

Gred, (*sb.*) cry, clamour, 3230, 3717.

Gredde, cried, 3585. A.S. *grǽdan,* to cry, call.

Gredi, hungry, 1494. A.S. *grǽdig,* greedy, from *grǽdan,* to cry, call for. Goth. *gredags,* hungry.

Grei, grey, 1723.

Greim, grievous, hard, 392. A.S. *gremian,* to make severe or cruel ; *grim,* rage ; *grim,* sharp, bitter.

Greiꝺet, hastens, 1738. O.N. *greiꝺa,* to make ready.

Grene, green, 608, 2775, 2776.

Gres, grass, 3049, 3088.

Gresseoppes, grasshoppers, locusts, 3065. A.S. *gærshoppa,* grasshopper.

Gret, great, 2098, 3226.

Gret, grit, earth, 3774. A.S. *greót,* dust, earth.

Gret, (*sb.*) weeping, 3888.

Gret, wept, 1975, 2287, 2341. A.S. *grǽtan,* to weep (pret. *grét ;* p.p. *grǽten*).

Grete, (*pl.*) great, 2892.

Greten, (*pl.*) wept, cried, 3207, 3659.

'*helle*-bale,' 2525 ; '*helle*-dale,' 1983 ; '*helle*-pine,' 2530.

Helles, hell's, 22.

Helpe, (*vb.*) help, 2528 ; (*sb.*) help, assistance, 496, 1802, 2647.

Helped, helpeth, 4062.

Helpeles, helpless, 3558.

Helpen, to help, 176, 1272.

Helpes, helpers, 3409.

Helðe, health, safety, 2344.

Hem, an error for *him*, 180.

Hem, them, 392, *et passim.*

Hem-seluen, themselves, 537, 2889.

Hemward ; *to h.*, to them, 2726.

Hende,) near, 3361, 3370.
Henden,) O.E. *i-hende ;* A.S. *ge-hende, hende.*

Heng, hung, 3899.

Hente, seized, caught, struck, 2715. A.S. *hentan*, to seize.

Her, here, 170, 175, 177, 184.

Her = *here*, of them, 2258.

Her, hear, 3525.

Her = *er*, before, 801.

Her-after, here-after, 243.

Herberge, lodging, 1392.

Herberged, lodged, 1602. A.S. *here-bergan*, to lodge, harbour, from *here*, an army.

Herbergen, to lodge, 1057.

Her-bi, hereby, 3572.

Herdes, (*gen.*) ; uten herdes = out of (his) own country, 2410.

Herdes-folc = *erdes-folc*, land-folk, people, 3372.

Herde, heard, 1285, 1611.

Herden, (*pl.*) heard, 1139, 3492, 3521.

Here, theirs, 1920.

Here, army, host, 1787, 2679. A.S. *here.*

Here, hear, 3426, 3473.

Here-gonge, invasion, 848.

Here[n], expedition, 2479. See *Here.*

Heren, to hear, 1370, 2531.

Herf = *erf*, cattle, 2991.

Herte, heart, 518, 520, 1302 ; *g.s.* of heart, 2936 ; courage, 3253.

Herte-bren, heart-burning, lust, 4054.

Hertedin, encouraged, consoled, 1980.

Hertes, hearts, 1917.

Herting, consolation, 1982.

Herðe, an error for *herte*, heart, 2856.

Herðe = *herde* = *erde*, land, 806.

Het, promised, 2365, 2954 ; was called, 2588, 2589, 3333. A.S. *hátan*, to command, promise (pret. *hét*, p.p. *háten*) ; *hátan*, to call (pret. *hátte*).

Hete, heat, 1228, 1229.

Heten, (*pl.*) promised, 3450.

Heðen, hence, 1644, 2508. O.N. *héðan.*

Heued,) head, 376, 1193, 1604.
Heuod,)

Heuedes, heads, 2926.

Heued-welle, spring, 868.

Heuene,) heaven, 40, 270 ;
Heuone,) '*heuene* bem' (the sun?), 1606 ; '*heuene* dew,' 1547, 1573 ; '*heuene* gate,' 1620 ; '*heuone* hil,' 281 ; '*heuene* rof' (heaven-roof, firmament), 101.

Heuene-ward, heaven-ward, 3025.

Heuerilc, every, 368.

Heui, heavy, 2565.

Heuones, heavens, 287.

Hewe, form, 4051.

Hic = *ic*, I, 34, 2783.

Hicte = *higte*, was called, 713. See *Hiegt.*

Hidden, (*pl.*) hid, 3028.

Hidel-like, secretly, 2882.

Hiden, to hide, 352.

Hider, hither, 2344, 2895.

Iglic, ugly, 2918. See *Uglike*.
Ik = ilk, same, 73.
Ilc,) each, 68, 119, 134. A.S.
Ilk,) *ælc*.
Ilc,) same, 258, 313, 1184.
Ilke,)
Ilc-kinnes, of each kind, 220.
Ilc-on, each one, every, 1379.
Ille, ill, wicked, 1916, 4038, 4063 ; badly, wickedly, 1706, 4029.
In = hin = him, 3887.
In-gon, entered, 1068.
In-wis = iwis, truly, indeed, 1515, 2521. A.S. *gewís*.
Irin, iron, 467.
Is, his, 482, 483, 1737.
Is = his, its, 327.
Is, them, 1702, 1768, 1769, 1770, 1833, 1873, 1877, 2654, 2655, 3115, 3831, 3832.
Ist = is it, is there, 1121.
It, they, 298, 1920.
It, there, 2808.
Iurnes, days' journeys, 1291, 3696.
Iusted, allied, intermarried, 1589.
Iuel,) (*sb.*) evil, 328 ; (*adj.*) bad,
Iwel,) evil, 310, 502, 3718 ; (*adv.*) wickedly.
I-wis,) truly, indeed, 91, 109.
I-wisse,)
I-wreken, avenged, 1856.
I-wrogt, wrought, 3215.

Kagte, pret. of *catch*, drove, 949.
Kalues, calf's, 1013.
Kamel, camel, 1398.
Kameles, camels, 1365.
Kenned, taught, 216. A.S. *cennan*, to adduce, to vouch the truth.
Kep, care, heed, 939, 946, 1333, 2602. A.S. *cépan*, to *keep*, heed.
Kepen, to keep, look to, 2453, 3378.

Kepte, kept, 2625.
Kepten, (*pl.*) kept, 2772.
Kid, made known, 2357.
Kidde, made known, 1651.
Kiddit, showed it, made it known, 1394, 1654.
Kides, kids, 1535 ; kid's, 1967.
Kin, family, kin, 652.
Kinnes, kin's, 756, 828.
Kinde, natural, 78 ; native, 1279.
Kinde, kind, nature, 185, 250, 457.
Kinde, kin, family, 488, 650.
Kindelike, *kindly*, with natural affection, 2500.
Kinderedes, kindreds, 4127.
Kindes, kinsmen, 1549 ; 'in *kindes* wune,' kin-wise, naturally, 1345; 'aftre *kindes* wune,' after the manner of relatives, 1652 ; family's, tribe's, 1389, 3824.
Kinge-riches, kingdoms', 2789.
Kipte, seized, 3164. O.N. *kippa*. See Allit. Poems, B. 1510, and Gloss., s.v. *Kyppe*.
Kire, purity, 451 ; choice, 1536 ; custom, 1693, 2451. A.S. *cýre*, choice ; Ger. *küren*, to choose.
Kiste, kissed, 1652, 2355.
Knape, man-servant, 477, 482 ; male, 2585. A.S. *cnápa*, a man.
Knapes, boys, 2573.
Knaue, male child, 1151.
Kne, degree, 444. A.S. *cneo*.
Knewen, (*pl.*) knew, 2904.
Knigt, knight, 283.
Knol, knoll, top, 4129. A.S. *cnoll*.
Knowen, know, 2872 ; known, 3037.
Komen, (*pl.*) came, 2577.
Kude = *cuðe*, could, 2114, 2366.
Ku[n]glond, kingdom, 1262.
Kumeling, stranger, 834. O.H. Ger. *chomeling*. O.E. *comeling*.

Kumen, to come, 399, 984, 1007.
Kumen, (*p.p.*) come, 902, 1556.
Kuppe, cup, 2047.
Kuð, renowned, 2666. A.S. *cúð*, known.
Kuðe, could, 289.

La, lo! 3113.
Lage, marriage, 538; 'in *lage*,' in marriage, 2764. Cf. Goth. *liugan*, to marry, *liuga*, wedlock.
Lages, } laws, 2446, 2456.
Laiges, }
Lagt, seized, 2081, 2621; caught, 3141. A.S. *læhte*, pret. of *læccan*, to seize.
Laken, to fail, lack, 1231. O.E. *lac*, *lak*, fault. Du. *lack*, want, fault; *laecken*, to decrease.
Laten = *leten*, to let, 3071.
Laðes, barns, 2134. Dan. *lade*.
Lay, law, 1201.
Leate, (*imp.*) leave, 1811.
Leateð, (*imp.*) let, 3726.
Leaued, leafy, 3839.
Lecher-crafte, lechery, 1064.
Lecher-fare, lechery, 776.
Lecherlike, lecherously, 770.
Lecherie, lechery, 3510.
Lechur-hed, lechery, 1997.
Led, song, 27. A.S. *leoð*. Ger. *lied*.
Led, (*p.p.*) brought, 649; (*imp.*) lead, 3607.
Ledde, (*pret.*) led, 89, 92.
Leddede = *ledde*, led, 3995.
Ledden = *ledde*, led, 2845.
Ledden, (*pl.*) led, 858, 1990.
Leded = *ledeð*, (*imp.*) lead, pass, 398.
Leden, to lead, 2193; pass, 304; take up, 699; act, 2301, 2304.
Leddre, ladder, 1607.
Leet, left, 1280. A.S. *lætan*, to leave (pret. *lét*, p.p. *læten*).
Lef, agreeable, pleasant, 340,

2664; dear, precious, 793, 1774, 3431; joyful, 4136. A.S. *leóf*.
Lefful, dear, precious, 155, 2524; faithful, 3447.
Legeð, lies, speaks falsely, 1281.
Leid, (*p.p.*) laid, 817, 2426, 2427.
Leide, (*pret.*) laid, 943, 2693.
Leiden, (*pl.*) laid, 1969.
Leigen, (*pl.*) lay, 1920.
Leiste, least, 198.
Leið, layeth, 3994.
Leman, wife, 782. A.S. *leof-man*.
Len, reward, 2838.
Lene, lean, 2099, 2101, 2106.
Lene, grant, 4159.
Lened, leaned, 1610.
Lenen, lend, grant, 3170. A.S. *lænan*.
Leng, } longer, 1594, 1736.
Lengere, }
Lentil, 1488.
Lep, leapt, 2726.
Lepre, leprosy, 3690.
Lered, learned, 4.
Lerede, taught, instructed, 791, 2300, 2963; learnt, 1383.
Lereden, (*pl.*) learned, 3137.
Leren, to learn, 354. A.S. *læran*, to teach, inform.
Lereð, (*imp.*) learn, 3486.
Les, less, 3595.
Les, delivered, *loosed*, 2874.
Les, falsely, 3498. A.S. *leas*, false.
Lese, lie, 3514.
Lesen, loosed, 3152; deliver, 2897.
Lesing, lies, 2578.
Lesse, less, 994.
Leste, least, 189.
Lested, } lasted, 600, 2952,
Lestede, } 4147.
Lested = *lesteð*, lasteth, 111.
Lested = *lesteð*, (*imp.*) listen *or* perform, 2510.

Liue-dai, life, 652 ; liue-dages, life-days, life-time, 4119.

Liuede, lived, 777, 908.

Liuen, (*inf.*) to live, 308, 573, 2044.

Liuen, (*pl.*) live, 2496.

Liues, life's, 201, 496.

Liues, alive, 1477, 3042 ; living, 3802 ; 'of *liues*,' alive, 2834.

Liueð, liveth, 503.

Liwe, life, 3884.

Liwen, live, 4097.

Loac = *loc*, gift, 1798. A.S. *lác, gelác.*

Loar, loss, 177, 181. A.S. *lor.*

Loc, look, behold, 3331.

Lockende, looking, seeing, 2822.

Lodelike, loathly, 3030.

Loder-man, leader, 3723, 4110. A.S. *láa-man ;* O.E. *lodesman,* from A.S. *lád, ládu,* a way. Cf. Eng. *loadstar.*

Logede men, laymen, 2.

Loke, (*imp.*) look, take heed, 3511.

Loked, kept, guarded, 193.

Loked, awarded, decided, 3810.

Loken, to look, 2600 ; look to, take care of, 2771, 3193. A.S. *lóciun.*

Loken, to keep from, abstain from, 215.

Lond, ⎫
Londe, ⎬ land, 103, 208, 1843.

Londes, lands, countries, 3700.

Londes-speche, (native) language, 18.

Lond-speches, languages, 669.

Lond-weige, land-way, path, 2681.

Lore, learning, wisdom, 3635. A.S. *lár.*

Lordehed, lordship, 196.

Lote, cheer, face, 1162, 2328. S.Sax. *lote, late.* O.N. *læti.* A.S. *wlite.*

Loten, features, 2258.

Loten, to fail, 3131.

Loð, loathsome, 369 ; displeasing, 1216, 1736. A.S. *láð.*

Loðt = *loð*, displeasing, 340.

Loðlic, loathsome, horrid, 749.

Louerd, ⎫ lord, 30, 275, 282,
Louered, ⎬ 997. A.S. *hlaford.*

Louerdhed, lordship, 190, 832.

Louereding, *lording*, lord, ruler, 833.

Louerdes, lord's, 1388.

Louerdis, lord's, 2272.

Lowe, flame, 643. O.N. *log.*

Lude, loudly, 3585.

Luked, *locked*, closed, 3276.

Luken, (*p.p.*) enclosed, 94, 3779; shut, 362 ; beset, 2886.

Luket = lukeð, encloseth, 98.

Luten, to bow down to, 1926. A.S. *lútan,* to bow down to (pret. sing. *leát ;* pl. *luton ;* p.p. *loten*).

Lutten, (*pret. pl.*) bowed down to, worshipped, 2163, 3550, 4070.

Luue, love, 8, 35, 51.

Luue-bonde, power of love, 2692.

Luued, ⎫ loved, 770, 1174.
Luuede, ⎬

Luueden, (*pl.*) loved, 549, 2152.

Luuen, (*sb.*) love, 635, 1517, 2002, 4081.

Luuen, to love, 1, 5, 9, 2042.

Luuen, (*pl.*) love, 49, 3586.

Ma = mai, may, 295.

Mac, (*imp.*) make, 3541.

Mad, (*p.p.*) made, 122, 184.

Maden, (*pl.*) made, 1992, 2960, 2974.

Magnie = manige, many, 877.

Magti, mighty, 584, 3797.

Mai, may, 371.

Maidenes, maidens, 1145, 1153, 2749.

Maidenhed, maidenhead, 1852.

Maked, makeð, maketh, 1591.

Migtful, (*adj.*) mighty, powerful, 100, 2902, 2916, 3464, 4008, 4025, 4026 ; (*sb.*) mighty ones, 3755.

Migti, mighty, 546, 983.

Mikel,) great, 26, 389, 486, 1252.
Mikil,) See *Michel.*

Milce, mercy, 3728. A.S. *milts.*

Milche, milk, 2788.

Milche = *Milce,* mercy, 3732 ; merciful, 2903, 3603.

Milde, kind, merciful, 128 ; meek, gentle, 1306, 1441.

Mildelike, meekly, 1321, 1371, 1423 ; gently, 2778.

Min, mine, 1566, 1567.

Mind, quantity, 3676.

Mirc, dark, *mirk,* 286. O.N. *myrkr,* dark ; *myrka,* to darken.

Miri,) merry, pleasant, 212,
Mirie,) 294 ; cheerful, 2258.

Miries, an error for *mirie,* pleasant, 1038.

Mirknesse, darkness, 3104.

Mis, (*sb.*) wrong, 206.

Mis-ches = *mischose,* sinned, 190.

Misdede, misdid, sinned, 1847, 1890.

Misdedes, misdeeds, 3637.

Misdon, misdone, 1680, 2642, 3054.

Miserlike, indistinctly, 2658. A.S. *misse-líc,* dissimilar, various.

Misfaren, to misbehave, 1911.

Misleuede, disbelieved, 3906.

Misliked,) displeased, 1728,
Mislikede,) 4011.

Misnumen, (*p.p.*) sinned, 3091. See *Nimen.*

Missen, to miss, lose, 3336. O.N. *missa.* Du. *missen.*

Mistagte, misdirected, misled, 475.

Miste, missed, 3872, 3874.

Miswiuen, to miswive, marry unlawfully, 540.

Miðe, cease, remain quiet, 3807. Du. *mijden,* to avoid, shun.

Mo,) more, 354, 414, 428.
Moo,)

Moal = *mal,* speech, 81. Du. *maal.* O.N. *mál.*

" For Iesus o Grickisshe *mal*
Onn Ennglissch iss, Hælennde."
—(Orm. i. 147.).

Mod,) mood, mind, 36, 128,
Modd,) 333, 717, 3577. A.S.
Mode,) *mód.*

Moder, mother, 122, 1421.

Moderes, mother's, 1434.

Modi, *moody,* angry, 2660, 2712. A.S. *módig.*

Modilike, cruelly, 2584.

Mog, male relative, 1761. A.S. *mæg,* (*m.*) a relation, kinsman ; *mæge,* (*f.*) a kinswoman.

Mogen, may, can, 3227.

Moned = *moneð,* month, 593, 597, 615.

Mone, moon, 132, 139, 141.

Monen, to moan, bewail, 180.

Mones, moon's, 144, 145.

Moneð, month, 145, 152, 619 ; months, 2592.

Moo, more, 428.

Mor, more, 511, 993.

Morgen, morrow, morning, 247, 1161. A.S. *morgen.*

Morgen-giwe = *morgen-giue,* nuptial gift, 1428. A.S. *morgen-gifu.*

Morge-quile,) morning while, a
Morgen-quile,) short space of time, 3275, 3443, 3461.

Morgen-tid, morning time, 59.

Morwen, morrow, morning, 2305, 3162.

Moste, most, greatest, 189, 198.

Mot,) may, might, 1304, 1621,
Mote,) 3188 ; should, 2645.

Moðed = *moded,* minded, 1584.

Mouies, aunt's, 1651. Cp. Du. *moei,* aunt. See *Mog.*

Mount, 2853.

Mugen, (inf.) to be able, 1818, 2090, (pl.) 3017. A.S. mágan.

Mune, (imp.) bear in mind, 45.

Mune,) to bear in mind, remem-
Munen,) ber, 197, 972, 1622, 2422 ; commemorate, 687, 3138. A.S. ge-munan, to remember, call to mind.

Munen, (pl.) bear in mind, 558, 1350.

Munendai, Monday, 72.

Muneð, remembers, 2409.

Muniging,) commemoration, me-
Muning,) morial, 678, 1623, 3344, 3394.

Munt, mount, 1744, 2773.

Muntes, mount's, 3487.

Murnen, to mourn, 2053.

Murning, mourning, 2908, 3205.

Musike, music, 460.

Muste, (pret. of mot) might, 2624.

Muð, mouth, 2655, 3971.

Muðes, mouths, 2216.

Muwen, may, 3316. See Mugen.

Nagt, night, 1678, 3142, 3832.

Naild, nailed, 564.

Nam, took, 85, 200, 1218 ; seized, 482, 673 ; conceived, 1177 ; came, 698, 1402 ; came upon, 1490 ; went, took the way, 744, 745, 1247, 1436. See Nimen.

Name[n], name, 3497.

Narwere, narrower, 3965.

Ne, not, 554, et passim.

Ne-gate, no-gate, no-wise, 3224.

Nede, necessity, 2161, 2165, 3165.

Neddre, adder, serpent, 323, 369, 374.

Neddres, adders, serpents, 2930.

Nedful, needy, 2130.

Neet, neat, cattle, beeves, 2097. See Net.

Neg, nigh, 833, 1234, 3320.

Negt = neg it, nigh it, 3964.

Neiðere,) neither, 394, 1276.
Neiðer,)

Nemeld = nemned, assigned, 3533.

Nemnen, name, call, 82 ; number, 4085. A.S. nemnan, to name, call upon.

Ner, near, 478, 1395.

Nest, nearest, next, 3791, 3921.

Nestes, neighbour's, 3515. A.S. nesta, a neighbour.

Net,) neat, cattle, 940, 2097.
Neet,) A.S. nýten, niten, cattle, beast. O.N. naut, an ox.

Netes, neat's, 3712.

Ne-ðe-les, nevertheless, 3853.

Neðer, downwards, 370.

Neðer-ten, to descend, 3567. See Ten.

Neue,) nephew, 724, 799, 1761.
Neve,) A.S. nefa; Fr. neveu; O.Fr. neve.

Neuere, never, 230, 1240.

Newe, new, 694, 1286.

Newes, anew, 250.

Newelike, recently, 293.

Nifte, niece, 1386. A.S. nift.

Nigt, night, 43, 76, 79.

Nigtes, nights, 590.

Nigenti,) ninety, 990, 1027.
Nigneti,)

Nile, will not, 1806.

Nim, take, 1720.

Nimen, to take, 1042, 1739, 2362. A.S. niman (pret. nám, p.p. numen).

Nið, envy, 373, 1915. A.S. níð, malice ; Ger. neid ; O.N. nída, to abuse, disgrace. Níðíngr, a niggard, coward.

Niðede, envied, 1521.

Niðful, envious, 369, 1917.

Niðing, niggardliness, 3432.

Nogt, not, 330.

Nogwer, nowhere, 1271.

Nolden, pl.) would not, 3029.

Nome, (sb.) hostage, pledge, 2268.
See *Nimen.*
Nome, should take, 3341.
Nomen, (pl.) took, accepted, 1016, 1965; (p.p.) come, 3039.
Non, no, none, 223, 275.
Noten, use, enjoy, eat, 3144.
A.S. *notian,* use, enjoy.
Nov, now, 749.
Nu, now, 356, 379.
Nuge, now, at once, 1328.
Numen, (p.p.) taken, 343, 366, 400, 409, 1316; smitten, seized, 2107, 2826; kept, 2268; passed, gone, 579, 594, 1142, 2485, 2753, 2769; practised, 1382.
Nunmor, no more, 788, 1118, 1420.
Nutes, nuts, 3840.
Nyð, envy, 273. See *Nið.*

O, of, 111, 353, 674, 1196, 2330, 2556, 3577.
O = on, in, 81.
Oc, but = O.E. *ac,* 187, 213, 488, 852, 861. A.S. *ac.*
Oc, also, 54, 465. A.S. *eác.*
Oc = *og,* ought, 197.
Of, in, 1355, 1901 ; from, 2390.
Of-dred, afraid, 3955.
Offerd, afraid, 2844.
Offiz, office, 2071.
Offrande,) (sb.) offering, 1298,
Offrende, } 1309, 1312, 1314,
Ofrende,) 3631; (adj.) 1503.
Offreden, (pl.) offered, 3619.
Offrendes,) offerings. 1627, 3551.
Ofrendes, }
Offrigt,) afraid, 2050, 2225,
Ofrigt,) 3652, 3692.
Of-slagen, slain, 4077.
Og, (pres.) owe, 2187 ; ought, 1.
Ogen, (pres.pl.) ought, 15; would, 2054.
Ogen, (adj.) own, 884.
Oget, ought, should, 324.

Ogt, aught, 1793.
Ok, also, 944. See *Oc.*
Olde, old (ones), 3852.
Olie, oil, 1548, 2458.
Olige, oil, 1624.
Olike, alike, 2024.
Oliues, olive's, 608.
On, after, 1751.
On, an error for *of* = from, 649.
On, in, 4, 14, 38, 151, 161, 162, 164.
On, one, 56, 185, 454, 665 ; 'on and on,' singly, 1639, 2323.
On-dreg, (imp.) endure patiently, 3319. See *Dreg.*
One, alone, 134, 308, 974, 2015.
Ones, once, 3288 ; of one, 1720, 1725, 1730.
On-felde, afield, 1437.
On-kumen, invaded, 841. A.S. *on-cuman,* to enter in.
On-liue, in life, alive, 2417, 3105, 3595.
On-morgen,) a morrow, in the
On-morwen.) morning, 1093, 1161, 1417, 1680, 2305, 3162.
On nigt,) by night, 869, 1781,
Onigt,) 2049, 2123, 3293.
Onon, anon, at once, 1067, 1145.
On-ros, arose, 1936. A.S. *on-rísan,* to rise up.
On-rum, aside, apart, 4000, 4021. A.S. *rúm,* room, space, place.
On-sagen = *unsagen* = *unsaw,* reproach, 2045.
On-seken, (pl.) attack, 851.
On-sel,) in time, betimes, timely,
On-sele,) 1537, 2051. See *Sel, Sele.*
On-sunder, separate, apart, 148, 3909.
On-ðrist, athirst, 1229.
Oo, ever, 111.
Ooc, oak, 1873.
Opelike, openly, publicly, 2583.
Opnede, opened, 3773.
Opperes, *hoppers,* locusts, 3096.

A.S. *hoppere*, a hopper. Cf.
Eng. grasshoppers.

Or, ere, before, previously, 48,
490, 645, 649, 658, 905, etc.;
'*or* ðan,' ere that, 2435; first,
88, 490, 658, 905, 2929.

Or, than, 1510, 2928.

Orest, first, 2061.

Orf, cattle, 795, 883, 1642. See
Erf, Erue.

Orgel, presumptuous, 3767. A.S.
orh, orgel. Fr. *orgueil.*

Origt, aright, rightly, 1299, 2226.

Ostel, lodging, 1056. See *Hostel.*

O-sunder, asunder, apart, 58, 116.

Oten = *hoten*, called, 1131.

Oðer, second, 93, 705.

Oðer, or, 1940.

Oðere, others, 1187, 2132, 2199,
3613.

Oðer sum, 'some other,' 686.

Ougt, aught, thing, 121.

Ouer-cam, passed over, 1633.

Ouer-cumen, (*p.p.*) overcome,
2108.

Ouer-flet, overflowed, 586. See
Flet.

Ouer-flowged, overflowed, 556.

Ouer-gon, passed, 1186, 1903,
3031.

Ouer-man, ruler, 3424.

Ouer-meten, passed over, elapsed,
1665.

Ouer-pharan = *over-faren*, over-
fare, pass over, 2487. See
Faren.

Ouertakeð, overtakes, 2313.

Ouer-toc, overtook, 1756.

Owen, should, 1944.

Owen, own, 120, 348, 1838.

Owold,) signify, 324; happen,
Awold,) 525. See *Awold.*

Paid, (*p.p.*) 2215.

Pais, peace, 8, 2535.

Palme-tren, palm-trees, 3305.

Paradis, Paradise, 291, 406.

Pert = *apert*, open, clear, 3292.

Pilches, garments of skin, 377.
A.S. *pylce.*

Piler, pillar, 3293.

Pilt, thrown, put, 2214. O.E.
pult. Dan. *putte*, to put into.

Pine, (*vb.*) torment, plague, 179.

Pine, (*sb.*) sorrow, torment, 177,
244, 955, 2530, 2785, 3094.

Plage, play, lust, 537.

Plages, plays, amusements, 3575.

Plaigen, to play, 2016.

Plates (of silver), 2370.

Pleide, played, 1214.

Plenteð = *plenté*, plenty, 3709.

Pligt, (*sb.*) pledge, 1269; sin,
offence, 'to *pligt*' = for the
offence, 3611. A.S. *pliht.*

Pligt, (*vb.*) pledge, 1776; (*p.p.*)
pledged, 1275, 2677.

Podes, toads, 2977. O.N. *padda*,
a toad.

Polheuedes, tadpoles, 2977. Does
it signify spade-headed, from
O.N. *pál*, a spade, as in pole-
axe?

Pore, an error for *gore* = *gure*,
your, 2190.

Preige, prey, 4028.

Prenes, brooches, 1872. A.S.
preon, a clasp, bodkin. O.N.
priona, to sew.

Present, (*sb.*) 1831, 2273.

Prest, priest, 3886, 3922.

Prikeð, pricks, spurs, 3964.

Pris, honour, 292, 326; value,
worth, 2247, 2700; riches,
2690.

Prisun, prison, 2040, 2046, 2070.

Prísuner, gaoler, 2042.

Prisunes, prisoners, 2044.

Prud, proud, 858, 1414; pride,
1966.

Quad = *quead*, bad, evil, 536.

Quad = quoth, said, 755, 929,
1041, 1045.

Quake = *wake*, watch, 1054.
The rhyme requires *quate* = wait.
Quamede, pleased, 1019. See *Quemede*.
Quam, whom, 1768.
Quan, }
Quane, } when, 16, 92, 418, 576, 708, 721, 930.
Quanne, }
Quan, since, 1817.
Quar, where, 1311.
Quase, whose, 2870.
Quat, what, 171, 324, 357, 634; which, 4160.
Quat, quoth, 1313, 1775.
Quatso, whatso, 1324.
Quaꝺ, (*pret.*) quoth, 1311, 1371; in line 3988 read 'queꝺ' (*imp.*), speak.
Quead, wretch, wicked one, 295, 4063. Du. *kwaad*, bad.
Quede, promise, 1163. A.S. *cwede*, a saying; *cwiddian*, to speak.
Quemed, beloved (ones), 86. A.S. *cweman*, to please, satisfy.
Quemede, satisfied, 978, 1380.
Quemest, most pleasing, 3764.
Quemeꝺ, easeth, lightens, 408.
Quer, where, 762.
Quer-of, whereof, 366.
Queꝺe = *quede*, word, 4011. See *Quede*.
Queꝺen, to speak, 3525, 4002; to promise, 2788; to enquire, 1792. A.S. *cweꝺan* (pret. *cwæꝺ*, p.p. *ge-cweden*).
Queꝺen, (*p.p.*) called, 1496; promised, 3944.
Queꝺen, whence, 1401. O.N. *hvaꝺan*.
Queꝺer, whether, 3272; which (of the two), 1471.
Queꝺer-so, whether, 340, 491.
Quhu, how, 20.
Qui, why, 1759, 1760.
Qui = quile, awhile, 4000.

Quider, whither, 2600.
Quil = quilc, which, 3631.
Quilc = what, 1572; which, 3764; how, 3212.
Quile, while, 2041; 'ꝺor quile,' while, whilst, 205, 1104, 1106.
Quiles; 'ꝺor quiles,' whilst, 186, 204, 574.
Quilke, (*pl.*) which, 2080; what, 2350.
Quilum, whilom, formerly, 801, 1139, 1171, 1464.
Quit, white, 2810.
Quo, who, 359, 2821, 2822, 2823.
Quor, where, 356, 714.
Quor-at, where to, 3237.
Quor-bi, whereby, 573.
Quor-fore, wherefore, 1632.
Quor-of, whereof, 1314.
Quor-on, whereon, 1310.
Quor-so, where-so, 943, 3107.
Quo-so, whoso, 924.
Quoꝺen, (*pl.*) spake, 2993, 3267.
Quow, how, 1560.
Quuad = *biquad*, ordained, 64.
Quuad, quoth, 1021.
Quuam, which, 696.
Quuan, } when, 190, 206, 991, 2311.
Quuanne, }
Quuat, what, 1310.
Quuat-so-euere, whatsoever, 270.
Quuen, queen, 296.
Quuo, who, 1003.
Quuor, where, 2428, 2430, 2431.
Quuow, how, 2732.
Qwel = *quelc* = *quilc*, which, 170.

Rad, hasty, 617, 2730; expeditious, 2481; eager, 3617; readily, quickly, 998, 1783. A.S. *rád*, ready, quick.
Raken, to scatter, 2132. Sw. *raka*.
Raken, to gather, 3324. A.S. *récan*, to reach. Du. *ráken*, to handle.

Ranc = wrang (?) = was wrung (with pity), 1658.

Ranc, strong, 2105, 2108. A.S. *ranc.*

Ransaken, to search, 2323. O.N. *ransaka.*

Ransakes, searchest, 1773.

Rapede, hastened, 1221. Du. *rap,* nimble. O.N. *rapa,* to hasten.

Rapen, to hasten, 2376.

Rapeð, (*imp.*) hasten, 2349.

Raðe, quickly, soon, 1784, 2313, 3664. A.S. *hraðe.*

Read,) counsel, advice, 401, 659,
Red, } 1222, 1737, 2547,
Reed,) 3808, 4064; instruction, 1515, 2830; device, plan, 309, 3663, 4059; remedy, help, 2996. A.S. *réd,* counsel, advice, opinion.

Reade se, Red Sea, 2670.

Rechede, interpreted, 2124.

Rechen, to interpret, 2086, 2122. A.S. *recan,* to explain, interpret.

Reclefat, censer, 3782.

Redde, advised, 3436.

Redden, (*pl.*) consulted, 1145; advised, 2861. See *Read.*

Rede, read, 34.

Rede,)
Reed, } red, 637, 640, 1256.

Rede, advise, 3118.

Reden, to counsel, 1534. A.S. *rǽdan,* to counsel (pret. *réd,* p.p. *réden*).

Redes, advisest, 2934.

Redi, readily, 998; ready, 1066.

Redles, foolish, wicked, 3574. A.S. *rǽdleas,* rash.

Ref, rough, 3726. A.S. *hreof,* rough, scabby.

Reflac, robbery, 436, 3512. A.S. *reáflác,* spoil, rapine.

Rein, rain, 3265, 3326.

Rein-bowe, rainbow, 637.

Reke-fille, April, 148, 3136.

Rekelefat,) censer, 3761, 3800.
Reklefat, } A.S. *récels,* incense; *récelsfæt,* a censer.

Reken, ready, 3485.

Reklefates, censers, 3787.

Rem, cry, outcry, 1962, 2613, 3858. A.S. *hream.*

Ren, course, 1. A.S. *ryne, rene.*

Ren, swift, 3218. A.S. *ryne,* course, race.

Reste,) (*sb.*) rest, 11, 249, 252,
Resten, } 400.

Restede, (*pret.*) rested, 257.

Resten, to rest, 1369.

Reu,) grieved, 1166; sorrowed,
Rew, } 1828. A.S. *hreówan,* to rue, grieve (pret. *hreáw*).

Reuen, spoil, 2802. A.S. *reáfian,* to rob, spoil.

Reuli, sorrowful, mournful, 1162. A.S. *hreówlíc.*

Rew, bitter, 3151. A.S. *hreów,* raw, fierce.

Rewde,) sorrow, grief, 2339;
Rewðe, } pity, 2608.

Reweli,) = piteous, sorrowful,
Rewli, } 1968, 2328. See *Reuli.*

Rewlike, sorrowfully, 3106. A.S. *hreówlíce,* mournfully.

Reyn, rain, 582.

Riche-like, richly, 2442.

Richere, richer, 1280, 3937.

Ride, road, way, course, 3950.

Rif, widely known, renowned, 232; wide-spread, 1252. A.S. *ryf,* rife, prevalent.

Rigesses, rushes, 2595. A.S. *risce, rixe,* a rush.

Rigt, right, justice, 52, 451; rights, 3714; rightly, 885, 1565; mode, wise, 1270.

Rigted, set right, 3427.

Rigten, to righten, set right, decide, 3421, 3423, 3426. A.S. *rihtan,* to righten, correct, govern, rule.

Rigt-wise, righteous, 418, 516, 1043.
Rigt-wised, } righteousness, 936,
Rigt-wished, } 3740.
Rimes, rhyme's, 1.
Rim-frost, rime, hoar frost, 3328. A.S. *rím-forst*.
Ringes, rings, 1872, 2703.
Risen, to rise, 4039.
Roche, rock, 256, 1138.
Rode, cross, 386, 388. A.S. *ród*.
Roke, reek, smoke, 1163. A.S. *reác, réc.*
Ros, rose, 261, 1055.
Rospen, to *rasp*, diminish, 2132. Du. *ruspen, to grate.*
Rotede, became rotten, 3342.
Ru, rough, 1539, 1544. A.S. *rúh.*
Run, discourse, conversation, 991. A.S. *rún.*

Sac-les, without strife, willingly, 916. A.S. *sacu*, strife; *sacleas*, without contention.
Sacrede, sacrificed, 612, 626, 938.
Sad, separated, divided, 58, 116, 266, 1784; set apart, 208; scattered, 672. See *Shad.*
Safgte, an error for *sagte*, cure, heal (?), 470.
Saft, u polo, 3899. A.S. *sceaft, sceft*, a shaft, pole.
Safte, making, work, 3628; creatures, 127. A.S. *sceaft*, a creature, created, made, formed, from *scapan*, to form.
Safte, of form, 349.
Sag, saw, 26, 127; looked, 3901.
Sage, words, sayings, 4153. A.S. *sagu*, a saying, speech, *saw.*
Sagen, saying, 14. See *soðesagen.* A.S. *sægen*, a saying.
Sagt, an error for *sag*, 1301. It may = *sag* + *it* = saw it.
Sake[n], sake, 1392, 3731.

Sal, shall, 12, *et passim.*
Sal = salt, shalt, 1815.
Salt, shalt, 1042, 1043.
Salte, salt, 3280.
Saltes, of salt, 1131.
Saltu, shalt thou, 1041, 1813.
Same, shame, 234, 302, 349, 351.
Sameden, (*pl.*) assembled, gathered, 434. A.S. *samnian*, to assemble, collect.
Samen, together, 40, 398, 412.
Samening, assembling, matching, 458; intercourse, 1442. A.S. *samnung*, a congregation.
San, infamy, shame, 373. A.S. *scænan*, to destroy; *scand*, disgrace.
Sanc, sank, 1108.
Sarp, sharp, 2989, 3577.
Sat, set, 945.
Sat, treasure, money, 795, 881, 3169. A.S. *sceat*, treasure, gift, money.
Scaðe, harm, ruin, 302, 2314. A.S. *sceaðan, sceaðian*, to hurt; *scaðþe*, injury, loss.
Schad, separated. A.S. *scádan*, to separate, divide. See *Shad, Sad.*
Sche, she, 235, 2619.
Schet, shot, 475.
Scheten, to shoot, 474. A.S. *sceótan*, to shoot (pret. *sceat*).
Schilde, shield, 2525. A.S. *scýldan*, to shield.
Schinen, (*pl.*) shine, 153.
Schir, sheer, sincere, 1835.
Schoren, cut. See *Abuten-schoren.*
Scir, bright, 3848.
Scité, city, 2415.
Sckaðe, harm, destruction, 850. See *Scaðe.*
Sckil = *skil*, reason, 203. See *Skil.*
Scrið, entreaty, 1419, 2021.
Scriðed, urged, 1715.

Scroð, urged, solicited, entreated, 1055, 1834, 2023, 2695. A.S. *scríðan*, to go (pret. *scráð*).

Scroðt, an error for *scroð*, 339.

Se, sea, 1123.

Seck, sack, 2309.

Seckes, sacks, 2213, 2223.

Sed, seed, 121, 1613.

Sedes-kin, Seth's kin, 4042.

Segen, (*pl.*) saw, 3222.

Segeð, cometh, falleth, 2232. A.S. *sígan*, to fall.

Sei, (*imp.*) say to, tell, 3445.

Seid, (*p.p.*) said, 2425.

Seide, (*pret.*) said, 277, 323.

Seiden, (*pl.*) said, 903, 1083.

Seien, to say, 1139.

Seigen, (*pl.*) say, 917; (*inf.*) 2494. A.S. *secgan*, *seggan*, to say.

Seilede, sailed, went, 3389.

Seið, says, 1127, 1293, 1295.

Seið, (*imp.*) say, 2350.

Sek, sick, 1175.

Seken, to seek, 3598.

Sekenesse, sickness, 775.

Sel, time, season, 417, 928, 1032, 1184, 1224, 1375, 1503, 1545, 2541, 2769, 3159 ; ' in *sel*,' quickly, opportunely, 1095 ; ' al swilk *sel*,' at such time, 1204 ; ' on *sel*,' ' on *sele*,' in time, timely, 1537. A.S. *sæl*, *seel*, time. Prov. E. *seel*.

Sel, (*imp.*) sell, 1495.

Selcuð, marvellous, 3972. A.S. *sel-cúð* = seldom known, wonderful, rare.

Seldum, seldom, 2181.

Seles = *selie*, good, 1542. See *Seli*.

Self ; ' Self his kinde' = his own kin, 1806 ; even, very, 2610.

Seli, blessed, righteous, 266, 1532, 1986, 2782; good, 2412, 4079; fortunate, 1244, propitious, 31; happy, blissful, 64. A.S. *sél*,

good ; *sælig*, happy, blessed, prosperous.

Seli-red, good advice, help, 2514.

Seli-sið, prosperity, 2546.

Seli-sped, bliss, happiness, prosperity, 240, 2138.

Selkuð, strange, 1286. See *Selcuð*.

Selkuðlike, wondrously, greatly, 1557.

Sellic, ⎫ rare, wondrous, 466 ; marSelli, ⎬ vellous, 1026 ; strange, ⎭ 3260, 3957.

Sellik, ⎫ wonderfully, miraculousSellic, ⎬ ly, 1315, 1316. A.S. *séllíc*, *síllíc*, wonderful.

Selðe, ⎫ bliss, luck, fortune, Selðhe, ⎬ 1023, 1341, 1404, 2001. A.S. *sælð*, *gesælð*, happiness, felicity.

Selðhelike, successfully, 1372.

Semelen = to assemble, 3865.

Semelike, ⎫ seemly, 1007, 1504. Semlike, ⎭

Semes, loads, 1368, 2373. A.S. *seam*.

Semet, seemeth, 2169.

Semeð, 1365. *Read* semede, loaded.

Sen, to be, 298, 1923, 3843. Ger. *sein*.

Sen, (*inf.*) to see, 279, 956 ; to look, 394, 2664; to look after, take care of, 1663, 2628; choose, take, 3723.

Sen, (*pl.*) see, 16, 140.

Sen, ⎫ visible, manifest, 74, 1173. Sene, ⎭

Sende, (*imp.*) send, 2820.

Senden, to send, 1683.

Sendet, sendeth, 1412.

Senkede = schenkede, poured out, 322. A.S. *scenc*, drink ; *scencan*, to pour out, give to drink.

Sent, (*imp.*) send, 2825.

Senten, (*pl.*) sent, 1970, 1973.

Senwe, sinew, 1805; sinews, 1804.
A.S. *sinewe*.

Sep, sheep, 1334.

Serf, (*imp.*) serve, 1685.

Seri, sorry, 408.

Seri-mod, sorrowful-minded, 1850.

Serue, to serve, 1715.

Serue, should serve, 3816.

Seruede, served, 1692, 2051.

Seruen, (*pl.*) serve, 4126.

Seruen, to serve, 5, 1670, 1694, 3634.

Seruen, to deserve, 1686.

Seruise, service, 1672, 1714, 3754.

Set, made, 562.

Sete, seat, 278.

Sette, planted, 1278.

Setten, (*inf.*) set, place, 2598.

Seð, sees, 181, 196.

Seð, sod, seethed, 1487. A.S. *seóðan*, to boil, seeth (pret. *seáð*; p.p. *soden*).

Seue, seven, 489, 1825.

Seuend,) seventh, 445, 593,
Seuende,) 611.

Seuendai = seuend dai, seventh day, 247, 607.

Seue nigt,) se'nnight, a week,
Seuene nigt,) 609, 1687, 2952.

Seuenti, seventy, 706, 3665.

Seweden, (*pl.*) looked, gazed, 2661.

Sex,) six, 575, 577, 578.
Sexe,)

Sexte, sixth, 167, 199, 531.

Sextene, sixteen, 1907.

Sexti, sixty, 663, 1475.

Sey, tell, 4114; sey we, let us say, 4162.

Seyen,) say, 1445, 3561.
Seyn,)

Sge, she, 1444, 1447, 1698.

Shad, separated, 148. A.S. *sccádan* (pret. *sccod*, p.p. *scaden*), to separate, divide.

Shauen, shaved, 2120.

She, 1925.

Shent, destroyed, 754. A.S. *scendan*, to shend, disgrace.

Sheren, to reap, 2347.

Shetten, (*pl. pret.*) shut, 1078.

Shewed = shewede, (*pl. pret.*) showed, 1971.

Shiftede, changed, 1732.

Shilde,) shield, 2525, 4157.
Schilde,)

Shire, make clear, 2036.

Sib,) akin, 228; relatives,
Sibbe,) 2503. A.S. *sib*.

Sibbe-blod, blood-relatives, 1468.

Sid, side.

Siden = siðen, since.

Sigande, sighing, 1436.

Sighe = sigðhe, sight, 518.

Sighteles, blind, 1528.

Sigt, sight, 1626, 2774.

Sigðhe, sight, 335, 360.

Sik, sighing, 1239. A.S. *sícan*, to sigh. Prov. E. *sike*.

Siker, secure, safe, 869, 876, 1269. O.Fris. *sikur*; Ger. *sicher*.

Sikerlike, certainly, surely, 1500; with confidence, boldly, 2319.

Silden, to shield, 214, 1788.

Sinfulhed, sinfulness, 180.

Sile — sel, time, 2978. See *Sel*.

Singe, sing, 34.

Singede, sinned, 4066.

Singen, to sing, 27.

Singen, to sin, 172, 188. A.S. *singian*.

Sinigeden, (*pl.*) sinned, 2205.

Sinne, sin, 182, 186.

Sinnes, sin's, 553.

Sinne-wod, sin mad, 1073.

Sir, *sheer*, pure, 518, 3580; clearly, 3045. See *Scir*.

Sired, enlighteneth, 327. A.S. *scir*, clear; *scýrian*, to divide.

Sitten, to sit, 279.

Sið, course, conduct, 274. A.S. *sið*, path, way. See *Seli sið*.

Siðe, time, 3093. A.S. *sið*.

Siðe,) since, 84, 262, 2405 ;
Siðen,) after, 237 ; afterwards,
509, 609, 1928. A.S. *síððan.*
Siðen = *siden,* sides, 1295.
Siðes, times, 1731, 1825.
Skie, cloud, 3294, 3643.
Skies, clouds, 3463.
Skige, sky, cloud, 3255.
Skil,) reason, discretion, wis-
Sckil,) dom, 193, 203, 1425 ;
'wit *skil,*' reasonably, 52. O.N.
skil.
Skipperes, locusts, 3087.
Skiuden, (*pl.*) skewed, changed,
1989.
Slagen, (*p.p.*) slain, 509, 591.
Sleckede, slaked, satisfied, 1230.
A.S. *sleacian,* to slacken ; Sw.
sloka, to droop.
Slen, to slay, 2837, 3729. A.S.
sleán.
Slep, slept, 967, 1605, 3466.
Slepi, sleepy, 871.
Slo, (*imp.*) slay, 1939, 3505.
A.S. *sleán ;* O.E. (N?.) *sla.*
Slog,) slew, 483, 2668, 2685,
Slug,) 3474, 3913, 4081.
Sloge, slew, 3048.
Slon, to slay, 1328, 1752.
Sloð, slays, 3964.
Sluge, would slay, 3976.
Slugen, (*pl.*) slew, 3916.
Smaken, to scent, 2443. A.S.
smæccan, to savour, taste.
Smale, small, 656, 2107 ; 'wordes
smale,' easy words, 18 ; 'speche
smale,' flattery, 4056.
Smere, fatness, 1573. A.S.
sméru, fat.
Smered, anointed, 2455, 2457.
Smerles, anointing, 2454. A.S.
smérels, ointment.
Smeren, to anoint, 2442, 2448.
A.S. *smérian,* to anoint.
Smette, smote, 2684.
Smit, smiteth, 3970.
Smit, (*imp.*) smite, 3360.

Smite, plague, 2990.
Smiten, to smite, 3866, 4040.
Smiten, (*p.p.*) smitten, 3867.
Smiten, (*pl.*) smote, 2109.
Smið, smith, workman, 466.
Smot, smote, 2925, 2943.
Snake, serpent, 2805.
So, as, 15, 57, 331, 332, *et passim.*
Sod, shod, 3149.
Softe, soft, mild, 335, 3061 ;
pleasant, 2057, 2412 ; lust,
pleasure, 3647.
Softere, (*adv.*) softer, 3874.
Sogen, saw, 3522 ; seen, 2785.
Sogt, united, at peace, 1934, 2161.
A.S. *saht.*
Sogt, (*p.p.*) sought, 848, 3189 ;
come near, 3130 ; ' was *sogt* '
= had come, 3707.
Sogte, sought, 682, 1533, 1947.
Sogten, (*pl.*) sought, 1081.
Solde, sold, 1843 ; (*pl.*) 1955.
Solstices, 150.
Son, shoes, 2781.
Son, shone, 3293, 3614.
Sond, sand, 2718.
Sond, shame, 2714. A.S. *scond.*
Sonde, messenger, 1414, 2313 ;
message, 3931. A.S. *sand.*
Sonde, dish, 2295. A.S. *sand.*
Sonder-man,) messenger, 1410,
Sondere-man,) 2791, 2871.
Sondere-men, messengers, 1792,
1969.
Sondes, messengers, 1007, 1014,
2165, 4052.
Sondes, messenger's, 1434.
Sone, immediately, *soon,* 329, 343,
979 ; quickly, 1145, 1221 ;
' *sone* so,' as soon as, 1109.
Sor, grief, heaviness, 512, 733,
1039, 1048, 1239, 1765, 3650.
A.S. *sár.*
Sor, sore, 3027.
Sore, sorely, 1166, 3223.
Soren = shorn, reaped, 1919.
Sorful, sorrowful, 2326.

Sorge, sorrow, 68, 302, 362, 512. A.S. *sorh.*
Sorges, sorrow's, 360, 778.
Sori, sorrowful, distressed, heavy, 974, 977, 1974 ; wicked, 1074.
Sori-mod, sorrowful-minded, 3520.
Sort, lot, 1186.
Sort-leui, short-lived, 712.
Sorwe, sorrow, 179, 268.
Sorwes, sorrow's, 19, 716, 3742.
Soth, foolish, 3685, 3688. A.S. *sot,* a fool.
Soð, } true, 17, 953, 1032, 1605,
Soðe, } 2091, 2842, 3972 ; 'ben *soð'* = be accomplished, 2505.
Soð, } truth, 74, 2034, 2036,
Soðe, } 2928. A.S. *soð,* truth, true.
Soðe-sagen, sooth-saw, true story, 14.
Soule, } soul, 486, 4136.
Sowle, }
Soules, } soul's, 496, 626, 2920.
Sowles, }
Sowen, saw, 3108.
Sowen, to sow, 2347.
Sowles, souls, 4156.
Spac, spake, 925, 1753, 1758.
Specande, speaking, 2821.
Speche, speech, language, 665.
Speches, speeches, languages, 666, 668.
Sped, *speed,* success, 25 ; abundance, 122 ; 'iwel *sped,'* misfortune, 310 ; 'in *sped,'* 'wið *sped,'* speedily, 935, 1083, 1221.
Sped, succeed, 1585.
Sped, succeeded, fared, 3311.
Speden, to prosper, succeed, 2303.
Sperd, fastened, enclosed, shut up, imprisoned, 22, 94, 384, 564, 2093.
Speken, to speak, 2016, 2027, 2710, 2827, 2832, 3400.
Speren, to shut up, 2194. A.S.

sparran ; O.N. *sperra.* See Hampole's P. of C., l. 3835.
Spice-like, with spices, 2443, 2515.
Spices, 2247.
Spices-ware, spicery, 1952.
Spien, to spy, 2172.
Spies, 2169, 2174.
Spile, sport, play, 3462 ; multitude, 2977.
Spiled, scattered, 3183.
Spilen, to play, sport, live joyously, 2532. A.S. *spilian.*
Spirit, 203.
Spoken, (*pl. pret.*) spake, 2913.
Spot, place, 3280.
Spotted, spotted ones, 1721.
Spred, (*p.p.*) spread, 650, 831.
Spredde, (*pret.*) 490.
Spredden, (*pl. pret.*) spread, 2567.
Springe, spring, 581.
Sprong, sprang, 60, 247, 2740.
Sprungen, (*pl.*) sprang, 1804 ; (*p.p.*) sprung, 4023.
Spureð, spurs, 3970.
Sren, an error (?) for *fren,* to deliver, save, 1103.
Srid, (*p.p.*) clothed, 379.
Srid, } (*pret.*) clothed, 23, 271,
Sridde, } 1539.
Sriden, to clothe, 351. A.S. *scrýdan* (pret. *scrydde*), to clothe.
Srifte, penance, 422, 3692.
Sriðen = *sriden,* to deck, 1878.
Srud, clothing, vestments, 176, 271, 795, 857, 2367, 3169. A.S. *scrúd.*
Staf, staff, 3149.
Stalðe, theft, 1767. A.S. *stálu.*
Stalwurði, stalworthy, strong, 655, 864, 3714.
Starf, died, 481, 658, 4133. A.S. *steorfan* (pret. *stearf ;* p.p. *storfen*), to die.
Stede, place, 117, 425, 433.
Steden, places, 3441.
Steden, place, 1114.

Steg, ascended, 319, 3527. See *Stigen.*

Stele, steal, 3511.

Stelen, to steal, do secretly, hide, 1035 ; hide from, 2594. A.S. *stélan.*

Stere, rule, 3418 ; ruler, 3420. A.S. *steóran,* to rule ; *steóra,* ruler ; *steóre,* rule.

Steres, rulers, 3413, 3415.

Steres-men, rulers, 3417, 3429.

Stering, rule, government, 3410.

Sterre, star, 132 ; star's, 134. A.S. *steorra.*

Sterres, stars, 1921.

Steuene,) voice, 355, 622, 1285.
Steuone,) A.S. *stefen.*

Sti, path, 3958. A.S. *stíg,* a way, path.

Stig, (*imp.*) ascend, go up, 4100.

Stigen, (*p.p.*) ascended, 4130. A.S. *stígan,* to ascend, go (pret. *stáh ;* p.p. *gestígen*).

Stille, secretly, 2015, 2428, 2718.

Stille, (*imp.*) be still, 3319.

Stillen, to quiet, still, 3924.

Stinc, stink, 2556, 2975.

Stinken, stinking, 1164.

Stired, stirred, 3580, 3961.

Stirte, started, 2931.

Stiꝺ, stiff, stubborn, 1591 ; severe, 3266. A.S. *stíꝺ, stýꝺ,* firm, stiff.

Stiward, steward, 1991, 2255, 2263, 2712. A.S. *stiward.*

Stod, stood, 1019.

Stoden, (*pl.*) stood, 3543.

Stodet = stood it, 590.

Ston, stone, 1120, 1604.

Stonde, (*imp.*) stand, 3760.

Stonden, to stand, 1607, 2639, 3666.

Stonden agon, (*pl.*) opposed, 438.

Stondende, standing, 3149.

Stondes, standest, 2782.

Stondeꝺ, stands, 392.

Stong, stung, 3896 ; pierced, 4083.

Stor, great, 842. A.S. *stór.*

Storue, should die, 1958. See *Starf.*

Storuen, (*pl. pret.*) died, 2975, 2982.

Storuen, (*p.p.*) dead, 3162.

Strekede, stretched, fell prostrate, 481. A.S. *streccan,* to stretch.

Strem, stream, 2096.

Streng,) string, 479, 714. A.S.
Strenge,) *streng.*

Strenge, strength, 3728. A.S. *strengo.*

Strengꝺe,) strength, 581, 673 ;
Strengꝺhe,) harm, 1075.

Strengthen, to make strong, 3410.

Strif, strife, 373 ; toil, 175, 503 ; grief, agony, 268, 716, 778, 779, 860.

Striuing, strife, 804.

Strond, strand, 2717.

Strong, 1846 ; unpleasant, 2057.

Stronge, (*pl.*) strong, 3713.

Stund, time, 41, 2041, 3277 ; a *stound,* short space of time, moment, 2109, 2639. A.S. *stund.*

Stunden, (*pl.*) wait, abide, 3211; waited, 1987.

Stungen, stung, 3901.

Sul,) (*pl.*) shall, 303, 305, 1775.
Sule,)

Sulde, should, 172, 175, 194.

Sulden, (*pl.*) should, 958, 1326.

Suldes, shouldst, 3984.

Sulen, (*pl.*) shall, 308, 316, 318, 3358.

Sum, (*sing.*) some, 337, 690, 834, 835 ; ' oꝺer sum,' 686.

Sumdel, somewhat, 380.

Sumertid, summertime, 1224.

Summe, (*pl.*) some, 399, 401.

Sunder, separate, 991 ; diverse, 3808 ; ' *sunder bles,*' party coloured, 1729.

Sundren, to separate, 468.

Sundri, separate, apart, 393, 1985,

2354, 2414, 3239; diverse, 1798; several, 2551.

Sune,) son, 46, 403, 1656.
Sunen,)

Sunedai,) Sunday, 71, 261.
Sunenday,)

Sunen, sons, 2175, 2899, 3481.

Sunen, to bear a son, 981.

Sunen, to shun, 1864.

Sunes, sons, 529, 540, 1251.

Sunes, son's, 1984; 'on *sunes* stede,' instead of a son, 723, 2629, 2637.

Sungen, (*pl.*) sang, 3288.

Sunken, (*p.p.*) sunk, 754; (*pl.*) sank, 3775.

Sunne, sun, 132, 139.

Sunnes, sun's, 143.

Surgerun,)
Suriuren,) sojourn, 64, 2696, 3308.
Suriurn,)

Suð, south, 829.

Suðen, south, 1167.

Suuen, *shoved*, driven, 107.

Swanc, toiled, laboured, 2014, 2877; travelled, 1657. See *Swinken.*

Swart, black, 286. A.S. *sweart.*

Swem, grievous, afflicting, 391; grieved, 1961.

Swep (*lit.* stroke, force), meaning, 2086, 2112.

Swer, (*imp.*) swear, 3498.

Swerd, sword, 1307, 1327.

Sweren, (*pl.*) swear, 1964.

Swerdes, of sword, 3721.

Swet,) sweet, nice, 210, 382,
Swete,) 1484, 3302.

Sweuene, dream, 224, 1753. A.S. *swefen.*

Swide = *swiðe*, quickly, 2726.

Swike, unfaithful, 2845. A.S. *swíc.*

Swike-dom, treachery, deceit, 2883.

Swilc, such, 143, 407, 417; such as, 3620.

Swinacie, quinsy, 1188.

Swinc, toil, labour, 268, 363, 2554, 2555. A.S. *swinc.*

Swing = *swinc*, toil, labour, 566.

Swinked, laboured, 4018.

Swinken, to labour, 3778. A.S. *swincan*, to toil (pret. *swánc*, p.p. *swuncen*).

Swinkes, labour's, 175.

Swiðe, very, 334, 1645; quickly, 1009, 1086, 1537. A.S. *swíð*, *swýð*, great, strong.

Swiulc = *swuilc* = *swilc*, such, 632. A.S. *swulc.*

Swog, swoon, 484.

Swolgen, (*p.p.*) swallowed, 1976. A.S. *swolgen*, p.p. of *swelgan*, to swallow.

Swor, sware, 1338.

Sworen, (*p.p.*) sworn, pledged, 824, 1525.

Swotes, of sweat, 364. A.S. *swát.*

Swunken, (*p.p.*) toiled, travelled, 1656. See *Swinc.*

Tabeles, tables, 3535.

Tabernacle, 3174, 3623.

Tac, (*imp.*) take, 1287, 3497.

Tagt, (*p.p.*) taught, directed, 3623, 3746.

Tagte, (*pret.*) taught, showed, 458, 1243, 1954.

Tagte, (*adj.*) assigned, promised, 827

Tagten, (*pl.*) taught, 1096.

Take, touch, 3456.

Takel, tackle, furniture, goods, 883.

Taken, to take, 1318, 3323.

Taken, to assign, give, 1340.

Tale, speech, language, 450; tale, story, 321; reckoning, number, 141, 1673, 2891, 4092; heed, account, 548. A.S. *tal.*

Tame, quiet, 1482.

Tamehed, quietness, docility, 1485.

210

Taune, (*imp.*) let him show, 3424.
Tauned,) (*pret.*) showed, 636,
Taunede,) 757, 3444.
Taunen, to show, 1022, 1290.
Du. *toonen.*
Taunet = *taune it*, let him show it, 3422.
Tawned,) showed, 1294, 4118.
Tawnede,)
Tawnen, to show, 2034, 2126.
Techen, to teach, 2792.
Teding, suckling, 1208. A.S. *tiedrian, tyddrian,* to propagate, nourish, feed.
Teen = *ten*, to go, 1344. A.S. *teón*, to pull, go, lead (pret. sing. *teah*, pret. pl. *tugon*, p.p. *togen*).
Te, the, 2756.
Teg, went, 320, 1135, 3644. See *Teen.*
Teld, tent, 3769. A.S. *teld.*
Teldes, tents, 3442.
Telled = *telleð*, telleth, 17.
Tellen, to tell, 651, 2755 ; to reckon, 87 ; recount, 497.
Tellet, (*imp.*) tell it, 3526.
Telleð, tells, 414.
Temple, 1296.
Ten, (*inf.*) proceed, go, 934, 1238, 1953 ; lead, 1913 ; draw, 3005. See *Teen.*
Ten, (*pl.*) go, 856, 3210.
Tende, tenth, 597, 704, 3141.
Tene, sorrow, grief, affliction, 2992. A.S. *teóna*, injury, reproach ; *teonan*, to anger, incense.
Ter, tar, pitch, 662. A.S. *tearo.*
Teres, tears, 364, 2356.
Teres, of tears, 2288, 2342.
Terred, tarred, 2596.
Teten, teats, breasts, 3480.
Tette, teat, pap, breast, 2621. A.S. *tite, titte.*
Tgeld = telt, tent, 2025. See *Teld.*

Tgelt, encamped, pitched tents. A.S. *teldian*, to pitch a tent.
Tgen, ten, 3413, 3418.
Tgen, (*pl.*) = *ten*, belong, 3824. See *Teen.*
Thaunen, show, declare, 32. See *Taunen.*
Then, ten, 3305.
Then = *ten*, go, 1514. See *Ten.*
Tho = *to*, two, 731.
Tholen, suffer, 508. A.S. *þólian*, to suffer, bear, endure.
Tid,) time, 59, 263, 1507. A.S.
Tide,) *tíd.*
Tidi, in good condition, beautiful, 2105. O.Sw. *tidig*, beautiful. Cf. Shakespeare's use of *tidy* = plump, well-conditioned.
Tidelike, soon, quickly, 2752. A.S. *tídlíce.*
Tiding,) tidings, message, 396,
Tidding,) 407, 134, 2907.
Tidlike, quickly, 1231, 3353. See *Tidelike.*
Tigel, tile, brick, 461, 662, 2552. A.S. *tigel.*
Tigeles, bricks, 2891.
Tigðe, *tithe*, tenth, 895. A.S. *teogeða.*
Tigðes, tithes, 1628.
Til, till, until, 85, 254, 255 ; to, 879, 945, 1606. O.N. *til*, to.
Tile, gain, 1519. A.S. *til*, fit, good ; *tilian*, to honour, to get, obtain.
Tilen, to earn, 363. A.S. *tilian.*
Tiliere, tiller, 1482.
Tillede, (*pret.*) cultivated, 1278.
Timed, (*p.p.*) prospered, 4024.
Timede, (*pret.*) prospered, 3392.
Timen, to occur, happen, befall, 1763, 3820. A.S. *getimian*, to happen, fall out.
Timen, to prosper, 1023, 2361, 4010.
Timen, to teem, bring forth, 982. A.S. *tíman*, to teem.

Ðewe, courtesy, respect, 2757.

Ðewed, behaved, conducted, 1914.

Ðewes, virtues, 4159.

Ðgere = gere, haste, 4052.

Ðhanc, thanks, 1659.

Ðhankede, thanked, 3405.

Ðhauen, to tolerate, endure, 275. See Ðauen.

Ðheg,) throve, 1266, 2779. See
Ðehg,) Ðeg, Ðen.

Ðhenken, think, 393.

Ðhenkeð, thinks, 2028.

Ðherknesse, darkness, 3102.

Ðhikke, thick, 3102.

Ðhing,
Ðhinge,) thing, 301; things, 29,
Ðing, } 52, 297, 300; affairs,
Ðinge,) 3378.

Ðhinges, things, 280.

Ðhog, though, 3978.

Ðhogen, throve, increased, 1480, 2567. See Ðen.

Ðholede, suffered, 778. See Ðolede.

Ðhogt, mind, 2167; anxiety, 2111; thought, 1149; purpose, 1579.

Ðhogt,) seemed, appeared, 407,
Ðhogte, | 436, 438, 491, 1469,
Ðhugte, } 1765, 1849, 2064,
Ðhute, | 3260. A.S. þincan
Ðuhte,) (pret. þúhte), to seem.

Ðhogte, (pret.) thought, 319.

Ðhowtes, thoughts, 3544.

Ðhre, thre, 55, 152, 563.

Ðhride,) third.
Ðhridde,)

Ðhrowing, agony, suffering, 1317. A.S. þrówung, from þrówian, to suffer.

Ðhu, thou, 361, 362, 397.

Ðhunder,) thunder,
Ðhunerg = ðuner,) 1108, 2900. A.S. þunor.

Ðhurg,) through, 588, 2192.
Ðhurge,)

Ðhusant,) thousand, 489, 577,
Ðhusent,) 654.

Ðider,) thither, 1068, 1366,
Ðidir,) 1402, 1844.

Ðicke, thick, thickly, 2988.

Ðig = thick, 564.

Ðin,) thy, 397, 1764.
Ðine,)

Ðing, affairs, 3378.

Ðinken, to seem, appear, 234.

Ðinkeð, seemeth, 391, 2403. See Ðhogt.

Ðis,) these, 1083, 2125, 2131,
Ðise,) 2527.

Ðisternesse = cisternesse, pit, 1942.

Ðisternesse, darkness, 58. A.S. þýstre, dark, þeosternes, darkness.

Ðit = ðis, this, 1233.

Ðo, those, 305, 875, 2099. A.S. þá.

Ðo, the, 1303, 2110.

Ðo, then, 424, 717. A.S. þa.

Ðoa, then, 840.

Ðog,) though, nevertheless, 4,
Ðoge,) 1794, 1928, 2404, 2908, 3807, 3808.

Ðogen, (pl.) throve, flourished, 2542.

Ðogt, thought, mind, 1558, 2013; purpose, intention, 1072; anxiety, 1433; 'kinde ðogt,' natural affection, 2254.

Ðogt,
Ðogte, } seemed, 948, 2015, 2298.
Ðoht,)

Ðogte, thought, 333, 1089.

Ðohgteful, anxious, 1437.

Ðole, forbearance, 3496.

Ðolede, suffered, 1180.

Ðolen, (inf.) suffer, 3664; (imp.) 3457; (pl.) 3445. A.S. þólian, to suffer, bear, endure.

Ðoo = þo, then, 3135.

Ðor,) there, 211, 222, 279,
Ðore,) 2270; where, 438, 757, 1520.

Under-nam, perceived, 1553; questioned, 2728. A.S. *under-niman* to comprehend, take.

Vnder-numen, taken unawares, surprised, 2135, 3221.

Vnder-stod, bore, 1467; accepted, received, 2275, 2393, 3434; understood, 2210.

Vn-don, undone, opened, 385, 603; removed, 3902.

Vn-don, to explain, 2114.

Vndren = *undern*, the time extending from nine to twelve in the morning, 2269. A.S. *undern*.

Vn-drincled, undrowned, 3280. O.E. *drinkle*, to drown.

"Alle *drenkled* thorgh folie."
—(Robt. of Brunne, p. 241.)

[Vn]eꝺe, uneasy, disturbed, 3924.

Vn-ended, everlasting, 3518.

Un-eꝺes, with difficulty, scarcely, 2341. A.S. *uneaꝺe.*

Unfer, diseased, 2810. See *Fer.*

Un-frame, disadvantage, 1566; sorrow, 3037. A.S. *unfreme.*

Un-framen, be hurtful, 1213.

V[n-]frigt, fearless, bold, 3713.

Vughere — *ungaro,* unexpectedly, 3047. A.S. *un-gearu,* un-prepared, sudden.

Vn-hileden, uncovered, 2976.

Vn-hillen, disclose, 1912. A.S. *unhélan,* to unhele, reveal, uncover.

Unkinde, unnatural, 449, 1113; foreign, 2302.

[Vn-]lage, wrong, 1762. A.S. *unlagu,* wrong, injustice.

Vn-lif, displeasing, 206.

Vn-lif, unleavened, 3153.

Vn-like, unlike, 1726.

Un-mad, unfinished, 671.

Vn-miꝺe, anger, 3973, from O.E. *miꝺe,* quiet. A.S. *myꝺgian,* to sooth, quiet. *Vn-miꝺe* may

signify *truth,* from A.S. *miꝺan,* to hide, dissemble.

Un-red, sin, 1906. A.S. *unréd.*

Vn-reken, slow, unready, 2817. See *Reken.*

Un-rigt, wrong, 1276.

Vn-rigt-wis, unrighteous, 2014.

Vn-seli, wicked, wretched, 1073, 2315. A.S. *unsǽlig.*

Vn-selꝺehe,) misfortune, misery,
Vn-selꝺe,) 2316, 3026. A.S. *unsǽlꝺ.*

Vnsene, unseen, secret, 2878.

Vn-skil, wrong, 3506. See *Skil.*

Un-slagen, unslain, 1332.

Unspered, undid, spoilt, 25. See *Sperd.*

Vnsteken, disclose, 2828. See Gloss. to Allit. Poems, s.v. *Steke.*

Vn-swac, displeasing, offensive, 1212.

Un-timing, misfortune, 1180.

Untuderi, barren, 964. See *Tudered.*

Vn-ꝺewed, foul, 2555. See *ꝼeuwe.*

Unwarde,) unwarned, una-
Un-warnede,) wares, 480, 2682.

Vn welde, unwieldy, 347. See *Welden.*

Vnweder, storm, 3058. A.S. *unweder.*

Vp, upon, 2320.

Up-dragen, carried off, 1858.

Up-gon, (*pl.*) ascend, 1608.

Up-rekeꝺ, up-reeks, 3465.

Up-rigt, upright, 3248.

Up-sprungen, up-sprung, grown up, 3050.

Up-stod, up-stood, 3247.

Up-wakeꝺ, rouses up, awakes, 3466.

Up-wond, up-winded, up-went, 3084.

Vr, Ur,) our, of us, 2172, 2261,
Vre, Ure,) 2262.

Ut,) out, 13, 227, 362, 607,
Vte,) 3703.

Ut-comen, (*pl.*) out-came, 2097.

Vt-dragen, out-drawn, opened, 2856.

Ut-drog, out-drew, 1327.

Vten, foreign, strange, 1741 ; out of, 956, 2406, 2410 ; without, 653, 2739, 3744 ; apart, 3691.

Vt-fare, out-go, 2865.

Ut-faren, depart, 3056.

Vt-gon, depart, out-go, 2966, 3021.

Ut-gong, out-go, 2800.

Ut-lage, outlaw, 431.

Vt-pharen = *vt-faren*, depart, 3017, 3071.

Ut-sped, hurried away, 3178.

Vt-stal, stole out, 2882.

Ut-suuen, out-shoved, aroused, 1610.

Ut-ten, go forth, 4004.

Ut-Ѕhurg, throughout, 2688.

Vt-wrogte, brought on, caused, 4144.

Uuer-slagen, lintel, 3155. A.S. *oferslæge.*

Wac, weak, 1197, 1528. A.S. *wác, waac*, weak, frail.

Waden, to ford, 1799.

Waines, wains, waggons, 2362.

Waked, aroused, stirred up, 360. A.S. *wacan*, to awake, take origin.

Waked, (*pret.*) kept a vigil or liche-wake, 2469 ; (*p.p.*) 2516.

Waken, to keep a vigil or liche-wake, 2449. A.S. *wæccan*, to watch.

Waken, to watch, 2551.

Wal,) choice, select, 888, 3635.
Wale,) Ger. *wählen*, to choose, select. O.N. *wal*, choice.

Wale, prosperity, 809, 1355. A.S. *wæla*, weal, bliss.

Walkeden, 'aren *walkeden*,' have

walked, 3882. *Walkeden* is evidently an error for *walked.*

Walkene,) welkin, clouds, 96,
Walkne,) 103,136,161. A.S. *wolcen*, a cloud, air, welkin ; *wealcan*, to roll, turn.

Walknes, welkin's, 288.

Walled,) enclosed with a wall,
Wallede,) 435, 2554.

Wan,) when, 642, 4130.
Wane,)

Wane, wanting, 1028, 3353. A.S. *wana*, want, lack.

Wanmol, uneloquent, 2817 (from *wan = un*, and *mol, mal*, speech). See *Moal.*

Wansum, sorrowful, 1099. A.S. *wannan*, to be wan, pale.

Wante, should be wanting, 2244.

Wantede, wanted, failed, 1233, 2155, 2995, 3310.

Wapman, man, male, 1001. A S. *wǽpman*, a man, from *wǽpn*, a weapon.

Wapmen, men, 536, 2920, 3078, 3080.

War, aware, 721, 1308. A.S. *wǽr*, wary, prepared, ready.

Warc = *warg*, defended, 2876.

Ware, merchandise, 1990 ; property. A.S. *wáru*, ware, merchandise.

Waren, to make secure, 1088 ; to provide for, 2154. A.S. *wárian*, to beware, to guard, ward off.

Waried, cursed, 544. A.S. *werigan*, to curse.

Warnede, warned, 1091.

Warnen, to warn, 1581.

Warp, (pret. of *werpen*) threw, 2640, 2804.

Wassen, to wash, 1116, 2291, 2442.

Waspene = *wasteme*, form, 1910. A.S. *wǽstm*, growth, form.

Water, lake, 749, 1125.

Wateres, water's, 638.

Wateres, waters, 592, 2594.

Wateres-springe, water-spring, 581.

Water-gong, passage of water, 662.

Watres, water's, 598, 1246, 1380.

Watres, waters, 108, 117.

Wattre, } to water, 1648, 2745.
Wattren, }

Wattrede, watered, 2751.

Waꝺ = quaꝺ, spake, 1666.

Waxen, grow, increase, 1128, 2548.

Waxen, (p.p.) increased, 831; full-grown, 2060.

Wech-dede, watch-deed, vigil, 2460.

Weches, vigil's, 2467.

Wedde, hostage, pledge, 2198. A.S. wed, pledge (dat. wedde).

Wedden, to marry, 1090.

Wedding, marriage, 1428.

Wede, garment, 1972. A.S. wǽd, a garment.

Weden, garments, 2369.

Weder, weather, storm, 3055, 3059.

Wei, } way, 1100, 1228, 1429,
Weie, } 1435.

Weige, way, 1614, 2681. A.S. weg.

Weiges, ways, 3240, 3244.

Weila-wei, alas! 2088.

Weis, washed, 2289.

Weken = wreken, taken, 3282.

Wel, well, 229, 1521, 1541.

Welcume, welcome, 1830.

Welcumede, welcomed, 1396.

Welden, to rule, 2143; take, enjoy, 916; possess, 3738. A.S. wealdan, to rule, direct, possess.

Welden, (pl.) rule, 50, 3418.

Weldeꝺ, influences, 274.

Weledes = welꝺes, wealth's, 748.

Weli, blissfully, prosperously, 2528. A.S. welig, rich, bountiful.

Welkede, withered, 2107. A.S. wealwian; Ger. welken, to fade.

Welken, (pl.) elapsed, 568. A.S. wealcan, to revolve (pret. weolc).

Welle, well, 2756.

Welles, wells, 3306.

Welle-spring, well-spring, 1243.

Welle-springes, well-springs, 3304.

Welt, exercises, 54. See Welden.

Welte, ruled, 3371.

Welten, (pl.) wielded, 532; ruled over, governed, 840.

Welꝺe, } wealth, 796, 1268,
Welꝺhe, } 1355, 1404, 1550, 2374.

Welꝺes ware, wealth, property, 929. Cf. Spices-ware, etc.

Wen, belief, 73; doubt, 3271. A.S. wén, hope, weening.

Wen = wenen, believe, 3809. A.S. wénan, to ween, think.

Wend, (imp.) turn, 3510.

Wende = weened, thought, 477, 1240, 1543, 2209.

Wende we, let us turn, 3267.

Wended, — agon, turned back, 1904.

Wenden, (pl.) weened, thought, believed, 869, 1141, 3258.

Wenden, (inf.) turn, 693, 884, 4057, 4061. A.S. wendan, turn, change.

Wenden-agen, return, 979, 1159, 3719, 3724. A.S. wendan (pret. wende), to turn, proceed, go.

Wene, think, ween, 309, 315, 317, 3572.

Wenen, (pl.) think, 3812. A.S. wénan.

Went, course, 136. A.S. wend, a turn.

Went, (p.p.) changed, 753; gone, 1429, 2201; turned, 2896.

Wente, turned, 321, 606, 1120, 3950, 3951; removed, 1649;

took away, snatched, 2613 ;
went, 1107.
Wente agen, returned, 606, 985,
1048, 1343, 1356 ; (subj.)
should return, 1097.
Wente agon, turned back, 1119.
Wenten, (pl.) went, 533, 623 ;
turned, changed, 1149, 1967 ;
returned, 2200.
Wep, weeping, 2328, 3888. A.S.
wóp.
Wep, wept, 4149. A.S. wépan, to
weep (pret. weóp ; p.p. wépen).
Wepen, weapon, 3283. A.S.
wǽpen.
Weph, web, 4096.
Werchen, to work, 3220.
Werdes = werldes, world's, 32.
Were, protector, 2680. See
Weren.
Were, man, 3977 ; husband, 1587.
A.S. wer.
Were, war, 1788.
Wereden, saved, protected, 2578.
See Weren.
Weren, were, 377, 570, 1468.
Weren, annoy, 2898. A.S. wérian,
to weary.
Weren, defend, protect, 851, 1272,
1794, 1817, 2083, 2090, 2564,
3714 ; spare, 1043. A.S. werian,
protect, hinder.
Weres, man's, 532.
Werger, defender, guardian, 926.
A.S. wergan, to defend.
Weri, weary, 975, 1493.
Werk = wrek, plague, 3902. See
Wrake, Wrech.
Werken = wreken, to take ven-
geance, 2799. See Wrake,
Wrech.
Werken, (pl.) work, 850.
Werld, } world, 38, 42, 60.
Werlde, }
Werlde, world's, 1318.
Werldes, world's, 48, 102, 142,
707, 1594, 2440.

Werlꝺe, world, 901.
Werne, deny, 2797. A.S. wyrnan,
to deny, forbid.
Werned, (p.p.) refused, 3171.
Wernede, forbad, 2966, 3000.
Werneden, (pl.) denied, refused,
2207.
Werp, (imp.) throw, cast, 2803.
Werpen, to throw, cast, 3358,
3794. A.S. weorpan, to throw,
cast (pret. wearp; p.p. worpen).
Werre, worse, 3951.
Werren, were, 1089.
Westen, west, 3096.
Westen, (pl.) wasted, 3915.
Weꝺer, wether, 3998.
Wex, increased, grew, 273, 584,
585, 1118, 1266. See Waxen.
Wex = wexe, (pl.) grew, 1917.
Wexe, should increase, 554.
Wexen, (pl.) grew higher, 599 ;
increased, grew, 2104, 2502,
2542.
Wexem, for wexen, grew, increased,
1915.
Wi, war, 1854, 3220. A.S. wig,
wih, war.
Wiches, wizards, magicians, 2919,
2927.
Wicke, wicked, 1072, 3952.
Wid, an error for wiꝺ, with, 79,
86, 128, 168, 928.
Wid, (adj.) wide, 60, 565 ; (adv.)
1256.
Wid-held, } withheld, 914, 3019.
Wiꝺ-held, }
Wid-hin, } = wiꝺ-in, wiꝺ-
Wid-innen, } innen, within,
555, 640, 1352.
Wide, widely, 672, 831.
Wif, wife, 231, 367.
Wifes, wife's, 530.
Wifes, } wives, 453, 559, 624,
Wifwes, } 857.
Wif-kinnes, woman-kind, 1177.
Wifuede, wived, married, 1588.
Wigt, brave, 863. Sw. vig.

Wigte, war (?), or sharpness (?), 469.

Wigte, weight, 439. A.S. *wiht*.

Wikke, wicked, 3574.

Wil, (*sb.*) will, 194.

Wil, homeless, astray, 975. See Gloss. to Allit. Poems, s.v. *Wyl*.

Wil, blindness, 1079.

Wilde, lascivious, 2013 ; wild, 169, 178.

Wile, while, 371.

Wile, (*vb.*) will, 191, 277, 1318. A.S. *willan*.

Wile, desires, likes, 206, 2020. A.S. *willan*.

Wilen, (*pl.*) will, 2304, 2531, 3723.

Wimman, woman, 374, 375. A.S. *wifman, wimman.*

Wimmanes, woman's, 1426.

Wimmen, women, 532, 653, 2570.

Win, wine, 2295.

Win, strife, 347, 4055 ; force, 598. A.S. *win*, contention.

Winden, to enshroud, 2448.

Windoge, window, 602.

Wines, wine's, 894, 1542.

Win-grape, bunch of grapes, 3710.

Winter, (*pl.*) years, 507, 919.

Win tre, vine, 2059. A.S. *wintreow.*

Wintres, winters, years, 1211.

Wird, } troop, host, 1786, 1790,
Wirð, } 4140. A.S. *werod*, host, army.

Wirm, } reptile, 178 ; serpent,
Wirme, } 321, 2925, 3898. A.S. *wyrm.*

Wirmede, bred worms, 3342.

Wirmes, reptiles, 2982.

Wis, wise, 100, 260, 462, 617.

Wisdam, wisdom, 35.

Wise, (*pl.*) wise, 331.

Wise, manner, 2961.

Wislike, wisely, 45, 1091 ; with wisdom, 520 ; properly, 3630.

Wisseð, teacheth, showeth, 2. A.S. *wissian*, to instruct, show.

Wiste, knew, 779, 901, 961, 962, 1154, 1310. See *Wot*.

Wisten, (*pl.*) knew, 768, 2217, 3841.

Wisten, wished, 801, 1060.

Wistom, wisdom, 462.

Wit, we two, 1775. A.S. *wit.*

Wit, wisdom, 460, 900. A.S. *wit.*

Wit, with, 44, 52, 53.

Wite, (*pl.*) learn, know, 390.

Wite, (*sb.*) blame, 2035. A.S. *witan*, to blame.

Witen, to know, 328, 1302 ; to learn, 2651, 3928. See *Wot*.

Witen, (*pl.*) know, 74, 523.

Witent — *witen*, to know, 330.

Witnesse, } witness, 507, 1778,
Wittenesse, } 3843.

Witter, } wise, skilful, 168, 456,
Wittere, } 1910, 2330, 3624 ; true, 2903 ; cognisant, 1308.

Witter-hed, wisdom, 3667.

Witterlike, surely, truly, indeed, 769, 791, 1322, 2320, 2425. Da. *viterlig*, known, manifest.

Wið, of, 432 ; in, 1083, 1668, 1915.

Wið-dragen, with-drawn, 596, 3983.

Wið-drog, with-drew, 599, 3803.

Wið-[h]eld, } withheld, 1178,
Wið-held, } 2033, 3927.
Wið-helð, }

Wiðer, hostile, 3386. A.S. *wiðerian*, to oppose.

Wiðer-ward, contrary, hostile, 2935. A.S. *wiðer-weard*, contrary, rebellious.

Wið-stod, opposed, 2649 ; stood still, tarried, 3646.

Wið-ðan, with that, thereupon, 481, 1409.

Wið-ðan-ðat, } provided that,
Wið-ðhan-ðat, } 2019, 2335.

Wið-uten, } except, 557, 611,
Wið-vten, } 875, 910, 3739 ;
Wið-ðuten, } without, 503, 639,
 1317, 2454 ; outside, 1080,
 1367. A.S. *wið-útan* (adv.),
 wið-útan (prep.), without.
Wiue, wife, 2008, 2147.
Wiues, wife's, 1219.
Wiues, } wives, 543, 1858, 2363 ;
Wiwes, } wife's, 994, 2037.
Wlath, bad, loathsome, 3300.
 A.S. *wlætian*, to nauseate,
 loath ; *wlath* I take to be an
 error for *wlach*, A.S. *wlæc*,
 warm, slack.
Wlite, } face, 2288, 2289, 2342,
Wliten, } 3614, 4055. A.S. *wlíte*,
 form, person, countenance.
Wo, } woe, sorrow, grief, 216,
Woa, } 237, 353, 880 ; sorry,
 1833. A.S. *wá, waa.*
Woc, } weak, 1874. See *Wac.*
Wooc, }
Woc, awoke, 2111.
Wod, mad, foolish, 1073, 2959,
 3545. A.S. *wód*, mad, insane.
Wod-hed, } madness, 533, 3539.
Woded, }
Wol, very, 1266, 1995.
Wold, power, 1958, 2000. A.S.
 wald, power.
Wold, meaning, 2122. It liter-
 ally signifies power.
Wold, hill, 938, 3892. A.S.
 wald, weald.
Wold, ruler, 3412. A.S. *walda.*
Wold, sacrifice, 3116.
Wold, } would, 912, 1418, 1419.
Wolde, }
Wold, (1) killed, slain, 420 ; de-
 stroyed, 526 (?), or (2) flooded
 (?). (1) A.S. *cwelian*, to kill.
 (2) A.S. *weallan*, to flow.
Wolden, (*pl.*) would, 3756.
Wond, wand, 2715, 2803, 2808.
 Du. *vaand*, a switch.
Wond, went up, 3782, 4136.

A.S. *windan*, to move or be
 borne in a winding course, to
 wind.
Wondes, wands, 2923.
Wooc, weak, 1874. A.S. *wác.*
Wopen, weapon, 469, 3228, 4062.
 A.S. *wǽpen.*
Wopened, } armed, 1787, 2479,
Wopnede, } 3373, 3376.
Wordes, words, 18.
Wore, (*subj.*) were, 768, 1144,
 1148, 1170, 2192.
Wore, (2 *pers. sing.*) 1759, 1814.
Woree = *woren*, were, 2950.
Woren, were, 347, 488, 790,
 1207, 2380.
Worn, were, 61, 147.
Wor-of, whereof, 3530.
Worpen, cast, 1943, 2923. See
 Werpen.
Wort, word, 73.
Worðed, honoured, 262. See
 Wurðen.
Wot, know, 487, 1473 ; knows,
 353. A.S. *witan* (ic *wát*, þu
 wást, he *wát* ; we *witon* ; pret.
 wiste).
Wrake, punishment, destruction,
 552. A.S. *wræc*, punishment.
Wrech, } vengeance, destruction,
Wreche, } 552, 632, 634, 641,
 1042, 1076, 1142, 3396 ;
 plague, 1176. A.S. *wracu*,
 vengeance, pain, punishment.
Wrecches, wretches, 1074, 1080.
 A.S. *wræcca*, an exile, wretch.
Wreken, (*p.p.*) revenged, 2028,
 3067, 3281. A.S. *wrécan*, to
 avenge.
Wreken, (*p.p.*) taken, 3148.
Wrestelede, wrestled, 1803.
Wreðe, } wrath, 482, 3793,
Wreððe, } 3863. A.S. *wræðo*,
 wrath.
Wreðed = *wreðeð*, is angry,
 1584. A.S. *wraðian*, to be
 angry.

Wrigtful, guilty, 2204. A.S. *wróht ;* Da. *rygte,* a crime.

Wrigteleslike, guiltlessly, 2076. A.S. *wróhtlíc,* accusing.

Wrim, reptile, 169, 187, 299. A.S. *wyrm,* a worm, reptile, serpent.

Wrim-kin, serpents, 3895.

Writ, 1974.

Wriðel, herbs (?), from Du. *wortel,* an herb, 3153. The A.S. *wriðels,* a band, fillet, cover, does not help us to explain this satisfactorily. Is *wriðel* written for *wrixel,* change, alternation, course?

Wrocte, hurt, 230. A.S. *wrécan,* to afflict. *Wrocte* is the pret. of *werken = wreken,* to hurt. Cf. *wirm* and *wrim, werk* and *wrek,* etc.

Wrogt,) wrought, did, made, 40,
Wrogte,) 61, 249 ; done, 1150 ; bestowed, 1812.

Wrogten, (*pl.*) wrought, struggled, 1470 ; did, 529, 547, 4069.

Wroken, turned, 3191. A.S. *wrécan,* to banish, afflict (pret. *wráec ;* p.p. *wrecen*).

Wrong, squeezed, 2064. A.S. *wringan* (pret. *wrang ;* p.p. *wrungen*), to wring, press.

Wrot, wrote, 462, 523, 2524, 2527.

Wroutis, wrought them, 156.

Wroð, angry, 1215, 1735. A.S. *wráð.*

Wroð = *worð,* became, 3013.

Wude, wood, 476, 1306. A.S. *wude, wudu.*

Wudes, woods, 473.

Wukes, weeks, 2473. A.S. *wuce, wucu.*

Wulde, would, 214, 846, 1195, 2430.

Wulden, (*pl.*) would, 1071, 1075, 3324.

Wuldet, would it, 969.

Wunded, wounded, 853. A.S. *wúndian,* to wound.

Wunden, wrapped up, 2597. A.S. *windan.*

Wunder, sin, mischief, 69, 3588, 3977. S.Sax. *wundre,* mischief.

Wunderlike, wonderfully, 585.

Wune, (*sb.*) custom, 494, 1639, 1681, 1806, 3857 ; wise, manner, 971, 1345, 1405, 1652 ; practices, 676 ; abilities, 1910 ; privilege, 1501. A.S. *wune,* practice, custom.

Wune, abode, 513, 3370. See *Wunen.*

Wune, wont, 1504, 1530, 2066, 2080.

Wune, to dwell, 785.

Wune, (*pl.*) dwell, 1156, 1254.

Wune = *wunede,* dwelt, 1842.

Wuned,) abode, dwelt, 789,
Wunede,) 811, 825, 1133, 1167, 1249, 1282.

Wuneden, (*pl.*) dwelt, 3122, 3845.

Wunen, to dwell, 306, 367, 404, 406, 1863, 1898. A.S. *wunian,* to dwell, inhabit.

Wunen, (*pl.*) dwell, 300, 332, 932, 2464.

Wunen, custom, fashion, 688 ; customs, laws, 3137 ; abilities, 3482.

Wunen, accustomed, 2900, 3289.

Wunes, customs, usages, 1480, 2293 ; practices, 539 ; privileges, 1495.

Wuneð, dwells, 465, 2410.

Wuniende, dwelling, 2742.

Wurd, word, 736.

Wurd = *wurð,* became, 995, 1197.

Wurdes, words, 2818, 3726.

Wurlike = *wurðlike,* worthily, 1456.

INDEX OF NAMES.

INDEX OF RIMES.

-a

Cedima, s.
 ða, *adv. or pron.* 36/1264.
Bozra. *See* ða.
Eua, s.
 Sarra, s. 24/818. *See* woa.
Fasga, s.
 ðoa, *adv.* 117/4130.
Gomorra, s.
 ðoa, *adv.* 24/840.
Lia. *See* Rebecca.
Oba, s.
 woa, s. 26/880.
Rebecca, s.
 Lia, s. 24/820.
Salmona, s.
 ðoa, *adv.* 110/3894.
Sarra. *See* Eua.
Syna, s.
 ðor-fra, *adv.* 82/2880.
ða, *adv.*
 Bozra, s. 55/1902. *See* Cedima.
ðoa. *See* Fasga, Gomorra, Salmona.
ðor-fra. *See* Syna.
woa, s.
 Eua, s. 7/238. *See* Oba.

-ab

Iraab. *See* bad.

-ac

Balaac, s.
 spac, *pret.* 114/4030.
Ysaac, s.
 swac, a. 44/1528;
 vn-swac, a. 35/1212. *See* wac.
spac. *See* Balaac.
swac. *See* Ysaac.
vn-swac. *See* Ysaac.
wac, a.
 Ysaac, s. 34/1198.

-ad

Adad. *See* rad.
bad, *pret.*
 glad, a. 69/2434, 81/2836;
 Iraab, s. 13/442;
 rad, a. 29/998;
 sad, *pp.* 2/58, 4/116. *See* rad.
glad, a.
 sad, (?) 115/4052. *See* bad.
mad, *pp.*
 rad, a. 78/2730;
 sad, *pp.* 7/208;
 shad, *pp.* 5/148.
rad, a. or *pp.*
 Adad, s. 71/2482;
 bad, *pret.* 18/618, 103/3618;
 sad, *pp.* 51/1784. *See* bad, mad.
sad. *See* bad, glad, mad, rad, un-mad.
shad. *See* mad.
un-mad, a.
 sad, *pp.* 20/672.

-aden

laden. *See* waden.
waden, *inf.*
 laden, *pp.* 52/1800.

-af

chaf, s.
 gaf, *pret.* 82/2890.
cuuel-staf. *See* gaf.
gaf, *pret.*
 cuuel-staf, s. 105/3710. *See* chaf.

-aft

craf[t]. *See* saft.
saft, s.
 craf[t], s. 111/3900.

-ag

sag, *pret.*
 [ðag], 64/2254.

-age

age, *s.*
 lage, *s.* 115/4058. *See* dage, lage,
 ut-lage.
dage, *s. dat. pl.*
 age, *s.* 101/3546.
felage, *s.*
 [vn-]lage, *s.* 51/1762.
hore-plage, *s.*
 lage, *s.* 115/4068. *See* vn-lage.
lage, *s.*
 age, *s.* 103/3632. *See* age, hore-
 plage, plage, sage.
plage, *s.*
 lage, *s.* 16/538.
sage, *s.*
 lage, *s.* 118/4154.
vn-lage, *s.*
 hore-plage, *s.* 16/530.
[vn-]lage. *See* felage.
ut-lage, *s.*
 age, *s.* 13/432.

-agen

agen. *See* to-dragen.
dagen, *s. pl. See* of-slagen.
dagen, *inf. See* fagen.
dragen, *inf. See* fagen.
dragen, *pp.*
 sagen, *s.* 1/14. *See* on-sagen, slagen,
 uuerslagen.
fagen, *a.*
 dagen, *inf.* 1/16 ;
 dragen, *inf.* 67/2360, 68/2378 ;
 un-slagen, *a.* 38/1332 ;
 vt-dragen, *pp.* 81/2856. *See* sla-
 gen.
of-slagen, *pp.*
 dagen, *s. dat. pl.* 116/4078.
on-sagen, *s.*
 dragen, *pp.* 59/2046.
sagen. *See* dragen, *pp.*
slagen, *pp.*
 dragen, *pp.* 98/3458, 106/3722,
 108/3806 ;
 fagen, *a.* 15/510, 25/854, 101/3560 ;
 up-dragen, *pp.* 53/1858 ;
 wið-dragen, *inf.* 17/592. *See* wið-
 dragen, *pp.*
to-dragen, *inf.*
 agen, *s.* 6/192.
un-slagen. *See* fagen.
up-dragen. *See* slagen.
vt-dragen. *See* fagen.

uuerslagen, *s.*
 dragen, *pp.* 90/3156.
wið-dragen, *inf. See* slagen.
wið-dragen, *pp.*
 slagen, *pp.* 113/3984.

-ages

dages, *s. pl.*
 lages, *s. pl.* 117/4120.
lages. *See* dages, plages, daiges.
plages, *s. pl.*
 lages, *s. pl.* 102/3576.

-agt

agt. *See* bi-tagt.
bi-lagt, *pp.*
 bi-tagt, *pp.* 23/774.
bi-tagt, *pp.*
 agt, *s.* 27/924, 117/4122 ;
 hagt, *s.* 59/2044 ;
 nagt, *s.* 48/1678, 109/3832. *See*
 bi-lagt, lagt.
dragt, *s.*
 tagt, *pp.* 106/3746. *See* tagt.
hagt. *See* bi-tagt, lagt, twin-man-
 slagt.
lagt, *pp.*
 bi-tagt, *pp.* 75/2622 ;
 hagt, *s.* 60/2082 ;
 nagt, *s.* 89/3142.
nagt, *s.*
 tagt, *pp.* 111/3928. *See* bi-tagt,
 lagt.
tagt, *pp.*
 dragt, *s.* 103/3624. *See* dragt, nagt.
twin-manslagt, *s.*
 hagt, *s.* 14/486.

-ai, -ay

ay, *adv.*
 day, *s.* 3/88, 5/156 ;
 may, *v.* 1/6. *See* sunenday.
awai. *See* dai.
dai, *s.*
 awai, *adv.* 18/616 ;
 a-wei, *adv.* 50/1750, 66/2306 ;
 awei, *adv.* 98/3440 ;
 lay, *pret.* 94/3312 ;
 mai, *v.* 10/314, 78/2748, 80/2820,
 89/3144, 92/3234 ;
 wei, *s.* 103/3642. *See* mai, wei.
day, *s.*
 wey, *s.* 78/2722. *See* ay, lay, *s.*,
 lay, *pret.*

dale, *s.*
 bale, *s.* 25/850, 32/1122, 34/1166, 57/1984 ;
 dwale, *s.* 1/20 ;
 tale, *s.* 22/746, 33/1132 ;
 wale, *a.* 26/888. *See* dwale, tale, wale, *s.*
dwale, *s.*
 bale, *s.* 3/68 ;
 dale, *s.* 30/1038 ;
 smale, *a.* 115/4056. *See* dale, tale.
male. *See* [bale].
smale. *See* dwale, tale.
tale, *s.* :
 bale, *s.* 10/322, 58/2038 ;
 bridale, *s.* 48/1674 ;
 dale, *s.* 5/142 ;
 dwale, *s.* 35/1220, 97/3404 ;
 smale, *a. pl.* 1/18, 19/656, 82/2892. *See* bale, dale.
wale, *s.*
 dale, *s.* 24/810, 39/1356.
wale, *a. See* dale.

-alem

Ierusalem. *See* Salem.
Salem, *s.*
 Ierusalem, *s.* 26/890.

-am

Abraham, *s.*
 bi-cam, *pret.* 29/996, 40/1404 ;
 cam, *pret.* 36/1268 ;
 Canaan, *s.* 99/3478 ;
 Ceturam, *o.* 42/1446 ;
 for-ðan, *adv.* 34/1190 ;
 nam, *pret.* 35/1210, 35/1218. *See* am, cam, nam, ðan.
Abram, *s.*
 ham, *v.* 27/926 ;
 Iurdan, *s.* 23/806 ;
 leman, *s.* 23/782 ;
 man, *s.* 26/910. *See* Aram, cam, Melcam, bi-gan.
Adam, *s.*
 cam, *pret.* 7/224, 12/416, 13/446 ;
 nam, *pret.* 6/200. *See* cam, nam.
am, *v.*
 Abraham, *s.* 46/1612.
Aram, *s.*
 Abram, *s.* 21/710, 22/736 ;
 Mesopothaniam, *s.* 21/728 ;
 nam, *pret.* 46/1600.

Balaam, *s.*
 nam, *pret.* 112/3940. *See* cam, nam.
bi-cam, *pret.*
 nam, *pret.* 58/2008 ;
 up-nam, *pret.* 86/3024. *See* Abraham, nam.
bi-nam. *See* cam, Dinam.
cam, *pret.*
 Abraham, *s.* 40/1386 ;
 Abram, *s.* 21/708 ;
 Adam, *s.* 6/172, 11/356 ;
 Balaam, *s.* 39/1354 ;
 bi-nam, *pret.* 32/1110 ;
 Liam, *s.* 48/1676 ;
 nam, *pret.* 20/698, 40/1402, 41/1436, 43/1490, 52/1824, 57/1988, 74/2604, 76/2668, 88/3096, 92/3254. *See* Abraham, Adam, Cananeam, nam, under-nam.
Canaan. *See* Abraham.
Cananeam, *s.*
 cam, *pret.* 51/1786 ;
 nam, *pret.* 22/744. *See* Mesopotaniam.
Ceturam. *See* Abraham.
Dinam, *s.*
 bi-nam, *pret.* 49/1706.
gram. *See* nam.
Habram, *s.*
 nam, *pret.* 22/758.
ham. *See* Abram.
Liam. *See* cam.
Melcam, *s.*
 Abram, *s.* 21/720 21/730.
Mesopotaniam, *s.*
 Cananeam, *s.* 50/1746.
Mesopothaniam. *See* Aram.
nam, *pret.*
 Abraham, *s.* 79/2784 ;
 Adam, *s.* 3/86, 10/338 ;
 Balaam, *s.* 49/1698 ;
 bi-cam, *pret.* 50/1744, 61/2148, 80/2808 ;
 cam, *pret.* 39/1366, 78/2738, 81/2854, 93/3262 ;
 Canahan, *s.* 21/726 ;
 gram, *a.* 35/1228 ;
 Laban, *s.* 48/1654 ;
 Saram, *s.* 34/1178 ;
 Sellam, *s.* 14/454. *See* Abraham, Adam, Aram, Balaam, bi-cam, cam, Cananeam, Habram, Sephoram, wið-ðan, tok.

ouer-cam, *pret.*
Tharam, *s.* 47/1634.
Saram. *See* nam.
Sellam. *See* nam.
Sephoram, *s.*
 nam, *pret.* 79/2764, 81/2840.
Tharam. *See* ouer-cam.
under-nam, *pret.*
 cam, *pret.* 45/1554.
up-nam. *See* bi-cam.

-ame
frame, *s.*
 name, *s.* 5/134, 53/1838 ;
 tame, *a. pl.* 6/174. *See* name.
hun-frame. *See* same.
lichame. *See* same.
name, *s.*
 frame, *s.* 18/626, 73/2540 ;
 same, *s.* 7/234, 9/302, 13/436 ;
 un-frame, *s.* 45/1566. *See* frame,
 tame, un-frame.
same, *s.*
 hun-frame, *s.* 16/554 ;
 lichame, *s.* 11/350. *See* name, tame.
tame, *a. pl.*
 name, *s.* 7/222 ;
 same, *s.* 85/2972. *See* frame.
un-frame, *s.*
 name, *s.* 86/3038. *See* name.

-amen
framen. *See* samen, to samen.
gamen, *s.*
 samen, *adv.* 12/412, 58/2016. *See*
 name[n], un-framen.
name[n], *s.*
 gamen, *s.* 99/3498.
samen, *adv.*
 framen, *inf.* 47/1642. *See* gamen.
to samen, *adv.*
 framen, *v.* 89/3146.
un-framen, *inf.*
 gamen, *s.* 35/1214.

-an
Basaan. *See* Iordan.
bi-gan, *pret.*
 Abram, *s.* 27/922. *See* man, wap-
 man.
Caynan. *See* can.
can, *v.*
 Caynan, *s.* 15/498 ;
 ouer-man, *s.* 97/3424. *See* man.

Canaan, *s.*
 gan, *pret.* 95/3350. *See* man.
Canahan. *See* nam.
Chanaan, *s.*
 for-ðan, *adv.* 62/2158 ;
 man, *s.* 68/2392.
for-ðan, *conj. See* man.
for-ðan, *adv.*
 Madian, *s.* 111/3920 ;
 Teman, *s.* 36/1262. *See* Abraham,
 Chanaan, Laban, man.
forð-ran, *pret.*
 wimman, *s.* 75/2620.
gan, *pret.*
 Laban, *s.* 45/1582, 47/1644 ;
 man, *s.* 81/2832 ;
 Pharan, *s.* 104/3646. *See* Canaan,
 man, ran.
Iordan, *s.*
 Basaan, *s.* 111/3916. *See* ðan.
Iurdan. *See* Abram.
Laban, *s.*
 for-ðan, *adv.* 41/1422. *See* nam,
 gan, ran.
leman. *See* Abram.
Madian. *See* for-ðan, *adv.*, man.
man, *s.*
 bi-gan, *pret.* 6/188, 7/236, 13/448,
 69/2408 ;
 can, *v.* 76 / 2650, 82 / 2872, 97 /
 3426 ;
 Canaan, *s.* 23/798 ;
 for-ðan, *conj.* 57/1996 ;
 for-ðan, *adv.* 86/3028 ;
 forðan, *adv.* 90/3162 ;
 gan, *pret.* 116/4080 ;
 Madian, *s.* 78/2742 ;
 ðan, *pron.* 80/2792. *See* Abram,
 Chanaan, gan, ðan, wið-ðan,
 Moysen.
ouer-man. *See* can.
Pharan. *See* gan, ðan.
ran, *pret.*
 gan, *pret.* 44/1534 ;
 Laban, *s.* 40/1394.
san, *s.* (= schond).
 wimman, *s.* 11/374.
Teman. *See* for-ðan, *adv.*
ðan, *pron.*
 Abraham, *s.* 91/3202 ;
 Iordan, *s.* 25/868 ;
 man, *s.* 14/472 ;
 Pharan, *s.* 36/1248, 105/3696. *See*
 man.

wapman, *s.*
 bi-gan, *pret.* 29/1002.
wimman. *See* forð-ran, san.
wið-ðan, *adv.*
 man, *s.* 40/1410 ;
 nam, *pret.* 14/482.

-anc
dranc. *See* ðhanc.
ranc. *See* swanc.
swanc, *pret.*
 ranc, *pret.* 48/1658.
ðhanc, *s.*
 dranc, *pret.* 48/1660.

-and
fand, ?
 land, *s.* 106/3738.

-ande
specande, *pres. p.*
 lockende, *pres. p.* 80/2822.

-ane
hane. *See* wane.
wane, *a.*
 hane, 95/3354.

-ar
Agar, *s.*
 bar, *pret.* 28/966, 36/1250.
bar, *pret.*
 Ysakar, *s.* 49/1704 ;
 war, *a.* 38/1308, 42/1462, 59/2062,
 62/2150, 113/3966. *See* Agar,
 Cedar, war.
Cedar, *s.*
 bar, *pret.* 36/1258.
Eleazar, *s.*
 war, *a.* 117/4112.
Eliazar, *s.*
 or, *adv.* 116/4092.
Ysakar. *See* bar.
Putifar, *s.*
 to-bar, *pret.* 61/2146.
war, *a.*
 bar, *pret.* 21/722. *See* bar, Eleazar.

-ard
forward. *See* hard, on hard, stiward.
hard, *a.*
 forward, *s.* 64/2236, 87/3062, 88/
 3100. *See* wiðer-ward.
hard, *adv.* *See* heuene-ward.

heuene-ward, *adv.*
 hard, *adv.* 86/3026.
on hard, *pp.*
 forward, *s.* 86/3014.
stiward, *s.*
 forward, *s.* 57/1992, 65/2264.
wiðer-ward, *a.*
 hard, *a.* 84/2936.

-are
care, *s.*
 fare, *s.* 41/1434 ;
 gare, *adv.* 12/390 ;
 lecher-fare, *s.* 23/776.
chafare, *s.*
 ware, *s.* 56/1952.
chare, *v. sbj.* *See* fare, *inf.*
fare, *s.*
 gare, *adv.* 90/3180 ;
 ware, *s.* 57/1990, 79/2772. *See*
 care.
fare, *inf.*
 chare, *v. sbj.* 68/2390 ;
fare, *v.* 1 *sg.* *See* ware.
gare. *See* care, fare, *s.*, vt-fare.
lecher-fare. *See* care.
vt-fare, *pres. subj.*
 gare, *a. or adv.* 82/2866.
ware, *s.*
 fare, *v.* 1 *sg.* 27/930. *See* chafare,
 fare, *s.*

-aren
baren. *See* mis-faren, *inf.*
charen, *inf.*
 ut-faren, *inf.* 87/3056. *See* faren,
 inf., mis-faren, *pp.*
charen, *v. pl.* *See* faren (*both*).
faren, *inf.*
 charen, *inf.* 49/1712, 70/2436, 110/
 3878 ;
 charen, *v. pl.* 86/3010 ;
 garen, *inf.* 5/138, 90/3168. *See*
 garen.
faren, *v. pl.*
 charen, *v. pl.* 105/3704 ;
 waren, *inf.* 62/2154.
for-faren, *inf.*
 waren, *pret.* 31/1088. *See* vt-pharen.
garen, *inf.*
 faren, *inf.* 41/1418, 46/1596. *See*
 faren, *inf.*
mis-faren, *inf.*
 baren, *inf.* 55/1912.

for-bead, *pret.*
　　dead, *s.* 10/312 ;
　　frigti-hed, *s.* 16/542.　*See* dead, *s.*
for-bead, *pp.*　*See* bread.
qu[e]ad, *s.*
　　dead, *s.* 115/4064.
read, *s.*
　　dead, *s.* 104/3664.　*See* dead, *a.*
read, *a.*
　　dead, *a.* 84/2946.

-eaf

bi-leaf.　*See* leaf.
leaf, *s.*
　　bi-leaf, *pret.* 79/2776.

-eai (= ai)

deai.　*See* a-wei.

-eam

bernteam.　*See* eam.
eam, *s.*
　　bernteam, *s.* 106/3748.

-ear

ear, *adv.*
　　ðear, *adv.* 31/1090.

-ech

Amalech, *s.*
　　wrech, *s.* 96/3396.

-ed

bed, *s.*
　　for-dred, *pp.* 85/2974.
bed, *pret.*
　　bred, *s.* 59/2048.　*See* bred, ded.
bred, *s.*
　　bed, *pret.* 29/1014.　*See* bed, *pret.*
ded, *s.*
　　bed, *pret.* 8/258.　*See* for-bed.
dred, *s.*
　　gred, *s.* 92/3230 ;
　　red, *s.* 76/2672, 87/3044 ;
　　sinfulhed, *s.* 6/180 ;
　　sped, *s.* 74/2576.　*See* red, *s.*, sped,
　　　　s., reed.
faire-hed.　*See* lechur-hed.
fed, *pp.*
　　leð, *s.* 95/3348.
fetthed, *s.*
　　fulsum-hed, *s.* 45/1548.
for-bed, *pret.*
　　dead, *s.* 38/1330 ;
　　ded, *s.* 7/214.

for-dred, *pp.*
　　for-red, *pp.* 63/2192 ;
　　led, *pp.* 45/1558, 84/2954 ;
　　red, *s.* 108/3808 ;
　　sped, *pp.* 94/3314.　*See* bed, *s.*
for-red.　*See* for-dred.
frigti-hed.　*See* for-bead, *pret.*, sped, *s.*
fulsum-hed.　*See* fetthed.
godefrigtihed, *s.*
　　red, *s.* 15/496.
godfulhed.　*See* reed.
gred, *s.*
　　red, *s.* 106/3718.　*See* dred.
idel-hed　*See* led, *s.*
lechur-hed, *s.*
　　faire-hed, *s.* 57/1998.
led, *s.*
　　idel-hed, *s.* 2/28.
led, *inf.*　*See* red, *s.*
led, *pp.*
　　spred, *pp.* 19/650.　*See* for-dred,
　　　　of-dred.
louerd-hed.　*See* spred.
maiden-hed.　*See* red, *s.*
manliched, *s.*
　　red, *s.* 1/24.
ned, *s.*
　　red, *s.* 64/2242.　*See* red, *s.*, sped, *s.*,
　　　　witter-hed, reed.
of-dred, *pp.*
　　led, *pp.* 112/3956.
opened, *pp.*
　　dead, *a.* 12/388.
red, *s.*
　　dead, *s.* 12/402, 102/3590 ;
　　dead, *a.* 51/1768 ;
　　dred, *s.* 19/660 ;
　　led, *inf.* 115/4060 ;
　　maiden-hed, *s.* 53/1852 ;
　　ned, *s.* 72/2524 ;
　　sped, *s.* 8/240, 9/310, 46/1598, 50/
　　　　1738, 56/1950, 61/2138, 73/2548,
　　　　83/2922, 108/3820, 115/4048.　*See*
　　　　dead, *a.*, dred, for-dred, godefrig-
　　　　tihed, gred, manliched, ned, sed,
　　　　sped, *s.*, sped, *inf.*, tamehed, wurð-
　　　　fulhed.
red, *inf.*
　　sped, *s.* 81/2830.
rigt-wished.　*See* sped, *s.*
sed, *s.*
　　red, *s.* 46/1614 ;
　　sped, *s.* 4/122.
sinfulhed.　*See* dred.

sped, *s.*
 dred, *s.* 54/1880 ;
 frigtihed, *s.* 64/2222 ;
 ned, *s.* 1/26 ;
 red, *s.* 31/1084, 85/2996, 112/3930 ;
 reed, *s.* 35/1222 ;
 rigt-wished, *s.* 27/936. *See* dred,
 red, *s.*, red, *inf.*, sed.
sped, *inf.*
 red, *s.* 46/1586.
sped, *pp.* *See* for-dred.
spred, *pp.*
 louerd-hed, *s.* 24/832. *See* led, *pp.*
tamehed, *s.*
 red, *s.* 43/1486.
un-red. *See* dead, *a.*
ut-led, *pp.*
 ut-sped, *pp.* 90/3178.
witter-hed, *s.*
 ned, *s.* 104/3668.
wurðfulhed, *s.*
 red, *s.* 99/3500.

-ede

bede, *s.*
 dede, *pret.* 19/632 ;
 stede, *s.* 85/2982, 104/3654, 107/
 3772.
child-hede. *See* dede, *pret.*
dede, *s.* *See* stede.
dede, *pret.*
 child-hede, *s.* 76/2652 ;
 estdede, *s.* 79/2758 ;
 mide, *adv.* 71/2478 ;
 ride, *s.* 112/3950 ;
 stede, *s.* 7/212, 20/680, 26/884, 38/
 1336, 54/1882, 54/1888, 69/2414,
 94/3302, 117/4116 ;
 ðor-mide, *adv.* 76/2656. *See* bede,
 quede, stede, mide.
estdede. *See* dede, *pret.*
for-dede. *See* stede.
mis-dede, *pret.*
 stede, *s.* 53/1848.
quede, *s.*
 dede, *pret.* 42/1464.
stede, *s.*
 dede, *s.* 15/502 ;
 dede, *pret.* 2/42, 4/118, 18/606, 21/
 724, 22/762, 37/1298, 37/1302,
 50/1742, 54/1896, 56/1948, 57/
 1986, 70/2468, 75/2630, 75/2638,
 91/3204, 95/3346, 110/3890, 114/
 4016, 117/4140 ;

for-dede, *pret.* 13/426. *See* bede,
 dede, *pret.*, mis-dede, undede, vn-
 dede, deden, queðe.
undede, *pret.*
 stede, *s.* 17/582.
vn-dede, *pret.*
 stede, *s.* 84/2956.
wech-dede. *See* mide.

-eden

beden. *See* deden.
deden, *pret. pl.*
 beden, *pp.* 63/2212 ;
 stede, *s.* 94/3296 ;
 stede[n], *s.* 101/3552 ;
 steden, *s. sg.* 32/1114. *See* steden,
 s. pl., abiden.
leden, *inf.*
 ðeden, *s. pl.* 66/2302. *See* speden.
speden, *inf.*
 leden, *inf.* 66/2304.
stede[n]. *See* deden.
steden, *s. sg.* *See* deden.
steden, *s. pl.*
 deden, *pret. pl.* 98/3442.
ðeden, *s. pl.* *See* leden.
ðeden, *adv.*
 queðen, *inf.* 51/1792.

-eed

reed, *s.*
 dred, *s.* 20/694 ;
 godfulhed, *s.* 2/56 ;
 ned, *s.* 36/1242 *See* sped, *s.*

-een

seen. *See* ben, *inf.*
teen. *See* a-gen, *adv.*
treen. *See* ben, *inf.*

-eet

neet, *s. pl.*
 gret, *a.* 60/2098.

-ef

Calef, *s.*
 lef, *a.* 106/3740 ;
 ref, *a.* 106/3726.
dref. *See* lef.
lef, *a.*
 dref, *s.* 118/4144. *See* Calef, ðef.
ref. *See* Calef.
ðef, *s.*
 lef, *a.* 51/1774.

gete, *adv.* *See* mete.
mete, *s.*
 eten, *inf.* 44/1538 ;
 gete, *adv.* 43/1488. *See* gete, *v.*

-eten

bi-geten, *inf.*
 eten, *inf.* 104/3670 ;
 for-geten, *inf.* 58/2022 ;
 teten, *s. pl.* 99/3480. *See* eten, *inf.*,
 for-geten, *pp.*, freten, *inf.*, ouer-
 meten.
bi-geten, *pp.*
 feten, *inf.* 78/2744 ;
 for-geten, *inf.* 27/912 ;
 for-geten, *pp.* 33/1152, 89/3128. *See*
 for-geten, *pp.*
eten, *inf.*
 bi-geten, *inf.* 44/1532 ;
 for-geten, *inf.* 40/1400, 52/1806, 105/
 3682. *See* mete, bi-geten, *inf.*,
 mete[n], *s.*, meten, *s.*, wliten.
eten, *v. sbj.* *See* mete[n] (?)
eten, *pp.*
 forgeten, *inf.* 10/330.
feten. *See* bi-geten, *pp.*
for-geten, *inf.* *See* bi-geten, *inf.*, bi-
 geten, *pp.*, eten, *inf.*, eten, *pp.*,
 freten, *pp.*, meten, *pp.*
for-geten, *pp.*
 bigeten, *inf.* 62/2180 ;
 bi-geten, *pp.* 77/2706. *See* bi-
 geten, *pp.*
freten, *inf.*
 bi-geten, *inf.* 114/4028.
freten, *pp.*
 for-geten, *inf.* 60/2102.
mete[n], (?)
 eten, *v. sbj.* 90/3152.
mete[n], *s.*
 eten, *inf.* 11/364, 104/3658.
meten, *s.*
 eten, *inf.* 60/2080, 65/2256.
meten, *pp.*
 forgeten, *inf.* 77/2702.
ouer-meten, *pp.*
 bi-geten, *inf.* 48/1666.
teten. *See* bi-geten, *inf.*

-eð, eth

beð. *See* seð.
bleð, *a.*
Iareth, *s.* 111/3908. *See* Iaca-
 beð.

Iacabeð, *s.*
 bleð, *a.* 74/2590.
Iareth. *See* bleð.
leð. *See* fed.
með. *s.*
 seð, *v.* 3 *sg.* 6/196.
 seð, *v.* 3 *sg.*
 beð, *v.* 3 *sg.* 6/182. *See* með.

-eðe

queðe, *s.*
 stede, *s.* 114/4012.

-eðen

beðen, *inf.*
 bi-queðen, *inf.* 70/2448.
bi-neðen, *adv.*
 queðen, *inf.* 114/4002 ;
 queðen, *pp.* 112/3944. *See* queðen,
 inf., quuemeðen, ðeðen.
bi-queðen. *See* beðen.
queðen, *inf.*
 bi-neðen, *adv.* 100/3526. *See* bi-
 neðen, ðeden, *adv.*, ðeðen.
queðen, *pp.* *See* bi-neðen.
quuemeðen, *pret. pl.*
 bi-neðen, *adv.* 4/126.
ðeðen, *adv.*
 bi-neðen, *adv.* 3/66 ;
 queðen, *inf.* 79/2788.

-eðer

alðerneðer, *adv.*
 weðer, *s.* 113/3998.
neðer. *See* liðer.
weðer. *See* alðerneðer.

-eue

dreue. *See* Eue.
Eue, *s.*
 dreue, *inf.* 10/318.

-euen, ewen

bi-lewen, *inf.*
 liuen, *inf.* 64/2234.
geuen, *pp.*
 liuen, *inf.* 75/2610. *See* liuen, *v. pl.*

-euene, euone

euene, *adv.*
 heuone, *s.* 10/332.

-ew

glew, *s.*
 knew, *pret.* 14/460.

-i, -y

Adonay. *See* for-ði.
Ai. *See* seli.
Ay. *See* Sarray.
bi, *adv.*
 Gibi, *s.* 24/826.
bi, *postp. See* for-ði, redi, Sarray,
 seuenti, weri.
dor-bi, *adv.*
 for-ði, *adv.* 47/1638.
dredi. *See* slepi.
Eley, *s.*
 Ely, *s.* 83/2904.
Eliopoli, *s.*
 forði, *adv.* 57/2004.
for-ði, *adv.*
 Adonay, *s.* 83/2902 ;
 bi, *postp.* 91/3208 ;
 her-bi, *adv.* 58/2034 ;
 Leui, *s.* 53/1862 ;
 sti, *s.* 112/3958 ;
 wi, *s.* 53/1854, 92/3220. *See* dor-bi,
 Eliopoli, merci, Moysi, Sarrai,
 Sinay, ðor-bi.
Gibi. *See* bi, *adv.*
gredi. *See* weri.
her-bi. *See* for-ði, Moysi.
Leui. *See* for-ði.
merci, *s.*
 for-ði, *adv.* 63/2208. *See* Synay.
Moysi, *s. dat.*
 for-ði, *adv.* 77/2692 ;
 her-bi, *adv.* 101/3572.
redi, *a.*
 bi, *postp.* 107/3760.
Sarrai, *s.*
 for-ði, *adv.* 22/766 ;
 untuderi, *a.* 28/964.
Sarray, *s.*
 Ay, *s.* 23/800 ;
 bi, *postp.* 22/742 ;
 sori, *a.* 28/974 ;
 sort-leui, *a.* 21/712.
seli, *a.*
 Ai, *s.* 22/760.
seuenti, *a.*
 bi, *postp.* 42/1454, 104/3666.
Sinay, *s.*
 forði, *adv.* 94/3310.
Synay, *s.*
 merci, *s.* 102/3600 ;
 ðor-bi, *adv.* 79/2774. *See* ðor-bi.
slepi, *a.*
 dredi, *a.* 25/872.

sori. *See* Sarray.
sort-leui. *See* Sarray.
sti. *See* for-ði.
ðor-bi, *adv.*
 for-ði, *adv.* 113/4000 ;
 Synay, *s.* 96/3362, 109/3850. *See*
 Synay, ðritti, tidi.
ðritti, *a.* [xxxvij = seuen and ðritti].
 ðor-bi, *adv.* 42/1458.
tidi, *a.*
 ðor-bi, *adv.* 60/2106.
untuderi. *See* Sarrai.
weri, *a.*
 bi, *postp.* 28/976 ;
 gredi, *a.* 43/1494.
wi. *See* for-ði.

-ib

rib, *s.*
 sib, *a.* 7/228.

-ic

geuelic. *See* dik.

-id

bi-tid, *pp.*
 hid, *pp.* 11/358, 74/2592, 78/2732,
 117/4138. *See* for-hid, hid, kid,
 srid.
for-hid, *pp.*
 bi-tid, *pp.* 54/1876.
hid, *pp.*
 bi-tid, *pp.* 34/1194. *See* bi-tid, srid.
kid, *pp.*
 bi tid, *pp.* 67/2358.
srid, *pp.*
 bi-tid, *pp.* 57/1978 ;
 hid, *pp.* 11/380.
tid, *s.*
 wid, *a.* 2/60, 8/264.

-ide

mide, *adv.*
 dede, *pret.* 84/2964, 91/3198, 104/
 3656 ;
 wech-dede, *s.* 70/2460. *See* dede,
 pret.
ride. *See* dede, *pret.*
ðor-mide. *See* dede, *pret.*

-iden

abiden, *pret. pl.*
 deden, *pret. pl.* 71/2484 ;
 gliden, *pp.* 98/3460.

gliden. *See* abiden.
hiden. *See* sriden.
sriden, *inf.*
 hiden, *inf.* 11/352.

-ider

hider, *adv.*
 to-gider, *adv.* 67/2352.

-if

lif, *s.*
 strif, *s.* 8/268, 23/778, 70/2440, 103/
 3638 ;
 wif, *s.* 22/768, 34/1170, 99/3484.
 See strif, wif.
rif. *See* wif.
strif, *s.*
 lif, *s.* 6/176, 15/504, 108/3818 ;
 wif, *s.* 23/780. *See* lif, wif.
wif, *s.*
 lif, *s.* 9/304, 10/316, 12/398, 34/1174,
 39/1364, 41/1440, 46/1594, 97/
 3402 ;
 rif, *a.* 7/232, 36/1252 ;
 strif, *s.* 21/716, 25/860, 34/1182. *See*
 lif, strif.

-igt

brigt, *s.*
 ligt, *s.* 5/144.
brigt, *a.*
 ligt, *s.* 5/154 ;
 ligt, *a.* 93/3256 ;
 rigt, *a.* 118/4148 ;
 rigt, *adv.* 28/952, 115/4040. *See*
 migt, nigt.
figt, *s.*
 nigt, *s.* 38/1318. *See* migt, nigt,
 rigt, *adv.*, wigt.
fligt, *s.*
 migt, *s.* 5/162 ;
 nigt, *s.* 5/166.
frigt. *See* migt, nigt.
fugel-fligt, *s.*
 rigt, *adv.* 94/3322.
knigt, *s.*
 ligt, *a.* 9/284.
lig[t], *s.*
 nig[t], *s.* 8/246.
ligt, *s.*
 migt, *s.* 2/54, 5/168 ;
 nigt, *s.* 3/76, 9/288 ;
 rigt, *adv.* 30/1050. *See* brigt, *s.*,
 brigt, *a.*, nigt.
ligt, *a. See* brigt, *a.*, knigt, nigt.

ligt, *adv. See* rigt, *adv.*
ligt, *pp.*
 o-frigt, *pp.* 104/3652.
migt, *s.*
 brigt, *a.* 4/132, 118/4156 ;
 figt, *s.* 26/898 ;
 frigt, *s.* 35/1234 ;
 up-rigt, *adv.* 92/3248. *See* fligt,
 ligt, *s.*, nigt.
nig[t]. *See* lig[t].
nigt, *s.*
 brigt, *a.* 31/1058 ;
 figt, *s.* 25/870, 31/1066, 42/1470, 88/
 3086 ;
 frigt, *s.* 28/950 ;
 ligt, *s.* 2/44, 3/90, 4/114, 4/130, 5/158,
 94/3294, 112/3948, 118/4158 ;
 ligt, *a.* 51/1782 ;
 migt, *s.* 17/584, 52/1802, 70/2450 ;
 offrigt, *pp.* 105/3692 ;
 rigt, *adv.* 3/80, 46/1604, 61/2124,
 70/2462, 90/3160, 93/3288. *See*
 figt, fligt, ligt, *s.*, pligt, *s.*, rigt, *s.*,
 rigt, *adv.*
offrigt. *See* nigt.
ofrigt, *pp.*
 o-rigt, *adv.* 64/2226. *See* ligt, *pp.*
 onigt.
onigt, *adv.*
 o-frigt, *pp.* 59/2050.
o-rigt. *See* ofrigt.
pligt, *s.*
 nigt, *s.* 103/3612 ;
 rigt, *s.* 36/1270.
pligt, *pp.*
 un-rigt, *s.* 37/1276.
rigt, *s.*
 nigt, *s.* 37/1300. *See* pligt, *s.*, v[n]-
 frigt.
rigt, *a. See* brigt, *a.*
rigt, *adv.*
 figt, *s.* 26/886, 77/2682 ;
 ligt, *adv.* 64/2252 ;
 nigt, *s.* 70/2454, 84/2952. *See* brigt,
 a., fugel-fligt, ligt, *s.*, nigt.
v[n]-frigt, *a.*
 rigt, *s.* 105/3714.
un-rigt. *See* pligt, *pp.*
up-rigt. *See* migt.
wigt, *a.*
 figt, *s.* 25/864.

-igti

frigti. *See* migti.

migti, *a.*
 frigti, *a.* 29/984.

-ik

dik, *s.*
 geuelic, *adv.* 9/282.

-ike

arsmetike. *See* witterlike.
bitter-like, *adv.*
 luue-like, *adv.* 117/4126.
bliðelike, *adv.*
 sikerlike, *adv.* 43/1500. *See* milde-
 like.
brigt-like, *adv.*
 witterlike, *adv.* 99/3492.
festelike, *adv.*
 witterlike, *adv.* 97/3408.
frigtilike, *adv.*
 mildelike, *adv.* 62/2164 ;
 wittirlike, *adv.* 47/1618.
kinde-like. *See* mildelike.
lecherlike. *See* witterlike.
liðer like, *adv.*
 witterlike, *adv.* 45/1564. *See* bi-
 swiken.
luue-like. *See* bitter-like.
mildelike, *adv.*
 bliðelike, *adv.* 41/1424 ;
 kinde-like, *adv.* 71/2500 ;
 selðhelike, *adv.* 39/1372 ;
 witterlike, *adv.* 38/1322. *See* frigti-
 like, witterlike.
miserlike. *See* witterlike.
modilike. *See* opelike.
opelike, *adv.*
 modilike, *adv.* 74/2584.
selðhelike. *See* mildelike.
sikerlike, *adv.*
 witterlike, *adv.* 66/2320. *See* bliðe-
 like.
swike, *a. pl.*
 witterlike, *adv.* 81/2846.
trike, *s.*
 witterlike, *adv.* 84/2948.
witterlike, *adv.*
 arsmetike, *s.* 23/792 ;
 lecherlike, *adv.* 22/770 ;
 milde-like, *adv.* 79/2778 ;
 miserlike, *adv.* 76/2658. *See* brigt-
 like, festelike, liðer-like, milde-
 like, sikerlike, swike, trike.
wittirlike. *See* frigtilike.

-iken

bi-swiken, *pp.*
 liðerlike, *adv.* 101/3562.

-il

hil, *s.*
 wil, *s.* 17/588, 37/1294, 113/3996.
sckil, *s.*
 wil, *s.* 7/204.
[s]kil. *See* wil.
skil, *s.*
 wil, *s.* 6/194, 41/1426, 92/3236.
ðor-til, *adv.*
 wil, *s.* 68/2372.
unskil. *See* wil.
vn-skil. *See* wil.
wil, *s.*
 [s]kil, *s.* 2/52 ;
 unskil, *s.* 10/342 ;
 vn-skil, *s.* 100/3506. *See* hil, sckil,
 skil, ðor-til.

-ild

child, *s.*
 milde, *a.* 29/986. *See* fild, mild.
fild, *pp.*
 child, *s.* 35/1226.
mild, *a.*
 child, *s.* 75/2636. *See* childe.

-ilde

childe, *s.*
 mild, *a.* 37/1306.
milde. *See* child.

-ile

quile, *s.*
 spile, *s.* 98/3462 ;
 wile, *v.* 3 *sg.* 93/3276, 98/3444.
sile. *See* spile.
spile, *s.*
 sile, *s.* 85/2978. *See* quile.
tile, *s.*
 wile, *v.* 3 *sg.* 44/1520.
wile, *v.* 3 *sg.*
 wile, *v.* 3 *sg.* 58/2020. *See* quile, tile.

-iled

hiled. *See* spiled.
spiled, *pp.*
 hiled, *pp.* 91/3184.

-ilen

spilen. *See* wilen.

wroken, *pp. or pret. pl.*
broken, *pp.* 91/3192.

-old

arche-wold. *See* hold (= old).
awold,
　bold, *a.* 78/2728 ;
　told, *pp.* 48/1672 ;
　wold, *pp.* 16/526. *See* cold.
bi-told. *See* hold (= old), *a.*
bold, *a.*
　o-wold, 10/324 ;
　told, *pp.* 55/1918 ;
　wold, *s.* 61/2122. *See* awold.
cold, *a.*
　a-wold, 56/1944 ;
　wold, *s.* 57/2000. *See* wold, *pp.*
gold, *s.*
　hold, *a.* 77/2704, 93/3284. *See* hold,
　　hold, *a.*
hold, (?)
　gold, *s.* 112/3942.
hold, *a.*
　gold, *s.* 23/794, 40/1390. *See* gold.
hold (= old), *a.*
　arche-wold, *s.* 17/576 ;
　bi-told, *pret.* 27/920 ;
　manige-fold, *a.* 71/2502 ;
　told, *pp.* 30/1028, 54/1894, 83/2912,
　　106/3736, 116/4088 ;
　wold, *s.* 27/938 ;
　wold, *pp.* 13/420.
manige-fold. *See* hold (= old).
old, *a.*
　sold, *pp.* 55/1908 ;
　told, *pp.* 35/1206, 39/1358, 42/1476.
　　See told.
o-wold. *See* bold.
sold, *pp.*
　wold, *s.* 56/1958. *See* old, told.
told, *pp.*
　old, *a.* 19/658, 29/990, 37/1284, 118/
　　4146 ;
　sold, *pp.* 57/1994 ;
　wold, *s.* 97/3412 ;
　wold, *s.* 110/3892. *See* awold, bold,
　　hold (= old), old.
wold, *s.* (= hill). *See* hold (= old),
　told.
wold, *s.* (= power, &c.). *See* bold,
　cold, sold, told.
wold, *pp.*
　cold, *a.* 8/256. *See* awold, hold
　　(= old).

-olde

arche-wolde. *See* olde.
golde, *s.*
　wolde, *pret.* 103/3620.
olde, *a.*
　arche-wolde, *s. dat.* 18/614.
wolde. *See* golde.

-olen

colen, *s. pl.*
　ðolen, *inf.* 76/2654.
for-holen, *pp.*
　stolen, *pp.* 51/1760, 66/2318, 67/
　　2332. *See* stolen, ðolen, *v. pl.*
for-olen, *pp.*
　stolen, *pp.* 50/1748.
stolen, *pp.*
　for-holen, *pp.* 54/1870. *See* for-
　　holen, for-olen.
ðolen, *inf.*
　to-bolen, *pp.* 28/970. *See* colen.
ðolen, *v. pl.*
　for-holen, *pp.* 98/3446.
to-bolen. *See* ðolen, *inf.*

-om

hom. *See* on-on.

-ome

come, *s.*
　nome, *s.* 65/2268.

-omen

comen. *See* numen.
nomen, *pp.*
　cumen, *inf.* 87/3040.

-on

Aaraon. *See* on, *postp.*
Aaron, *s.*
　don, *inf.* 85/2980 ;
　don, *pp.* 109/3842 ;
　gon, *inf.* 108/3800, 116/4094 ;
　on, *postp.* 85/2998 ;
　ouer-gon, *inf.* 99/3490 ;
　Pharaon, *s.* 85/2986, 87/3064 ;
　ston, *s.* 96/3388 ;
　ðor-on, *adv.* 109/3838. *See* a-non,
　　on, *postp.*, vt-gon, *pp.*
Abiron, *s.*
　a-non, *adv.* 107/3758. *See* don, *pp.*
a-gon, *pp. See* a-gon, *adv.*
a-gon, *adv.*
　a-gon, *pp.* 3/78 ;

mune, *inf.* 69/2422 ;
wune, *s.* 15/494, 20/676, 47/1652,
55/1910, 96/3370 ;
wune, *v.* 33/1156, 36/1254 ;
wune, *a.* 44/1530 ;
wunen, *inf.* 12/404, 27/932. *See*
mune, *sbj. or imp.*, wune, *s.*
wune, *s.*
mune, *inf.* 28/972 ;
sune, *s.* 15/514, 39/1346, 40/1406,
43/1502, 75/2626 ;
sunen, *s. ? pl.* 48/1656. *See* sune.
wune, *v. See* sune.
wune, *a. See* sune.

-unen

munen, *inf.*
binumen, *pp.* 6/198 ;
wunen, *s. pl.* 20/688. *See* cumen,
inf., wunen, *s. pl.*
munen, *v. pl. See* sunen, *s. pl.*
sunen, *s. pl.*
cumen, *inf.* 62/2176 ;
munen, *v. pl.* 16/558, 39/1350 ;
wunen, *s. pl.* 99/3482 ;
wunen, *inf.* 42/1448, 54/1898 ;
wunen, *v. pl.* 19/648 ;
wunen, *pp.* 83/2900. *See* wune, *s.*
sunen, *inf. See* wunen, *inf.*
wunen, *s. pl.*
cumen, *pp.* 23/802 ;
munen, *inf.* 89/3138. *See* munen,
inf., sunen, *s. pl.*
wunen, *inf.*
numen, *pp.* 11/368 ;
sunen, *inf.* 53/1864. *See* cumen,
inf., sune, sunen, *s. pl.*
wunen, *v. pl.*
cumen, *pp.* 17/570 ;
numen, *pp.* 97/3416. *See* sunen,
s. pl.
wunen, *pp.*
cumen, *inf.* 94/3290. *See* sunen,
s. pl.

-unes

sunes, *s. gen. sg. See* wunes.
sunes, *s. pl.*
wunes, *s. pl.* 43/1480. *See* wuncs.
wunes, *s. pl.*
sunes, *s. gen. sg.* 43/1496 ;
sunes, *s. pl.* 16/540, 66/2294. *See*
sunes, *s. pl.*

-uneð

muneð, *v.* 3 *sg.*
wuneð, *v.* 3 *sg.* 69/2410.

-urg

burg, *s.*
ðurg, *postp.* 110/3882 ;
ut-ðhurg, *adv.* 77/2688.

-urn

suriurn. *See* turn.
turn, *s.*
suriurn, *s.* 3/64.

-us

Exodus. *See* vs.
hus, *s.*
us, *pron.* 17/1620.
vs, *pron.*
Exodus, *s.* 73/2538.

-uth (= ut)

Teremuth, *s.*
out, *adv.* 75/2616.

uð.

guð, *s.*
kuð, *pp.* 76/2666.
muð, *s.*
selcuð, *a.* 113/3972.

-uue

xi°. (= endluue), *a.*
luuo, *s.* 55/1922.

-uuen

a-buuen, *adv.*
luue[n], *s.* 57/2002 ;
ut-suuen, *pp.* 46/1610. *See* luue[n],
luuen, *s.*, luuen, *inf.*, luuen, *v. pl.*,
suuen.
luue[n], *s.*
a-buuen, *adv.* 44/1518. *See* a-
buuen.
luuen, *s.*
a-buuen, *adv.* 19/636, 116/4082.
luuen, *inf.*
abuuen, *adv.* 1/10.
luuen, *v. pl.*
abuuen, *adv.* 2/50.
suuen, *pp.*
a-buuen, *adv.* 4/108.
ut-suuen. *See* a-buuen.

ABBREVIATIONS USED IN THE INDEX OF RIMES.

a. = adjective; *adv.* = adverb; *conj.* = conjunction; *dat.* = dative; *gen.* = genitive; *imp.* or *imper.* = imperative; *inf.* = infinitive; *int.* = interjection; *p.* = participle; *pl.* = plural; *postp.* = postposition; *pp.* = past or passive participle; *pres.* = present; *pret.* = preterite; *pron.* = pronoun; *s.* = substantive; *sbj.* = subjunctive; *sg.* = singular; *v.* = verb.

ADDITIONS.

P. 239, add 'ston' to the cross-references under 'agen, *postp.*'

P. 239, after 'bi-twen, *postp.*' under 'ben, *inf.*' insert '51/1776.'

JOHN CHILDS AND SON, PRINTERS.